W9-AVS-523

THE ARTS

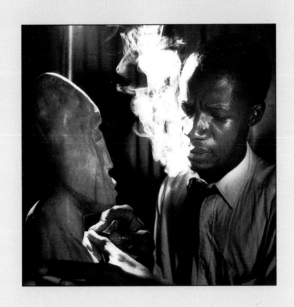

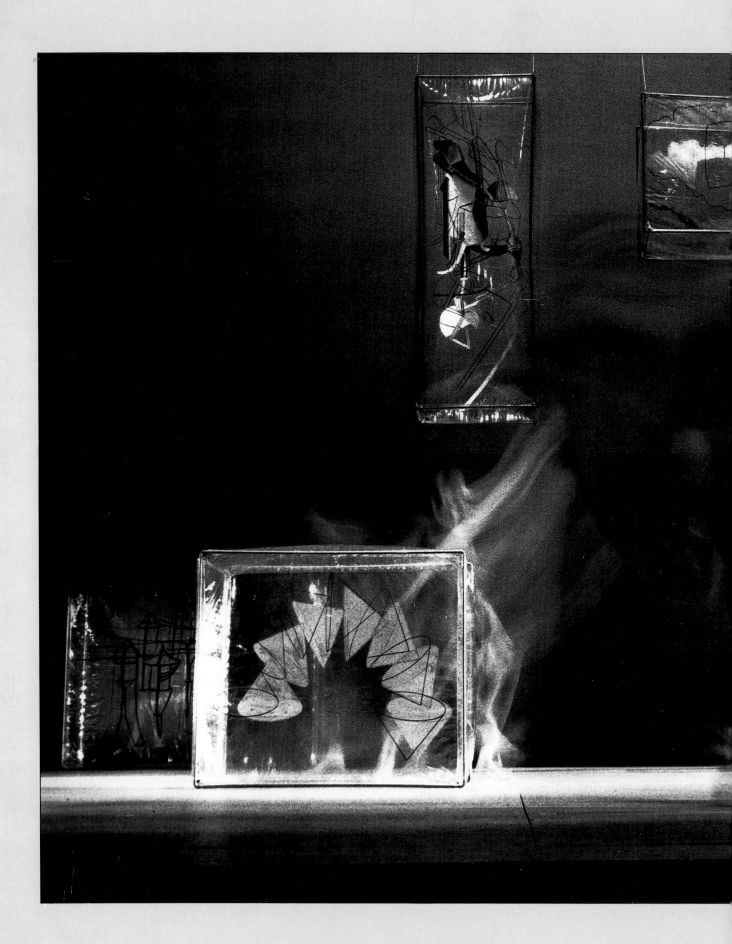

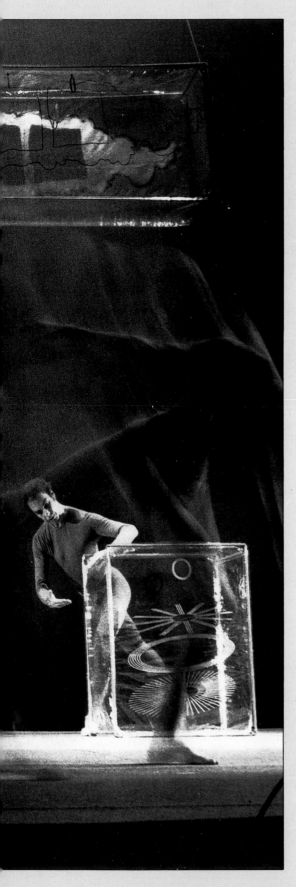

THE ARTS

A History of Expression in the 20th Century

EDITED BY

RONALD TAMPLIN

Oxford • New York
OXFORD UNIVERSITY PRESS
1991

Volume editor Sue Martin
Art editors Ayala Kingsley, Dave Sumner
Designers Frankie Macmillan, Wolfgang Mezger, Tony de Saulles
Picture research manager Alison Renney
Picture editor Christine Vincent
Picture research Diana Phillips
Project editor Peter Furtado

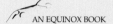

AN EQUINOX BOOK

Planned and produced by
Andromeda Oxford Ltd

Copyright © Andromeda Oxford
Ltd 1991

Published in the United States of
America by
Oxford University Press, Inc.
200 Madison Avenue
New York NY 10016

Oxford is a trademark of Oxford
University Press

All rights reserved. No part of this
publication may be reproduced,
stored in a retrieval system, or
transmitted, in any form or by any
means, electronic, photocopying,
mechanical, or otherwise, without
permission of the publisher.

ISBN 0-19-520852-8

Library of Congress Catalog Card
Number: 90-52898

Printing (last digit) 9 8 7 6 5 4 3 2 1

Printed in Singapore by
CS Graphics

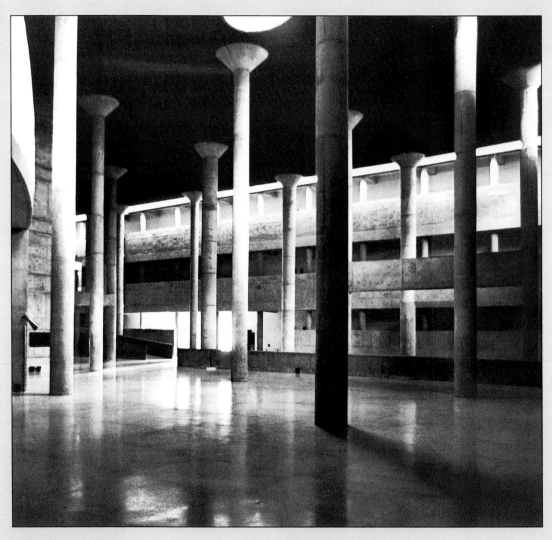

ADVISORY EDITORS

Richard Maltby
University of Exeter

Mike Weaver
Linacre College, Oxford

CONTRIBUTORS

Jill Burrows Freelance writer

Richard Hayward Oxford Polytechnic

W.N. Herbert Freelance writer

Louise Jones Freelance writer

Judith Mackrell *The Independent*, London

Rosalind Marsh University of Bath

Dan Millar Freelance writer

Paul Oliver Oxford Polytechnic

Michael Wood University of Exeter

CONTENTS

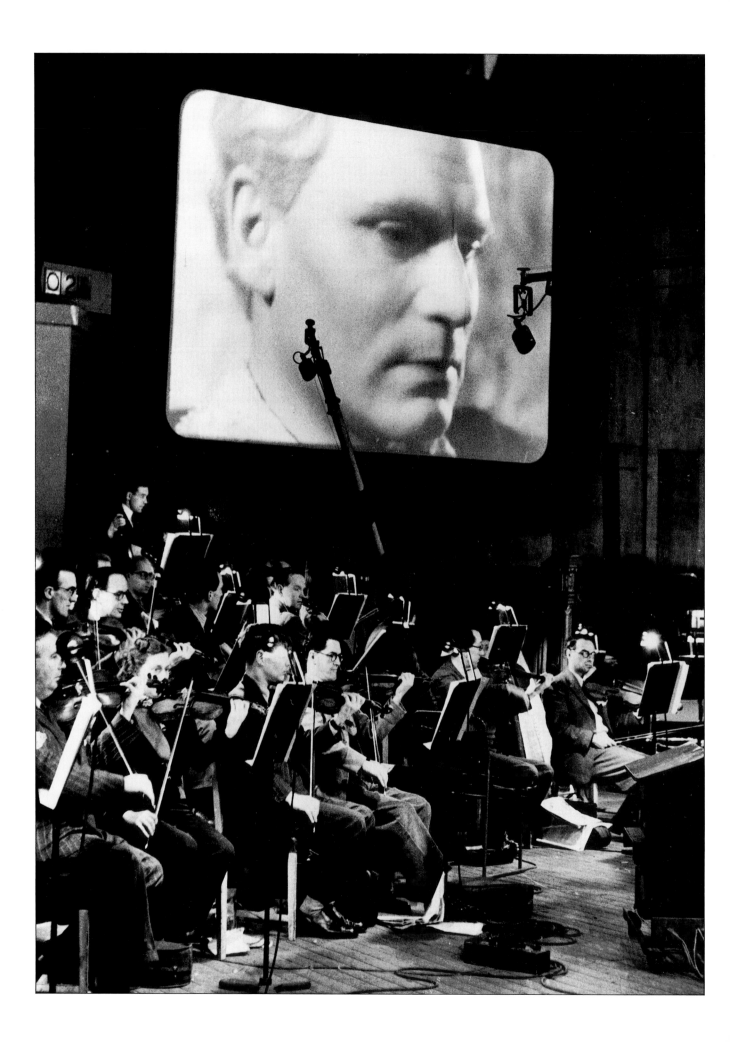

PREFACE

The arts are one of the most important ways by which we understand the world and ourselves. The complex world of the 20th century has called forth a complex art. But to fail to try and understand what artists have perceived is to make their art – and our world – seem more complex, not less. Just as the pace of change has accelerated in every other sphere, expression in the arts has changed profoundly. We need to be able to map these changes and to feel at first hand their excitements.

Artists, architects, composers and writers have produced works of great daring throughout the century. Developments in transport and communications technology have made what they do more instantly available to more people in the world than ever before. At the same time people have felt the fatigue of keeping up with relentless change. Many have been overwhelmed by the question of how to select what is vital from what can safely be left as padding; this is especially true in the arts which are sometimes obscurely, rather than immediately pleasurable.

This book comes from a team of writers expert in literature, visual arts, architecture, music and the performing arts. But they are all conscious that there is a story to be told, not just of fact but of feeling too. They are aware that, as the world moves towards the year 2000, this cannot be just another book telling the story of the acknowledged masterpieces of modern art, from Picasso to Warhol or Schoenberg to Stockhausen. That story is here, as crisp as it should be, because, without these masterpieces, not only would the Western fine arts in the century be very different, but much broader cultural perceptions would not exist as they do. The arts of the whole world, in Africa and India, in the Pacific and the Americas would also be different without Picasso and Proust, Debussy and Stravinsky. So the story of a modern art born in Europe extends to the world and then turns back to criss-cross the globe; and sounds, colors, words and ways of life become the interchange of art. This book sets out to tell this intertwined story and to listen in on a global conversation as it gradually becomes clearer and moves from one center to many centers throughout the world.

Potentially such a story has a cast of thousands and, naturally, each contributor has selected some rather than others to concentrate on. This has not always been easy. The principle followed has not been to make dubious value judgments but to see whether an artist's works add something new to the story and put somewhere new on the map. It is therefore a book that leads not just to New York and Paris but to the Pacific, India, Africa and Latin America. There are a fair number of introductions to be made, more introductions than apologies. The aim is to encourage the reader to read more books, look at more buildings, feel the excitement of more pictures, hear more music. Experiencing the arts is the key to knowing about them and this book is offered to that end.

In the 20th century the role, even the nature of art has been questioned, not least by artists themselves. What relevance have the arts in the face of horrific war, holocaust, paralyzing spiritual doubt? If this book leads to questions, they are asked in hope not fear. What the French writer Albert Camus said of books is true of the arts in general, "a despairing literature is a contradiction in terms."

Ronald Tamplin University of Exeter

INTRODUCTION

Art is not something remote from us. We make art whenever we apply our imagination to the circumstances of life; and so we always exist in a condition of art, of invention. The skills of art are deployed when we play a sport, when we add seasoning to a meal, decorate a room, choose a dress or a neck tie or decide what would be the best way, tactfully, to approach our bank manager or our client. In short, art is present in any human action where function is not the whole story. Far from being rarefied and elitist, art is everpresent to us and vital to our being, the lubricant which allows free movement in our lives and lets us work.

Art is usually thought of in a more limited sense, to mean the fine arts – painting, sculpture, literature, music – the applied arts such as architecture and design, or the performing arts such as opera, theater, dance or film. Many of these have a history in Western civilization which links them closely to the cultural elite, to the royal or imperial courts of Paris, London and Vienna, or Italian city-states, or the 19th century centers of middle- and upper-class culture. One feature of this traditional approach to the arts was their emphasis on notions of beauty, which derived ultimately from the ancient Greeks. This classical esthetic was basic to judgements about what was good or bad in art, and what was ugly and what was beautiful; however, it came under attack on a number of fronts from the end of the 19th century.

Adopting a much broader definition of art means that, in approaching the particular arts found in galleries, bookshops, concert halls, theaters and other buildings, we should be open-minded in searching out and banishing our undeclared assumptions about what is good or bad, interesting or dull. This has been especially necessary in the 20th century when the conditions of life, accelerated by technology, have given growing importance to change. The American poet Ezra Pound issued a dictum to artists and poets for the new century, "Make it new". This may have been an appropriate response for artists who sought to express the tenor of their times, but it meant that there was a danger of creating an art of as much obscurity as originality.

Yet the arts are produced for the rest of us as much as for the artist, and for our own dignity we should not be embarrassed if we choose to like or dislike particular works against the general view. Taken worldwide and through the century there has been no limit on human expression. The dictates of fashion are, by definition, temporary; they are included in the range of the arts, as much as in any other field, but cannot describe their full possibilities. Much of art (even that which is not purely the product of fashion) is still socially or culturally bound and it would be difficult for anyone to appreciate it *all* – even the art which claims, often loudly, to be of our times – without denying ourselves the freedom to choose what we like. Art is not supposed to limit freedom, especially the freedom to dissent from the prevailing or fashionable view.

Art is everywhere

Despite the broad assumptions that art is everywhere and choice is free, some more precise categories must be constructed. All arts have their disciplines and choice is best based on an informed knowledge of those disciplines. So it is with the particular arts on which this book concentrates: writing, architecture, music, the visual and the performing arts. They all have their codes of behavior. But however elitist some people may seek to make them appear, none of them is a distant art. To take them back to their origins, writing was about human contact, architecture about shelter. The others – music, painting and performance – are more enigmatic in origin but speculation tends to propose communal or ritual origins to them. So all these arts are central to human needs for love, warmth, fear, joy and survival. And although these origins may be disguised or hidden now, their traces still survive. Writing is still about communication (though other functions may have been added), and while, when we first learn to write, we think in terms of mundane messages, the seeds of an Alexander Solzhenitsyn or a James Joyce are there in these first labors, bearing the potential for communication or the lack of it at an international level.

Buildings, however controversial their looks may be, are still intended to provide shelter, though here too other functions, and other messages, may overlay this basic purpose. Office blocks, for example, shelter the economic membranes of our society and so contribute to the way we survive. The expressive power of music and painting at every level is clear, though we tend to think of these arts as being the outlets for the individual creative genius; their communal functions are clearer, perhaps, in a popular form, such as rock concerts, discos, the art of advertising, than in their "fine art" form. Nonetheless each one of those particular applications connects with so-called "high art". To watch the commercials on television, for example, is to be subjected to a barrage of artistic techniques developed in the painting of Europe from the middle of the 19th century; Impressionist imagery abounds, while the techniques of intercutting owe much to the experiments of the avant-garde filmmakers working in Russia in the early days of the Revolution. The arts are all around us, perhaps too much so. We are bombarded by them, innumerable tiny detonations that, like the drone of traffic past our doors, we learn not to notice.

If the arts are all around us, so too are the artists. In our time poets may take jobs as copywriters and teachers but the techniques of the catchphrase, the competition tiebreaker and the well-shaped lesson are the techniques of poetry. It is difficult to earn a full-time living as a novelist, composer or a painter and so, in modern society, such people will never form an elite or a class apart. It is to be expected that schools and universities, art colleges and music academies will give sanctuary to a lot of creative artists, but poets and painters in this century have, for example, worked as bankers, insurance men, civil servants, secretaries, solicitors, boilermakers, priests and doctors. Each of them is distinguished from the rest of us by one thing and one thing only, an excessive development of a single attribute: the courting and controlling of the imagination acting through words or images. They have succeeded in turning this excess to use. Which is what we all do, except for most people our "excesses" – our talents and expertise – fit us characteristically into different, more socially conditioned, roles. So job advertisements say "bricklayer wanted" or "sales person" or "systems analyst"; seldom do they ask for "a free spirit". The

commercial world often ignores that quality but it does not always kill it. And the artist makes a vocation, though not necessarily a living, out of freedom of the spirit.

The need for art

But how is that freedom of the spirit vital to society? The 19th century French sociologist Emile Durkheim argued that society maintains itself as a balance between specialized groupings and the different views, aptitudes or needs which go with them. The model seems a good one. The fact that there are coalminers enables others to be doctors and vice versa. Both are specializations, and we cannot be coalminers in our spare time, or heal each other's injuries as cheerful amateurs. Each of us carries particular burdens and reaps particular rewards in a more or less unconscious promotion of the general well-being of society. Only when the general good is not respected, and

something – usually wealth and its consequence, power – flows to some social group in excess of that group's need, does society tip into imbalance. But in all societies, however stable, there is movement towards one group or another.

Where there is always need for adjustment, there is a need to understand the past, account for the present and, indeed, to prophesy the future. And, as each shift occurs, the past, present and future will shift too, and each will need reevaluation. Much of this adjustment will be technical, requiring specialists in history, economics, science, politics and so on. But even in such theoretical fields the imagination is paramount, providing the facility to tell the story newly, to see and hear things differently as the vision or the rhythms of society change. This is the role of the artist, to operate as the imaginative cutting edge

▲ The entrance to the Paris Exhibition, 1900.

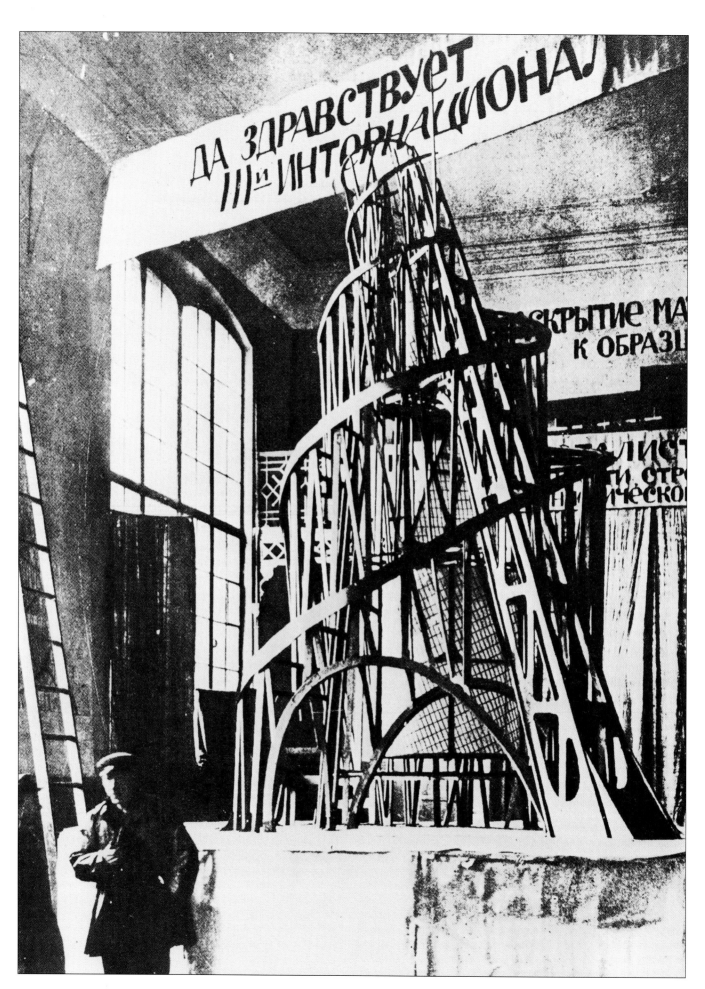

which helps to shape society's view of itself, by suggesting what it is and where it is at. In a stable society – one that knows its direction towards a spiritual or social ideal, perhaps over centuries – artists can themselves be stable and their arts come close to crafts, with techniques handed down and only subtly changed within a broad and affirming consensus of belief. But in times of rapid, often catastrophic, change the artist's role is very different, and may be confused. The artist may be out of step with the mainstream of the times. Allegiance to a contemplative ideal of stability may suddenly become an individual indulgence in a society which pursues a vision of progress based on materialism and skepticism; alternatively the artist may see a particular form of change as necessary, but this may appear socially unacceptable where other choices are possible. In such situations the artist has to maintain his position. It is not so crucial, in the long run, for him to convert others to his viewpoint, so much as to assert the simple freedom to assent or dissent, to see exclusion from the mainstream as a platform for comment and endeavor. In philosopher Jean-Paul Sartre's wry phrase, which he applied to humanity in general, the artist is "condemned to freedom".

In modern times, artists have often felt thrown on their own resources – characteristically the workings of their own minds – and have hoped simply that their minds will indicate something of general application. They have often had to accept that they may be ahead of their times, that the application of their vision will come later rather than sooner. As Paris celebrated the technological excitements of the new century in the Universal Exhibition of 1900, the art it chose to exhibit largely looked back to the well-acclimatized qualities of the 19th century. The men and women whose imaginations were to change the face of the 20th century were, many of them, working in Paris at the time; but they were mostly outside the pavilions, unreckoned. It was not just that they were new, young, poor and unknown but that there was no common basis for understanding their art. It was as yet free.

The artist and the market
Arguably no art can remain free for long. If the story of art is seen as a succession of declarative acts of imaginative freedom, then it follows that the freedom gained in one generation becomes the bondage of the next. Put another way, as each generation becomes successful it loses part of its freedom. The successful artist is like a country that has become dependent for survival on attracting tourists, its essence dying as its body survives. The difficulty faced by artists is that their art involves both individual and social expression and that the two may actually be in conflict. Nonetheless art, in most cases, can scarcely survive without society to support it, to see it and hear it, and to buy it. There is a network to provide this support, the art world. From the outside this world often seems chic and exclusive. The "private view" is important to the painter who hopes to sell some paintings, but to most people it looks more like a place where smart people go to see and be seen, a useless extravagance. Reports from the auction houses tell of enormous amounts of money paid for paintings bought for investment or display. A work by Van Gogh may sell for US$ 50 million or more; this figure is often contrasted with the tortured life of an artist who never sold a picture and who could have done with a little money to buy bread and paint.

The creativity of the artist, his freedom, seems swamped by the crudity of commercial valuations. But this world of sales, high finance and art critics is only the tip of the iceberg of the art world. Nor is it ultimately the most important part, just as examinations and degree ceremonies are not ultimately the

measure of education. The life of the artist is bound up with practical questions and involvement with frame makers, paint manufacturers, brushmakers: innumerable discussions with experts in supporting crafts, without whose skill and dedication few paintings could ever be completed in the form we know them. When a critic talks about "precise drawing", we know, among other things that are meant, one of the most fundamental and simple is that the artist has kept her pencil sharp. Every one of those distilled phrases used by the art critics to describe a drawing or painting depends ultimately on somebody mixing paints on a palette and, before that, in a factory.

There are other threads in the web of activity constituting the art world: models and teachers, gallery owners, electricians, agents, the authors of catalogs, journalists and, finally, spectators, people standing in front of pictures and looking at them. Similar networks exist for literature, or for music: specialist instrument makers, players, conductors, acoustics experts, electronics engineers, and at the end of it all, the audience. In the West the symphony orchestra can be seen as the elegant echo of a hugely organized and complex society. It is not simply a vehicle for a composer's musical vision but an endorsement of orchestral balance as an image of order. Acceptance of the structures, of course, does not determine what the composer chooses to utter through the ranks of strings, woodwind, brass and percussion. The point is, rather, that the artistic vision may be critical but it cannot be made without the help of society itself. Otherwise the artist is forever condemned to an audience of one.

It is a strange relationship between artist and audience. In earlier times, where many artists were attached to a patron and wrote with him or her as the most important member of the audience, the artist had somewhat more freedom, or at least had an allowance to create. If in the 17th century artists and composers were attached to a great court, then their music or painting could prosper and find sympathy in a known and responsive group. Nor would they normally need to seek outside it. But in the modern world their descendants compete for an audience in a free market. As a result they know very little about their audience as individuals, and may find it difficult even to get one. Alternatively, they may be aware of the need to satisfy the needs of different parts of the audience, each of which may have to be convinced in a different way. Writers, for example, have to persuade agents, editors and publishers of the worth of each of their works as against the works of other aspirants; and, once published, reviewers and readers will have their own views.

It is a hard enough school to write in with all these conflicting audiences in mind; and since, almost by definition, the best writers are different from and ahead of the generality of writing in their own time, explorers on the brink of discovery, the elaborate mechanisms employed by the market for sorting out the very best may actually inhibit recognition of it. It is probable that society strikes a balance based on a degree of calculated risk. The exploratory strangeness of the writing or the paintings has to be recognized and matched by the acumen of the editor or gallery owner. Artists then, though committed by their imagination to move beyond society, are yet conditioned by it. If the lead of the pencil is too long, protruding from its protective wood, it snaps off; the artist cannot, in fact, be too far ahead of the bunch.

In all this the audience plays the ultimately decisive role. It determines sales, appreciation and support. Theoretically

◄ **Model for Tatlin's Tower, 1920.**

11

individual artists can survive without these, at least for a time, before they abandon their work, opt for a pension from regular employment, or die; society may catch up with their work later, a researcher finding a bonanza in an attic or a bottom drawer. There are enough such cases for this scenario not to be dismissed as romantic nonsense. But there are not enough to challenge the general principle that, in a well-tuned society, artists and audience exist in a relationship of mutual interdependence; in return for imaginative services rendered, society, via the audience, gives the artist a modest security and occasional encouragement. Of course the art world, like any other, has its stars – people who gain fame, power and money – but they are not legion. In this balance the critics and the art market, the impresarios, the gallery owners and the publishers, serve as intermediaries. We need to appreciate where the artists stand in this balance if we are to understand ourselves. In essence they are very like the rest of us.

The diversity of modern art

The arts in this century are characterized more than anything else by their variety and their profusion. There has been no single formula, except latterly, perhaps, "anything goes". Yet artists have in many instances responded to the startling events of the political world, and sought to make their mark, sometimes even trying to use their art to shape events as they unfold. In revolutionary Russia, for instance, extraordinary artists like Vladimir Tatlin adopted the specious analogy that revolution in the arts would go hand in glove with revolution in the state. He promulgated a vision of a peoples' art, though the work he and his collaborators produced frightened most people off; yet the dynamism of the times meant that he could plan as daring a project as the *Monument to the Third International*, otherwise known as "Tatlin's Tower". It was never more than a model. It would have fallen down had it ever been built (it took another Russian Constructivist, Naum Gabo, to point this out), and this may be seen, in the fast-moving latter days of the century, as an example of the prophetic power of art. But, though it was never built, the fact that the project was seriously considered as a contribution to the Communist revolution, and gained the approval of the hard-headed revolutionary Lenin, did show that art and state can attempt to act together. The collaboration may call for accommodation and perhaps "a willing suspension of disbelief" on both sides but it is not impossible.

The arts in our century have been used to bolster the barbarity of the fascist or totalitarian state as well as to mourn its victims. They have been used to celebrate war as well as scorn it, to foster empire as well as to resist it, to feed on capital as well as to fight it. There is no single statement or stance that the arts make. In that sense, as the arts apply to the quarrels of society, they are the means of conducting the argument, not the end in itself. But in another sense the end of art is art itself, or so a large number of artists and writers in this century, in particular, have held. Such an idea is not so rarefied as it might sound. Nor was it as petulant as the doctrine of "art for art's sake", which was a late 19th century reprisal against cultural philistinism. Rather it was generated from a sense that art can construct an alternative creation, and that the attempt to do so is more important, and ultimately more valuable, than the attempt to engage directly in the political struggle.

The source for the idea that art is an end in itself lies in the difficulty of determining how art relates to nature, on the one hand, and society on the other. To what extent does it imitate the one and serve the other? Since perfect imitation is impossible and pure service is fraught with problems of commitment,

artists have increasingly sought to explain what they make as independent of both the natural world and also of the concerns of society (in terms both of subject matter and eventual impact). But such a position is also impossible to sustain. Simply by existing, an artist is inescapably a part of both the natural and the social world. Nonetheless thinking of this kind has led to an increasing preoccupation with the forms of art, and the interrelationships of its parts, at the expense of concern for an external meaning.

Such a situation was easy to assimilate to music, which is mathematical and abstract by its very nature, but in painting it required a shift away from attempts at representation of reality, however that is defined, towards a constructional interest in color, shape, the space enclosed by the frame and abstract relationships within it. In architecture it implied a move from organic form and analogy with the natural, and from the use of

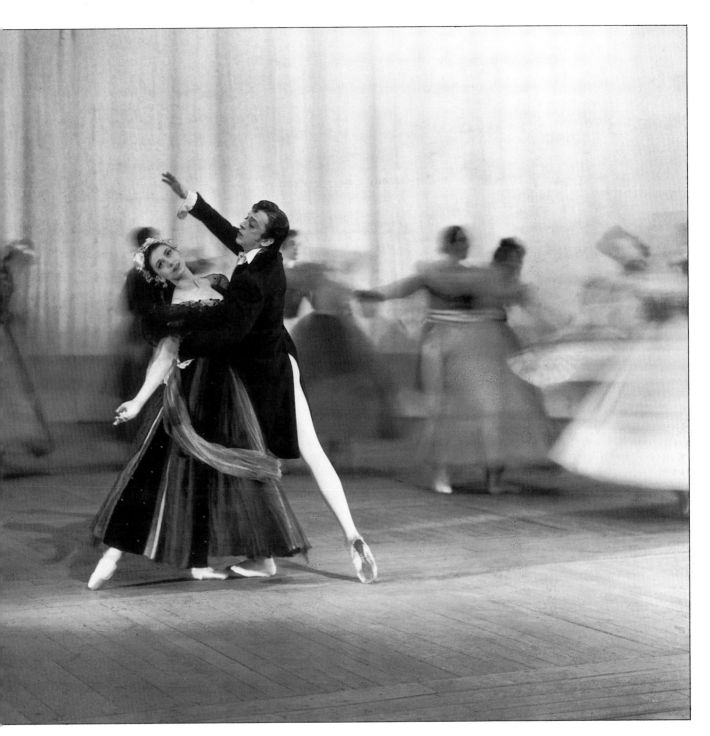

historical allusions, towards the geometric forms habitually associated with modernism. Writing was not so easily rendered independent from extrinsic references, in that words are difficult to separate from communication at the informational level. But by concentrating on the structure of novels, which were conceived as a balancing act between their parts, and a concern for suggested, "difficult" meaning, writers were able to make even novels look like alternatives to life. And there still remained the fact that very often we quite blatantly read novels as a means of escape, as an alternative to the tedium of everyday life; though what is merely escapist is, in fact, usually also in itself tedious.

The view of art as an end in itself allowed artists to claim they were in touch with some alternative world of form, in the French sociologist Jean Duvignard's luminous phrase, to see themselves as "priests of the absolute". So, far from being a declaration of nonparticipation in the world and society, art thus came to fill the gap in the social and intellectual fabric opened up by the challenge to religious faith from the mid-19th century on, and thereby adopted a novel social function. It is too simple to see art as a straightforward substitute for religion. Even in the West, the artists who pursued abstract and formal perfection as a key to an ultimate truth tended to see this as personal knowledge rather than to institutionalize it as a cult of art.

In the 20th century, then, art embraced a whiff of the eternal, the rigors of social realism, nostalgia for the past and the heady fervor of revolution. It both sought an audience and frustrated it. It is more to be understood in the variety of its forms than by blanketing it in a spurious unity.

▲ **Margot Fonteyn and Robert Helpmann.**

The sources of modern art

There is, nevertheless, a pattern to art in our century, an old yet lively story spiraled about by a newer one. The center from which the first story starts is Paris. Its various chapters pass through a multitude of art movements, many of which throw up acknowledged masterpieces, and the focus remains tightly on a group of familiar artists based, for the most part, in Paris, Berlin and New York. The newer story has many centers: to express it paradoxically, a global center. It is the story of the interaction of other parts of the world, some bringing ancient cultural traditions, others tending the offshoots of Western culture transplanted into a new and more spacious terrain, with the art of Europe and the West. It is an involvement that has brought a genuine exchange; sometimes the West has learnt new ways and new ideas from these other cultures, and sometimes the arts of the West have themselves flourished in unexpected ways in their new environments. To choose one instance, this story may be symbolized by the ballet partnership in the 1940s of Robert Helpmann, from Australia, island-continent of the Pacific, last sea to be mapped, and Margot Fonteyn, the doyenne of the traditional European ballet. But as we move towards the year 2000 such cultural meetings have become commonplace and art is now not so much metropolitan (centered on Paris, London or New York) but cosmopolitan. It is too early to estimate the loss and the gain in building such an international world, but it is not too early to give some account of the process.

The arts of this century are often gathered together under a single term, modern art. As has frequently been pointed out the artistic products of the time are actually very varied. Much of it is not distinctively "modern" at all, even though it may be vital to the century's art. The word "modern", in fact, particularly describes those modes that originated in Paris, with Paul Cézanne in the visual arts, with Marcel Proust and James Joyce among the writers and with Arnold Schoenberg among the composers. But there are other lines of descent. One could say that the modern age was shaped by a series of developments in thought which all were rooted in the 19th century – the political economy of Karl Marx, the evolutionary theory of Charles Darwin, the theology of Søren Kierkegaard, the philosophy of Friedrich Nietzsche and, crossing into the new century, the psychology of Sigmund Freud. Meanwhile, the "modern age" itself could be characterized in terms of a succession of disasters and regenerations in many societies: two World Wars, revolutions in Russia, Mexico and China, dictators and depressions, the decline of European empires and the birth of many new nations.

It is best to lay down the deep structures first, abbreviating their terms so that what is important for the production of art is uppermost. Karl Marx developed an analysis of history which contains two ideas that have had a particular potency in the arts of the 20th century, beyond the actual social and political effects of Marxist revolutionary politics themselves. First, he argued that, by due historical process, capital would inevitably be destroyed and the proletariat or working class would come into its own; in these circumstances it was assumed that art would inevitably become proletarian in its subjects and moral in its approach, rather than, as in capitalist society, privileged, cash-dominated and careless of its social obligations. The form of art that emerged from this analysis, in the Soviet Union and revolutionary China particularly, is called "Socialist Realism", but many artists in other countries have found inspiration in a form of realism that focuses on the working-class and the patterns of the class struggle.

Marx's other contribution to the mental framework of 20th century art is the concept of alienation. According to this theory, workers are estranged from their work since, in capitalist society, they can have no abiding interest in its outcome. The end result of capitalism is not simply our alienation from our work but even from the deepest needs of ourselves and our fellow beings. It would be too simple to derive the preoccupation with loss, anguish and depersonalization that has been common in art in the early part of the century, as in, for example, Expressionist painting and the novels of Franz Kafka, from no more than an idea proposed by Marx; but there is no question that the conditions of industrial society did bring about alienation and this has profoundly affected modern art.

The condition in which we exist also provided a basis for the examination of spiritual identity by the Danish theologian Kierkegaard, a quest for self in the crisis-racked individual. Kierkegaard's work lay, in particular, behind the Existentialist thinking of French philosopher and novelist Jean-Paul Sartre in and around World War II, which in turn had a worldwide effect, especially on writers.

Nietzsche, philosopher and powerful poet of *Also Sprach Zarathustra*, brought a widely-felt though slightly manic feel to much 20th century thinking. His celebration of the "will to power" and the "superman" certainly contributed to fascism, though his apologists, conscious of his brilliant if inchoate intellect, tend to underplay this link with *realpolitik* as a misunderstanding of what he intended. But the joyous nature of the will to power in Nietzschian utterances found other echoes, in the British novelist D.H. Lawrence for example. And another aspect of the German philosopher's thinking has had a general relevance to the century: his so-called relativism, or belief that there are no facts, only interpretations. From this angle it seems often difficult to believe anything, except momentarily and with "a passionate intensity". When Pablo Picasso said, for example, that "art is a lie that makes us realize truth" and that such "lies are necessary to our mental selves, as it is through them that we form our esthetic view of life", there may well have been a Nietzschian element in what he said. Nietzsche had argued that language falsified reality, but that the artificial structures it created ensured our survival. The relativism in Nietzsche's thought was the more potent because he did much to undermine the alternative certainties of faith that were offered by religion, especially Christianity with its emphasis on compassion and the acceptance of suffering. This was diametrically opposed to his own adulation of power.

Nietzsche claimed that God was dead. Man no longer thought in terms of the supernatural and so, in effect, replaced an external creator. In such a substitution the role of art and the imagination becomes crucial. But the more generalized effect of this dictum was to make doubt a more acceptable stance. Charles Darwin's investigations into the *Origin of Species*, in which he proposed the theory of evolution through natural selection, also struck a body-blow at traditional Christian views. Ironically, for the arts, in this viewpoint change itself could be seen as intrinsically more vital than it had been in the traditional worldview, since it was the very process by which life evolved. Natural selection provided a model for progressive views of human development and set the stage for condescending views of human races which were thought to be at an earlier (and therefore) lower stage of development.

This contributed to the ideology of imperialism, the belief that white Europeans were biologically as well as culturally superior to other races and therefore justified in seeking

▶ **Herbert von Karajan in rehearsal, 1958.**

14

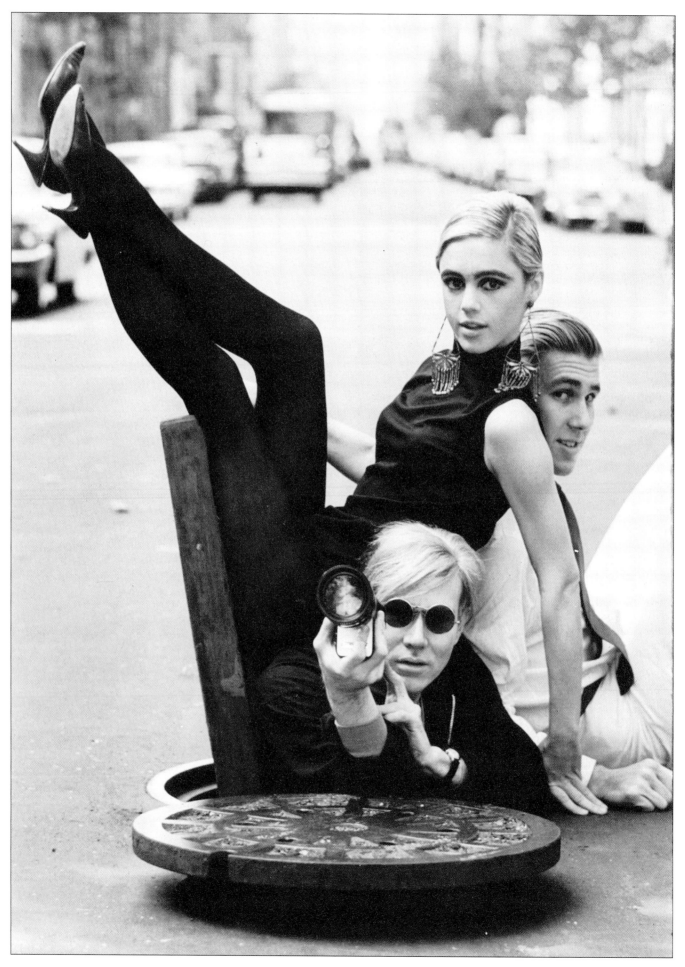

dominion over them. Among artists, however, there was considerable interest in "the primitive" because it could be seen as original, the raw material of being. At the same time, Sigmund Freud's investigations of dreams as revealing the subconscious springs of human action, characteristically located in sexuality, have pervaded the century and uprooted the notion that humans are ultimately rational beings. The Surrealists, painters and poets alike, sought their forms in dreams and novelists could write of psychology and sex as if they were the same thing. Between them these key thinkers set the stage on which the artists were to play.

A world where values were in flux demanded that people should see, think and hear new things. The French painter Cézanne changed the way we look at both the subjects of painting and the paintings themselves, simply by multiplying the viewing points from which the subject was seen, so to build up a more considered and total view of it. This was one of Picasso's "lies" to uncover a "truth". The rest of the century's art, that of Picasso included, can virtually be seen as footnotes to Cézanne's. Proust and Joyce opened out the form of the novel. Proust used ordinary, even trivial incidents to disclose layered memories which become the substance of the novel. Joyce in *Ulysses* and *Finnegan's Wake* built upon techniques of language that he began developing early in the century. Through them he amassed vast experiences in a single time-bound narrative and framed the potentially chaotic materials of life into ingenious order. *Finnegan's Wake*, published in 1939, is so complex and difficult to read that it is often seen as a dead end since it could scarcely be followed. It is perhaps better seen as a compendium of life, in sound and verbal color, rather than as a novel. It is full of the writer's delight in language. To that extent it is not a dead end but the point from which writing begins, the century's word-hoard. Schoenberg similarly changed the musical vocabulary of the century by adopting other scales than those traditionally used. To ears accustomed to that tradition, this was a difficult new music born in the years around World War I, a difficult age, and Shoenberg's serialism, and the radical musical developments that it permitted, has taken time to mellow.

Modern art and the world

From the point of view of the audience, a multiplicity of musical, pictorial and verbal languages is available. By the late 20th century a week or two in the concert halls of a major arts capital in the West would allow a person to hear almost any form of music, from medieval to modern and African, Indian and Far Eastern. A trip to a record library would do the same, without the excitement of live performance but with a compensating perfection of sound. Today it is possible to get within reach of every kind of art, and accustom ourselves to it, with no more than a library, a record player and access to good museums and galleries. In that sense the story of expression in the 20th century is not just the story of the new art made for the changing times, but also the story of the audience's ability to engage with all the expressions of our own day and all previous days, of our place and all other places. This is to apply for ourselves the French novelist André Malraux's concept of "the museum without walls"; the forms of the world's art are now universally available to us, independent of their time and, as illustrations in books, independent of their place. Again, this is an aspect of the relativism of the 20th century world, in which we may choose the traditions we come to, and construct our own coherence.

◀ Andy Warhol and friends enjoy 15 minutes of fame.

The history of the modern arts has itself conformed to this mobile pattern. The modes of turn-of-the-century Paris spread throughout Europe, then to the Americas, and subsequently throughout the world, impinging on indigenous styles in Africa, India, Japan and China and absorbing changes dictated by the environment in settler cultures like Latin America, Australia and New Zealand. In literature, the availability of modern European forms like the novel, and Western styles in poetry, similarly influenced indigenous writing in all countries. In music, the Western thrust was more uneven. Countries with a strong tradition of their own, India especially, resisted Western forms or, as with Japan, developed parallel indigenous and Western forms to high degrees of proficiency. In most of the rest of the world, Western forms have prevailed in many arts, though often mediated through the United States and infused with local color. The International Style in architecture has made airports throughout the world, and many cities, seem, on the face of it, interchangeable; its effect has sometimes been tyrannical, and only relatively recently have architects rebelled against its dictates, and reasserted the validity of local styles and materials. Dance forms on the other hand have tended to remain national, or at least non-Western, in countries outside Europe and America. Nonetheless they are internationally available and, indeed, the focus of great national pride. In film the commercial domination of the United States through Hollywood has meant that national traditions have developed as often in the area of "art cinema" as of films seeking success at the box office. Distinct national styles have evolved in many East European countries, the Far East and Latin America as well as Western Europe. In all the arts the demands of the national consciousness have ensured a different content in at least some of the work: in Irish writing about Ireland, African writing about Africa and so on.

At the level of style the pressure of cosmopolitan availability has been powerful. Once the old imperial capitals – London, Paris, Berlin, Madrid – sucked in artists from their colonies or former colonies, trained them and made them European in all but privilege. Latterly these same capitals, with the addition of New York and Moscow, deliver their styles across the globe. A bewildering sequence of fashions, bred in New York galleries and answering the needs of American society, becomes the global arbiter of painting. Andy Warhol's Pop art had its variations in Japan, every country of Europe (it was anticipated in Britain), in Latin America, Canada and Australia. The same is true of Conceptual art and every succeeding manner. Sometimes the style will take root and absorb local color but it is difficult not to regret the loss of traditional forms – not viewed as something static, for they never are, but as something that could absorb foreign influence into its own strengths. Were that to be the general pattern, the expanding circles of influence from the dominant Western powers would be genuinely fostering rather than obliterating. Art should not be about multinational enterprises purveying identical products but about many nations contributing to the world's stock, and responding to their own passions. What is the evidence of the century on this?

To some degree the report would be a healthy one. As the baton of modern art moved from Europe to the Americas in the 1920s, then even more definitively after World War II, it responded there to growing national pride and then to economic depression in the United States and to revolution and renewal in Latin America. Each area achieved its own distinctive forms: initially mural art and music in Latin America and new types of realism and Cubism, a new language for poetry and a supremacy in film in the United States. So too in India, in

17

digenous styles tended to dominate international borrowings in painting to produce work of exceptional vigor and range. In literature the case is less clear but strong Indian story lines, in keeping with old traditions, tended to resist overseas stereotypes of Indian experience. In music the traffic in classical dance and instrumental music tended to be the other way, as the Indian arts lent new experiences to Western theaters and concert halls and, in some cases, composers and artists.

In Japan, the experience has been complicated by war, American occupation and by the seductive nature of Western modes. But there is variety and arguably an irreducible core of Japanese cultural bearing. In China the dominant Western manner has been Socialist Realism – a style that owes its origins to Europe rather than indigenous arts – but it has co-existed alongside traditional means. And Chinese Socialist Realism often had an heroic attraction about it that was absent from Soviet usage, and the parallel totalitarian modes of art adopted in Italy and Germany in the 1930s and 1940s. In Africa traditional art forms have taken on new vigors in response to the continent's struggles. This is especially clear in contemporary South Africa, where township art has an astonishing and genuinely exciting range. All over the continent of Africa what seems like an instinct for artistic expression and an ingenuity in the use of materials seems to operate. Western art learnt from traditional Africa in the early years of the century and Africa has yet more to give. In music and literature there has been considerable fusion of European form, as in the novel, and African sensibility. Lastly the Pacific, the last of the world's "inland seas" (after the Mediterranean and the Atlantic), has emerged with a high degree of individuality. In the islands, for example, Albert Wendt has adapted the European novel to the rhetorical traditions of Samoan life. Australian painting, in its treatment of particular landscape and light along with a mythic evaluation of history, has continued a tradition of high quality which began before the century opened. In New Zealand poets, both Maori and Pakeha (of European descent) have shown considerable power in responding to an environment where the island condition can act as an apt symbol for existential isolation.

Meanwhile Europe has responded to cataclysmic war. In World War I its arts were forced to respond to horror by depicting it, then excoriating it and lastly, with Dada, matching its insanity with zany social outrage. In the Spanish Civil War the arts gathered about the torn body of a passionate country, drawn to a war that was seen as almost cosmic in its implications of good and evil. Out of it came perhaps the single most compelling image of the century's art, Picasso's *Guernica*, modern in style and searing in its commitment. World War II submitted European artists, in common with whole populations, to occupation, blitzkrieg, aerial bombardment and genocide. Artists went underground, sometimes to rally resistance fighters but sometimes to wait, storing experience for reconstruction. Since that reconstruction, art has taken its cues very largely from New York, though responding to everwidening ideas of art, born first of all from a clear conjunction between abstraction and Expressionism, but latterly seeming to call the nature of art itself into question. In literature, however, the interchange has been more fruitful. In particular the novel has emerged, perhaps especially in Switzerland, Germany and Italy as a considerable European form once again.

The question of the international status of art has already been raised. Clearly at the end of the century, when the international order itself is in a great deal of flux, this is a most pressing question, notwithstanding the healthy state that seems to exist. Latin America, with its galaxy of world-acclaimed

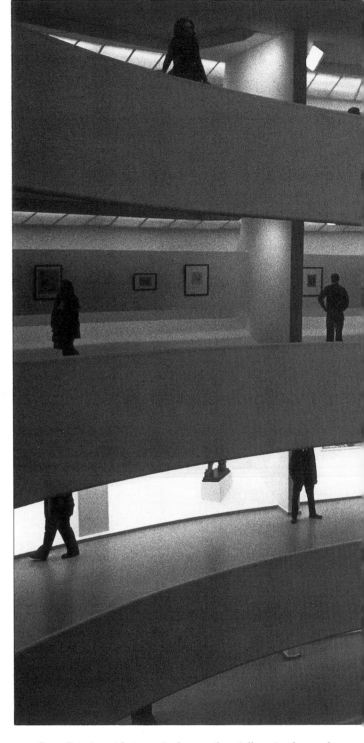

novelists; Britain with its articulate and racially mixed population operating in conditions of relative freedom, visible affluence and selective impoverishment, and the West Indies, open to both British and American influences but, island by island, strongly self-conscious, all provide good case histories for examining how things stand.

There are other issues too, which call into question the role of the arts themselves in a world seething with change. None of the issues is entirely new to the century. The relationship of the arts with politics, with social action, with technology and the environment are all recurring problems for each artist to solve. And they will not go away. But the very variety and range of the visual arts, in particular, is such as to raise questions of the nature of art itself – even within the very broad

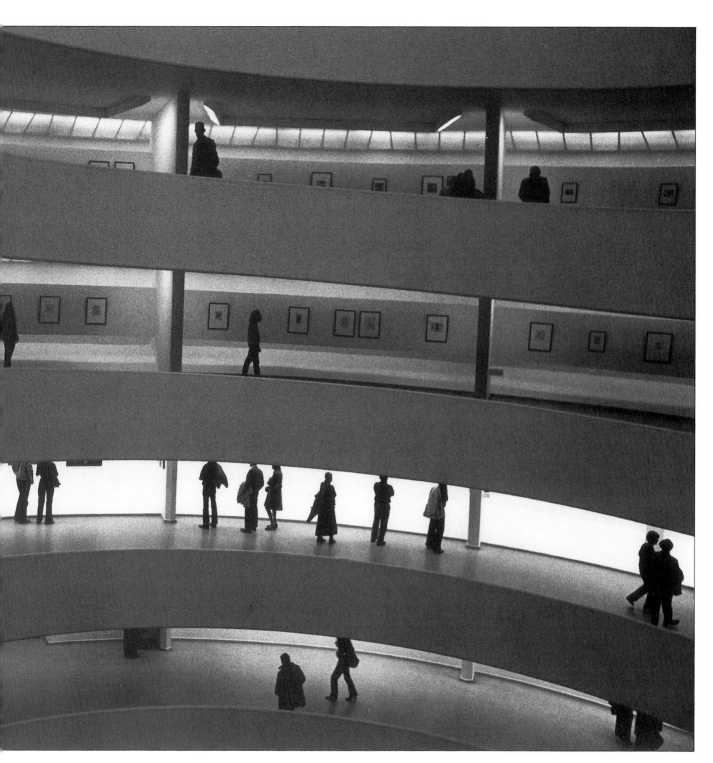

sense of art adopted here: "art is anything where function is not all". It is proper to add one more note to that. Art should add to the world's stock, be some further aid to our self-understanding, to our spiritual and material relationships, to our celebrations of passion and joy and our ability to withstand disaster and despair. The arts will inevitably be multiple rather than unitary in their appearances. The collective "museum" (with or without walls) should not expect or enforce a specious unity so much as savor a cornucopian variety, offer a stock to hand on, individual in its insights, common in its attraction.

The greatest German lyric poet of this century, Rainer Maria Rilke, thought long and deeply about the arts, no artist more so. At one time he was the secretary of the French sculptor Auguste Rodin. Near the beginning of the century, in 1903, he

suggested that art's particular value was to be "the medium in which man and landscape, form and world, meet and find one another". Usually they were simply side by side, not quite aware of each other but "in the picture, the piece of architecture, the symphony, in a word in art they seem to come together in a higher, prophetic truth", completing each other in the unity essential to art. Rilke here pondered and brought together most of the things that go to make up art and its place in the world. Near the close of his own century the arts themselves sometimes seem to deny such a high sense of art. But if the arts force questions from us, even about themselves, that too is part of their function.

▲ The continuous art gallery in the Guggenheim Museum, New York.

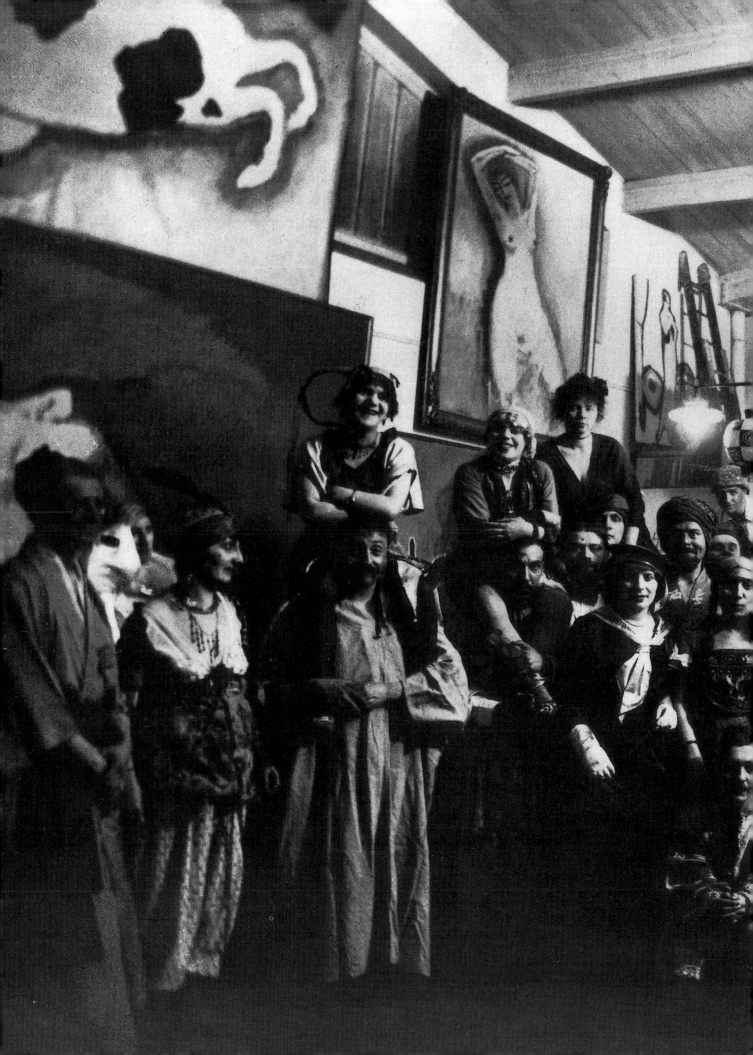

1900 · 1914
THE EUROPEAN CENTER

Time Chart

	1900	1901	1902	1903	1904	1905	1906	1907
Visual Arts	• Gwen John: *Self-Portrait*, painting (UK) • Henri Toulouse-Lautrec: *La Modiste*, painting (Fr) • Pierre-Auguste Renoir: *Nude in the Sun*, painting (Fr)	• Paul Gauguin: *The Gold in Their Bodies*, painting (Tahiti) • John Byam Shaw: *The Boer War*, painting (UK) • Beginning of Pablo Picasso's Blue Period (Fr)	• Claude Monet: *Waterloo Bridge*, painting (Fr) • Gustav Klimt: *Beethoven-frieze*, murals (Aust-Hung) • Max Klinger: *Bust of Friedrich Nietzsche* (Ger)	• Foundation of the Salon d'Automne (Fr)	• Henri Rousseau: *The Wedding*, painting (Fr) • Kōkyo: *The Destruction of the Petropavlousk* (Russo-Japanese War) woodblock print (Jap)	• Beginning of Pablo Picasso's Rose Period (Fr) • Paul Cézanne: *Bathers*, painting (Fr) • Formation of *Die Brücke* (The Bridge) group of painters: Ernst Kirchner, Erich Heckel, Karl Schmidt-Rottluff and Fritz Bleyl (until 1913) (Ger) • Henri Matisse founds *Les Fauves* (Fr)		• Cézanne Retrospective in Paris inspires the development of Cubism • Pablo Picasso: *Les Demoiselles d'Avignon*, painting (Fr) • Gustav Klimt: *Philosophy, Medicine and Jurisprudence*, fresco at Vienna University (Aust-Hung) • Kahnweiler Gallery opens in Paris (Fr)
Architecture	• C.F.A. Voysey: *The Orchard*, Hertfordshire (UK) • Victor Horta: *Maison du Peuple*, Brussels (Bel)	• C.R. Mackintosh: *Windyhill*, Kilmacolm near Glasgow (UK) • J.M. Olbrich: *Ernst Ludwig House*, Darmstadt (Ger)	• C.H. Townsend: *Horniman Free Museum*, London (UK) • Auguste Perret: *Apartments at 25 bis, Rue Franklin*, Paris (Fr)	• H.P. Berlage: *Exchange*, Amsterdam (Neth)	• Hector Guimard: *Entrances to the Paris Métro* (Fr) • Louis Sullivan: *Schlesinger & Mayer* (now Carson Pirie Scott) Store, Chicago (USA)	• Frank Lloyd Wright: *Larkin Building*, Buffalo (USA)	• Frank Lloyd Wright: *Unity Temple*, Oak Park, Illinois (USA) • Otto Wagner: *Post Office Savings Bank*, Vienna (Aust-Hung)	• Foundation of the Deutscher Werkbund an architecture and design workshop anticipating the work of the Bauhaus (Ger) • Peter Behrens joins AEG (industrialists) as chief architect and designer (Ger)
Performing Arts	• Anton Chekhov: *Uncle Vanya*, play (Russ) • Charles Péguy: *The Mystery of the Charity of Joan of Arc*, play (Fr)	• August Strindberg: *The Dance of Death*, play (Swe) • Frank Wedekind: *König Nicolò, oder So Ist das Leben* (King Nicolò, or Such Is Life), play (Ger)	• Maurice Maeterlinck: *Monna Vanna*, play (Neth)	• Anton Chekhov: *The Cherry Orchard*, play (Russ) • George Bernard Shaw: *Man and Superman*, play (UK) • Guillaume Apollinaire: *Les Mamelles de Tirésias* (The Breasts of Tiresias), play (Fr)	• Frank Wedekind: *Die Büchse der Pandora* (Pandora's Box), play (Ger) • W.B. Yeats: *On Baile's Strand*, play (UK) • J.M. Synge: *Riders to the Sea*, play, cast as an opera by Ralph Vaughan Williams in 1931 (UK)	• Herman Heijermans: *All Souls*, play (Neth)		• Mikhail Fokine: *Les Sylphides* (choreography of orchestrated Chopin piano pieces) (Russ) • J.M. Synge: *The Playboy of the Western World*, play (UK)
Music	• Edward Elgar: *The Dream of Gerontius*, oratorio (UK) • Jean Sibelius: *Finlandia*, tone-poem (revised version – original written 1899) (Fin) • Gustav Mahler: *Fourth Symphony* (Aust-Hung)	• Maurice Ravel: *Jeux d'eau*, for orchestra (Fr) • Bruno Walter becomes associate conductor to Gustav Mahler at the Vienna State Opera (Aust-Hung)	• First recordings made of tenor Enrico Caruso (It) • Claude Debussy: *Pelléas et Mélisande*, opera (Fr)	• Beginning of Gustav Mahler's collaboration with stage designer Alfred Roller at the Vienna State Opera (Aust-Hung) • Leoš Janáček: *Jenufa*, opera (Aust-Hung) • Arnold Schoenberg begins teaching composition in Vienna: among his pupils are Anton Webern and Alban Berg (Aust-Hung)	• Gustav Mahler: *Sixth Symphony* (Aust-Hung) • Béla Bartók begins fifteen years collecting and recording (on wax rolls) folk songs in Central Europe, Asia Minor and North Africa • Giacomo Puccini: *Madame Butterfly*, opera (It)	• Claude Debussy: *La Mer*, for orchestra (Fr) • Richard Strauss: *Salome*, opera (Ger) • Frederick Delius: *A Mass of Life*, choral work on texts from Friedrich Nietzsche's *Also Sprach Zarathustra* (UK)	• Thaddeus Cahill demonstrates his Telharmonium, a prototype electric organ (Can) • First Mozart Festival held in Salzburg (Aust-Hung) • Arnold Schoenberg: *First Chamber Symphony* (Aust-Hung)	• Ferruccio Busoni: *Sketch of a New Esthetic of Music* (enlarged 1910), in which the author outlines the possibility of electronic music (It) • After resigning from the Vienna State Opera, Gustav Mahler begins directing the Metropolitan Opera in New York (Aust-Hung/USA)
Literature	• Leo Tolstoy: *The Resurrection* (Russ) • Colette: *Claudine à l'école*, novel (Fr) • Joseph Conrad: *Lord Jim*, novel (UK)	• Thomas Mann: *Buddenbrooks*, novel (Ger) • Yosano Akiko: *Tangled Hair*, poems (Jap) • First Nobel Literature Prize awarded (Swe) • J.V. Jensen: *The Fall of the King*, novel (Den)	• Hugo von Hofmannsthal: *Letter by Lord Chandos*, essay (Ger) • Arnold Bennett: *Anna of the Five Towns*, novel (UK) • André Gide: *The Immoralist*, novel (Fr)	• Samuel Butler: *The Way of all Flesh*, novel (posthumous) (USA) • First issue of Benedetto Croce's review *La critica* (until 1944) (It)	• Thomas Hardy: *The Dynasts* (Part I; Part II published 1906, Part III in 1908), poem (UK) • Joseph Conrad: *Nostromo*, novel (UK) • Henrik Pontoppidan: *Lucky Peter*, novel (Den) • Henry James: *The Golden Bowl*, novel (USA)	• H.G. Wells: *Kipps*, novel (UK) • Rainer Maria Rilke: *The Book of Hours*, poems (Ger)	• Carl Spitteler: *Olympian Spring*, novel (Swi) • Shimazaki Tōson: *The Broken Commandment*, novel (Jap)	• Stefan George: *The Seventh Ring*, poems (Ger)
Misc.	• Sigmund Freud: *The Interpretation of Dreams*, psychology text (Aust-Hung)			• Otto Weininger: *Sex and Character*, psycho-philosophical text (Aust-Hung)	• Jean Jaurès founds the socialist (later Communist) periodical *L'Humanité* (Fr)	• "Bloody Sunday" in St Petersburg when Czarist militia fire on demonstrators during the first revolution in Russia	• Rehabilitation of Alfred Dreyfus after it is proved that the charges of treason brought against him in 1894 were false (Fr)	• Henri Bergson: *L'Évolution créatrice*, philosophy text (Fr)

908	1909	1910	1911	1912	1913	1914
Constantin Brancusi: *The ...ss*, sculpture (Fr) ...Henri Matisse: *Harmony ...Red*, painting (Fr) ...Wassily Kandinsky: *Blue ...ountain*, painting (Ger)	● Auguste Rodin: *Bust of Gustav Mahler* (Aust-Hung) ● Wassily Kandinsky founds the New Artists' Association (Ger) ● Oskar Kokoschka: *Portrait of Adolf Loos* (Aust-Hung)	● Henri Matisse: *Dance*, painting (Fr) ● Georges Braque: *Violin and Palette*, painting (Fr) ● Development of Analytical Cubism by Pablo Picasso and Georges Braque (Fr) ● Henri Rousseau: *The Dream*, painting (Fr)	● Pablo Picasso: *Man Smoking a Pipe*, painting (Fr) ● Marc Chagall: *I and the Village*, painting (Fr) ● Formation of *Der Blaue Reiter* (The Blue Rider) group by Franz Marc and Wassily Kandinsky (until 1914) – the name originates in the title of a Kandinsky painting (Ger) ● Arnold Schoenberg exhibits three paintings with *Der Blaue Reiter* (Ger)	● Marcel Duchamp: *Nude Descending a Staircase*, painting (Fr) ● Wassily Kandinsky: *On the Spiritual in Art*, essay on painting (Ger) ● First of Pablo Picasso and Georges Braque's "papiers collés", leading to Synthetic Cubism (Fr) ● Giacomo Balla: *Dynamism of a Dog on a Leash*, painting (It) ● Guillaume Apollinaire: *The Cubist Painters*, collection of essays (Fr)	● Robert Delaunay: *Circular Forms: Sun and Moon*, painting (Fr) ● Armory Show (exhibition) in New York (USA) ● Formation of the London Group of artists and writers, including Jacob Epstein and Wyndham Lewis (until 1916) (UK) ● Man Ray: *Portrait of Alfred Stieglitz*, painting (USA)	● Marcel Duchamp begins his series of "ready-mades" (Fr) ● Jacob Epstein: *The Rock Drill*, sculpture (UK) ● Giorgio de Chirico: *The Philosopher's Conquest*, painting (Fr) ● Egon Schiele: *Portrait of Friederike Maria Beer*, painting (Aust-Hung) ● Oskar Kokoschka: *The Tempest*, self-portrait with Alma Mahler (Aust-Hung)
...Adolf Loos: *Ornament ...nd Crime*, essay on ...chitecture and design ...ust-Hung) ...Louis Sullivan: *National ...armers' Bank*, Minnesota ...SA)	● C.R. Mackintosh completes his *School of Art*, Glasgow (since 1897) (UK) ● Daniel Burnham produces his plans for the improvement of Chicago (USA) ● Peter Behrens: *AEG Turbine Factory*, Berlin (Ger)	● Adolf Loos: *Steiner House*, Vienna (Aust-Hung) ● Bernard Maybeck: *Christian Science Church*, Berkeley, California (USA) ● Antonio Gaudí: *Casa Milà*, Barcelona (Sp)	● Josef Hoffman: *Palais Stoclet*, Brussels (Bel) ● Walter Gropius and Adolf Meyer: *The Fagus Factory*, Alfeld-an-der-Leine (Ger)	● Peter Behrens: *AEG Factory Complex*, Berlin (Ger)	● C. Gilbert: *Woolworth Tower*, New York (USA) ● M. Berg: *Centenary Hall*, Breslau (Ger)	● Henry Van de Velde: *Werkbund Exhibition Theatre*, Cologne (Ger) ● Antonio Sant'Elia produces his Futurist city designs (It) ● Walter Gropius and Adolf Meyer: *Model Factory*, Werkbund Exhibition, Cologne (Ger)
	● 18 May: Debut of *Ballets Russes de Serge Diaghilev*, with Mikhail Fokine as chief choreographer, in Paris (Fr) ● Oskar Kokoschka: *Mörder, Hoffnung der Frauen* (Murderer, Hope of Women), a prototype expressionist play (Aust-Hung)	● Mikhail Fokine's ballet *Scheherazade*, starring Ida Rubinstein and Vaslav Nijinsky, set design by Leon Bakst (Fr)	● Émile Jacques-Dalcroze founds his school of eurhythmics at Hellerau (Ger)	● Vaslav Nijinsky presents his choreography of Debussy's *L'Après-midi d'un faune*, with the *Ballets Russes* (Fr)	● George Bernard Shaw: *Pygmalion*, play (UK) ● F.T. Marinetti: *Zang tumb tumb*, Futurist performance piece based on the siege of Adrianople (First Balkan War) (It)	● Paul Claudel: *The Hostage*, play (Fr) ● Giacomo Balla: *Macchina tipografica* (Printing press), in which twelve performers together simulate a printing press with actions and onomatopoeic sounds (It)
...Arnold Schoenberg: ...econd String Quartet*, the ...al movement of which (a ...prano setting of a poem ...Stefan George) is the ...st instance of "atonal" ...usic (Aust-Hung) ...Arturo Toscanini takes ...er directorship from ...ustav Mahler at the ...etropolitan Opera in New ...ork (USA) ...Anton Webern: ...assacaglia* for orchestra ...ust-Hung)	● Gustav Mahler: *Das Lied von der Erde* (The Song of the Earth), a setting of Hans Bethge's translations of Chinese poems for tenor, contralto and orchestra (Aust-Hung) ● Ralph Vaughan Williams: *Fantasia on a Theme by Thomas Tallis* for double string orchestra and string quartet (UK)	● Alexander Skryabin: *Prometheus*, in which the composer employs his imaginary "clavier à lumières", that controls the production of colored light instead of sound (Russ) ● Gustav Mahler: *Ninth Symphony*, premièred posthumously by Bruno Walter (1912) (Aust-Hung)	● Béla Bartók: *Duke Bluebeard's Castle*, opera (Aust-Hung) ● Maurice Ravel: *Daphnis and Chloe*, for the *Ballets Russes* (Fr) ● Arnold Schoenberg: *Harmonielehre*, a music theory teaching text, dedicated to Gustav Mahler (Aust-Hung) ● Jean Sibelius: *Fourth Symphony* (Fin)	● Arnold Schoenberg: *Pierrot Lunaire*, semistaged with a small ensemble and *sprechsgesang* soloist (Aust-Hung) ● Henry Cowell: *The Tides of Manaunaun* for piano, an early instance of the use of pitch-clusters (USA) ● Paul Dukas: *La Péri*, ballet (Fr)	● Igor Stravinsky: *Le Sacre du Printemps*, for the *Ballets Russes* (Fr) ● Claude Debussy: *Jeux*, for the *Ballets Russes* (Fr) ● Luigi Russolo first demonstrates his "intonarumori" (noise intoners) (It) ● Mikhail Matyushin: *Victory Over the Sun*, first Futurist opera, designed by Kasimir Malevich (Russ)	● Charles Ives: *Three Places in New England* for orchestra (USA)
...First issues of Ford ...adox (Ford) Hueffer's ...nglish Review*, publishing ...e work of Thomas Hardy, ...enry James, W.B. Yeats, ...ohn Galsworthy, Ezra ...ound, Wyndham Lewis ...d others (UK) ...Rainer Maria Rilke: *Neue ...edichte*, poems (Ger) ...Foundation of the *New ...ge review* (until 1921) (UK)	● 20 Feb: F.T. Marinetti: Futurist manifesto, printed in *Le Figaro* (Fr) ● André Gide: *Strait is the Gate*, novel (Fr) ● First issue of the Acmeist periodical *Apollo* (until 1917) (Russ) ● Wladislaw Reymont: *The Peasants* (four-volume novel, since 1902) (Pol) ● Robert Walser: *Jacob of Gunten: a Diary*, novel (Swi)	● E.M. Forster: *Howard's End*, novel (UK) ● Rainer Maria Rilke: *The Notebook of Malte Laurids Brigge*, novel (Ger) ● Foundation of the review *Der Sturm* by Herwarth Walden (Ger)	● Thomas Mann: *Death in Venice*, novel (Ger) ● Foundation of the review *Les Soirées de Paris* (Fr) ● John Galsworthy: *The Forsyte Saga*, novel (UK)	● Harriet Monroe founds *Poetry: A Magazine of Verse* in Chicago (USA) ● Viktor Khlebnikov and Vladimir Mayakovsky: *A Slap in the Face of Public Taste*, a Futurist literary manifesto (Russ)	● Guillaume Apollinaire: *Alcools*, poems (Fr) ● Alain-Fournier: *Le Grand Meaulnes*, novel (Fr) ● First Imagist manifesto appears in *Poetry*, Chicago (USA)	● First issues of Wyndham Lewis's *Blast*, a Vorticist periodical (folds in 1915) (UK) ● H.L. Mencken takes up editorship of *The Smart Set*, a literary magazine (until 1923) (USA) ● James Joyce: *Dubliners*, a collection of sketches and short stories (UK)
			● Mexican dictator Porfirio Diaz forced to resign after revolution		● Edmund Husserl: *Phenomenology*, philosophy text (Ger) ● Rudolf Steiner founds the first Goetheanum (Swi)	● Assassination of Jean Jaurès (Fr)

Datafile

Between the turn of the century and the start of the First World War, Paris was not only the center of the art market, it was the home of the avant-garde. Movements sprang up seemingly overnight, whose theoretical implications would reverberate throughout the century. But whilst the Fauves and the Cubists began inspiring Europe, the dealers kept their coffers closed. Because their work was shocking in its coloration, or bewildering in its treatment of conventional form, these painters were seen as ridiculous extremists or even deranged. This attitude has become one typical response to modern art, despite or even because of the quantity of "explication" that critics have interposed between the public and the paintings. Unable, perhaps, to assess their real cultural value, collectors have been caught up in a spiral of ever-increasing price rises. Only a few enthusiasts bought the work of Braque, Picasso and Matisse, and it is doubtful anyone anticipated the explosion in prices these artists were to experience.

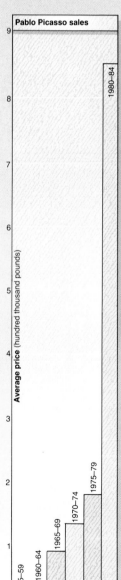

Pablo Picasso sales

▶ Paul Cézanne can be described as the father of the modernist movement in painting. An exhibiton of his late works in 1906 inspired Picassso to begin experimenting with picture planes and, eventually, to create Cubism. This enviable position is reflected in the very high prices his pictures have fetched.

Paul Cézanne sales

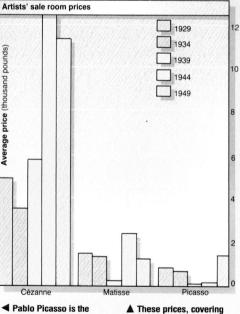

Artists' sale room prices

	1929
	1934
	1939
	1944
	1949

Cézanne Matisse Picasso

◀ Pablo Picasso is the world's most famous modern artist. He combined extremism and showmanship. As such he commands, naturally, extremely high prices, but since his death even these have begun steadily mounting into ever more absurd regions. He was also one of the most prolific artists ever.

▲ These prices, covering 20 years of upheaval and conflict, display the slow assimilation of modern art. They are calculated (as are all similar files on sale room values) by taking an average of each artist's top three prices each year. All the currencies involved have been converted into sterling at current rates of exchange.

The world of 1900 was dominated by the single continent of Europe. The power of Western imperialism, ideas and technology thrust European values and examples upon almost every country in the world. This dominance was as strong in the world of the arts as in any other field, and within that world, especially in painting itself, the undisputed center of excellence was Paris. Throughout the 19th century, French painters had produced an outstanding succession of exciting and experimental work, while maintaining the highest technical standards. By the turn of the century, France could boast the most impressive tradition of recent visual art in the world. Paris offered excitement, example and opportunity. It was not only the chance to meet and share ideas with other artists, or to see earlier masterpieces, that drew artists from the Old and New Worlds alike. There were more galleries in Paris than in any other capital city, and more knowledgeable – and rich – patrons.

Paris was a magnet for writers, too. The French 19th-century literary tradition, both in the novels and short stories of Flaubert, Balzac, Maupassant, Stendhal and Zola, and in the poetry of Baudelaire, Laforgue, Rimbaud and Mallarmé, was as distinguished as anything in Europe. Paris attracted writers as it attracted artists, and young writers such as T.S. Eliot, James Joyce and the Austrian poet Rainer Maria Rilke, all destined to become key figures in modern literature, spent time there. Only in music was the major center elsewhere, in Vienna or, in the case of ballet, in St Petersburg. But Paris was hospitable to music as well, beguiled as ever by the best and the exotic.

The Paris Exhibition

Perhaps nothing could have summed up the central importance of Paris so well as the Universal Exhibition of 1900, with which the city marked the new century. In the summer and autumn of that year, the world flocked to its pavilions and exhibitions. The biggest exhibition Europe had ever seen, it displayed the wealth and wonders of the world. Electricity, automobiles, films projected on to enormous screens caught the eye, as did the entrances of the new Metro underground railroad, designed by Hector Guimard in the Art Nouveau style.

Painting, too, was on display in plenty, though there was little to be seen of new trends in the largest exhibition, which was international in scope (though with more than a thousand pictures from France alone) but conservative in taste, full of painting in the style that had graced the academies and salons of Europe for several decades: competent, realistic, rather sentimental and a little dull. A second exhibition, however, showed the treasures of French art since 1800,

PARIS: THE CULTURAL CAPITAL

culminating in the comparatively recent works of the Impressionist and Post-Impressionist painters, including Monet and Renoir, Gauguin and Seurat, Pissarro and Cézanne. In their work lay the seeds of the painting of the dawning century.

The future takes shape

Meanwhile, beyond the gallery walls, the men who would shape the future were gathering in the city, still young and unknown. Henri Matisse and Albert Marquet, who went on to lead the group known as the Fauves, were earning their living by painting a frieze high up in the Grand Palais of the Exhibition; two other artists who became part of the same group, André Derain and Maurice de Vlaminck, met by chance when a train was derailed in the Paris suburbs. Georges Braque and Raoul Dufy arrived in Paris from Le

▼ The Paris Exhibition, 1900. A large display of academic sculpture typifies the tone of the exhibition.

Havre in Normandy. Most important of all, the young Pablo Picasso moved from Barcelona to settle finally in Paris in 1904.

In the years before the outbreak of war in Europe in 1914, all these were to make a name within the relatively small social group that took an interest in the latest developments in painting; but their work had a much wider influence that has reverberated through the century. None of them was frightened of remaining obscure, and some deliberately set out to shock the broader art-viewing public, equating challenge in the visual arts with political attacks on the *status quo*. Thus they attacked ancient assumptions as to what art should be about, and how the subject should be approached, creating a new language for self-expression, and inspiring artists far beyond the borders of France.

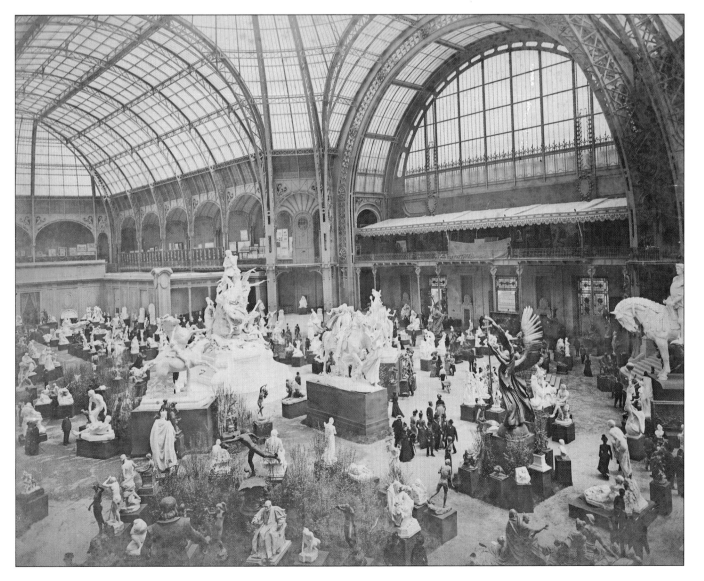

Naturalism and Symbolism: Zola and Mallarmé

Writers, too, were setting out to challenge the comfortable consensus of a conservative order. There was a great flurry of literary and artistic movements at the end of the 19th century. Two names emerged, each associated with a particular movement. The names were those of Emile Zola (1840–1902) and Stéphane Mallarmé (1842–1898); the movements Naturalism and Symbolism.

Naturalism was a development of Realism; though even more specialized, more scientific, aiming at a yet closer approximation to life as it is ordinarily lived. Zola's own prodigious novel sequence, which recounted the decline and further decline of the Rougon-Macquart family in 20 volumes, of which the best-known are *L'Assommoir* (1887), *Nana* (1880) and *Germinal* (1885), had explored the terrible effects of heredity and environment. The novels are remarkable for their brooding atmosphere and for their sense of succeeding generations doomed to squalor, disease and ill luck – a far cry from the comfortably accepted view of French middle-class life. Zola researched his fiction with unusual diligence, and his reach encompassed both the urban and rural working classes, and many of the phenomena now accepted as part of the modern industrial state.

▼ A typical Parisienne of the middle classes, photographed by J-H. Lartigue, in a pioneering example of the photograph as art. Such attempts to capture the fleeting moment parallel the Naturalist novel. Writers like Zola, rebelling against Classical decorum, began to examine ordinary life. Photography, combining artistic self-expression with scientific accuracy, provided the perfect model. Zola himself took many notable photographs of Paris at the turn of the century.

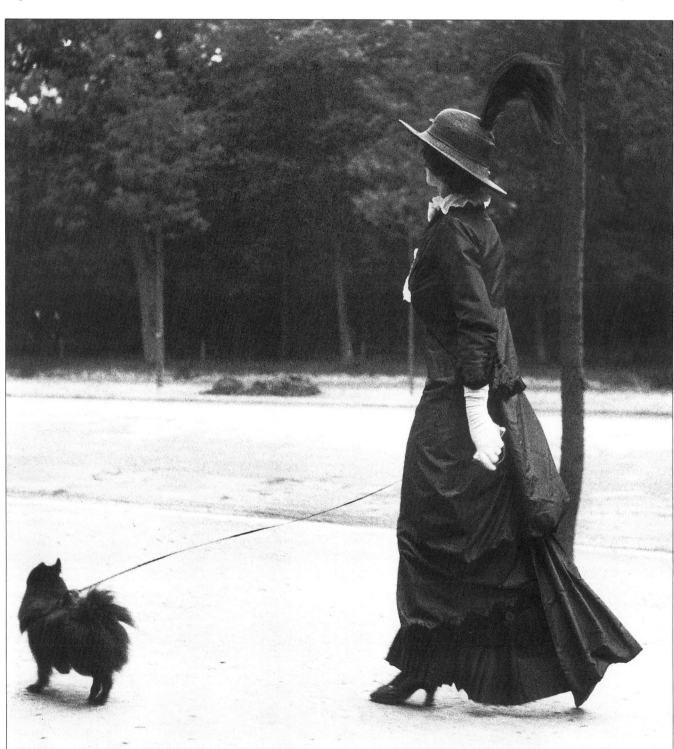

Naturalism often told unpleasant truths, and in the minds of respectable people seemed to pursue mere unpleasantness for its own sake. Just to mention Zola, or the Norwegian playwright Henrik Ibsen, whose subject matter was equally alarming to the general public and with whom Zola was often associated, was to risk causing a scandal. Mallarmé's intervention in the world's business was quieter, but no less influential. He was a schoolmaster, and like Zola, a friend of the best-known painters of his time. His slender output of difficult verse, highly intellectual and yet hauntingly musical, made him a legend, an embodiment of the age's idea of the pure poet. Mallarmé's dense and witty critical writings had a far-reaching influence. His Tuesday evening gatherings in Paris were a focus for literary and artistic discussion, and their echoes, through the work of the poets W.B. Yeats, Paul Valéry and others, affected the whole modern movement in literature.

Symbolism, the movement of which Mallarmé became the reluctant high priest, was not a deliberate practice like Naturalism but rather a set of imprecise but forceful aspirations. It was close to Impressionism in certain respects – his aim, Mallarmé said, was "to paint not the thing but the effect it produces" – but it also looked to music for an image of its ideal. The continuing theme of Symbolism was the inexpressible, the realm of human longings increasingly driven to the margins of a materialist world.

Document against suggestion, solid reality against everything such reality denies: Naturalism against Symbolism: the two movements can conveniently be seen as the two poles of the complex field of modern art. And yet there is a sense in which they are complementary rather than op-posed. Zola's novels are dominated by vast symbols – the mine, the machine – and Mallarmé's poems treat language as a zone of almost scientific experiment. Both movements attack what they perceive as being too narrow an understanding of reality. The world, they claim, is wider and more mysterious than we think, since it includes all the broken, humble lives we have forgotten or neglected, and all the dreams we cannot realize.

The novel of the mind

Writers and artists were both equally involved in pursuing the implications of Naturalism and Symbolism, but there was another development taking place in the area of literature that was concerned not with the external and visible, but with the internal landscape of the mind. Developments

▲ A scene from Zola's novel *Germinal*. This illustration by Steinlen appeared in a magazine serialization. Such characters, drained of hope and worn down by their environment, are typical of Zola's fiction. His theories on the debilitating effects of heredity were a little eccentric, but the close attention he paid to actual living conditions introduced an aspect of social comment to European fiction.

Auguste Rodin

The career of the French sculptor Auguste Rodin (1840–1917) got off to a slow start. He failed exams, lost jobs and had his works rejected. Nevertheless, by 1900 he had a worldwide reputation, and he was so highly thought of that a whole pavilion was devoted to his work at the Paris Universal Exhibition. Well over a hundred of his sculptures, as well as a host of drawings, were on display.

Many of Rodin's major works were surrounded by controversy. His Balzac, commissioned by the Society of Men of Letters and showing the head of the great French novelist seeming to struggle upwards from the constraining folds of the cloak that wraps most of the figure, was rejected in 1898. His decision to portray another French novelist, Victor Hugo, naked, also caused a storm. The sensuousness of *The Kiss* created yet more trouble. Yet although he formed no school, much of the expressive daring and risk-taking of 20th-century sculpture may well be traced to Rodin's spectacular vigor, and his ability to suggest the further passions still pent up within his sculptures, more powerful even than those shown on the expressive surfaces he had modeled. The major modernist sculptor, Constantin Brancusi, worked briefly in Rodin's studio but refused to study with him. "Nothing grows in the shade of a big tree", he said.

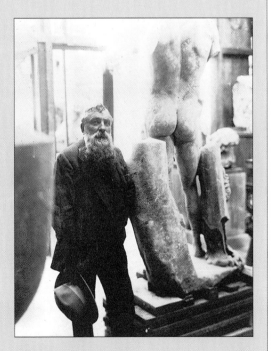

▲ Rodin in his studio, c.1911.

Contemporaries, noticing the frequency of olfactory descriptions in the Rougon-Macquart novels, supposed that Zola must have a peculiarly constituted nose. It was, indeed, perhaps the most characteristic feature of his face. It was a highly mobile and expressive organ. Both Léon Daudet and Edmond de Goncourt likened it to the muzzle of a retriever, and the latter, in a vivid passage of his diary, referred to it as "a questioning, approving, disapproving nose, a nose that can show gaiety or melancholy, a nose in which the physiognomy of its owner is concentrated".

F.W.J. HEMMINGS 1977

in contemporary psychology encouraged contemplation of the powers of the subconscious, and posed the problem of finding a new style to convey the curious and subtle ramifications of mind and memory.

Henry James was born in New York in 1843, but became fascinated by European culture, and eventually settled in Europe. Although he was influenced by both Naturalism and Symbolism, as well as by the French tradition of realism in the novel, James's great concern was with a more philosophical issue: the freedom and responsibility of the moral intelligence. In an attempt to find a way of expressing the layers of conscious and subconscious thought experienced by his characters James, particularly in his late novels *The Wings of a Dove* (1902), *The Ambassadors* (1903) and *The Golden Bowl* (1904), evolved a prose style of extreme difficulty and delicacy.

The process that James had begun was refined and elaborated by his French contemporary Marcel Proust in the years just before and after World War I. In the early pages of Proust's novel *Remembrance of Things Past* (seven volumes published between 1913 and 1927), are found two of the great mythological moments of modern literature: a boy waits for and finally receives a goodnight kiss from his mother; an adult dips a

▲ *Ophelia among the Flowers* (1905–08), by Odilon Redon. A major Symbolist artist, Redon attempted to give form to subconscious motives. The poet Mallarmé was similarly concerned with the limitations of conventional imagery. By charging objects with subjective meaning the Symbolists hoped to broaden their audience's perceptions.

◀ The French actress Sarah Bernhardt (1844–1923) dominated the European stage in the early part of the century. She acted in Classical roles such as Racine's *Phèdre*, but excelled in popular melodramas like those of Sardou, who wrote for her from the 1880s. A leg amputation narrowed her range in later life, but could not diminish her zest or popularity.

cake in tea and opens wide the floodgates of his memory. Both moments have their origins in Proust's life, but they take on mythological proportions because they are shaped as models for what might be crucial in any life-story: the first definitive experience and the return to a lost past. The boy's anxiety over his mother's kiss is an image for a whole anxious, haunted life, a simultaneous condemnation and celebration of neurosis as *the* modern form of sensibility. The cake dipped in tea triggers an unsuspected, alternative mode of memory, producing a total recall of the taste and texture of past events, as distinct from ordinary, deliberate remembering, which digs up only partial memories. Proust's long novel records a reordering of the relation between what we consciously know and what we unconsciously may need. To achieve his intention, Proust continually added to the central sections of the novel, so as to convey the most minute shades of meaning. This form of enlargement allowed him to encompass not only a portrait of the artist

as a distraught young man but also a brilliant panorama of French society. Painting and music also played a prominent part in the novel. His work was chronicle, satire and metaphor all at once.

Proust, with Dostoyevski and Thomas Mann, was one of the great philosophical novelists, edging the genre away from character and incident toward speculation and reflection, and opening up the mind as the new territory of literature.

Cézanne: the father of modern painting
In painting the roots of the new thinking were similarly to be found in the later years of the 19th century. Paul Cézanne had been a leading figure in the Impressionist movement since the 1860s. Although he lived only until 1906, Cézanne's work was to have enormous influence on the art of the new century. The spread of this influence was set in motion through the small group of people who championed all that was new in Parisian art, such as the art dealer Ambroise

At the ... instant when the mouthful, mixed with cake crumbs, touched my palate, I shivered, alert to the extraordinary event which was taking place in me. A delicious pleasure had invaded me, isolated, with no hint of its cause. It had at once rendered for me life's vicissitudes indifferent, its disasters inoffensive, its brevity illusory, in the same way that love operates, by filling me with a precious essence: or rather the essence ... was me.

MARCEL PROUST, 1913

Art Nouveau

When an American connoisseur, Samuel Bing, opened a shop in Paris in 1895 he called it "La Maison de l'Art Nouveau" – and gave a name to a whole new artistic movement. England was the source of the new trends that were already being called "style anglais"; their origins can be traced back to the sinuous figures, sometimes wreathed in plant forms, that William Blake and his circle had drawn in the 1820s and that had been re-explored by Arthur Mackmurdo and the Arts and Crafts designers toward the end of the 19th century. Equally important was the fashion for Japanese prints, ceramics and artifacts, which had been given considerable impetus by the American painter James McNeill Whistler.

By 1900 the new esthetic was evident in the work of Post-Impressionist painters such as Paul Gauguin and Paul Signac, and especially in the posters of Henri de Toulouse-Lautrec and Pierre Bonnard. But Art Nouveau as a style extended far beyond the fine arts. There was hardly an aspect of material culture, from riding boots to ashtrays, postage stamps to writing desks, that was not redesigned in the style, with its characteristic swirling fabrics, windblown plants and trailing tendrils.

Probably the most representative Art Nouveau artist was the Czech Alphonse Mucha, designer of posters for Sarah Bernhardt. International to an unprecedented degree, Art Nouveau was embraced as enthusiastically in Finland as it was in Italy. Many centers emerged, among them Nancy in France, where the genius of glassmaking, Emile Gallé, developed his glass paste technique to produce milky vases and light fittings with blended colors. In New York, his principal rival Louis Comfort Tiffany produced lampshades dripping with fruit illuminated from within, contrasting with glass dishes that fully exploited the potential of the material in its liquid state.

In Austria the *Jugendstil* (youth style) was espoused by the Secessionist movement of young artists and designers. The painter Gustav Klimt was one of its most prominent figures. Joseph Maria Olbrich designed the Secession building in Vienna; its chunky base supported a vast hollow

ball of gilded leaves. He also designed the artists' colony at Darmstadt, surmounted by a great "wedding tower" inspired by the marriage of the Grand Duke of Hesse. In Brussels, Victor Horta designed the Maison Tassel, with wrought iron coiling round staircases. The Spaniard Antonio Gaudí designed many buildings in a very personal style. In Paris, Hector Guimard created some of the most enduring icons of Art Nouveau in his entrances to the newly built Paris Metro. In many ways Art Nouveau anticipated later developments of the 20th century: it was international, genuinely popular and not restricted to an artistic elite. It embraced all the areas of design from posters to post offices, and it drew inspiration from the East rather than from Western historical styles.

▲ Favrile vases and a stem cup by the American craftsman L.C. Tiffany (1848–1933). This iridescent glassware was produced according to a technique Tiffany patented in 1880, in which molten glass was exposed to the fumes of vaporized metals. His fluid, organic forms were characteristic of Art Nouveau, and proved very popular.

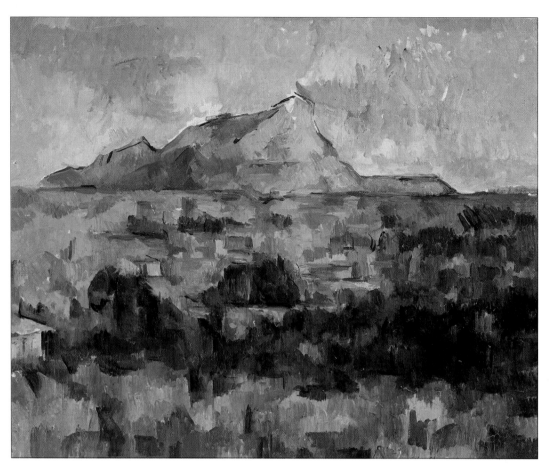

◀ *Mont Sainte Victoire* by Cézanne, a late study of one of this artist's obsessive themes. First attempted in 1870, this subject appeared with increasing frequency in the next 30 years. In a letter to Zola, from April 1878, he described the view of Mont Sainte Victoire from a train as "a stunning motif". By his death in 1906 Cézanne had painted the mountain more than 60 times. Unlike the Impressionists, who repeated images in order to explore the effects of different lights, Cézanne wanted to reduce nature to its fundamental components. In the last decade of his life his canvases became increasingly abstract, highly orchestrated arrangements of brushstrokes. This approach held revolutionary implications for successors like Picasso and Braque.

Vollard, who had exhibited Cézanne's paintings at his gallery in the rue Lafitte in 1895. In 1901 he presented Picasso's first Paris pictures.

Impressionism, as practiced by Claude Monet, Camille Pissarro and others, had attempted to represent objects as if they were momentary appearances of light. The artists were no longer concerned with the representation of things as they appeared to be. Instead, their aim was to select one key aspect of the whole experience, the way in which conditions of light and color impacted on the eye, and to represent that. Their art focused less on the object than on the mechanics of seeing, and on the sensation that was impermanent and irrecoverable once the moment had passed. Impressionism was revolutionary in both theory and technique, yet it still sought to "represent" things, even if highly selectively.

Cézanne absorbed the insights of Impressionism and then took his own work some steps further. So, in their various ways, did Georges Seurat, Vincent Van Gogh and Paul Gauguin, though later critics grouped them together under the general term Post-Impressionism. Seurat adopted a method, known as Pointillism, in which shape and tone were broken down into multiple spots of color. Van Gogh intensified his colors and thickened the textures of his paint to render the intensity with which he saw. Gauguin placed flat areas of color next to one another to emphasize the two-dimensional nature of the picture surface. Color was central to them all. Cézanne, though, was more concerned with solidity and volume than with color, and with permanence rather than impression. His choice of

subjects became compulsive: he painted the Mont Sainte Victoire in southern France many times, and he became almost equally obsessed by the still life based on a bowl of fruit. His portrayals unlike those of the Impressionists, seemed to occupy an eternal, monumental world. He resolved the structure of that world into its underlying basic shapes, the cone, the cylinder and the sphere. His paintings were not impressions, but explorations of faith in the importance of the world he contemplated. The subject was not represented from a single viewing point: by shifting the line of vision, he delved beneath the surface of nature, to prize its planes apart and open up its forms as if by lifting a lid. To the new century Cézanne bequeathed his shapes and methods, and an intellectual approach to art.

Loud and colorful cries: the Fauves
While Cézanne's passion for geometry later inspired the Cubists, his color was of relatively little significance to them. Color, though, was to be the field of the first dramatic, challenging art movement of the 1900s in Paris. In 1905 a group of artists, among whom the dominant character was Henri Matisse, exhibited at the Salon d'Automne, their work so violently vivid that a notable critic described them as being "at home with the wild beasts" (*les fauves*). The Fauvist movement was short, but lived at a passionate peak: line, tone, volume and the graded subtleties of everyday vision were all sacrificed to color, though their subjects were frequently moments of modern life, in pictures of the metropolis or daily events. Yet, by taking this one element of the painter's mental

When one enters the gallery devoted to their work... one feels completely in the realm of abstraction. Here one finds, above all in the work of Matisse, the sense of the artificial; not literary artificiality ... not ... decorative artificiality ... it is painting outside every contingency, painting in itself, the act of pure painting... here is in fact a search for the absolute.

MAURICE DENIS, REVIEWING THE 1905 SALON D'AUTOMNE

▶ *Le Havre, 14 juillet* (1906) by Albert Marquet. Painted at the height of the brief Fauve movement, which sought a liberated use of color. Marquet was close to Matisse, the principal Fauve, and this work displays his influence. Matisse might put green on a face, or tint the whole ground of a room red. But his principal aim was decorative rather than expressive. Marquet was also closely associated with Dufy, who used color to display public exuberance, not private emotions.

"In the new century everything cracks, is destroyed, isolated." Gertrude Stein

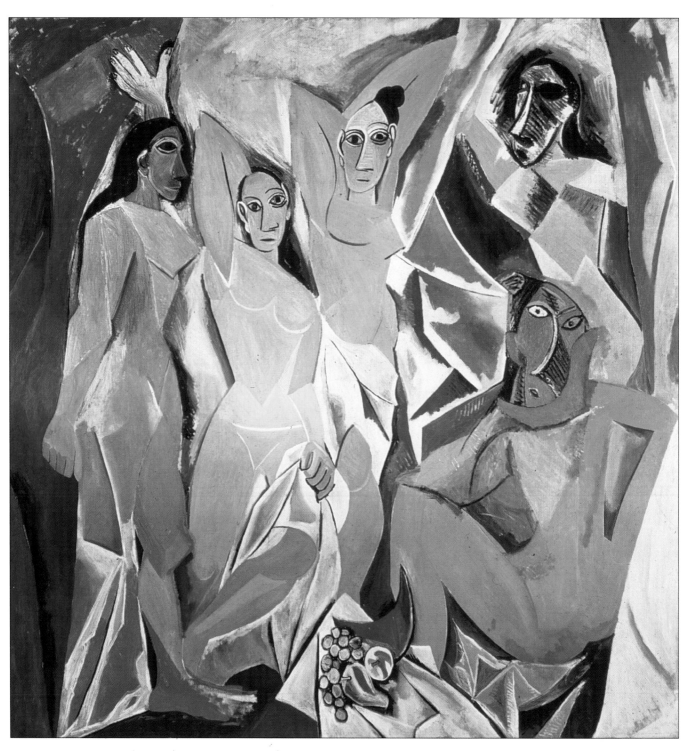

▲ *Les Demoiselles d'Avignon* (1907) by Pablo Picasso, perhaps the most influential painting of the century. Publicly exhibited for the first time as late as 1938, it was nonetheless seen by many artists at Picasso's studio. Absorbing a collage of influences from Cézanne's *Bathers* to African masks, the painting decisively dismissed conventional perspective, modeling and concepts of beauty. What it affirms is a difficult and violent new art, soon to be labeled "Cubism".

equipment to the limits, the Fauves pointed out the possibilities of the extreme statement, possibilities that would be of great fascination to the new century. Of the Fauves, only Dufy and Matisse managed in their subsequent careers as colorists to discipline the "wild beast" in them for their Fauve palette to survive the short moment of the movement's passion. Both achieved this by paying as much attention to the line element in their work as had Cézanne, though detached from the substance of the color to allow the color free rein. In Dufy's later paintings of racehorses, the body of the horse seems to dash free from its splash of color. Unlike earlier colorists Matisse used line to hold his color together. In this his

work reflected traditional Islamic calligraphy, and Japanese prints, which had been so influential in Western art since the last years of the preceeding century.

The severity of Cubism

Meanwhile, at the same time as the Fauvist paintings were exploding with color, experiments in line and volume were also being conducted in another studio in Paris. Here the example of Cézanne was consciously invoked. One painting in particular took Pablo Picasso through a maze of sketches and redraftings, and led him far beyond the soft, Symbolist but broadly traditional images of his "Blue Period" and "Rose Period". It was

► Braque in his studio in the Hotel Roma, 1910. Georges Braque (1882–1963) was, together with Picasso, the prime theorist and exponent of Cubism. Their close association lasted from 1907 until World War I. The musical instruments and African masks on his walls were of great significance in their work. Both artists utilized the simplification of form in the masks. Analogies between the body of a violin and the human form also fascinated them. Cubism delighted in such "rhymes".

▲ A calligramme by Guillaume Apollinaire (1880–1918). A poet and critic, Apollinaire took it on himself to explain Cubism to a bewildered public. His own poetry imitated the Cubists' disruptions of visual depth by breaking up the conventional metric line. "Calligrammes" were hand-written arrangements of language into portraits of their subject-matter.

► *Portrait of Ambroise Vollard* (1910) by Picasso. Vollard was a dealer who handled Cézanne's late work, as well as Picasso's own early paintings. Here the artist celebrates him as a Cubist icon. For Picasso, the portrait had become an assemblage of the many angles from which a person can be seen, organized on a single picture plane. Rather than a single, photographic image of a sitter, he was attempting to reproduce an entire personality.

completed in 1907 and brought into being a whole new school of painting, but it was not seen by a wider public until it was first exhibited in 1907. This was the work known as *Les Demoiselles d'Avignon.* In it the figures are distorted and totemlike, their features simplified or shaped after African masks, their limbs molded into three dimensions by sculpted planes. At the bottom of the picture was an acknowledgement to Cézanne, a folded-out bowl of fruit. In this work Picasso sought a personal means of creating the illusion of a third dimension on the flat surface of the painting. His difficulties in completing the work reflected his struggle to deny himself all the techniques of traditional perspective painting that had been conventionally used in Europe since the Renaissance. These conventions, although they seemed natural to most people in France in 1900, had not been always used, nor were they the chosen manner of art outside the West. Picasso was linking up with other traditions of seeing.

Traditional perspective can be seen as a deviation from reality, a means of subduing the world to the limits of vision, but other views are possible. Early medieval art, for instance, varied the size of figures according to their importance, so Christ would often be represented as bigger than his disciples. Ancestor figures in much of the art of Africa and Polynesia are similarly prone to variation from the human norm, perhaps to represent another dimension of existence. The 17th-century Greek–Spanish painter El Greco had made his figures longer than the rules of perspective would suggest, perhaps to express some human straining towards the eternal. Picasso was beginning to devise a visual language that would reinstate these older methods and aims. *Les Demoiselles d'Avignon* conflated all the sources and led directly to Cubism.

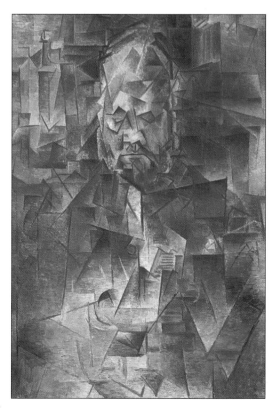

Cubism came into being in a series of closely related works produced between 1907 and 1911 in an alliance between Picasso and Georges Braque. Both were already accomplished painters, Braque in a Fauve style, and Picasso in a wide range of styles and techniques. Picasso's portraits are characteristic of the new style. Cubist paintings constructed their subject by assembling and superimposing different views of it to form a multiple and concealed impression, yet they never lost the subject entirely nor dissolved into abstraction. The subject – whether a human figure, a guitar, a violin, or a bottle – remained to specify the main elements of the composition.

Cubism was considered even more freakish and bizarre then Fauvism when first exhibited, but it was in fact a severe and intellectual discipline, its severity emphasized by its resistance to the very thing that gave the Fauves their ebullience – color. Cubist colors were muted browns, grays, olive greens, to avoid distraction from the overall method and control exercised by the lines, angles, and diamond-like facets. And, just as with the Fauves, once the first flush of invention was over, Cubism became one technique among others available to painters in the 20th century.

The Cubists made one other important extension to painting method, and here again they could appeal to the precedent of other traditions, both pre-Renaissance and non-European. This was the use on the picture surface of materials other than paint. To bring variation and a touch of everyday life into the severe lines of classic Cubism, first Braque and then Picasso introduced rectangles of pasted-on paper, newsprint and so on as integral parts of the picture, just as shells, sand, cord, gold leaf and wood had been used with paint in other types of art. This new art of collage radically widened the sense of what makes a picture, with important consequences for

"A melody does not have its harmony, any more than a landscape has its color." Erik Satie

20th-century painting. Collage resembles the superimposition or juxtaposition of different themes in music; and a Cubist collage bears the same relationship to "normal reality" that the sounds of music do to the sound of nature. This comparison with music as a means of explaining the methods of Cubism was first made by the poet Guillaume Apollinaire in *The Cubist Painters* (1913). The extrovert Apollinaire was the main defender of and propagandist for the Cubists as well as a very intelligent commentator on the whole range of contemporary Parisian painting.

The flamboyance of Futurism

The most flamboyant of all the painters and poets in Paris at this time were a group of Italians known as the Futurists. At times they seemed to be propagandists first, painters and poets second. In 1909 the poet F. T. Marinetti chose Paris as the place to publish *The Foundation and Manifesto of Futurism*, in which he announced an art for the future, given over to the celebration of speed, the machine and the modern world, and glorifying war, "the only true hygiene of the world". The manifesto preceded the paintings which were to

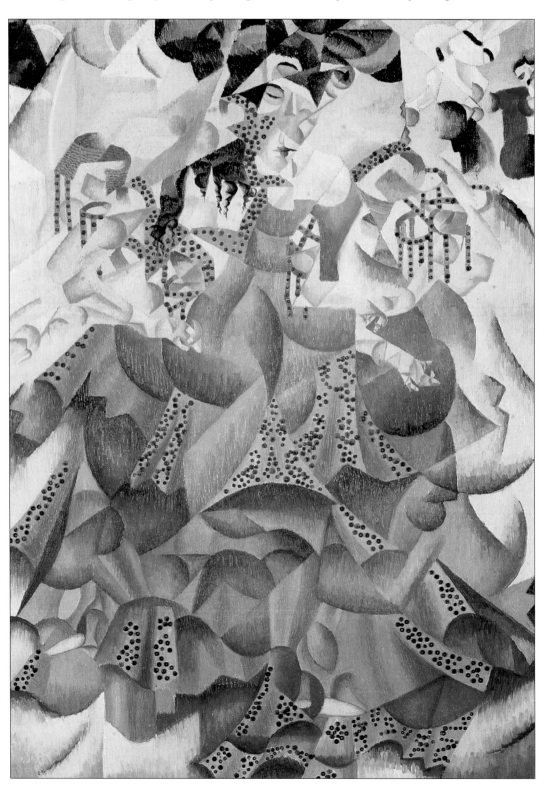

◄ *The Blue Dancer* (1912) by Gino Severini. A Futurist painting which demonstrates the distinction between this Italian-based movement and Cubism. The subject of a Cubist painting remains still, while the artist moves all round it. In a Futurist painting, the artist is stationary and the image is in motion.

▲ The cover of a book of Futurist poetry by Marinetti (1912). The principle of "words in liberty" which inspired this kind of radical typography was not dissimilar to Apollinaire's calligrammes. The Futurists' theorizing, however, was much more thorough going than the Parisian's. Vocal on subjects ranging from museums to macaroni, perhaps no other avant-garde movement produced as many manifestos.

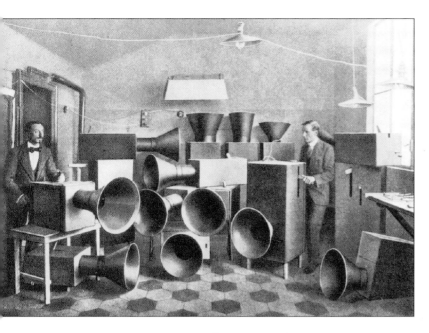

▲ Luigi Russolo with *intonarumori* or "noise instruments", 1913. The Futurists' wholehearted embracing of modern industrial life led them to rethink the basis of many artforms. The revolution in our aural environment brought about by cars and machinery prompted an abandonment of conventional instruments as well as conventional musical structure.

► The cover of the score of Debussy's *La Mer*. This image of a wave by Hokusai might serve to symbolize the impact of Japan generally in the arts at the turn of the century. The Fauves responded to the Japanese concern with line and flat areas of color. The realization that a culture could achieve a sophisticated art without the benefits of Western perspective slowly impressed itself on the consciousness of Cézanne and his followers. For Debussy himself, the focus in oriental music upon mood and spirit must have proved significant. *La Mer* is composed with great melodic and rhythmic freedom.

represent these views. They were to come from the Italian painters Giacomo Balla, Umberto Boccioni, Carlo Carra and Gino Severini, all of whom worked from time to time in Paris and exhibited there. They knew the work of the Fauves and the Cubists; their color was as startling as that of the Fauves, and their interest in line and the multiple appearance of forms was as pronounced as that of the Cubists. Yet the source of their art was very different from both. Their color had something of the effect of light through a prism, whereas the Fauves used natural colors intensely seen. And rather than trying to open out the essential form of objects as the Cubists were doing, they sought to display them in movement, much as photography had revealed and superimposed the successive stages of men running or birds in flight. Severini's *Bal Tabarin* or *Pam-Pam au Monico* are like jigsaw puzzles with a thousand pieces, and his portrayal of speed dissected rather than represented movement, like a film viewed frame by frame instead of continuously. While the Fauves and Cubists based their practice on what they saw, and proposed more potent or more accurate ways of seeing, the Futurists seemed more concerned to represent in paint an ideology that declared the shape of the future. In the event, the future they prophesied was fulfilled, not simply in the idea of war but in war itself.

Impressionism in music

"I wanted from music a freedom which it possesses perhaps to a greater degree than any other art, not being tied to a more or less exact reproduction of Nature but to the mysterious correspondences between Nature and Imagination", wrote the French composer Claude Debussy of his 1902 opera *Pelléas et Mélisande*. Freedom, mystery – these were focal ideas for a loosely associated group of composers centered on Paris in the early years of the century.

A term borrowed from the visual arts – Impressionism – quickly became associated with their work, and particularly with the music of Debussy. It served to identify music's equivalent of the visual artist's rejection of photographic precision: new techniques that produced tonal uncertainties, constantly shifting orchestral textures, a "shimmering" effect in the writing for stringed instruments.

By the turn of the century, Debussy had for some time been exploring alternative modes (scales) as a basis for composition. Two works completed at this time, the orchestral suite *La Mer* and the opera *Pelléas et Mélisande*, were indicative of this new freedom of harmonic discipline and consequent freshness, lightness and fluidity. In his operatic realization of Maeterlinck's fairy tale, Debussy deliberately set out to reduce the relative importance of music to opera. His orchestration was discreet and he was not afraid of silence. *Pelléas* was not an unqualified success at its première. Debussy's flexible treatment of the form – there were no set-piece arias or dance interludes – and his seamless yet unconventional harmonic progressions laid him open to charges of formlessness and unintelligibility.

Much of Debussy's orchestral writing was descriptive of nature at peace and in turmoil. *La Mer*, one of his most popular works, was typical. A symphony in all but name, it had three movements, each portraying the sea in a different mood. The work was constructed from fragments and suggestions, rather than recognizable tunes and harmonic progressions – an ideal way to represent the perpetually changing quality of water, almost an obsession with composers of the period. The opening movement contained much of what came to be called "Impressionist" in music: the rippling, shimmering strings, never at rest; harp arpeggios, and woodwind patterns built out of the pentatonic scale.

If reflections for Debussy were usually to be seen in water, for Maurice Ravel they were to be seen in glass, as in his collection of five piano pieces, *Miroirs*. Capable of great sensuousness and exoticism (as was borne out by his orchestral

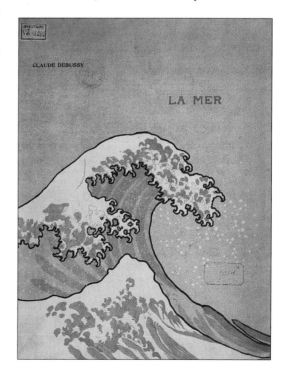

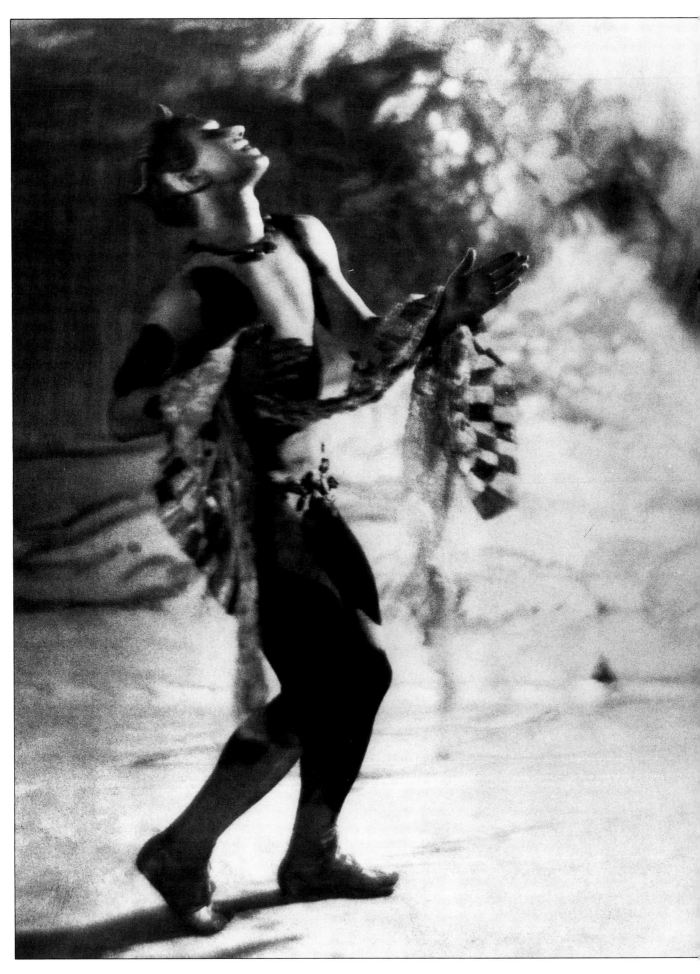

◀ Nijinsky in *L'Après-midi d'un faune* (1912). For his role as the Faun Nijinsky devised a form of movement which departed sharply from the five positions of traditional ballet. The attempt to express an Archaic Greek sensibility led to stark profiling and rigid processional files. These devices were invested with a revolutionary psychological subtlety, particularly in relation to the Faun's sexuality.

Nijinsky as the Faun was thrilling. Although his movements were absolutely restrained, they were virile and powerful, and the manner in which he caressed and carried the nymph's veil was so animal that one expected to see him run up the side of the hill with it in his mouth. There was an unforgettable moment just before his final amorous descent upon the scarf when he knelt on one knee on top of the hill, with his other leg streched out behind him. Suddenly he threw back his head, opened his mouth and silently laughed. It was superb acting.

LYDIA SOKOLOVA

song-cycle *Shéhérazade*), Ravel's stance was objective and detached. Essentially more conventional than Debussy, he combined traditional harmonic and rhythmic devices with a command of melody and inventive sonority. He too was no stranger to scandal and outrage. His setting of Jules Renard's *Histoires naturelles* (1907) for voice and piano upset academic sensibilities, and his one-act farcical opera *L'Heure espagnole* was accused of lewdness and obscenity.

The Spanish influence was an important one at this time. Isaac Albéniz, Manuel de Falla and Enrique Granados all visited Paris and met Debussy and Ravel. They brought with them the color and excitement of flamenco dance and the ornamented modal melodies of the Andalusian *cante jondo*, a type of popular song. Debussy's *Ibéria*, the central section of his orchestral *Images* and Ravel's *L'Heure espagnole* all profited directly from this contact. Another Spaniard, the pianist Ricardo Viñes, premièred many important works of the period. Viñes was among those who championed another French composer of the time, Erik Satie. Satie was a true eccentric. His music, much of it written for café performance in order to keep body and soul together, was deceptively simple. Imperturbably archaic in style, his piano music was harmoniously innovative.

The *Ballets Russes*

In 1907, Serge Diaghilev had arranged concerts of Russian music at the Paris Opéra, and in 1908 had put on a Paris production of Mussorgsky's opera *Boris Godunov*. In 1909, in association with the Russian dancer and choreographer Mikhail Fokine, he brought the newly formed *Ballets Russes* to the Théâtre du Châtelet. In a city already renowned for its delight in the new, experimental and shocking, they were welcomed with open arms. Fokine's dashing and informal choreography combined with the talents of young

dancers such as Nijinsky and Pavlova to revolutionize classical ballet. The influence of the stunning stage designs produced by Leon Bakst and Alexandre Benois ran through Paris like wildfire. Their color, like that of the Fauves, was strong and dramatic. It reached most Parisian homes and changed the taste of a generation.

Perhaps the greatest achievement of the *Ballets Russes* in the prewar years was their collaboration with Igor Stravinsky on three extraordinary ballets: *The Firebird* (1910), *Petrushka* (1911) and *The Rite of Spring* (1913). In the autumn of 1909, Diaghilev and Fokine were planning a new ballet based on an old Russian folk tale, *The Firebird*. However, the composer who had been commissioned to write the music, Liadov, proved too slow, and the untried Stravinsky was brought in. The result was an outstanding musical and critical success.

The score of *The Firebird* is full of the syncopations and aggression that were to be central to *The Rite of Spring*. But the inspiration for *The Rite of Spring* was Stravinsky's own: "I saw in imagination a solemn pagan rite: sage elders, seated in a circle, watched a young girl dance herself to death. They were sacrificing her to propitiate the god of spring."

Aside from Stravinsky's sharply appropriate orchestration and the daring of the volume of sound demanded, *The Rite of Spring* owed its terrifying onward drive partly to a new treatment of rhythm. Stravinsky combined two techniques: the individual beat retains its value while the time signature changes; and unequal beats join into equal units in a recurring pattern. The effect is disorientating and convulsive. The first performance, with Nijinsky's choreography, on 29 May 1913, provoked a riot, with some of the audience calling for silence while others became as frenzied as the music itself – but theirs was a frenzy of disapproval.

Puccini and the Paris Opera

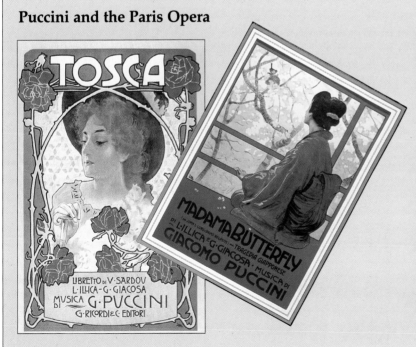

The influence of Paris and Parisian life even affected the Italian opera stage. In Turin, the year 1896 saw the première of Giacomo Puccini's *La Bohème*, based on stories of impoverished Parisian artists. Puccini's next opera, *Tosca* (1900), was influenced by a very different kind of French writing. It was his first attempt at opera in the style known as *verismo*, which took its cue from the realism of writers such as Zola, and was concerned with the psychological truth of its characters. Puccini was a superb technician who understood his audiences and their desire to be constantly engaged, shocked, touched or moved to laughter. *Tosca* was a great popular hit. *Madama Butterfly* (1904) is more delicate in approach. Although he was undoubtedly influenced by the modern music of his day, Puccini closed an operatic era rather than opening a new one. The skillful use of melodrama that made him popular with opera-goers also made him an easy target for a new generation of Italian composers, anxious to deny the romanticism of the previous century.

◀ Posters by Mucha for Puccini's operas.

ART AND MODERNISM

In 1852 the French novelist Gustave Flaubert had said that he wanted to write a book that would depend on nothing outside itself and would be held together "by the strength of its style". In 1913, two years after Henri Matisse painted *Interior with Eggplants*, the French poet Guillaume Apollinaire was able to say, with a great deal of truth, that in much contemporary painting, "the subject has little or no importance anymore". Instead of having external subjects, paintings were increasingly about their own interior dynamics, as expressed in color, line, volume and shape. A painting was more like a piece of music, creating its own harmonious relationships, and the ostensible subject – in this case eggplants on a table in a room – might serve only as a means of producing a symphonic structure, as Matisse himself said.

Artists and critics alike talked about "pure" painting; and in writing, equally, poets aimed to achieve "pure" poetry. Books like James Joyce's *Ulysses* or his last book *Finnegan's Wake*, Virginia Woolf's resonant *The Waves* or the poetry of Wallace Stevens in America were distinguished by their self-reflecting organization, full of facets like hugely worked jewels. In writing and painting this tendency is one of the key marks of Modernism. The equivalent Modernist movement in architecture, led by Mies van der Rohe and Le Corbusier, stressed the functional form, pure and simple in its line.

One of the marks of all the modern arts of this century has been an interest in the work as self-sufficient, constructed in response to its own laws and from its own materials – words, sounds, colors. Artists have sought to make their work meaningful without recourse to external "impurities" such as the conventional subjects: ordinary life, politics, history or even people. Often there seems nothing more useful to say about these works than that "the subject of the picture is itself". In one way, though, this is an important insight because it releases the arts from serving some other cause in an already too-busy world. Instead the work can be seen as a moment of balance, an object of contemplative harmony in a world where all else points towards chaos and confusion.

In *Interior with Eggplants* Matisse seems deliberately to have stacked the odds against achieving order and then triumphantly to have brought it off. If the image is broken down into its structure of rectangular shapes – windows, doors, tables, mirrors, screens, all flattened into a single plane – and then into its pattern of flowers and decorative curves, and finally into its distribution of colors, the complexity and then the range of elements to be resolved is clear. The picture seems itself to be an interplay of screens aimed to keep the eye concentrated on its one plane. Even the window does not tempt us to look outside but draws the landscape in. At the heart, the eggplants sum up the controlling idea of related shapes, engaged in their own pattern like a dance but, exact in color, defiant in their reality.

► The *Interior with Eggplants* was painted by Matisse in 1911, and is one of a series of works done around that time in which he explored rich and complex patterning. In the previous few years he had produced a series of statuesque nudes, often in somber colors; now he returned to the lavish coloring of his Fauvist period, combined with a new fascination with decoration. In this regard he was demonstrating his interest in Islamic art, of which a large exhibition had been seen in Paris the previous year. This painting and others done at this time owe something to Mughal and Persian miniatures, too; Matisse also traveled fruitfully to Morocco during these years. The fusion of space and pattern in this work, however, followed an internal logic that was unique to Matisse, and made this work a classic example of the artistic ideas later described as Modernism.

A work of art must carry in itself its complete significance and impose it upon the beholder even before he can identify the subject matter. When I see the Giotto frescoes at Padua I do not trouble to recognize which scene of the life of Christ I have before me but I perceive instantly the sentiment which radiates from it and which is instinct in the composition in every line and color. The title will only serve to confirm my impression. What I dream of is an art of balance, of purity and serenity devoid of troubling or depressing subject matter, an art which might be for every mental worker, be he businessman or writer, like an appeasing influence, like a mental soother, something like a good armchair in which to rest from physical fatigue.

H. MATISSE 1908

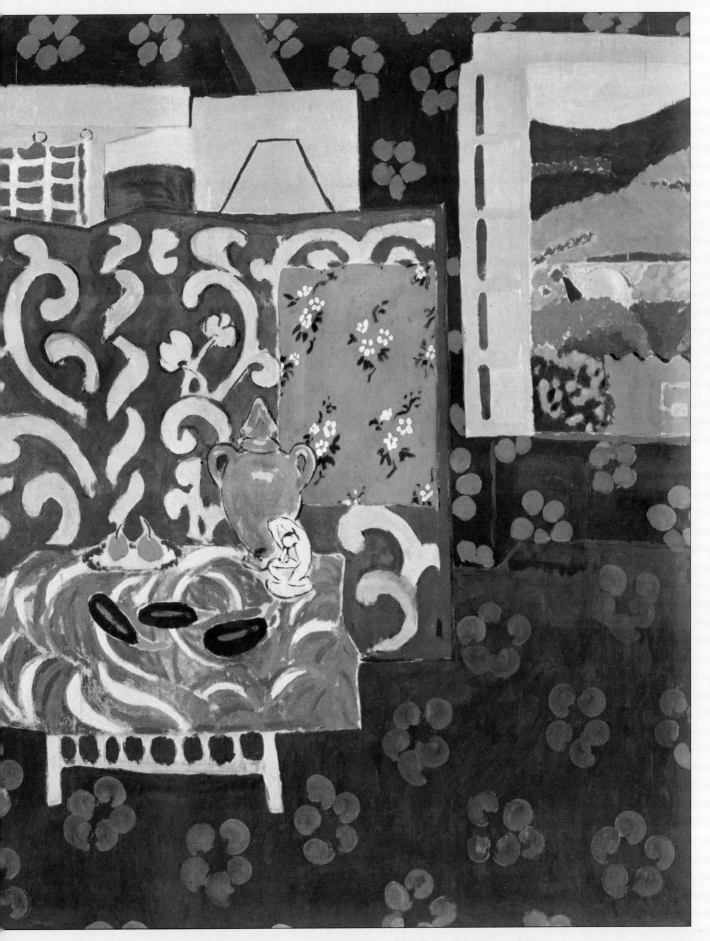

Datafile

Prewar Europe responded to the benefits of industrialization with an increased sense of national pride, and of faith in its own manifestations of culture. In France, literary prizes like the Prix Goncourt appeared, while in Sweden the Nobel Prize was set up in 1901. Meanwhile, in Italy, Germany and elsewhere, painters and writers who were not being considered for such awards were producing new and ever more shocking works. The German Expressionists were reacting against the dehumanizing elements of modern urban life, while the Italian Futurists celebrated industry and technology with a corrosive destruction of conventional values. Artists like Kandinsky and Mondrian were edging toward abstraction. Architects were rejecting the styles of classical architecture in favor of more functional, more austere designs. Poets, from Mayakovsky in Russia to Ezra Pound in London, were beginning to reject conventional meters, rhyme, and decorous imagery in favor of forms that reflected the mood of revolution.

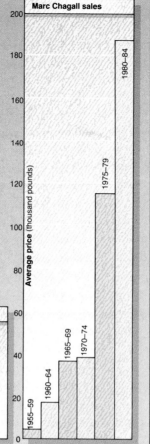

Prix Goncourt

1903 John-Antoine Nau *Force ennemie*
1904 Léon Frapié *La Maternelle*
1905 Claude Farrère *Les Civilisés*
1906 Jérôme and Jean Tharaud *Dingley, l'illustre écrivain*
1907 Emile Moselly, *Terres lorraines, le Rouet d'ivoire*
1908 Francis de Miomandre *Ecrit sur de l'eau*
1909 Martius and Ary Leblond *En France*
1910 Louis Pergaud *De Goupil à Margot*
1911 Alphonse de Chateaubriant *Monsieur de Lourdines*
1912 André Savignon *Les Filles de la pluie*
1913 Marc Elder *Le Peuple de la mer*

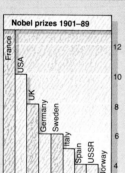

Nobel prizes 1901–89

▲ This chart shows the main countries winning the Nobel Prize for Literature from 1901 to 1989.

▶ Each winner of the Literature prize receives a short citation explaining the judges' reasoning. This is generally related to their preeminence in either their own culture or in the presentation of that culture to others. The Provençal poet and philologist, Mistral, was thus honored in 1904. Rabindranath Tagore, who was honored in 1913 for his writing, was an important painter too.

▲ The Prix Goncourt is awarded annually by the Académie Goncourt, established in France in 1903 as the legacy of Edmond Goncourt, who, with his younger brother Jules, had planned it in 1867. The prize, intended principally to honor younger authors, is awarded for novels published that year. The brothers Jérôme and Jean Tharaud, winners in 1906, were prolific over 50 years and celebrated for their travelogs, and political commentaries; they were later to be elected to the Académie Française.

▲ Marc Chagall can be seen as a kind of popularizer of modernist art. His early career took him from provincial Russia to Paris at the height of Cubist experimentation. He mixed avant-garde principles with folk-art elements in a wholly original manner, celebrating village life as well as Paris with a seemingly unquenchable *joie de vivre*. Chagall was, above all, an accessible painter, and this is reflected in the generous leaps in value of his work as he approached old age.

Nobel Prize for Literature

1901 Sully Prudhomme (France)
1902 Theodor Mommsen (Germany)
1903 Bjørnstjerne Bjørnson (Norway)
1904 Frédéric Mistral (France) and José Echegaray y Eizaguirre (Spain)
1905 Henryk Sienkiewicz (Poland)
1906 Giosuè Carducci (Italy)
1907 Rudyard Kipling (UK)
1908 Rudolf Eucken (Germany)
1909 Selma O.L. Lagerlöf (Sweden)
1910 Paul J.L. Heyse (Germany)
1911 Maurice Maeterlinck (Count) (Belgium)
1912 Gerhard J.R. Hauptmann (Germany)
1913 Rabindranath Tagore (India)

By 1900, many centuries of warfare and political change had fixed the frontiers of many European countries with little regard for the race, language or religion of the people who lived in them. The population of Austria-Hungary, for example, included Germans, Magyars, Czechs, Poles, Slovaks, Serbs, Jews and many others. Nationalism was a major issue throughout Europe, rousing strong passions. In Central Europe, there were to be disastrous consequences. But it was not only in Central Europe that nationalism was a major force in this period. Norway was demanding independence from Sweden, Finland from Russia and Ireland from Britain. On the other hand, the recently united German state could not subdue its newfound nationalistic fervor.

Nationalism can be destructive, but it also has positive values. Primarily, it seeks recognition of the right to statehood of people who think of themselves as capable of constituting a state. This can result in a deep sense of belonging, an awareness of the past and a determination not to let it be lost, which naturally finds its expression in the arts. Certainly, in the 19th and 20th centuries one of the effects of nationalism has been to invigorate the arts. The reasons have been twofold. On the one hand, artists in a small and beleaguered country were determined to assert their own equality with artists in countries of a more dominant culture; and on the other, they felt passionately that their own country, small and beleaguered as it was, nonetheless had its own qualities, dignity and history. It had myths and legends, a language and a people unlike those of any other country. All these were fit subjects for celebration in the highest art, whether literary, visual or musical.

Balkan nationalist writing

In many countries of Europe, especially in those swallowed up in the contending pressure on the frontiers between Russia, Germany, Turkey and the Austro-Hungarian Empire, nationalism gave birth to twin literary movements, one avant-garde and looking outward to wider European example, the other looking inward and back to a heroic past for inspiration and sustenance. Both asserted the importance of their own place and met in the portrayal of indigenous life, whether traditional peasant life or that of newly industrialized towns. Such writing was both local and in touch with the internationally renowned writing of Emile Zola in France, Henrik Ibsen in Norway or Giovanni Verga, whose work reflected peasant life in his native Sicily.

A number of important writers emerged from the melting-pot that was Central Europe. Bulgaria became effectively, if precariously, independent from Turkey in 1878, and at the turn of the

ART AND EUROPEAN NATIONALISM

▼ In this Hungarian poster: "A thousand years of statehood", nationalism found a cultural expression.

century the nationalist tone of Bulgarian literature reflected the struggle for freedom of the 19th century. It was to be seen most clearly in the work of Ivan Vasov, and particularly in his novel *Under the Yoke*, which deals with the 1876 rising against the Turks. The novel was written, as so much of the new century's literature was to be, in exile. Vasov's compatriot Pencho Slaveykov opposed him in drawing together a group of writers more concerned with current European thought; much influenced by the philosophical views of Friedrich Nietzsche, he asserted the independence and vitality of the artist's conscience. His best-known work, *The Isle of the Blessed*, took the distinctively modern form of a fictional anthology of poems, written by a series of invented authors. Nevertheless he too produced an epic account of Bulgaria's history, *Song of Blood* (1913), a work that was unfinished at his death.

In Poland, much writing at the turn of the century was concerned with the rigors of everyday life, and followed the path of European naturalism. Nevertheless, its intention was nationalist, in examining the life of the peasantry. Wladislaw Reymont, who later was to win the Nobel Prize for Literature, wrote his greatest novel, *The Peasants* (four volumes, one for each season, published between 1902 and 1909), in response to Zola's *The Earth*. It is a complex study of Polish village life as season follows season and generation succeeds generation.

The Irish revival
One of the most fruitful intersections between literature and national feeling came about in Ireland, where – as elsewhere in Europe – the 19th century had seen a massive growth of interest in early myths and legends, many made generally available for the first time through modern versions and editions. These stories were integral to the work of the major Irish poet W.B. Yeats, especially to the plays written in the early years of the century. But Yeats's impact was in no way local to Ireland, nor was it intended to be. It was rather that he saw that the way to achieve universally relevant statements was to present a particular place and feeling, not an abstraction. Much Irish writing of this period is strongly imbued with national feeling. Such feeling, and for some writers the use of the Irish language itself, was immensely important as a way of reinforcing Irish distinctiveness in a campaign of political and cultural self-assertion. Scholars, educationalists and politicians were equally involved. Padraic Pearse, teacher and poet, was executed in 1916 for his actions as leader of the Dublin insurrection of Easter 1916. Douglas Hyde, poet, translator and historian of Irish literature, was to become the first President of Eire in 1938.

Yeats's determination to found an Irish national theatre was shared by another Irish patriot, Lady Gregory, who herself both wrote and translated Irish material. The Abbey Theatre opened in Dublin in 1904, and proved an important focus for Irish drama. Yeats's plays of this period were highly stylized, imitating the Japanese drama, spare in language and drawing their subject matter from Irish mythology, while those of his fellow-dramatist J.M. Synge were intended to present the life of the Irish peasantry. He aimed to use a thoroughly naturalistic language, claiming that he had heard someone actually say every phrase he wrote. The intensity with which he used it, though, was one step away from naturalism, and *The Playboy of the Western World* caused a riot on its first night. It disrupted an unreal and idealistic vision of what the rural Irish were like,

for Synge showed them as cowardly, violent, comic, braggardly and using indecent language, and it was hard for the audience to see, as Synge himself saw, that they were also joyous, heroic and alive as few people were. The play – and the riots – represented alternative pictures of the same thing: both presented idealizations of the rural Irish. Both were therefore in their own ways attempts to create a national consciousness.

Yeats also encouraged one of his younger Irish contemporaries, James Joyce. Joyce spent most of his life away from Ireland, in Trieste, Zurich and Paris, but his writing never slackens in its preoccupation with Ireland. His volume of short stories, *Dubliners*, was published after great delays and difficulties in 1914, and was followed by the largely autobiographical *Portrait of the Artist as a Young Man*. The hero, Stephen Dedalus, follows his author into "exile", but he goes to "forge in the smithy of my soul the uncreated conscience of my race". Even in apparent rejection, Joyce too was concerned to establish a national consciousness.

Victorian values

While Ireland was emphasizing its separateness from the rest of the British Isles, Britain itself in the years before World War I was still very firmly rooted in the Victorian era of imperial solidity. But even as its writers contemplated the pleasures

of Empire, so divisions and doubts seemed to make the old certainties, if indeed they had ever in fact existed outside the imaginations of the well-fed, more complex and unclear. The early 20th-century vision of England was most powerfully expressed in Thomas Hardy's poetry, idyllic West Country landscapes overlaid with modern doubt. But in *Sons and Lovers* (1913) the novelist D.H. Lawrence presented another England, possessed of an almost elemental vigor, with his realistic portrayals of the Nottinghamshire mining community, based on his own youthful experiences. It is an unforgettable evocation. Another English variation which rings true is to be found in the world of smalltown enterprise documented in *Kipps* (1905), *Tono-Bungay* (1909) and *The History of Mr Polly* (1909), all novels written by H.G. Wells. For all Wells's science-fiction ingenuity and utopian speculation, he was at his best relishing "a nation of shopkeepers". Hardy, Lawrence and Wells all maintained a solid realism in their wider speculations about the human condition, impinged upon by the hand of fate, sexually driven or in pursuit of social betterment. So too did the leading champion of an already waning imperial splendor, Rudyard Kipling, whose view of the English in India, its soldiers, engineers and minor functionaries, was sharply drawn. The best of his Indian stories was *Kim* (1901), but he was also acutely sensitive to the

▲ **Illustration by Kipling to his story *The Cat who Walked by Himself*. Despite his vigorous use of jargon and slang, his stories, novels and poems about the Empire took a traditionally patronizing view of the "natives".**

▼ ***The Wake House* (1908) by the Irish artist Jack B. Yeats, brother of the poet W.B. Yeats. The Yeats family was central to the growth of a modern, independent Irish culture.**

The Arts and Crafts Movement

By the middle of the 19th century, industrialization, urbanization and shoddy mass production had caused a number of artists and thinkers in England to question the break with a cultural past that they perceived to be primarily rooted in the countryside and in an art that was never separated from the craft of production. The early focus for such ideas centered on the British poet and designer William Morris. Morris and his followers wanted to bring art and craftsmanship to all the commonplace objects of everyday life, and to make them widely available. His famous Red House (1859), designed by Philip Webb in close collaboration with Morris, was a first realization of his ideas in domestic architecture. Morris's influence on design extended to wallpaper, furnishing fabrics, furniture, tapestries and much more, though despite his socialist ideals he never succeeded in making such items cheap enough for ordinary working people to afford.

While Morris's inspiration was primarily medieval, in common with his early pre-Raphaelite circle, the work of C.R. Ashbee, Richard Norman Shaw, C.F.A. Voysey, W.R. Lethaby, Edwin Lutyens and the other artists and architects who followed him drew also upon the more recent pre-industrial past. In building, craft traditions in brick, timber, tile and plaster were closely studied, and forms and materials appropriate to the locality were advocated. Similar trends could also be seen as far away as California, where Greene and Greene built fine houses in timber and shingle, most notably the Gamble House at Pasadena. This vernacular or regional approach was highly regarded by the German architect Hermann Muthesius, author of the monumental study *Das Englische Haus* (1904–05). Muthesius had just completed a term as cultural attaché at the German Embassy in London, which had given him an opportunity to study English housing reform, and in particular the domestic architecture of the Arts and Crafts movement. In 1907 he founded the Deutscher Werkbund, a German association for the improvement of design in machine-made products, which retained many of the Arts and Crafts ideals but tried to harness them to the possibilities of modern machinery.

The movement was taken up in many other European countries, especially in Scandinavia, where its influence was felt through the century. Stockholm town hall, built by Ragnar Ostberg (1911–23), used Arts and Crafts principles.

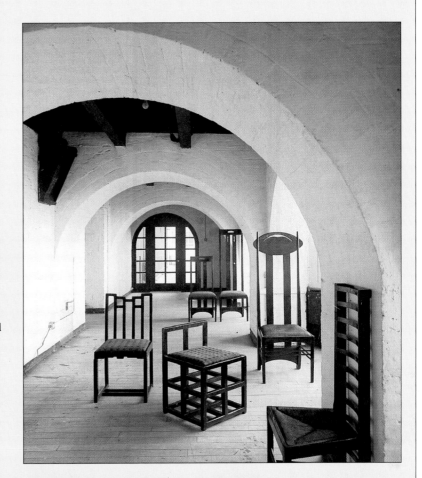

◀▲ The Glasgow School of Art (1897–1909) was designed and built by the Scottish architect and designer Charles Rennie Mackintosh, incorporating Arts and Crafts principles with Japanese and Art Nouveau elements. His design included furniture and a rose motif recurred.

seedbed of his England, the public school, in *Stalky & Co* (1899). At the heart of his imperial view was a sense of duty, a nationalism at once dangerous and fruitful, which found its earthly paradise in some English scene, Devon or the Sussex Downs, his final home.

Post-Impressionism outside France

In the visual arts, England wavered between deference to French art and resistance to it. The quest was on the one hand for the best in current painting and on the other for the formation of a genuinely national style. The work of Walter Sickert and Philip Wilson Steer exhibited with the New English Art Club in the years around 1900 achieved a successful balance. The art of both men derived its French elements from the Impressionists, Dégas in the case of Sickert, Monet and Renoir in the case of Steer. Many others, among them Robert Bevan and the Irish Roderic O'Conor, went to newer sources. They painted in Brittany and were much influenced by the paintings of peasant life by Gauguin and Van Gogh in particular.

A new pebble was thrown into the pool of London's art world by the English painter and critic Roger Fry, who effectively brought Cézanne's work to England when he put on major exhibitions in 1910 and 1912. He coined the term "Post-Impressionist" to describe the work of Cézanne, Gauguin, Van Gogh and the Fauves. These exhibitions signaled England's entry into the world of

On the stage one must have reality, and one must have joy, and that is why the intellectual modern drama has failed, and people have grown sick of the false joy of the musical comedy, that has been given them in place of the rich joy found only in what is superb and wild in reality.

J.M. SYNGE, 1907

modern art, for by now such painting was coloring the whole of Europe.

Another aspect of Fry's endeavors was in craft design. In 1913 he founded the Omega Workshops to produce well-designed "objects for common life". This was a community of artists working together on furnishings and ceramics; Duncan Grant, Vanessa Bell, and very briefly, Wyndham Lewis and Edward Wadsworth, all substantial English painters, were all involved. Painting was, in fact, crucially involved in their whole attitude to good design and the influences were totally up-to-date, taking in Matisse's color and the lines and planes of the Cubists. They also carried out complete decors for interior design. In all this they both continued the English Arts and Crafts tradition and assimilated contemporary design interests in Europe as well.

German Expressionism

Expressionism is a vaguer term than many used in describing paintings, and it may be the more useful for that very vagueness. Terms such as Fauvism, Cubism or Futurism are specific to particular styles and are used very precisely. Sometimes they are even restricted to the work of those very few painters most closely associated with these styles. But "Expressionism" defines not so much a singular style as a state of mind, and so it is widely used not only in the visual arts

▼ *Autumn Sea* (1910) by Emil Nolde. The German Expressionists employed distortions of color or line to convey an interior emotional state. Nolde's evocations of the autumn seascape (he did 21 versions of this subject) express a sense of personal freedom. The formlessness of the subject is matched by the freedom of his coloring. In 1937 the Nazis confiscated more than a thousand of his paintings.

but in other arts too. In the visual arts it is used to describe painting that appears to be governed by what the artist feels rather than what he or she sees. Distortions, extremes of color, simplifications of form or relationship occur in a response to the artist's attempt to convey a mental state. Rather than follow a visual decision controlling the treatment of externals, as the Cubists did, Expressionist painters chose to convey an internal reaction, and to make external objects participate in describing that reaction. Picasso's early work, particularly that of his Blue Period, can usefully be called Expressionist. So to an even greater degree can the work of Georges Rouault, whose powerful depiction of judges, prostitutes and crucifixions in their harsh thickened blacks and luminous blues and reds express the painter's gut reaction to the conditions of life.

Clearly a way of painting that seeks to express inner feelings will not be bound by national frontiers. But a number of critics have seen Expressionism as particularly Nordic and Germanic. Seen in that way, it affords a contrast with the dominant modes in France, which – with the massive exception of Rouault – were more analytical and cool. Most of the painters in Paris who could be called Expressionists at this time were, if not from Germany, then at least from outside France: Picasso from Spain, Marc Chagall and Chaim Soutine from Russia, Amedeo Modigliani from Italy and Frank Kupka from Bohemia. Certainly the contribution of German artists to an Expressionist manner in the first part of the century was substantial. However, its origins are to be found outside Germany, in the work of the Belgian artist James Ensor and that of the Norwegian Edvard Munch. The terror in the face of life that characterizes both Ensor's masks, jerking skeletons and grotesques, and Munch's desolate and tortured individuals, is reminiscent of Van Gogh and Redon, but without their harsh joy.

Some of that joy returns, however, in the work of the German Expressionists. Paula Modersohn-Becker learned her simplicity of line and form in Paris and owed much to Cézanne, but her warm yet impassive folk figures are rooted in the German countryside. Emil Nolde found the sources for his religious painting not in the Western Renaissance manner but in German folk art and in the equally powerful German tradition of the woodcut. At the same time he was strongly drawn to the art of the Pacific, which had been energetically, sometimes ruthlessly, collected to form major holdings in a number of German museums. Nolde himself took part in an expedition to German New Guinea in 1912. He also, however, delighted in what he called "strong healthy German art", and in this he was at one with many of the movements, especially the youth movements, in Germany during the late 19th and early 20th century. They, like nationalists in other countries, sought a sense of German identity in mythology and folk tradition, and in a retreat from the modern industrialized world to nature and the German countryside – if only for the weekend. For the painters, discovering their own souls through expression seemed to

▶ *Self-Portrait with Camellia Branch* (1906–07) by Paula Modersohn-Becker. Modersohn-Becker lived and worked at Worpswede, an artists' colony near Bremen. She had little use for the dramatic elements of her fellow Expressionists, concentrating instead on a lyrical, folk-based mode that had parallels with Cézanne's. Dying in childbirth aged 31, she was the subject of an elegy by the Symbolist poet Rilke.

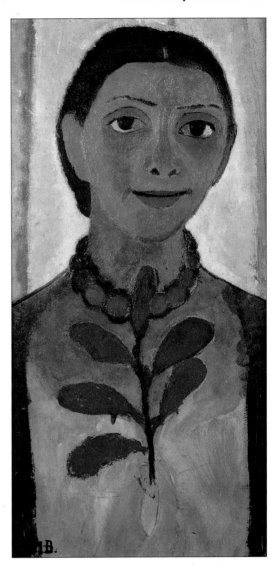

mean discovering a German soul, just as Czechs discovered Czech souls and Russians discovered Russian souls. National art is not always easy to distinguish from nationalist art.

Die Brücke and Der Blaue Reiter
Insofar as German Expressionism can be regarded as a movement, it begins with the founding in Dresden in 1905 of the group known as *Die Brücke* (The Bridge). The founding members of the group, Karl Schmidt-Rottluff, Erich Heckel and Ernst Kirchner, chose the name to represent the way they saw their work as forming a bridge to the future. They were later joined by Nolde and Max Pechstein, and the Dutch artist Kees van Dongen also painted with them. They all shared similar social aims, vaguely revolutionary and anti-bourgeois, and a similar painting manner: simplified forms, whether for figures or landscapes, hot color – lurid yellows, violent greens and reds – applied flat to large areas. Nolde's powerful religious paintings cut through the accepted portrayal of the Gospels to draw on a faith that conveys the scenes with a heavy and childlike emphasis, totally without sentimentality. Kirchner displays the squalor of the city streets in deep blues and violets, with the nightwalking figures as harsh caricatures. The group

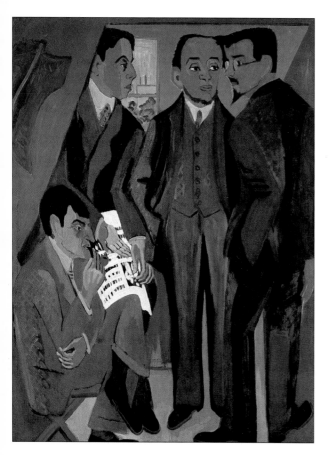

Experiments in Russia

Russian artists at this time were extremely receptive to all the main European trends, but produced distinctly Russian variations. Mikhail Larionov invented Rayonism, which flowered briefly from 1912 to 1914. It derived largely from Cubist and Futurist ideas, building up pictures from slanting lines representing invisible rays emanating from objects. The awarenesss of modern artistic speculation, and of the imaginative power to modify it that it implied, was to become very important in the development of art in Russia immediately after the 1917 Revolution. The key figure then was to be Kasimir Malevich, who at this time was close to Larionov and to the painter Larionov later married, Natalia Goncharova. All three had worked earlier in a more obviously Russian style. In seeking an art that was not dominated by Parisian styles, they looked for their models to Russian peasant art and to religious icons. Two artist-groups fostered this interest, The Jack of Diamonds and its breakaway, The Donkey's Tail. These groupings, while strongly aware of Paris, were closer to German Expressionism with its interest in folk art and the primitive. As we have already seen, Jawlensky and Kandinsky both painted in Germany, Kandinsky with *Der Blaue Reiter*, and exhibited with The Jack of Diamonds. However, the panache and exoticism of the Russians was always welcome in Paris, and both Larionov and Goncharova designed stage-sets for Diaghilev's *Ballets Russes*, notably Goncharova's designs for Rimsky-Korsakov's *Le Coq d'or* in 1914. Paris similarly exercised its perennial fascination for the Russians, and two collectors, Ivan Morosov and Sergei Shchukin, between them ensured that Russia would have one of the finest collections in the world of French painting, from the Impressionists to World War I.

It was in 1910 that perhaps the most attractive of Russia's 20th-century painters, Marc Chagall, first visited Paris, where he was to live for most of his life. His heady mix of glowing color, mystical intensity, Jewish comedy and village story-telling transcended theoretical movements and spoke more widely of a world beyond the geometry of machines. Certainly experimental, even surreal in his methods, the roots of his painting lay in a simplified folk world of poignant happenings, where suffering was transmuted because the artist had cared enough to celebrate its humble yet triumphant victims. And so ordinary people became heroic, the childlike became permanent and lovers floated and wreathed above yet within the world of the everyday. His first Paris studio was close to those of two other Russian artists, the painter Chaim Soutine and the highly original Cubist sculptor Alexander Archipenko. Archipenko's boldest advance was in bringing back color into sculpture, reviving polychrome techniques which had been part of medieval method and were still current in the folk tradition. His use of materials like glass, mixed with wood and metal in the same sculpture gave his work something of the atmosphere of Cubist collage. Soutine was the most anguished of Expressionists. A tragic gravity infuses his canvases. His work

◄ *The Painters of Die Brücke*, by Ernst Ludwig Kirchner, painted after the dissolution of the group in 1913. The artists are, from left to right, Otto Mueller, Kirchner himself, Erich Heckel, and Karl Schmidt-Rottluff. Other members included Max Pechstein, and, briefly, Emil Nolde. Nolde claimed "They ought to call themselves Van Goghians." Their Expressionism remained representational, untempted by abstraction.

▼ Catalog cover by Kandinsky for the first *Blaue Reiter* exhibition, 1911. The Blue Rider was the title of an almanac published in 1912. This contained essays by group members, including the composer Schoenberg, and an extraordinary range of imagery, from Easter Island sculptures to Bavarian glass paintings. Whilst color theory dominated, there was also space on the group's fringes for a deeply personal artist like Paul Klee. As Kandinsky said: "We aim to show … the variety of ways in which the artist's inner wishes manifest themselves."

► *Blue Horse 1* (1911) by Franz Marc, an emblem for the group Marc formed with Wassily Kandinsky, *Der Blaue Reiter* (the Blue Rider). The almost Fauvist use of color had, for Marc, Symbolist overtones. In a letter to another "Blue Rider", August Macke, he explained his theory of color: "*Blue* is the *male* principle, austere and spiritual. *Yellow* is the female principle, gentle, bright and sensual. *Red* is *matter*, brutal and heavy, the color which the other two have to fight against and overcome!" The horse has an awkward, contemplative air, inviting us to invest it with the artist's aspirations.

also worked extensively in woodcut, a form well suited by its sharpnesss of contrast, firmness of line and elimination of tone, to their liking for a stark expressiveness.

A second group of German painters cannot so easily be described as Expressionist, but nevertheless shared some qualities with the artists of *Die Brücke*. *Der Blaue Reiter* (The Blue Rider) was originally so called after a painting by Wassily Kandinsky, one of its founders, who in 1896 had left a promising legal career in Moscow to study painting in Munich. Kandinsky had founded the *Neue Künstlervereinigung* (New Artists' Association) in Munich in 1909, but by 1911 he was disillusioned with this group and left to form *Der Blaue Reiter* with Franz Marc. They were joined by August Macke, Kandinsky's friend and compatriot Alexei von Jawlensky, and the Swiss painter Paul Klee. The group was not sealed by a manifesto into some common sense of what art should be, like *Die Brücke* or the Futurists, but was rather an informal group based on an openness to experiment. This openness was visible too in the almanac that Kandinsky and Marc brought out in 1912, a collection of essays and illustrations principally of and about art, but also concerned with new ideas in music. The illustrations in the almanac included German and Russian folk art and non-European primitive art, as well as much of the new modern painting from France, Germany and Russia.

Both movements were effectively ended by the outbreak of World War I, the former by the dispersal of its members and the latter by the tragic deaths early in the war of two of its leading figures, Franz Marc and August Macke.

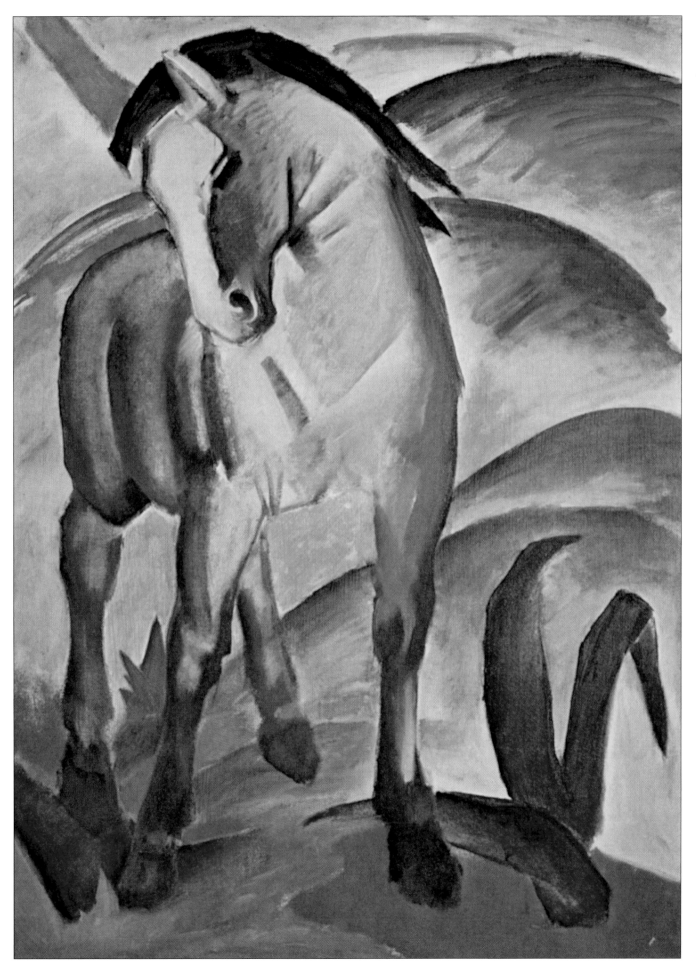

Books, banners and bombs

▲ *October Idyll* (1905) by Mstislav Dobuzhinsky.

The years leading up to World War I were characterized by jockeying for position among the European Great Powers, not just within Europe itself but throughout the world. Social agitation was exacerbated by nationalism in many countries, producing anarchism and revolution.

Writers responded in various ways to these events. The English novels of Joseph Conrad, seaman and son of a Polish political exile, reflected the movements of the times. In *Nostromo* he portrayed revolution in Latin American society, and *Under Western Eyes* depicted exiled Russian revolutionaries plotting in Geneva, while the short novel *Heart of Darkness* is concerned with the moral effects of economic rapaciousness in the Belgian Congo. For Conrad, however, brilliantly developed as these social settings are, they were always subservient to his central interest in the fabric of the mind.

In Russia, after the unsuccessful revolution of 1905, Maksim Gorky, an inspired reporter of the Russian scene at the turn of the century, was first imprisoned, then sent into exile until 1913. The disillusion of 1905 was compounded by the massive naval defeat inflicted on the Russians in that year by the Japanese. This reinforced a pessimism observable in Russian literature of the time.

Curiously, while his country was asserting its superiority over Russia so emphatically, the Japanese writer Futabatei Shimei was producing work much influenced by the 19th-century Russian novelists, particularly Goncharov, with the emphasis on an inadequate, indecisive "hero" in an aggressive, unprincipled society. Japan's swift economic rise was socially disorienting for many and Bunzo, the indecisive subject of Futabatei's novel *Drifting Clouds* (1887), was one of them, closely descended from Goncharov's Oblomov. *Drifting Clouds* marked the beginning of modern Japanese writing.

looked back to the earlier passion of Vincent Van Gogh and anticipated some of the preoccupations of the Irish painter Francis Bacon.

Classical music: the symphony under stress

In 1907 Gustav Mahler and Jean Sibelius, two of the greatest composers of their time, but with totally different approaches, discussed the symphony as a musical form. For Sibelius, the essence of the symphony lay in its serenity and logic, which allowed internal cross-references and echoes between all the motifs. Mahler's view was different: "A symphony must be a world. It must embrace everything."

The symphonic form is a great statement of stability and certainty. Its evolution over a period of some two hundred years from the Italian overture of the late 17th century to the full-blooded four-movement Romantic work reinforced, both harmonically and rhythmically, the concepts of development and resolution. Profound turmoil might be created in the course of a symphony, but the shape of the work demanded a settled, even if sometimes tragic, outcome.

In music as in the other arts, however, many of the old certainties were crumbling by the turn of the century and the standard forms of expression were under threat. The extraordinary tension between idea and expression produced some of the most remarkable examples of the symphonic form.

The continuing influence of late Romanticism, though now on the wane, meant that it was still possible to think in terms of a hero, and more

Impressionism threw open a window for us and cast the light of a rainbow across the horizon of our world. Although this world had been differently and more intensely colored, it seems in general to have become narrower than Courbet's naturalistic world, in the same way that Courbet's became narrower than Delacroix's. Delacroix's world was narrower than the Neoclassical world of David and Ingres. I will stop there. After Impressionism came the Cubist world, which led us into the geometric inwardness of things.... To continue like this would seem to mean moving forward towards a progressive narrowing of life.

MARC CHAGALL, 1963

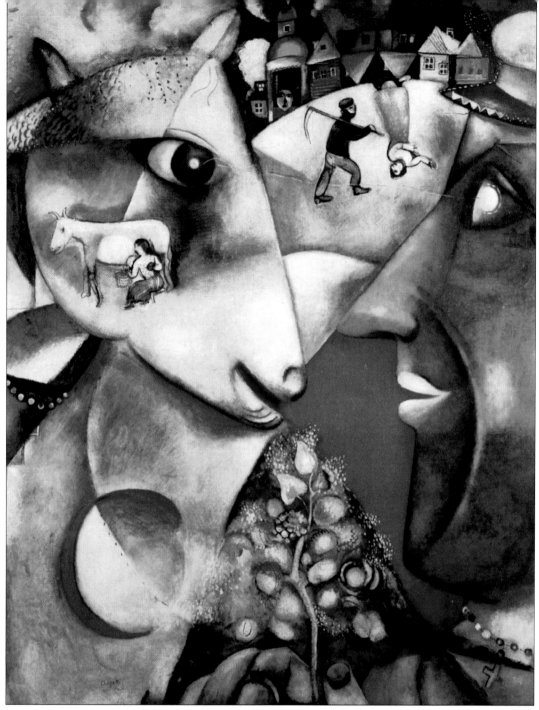

▶ *I and the Village* by Chagall, 1911. One of a number of works given their titles by the poet Blaise Cendrars. Chagall's use of bright color, alluding to Russian icon-painting, enchanted the Parisian intelligentsia, who were used to the somber palette of Cubism. But Chagall exploited Cubist technique to depict the magical universe of his childhood. The beast and the peasant stare at each other across fertile segments of the rural world. There is a sense of equality and interdependence, a natural balance which is reflected in the composition. The little figure of the woman is upended with exuberance, rather than the angst which inspired disruptions in Expressionist paintings. Chagall's world was topsy-turvy, not falling apart.

▼ Chagall teaching in Vitebsk. Marc Chagall (1887–1985) grew up in this small Russian town, and the idyll of rural life was a constant theme. In one poem he wrote: "You filled my hands with brushes and colors …." Chagall first visited Paris in 1910, absorbing Cubism. Returning when war broke out, he was briefly the Commissar of Fine Arts at Vitebsk.

particularly, of the artist as hero. Gustav Mahler, born in Bohemia in 1860, was in a sense the hero of his own music. He identified strongly with the questing folk hero of his earlier song-cycles, based on the nationalistic German collection of folk poetry, *Des Knaben Wunderhorn*, before gradually moving towards a more overt autobiographical stance. The composer's spiritual and psychological experience is charted in such works as the Fifth Symphony (1902), where the "hero" emerges at the height of his powers from the despair of the opening funeral march and desperation of the following scherzo, or the Sixth Symphony (1904), in which the "hero" suffers an ultimate defeat in the course of the explosive climax of the extended finale.

Mahler's fascination with the human voice spilled over into his symphonic works, and in *Das Lied von der Erde* (The Song of the Earth), the symphonic song-cycle of 1909, based on trans-lations of Chinese texts, his view of the symphony seemed particularly valid. All the possibilities of human experience, from the delights of social companionship to the apprehension of death, are represented, with the "hero" finally freeing himself from the bonds of mortality itself in the closing *Abschied* (Farewell). The dissolution of symphonic structure and tonality seemed close, as the voice united with the most pared-down of orchestral textures in an extraordinary restatement of the C major chord with an added sixth. (A).

If Mahler, despite large orchestral forces, could often seem austere, his near contemporary, the German composer Richard Strauss, was more likely to be described as lavish and luxuriant in his use of the orchestra. Although he was more preoccupied with the operatic stage in the early years of the century, two very personal symphonies were composed during this period. The

▼ Silhouettes of Mahler conducting. Gustav Mahler (1860–1911) conducted the Imperial Opera at Vienna from 1897 till 1907. This experience gave him considerable insight into the dynamics of performance, which he exploited in his own symphonic work.

Symphonia domestica (1903) was, as its title suggests, an often humorous picture of the home life of the Strauss family. It was constructed in one continuous movement and employed a vast orchestra, including four saxophones. It was a complex and virtuoso work, culminating in a triple fugue. Striking contrapuntal ability and brilliance of orchestral sound were also in evidence in the *Alpensinfonie* (1911–15), a massive nature picture describing the view from Strauss's study window at Garmisch.

It was, however, in his operas of this period that Strauss achieved popular success, if not notoriety. Although he gave instructions that both *Salome* (1903–05) and *Elektra* (1906–08) were to be conducted "as if they were fairy music by Mendelssohn", the music allowed outstanding opportunities to dramatic sopranos, concerned as it was with the portrayal of passion on the edge of insanity. The intensity of the characterizations granted Strauss a greater freedom from conventional tonality and instrumentation. *Elektra* contained violent polytonal episodes where tonality had all but broken down. *Salome* in particular created a sensation, but together the two operas consolidated Strauss's reputation.

Even in the music of Sibelius, the conventional symphonic composer, the strains on tonality were becoming apparent. Sibelius had aligned himself closely with the Finnish nationalist movement

(Finland had for centuries been under first Swedish, then Russian, rule), and his early works had been much influenced by his fascination with Finnish mythology. His *Kullervo Symphony* of 1892, like much of his later music, drew inspiration from the *Kalevala*, the epic poem that enshrines the myths and legends of Finland. The Second Symphony of 1902 is particularly nationalist in character: the finale positively glows with patriotic fervor. But like Mahler he was concerned with inner spiritual growth as well as national and cultural identity, and by the time of the Fourth Symphony (1911), Sibelius was making extensive use of the tritone, notably in the principal theme, while his use of the whole-tone scale owed something to Debussy. In this work he stretched the bounds of tonality as far as he was capable, to describe "experiences of an introspective, spiritual nature, arising from pondering over the most important problems of existence, life and death".

In the music of Sibelius's Danish contemporary Carl Nielsen, too, the conventional relationships of units arising from the diatonic scale are reexamined. Nielsen who was based in Copenhagen, developed an "extended tonality" in which it was permissible to use all twelve semitones of the chromatic scale without losing touch with the tonic. This allowed for lightning transitions between keys. Techniques of tonal and

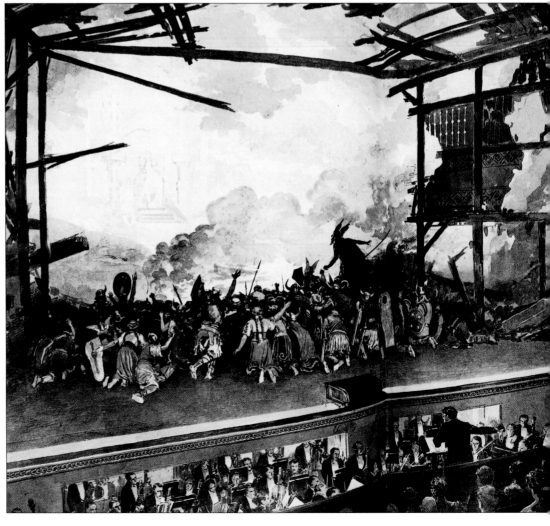

► The 1913 performance of *Götterdämmerung* at Bayreuth, conducted by Mahler. It is the final opera in the four-part *Ring Cycle*, by Richard Wagner (1813–1883). Wagner's principle of the *leitmotif*, or recurrent theme, can be said to have influenced not only the language of the symphony, but the literature of Proust and Joyce. The subject of his epic was nationalistic, the mythologies of the emerging German state, and aspects of this were to be seized upon by the Nazis.

Strauss, in no sense a supporter of the Jews, always stressed ... that certain ones, like Mahler, meant a great deal to him.... Strauss then observed that Mahler had always sought redemption. He had simply no idea what kind of redemption Mahler was thinking of. Strauss's precise words were: "I do not understand what I am supposed to be redeemed from. If I can sit down at my desk in the morning and get some sort of inspiration, then I certainly do not need redemption as well."

OTTO KLEMPERER OF
SUMMER, 1911

Dramatists and Drama

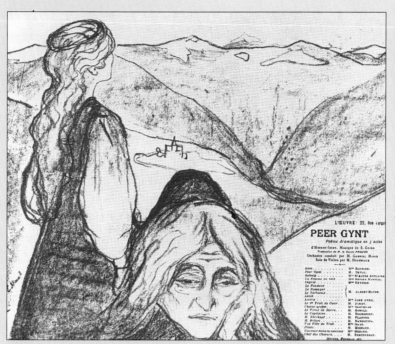

PEER GYNT

◀ Ibsen's early plays *Brand* (1966) and *Peer Gynt* (1867) made his name in Scandinavia, but it was over twenty years before he became more widely known. Even though his work appeared in translation, it was badly received by the critics. However, the Irish playwright and critic George Bernard Shaw admired his work and defended it in his *The Quintessence of Ibsenism*. In 1892 a performance of *The Master Builder* in English was well received by the public despite the complaints of the critics, and by the turn of the century Ibsen was internationally established.

The period 1900 to 1914 was punctuated by the deaths of three notable dramatists who together shaped the course of 20th-century drama – the Norwegian playwright Henrik Ibsen, the Swede August Strindberg and the Russian Anton Chekhov. They shared a concern with the way in which society is perceived, and in which it acts upon those who question its conventions. Ibsen used the stage (as in *Ghosts* and *An Enemy of the People*) to examine the morbid state of Norwegian society. Although realistic in dialog and their presentation of smalltown intrigues, his plays were to become steadily more concerned with the forces of the unconscious. Strindberg, too, was concerned with social realism, but after his earlier plays such as *The Father* and *Miss Julie*, he moved toward using drama as a means of exploring his own inner

conflicts in a manner prophetic of Expressionism. Chekhov set out as a writer of short stories. His delicate understatement of events with imponderable effects revolutionized the genre, and opened the door for the way it has been used since. His reputation as a dramatist rests on his four late plays, *The Seagull*, *Uncle Vanya*, *Three Sisters* and *The Cherry Orchard*, written between 1895 and 1904. They all portrayed aimless well- bred people, bored and unhappy, imprisoned by their own ineffectuality as well as by convention. Chekhov contrives to make them both comic and poignant, as well as tragic. The acting style developed around the turn of the century by Konstantin Stanislavsky at the Moscow Arts Theater was less melodramatic than earlier styles, and suited Chekhov's plays admirably, contributing to their great success.

thematic metamorphosis were prominent in his Second Symphony (1901–02), appropriately titled "The Four Temperaments".

The beginnings of atonality

All languages have their grammar, their underlying structure. The grammar of Western music from the Renaissance had been based on the diatonic scale, the familiar octave divided into five tones and two semitones. The relationships between pitches (intervals) and the combinations of pitches (chords) were "understood" by the Western ear to contain differing degrees of tension or comfort. The "meaning" of a sound was therefore not absolute but existed only in its relation to other pitches within a defined scale. The implications for music of such a basis for composition – and a basis that had proved to be remarkably flexible – were growth, development. Tension required resolution or, at the least, the deliberate denial of resolution. The tonal basis for composition thus had an inbuilt relationship to

rhythm, to regular (or irregular) change through time. It was this very grammar that was being challenged and questioned at the opening of the 20th century. In the music of composers such as Debussy, the tonal basis was stretched and distorted; the relationships within the scale were made more tenuous by the introduction of other scales or modes, such as the whole-tone scale. Tonality was under threat but the tonal relationships still remained identifiable.

In the music of three Austrian composers, Arnold Schoenberg, Anton Webern and Alban Berg, in the period leading up to the outbreak of World War I, the hierarchical distinctions implied by the diatonic scale were all but demolished. If the old grammar was not entirely abandoned, the need for a new syntax was becoming ever more apparent. With Schoenberg's First Chamber Symphony (1906), which he described as "the climax of my first period", it was still just possible to talk of the work as being "in E major". However, with the breakdown of tonality, the

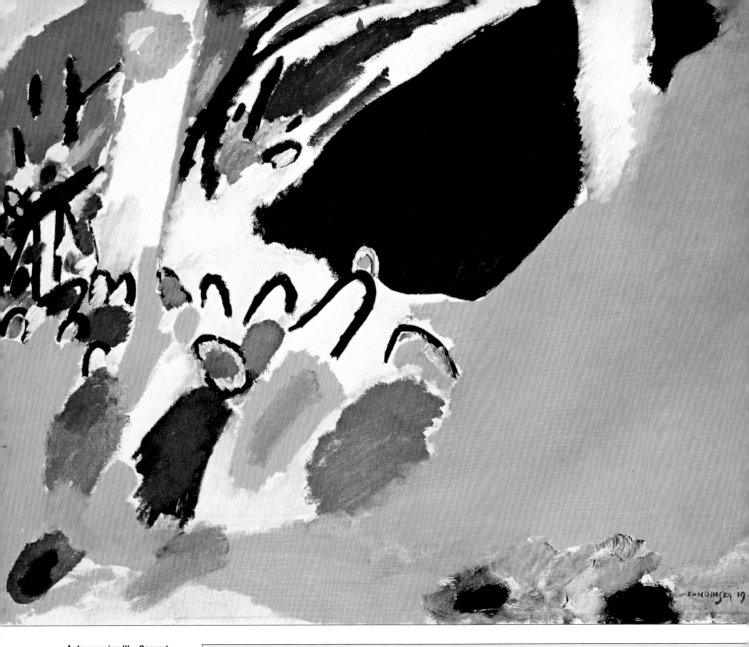

▲ *Impression III – Concert* (1911) by Kandinsky. Having attended a Schoenberg concert, Kandinsky set out to "represent" the experience. The concept of painting as something heard rather than something seen is very close to total abstraction. In 1909 Kandinsky wrote a stage composition called *The Yellow Sound* – here yellow is perhaps equivalent to Schoenberg's twelve-tone scale. In fact, some vestiges of representation remain in the "audience" to the left of the canvas, and the black wing of the grand piano.

The Folk-Song Gatherers

In Europe and North America folk music has come to mean music passed orally from generation to generation, free from the influences of popular entertainment or "classical" composers. Increasingly through the 19th century it became harder to find music or art fashioned or re-created by communities of people in isolation. Social changes brought about by industrial development and the break-up of rural communities either destroyed folk art or froze it into museum or tourist culture.

At the very times when folk music has flourished most, it has been most despised by artists. It is therefore all the more surprising that Zoltán Kodály and Béla Bartók should have begun to take a serious and fruitful interest in the indigenous music of their native Hungary in the early years of the century. For both there was a degree of political, nationalistic motivation to their researches, but their fascination with Hungarian folk music went much further than that. Traveling the country, persuading peasants to sing their songs into a cylinder phonograph, Bartók and Kodály collected hundreds of melodies. By the end of his life Bartók alone had

transcribed over eight thousand. For Kodály, the publication of *Folk Music in Hungary* was the culmination of his examination of his national heritage.

The music of the people was to influence the work of both men. Kodály evolved a new system of teaching music and Bartók was led towards the chromatic scale by the ease with which folk music manipulated the pentatonic scale and the ancient Greek modes. Bartók was well aware of what he had to gain as a composer from contact with folk music: "From this music we may learn unique terseness of expression and inexorable rejection of all inessentials – and that is exactly what we have been longing for after the prolixity of Romanticism." He shared this recognition of purity with the British composers Gustav Holst and Ralph Vaughan Williams, who both also became preoccupied with gathering folk songs, which again proved a liberating influence on their own music. The Australian-born composer and pianist Percy Grainger was also a keen collector of English folk songs.

▶ *Hungarian Country Chapel* by Károly Kós.

dividing line between melody and harmony could be less and less easily drawn. Schoenberg was certainly conscious of the melodic aspect of the work, for he insisted that the 15 players be rehearsed individually, "since every note must be heard".

Once the tonal relationships broke down, dissonance was no longer perceived as demanding resolution. This tonal liberation was completed in Schoenberg's music by 1908 and the composition of *Das Buch der hängenden Gärten*, settings of poems by Stefan George, in which Schoenberg was able to explore the unrestricted potential of dissonance. In this compositional no-man's-land, Schoenberg saw two possibilities for creating a much-needed coherence. The ear, after all, cries out for consistency and meaning. One route was to evolve musical ideas that were complete in themselves, no matter how minute, so that development would be out of place. Schoenberg wrote two brief fragments for chamber ensemble and the *Six Little Piano Pieces* of 1911, but then left this field to Webern. The other possibility was to use a text to give the work a structure. *Erwartung* (1909), a masterpiece of free-form composition, akin to stream-of-consciousness writing, was a dreamlike monolog for a female singer, moving through terror, yearning, doubt, remembered passion, horror, exhaustion.

In the Expressionist *Pierrot lunaire* (1912), a seminal work of the century, Schoenberg combined old and new techniques, often with a mildly parodic attitude. The work was a setting of Otto Erich Hartleben's German translations of 21 poems by Albert Girard for female voice and eight instruments. The voice was to be in *Sprechgesang*, a vocal quality nearer speech than song. In this sequence of lunatic perceptions, Schoenberg made use of different musical devices. Transposition, inversion, double diminution, canon – all were used by him here.

◀ Alban Berg posing over a portrait of himself by Schoenberg. Berg (1885–1935) became a pupil of Schoenberg in 1904. Although some of his early work such as the *Four Pieces*, Op.5, for clarinet and piano (1913) were highly compressed, Berg later adapted the austere vocabulary of atonality into large-scale projects like the operas *Wozzeck* and *Lulu*. Schoenberg's own ability as a painter (he was a member of the *Blaue Reiter* group) may have influenced his radical rethinking of Western musical structure.

Webern and Berg both began to study with Schoenberg in 1904. Described by Stravinsky as "the creator of dazzling diamonds", Webern composed works of extraordinary concentration and compression. He set out to write completely abstract music, without theme or tonality, and therefore necessarily without development. His music is precise, unevolving statement. While writing the *Six Bagatelles*, Op. 9, for string quartet (1913), he explained: "I had the feeling that once twelve notes [i.e. the pitches of the chromatic scale] had run out, the piece was finished. It sounds grotesque, incomprehensible, and it was immensely difficult."

The fourth of the *Five Pieces*, Op. 10, for orchestra (also 1913) was in fact only seven bars in length, but perhaps the ultimate point of compression was reached in the third of the *Three Little Pieces* for cello and piano (1914), which consisted of only 20 notes.

These works were, in their way, perfect. Yet the basis on which they were composed was finally limiting; the only musical material available boiled down to permutations of the chromatic scale. Berg too pursued this aphoristic technique of building a work of units too small to be considered motifs, resistant to any conventional process of development. However, Berg was later to write the large-scale operas *Wozzeck* (1925) and *Lulu* (1935). His need to create large, complex structures would require many techniques of musical pattern-making: repetition, alignment, inversion, thematic and harmonic cross-reference, symmetry and so on.

ZEBEGENYBŐLHATÁR·TEMPLOM·BROVHCHABDITE·ZALERVE·1904·

Now one word about your intention to analyse these pieces as regards to the basic set of twelve tones. I have to tell you frankly: I could not do this. I consider this question as unimportant. ... instead of the merely mechanical application I can inform you about the compositional and esthetic advantage of it. You will accordingly realize why I call it a "method" and why I consider the term "system" as incorrect.... And I expect you will acknowledge, that these works are principally works of musical imagination and not, as many suppose, mathematical constructions.

ARNOLD SCHOENBERG

ART AND RELIGION

Antonio Gaudí, Spanish architect of the fantastic and still unfinished Church of the Holy Family (Sagrada Familia) in Barcelona, once said, "my client is not in a hurry". Religion has, indeed, given many artists in the 20th century a meditative space in which to fulfil their ideas. Equally it has given some of them a fierce endeavor. The French painter Georges Rouault's ambition was to paint a Christ that would convert anyone to Christianity at sight.

These two artists signaled the preoccupation with religious questions and themes which has been so marked a feature of this century, despite its being frequently characterized as "godless" by believers and unbelievers alike. To go outside the Western world, to Africa, India, the Far East and Latin America, is to realize that the idea of the world as "godless" was always a European presumption. But even in the West, if the artists can be taken as indicative of the times, the 20th century has been, if not God-fearing or faithful, then certainly God-concerned, even where the concern has been for loss of faith. This has shown itself not only at the obvious level where architects like Le Corbusier and Gaudí have built chapels and churches; artists like Matisse and Chagall have decorated them; composers like Britten have written masses; and writers like Mauriac, Bernanos, Greene, Joyce, Eliot and Rilke have considered the matter of faith from many angles. There has also been an openness to religious questions across the frontiers of the great faiths: composers like Messiaen and artists like Mark Tobey have used not just the forms but the spirit of non-Western religious traditions in their work. Conversely, the Hindu Jamini Roy and Jew Marc Chagall – among others – have responded vividly to Christian imagery.

Equally fruitful, from the point of view of painting, has been a concern with contemplative themes. This involved an unspecific search for religious truth, especially in the work of Abstract Expressionists like Mark Rothko and Barnett Newman. The search after faith is part of faith itself. The degree of unspecificity is not a sign that the search has been abandoned, but that it has not been articulated in one of the world's dominant creeds. And the search for a living faith is continued, not concluded, in religion.

With the rise of skepticism and doubt in the past 150 years, there has been an ebbing away of religious certainty, which for many has left a gap in human understanding. A surprising number of people have sought to use art as a means of filling that gap, though art – a human creation – can never fully replace religious truth – the object of contemplation itself.

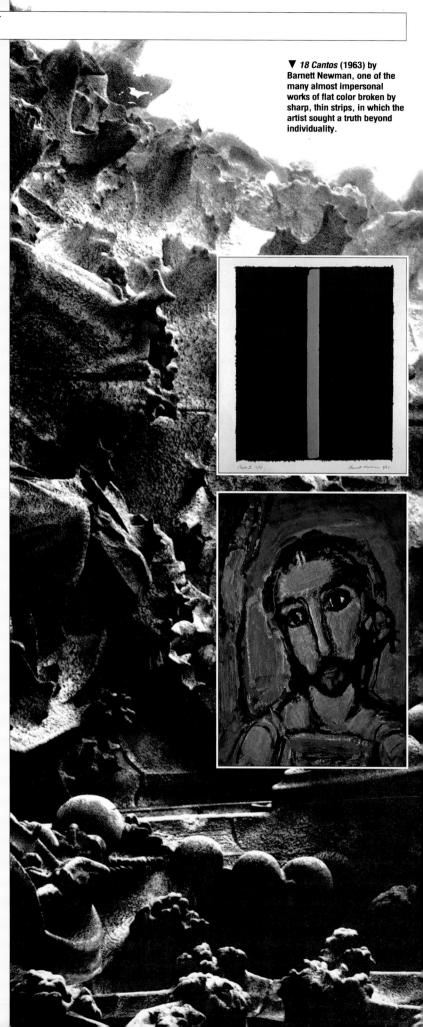

▼ *18 Cantos* (1963) by Barnett Newman, one of the many almost impersonal works of flat color broken by sharp, thin strips, in which the artist sought a truth beyond individuality.

►► Stained-glass windows by Chagall for the Hadassalem Medical Center, in Jerusalem. The subject is Napthali, one of the 12 tribes of Israel. His glowing vision made a religious celebration that reached across religious divides.

►▲ *Face of Christ* (1937–38) by Georges Rouault. The heavy outlines, glowing colors and simple composition of many of his works derived from his apprenticeship in stained glass. Rouault's other main theme was sinful humanity.

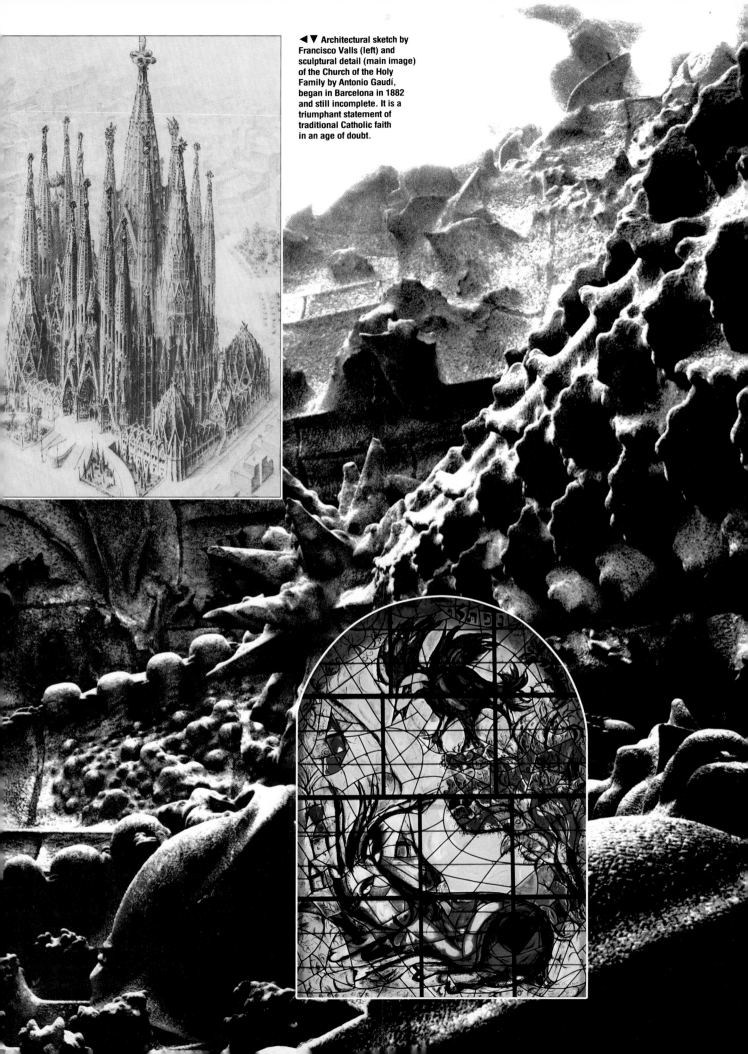

◄ ▼ Architectural sketch by Francisco Valls (left) and sculptural detail (main image) of the Church of the Holy Family by Antonio Gaudí, began in Barcelona in 1882 and still incomplete. It is a triumphant statement of traditional Catholic faith in an age of doubt.

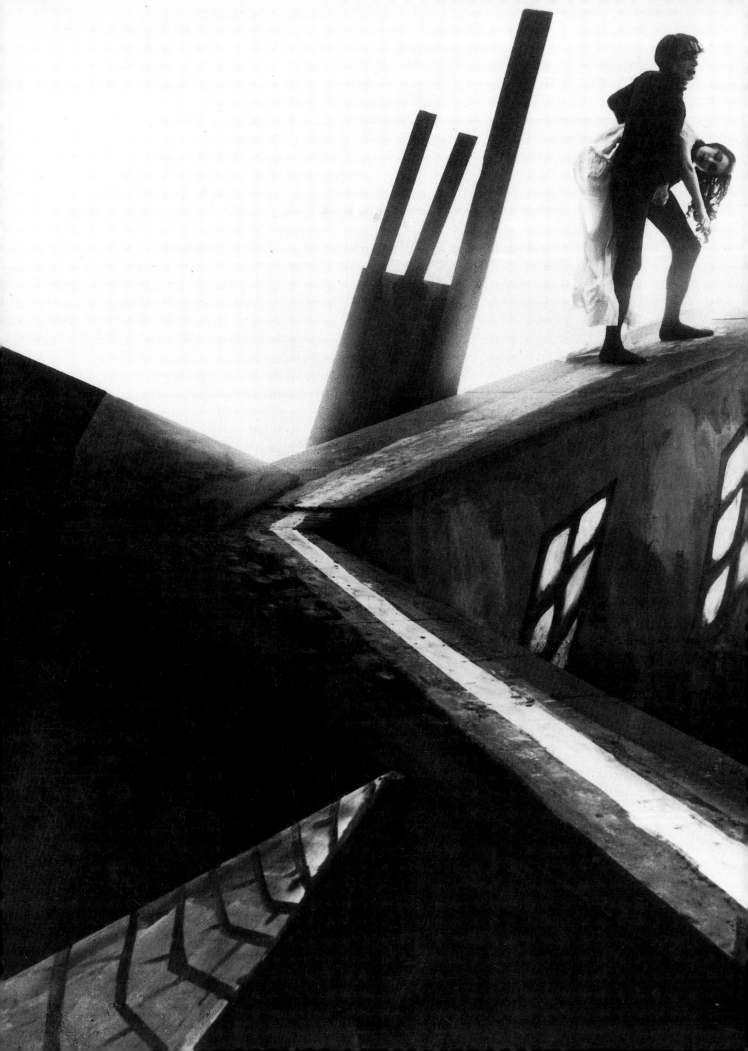

THE
WIDENING
CIRCLE

Time Chart

	1915	1916	1917	1918	1919	1920	1921	1922
Visual Arts	• Juan Gris: *Book, Pipe and Glasses*, painting (Fr) • Henri Gaudier-Brzeska: *Bust of Ezra Pound* (UK) • Amedeo Modigliani: *Moïse Kisling*, painting (It) • Vladimir Tatlin: *Counter Relief (corner)*, sculpture (Russ)	• A group of painters, writers and musicians, including Jean Arp, Tristan Tzara, Richard Huelsenbeck and others, launch Dadaism at Hugo Ball's night club in Zürich, the *Cabaret Voltaire*, and in 1917 open a gallery and publish a journal (Swi) • Mark Gertler: *The Merry-Go-Round*, painting (UK) • Jean Arp: *Portrait of Tristan Tzara*, relief (Fr)	• The Independents exhibition in New York, at which is shown Marcel Duchamp's *Fountain*, "ready-made" from a urinal (USA) • Foundation of *De Stijl* by Theo van Doesburg, Piet Mondrian and others (Neth) • Pablo Picasso's designs for the Diaghilev production of Erik Satie's ballet *Parade* are described as "sur-réaliste" by Guillaume Apollinaire, the first use of the term (Fr)	• Tristan Tzara's Dada Manifesto represents the high-water mark of Dadaism's notoriety (Swi) • Kasimir Malevich: *White Square on a White Background*, painting (Russ) • Christian Schad produces his first "schadographs", laying flat objects on photographic paper (Swi) • Formation of the *Nihon Sōsaku Hanga Kyōkai* (Japanese Creative Print Society) (Jap)	• Vladimir Tatlin: model of the *Monument to the Third International* (Russ) • Stanley Spencer: *Swan Upping at Cookham*, painting (UK) • Lyonel Feininger: *Socialist Cathedral*, woodcut, cover of the first Bauhaus manifesto (Ger)	• Piet Mondrian: *Composition I with Red, Black, Blue, Yellow and Grey*, painting (Fr) • Kurt Schwitters begins his "Merz" series of collages made from garbage (Ger) • First Dada Fair, at the Burchard Gallery in Berlin (Ger), and a Dada Festival at the Salle Gaveau in Paris (Fr) • Goyō Hashiguchi: *Woman After the Bath*, woodblock print (Jap)	• George Grosz: *The Face of the Ruling Class*, engravings (Ger) • Wassily Kandinsky founds the *Academy of Arts and Sciences of All the Russias* in Moscow (Russ) • Fernand Léger: *Three Women (Le Grand Dejeuner)*, painting (Fr) • Man Ray produces his "rayographs", laying opaque and translucent objects on photographic paper (Fr)	• Manifesto of the syndicate of worker artisans, sculptors a painters signed by David Alfaro Siquei José Clemente Oro and Diego Rivera (Mex) • László Moholy-N produces his first photograms, at the Bauhaus (Ger) • Paul Klee: *The Twittering Machine* painting (Ger)
Architecture		• Tony Garnier: *Olympic Stadium*, Lyons (Fr)	• H.P. Berlage: *Revision of Master Plan for Amsterdam* (Neth) • Tony Garnier publishes his plans for an Industrial City (first exhibited 1904) (Fr)	• W.J. Polk: *Hallidie Building*, San Francisco (USA)	• Foundation of the Bauhaus in Weimar, directed by Walter Gropius. Teachers there include Johannes Itten, Oskar Schlemmer, Paul Klee, Georg Muche, Theo van Doesburg, László Moholy-Nagy and Wassily Kandinsky (Ger)	• Foundation of the Devětsil group of architects (Czech)	• M. Trucco: *Fiat Works*, Turin (It) • Walter Gropius: *Sommerfeld House*, Berlin (Ger)	• Erich Mendelsoh *Einstein Tower*, Potsdam (Ger) • Le Corbusier exhibits his plans fo a Contemporary Ci for Three Million Inhabitants (Fr)
Performing Arts	• *Futurist Synthetic Theatre* manifesto, advocating the compression of space and events in performance works (It) • F.T. Marinetti: *They're Coming*, a performance work in which the main characters are eight chairs (It)	• A.G. Bragaglia: *Perfido Incanto*, futurist film (It)		• James Joyce: *Exiles*, play (UK) • Abel Gance: *J'accuse*, film about "the Dreyfus Affair" (Fr)		• Feb: *Futurist Aerial Theatre*, a manifesto text scattered from the sky by Fedele Azari during an "aerial ballet" by Mario Scaparro titled *A Birth* (It) • Dmitri Temkin and Yury Annenkov: *The Storming of the Winter Palace* in Petrograd, a staging of this event during the Bolshevik Revolution (Russ)	• 13 May: Dadaists enact the mock *Trial and Sentencing of M. Maurice Barrès* by Dada at the Salle des Sociétés Savantes in Paris (Fr) • Luigi Pirandello: *Six Characters in Search of an Author*, play (It) • Karl Kraus: *The Last Days of Mankind*, play (Aut)	• Karel Čapek: *R.U* play, backdrop designs by Frederic Kiesler, using mirro and film to create perspectival illusio the first time film an live performance ar combined (Czech) • Constructivist version of Fernand Crommelynck's *Th Magnificent Cucko* directed by Vsevolc Meyerhold (Russ)
Music	• Gustav Holst: *The Planets*, orchestral suite (UK)		• Alois Hába: *Suite for String Orchestra*, an early instance of the use of quarter-tones (Aust-Hung) • Erik Satie: *Parade*, for the *Ballets Russes* (Fr) • Sergei Prokofiev: *"Classical" Symphony* (Fr)	• Arnold Schoenberg, aided by Alban Berg, Anton Webern and Eduard Steuermann, founds the Society for Private Musical Performances in Vienna (Aust-Hung)	• Manuel de Falla: *The Three-Cornered Hat*, ballet (Sp) • Edward Elgar: *Cello Concerto* (UK)	• Formation of *Les Six*: Louis Durey, Germaine Tailleferre, Darius Milhaud, Arthur Honegger, Francis Poulenc and Georges Auric (Fr) • Igor Stravinsky: *Pulcinella*, ballet, a reworking of pieces originally attributed to Pergolesi (Fr)	• Edgard Varèse: *Amériques*, for orchestra (USA) • Nadia Boulanger begins her association with the Conservatoire américain (Fr) • Foundation of the Donaueschingen Festival (until 1930) (Ger)	• Wilhelm Furtwän' becomes director o the Berlin Philharmonic (Ger) • Alexander Zemlinsky: *Lyric Symphony*, setting of poems by Rabindranath Tago (Aut) • Carl Nielsen: *Fifth Symphony* (Den)
Literature	• Ezra Pound begins his poem sequence, the *Cantos* (final book of *Cantos – Thrones –* published 1959) (UK) • D.H. Lawrence: *The Rainbow*, novel banned on publication on charges of obscenity (UK)	• Natsume Sōseki: *Light and Darkness*, novel (Jap) • Henri Barbussé: *Feu*, novel (Fr) • Henrik Pontoppidan: *The Realm of the Dead*, novel (Den) • M.A. Nexø: *Pelle the Conqueror*, novel (Den)	• Paul Valéry: *La Jeune Parque*, poems (Fr) • Founding of the Hogarth Press by Virginia and Leonard Woolf (UK) • Knut Hamsun: *Growth of the Soil*, novel (Nor)	• First publication of the poetic oeuvre of Gerald Manley Hopkins (written 1884-89) (UK) • Alexander Blok: *The Twelve*, poem (Russ) • Katherine Mansfield: *The Prelude*, novella (UK)	• F.E. Sillanpää: *Meek Heritage*, novel (Fin) • Louis Aragon and André Breton found the review *Littérature* (Fr) • Vincenzo Cardarelli founds his neoclassicist review *La ronda* (It)	• W.B. Yeats: *Wild Swans at Coole*, poems (UK) • Ezra Pound: *Hugh Selwyn Mauberley*, poems (UK) • F. Scott Fitzgerald: *This Side of Paradise*, novel (USA) • Colette: *Chéri*, novel (Fr)	• D.H. Lawrence: *Women in Love*, novel (UK) • Anna Akhmatova: *Plantain*, poems (Russ) • Aldous Huxley: *Crome Yellow*, novel (UK)	• T.S. Eliot: *The Wa Land*, poem (UK) • James Joyce: *Ulysses*, novel (UK) • Rainer Maria Rilk *Duino Elegies* (Swi) • Boris Pasternak: *Sister: My Life*, poe (Russ) • Osip Mandelstam *Tristia*, poems (Rus
Misc.	• Albert Einstein's general theory of relativity (Swi)	• Easter Rebellion in Dublin as Republicans seize strategic buildings in the city (Ire)	• October Revolution in Russia; Bolsheviks seize Petrograd and Moscow and declare "all power to the soviets"		• Rosa Luxemburg murdered during the Spartacus Revolt in Berlin (Ger) • Foundation of the Third International in Moscow (until 1943)	• Split between Communists and socialists after the congresses of Tours, Halle and Leghorn	• Ludwig Wittgenstein: *Tractatus Logico-Philosophicus*, philosophy text (Aut)	• Oswald Spengler *Decline of the Wes* political philosophy (Ger)

	1924	1925	1926	1927	1928	1929
dwig Hirschfeld-...: *Reflected Light ...position*, moving light ...ctions, scored to ...ate color-sequences, ...sources, "dissolves", ...e-outs" and other ...meters, accompanied ... pianist (Ger) ● ...rcel Duchamp: *...e Stripped Bare by her ...helors, Even*, sculpture ...ished) (Fr) ● ...exander Rodchenko: ...omontage illustrations ...ladimir Mayakovsky's ...*Eto*, a collection of ...ns (Russ)	● Max Ernst: *Two Children are Menaced by a Nightingale*, painting (Fr) ● László Moholy-Nagy: *A 11*, painting (Ger) ● Exhibition of the Blue Four – Kandinsky, Klee, Feininger and Jawlensky (Ger) ● Official foundation of the Surrealist movement with the publication of André Breton's first Surrealist manifesto, the first issue of *La Révolution surréaliste* and the first Surrealist exhibition, in Paris (Fr) ● Otto Dix: *War*, series of 50 engravings (Ger)	● Constantin Brancusi: *Bird in Space*, sculpture (Fr) ● Publication of Paul Klee's *Pedagogical Sketchbook*, teaching text (Ger) ● First of Max Ernst's "frottages" (Ger)	● George Grosz: *Pillars of Society*, painting (Ger) ● Paul Klee: *Around the Fish*, painting (Ger) ● Pablo Picasso: *Guitar*, assemblage (Fr) ● Georgia O'Keeffe: *Black Iris*, painting (USA) ● Opening of a Surrealist gallery, in Paris (Fr)	● Stanley Spencer: *The Resurrection, Cookham*, mural painting (UK) ● Chaim Soutine: *Page Boy at Maxim's*, painting (Fr) ● Surrealists align themselves politically with Communism (Fr)	● Charles Demuth: *I Saw the Figure 5 in Gold*, painting, inspired by William Carlos Williams's poem *The Great Figure* (USA)	● Diego Rivera: *Workers of the Revolution*, mural (Mex) ● Max Ernst: *La Femme 100 Têtes*, engraving (Fr) ● Foundation of the Museum of Modern Art in New York (USA) ● Salvador Dalí develops the "paranoiac-critical" technique of creating visual illusions in his paintings (Sp) ● René Magritte: *The Use of Words I*, painting (Fr) ● Henry Moore: *Reclining Figure*, sculpture (UK)
...guste Perret: ...e-Dame, Le Raincy (Fr) ● ...st public exhibition of ...Bauhaus, the Bauhaus ...k, under the title "Art ...Technology – A New ...y" (Ger)	● Eugene Freyssinet: *Airship Hangars* at Orly, one of the earliest uses of prestressed concrete (Fr) ● G.T. Rietveld: *Schroeder House*, Utrecht (Neth)	● Bauhaus school moves to Dessau (Ger) ● The Exposition des Arts Décoratifs in Paris, an international showcase of design and architecture (Fr) ● G.F. Hartlaub's "Die Neue Sachlichkeit" (New Objectivity) exhibition in Mannheim (Ger)	● Konstantin Melnikov: "Club Rusakov", Moscow (USSR) ● Antoni Gaudi: *Cathedral of the Sagrada Familia*, Barcelona (Sp)	● Karl Ehn: *Karl Marx Hof*, Vienna (Aut) ● J.J.P. Oud: *Workers' Housing Estate*, Hook of Holland (Neth) ● Ludwig Mies van der Rohe: *Weissenhofsiedlung*, apartment building in the new International Style, Stuttgart (Ger)	● First meeting of the Congrès Internationaux de l'Architecture Moderne at La Sarraz, near Lausanne (Swi) ● Ludwig Wittgenstein and Paul Engelmann: *House for Gretl Wittgenstein*, Vienna (Aut)	● Raymond Hood: *McGraw-Hill Building*, New York (USA) ● Ludvik Kysela: *Bata Shop*, Prague (Czech) ● Le Corbusier: *Villa Savoye*, Poissy (Fr)
...kolai Foregger: ...hanical Dances (Russ) ● ...skar Schlemmer: *The ...ral Cabinet I*, a ...haus-produced stage ...: performed during the ...haus Week (Ger) ● ...rmation of the Blue ...se Group, whose ...rtoire consists of film, ...:e and "animated ...ers" with an overtly ...mmunist) political ...ne (Russ)	● Rodolfo De Angelis forms his New Futurist Theatre (It) ● Erwin Piscator founds the Berlin Proletarian Theatre (Ger) ● Francis Picabia: *Entr'acte*, filmed by René Clair, first shown in the interval in Picabia and Erik Satie's *Relâche* (Fr)	● Joost Schmidt's design for a mechanical stage for Bauhaus productions (consisting of four stages arranged telescopically, one of which is movable) (Ger) ● George Balanchine becomes principal choreographer of the *Ballets Russes* (Fr) ● Sergei Eisenstein: *The Battleship Potemkin*, film (USSR)	● Oskar Schlemmer: *Gesture Dance*, dance piece for which Schlemmer devises a new notation system for the movements of the dancers (Ger) ● Fritz Lang: *Metropolis*, film (USA)	● Antonin Artaud and Roger Vitrac open their Théâtre Alfred Jarry, from where originates the "theatre of cruelty" (Fr) ● Antonin Artaud: *Le Jet de sang* (The Jet of Blood), Surrealist play (Fr) ● Abel Gance: *Napoléon*, film, music by Arthur Honegger (Fr)	● George Balanchine: *Apollon Musagète*, ballet	● Oskar Schlemmer: *Glass Dance*, in which the dancer "wears" items of glassware (Ger)
...nold Schoenberg: ...o Suite, first fully ...ve-note work (Aut) ● ...hur Honegger: *Pacific ... for orchestra (Fr) ● ...ltán Kodály: *Háry ...s*, suite (Hung) ● ...liam Walton: *Façade*, ...ng of texts by Edith ...ell (UK)	● George Gershwin: *Rhapsody in Blue*, for piano and orchestra (USA) ● Erik Satie (with Francis Picabia): *Relâche*, ballet (Fr) ● Sergei Prokofiev: *Love for Three Oranges*, opera (Fr) ● Ferruccio Busoni: *Doktor Faust*, opera (Ger)	● Jean Sibelius: *Tapiola*, tone poem (Fin) ● Alban Berg: *Wozzeck*, opera, libretto from Georg Büchner's play *Woyzeck* (Aut)	● George Antheil: *Ballet mécanique*, scored for, among other things, electric doorbells and an aeroplane propeller (Fr) ● Alban Berg: *Lyric Suite*, for string quartet (Aut) ● Ernst Krenek: *Jonny Spielt Auf*, opera, a famous instance of the influence of jazz on concert music (Ger)	● Igor Stravinsky: *Oedipus Rex*, opera-oratorio, with texts by Jean Cocteau (Fr) ● Henry Cowell founds his New Music Edition, publishing, among others, works by Carl Ruggles, Charles Ives, Anton Webern, Arnold Schoenberg and Edgard Varèse (USA)	● Anton Webern: *Symphony*, for chamber orchestra (Aut) ● Leoš Janáček: *From the House of the Dead*, opera (Czech) ● Kurt Weill: *Die Dreigroschenoper*, adapted from John Gay's *Beggar's Opera* by Bertolt Brecht (Ger)	● Bruno Walter succeeds Wilhelm Furtwängler as conductor of the Leipzig Gewandhaus Orchestra (until 1933) (Ger) ● Paul Hindemith: *Neues vom Tage*, opera (Ger)
...roslav Hašek: *Good ...er Schweik*, novel ...ch) ● ...bert Frost: *New ...pshire*, poems (USA) ● ...llace Stevens: ...nonium, poems (USA) ● ...on Trotsky: *Literature ...Revolution*, essay ...s)	● Thomas Mann: *The Magic Mountain*, novel (Ger) ● E.M. Forster: *A Passage to India*, novel (UK) ● Pablo Neruda: *Twenty Love Poems and a Song of Despair* (Chi) ● St John Perse: *Anabase*, poem (Fr)	● Osip Mandelstam: *The Noise of Time*, autobiographical stories (USSR) ● J. Dos Passos: *Manhattan Transfer*, novel (USA) ● F. Scott Fitzgerald: *The Great Gatsby*, novel (USA)	● Franz Kafka: *The Castle*, novel (published posthumously by Max Brod) (Czech) ● T.E. Lawrence: *The Seven Pillars of Wisdom*, a semi-autobiographical account of the Arab independence struggle against the Turks (UK)	● Virginia Woolf: *To the Lighthouse*, novel (UK) ● William Faulkner: *Sartoris*, first of his novels to be set in the fictitious Yoknapatawpha County (published 1929) (USA) ● Marcel Proust: *À la Recherche du temps perdu* (since 1913), seven-novel sequence (Fr)	● André Breton: *Nadja*, novel (Fr) ● Marina Tsvetayeva: *After Russia*, poem (Fr) ● Percy Wyndham Lewis: *The Childermass*, novel (UK) ● D.H. Lawrence: *Lady Chatterley's Lover*, novel (It)	● Ernest Hemingway: *A Farewell to Arms*, novel (USA) ● Federico García Lorca: *Poet in New York* (published 1940) (USA) ● Tanizaki Jun-ichirō: *Some Prefer Nettle*, novel (Jap) ● Jean Cocteau: *Les Enfants terribles*, novel (Fr)
...rbert Bayer of the ...aus designs the new ... and two-million mark ...notes for the ...nsbank (Ger)					● Martin Heidegger: *Being and Time*, existentialist philosophy text (Ger)	● 22 Oct: "Black Friday" – Stock Exchange in New York collapses. Beginning of the Great Depression (USA)

Datafile

The arts in Europe were torn apart by World War I at every level. Close working partnerships were broken up, as in the case of Picasso and Braque. A tremendous toll was taken of young artists and writers, including Franz Marc, Gaudier-Brzeska and Umberto Boccioni, Georg Trakl, Wilfred Owen and Guillaume Apollinaire. Those who survived were sometimes scarred irredeemably, like Otto Dix, or found their inspiration shaken to its roots, like Stanley Spencer. One immediate result was a revolt of irrationalism. The Dada movement, begun in Germany at a time of near-revolution, was transformed into Surrealism in the Paris of the 1920s, where it threw up a whole school of artists dedicated to the subversion of the established order. The paintings of Magritte, Dalí, Miró and Max Ernst were to epitomize Europe between the wars. The American poet T.S. Eliot, in *The Waste Land* (1922), though not directly Surrealist, depicted a civilization shattered into the fragments of its great works.

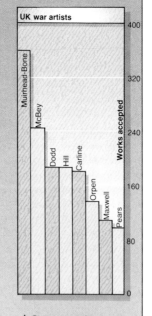

UK war artists

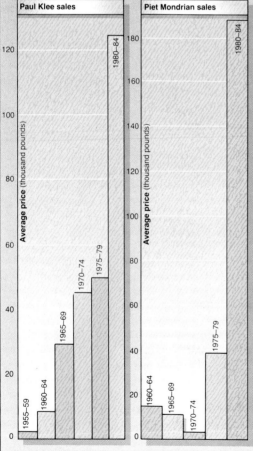

Paul Klee sales

Piet Mondrian sales

▲ Governments have always been adept at twisting art into propaganda. Traditional "representational" art has proven itself more than adaptable to the task. Official patronage was extended to figures like Muirhead Bone, whose work was described by Bernard Shaw as "too true to be good".

◄ Piet Mondrian's work introduced a new language to art: geometric abstraction. Based on a bare minimum of colors and forms, it seemed at first as though there was little that could be said in such a dialect. Perhaps the leap in his prices in the 1980s indicates a similar desire for clarity before complexity.

▼ The numbers of works sold by a group of modern artists (including Picasso, Matisse, Modigliani and Mondrian) in Paris during the 1920s. The prices of each artist's works increased in proportion to the number of works sold. The sudden drop probably reflects the shudders which went through the world's stock markets in 1929.

▲ The work of Paul Klee, despite its wholly personal, almost private imagery, has come to stand as an archetypal portrait of the modern psyche. His career, which involved a period at the Bauhaus, and consequent persecution by the Nazis, also seems symbolic of the European modern artist in the 20th century.

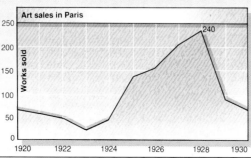

Art sales in Paris

The generation of the war years knew, in Guillaume Apollinaire's phrase, "death better than life". In the nightmare years 1914–18, in a war more horrific than had ever been experienced, writers and artists of all nationalities fought and died as other young men did, in the mud and carnage of the trenches. Perhaps the most distinguished of the writers who did not survive the war years were Apollinaire himself, Charles Péguy, Wilfred Owen, Edward Thomas and Georg Trakl. But there was a host of others – Rupert Brooke, Julian Grenfell, Francis Ledwidge, Alfred Lichtenstein, Isaac Rosenberg, Charles Sorley, Ernst Stadler, August Stramm...

Describing the indescribable: writers and the war
There were voices on all sides celebrating the war as just or cleansing or necessary, but the overwhelming consensus of the writers themselves was that it was in fact appalling, and that it served no good purpose. The brutal waste of young lives in the cause of national pride or economic domination was so poignant as to be almost beyond words. The English poet Siegfried Sassoon, who survived the war, speaks of it as beyond the imagination. But writers must try to embody what is beyond the imagination. How did they do it?

For some, the answer was to accept the necessity of war and to celebrate the bravery of those prepared to give their lives for their country or their beliefs. Some at least of the early war writing was of this kind. Frenchmen such as Paul Claudel spoke of saving France, and brought the language of worship and prayer to their work. Charles Péguy, who was himself to die on the Marne, similarly celebrated the "just" war: "Blessed are those who died in that coronation / In that obedience and that humility." The Italian poet, novelist and playwright, Gabriele D'Annunzio, was equally mystical, but his nationalist fervor was aggressive and macho, foreshadowing his later Fascism. He saw a torpedo boat, speeding to the attack in the Adriatic, as a cause for fierce joy, "death's first messenger on the war-torn sea". England's Rupert Brooke, who died early in the war at Skyros, of blood poisoning, evoked a pastoral sense of the country he had set out to defend, transforming the soldiers of his poems into "the rich dead", "rarer gifts than gold". W.B. Yeats, a noncombatant, also felt able to celebrate the "lonely impulse of delight" that drove an airman into the skies and to his death.

But in the face of the actual horrors of the war, the degradation of the trenches on the Western Front, the confusions and futilities of the Balkans, such accounts seemed false to the reality, if not false to a mood, especially as the war progressed. Irony was another way of approaching the

EUROPE: THE LEGACY OF WAR

unapproachable. In Jaroslav Hašek's great comic novel, *The Good Soldier Schweik* (1920–23), the Czech hero Schweik calls such glorifications "flapdoodle". Schweik may have been an idiot, but in the crazy context of war his views were refreshingly sane. Hašek chose to draw attention to the essential stupidity of war by rendering it as comic or insane. Schweik is finally taken prisoner by his own troops, wearing a Russian uniform he has stolen from a Russian deserter – and a naked Russian soldier hiding in the woods is left facing an equally ludicrous problem. Hašek, whose book was banned in three countries, lampooned military bureaucracy, codes, chaplains, notions of glory, everything about the war. Siegfried Sassoon, too, directed his irony against those who chose to send young men out to their deaths. But perhaps the most powerful voice to speak out against the war was another English poet, Wilfred Owen, who saw everywhere the waste and the pity of it. Seeing with clarity and anger the physical effects of shelling, bayoneting, machine-gunning, mustard gas and exposure, he wrote of it in jarring lines that mirrored the experience of thousands.

Owen was killed in action a week before the Armistice, in November 1918. Others found it impossible to live with the horrors of the war. The Austrian poet Georg Trakl was so unnerved by his powerlessness to help the wounded in an army hospital in Poland, "where all roads lead to blackest carrion", that he killed himself with an overdose. Reading the massive literature of the war, from its early account in Henri Barbusse's *Under Fire* (1916) through later novels such as Erich Maria Remarque's *All Quiet on the Western Front* (1929) to considered memoirs like Robert Graves's *Goodbye to All That* (1929), only one thing relieved this overwhelming horror that so often ended in the unhinging of minds or in the decomposing flesh of shattered corpses. This was the solidarity that grew between soldiers, the fierce loyalties between officers and men, a respect and compassion for an enemy as strong as the contempt for those who made the war, the politicians, the traders, the bureaucrats. Owen spoke of his subject as being the pity of the war and said the poetry was in the pity. So gigantic was the cause of that pity that it could not be summed up in the strategies of art. Simpler statements and stories seemed finally to be closer to it. In *Goodbye to All That* an officer shouts, "Forward", to the men of his platoon, who have just followed him over the top. There is no response so he shouts again: "You bloody cowards, are you leaving me to go on alone?" His platoon-sergeant, wounded behind him, answers "Not cowards sir. Willing enough. But they're all —— dead." And the noncombatant, Thomas Hardy,

writing at the signing of the Armistice on 11 November 1918, concluded his poem; "The Sinister Spirit sneered: 'It had to be.'/ And again the Spirit of Pity whispered, 'Why?'"

Displacement diagnosed: Kafka's fiction

Although the war formed a major focus for many writers of the period, there were others whose genius was already set on a particular course and who, although affected by the war, were not be to deflected. Jaroslav Hašek, the creator of *The Good Soldier Schweik*, was born in Prague in 1883. The same year and the same city saw the birth of Franz Kafka, a writer who could scarcely have been further from Hašek in subject matter or approach. Hašek was a Czech who wrote in Czech, in a country ruled by a German-speaking minority until 1918; Kafka was a member of that German-speaking minority. If Hašek gave voice to the feelings of common humanity, Kafka was

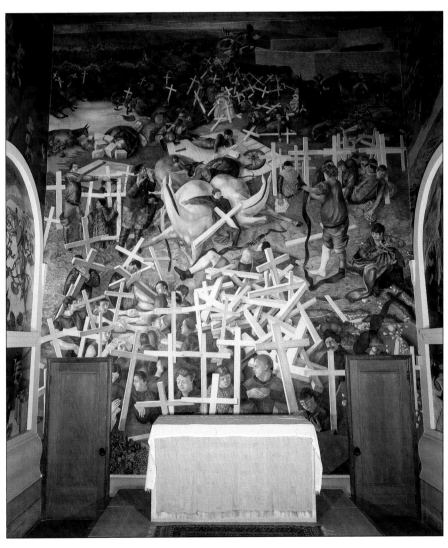

▼ *The Resurrection of the Soldiers* (1927–32), by Stanley Spencer. This powerful elegiac image was the centerpiece of Spencer's work in Burghclere chapel in Hampshire, England.

Expressionist Film and Architecture

Expressionism found its way into film from the theater, but acquired a new inflection in the process. The drama had emphasized the rage and isolation of individuals; the cinema portrayed a world of slants and shadows, where the very act of perception seemed to have gone askew. In Robert Wiene's *The Cabinet of Dr Caligari* (1919), a hypnotist sends out a sleepwalker to murder people by night; the hypnotist is then discovered to be the director of a mental hospital. Eventually this misconception is corrected – the murderous director is only the product of an inmate's fantasy. But the very thought that our doctors might be sicker than we are is unnerving. Fritz Lang's *Destiny* (1921) and *Dr Mabuse* (1922), and F.W. Murnau's *Nosferatu* (1922), similarly sought to picture not the material realities of the time, but the equally real forces of historical fear and stress.

The ominous settings of *Dr Caligari*, with their lurching buildings, served to emphasize the expressive potential of architecture. By 1915 the first use of the term "Expressionist architecture" was appearing in print, applied to buildings that were deliberately intended to stimulate the senses and arouse emotions. Romantic, organic, sometimes utopian, often immense in scale, Expressionism flourished in Germany in the years spanning World War I. Among the earliest examples, Hans Poelzig's massive chemical factory at Luban (1912), with its somber stepped profile, prepared the way for his vast man-made cavern, the *Grosses Schauspielhaus* in Berlin (1919). Rebuilt for the theatrical impresario Max Reinhardt, its stalactite galleries encircled an arena stage. Other visionaries dreamed of crystal halls or contorted villas, which they drew powerfully in charcoal or modeled in plaster. Erich Mendelsohn, a swift draftsman, sketched sweeping impressions of factories and airports. Rudolf Steiner's Goetheanum II (1922–26) at Dornach is an Expressionist masterpiece.

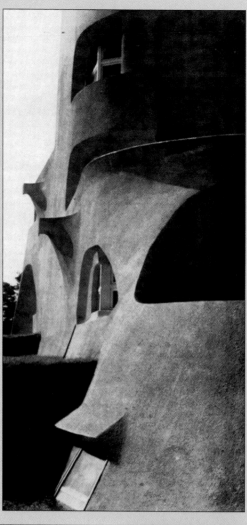

◀ A detail from the Einstein Tower (1920–24), designed by Erich Mendelsohn. Expressionist architecture, with its sculptural qualitites and romantic impact, would have to wait until after the war for expertise and materials to catch up with it. But here and there pioneers pushed an idea through. This example perhaps lies between Gaudí, whose Casa Milá was completed in Barcelona in 1920, and Le Corbusier, whose Chapelle de Ronchamp was not built until 1952. Although painstakingly practical (it was an observatory, complete with underground laboratory), it reveals Mendelsohn and his era as passionately in love with the powerful mystique of modern science.

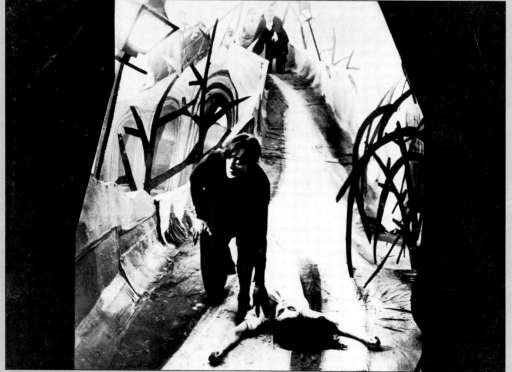

◀ A still from *The Cabinet of Dr Caligari* (1919). A classic example of Expressionism in the German cinema. Originally to have been directed by Fritz Lang, whose film *Metropolis* (1927) presented a terrifying image of the future, it was taken over by Robert Wiene. The contrast between their styles is evident in the famous distorted sets of the city, and the even more disturbing "normal" scenes in the Asylum gardens. These latter scenes were suggested by Lang. In *M* (1931), Fritz Lang and his wife Thea von Heubon (his scenarist) gave Peter Lorre his first starring role as a child murderer. As a study of the violent undercurrents in Weimar society it remains unsurpassed.

one of the century's great prophets, not because he literally foresaw the future but because he saw so deeply into the present. The personal anxieties to which he gave imaginative form were surreptitiously shared by many, and were already beginning to creep into social and political life as a consequence of the displacements caused by war. His story *In the Penal Colony* (1919) depicts an officer so dedicated to his barbarous and antiquated instrument of torture that he submits himself to its workings rather than have it fall into disuse. The two major novels, *The Trial* (1925, written 1914–15) and *The Castle* (1926, written 1922), portray nightmarish quests among endless uncertainties. In the first, a man is accused and brought to trial, and finally executed; but his crime is never named, no one attends to his pleas of innocence, and the court itself functions secretly, alongside ordinary life rather than as a part of it; it does not appear to belong to any recognizable system of justice. Is it the court of conscience, the invisible tribunal of God? Is the crime merely that of living, a secular, modern version of original sin? In *The Castle* a man seeks entrance to a mysterious castle, but never gets beyond the village at the castle's foot; all he receives are eerie messages and intimations, promises no one seems ready to keep. Is the castle a representation of heaven, or grace, or merely the awesome projection of a faceless, impenetrable bureaucracy? Is the castle whatever we want it to be, or are afraid it may be?

There have been countless interpretations of Kafka's work, each more ingenious than the last. But perhaps the persistent riddle is more important than any solution of it. The 20th century has witnessed so many tortures, so many arbitrary executions and exclusions, that Kafka's work is in one sense its ideal mirror, the place where we see our darkest and most cruel fears acted out to their logical limit, in a world where so-called sanity is just another form of madness. Yet in spite of the bleakness of Kafka's vision, a wry sense of humor permeates all his writings. Asked by his friend Max Brod if he thought there was no hope, he smiled and said there was "plenty of hope, an infinite amount of hope – but not for us". If Kafka imagined the worst torments of the century past and to come, the German writer Thomas Mann became the century's conscience, seeking to make novel-writing an honorable response to difficult times. At a period when writers such as James Joyce (*Ulysses* was published in 1922) and Virginia Woolf (*Mrs Dalloway*, 1925; *To the Lighthouse*, 1927; *The Waves*, 1931) were experimenting with the possibilities of the novel form, Mann remained conservative in style; but he did not hesitate to explore the great issues of the time through long conversations among his characters, and through the tangled fates those characters encountered. The short novel *Death in Venice* (1913) was prophetic: it demonstrated, through the life of an imaginary writer, the disastrous effects of excessive and self-deceiving discipline, and thereby raised issues that would be central to German affairs in the following decades. Similarly, the story "Mario and the Magician" (1930) describes an Italian hypnotist whose stage act resembles Mussolini's rhetorical performance, and who has cruelly understood how to undermine his audience's will. But the great work of these years was *The Magic Mountain* (1924), a major novel set in a tuberculosis sanatorium, a secluded yet feverish place in which the world is desperately discussed and judged. At the end its young hero descends to the plains and to a war in which he is likely to die, knowing that life itself is an affair of the will, and that the will, just as the physical organs, is subject to damaging diseases.

Artists and the War

World War I effectively brought to a close the century's early excitements in the world of the visual arts. The internationalism that had seen Italian Futurists exhibiting in all the main European capitals, artists of all nations flocking to the teachers and studios in Paris, and French artists freely exhibiting in Berlin, Dresden and Munich, was temporarily suspended. The artists instead became colleagues in death. At least three hundred and fifty artists died in the war, not many perhaps in relation to the number of carpenters and clerks, but a huge loss to Europe's cultural potential. As Franz Marc, one of the finest painters to die, said: "In war we are all equal." Others who did not survive included Umberto Boccioni from Italy, the French sculptor Henri Gaudier-Brzeska who had settled in England,

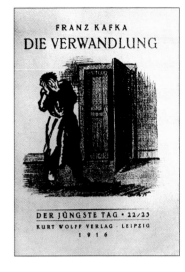

▲ The first German edition of *Metamorphosis* (1922–23). Kafka's parable of the young man who turns into a giant insect foreshadowed Nazi dehumanizing of the Jews.

▼ *Quiet Room*, by Oskar Schlemmer, 1925. Schlemmer joined the Bauhaus in 1923. His unnerving, Kafkaesque paintings feature static figures in an impersonal space.

Raymond Duchamp-Villon (who came from a famous French painting family that included Marcel Duchamp, one of the fathers of the Dada movement), Vladimir Burliuk, a Russian Futurist, and August Macke, a German member of *Der Blaue Reiter*.

It is hard to tell how careers which ended so soon might have developed, but the deaths of two artists in particular, Franz Marc and August Macke, effectively brought to an end the German *Blaue Reiter* movement. Marc was killed by an exploding shell at Verdun in March 1916. Macke, whose whole being was domestic and moderate, and who viewed the war with horror, ironically proved one of its earliest victims, dead after only six weeks. Despite deep friendship, he had al-

ways been a little at odds with *Blaue Reiter* thinking as it was realized in Marc and its other major representative, the Russian painter Wassily Kandinsky. It was too programmatic, too grandiose for what the artist actually did. We expect artists to speak out and think universally but the domestic virtues, in fact aligned Macke most precisely with life as most people live it. He did not withdraw into still life or landscape, but cherished the activities of life, painting people as they walked in parks or went window-shopping. In 1914 he visited Tunisia with the Swiss artist Paul Klee and painted unstoppably. Camels, minarets, port scenes and the luminosities of a sundrenched countryside, assisted by the immediacy of watercolor, flowed from his brush. Franz Marc, hearing

▼ *The Mule Track*, by Paul Nash. One of the official War Artists, Nash found that the devastating panorama of the Front profoundly affected his painting. He was obliged to adopt a more Modernist style in order to build the featureless landscapes into any kind of composition. This "simple and more staccato style", as he termed it, was influenced by his associate, C.R.W. Nevinson.

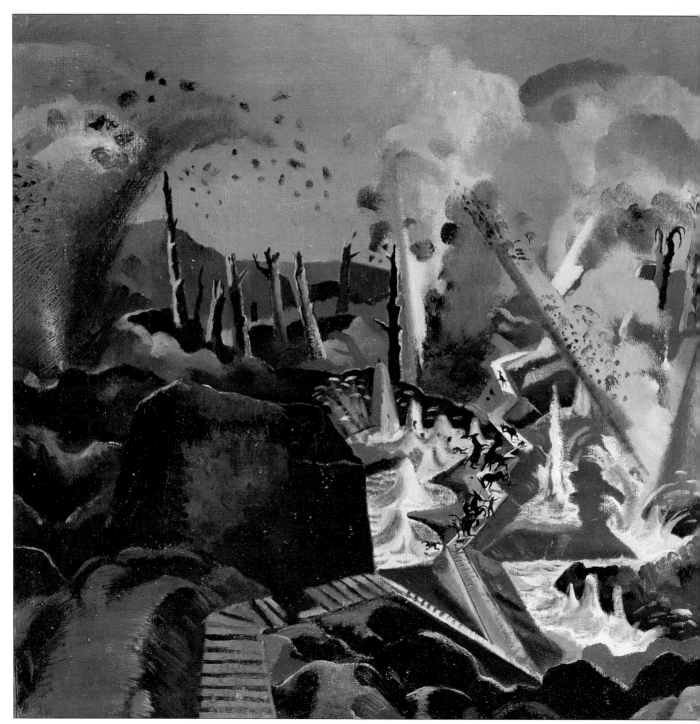

of his death, was to speak of that color as being "as clear and lucid as his whole being".

But if Macke and Marc, the leading figures in the Expressionist *Blaue Reiter* movement, had to die, others survived and used their art to recall all the dead. The Englishman Paul Nash, for instance, who fought with the Artists' Rifles, was invalided home, only to return as an official War Artist (commissioned by the government to record the realities of the war as faithfully and realistically as possible). He modulated the powerful tradition of English landscape painting to produce visions of war-blasted trees and cratered earth of an eerie clarity, as if the earth and its struggling occupants were undergoing some final test, bathed in a merciless light. It was still land-

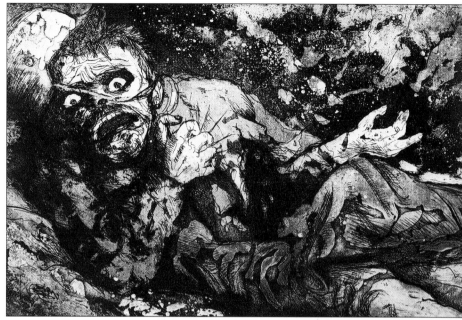

scape, an art his country had excelled at for nearly two centuries, but a landscape dishonored and disfigured by man's attempt to make "a new world". C.R.W. Nevinson, in the Red Cross and also an official War Artist, and Wyndham Lewis, a gunner, were both more modish but at their best no less powerful in portraying the inhuman quality of the war. The problem in their art was that the Futurist and Vorticist creeds, which they embraced, actually celebrated the very conditions that made the war so awful, its mechanistic steam-rollering of the human figure. In their work a machine gun was no longer an extension of a man, an instrument in his hands; it was as if the man was simply a molded and efficient lever, a means to the machine gun's design and end. Other official artists, such as the etcher Muirhead Bone, probably the most prolific of all the artists commissioned specifically to document the realities of the war, recorded it with a less personal intervention but with great power. But along with Nash, the most lasting of all the artists profoundly affected by the war was another original: Stanley Spencer, whose great memorial to the war was the decoration of Burghclere chapel in Hampshire in southern England. This was a tiny gemlike structure, its walls peopled with the soldiers and animals, victims, heroes and unsung heroes of the war in their daily lives and deaths. Spencer took their stories through and beyond the present tale of their lives to their fulfillment in resurrection after death. The whole scheme unfolded on the chapel walls was one of the finest of art's responses to the brutality of war, triumphant yet suffering.

Spencer's work was matched in its power and overtaken in its nightmare of macabre Expressionist horror by the Frenchman Georges Rouault's sequence of etchings *Miserere et Guerre*, executed as drawings from the beginning of the war onward but not finally published as finished etchings until after World War II. All Rouault's fierce faith and compassion is in them. Two other French artists whose art was deeply affected,

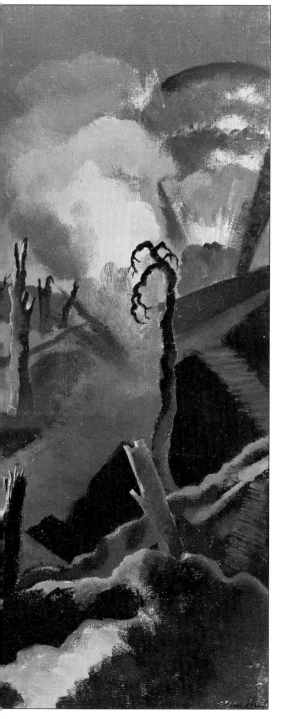

▲ *Wounded*, by Otto Dix, 1916. One of a series of lithographs inspired by Goya's famous series *The Horrors of War*. Dix's war experiences produced over six hundred drawings, and his paintings of cripples after the war were so opposed to the Nazi principles of war as "cleansing" that several of his greatest works were burnt.

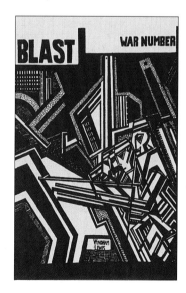

▲ Cover to *Blast*, by Wyndham Lewis, 1915. The English Vorticists, led by Lewis, shared some of the fascistic attitudes towards war of their principal influence, the Futurists. But the conflict took the movement's brightest star, the sculptor Gaudier-Brzeska.

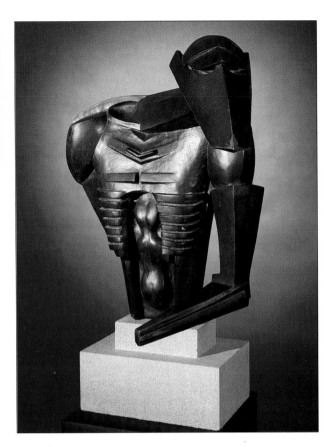

ing" that would purge the capitalist world of all its ills. It fitted with their sense that the old order had to be destroyed. Unfortunately the old order had a habit of staying on top, while the destruction fell precisely upon those whom the cleansing was intended to benefit. Lamenting the death in 1916 of his friend Henri Gaudier-Brzeska, one of the most able of the Vorticists, the American poet Ezra Pound, complained that war gave no one the chance to kill the right people, the "hundred fat rich men working overtime to start another war". Instead, it was people like Gaudier-Brzeska who had to go. He had set off excitedly to war in 1914, asserting that it was "a great remedy".

Vorticists – the title had been coined by Pound in 1913 – saw the vortex, the gathering of energy into a whirlpool of movement, as the key to human endeavor. The artists among them, principally Wyndham Lewis and William Roberts, the independently-minded American sculptor Jacob Epstein and Gaudier-Brzeska himself, sought to make that energy visible in their work. The Futurists represented movement as a continuum, the Vorticists sought to represent energy as a static but vibrant point or moment. In painting, this tended to produce a stolid, rather unsatisfactory simplification. The image became solid rather than dynamic. The work of other artists such as Nevinson suffered from the same arrested quality. Significantly, only the sculptors Gaudier-Brzeska and Epstein seemed to be able to achieve the simultaneous qualities of rest and movement that Vorticism prescribed. Central to the act of sculpture is the simultaneous representation of the monumental and the actual aspects of the subject. Thus Epstein's *Rock-Drill*, part man, part insect, part machine, is a potent account of the sinister power of technology.

Part of Epstein's strength was drawn from his knowledge of Polynesian sculpture, where simplified monumentality and ribbed, sequential

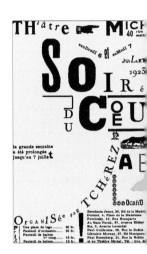

◀ *Rock-Drill*, by Jacob Epstein, 1913. Epstein's roboticized figure appears emblematic of the lot of modern humanity. Actually, the grooved mechanistic ribs were in part based on his study of Polynesian sculpture.

▼ Poster to a Dada exhibition, 1923. This relatively coherent example of Dadaist typography displays their love of discrepancy and inconsequence.

▼ The First International Dada Fair, at the Burchard Gallery in Berlin, 1920. Berlin Dada was especially highly politicized, but shared with the other German groups a total rejection of conventional artistic standards. The Prussian officer with pig's head, hanging from the ceiling, had a sign attached to him stating "Hung during the revolution."

though in different ways, by the war were the Cubists Fernand Léger and Georges Braque. Both were wounded. For Léger, the social mixing that the war brought, officers and men sharing the trenches and the equality of death led him to see that art was not a self-sustaining activity cut off from society but that it must act for the betterment of people's lives and the transformation of society. Braque's long convalescence equally confirmed the purposes of his art but in his case drove him toward a greater belief in its own integrity

German disgust at the war resulted in a new realism expressed in bitter satire. Max Beckmann, a medical orderly who had a nervous breakdown, saw his art as vital comment upon an evil world. His 1919 lithographs have the energy of a dislocated world in turmoil. George Grosz drew his generals, street walkers and military doctors with a savage cartoon line of such power that his drawings seem to make another war morally indefensible. Perhaps for Grosz the disgust aroused by war was too extreme to permit rehabilitation. Otto Dix, too in his *Der Krieg* etchings of 1924, struck a note of numbed horror which was inescapable nightmare. The viewer is pursued by the staring eye-sockets of gasmasks, invited to participate in blood and mud by the twisted hands of the wounded. Only in Käthe Kollwitz's work did there appear the indomitable survivor's strain, the mother's power of protection and rebuke.

A "cleansing" war: the Vorticists

While most detested war, a number of artists welcomed its onset. It was seen by the Futurists and their English parallels the Vorticists as a "cleans-

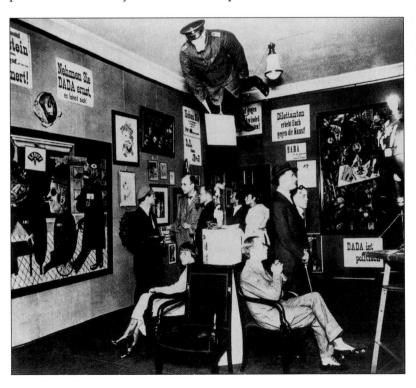

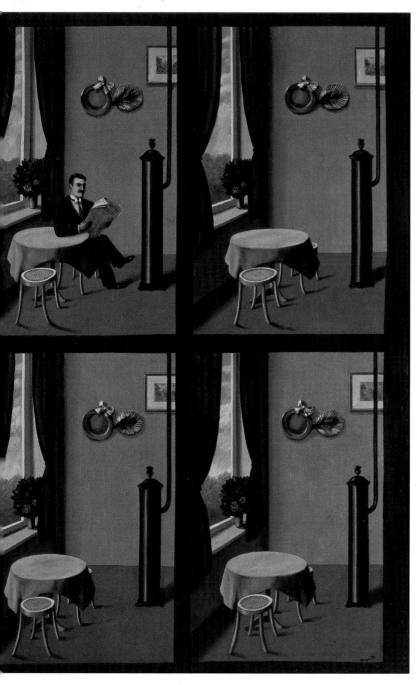

▲ *Man with a Newspaper*, by René Magritte, 1927. When Surrealist painting first emerged, it quickly divided itself into two camps. One was calligraphic, or based on techniques like automatic drawing, where the artist interpreted random marks. The other was more realistic, but only in order to convey disturbing or baffling images. Magritte, here employing a "cinematic" progression, was unquestionably a master of this "realistic" Surrealism.

who for various reasons would have no part in what they regarded as an insane war. There Hugo Ball, a German playwright, opened a nightclub called the Cabaret Voltaire. He intended to make it a focus for reassessing cultural and moral values through absurdity. The founders of Dada included the Franco-German poet and painter Jean (or Hans) Arp and the Romanian poet Tristan Tzara. It also drew on earlier work that emphasized the illogicality and uncontrollability of existence, especially that of Alfred Jarry (whose play *Ubu Roi* had created a riot when it appeared in Paris in 1896) and of Apollinaire.

The word Dada itself was plucked from a dictionary by Ball. It was a children's word meaning "hobbyhorse"; it was also a child's first sound, and so expressed "an absolute primitive origin, a new beginning". Jazz rhythms, generally regarded in Europe at this time as demonstrating that same primitive condition, were another major influence, especially on the work of the German poet Richard Huelsenbeck, who, like others associated with the movement, wrote poems consisting of pure sound, with no formal meanings attached to them, a mode later to be associated with Tristan Tzara and which the Surrealists were to call automatic poetry. Other artists helped to spread Dadaist feeling and activity throughout Europe and, importantly, to the United States; French-born Marcel Duchamp was to be especially influential there. Kurt Schwitters in Hanover, George Grosz in Berlin, the painter Francis Picabia and the poet André Breton in Paris, all became involved with the movement. Dada was in effect an extreme form of artistic protest against war and the societies that could generate war, by means of a anarchic rejection of art itself, and a glorification of the "found", the unintentional, the unstructured. Important art did, however, flow from it, especially through the work of Duchamp, Picabia, Schwitters and Arp.

André Breton went on to found yet another movement, the Surrealists, in Paris in 1924. Eventually Surrealism, which took for its intellectual base ideas drawn from the work of the psychologist Sigmund Freud, particularly on the value and meaning of dream-states and the workings of the subconscious, was to be more important than Dada. But it was the impassioned, if zany, flamboyance of Dada that made it possible.

patterning – a parallel to machine-like contours – were both used. Gaudier-Brzeska too was influenced by Polynesian art. The only piece of his wartime carving to survive, a design on a toothbrush handle, is distinctly Polynesian in manner. In his drawing, Gaudier-Brzeska had an unerring sense of line. Animals and human figures are indeed arrested, all their movement still tensed within them. In bronze or stone he had the same classic power.

Dada: a new form of protest
If Vorticism produced one response to war, embracing it as a dynamic force, so another, perhaps saner, response was to be found in the emergence of an apparently insane movement – Dada. Insanity called forth insanity. Dada was founded in 1916 in Zürich in neutral Switzerland, which had become a meeting place for a group of young men

Russia: art in revolution
In October 1917, the revolution in Russia took the country out of World War I. It was greeted by Russian artists as an opportunity to match their own revolutionary advances in painting or sculpture with genuine social advance. There was a spectacular commitment to the new Soviet state. Some artists who had been away from Russia during the war came back, including Naum Gabo and his brother Antoine Pevsner. Wassily Kandinsky had returned from Germany in 1914. Marc Chagall had been visiting his home town of Vitebsk at the outbreak of war and could not return to Paris. Vladimir Tatlin was in Moscow, and Kasimir Malevich had never left. All played their part in bringing art to the aid of the Revolution, teaching, theorizing and organizing.

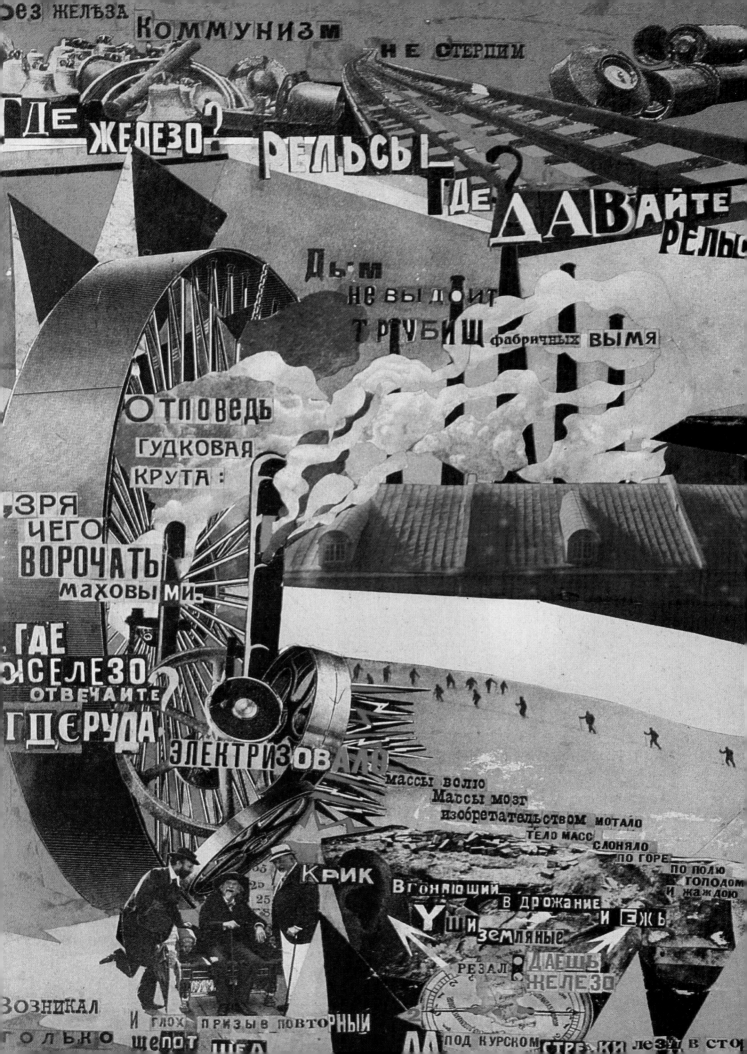

Russian Revolutionary Architecture

Little building took place in Russia in the aftermath of the October Revolution and the Civil War, but architects like the Vesnin brothers and the young El Lissitzky joined such artists as Kasimir Malevich and Vladimir Tatlin in exploring new forms and spatial concepts appropriate to a revolutionary society. Constructivist design was brought to the streets in the form of kiosks and pavilions, and particularly to the theater, where stage sets were effective workshops for architectural ideas. Tatlin's model of the *Monument to the Third International* most dramatically symbolized the new spirit. Intended when built to be 400 meters (1300 feet) high – the Eiffel Tower in Paris is 300 meters (984 feet) – with revolving cylindrical halls of steel and glass, it was never more than as a model in wood and wire.

Schools opened for the training of young designers, especially Vkhutemas, the State Higher Art and Technical Studios in Moscow where many architects taught, including the talented Moisei Ginsburg (1892–1946). He founded the journal *Arkhitektura* in 1923 and his book *Style and Epoch* provided a philosophical and technological base for a new architecture which wedded Constructivist forms to functionalist principles.

Many architectural projects, such as El Lissitzky's right-angled "Cloudprops" (making punning references to skyscrapers), and the influential ideas of the young Ivan Leonidov, never got beyond the drawing board. However, several Soviet architects designed strong, functional buildings, among them Ilya Golosov and Konstantin Melnikov, who was chosen to design the Soviet Pavilion at the 1925 Paris Exposition. Melnikov's Rusakov Workers' Club in Moscow (1929), with its three cantilevered auditoria, was one of the major buildings of the era.

Yet, in the heady atmosphere all was not well. Revolutionary architectural thinking was split by factionalism. Functionalists believed that architecture should derive its plans and forms from the rationalist analysis of the functions that a building was to perform. Formalists, on the

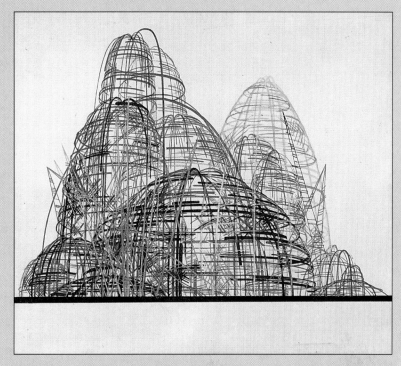

other hand, contended that architecture was an art of forms, masses and volumes esthetically deployed, accommodating functions but not dictated by them. The proletarian architects attacked both groups, believing that such positions were abstract and elitist and that architecture's role was to meet social needs and to be accessible to the proletariat. In 1932, reactionary forces imposed the dissolution of all associations. A new Union of Soviet Architects was established that led to the design of the monumental, neoclassical but drearily executed architecture of the Stalinist era. Many of the achievements of Soviet architects of the early years of the Revolution were fully recognized only in the 1980s – too late to save many of them from destruction.

▲ An architectural fantasy, by I.G. Chernikhov. Soviet architects and planners began to consider how the ideals of Communism could be translated into architecture. Workers' clubs were built which contained sports, health and leisure facilities, as well as libraries and even observatories. This flowering of design was stamped out by a return to neoclassical principles under Stalin.

Initially their work found favor with government. Trotsky was on their side and the use of materials like metal and glass in the construction of sculpture, as well as Malevich's Suprematist espousal of the geometric square as the key to his art, gave them a rapport with the Bolshevik desire to modernize and industrialize the country. But even before Trotsky's influence waned, and Lenin declared modern art unsuitable for the proletariat, the artists began to fall out among themselves. Kandinsky, pioneer of abstract painting and author of *The Spiritual in Art* (1912), which argued that the aim of painting was to produce "spiritual vibrations", fell foul of Tatlin and the Constructivists, who saw art as essentially applied art, working with "real" materials in three-dimensional space and having some direct use to society. Kandinsky left Russia again in 1922 to teach at the Bauhaus in Germany and became a German citizen in 1927. Malevich, though totally dedicated to the Revolution, nonetheless sided with Kandinsky in the battle over abstraction.

His own Suprematist work was geometrical and abstract to a remarkable degree. It was hard to go much further than his "white on white" paintings of 1917–18. He felt that the artist should express "pure" esthetic feeling and that applied art and industrial design derived from such creativity and could not supplant it. Chagall himself, steeped in an Expressionist Jewish mysticism, one of the most imaginative, least theory-ridden artists of the century, felt compelled to leave and by 1923 was back in Paris, pursuing obsessive images rooted in his memories of Russia. Naum Gabo and his brother, who had been active Constructivists, came to feel that Tatlin and his followers, in pursuing function, were arguing that art should "liquidate" itself, and both again left the country. Even Tatlin, while he argued for applied art, is most remembered for his "Tower", a monument to the Third International. It was visionary and never built. Indeed Gabo, who had trained as an engineer, said that it would have fallen down.

◄ Collage of a poem by Vladimir Mayakovsky. In 1924 Yuri Rozhkov, a student at the Vkhutemas, the State school for Art and Design, made 17 collages using lines from the poetry of Mayakovsky, who was at that point, like many others, basking in the temporary favor of the authorities. He was attempting to write a revolutionary poetry which addressed the ordinary worker without surrendering the avant-garde principles of his early career as a Futurist. This collage suited Mayakovsky's purpose so well that he included it in his exhibition "Twenty Years of Work." By 1930, the strain of satisfying an increasingly repressive state machine proved too much, and he committed suicide.

All these arguments raised points about the relationship between art and design, about the role of theory in art, about abstraction and representation, which were to succumb to state dictates in the 1930s imposing "Socialist Realism" on the arts. Function within the political framework was the new watchword. Already by 1923 Trotsky was asking what Tatlin's tower was *for*, and arguing that the Eiffel Tower was at least used as a radio station.

The De Stijl movement

The relationship between art and design was a prime concern of the group of Modernist artists and architects brought together by the writer and painter Theo van Doesburg in Leiden in 1917. They became known by the name of the magazine they published until 1931, *De Stijl* (Style). The original members included van Doesburg's friend, the architect J.J.P. Oud, and the painter Piet Mondrian. In 1918 they were joined by the furniture designer and architect, Gerrit Rietveld.

Rietveld created two of the most memorable of modernist artifacts: the protoconstructivist "red-blue" chair (1917) and the Schroeder House in Utrecht (1924). Both of these works take the primary colors favored by Mondrian and use them in three dimensions. The Schroeder House is an elegant and fastidious expression of interconnected planes articulating space both within and beyond the building. In this respect it has much in common with Mies van der Rohe's De Stijl-influenced Barcelona Pavilion of 1929. Oud, now known primarily for his housing work, also produced a design that encapsulated De Stijl theories: the Café De Unie, in Rotterdam (1925). Built primarily of timber and plaster, the Café was intended to last ten years, but endured until its destruction in 1940. The use of primary colors and bold typography on the façade gained emphasis from its siting between two larger historicist buildings.

Van Doesburg, Oud and Rietveld were all widely influential. Van Doesburg lectured at the Bauhaus and his book on painting (which gave rise to the term Neoplasticism) became a Bauhaus text. Oud was an exhibitor at the Deutscher Werkbund's Weissenhof Exhibition in Stuttgart in 1927, and Rietveld was a founder member of the Congrès Internationaux d'Architecture Moderne in 1928.

The Bauhaus: functional design

Retiring as head of two design schools in 1915, the Arts and Crafts architect Henry van der Velde recommended Walter Gropius as his successor. Gropius had designed the remarkable steel-framed, fully glazed Fagus shoe-last factory (1911), and the Deutscher Werkbund Exhibition building (Cologne, 1914) flanked by cylindrical glass and steel spiral staircases, which were landmarks in modern architecture. Taking up the appointment after World War I, Gropius brought the schools together as Das Staatliches Bauhaus – the state house of building. It was to be a school where the boundaries between architects, artists and craftsmen did not apply. Every student was to study theories of design and to work in all

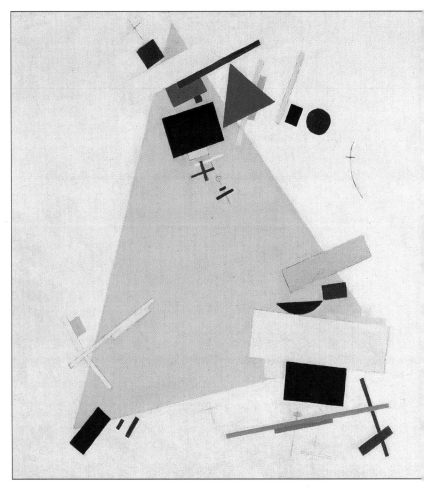

materials and crafts, tutored by professors who themselves moved from one department to another.

An educational innovator and color theorist, Johannes Itten, was appointed to direct the preliminary course, and Gropius attracted many of the major artists and theorists of the day to join the staff. They included the German-American printmaker Lyonel Feininger, the stage designer Oskar Schlemmer and the Swiss artist Paul Klee, whose *Pedagogical Sketchbook* was a novel and aphoristic teaching tool. In 1922, Wassily Kandinsky left Russia to join them. A strong Expressionist element was prevalent in the early staffing, but tutors soon focused on the problems of an approach to design which would respect such modern materials as synthetics, rolled glass and steel, and use them in the design of functional artifacts capable of being mass-produced. The appointment of the Hungarian-born Constructivist designer and photographer László Moholy-Nagy in 1923 shifted the emphasis farther away from fine art, while the studio unit set up by Theo van Doesburg and members of the Dutch De Stijl group had a more profound influence than Gropius cared to admit.

Though the work of the first years culminated in a brilliant exhibition "Art and Technology – A New Unity" in 1923, Gropius was obliged to close down the school under pressure from the Thuringian government. A new home was found in Dessau, where he designed a modern purpose-built complex, partly in reinforced concrete. A

▲ *Dynamic Suprematism*, by Kasimir Malevich, 1916. Suprematism was launched by Malevich in the exhibition "0–10", held in Petrograd in 1915. This featured the black square on a white background that is his starting-point. Malevich declared: "Art has a duty laid upon it to supply the shapes that are of its essence." This reductionism was, however, based firmly in the spatial theories of Russian icon painting. Suprematist works manipulate our sense of distance, as though we viewed buildings from the air. Malevich's relentless logic led him to the movement's spiritual peak in 1917–18, when he began painting white squares on white backgrounds.

► A room in the Schroeder house, designed by Gerrit Rietveld, 1924. This house in Utrecht was built according to Neoplasticist principles as outlined by Theo van Doesburg in *De Stijl*. Rietveld was probably the first fully to realise these concepts in three dimensions at architectural scale. Even the chair confines its colours to red and blue. His use of right angles and the total absence of decoration was to become part of the basic vocabulary of Modernist architects.

past student, Josef Albers, took over the preliminary course from Itten and designed laminated furniture, while another former student, Marcel Breuer, directed the furniture workshop. Breuer's designs for tubular steel chairs (1925–26), like Marianne Brandt's globular and hemispherical light fittings in frosted glass and chromium-plated steel, were among the most enduring of Bauhaus designs, still virtually unchanged.

After the move to Dessau the Bauhaus addressed the problems of architecture, becoming involved with Gropius's own work, exploring the possibilities of prefabrication and industrialization of the building process using precast concrete techniques. Gropius resigned in February 1928 to pursue his own practice, and was succeeded by the Swiss socialist architect, Hannes Meyer. Dismissed for political reasons in 1930, Meyer was succeeded by the well-known architect, Ludwig Mies van der Rohe, who bravely tried to continue the school's teaching in Berlin after its closure in Dessau by the National Socialist city council. He finally succumbed to Nazi pressure and closed the school in August 1933.

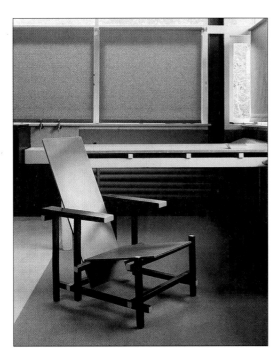

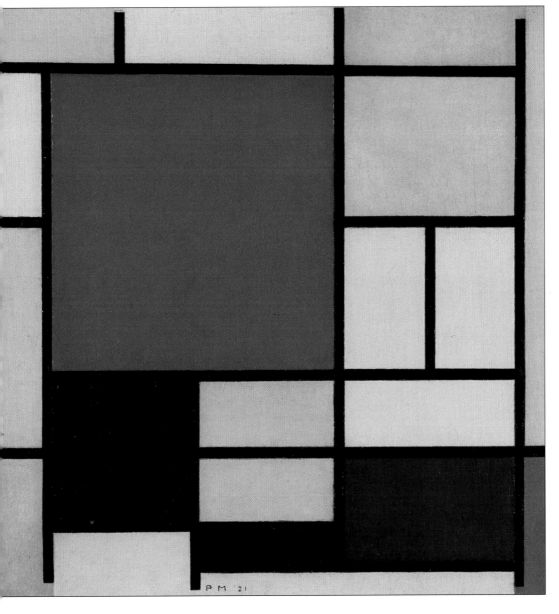

◄ *Red, Yellow and Black*, by Piet Mondrian, 1921. Mondrian, who had been developing a Cubist style in Paris, found himself isolated in his native Holland when the war broke out. Seeking justification for the increasing abstraction of his work he encountered the Theosophist M.H.J. Schoenmakers, whose unusual theory of colors gave Mondrian his basic color vocabulary. If color and form could be reduced to a simple symbolic language, then the step into total abstraction need not be merely decorative. Mondrian fixed on yellow, blue and red, with only the black right angle to delineate shape. This was seized upon by a close associate, Theo van Doesburg, and, as propounded in his magazine *De Stijl* (The Style), became the basis for Neoplasticist architecture.

Musical reactions against Romanticism

The artists and architects of the Bauhaus were not alone in feeling that after a war that had left much of Europe in ruins, the grandiose gestures of Romanticism should finally be dispensed with. Composers felt the need for a clean, clear sound to sweep away what looked in retrospect hollow, excessive and almost shameful. One place to search for such a sound was in the past, and especially in the Baroque era of the 17th and early 18th centuries, with its crisp lines and hard edges. "Back to Bach", declared Igor Stravinsky, "whose universal mind and enormous grasp upon musical art has never been transcended." It is one thing, though, to resurrect the forms of the past, but quite another to re-create and re-experience them in the same way the second time around. Finally, the advocates of neoclassicism – as this movement became known – found it impossible (even had they wished to) to sweep away the years of musical exploration and development since the Baroque. The temptations of atonality, the spice of permissible dissonance, the playfulness of rhythmic distortion – none of these could be wholly resisted.

At the same time, the involvement of music with the theater was considerable. Many of the composers of the day were concerned not only with instrumental music but with new work in the fields of ballet and opera, in both experimental and neoclassical forms. Serge Diaghilev's *Ballets Russes* continued to shock and amaze. The French writer Jean Cocteau, who through his long life was to champion modernism in all the arts, became a key figure in bringing together some of the most radical painters and composers in Paris (Pablo Picasso, Erik Satie, Francis Poulenc, Darius Milhaud, Georges Braque) to produce outrageously modernist *Gesamtkunstwerke* – theatrical combinations of the arts. *Parade* (1917) was conceived by Cocteau, designed by Picasso and set to music by Satie, with choreography by Leonid Massine. Satie's score incorporated noises like a ship's siren, an aircraft engine, pistol shots and a typewriter. Diaghilev's ability to link dance to developments in the other arts freed choreographers from the straitjacket imposed by a classical past and allowed composers a new freedom.

Stravinsky – who had spent the war years in Switzerland, where he had been stranded at the

Walking up and down slowly Klee spoke a few words, softly, with long silences. After that we all felt without exception that we had never seen a leaf, or rather the leaf, the essential leaf ... [the need was] to trace back deliberately and intensively the path of creation from the mature organism to its origin, in so far as insight into these secrets is given to man.

MARIANNE AHLFELD-HEYMANN, BAUHAUS STUDENT, 1924

The Jazz Thieves

Jazz is the supreme Afro-American contribution to world sound. For composers of classical music at this period it represented freedom, excitement and new possibilities.

The best-known jazz thief is probably the American George Gershwin. In *Rhapsody in Blue* (1924), Gershwin took from jazz the idea of "blue" notes, a dislocating syncopation and "walking" bass lines of parallel sixths and tenths. The opening motif, the famous clarinet *glissando*, was originally written as a 17-note ascending scale. In rehearsal, clarinettist Ross Gorman injected the jazz-oriented *glissando* as a joke. It was exactly what Gershwin was after, and he kept it in. Darius Milhaud, much excited by his visit to Harlem in 1922, brought back with him many records of black popular music. He collaborated with Fernand Léger and Blaise Cendrars on the ballet *La Création du monde* (1923), using the saxophone (a newcomer to the conventional orchestra) and drums to give the work its distinctive "dirty" sound.

Ironically, Ernst Křenek – an Austrian who settled in America – turned to jazz as a popular idiom for his opera *Jonny spielt auf* (1926) and subsequently became irritated by the success of the work. Another American, Aaron Copland, discovered jazz when he was on the lookout for indigenous musical material that would be immediately recognizable and accessible to his audience, an American equivalent of Europe's folk heritage. He experimented with jazz in his 1925 *Music for the Theater*. George Antheil used the jazz idiom as a release from the past. Like so many other composers of the time, he was in revolt against the "mountainous sentiment" of Strauss and the "fluid diaphanous lechery" of the Impressionists. His opera of 1927–28, *Transatlantic*, took as its story line that most American of festivities, the presidential election. The boisterous rhythms and rough sound qualities of jazz proved ideal for his purposes.

▶ Milhaud, Léger and Maurois before a painting by Léger.

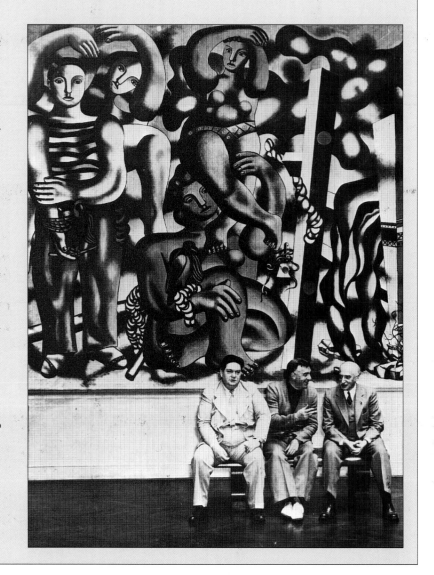

► *Fugue in Red*, by Paul Klee, 1921. Klee's highly individual art depicted an imaginary universe which, in its spiritual aspiration and disturbing, calligraphic imagery, expressed some of the contradictions of his era. He taught at the Bauhaus between 1921 and 1931, and this work illustrates some of that group's principles. Music, in its structural exactness, provided them with an analogy for architecture. The fugue, with its dialog between parts, became a kind of question and answer in Klee's painting.

▼ A score showing Schoenberg's basic methods. Classical music, having hitherto confined itself to the idea of tonality, had produced a notational system in which, by the turn of the century, it seemed little new could be said. Schoenberg therefore attempted to establish an entirely new musical theory which would be free from the dominance of any one tonal center and related keys. The twelve-tone or dodecaphonic system, as it became known, was built on principles which made enormous demands on an audience trained to listen for conventional keys. It utilized principles sometimes employed in the classical fugue based on the inversion and retrograde set. Schoenberg, who could skillfully manipulate keys and thus our expectations of them, preferred to call this *pantonality*.

outbreak of hostilities in 1914 – himself continued his prewar association with the *Ballets Russes*, but was now concentrating on the abstract qualities of music. He went through a spiritual crisis in the 1920s, and in 1926–27 his creative and religious urges came together in the composition of *Oedipus Rex*, a still life opera-oratorio, and Stravinsky's longest and most ambitious work to date. More serious than much of his previous writing, its operatic qualities owe much to Verdi. Jean Cocteau, taking Sophocles as a starting point, evolved a text for narrator, soloists and chorus that was simple, emotionally affecting and also mysterious. The narrator, in evening dress, was both an empathetic bridge between the audience and the austere, near-motionless masked singers, and a philosophical commentator moving the audience from sharing in a personal tragedy toward partaking in a universal ritual. The work was intended as a present for Diaghilev to mark his 20 years in the theater. It was, as the recipient remarked, "a most macabre present".

The Swiss composer Arthur Honegger, who specialized in chamber music in the early 1920s, also collaborated with Cocteau, in his stylized opera of 1927, *Antigone*. Honegger was a member of the group known as *les Six*, together with Louis Durey, Georges Auric, Germaine Tailleferre, Francis Poulenc and Darius Milhaud. This group, taking Satie as its mentor, were briefly united by their support for Cocteau's anti-romantic manifesto *Le Coq et l'arléquin* (1918). Honegger, however, turned toward neoclassicism in his oratorio *Le Roi David* (1921), which was strongly influenced by Bach. His orchestral description of a steam train, *Pacific 321* (1923) showed another side to his writing.

In Germany, Paul Hindemith's early works, published just after the war (in which he served in 1917–18) were Expressionist in manner. The next phase was an interest in the Dadaist celebration of the disjointedness of the world, after which Hindemith finally embraced neoclassicism in a search for clarity and objectivity. Most of Hindemith's neoclassical works were written for small chamber ensembles, with the fresh, clean sounds of the wind and brass instruments dominant. His first full-length opera, *Cardillac* (1926), made use of such Baroque units as the *da capo* aria, the scena and recitative. In the ensuing years he wrote several comedies satirizing contemporary life.

Sergey Prokofiev had already made his mark in St Petersburg before World War I with a number of avant-garde piano pieces, despite a highly conservative musical education that had concentrated on Bach, Haydn and Mozart. He regarded the title of his "Classical" Symphony (1915–17) as a joke, but nevertheless it was a fine neoclassical work, mingling the vivacity and precision of the Baroque with a joyful wit and irony. Prokofiev left Russia on the outbreak of revolution, and did

not return for good until the early 1930s. A meeting with Diaghilev in London set off an enduring interest in the theater, and his sparkling score for the comic opera *The Love for Three Oranges* (first produced in Chicago in 1921) established his reputation in this field.

A question of identity: Eastern European opera

In Eastern Europe, where in the aftermath of war national boundaries were finally taking shape, albeit with countless disputes about national minorities in the new states, one way of reasserting national identity was through recourse to musical roots in folk song and peasant life, and here too opera played a part. A return to the purity of folk song also, as the Hungarian composer Béla Bartók saw, provided a route away from Romanticism. After the war Hungary was carved up, with the north incorporated into the new Czech state and Transylvania annexed by Romania, but Bartók persisted in developing a new and specifically Hungarian style. Evidence of his researches into folk song can occasionally be

heard in the strong modal lines of his only opera, *Duke Bluebeard's Castle*, written in 1911 but not performed until 1918 after being rejected by the organizers of the competition for which it was submitted. There are only two singing roles, Bluebeard and his bride, Judith. The orchestra takes on a pictorial function, as in turn Judith persuades Bluebeard to open seven doors – the seventh revealing Bluebeard's three imprisoned wives. What lies behind each of the doors is expressed by the orchestra. The vocal writing is close to speech and there are no sustained arias. Bartók creates characterization by a contrast in musical manner: Bluebeard's music is pentatonic and folk-like in quality, while Judith's is chromatic. Bartók's ballet *The Miraculous Mandarin* (1918–19), which has been described as "an opera without words", also had difficulty getting performances. The subject matter – violent sex and violent death – was considered obscene. The orchestral writing is barbaric, jagged and virtuoso, leading inexorably to the erotic and cathartic climax between mandarin and prostitute.

▲ Part of the score for *Sinfonietta* by Janáček, 1926. This piece, one of Janáček's later major works, requires a very large ensemble. It is typical of this individual, direct composer. Leoš Janáček (1854–1928) strongly supported the Czech national movement, and folk-song and traditional playing styles greatly influenced his style. By this stage he had stopped using ruled staves, but his writing, like his scoring, remains expressive.

▶ The set for Janáček's opera *The Makropoulos Case*, 1926. The "case" in question is actually an alchemical formula, the elixir of life. The central character is a woman 300 years old, yet still in the prime of life. However, the elixir does not bring contentment, and her life is reduced to legal wrangling. Only in death can she find eventual peace. This was his eighth opera, based on a play by Karel Čapek, who in *R.U.R.* had created the concept of the robot.

Art Deco

Despite a growing tendency in the 1920s and early 1930s towards functionalism in the arts and away from decoration, by the time of the 1925 Paris Exposition International des Arts Décoratifs et Industriels Modernes, there was evidence of a new trend in decorative art. Dubbed "Art Deco" after the title of the Exposition, it was notable for its Cubist shapes, Fauvist color schemes and Futurist dynamism, coexisting in Jazz Age juxtaposition. Art Deco dominated design in the late 1920s, and exerted its influence during the following decade. Objects from clocks to cocktail cabinets were refashioned with the distinguishing features of Art Deco forms. Their sources were eclectic, including the contents of the tomb of Tutenkhamun, revealed in 1923, and the symbols of American Indian cultures. Ziggurats and stepped plinths, opening fans and encompassing rainbows, exotic blooms and radiant suns, a panoply of ancient symbols of spiritual wealth, were prominent, whether they were on beach pajamas or the bronzed gates of department store elevators.

Large-scale production was now possible, with the Primavera Studios of the Printemps store in Paris producing a thousand different "models" a year. Clear, flat colors with emphasized outlines were popular in posters and ceramics. Peach-colored glass and chromium tubing, maple and walnut veneers, colored hide upholstery, green onyx and pink marble, and the plastics celluloid and Bakelite in every color, were lavishly used on the knife-edge of taste. In the ordinary home Art Deco was most evident in light fittings and mantelpiece ornaments, cigarette lighters and powder compacts. But its most impressive expression was in architecture: in hotels like the Savoy or Claridge's in London, in Radio City and the Chrysler Building in New York, the galleries of the Bellas Artes in Mexico City or the State Capitol in Lincoln, Nebraska. World War II brought an end to such luxury and in the austerity of the postwar years Modernist designs prevailed.

▶ **The Hoover Building, London (1935).**

The musical language of the Czech composer Leoš Janáček was grounded in Romanticism, but toward the end of his life – perhaps in response to the newfound independence of his beloved Czechoslovakia – he countenanced a much greater degree of dissonance, whole-tone scales and the modal influence of Moravian folk music. One of his aims was to find a style that would reflect his own particular language, and he achieved this in a series of operas, both tragic and comic, written during the 1920s: *The Excursions of Mr Brouček, Katya Kabanová, The Cunning Little Vixen, The Makropoulos Case* and the unfinished *From the House of the Dead,* based on Dostoyevski's novel of prison life. Fate, tragedy, darkness, hopelessness, love, natural justice, were Janáček's raw material. His music can be heard as a series of conflicting elements, where a melody can be contradicted by a harsh accompaniment, as in the overture to *The Makropoulos Case.* The use of very high or very low instrumentation, such as the three low trombones and three high piccolos of *From the House of the Dead,* underlines the emo-

tional extremes. In the same work, "natural" sounds – the rattling of chains, the crack of a whip, the beating of hammer on anvil – add to the aura of fear and despondency.

Karel Szymanowski, too, used sounds not always recognized as music in his work. After his family lost their Ukrainian estates in the Russian Revolution of 1917, Szymanowski returned to Poland, which was restored to independence in 1918. His first composition after his return, the song cycle *Slopiewnie,* asks for cries, shrieks and similar "natural sounds". Here Szymanowski was seeking to recreate what he imagined primitive Polish music to be, in an attempt to "crystallize elements of tribal heritage". The text was in a made-up Slavic language. Coupled with his fascination with the folk music of his homeland was an obsessive orientalism, and these two aspects of his creativity found expression in his opera *King Roger,* written between 1918 and 1924. Based on Euripides' *The Bacchae,* the opera concerns the age-old conflict between order and anarchy, asceticism and unbridled passion.

After a few hours of sleep, I suddenly wake up ... I look down into my soul. Innumerable notes ring in my ears, in every octave; they have voices like small, faint telegraph bells. I would tune them all to an a''''– only the a stands out clearly – and on the left, out of this whole cobweb of sounds, I would also place the buzzing a which ... interrupts the deep and regular breathing of my daughter at my back ... This is the sound of silence ... I am listening to the music of the soul – I see it quite clearly noted down.

LEOŠ JANÁČEK

SURREALISM

Surrealism was a movement in the arts first announced in 1924 in a manifesto written by French poet André Breton and issued in Paris. It sought to resolve the two states of dream and reality and so produce "absolute reality or sur-reality." The surreal was generated by techniques like automatic writing (using techniques of free association), attention to dreams as evidence of the unconscious, random artistic processes such as Max Ernst's *frottage* (the technique used in brass-rubbing), and hallucinatory experience. The Surrealists were interested in anything that acted as a release from rationalistic logic, which was perceived by them as false to the true condition of the world.

Surrealism was not a wallowing in fantasy but an engagement with a hidden truth which could be sprung from the world by bringing together things which seem not to be related. Its importance was not simply that its methods stimulated a large number of important artists, including the Swiss Paul Klee, the Spaniards Salvador Dalí and Joán Miró, the Belgian René Magritte, and inspired the "automatic" methods of the American Abstract Expressionists such as Jackson Pollock dripping paint from punctured cans. Further, it reaffirmed, in an extreme way, that the arts work not so much by logic as by association, so that a poem or painting or piece of music can never be "explained" and its meaning exhausted. Art is not simply to be seen as communication. It is always more than simply rational. Those who have problems with Surrealist paintings are probably asking for more "rationality" than the artist was interested in giving. According to the ideas of the psychologist Sigmund Freud, the triggers of our actions and our deepest meanings are revealed in our subconscious behavior and dream states. Other related interests in the springs of personality can be found in novels of psychological analysis like the searching *Confessions of Zeno* by the Italian Italo Svevo, in the associative stream-of-consciousness technique in the novels of Virginia Woolf and James Joyce, and in the concern with multiple identity in the plays of Luigi Pirandello.

Miró's *Harlequin's Carnival* was completed in 1925. It presents a mass of dreamlike, dislocating images, set in a space which is disturbingly empty-feeling in spite of the picture's fantastic clutter. Miró's sinuous yet spiky lines hold everything together, but suggest an infinite and unanalyzable world, comic, certainly, but tense too with ladders to infinity, disembodied eyes, dice – symbols of chance – and half-formed embryonic creatures. Tubes hang in or through vacancy. What, the painting asks, is at the heart of appearances? This art invites the modern worlld to return to the enigmatic origin of art itself.

▶ *Harlequin's Carnival (1924–25) by Joán Miró.*

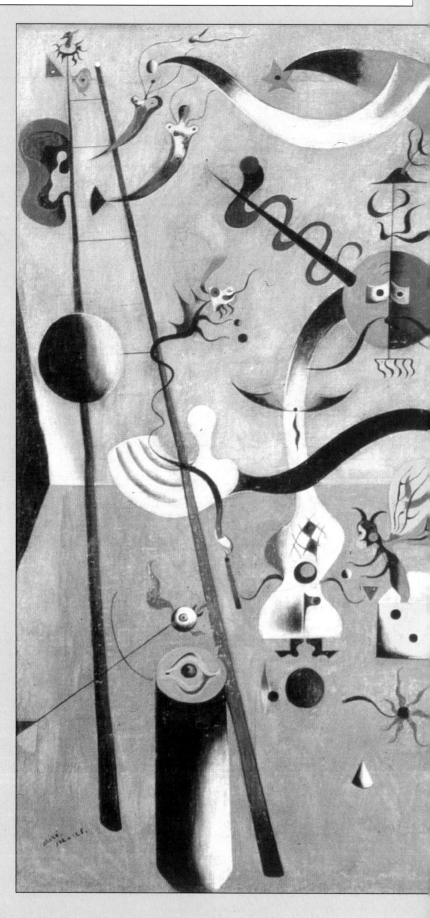

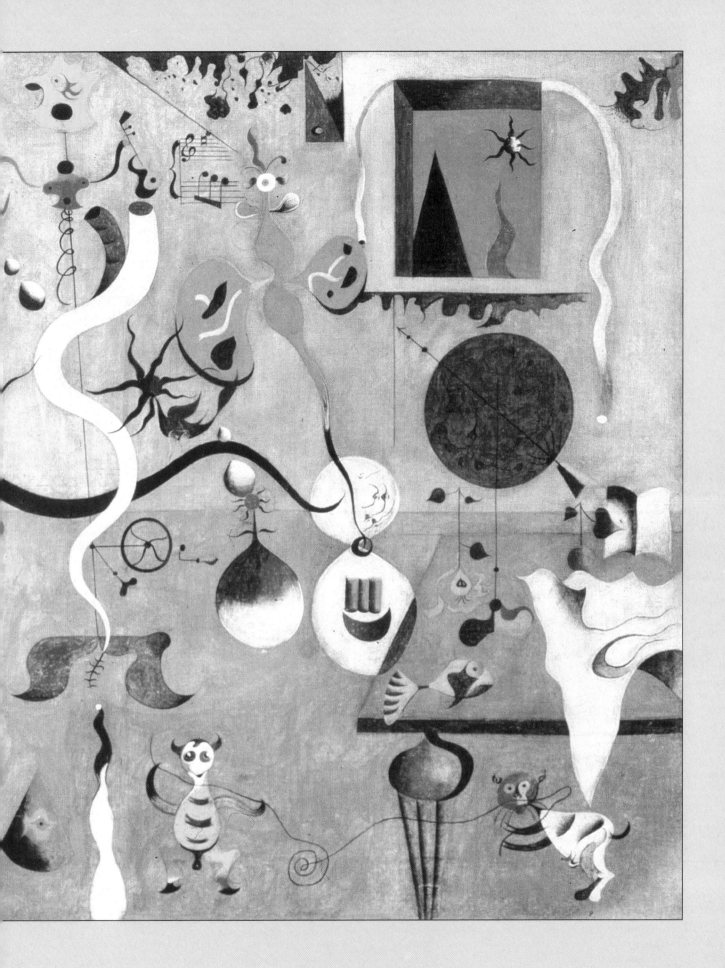

Datafile

The United States and Mexico, in their different ways, both reacted against European modernism. Muralists like Diego Rivera celebrated the Mexican revolution by returning to 15th-century Italian painting. Ruralists like Thomas Hart Benton strove to celebrate a pastoral America untouched by Parisian decadence. However the impact of modernism could not be wholly evaded. Rivera's later industrial landscapes are charged with the same desire for social harmony as inspired the French painter Fernand Léger. Benton's figures are not completely free of a certain Expressionist energy. In the work of painters like Max Weber, the European influence was positively accepted.

▼ Thomas Hart Benton studied the European avant-garde before embracing the somewhat narrow theories of the American Ruralist school. He worked with the Mexican painter Orozco on a series of murals that display this heritage. These sales figures are calculated (as are the similar files in this section on Klee and Mondrian) by taking an average of the artist's top three prices each year, converted into sterling at current rates of exchange.

Nobel Prize for Literature
1914 Reserved
1915 Romain Rolland (France)
1916 Carl Gustaf von Heidenstam (Sweden)
1917 Karl A. Gjellerup and Henrik Pontoppidan (Denmark)
1918 Reserved
1919 Carl F.G. Spitteler (Switzerland)
1920 Knut Hamsun (Norway)
1921 Anatole France (France)
1922 Jacinto Benavente (Spain)
1923 W.B. Yeats (Ireland)
1924 Wladislaw S. Reymont (Poland)
1925 George Bernard Shaw (UK)
1926 Grazia Deledda (Italy)
1927 Henri Bergson (France)
1928 Sigrid Undset (Norway)

Thomas Hart Benton sales

Average price (thousand pounds) — bars for 1960-64, 1965-69, 1970-74, 1975-70, 1980-84

▼ Marcel Proust, who won the Prix Goncourt in 1919, went on to create, in *Remembrance of Times Past*, the definitive portrait of the modern psyche. The Pulitzer Prize was established in 1917 as an award for novels, plays, works on US history and American biography. Prizes for poetry soon followed. Sinclair Lewis was made a Nobel laureate, while Thornton Wilder has been seen as a significant American dramatist. *The Magnificent Ambersons* was made into an important film by Orson Welles.

▲ The winners of the Nobel Prize for Literature during this period included an interesting mixture in political terms. Both the Norwegian novelist Knut Hamsen and the Irish poet W.B. Yeats espoused forms of fascism, Yeats in his depiction of the Anglo-Irish aristocracy, and Hamsen in his open support of Hitler and later the Norwegian collaborator Quisling. George Bernard Shaw, on the other hand, a lifelong socialist and a member of the Fabian Society, was praised for his "idealism and humanity".

Major literary prizes	
Prix Goncourt	**Pulitzer Prize novels**
1914 Adrien Bertrand *L'Appel du sol*	No prize
1915 René Benjamin *Gaspard*	No prize
1916 Henri Barbusse *Le Feu*	No prize
1917 Henri Malherbe *La Flamme au poing*	No award
1918 G. Duhamel, Denis Thévenin *Civilisation*	Ernest Poole *His Family*
1919 Marcel Proust *A l'Ombre des jeunes filles en fleurs*	Booth Tarkington *The Magnificent Ambersons*
1920 Ernest Pérochon *Nêne*	No award
1921 René Maran *Batouala*	Edith Wharton *The Age of Innocence*
1922 Henri Béraud *Le vitriol de lune et le maigreur de l'obèse*	Booth Tarkington *Alice Adams*
1923 Lucien Fabre *Rabevel*	Willa Cather *One of Ours*
1924 Thierry Sandre *Le Chèvrefeuille*	Margaret Wilson *The Able McLaughlins*
1925 Maurice Genevoix *Raboliot*	Edna Ferber *So Big*
1926 Henri Deberly *Le Supplice de Phèdre*	Sinclair Lewis *Arrowsmith*
1927 Maurice Bedel *Jérôme, 60° latitude Nord*	Louis Bromfield *Early Autumn*
1928 Maurice Constantin-Weyer *Un Homme se penche sur son passé*	Thornton Wilder *The Bridge of San Luis Rey*

In the early years of the century American writers tended to divide into two camps. There were those who found their subjects at home, and those who looked to Europe for inspiration. Nearly all of them visited Europe at some time, but some – notably Henry James, Ezra Pound and T.S. Eliot – found their true voices in the Old World. It was not just a question of preferring one place to another; it had to do with the ability of the United States to satisfy the creative imagination. Toward the end of the 19th century, contemplating a Europe overcrowded in many respects – with palaces, museums, abbeys, objects – Henry James had defined America in negatives where "almost everything is left out". And although in recent years the United States had been filling up at a hectic rate – with telephones, electric lights, typewriters, Italian pictures, railroads, bridges and above all people (if not American Indian people) – nonetheless many Americans still regarded their country as James had done. At the very least, they felt that Europe had the cultural edge over them.

Writers in the American grain

There were, however, others who saw it almost as a duty to realize and extend the potential of their own country as a resource, just as its industrial and political potential was being realized. A solid foundation had indeed been laid during the 19th century by the novelists Nathaniel Hawthorne, Herman Melville and Mark Twain, and by the poets Walt Whitman and Emily Dickinson. Between them they had constructed a tradition characterized by its moral purpose and the hugeness of its canvas, a response to the physical vastness of the United States, the stern and homespun nature of its society, and the grandeur of its hopes. And it was clear that it was something specifically American that was being developed – something that could match the achievements of its most immediate parent, England.

Even while developing their own traditions, American writers were clearly aware of the main European trends and incorporated them into their own concerns. Writers recording rural Louisiana or Maine or the rapidly expanding industrial cities also explored the possibilities of women's consciousness and social conditions. Some, like Stephen Crane, became masters of realist description. The further potential of such themes was to be realized in the period after World War I, in war novels such as John Dos Passos's *Three Soldiers* and Ernest Hemingway's *A Farewell to Arms*, and in Willa Cather's extensions of the feminist and local colorist concerns of the old century (*O Pioneers*, 1913; *My Antonia*, 1918; *A Lost Lady*, 1923). Sinclair Lewis took on the challenge of finding fit subject matter at home, writing about

THE ARTS IN THE NEW WORLD

smalltown life (*Main Street*, 1920), business (*Babbitt*, 1922) and evangelical religion (*Elmer Gantry*, 1927). The more powerful Theodore Dreiser met initial hostility and censorship but his examination of power and money in *An American Tragedy* of 1925 silenced all criticism. Money and power preoccupied F. Scott Fitzgerald, too; his novel *The Great Gatsby* came to symbolize the Jazz Age and life in the "lost generation" of the 1920s. Fitzgerald felt most strongly the romantic dream that pulsed within the financial striving: love, money, power and death fused together to create one version of the American Dream. As the American poet Wallace Stevens wrote, "Money is a kind of poetry." Money brought the possibility of excitement and romance, but was no safeguard against brutishness and disaster, as exemplified in Fitzgerald's own eventually disastrous life.

American subjects preoccupied the poets too – Edward Arlington Robinson, Robert Frost, Carl Sandburg, and above all William Carlos Williams, whose whole aim as a poet was to legitimize the voice and cadences of America. To go to Europe to find your voice was, he felt, a short cut. Although a busy doctor, Williams kept in touch with leading writers including Ezra Pound. For him, language was the key. While the expatriates Pound and Eliot saw the revolution in poetic meter as part of a general and modern subversion of older poetic methods, Williams saw it as specifically necessary to America. He felt that

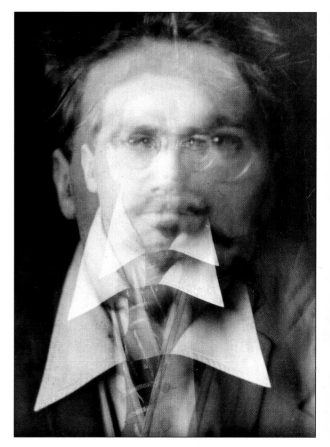

► A Vortograph by Alvin Langdon Coburn of the poet Ezra Pound (1916). Pound was closely involved with Wyndham Lewis in the Vorticist movement. Pictorially this was a compromise between Cubism and Futurism, depicting objects as possessing a radiant center or vortex of forms. Coburn experimented with this imagery in photographic form.

◄▼ F. Scott Fitzgerald's novels epitomized both the excitement and the dangers of the Jazz Age. *The Great Gatsby* provided a clear analysis of the darkness at the heart of the American Dream. *Tender is the Night* foreshadowed his own life: he and his wife Zelda fell victim spectacularly to alcoholism and mental breakdown.

ideas should only spring from the particular observation of things, and in his case of American things. His early collection of poems, *Spring and All* (1913), was in this style, but equally important in defining his attitude was his prose account of significant moments in his country's past, *In the American Grain* (1925). Here Williams imitated the various styles of language appropriate to the historical episodes – Elizabethan English for Sir Walter Raleigh and so on – as if to suggest that the United States incorporates all these different forms and renders them newly. All this culminated in his major poems *Paterson* (1946–58). Hart Crane's *The Bridge* was another important long poem about America.

One aspect of the American grain was a strong and distinct Southern sensibility. The South may have lost the Civil War, but ironically it went on to win the battle of the books insofar as writers from the South have always seemed to exert a compelling power in the United States, none more so than the novelist and Nobel Prizewinner William Faulkner. After initial attempts at writing in an orthodox and traditional manner, he hit upon a new method of storytelling in *The Sound and the Fury* (1929), which brought the American novel very firmly into the mainstream of the

modern novel as it had been opened up by James Joyce and Virginia Woolf in Europe. Faulkner followed *The Sound and the Fury* with a string of other novels, including *As I Lay Dying* (1930) and *Absalom!, Absalom!* (1936), which left permanently in his debt all modern writers concerned with the complexities of motive and the springs of human action.

In *The Sound and the Fury* he developed his materials out of a basic situation, the lives of the children of the Compsons, a formerly rich family but now in terminal decline. By telling the story in a series of different voices, one of them the mentally backward Benjy, another the suicidal intellectual Quentin, then the scheming Jason and, last, the old black servant Dilsey, Faulkner presented the whole panorama of the South, its history, its prides, its fall, its guilt, its colors and

its surviving fabric, sometimes grotesque but always alive. Faulkner's territory was small in range, yet in his own imaginary district – Yoknapatawpha County – every family and every meter of land is documented and stands for more than itself. In this work the regional, by being fully observed, became universal.

American expatriates

On the other side of the Atlantic, Pound and Eliot both played major roles in the development of writing in England itself. Pound, who was widely read in European languages, left for Italy in 1908, moved to London and quickly established himself in literary circles. Through the Imagist movement, he advocated a spare style of writing, using crisp direct images. It led to an economic and vivid style, but also to a rather fragmented kind of

▶ The third panel of *The Voice of the City of New York Interpreted* (1920–22), by Joseph Stella. Stella was one of the first generation of Americans, like Max Weber, to be affected by Cubism. He put its techniques to vertiginous use in his reconstructions of New York's vistas and skyline. A similar delirium appeared in the representation of the city in the collage work of the Dadaist Hannah Hoch.

Skyscraper Style

In the last decade of the 19th century, masonry construction was taken to its limits in office buildings. In Chicago in 1891, the Monadnock Building achieved 16 stories in masonry and reinforced concrete. But it was the exploitation of the steel frame that enabled architects to reach for the clouds. The rapid evolution of the skyscraper was made possible by a combination of new technology: the availability of structural steel; the introduction of the electric elevator in 1880; and the spread of the telephone in commerce. Also, efficient mass-transport systems permitted the rush-hour movements of working people generated by skyscraper business districts.

In the years between 1867 and 1876, steel production in the United States rose fifty times and the price per tonne halved. By 1900 the United States had over 600,000 telephone subscribers, three times as many as Germany, its nearest competitor. New York, the city synonymous with the development of the skyscraper, entered the new century with an unrivaled public transport system, comprising the "elevated", the subway, electric streetcars and the older steam railroads.

The Woolworth Building (1913) designed by the architect Cass Gilbert, was 52 stories and 240 meters (792 feet) high, with "Gothic" details to the stone cladding. After 1916, skyscraper building was controlled in New York by a succession of City Zoning Ordinances which required new developments to guarantee minimum standards of daylight penetration and ventilation in the city. In 1932 the 85-story Empire State Building, by Shreve, Lamb and Harmon, became the highest office block in the world, a record it retained for more than thirty years. Skyscraper architecture has changed over time, most strikingly in the treatment of the tops which have moved from decorated to plain and back again. The exuberant glittering Art Deco of the Chrysler Building remains one of the most memorable on the New York skyline.

For some American painters of the time, skyscrapers represented all that was exciting about the New World. Artists such as John Marin, Joseph Stella and Georgia O'Keeffe, and photographers such as Joseph Hine and Paul Strand, all captured the magic of this new form of creation and its artistic possibilities.

▶ *Canyon, Broadway and Exchange Place*, by Berenice Abbot.

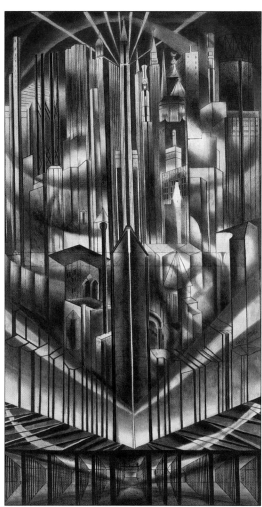

poems of the century, *The Waste Land* was Eliot's own attempt to construct a unity out of fragments, possibly in an effort to restore some kind of cultural unity after the dislocations of World War I. Eliot's search was for a more personal coherence – a structure of belief – that he seemed to have found by 1927, when he was received into the Church of England and took British nationality.

Modern art hits America

Both the writers who stayed at home and those who left for Europe shared a grandeur of ambition and endeavor on a truly American scale. Poetically speaking, it would from now on be difficult to tell which was outpost and which was center. The same could be said for painting, but for American artists there was one particular

▼ *Nude Descending a Staircase*, by Marcel Duchamp (1912). This painting caused a sensation at the Armory Show in 1913. This exhibition in New York had over 400 European paintings, displaying for the first time to many Americans the revolution that had taken place. Duchamp's painting was a brilliant adaptation of Cubist principles into an image that anticipated Futurism. The image possessed an iconic power that Duchamp would parody in later titles, like *The King and Queen Surrounded by Swift Nudes*.

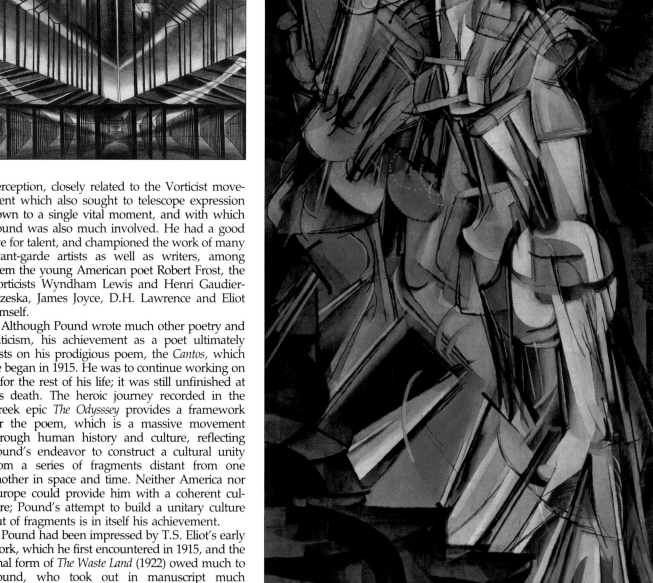

perception, closely related to the Vorticist movement which also sought to telescope expression down to a single vital moment, and with which Pound was also much involved. He had a good eye for talent, and championed the work of many avant-garde artists as well as writers, among them the young American poet Robert Frost, the Vorticists Wyndham Lewis and Henri Gaudier-Brzeska, James Joyce, D.H. Lawrence and Eliot himself.

Although Pound wrote much other poetry and criticism, his achievement as a poet ultimately rests on his prodigious poem, the *Cantos*, which he began in 1915. He was to continue working on it for the rest of his life; it was still unfinished at his death. The heroic journey recorded in the Greek epic *The Odysssey* provides a framework for the poem, which is a massive movement through human history and culture, reflecting Pound's endeavor to construct a cultural unity from a series of fragments distant from one another in space and time. Neither America nor Europe could provide him with a coherent culture; Pound's attempt to build a unitary culture out of fragments is in itself his achievement.

Pound had been impressed by T.S. Eliot's early work, which he first encountered in 1915, and the final form of *The Waste Land* (1922) owed much to Pound, who took out in manuscript much material of lesser intensity. Arguably his greatest poem, and certainly one of the most important

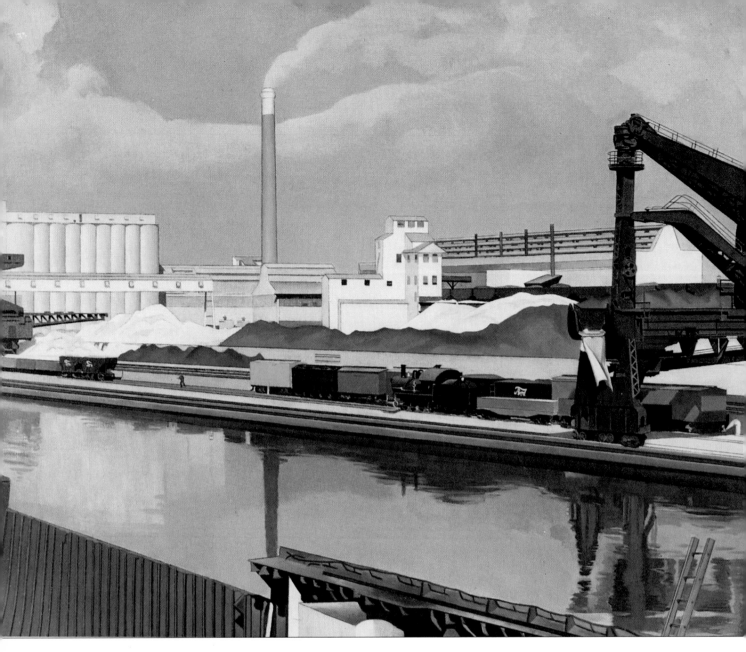

event that was to prove a watershed – the Armory Show of 1913.

Modern art really hit America with the Armory Show (so called because the 1600 paintings were first displayed in the Sixty-Ninth Regiment Armory in New York, before going on to Chicago and Boston). There were around four hundred paintings from Europe, which had been collected in France, Germany and England largely on the initiative of an American painter, Arthur B. Davies. They included a good selection of Fauves, Cubists and Orphists, as well as Dada. Earlier French paintings, going back as far as Ingres and Delacroix, provided a context, with Van Gogh, Gauguin and Cézanne all represented. The show was extraordinarily well attended and also sold well – some 174 pictures, just under a third of these being American. By any standards it was a sensation, putting the visual arts as a point of controversy and excitement on the American map in a way that was entirely new. It fueled American developments too, indicating paths of artistic freedom and inventiveness to a land that, in other walks of life, valued just those things.

Although Armory provided a symbolic focus

for the new European impact, the photographer Alfred Stieglitz had since 1907 been showing avant-garde work at his Gallery 291, home of the informal group Photo-Secession. There he showed Rodin, Picasso, Matisse, Toulouse-Lautrec and Rousseau well before Armory. It was already a center too for young American artists such as John Marin, Max Weber, Arthur Dove, Marsden Hartley and Alfred Maurer, most of whom had already absorbed modern developments in Europe. If Armory put European art on the American map, then Stieglitz's activities were to provide a growing point that would in time put American art on the world map.

The Ashcan School and American Realism

A strong Realist movement had developed in American art in the years before Armory, notably in the work of "The Eight", a group centered on Robert Henri from Philadelphia. The others were John Sloan, George Luks, Everett Shinn and William Glackens, all Realists, Arthur B. Davies, begetter of Armory and given to a slightly fey and fantastic Symbolist manner, the Impressionist Ernest Lawson and, most advanced of all, in

▲ *American Landscape*, by Charles Sheeler, 1920. Sheeler assimilated the rhythm and beauty of form he perceived in industrial structures. Far from celebrating industry, however, he scarcely seemed to notice it, concentrating on a figureless harmony of forms. American landscapes, under this objective light, yielded a lonely beauty explored in the very different work of Edward Hopper.

European terms, Maurice Prendergast, who painted in an attractive Post-Impressionist style. Centered on New York, the Realists, often referred to as the "Ashcan School", took their subjects from everyday American life and, to some extent, romanticized squalor. John Sloan, who like Glackens, Luks and Shinn worked as an artist-reporter on newspapers, was often able to convey the momentary atmosphere of the streets or the rich but ordinary incidents of life (*Sunday, Women Drying Their Hair*). George Bellows, a pupil of Henri's, developed this aspect further. His paintings, such as the Hogarthian *Cliff Dwellers* (1913) or the formally daring *The Lone Tenement* or his boxers ripping punches into each other's bodies, seemed driven on by the energy of city life. Glackens, while urban, tended to pass his subjects through a filter of French Impressionism (*The Drive, Central Park*). Prendergast more than any of the others married American objectivity and French technique, so that his pictures became totally related schemes of shape, brushwork and color (*The Flying Horses*).

European influences

The 20th-century sense of a picture as providing its own reality and achieving an independence of anything simply observed in nature was more fully exemplified in the Stieglitz-centered artists. Max Weber, a Russian émigré, moved through all the European possibilities, but interestingly his *Synthetic Cubist Chinese Restaurant* incorporated elements and colors drawn from North American Indian art. When Theodore Roosevelt said of the Cubist paintings in the Armory Show that he preferred the patterns on his Navajo rug, he was, perhaps unwittingly, pointing up not just a neglected American heritage but also a non-Americanness inherent in much of the European vision. Arthur Dove simplified plant-forms into abstraction in a way that anticipated the more elaborate work of Georgia O'Keeffe. His *Foghorns* uncannily seem to represent the "look" of sound. Alfred Maurer painted effectively within a Cubist sensibility. John Marin excitedly splintered New York streets in a way that was reminiscent of Robert Delaunay exploding the Eiffel Tower. Marsden Hartley, though gathering styles eclectically in his extensive travels, handled landscape in an Expressionist way that connected him with one of the most interesting of American 19th-century painters, the mystical Albert Pinkham Ryder. The "object" is frequently seen as a key to American painting, but the work of Ryder, Dove, Hartley and O'Keeffe perhaps suggests another axis, towards expressive abstraction.

Two painters arrived at total abstraction by an independent means, synchronizing colors in relationship, keyed one to another like musical notes. These were Morgan Russell and Stanton Mac-Donald-Wright, who actually checked his color combinations by playing their equivalent musical values on a piano. Their pictures, while looking like Orphist and Futurist paintings, resulted more in the visual expression of abstract ideas.

One of the sensations of the Armory Show had been the French painter Marcel Duchamp's *Nude Descending a Staircase* (1912). Its deliberate appli-cation of Cubist and Futurist principles had a considerable effect on Man Ray, whose *The Rope Dancer Accompanies Herself and Her Shadows* (1916), its shapes derived from cutouts, is a massively accomplished painting. Its angularity and solid forms, clearly related to Synthetic Cubism, linked it in turn with the later work of Stuart Davis and also with the more objective and American manner of Charles Demuth and Charles Sheeler, whose austere Cubist renderings of American landscape and buildings were as silently objective and cool as their name ("Precisionists" or "Immaculates") implied.

The Mexican Revolution

Meanwhile south of the border artists were engaging with more explosive changes. The Mexican Revolution had been underway since 1910. It had begun as an armed thrust against the rule of the ageing dictator Porfirio Díaz. The ebb and flow of revolutionary activity was continuous and complex, involving charismatic local leaders, but its eventual outcome was to establish a new constitution in 1917, which went further than previous constitutions, stating the obligation of government to promote the overall good of the Mexican people in every sphere: in culture and education, distribution of land, exploitation of resources, wages, health and social welfare. Ever since 1917 the intended aim of the Mexican state has been to realize this visionary program.

An interesting thing can be made by taking a piece of beaver board and working in tin cans, china-ware, and paint. A symphony in barbarisms. To do a picture like this would be very instructive to the tactile sense.

STUART DAVIS, 1920

▼ *I Saw the Figure 5 in Gold*, by Charles Demuth (1928), an exuberant response to a poem by William Carlos Williams, who was trying to establish an American modernism. Williams had dedicated *Spring and All* to Demuth in 1923. The volume presented an authoritative version of the voice he sought to achieve. They were both establishing a new iconography, as expressed in the poem "The Great Figure": "Among the rain/and lights/I saw the figure 5/in gold/on a red/firetruck/moving/tense/unheeded/to gong clangs/siren howls/and wheels rumbling/through the dark city."

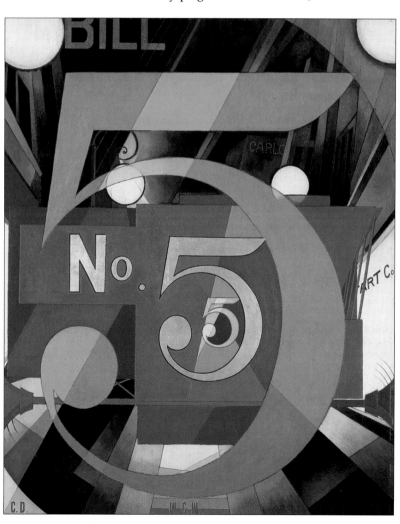

The initial steps were taken when General Alvaro Obregón became president in 1920. He appointed the philosopher José Vasconcelos as minister of education. Vasconcelos immediately enlisted Mexico's artists to present the country's history on public buildings. He gave them a very free hand. Most important among these Mexican muralists were Diego Rivera, José Clemente Orozco and David Alfaro Siqueiros. Their work made Mexico's art influential throughout the world.

The North American artists who were caught up in the effort to evolve a truly American vision were more concerned with probing the particularities of landscape and urban realities than with the more distant American past. Such American myths as the artists had produced did not extend to the American Indians. The heyday of frontier heroism, with the wagons rolling westward, had produced a crop of white settler myths, notably in the paintings of Albert Bierstadt. But the painters had created no racial myth to link the two cultures. In Latin America generally, and in Mexico in particular, the story was altogether different. Mexican artists found their national origins in a pre-Colombian past, much as nationally conscious Europeans ransacked their histories and mythologies for clues to their identities. The vitality of the Aztecs, with their elaborate cosmology, developed art and awe-inspiring buildings,

was allied to peasant traditions, folk art and a feeling for caricature, inspired by the popular prints of José Guadalupe Posada, who used ironic and ubiquitous skeletons based on earlier woodcuts as an instrument of social satire. There was a readiness to use the best of Europe, anything that flowed genuinely from Cézanne, but not, as Siqueiros put it, "all that marketable Art Nouveau". The murals also bear witness to a Hispanic continuity in method and image. The excitement of Spanish Baroque, with its public use of three-dimensional painted surfaces and the Christian iconography of pain and suffering as redemptive, was appropriate to Aztec religion and socialist revolution alike. Art was not private and bourgeois, but the people's birthright.

Vasconcelos first let the painters loose on the walls of the National Preparatory School in Mexico City. In 1922 Diego Rivera, fresh from success as a Cubist painter in Europe, began work on an allegorical *Creation*, mildly Mexican but owing a lot to Giotto. In 1923 he began painting the walls in the Ministry of Education, and here his work was more impressively Mexican. It included images of daily work in the fields and in the mines, and of the Day of the Dead celebrations. Caricature, skeletons, grotesque comedy and impassive Indian piety all combine in these frescoes. Rivera maintained a steady leftwing political input, extolling the revolution and socialist progress, but his style is never just what the state ordered. In 1929 he began work in the National Palace on a Mexican historical sequence still unfinished when he died in 1957. In his portrayal of the market in the Aztec city of Tenochtitlán the immense variety of traders and their goods is presented against a vast, panoramic traverse of the city's monuments, thoroughfares and houses as reconstructed by scholarship and imagination.

David Alfaro Siqueiros, again firmly Marxist, and the propagandist for the muralists, was much less in favor with the state. Active in union affairs, he was frequently imprisoned. He was much less concerned with Mexican history than with the current proletarian struggle. He too worked in the National Preparatory School, on *The Elements*, but this, like much of his work, was unfinished. A restless innovator, who learnt much from film and photographic techniques, his later work is characterized by its use of unusual wall spaces and points of view within the picture, as well as by its huge size.

José Clemente Orozco began as a cartoonist and his work preserved an Expressionist simplification of line, used however to project an agonized force. He painted many Crucifixions, in which the human suffering of a revolutionary Christ is emphasized. *The Trench*, one of his murals in the Cabanas Cultural Institute in Guadalajara, again used traditional Christian iconography. Three soldiers, naked to the waist, are grouped so as to suggest the moment, traditional in Christian painting, when Christ is taken down from the cross. Here, though, all three men seem wounded and, while grouped as one, none seems quite able to help the others. Such entwined poignancy and heroism was central to the Mexico these three great muralists celebrated.

▶ The National Preparatory School, Mexico, displaying the murals of José Clemente Orozco. Orozco, like Diego Rivera and David Alfaro Siqueiros, became much admired in the United States as a result of their mural work.

▲ *Streets of Mexico City, the Morning of 9 February 1913*, by José Guadalupe Posada (1852–1913). Posada was a hero of the Mexican muralists. Both Orozco and Rivera talk of watching him work in his shop as children. From 1890 he worked for Antonio Vanega Arroyo, a publisher of immensely popular broadsides and booklets. Posada illustrated these, usually depicting topical or lurid events in a popular mode.

▶ *The Trench*, a fresco in the Ministry of Education, Mexico City, by Diego Rivera, 1928. Rivera had spent time in Paris, going through and rejecting a Cubist phase. After studying 15th-century frescoes in Italy, he returned to Mexico in 1921, after the revolution. A great program of mural work and general expansion in the arts had been inaugurated. By 1923, when he completed his first series of murals at the *Secretería de Educación Pública*, Rivera had established his preeminence. During the 1930s he visited America, doing murals for the Chicago World's Fair, as well as the New Workers School in New York. His visit to the United States was a chance for him to explore an industrial society, and examine the role of the artist within it.

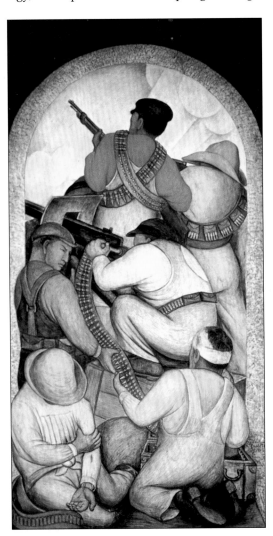

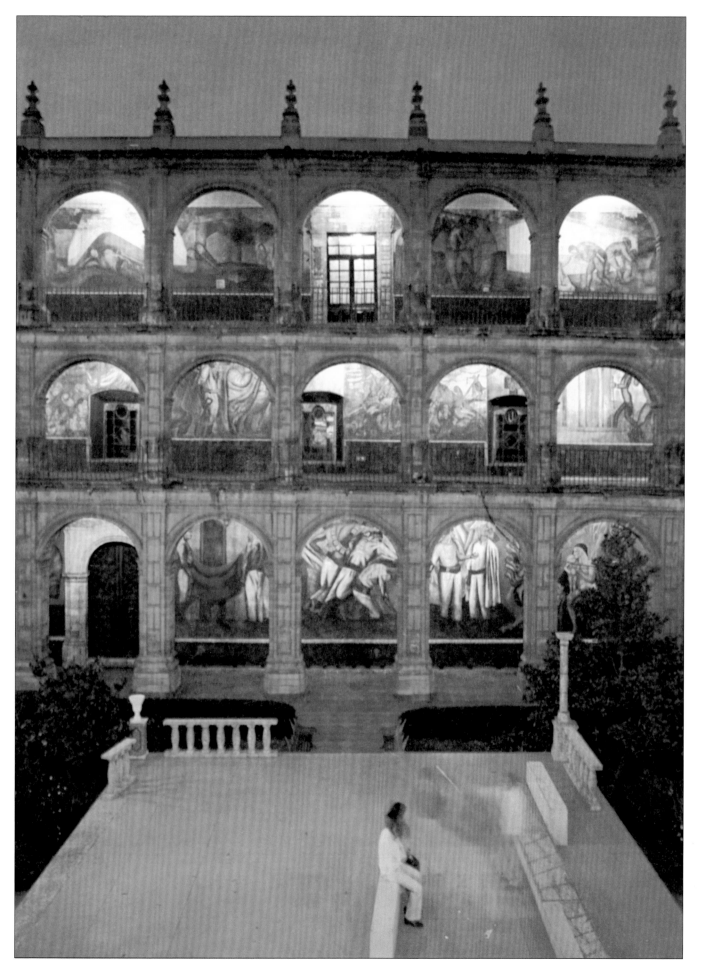

Musical roots and renaissance: Mexico and Cuba

The new government was determined to encourage the enjoyment of all the arts right across the social spectrum. There were both political and psychological reasons for reinforcing the national identity by cultural means, and in music as in art composers drew on the indigenous Indian cultures, particularly of the pre-Conquest era.

Aztec music was generally for wind and percussion. Flutes were made of clay, reed and bone and there were also metal and conch trumpets. Percussion instruments included maracas and a great variety of drums. The pitch and sound quality of the music was related to the choreography of Aztec dance, which had such a fundamental religious and cultural significance that dancers could be summarily executed for making mistakes.

The contemporary popular or folk forms – *mestizo* – had a number of elements, including the *son*, a rural, peasant music marked by an unequal triple rhythm based on six-beat patterns; the *jarabe*, a spectacular dance sequence in which most of its sections were named after animals; the *corrido*, a strophic narrative ballad, usually accompanied by guitars, and the *canción*, a lachrymose song form. These were the materials available to the composers working during the so-called Aztec Renaissance.

Carlos Chávez was himself of Indian extraction and worked as a composer, conductor, teacher, writer and government official. His overtly nationalistic pieces accounted for about a quarter of his works. In 1928 he became director of the national conservatory and also director of the first

permanent symphony orchestra in Mexico, which was formed by the musicians' union. He founded three *academias de investigación* specifically for research into folk music, including music from Asia and Africa, and into "new musical possibilities", particularly in relation to new scales. Chávez wrote two "Aztec" ballets, *Caballos de vapor* and *Los cuatro soles*. The first, written in 1926–27, had a contemporary setting, but pits the relaxed, wild life of the tropics against the industrialized urbanization of the United States. The tropical world is represented by Mexican *sones*, and by the dance forms of *huapango, zandunga* and tango.

Like Chávez, Julián Carrillo, also of Indian descent, was a theorist and teacher with strong ties to the United States, having lived in New York between 1914 and 1918. He returned to Mexico to take up the post of director of the National Symphony Orchestra. Back in 1895 he had made his first experiments in microtonality. His theoretical work on the implications for composition covered scales, melody, harmony, meter, rhythm, texture and the invention of new instruments. In 1924 Carrillo was able to retire from public life to

◄ A still from *Que Viva Mexico!* by Sergei Eisenstein (1932). Eisenstein's film was intended as a celebration of the revolutionary spirit. Full of lingering shots of great tracts of sky, the surviving fragments seem to have owed some allegiance to the Suprematists' principles of representation, in which objects seem to be seen from such a distance they lose any figurative meaning. Other scenes, like the extraordinary *Cadavera* or skeleton sequence, seem borrowed directly from the prints of Guadalupe Posada.

concentrate on his explorations, and in 1926 the New York League of Composers commissioned a work to test his theories, the *Sonata casi-fantasía*. It earned Carrillo the enthusiasm of Leopold Stokowski, who then commissioned the *Concertino* for his Philadelphia Orchestra. In effect Stokowski advised Carrillo to develop the baroque concerto grosso form, in order better to examine his idea of "metamorphosis", an interlocking chain of development involving both microtonality and traditional forms.

In Cuba the musical roots were not Indian but African. Amadeo Roldán, a mulatto, was among the first composers to integrate the energetic dance rhythms of black Cuban folk music and the technical expertise and high seriousness of art music. He was associated with a group of young Cuban painters and writers, the Grupo de Avance, who were anxious to revitalize the cultural life of their country. Roldán's music has been likened to Stravinsky's in his absorption of such forms as the conga, *comparsa, son* and rumba into impressionistic or openly dissonant textures, as in his lively ballets, *La rebambaramba* (1927–28) and *El milagro de Anaquillé* (1928–29).

Roldán's interests were shared by another Cuban composer, Alejandro García Caturla, who studied in Paris in the late 1920s. His work, too, was reminiscent of the Stravinsky of *The Rite of Spring*; it has an abrupt, surprising, asymmetric quality. Expectation is constantly denied. His music was an attempt to reconcile black Cuban music with the popular *mestizo* forms. Caturla was a lawyer by profession and, tragically, his promising musical career was ended when he was shot dead by a criminal he had prosecuted.

Musical experiment in North America
The early musical influences on Connecticut-born Charles Ives were unconventional, to say the least. His father was a bandmaster and provided his son with a solid grounding in Bach and contemporary American music. Yet it seemed as if both father and son were incapable of pursuing the simple, single line of development. They needed more than one thing to be happening at any one time. Together they experimented with polytonality, polyrhythm and polytexture. Ives left a vivid description of his father: "He thought that man as a rule didn't use the faculties that the Creator had given him hard enough ... he would have us sing a tune in E flat, but play the accompaniment in C ... he made us stick to the end, and not stop when it got hard ... At the outdoor Camp Meeting services, Father, who led the singing sometimes with his cornet, ... would always encourage the people to sing their own way ... The fervor would at times throw the key higher ... Father had a sliding cornet made, so that he could rise with them and not keep them down." With such an omnivorous and joyous musical background and a transcendentalist religious upbringing, it was not surprising that Ives should seek to relate the minutiae of small-town America to the infinite, pulsating cosmos. His "Concord" Sonata (1911–15) is a celebration of the literary-philosophical figures that brought fame to the village of Concord, Massachusetts, in the 19th century: Ralph Waldo Emerson (1803–82), Nathaniel Hawthorne (1804–64), the Alcotts and Henry David Thoreau (1817–62). His Fourth Symphony, finished in 1916, set out to answer metaphysical questions in musical terms. In a prelude, a great philosophical question is posed by the Star, and Humanity seeks the answer from the Watchman. There are three solutions: the comic, an anarchic cascade; the formally religious, an academic fugue; and the transcendental, a meditation on hymn tunes, including "Bethany". Ives spent much of the period 1915–28 working on his unfinished "Universe" Symphony, a "spatial" composition for two or more orchestras. It was "a striving to ... contemplate in tones rather than in music as such ... to paint the creation, the mysterious beginnings of all things known through God to man, to trace with tonal imprints the vastness, the evolution of all life ... from the great roots of life to the spiritual eternities, from the great inknown to the great unknown."

Henry Cowell was described once as the "open sesame" for new music in America. He was a great supporter of Charles Ives. He too was freed by his upbringing – his parents were

▼ The cover of *Legends, Beliefs and Talismans of the Amazon Indians* (1923) by Vicente do Rego Monteiro. Monteiro was a member of the Brazilian Modernists, a group which manifested itself at a Modern Art Week in Sao Paulo, in 1922. European influences were seen as a destructive phase through which Brazilian painting had to pass.

◄ *African Nostalgia*, by Pedro Figari. In the 1930s, in Paris, Figari published *Historia Kira*, a utopian account that satirized his native Rio de la Plata. This formed a curious parallel to his style, which was also relatively unaffected by his surroundings, picturing dances populated by girls and gauchos. Whilst there was some debt to the manner of Bonnard and Vuillard, he remained unaffected by the more radical forms of modern art. There is something almost Victorian in his passionate concern for all kinds of reform and his preference for nature over civilization.

"philosophical anarchists" – to accept as "music" a tremendous variety of sound qualities and to produce a multistranded music in which seemingly incompatible pitches or rhythms could co-exist. His most memorable innovation was the tone-cluster, so named for its appearance on the page. Clusters are clumps of adjacent notes played with fingers, fists or forearms. Cowell treated these sounds in the same way as chords and used them as support for melody lines. Their first appearance was in *The Tides of Manaunaun*, written for a pageant in 1917. Cowell used clusters made with hand and forearm in the low register of the keyboard to represent the great seas stirred up by the Irish god.

Cowell's treatise *New Musical Resources* (1916–19) formalized his new musical ideas and set out a suggested notation to cope with them. In the book he dealt with clusters, free dissonant counterpoint, polytriadic harmony, counter-rhythms, shifting accents and his "rhythm-harmony" system. In both his *Quartet Romantic* (1917) and *Quartet Euphometric* (1919), a simple four-part theme provides, through his theories of "rhythm-harmony", the rhythms for the four freestanding melodic lines. During the 1920s he further developed his cluster concept, categorizing the distinctive ways of producing clusters: by stopping, strumming, scraping and plucking. He also began inserting different objects inside the piano in order to produce percussive sounds. At this period he made five tours of Europe where he was greeted with a mixture of suspicion and fascination. Bartók sought his permission to use the cluster in his own music and Schoenberg invited him to play for his composition class.

Meanwhile Carl Ruggles was taking the first steps towards a form of serialism. The music of Alban Berg was certainly known to him, but his harmonic and melodic structures are chromatic rather than atonal. Strictly speaking, his method was not serial, yet he tried to avoid repeating a note in a melody line until up to ten other pitches had been used. He was not a prolific composer and his largest composition was *Sun-treader* (1926–31), a single-movement orchestral work lasting some seventeen minutes.

"I prefer to use the expression 'organized sound' and avoid the monotonous question, 'But is it music?' " wrote Edgard Varèse, a French composer who emigrated to the United States in 1915. He considered music "an art science", and the composer as a kind of philosopher-mathematician. For him, rhythm and sound quality were more important than harmonic and melodic elements, and his alternation and variation between "sound-masses" and silence and between units differentiated by pitch, register, instrumentation or, most characteristically, rate of change, made for a perpetual tangle of sound, much akin to the modern urban environment he loved so much. Varèse had a profound enthusiasm for the new and, above all, for machinery, particularly if it led to the invention of new instruments. The title of his 1921 orchestral work for 132 players, *Amériques*, was "symbolic of discoveries – new worlds on earth, in the sky, or in the minds of men."

New Departures in Dance

During the late 19th century, ballet in America degenerated in much the same way as in Europe, with flashy technique and spectacle blocking out expressive content and artistic integrity. But three women mavericks – Loie Fuller (1862–1928), Isadora Duncan (1878–1927) and Ruth St Denis (1877–1969) – created the climate for change.

All had great charisma and each forged an individual style in opposition to the continuity of classical ballet. Loie Fuller's performances focused less on movement than on striking visual effects. Using huge lengths of silk, and almost sculptural lighting effects, she turned the dance recital into a series of poetic transformations.

Duncan's choreography also derived some of its inspiration from nature but what she sought to express was her own soul. She used a simple vocabulary of runs, walks, skips and gestures, which she imbued with a mesmerizing intensity of feeling. The unfettered simplicity of her work was emphasized by her adoption of skimpy Greek tunics, its spiritual loftiness by her innovative use of great classical music. She inspired a host of followers throughout Europe.

Ruth St Denis was the most technically accomplished dancer of the three, and her choreography was an eclectic, exotic mix of ballet, vaudeville and watered-down oriental dance. Her works combined the high moral seriousness of Duncan with the theatricality of Fuller – a mix made irresistible by St Denis's considerable personal beauty. Her most important contribution to history, though, was the school which she ran with her husband Ted Shawn from 1915. Among their pupils were the two great pioneers of American modern dance, Martha Graham and Doris Humphrey.

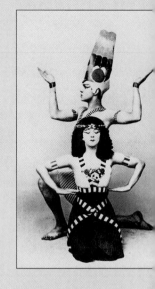

▲ **Ruth St Denis applied her knowledge of commercial theatre to highly successful "translations" of oriental dances.**

▶ **Loie Fuller and her billowing skirts created a sensation at the Paris *Folies-Bergères* in 1893.**

▼ **Isadora Duncan, in a sketch by Rodin. Her simple technique developed into monumental gestures.**

ART AND POLITICS

Since the mid-19th century the French term *avant garde*, meaning "vanguard", has been applied to art that is, supposedly, ahead of its time, revolutionary. Such art has often been associated with radical – usually leftist – politics, the impulse to upset an establishment in the art-world coinciding with the need to upset a class or political establishment. But after the flourish of revolution artists and politicians have often parted company; the individualistic creative spirit is soon disillusioned with what the Surrealist painter Jean Arp called "the termite state". The cry for freedom that is often heard in revolutionary politics can be overwhelmed in the human waste that the engines of war and the machinations of politicians leave behind.

There are other kinds of politics than those of revolution, however. The Constructivist sculptor Naum Gabo, turning his art away from political statement in England during World War II, asked what he could tell people devastated by war that "they did not already know?" Instead he used his art to keep hold of memories and hopes "to remind us that the image of the world can be different."

Political commitment in artists can show itself for the right or the left, for change or conservation; but artists tend to be slightly at odds with straightforward political responses, never quite toeing the party line. The establishment can frustrate the most outrageous acts of defiance by domesticating them. As Marcel Duchamp said of his "readymades", attempts to disturb the complacency of taste, "I threw the bottle rack and the urinal in their faces and they admired them for their esthetic beauty." Protest can become chic and the artist a licensed jester, never in the driving seat. And yet occasionally, if unexpectedly, art and artists themselves become focuses for political statement and provide the ideal medium for its expression to a wider public. Poster art in the political turmoil of the interwar years had a flair which married Expressionism and Cubism with the socialist and fascist doctrines alike. Artists and writers flocked to the Spanish Civil War, and a photograph or a novel recounting the realities of the frontline could stir consciences or more simply show the world the truth of the conflict. South African freedom songs have carried a message abroad, Mexican painters expressed a revolution, German satirists like George Grosz castigated a ruling class and an entire society. Occasionally philosophers like Jean-Paul Sartre have shared picket lines with students and workers. In all these cases artists have lent their talent to the cause.

At a more personal level, artists have been as involved in political conflict as anyone else, and they have sometimes used their arts as weapons. But the power of individual artists is uncertain when dealing with political dilemmas. The works that are produced on this level are often too strident to be effective as art, too individual for the blanket certainties of political faith and too humane for the crude facts of policy.

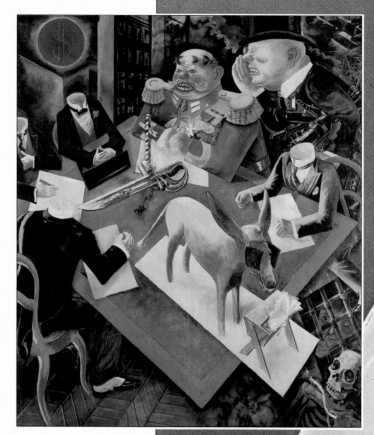

▲ *Eclipse of the Sun* (1926) by George Grosz, whose savage indictment of the rulers of Germany after World War I helped to seal the fate of the Weimar republic.

▼ Socialist Realism, esthetically conservative and ideologically unambiguous, was universally adopted in Stalin's Russia, as in this 1930s poster celebrating Lenin.

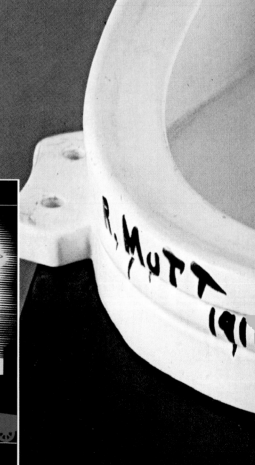

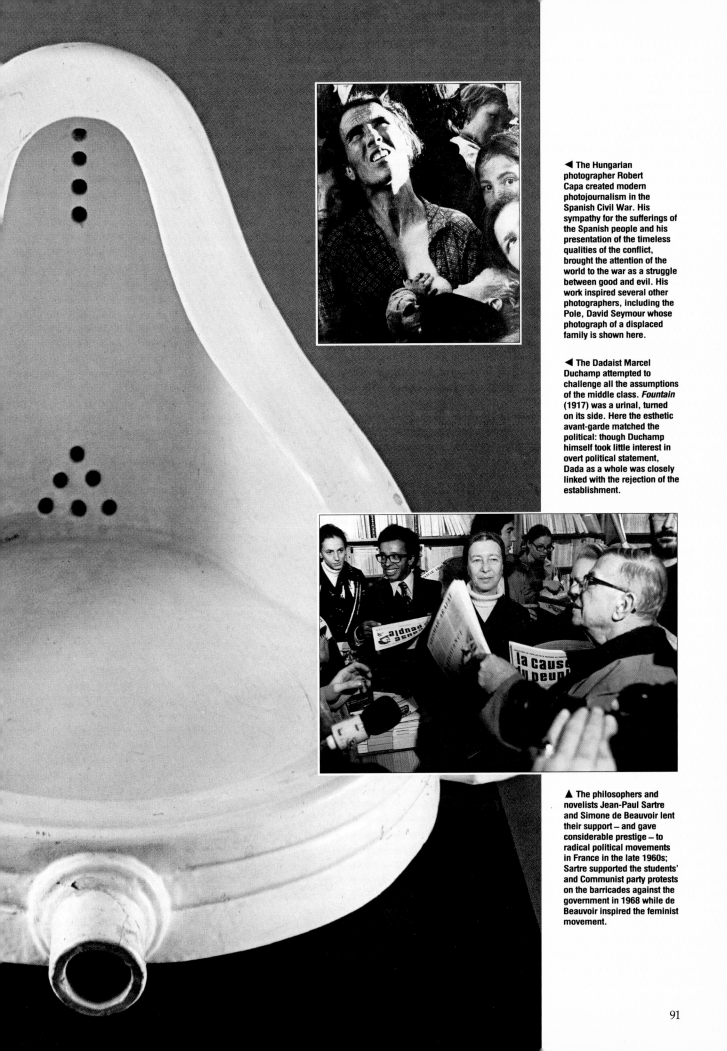

◀ The Hungarian photographer Robert Capa created modern photojournalism in the Spanish Civil War. His sympathy for the sufferings of the Spanish people and his presentation of the timeless qualities of the conflict, brought the attention of the world to the war as a struggle between good and evil. His work inspired several other photographers, including the Pole, David Seymour whose photograph of a displaced family is shown here.

◀ The Dadaist Marcel Duchamp attempted to challenge all the assumptions of the middle class. *Fountain* (1917) was a urinal, turned on its side. Here the esthetic avant-garde matched the political: though Duchamp himself took little interest in overt political statement, Dada as a whole was closely linked with the rejection of the establishment.

▲ The philosophers and novelists Jean-Paul Sartre and Simone de Beauvoir lent their support — and gave considerable prestige — to radical political movements in France in the late 1960s; Sartre supported the students' and Communist party protests on the barricades against the government in 1968 while de Beauvoir inspired the feminist movement.

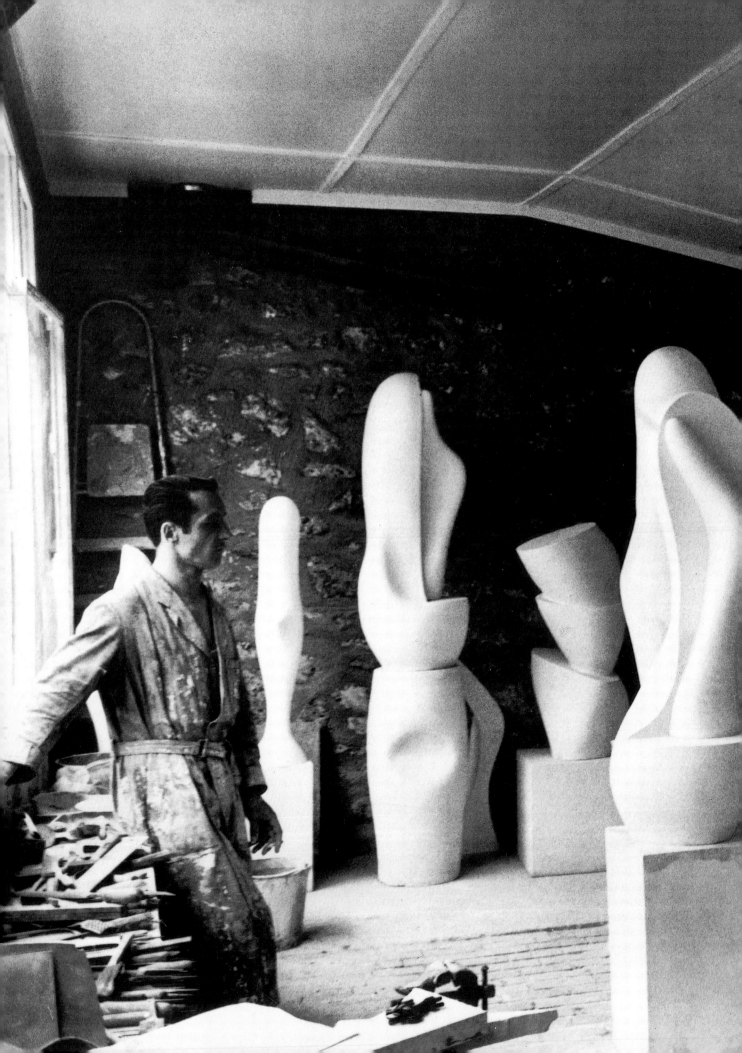

THE
ENDURING
ARTS

Time Chart

	1930	1931	1932	1933	1934	1935	1936	1937
Visual Arts	• László Moholy-Nagy: *Light-Space Modulator*, mechanical sculpture (Ger) • First issue of *Minotaure*, a primarily Surrealist journal (Fr) • Grant Wood: *American Gothic*, painting (USA) • L.S. Lowry: *Coming from the Mill*, painting (UK)	• Foundation of the Abstraction-Création association by Theo van Doesburg and others (Fr) • Jean Arp: *Amphora*, painting (Swi)	• Georgia O'Keeffe: *White Canadian Barn No. 2*, painting (USA) • Georges Rouault: *Christ Mocked by Soldiers*, painting (Fr) • Pierre Bonnard: *Nude in a Bathroom*, painting (Fr)	• Balthus: *The Guitar Lesson*, painting (Fr) • Institution of the "gleichgeschaltet" policy, condemning modern art, in Nazi Germany	• Ben Nicholson: *White Relief*, bas relief (UK) • Hans Hofmann founds the Provincetown Art School (USA)	• Jacob Epstein: *Ecce Homo*, sculpture (UK) • Surrealists break ideologically with Communism (Fr)	• Meret Oppenheim: *Fur-covered Cup, Saucer and Spoon*, sculpture (Swi) • Roland Penrose: *Captain Cook's Last Voyage*, sculpture (UK) • Salvador Dalí: *Autumn Cannibalism*, painting (Sp) • International Surrealist exhibition at New Burlington Galleries (UK)	• Exhibition by the Nazis of "degenerate" art in Munich including works by Picasso, Klee and Kandinsky (Ger) • Pablo Picasso: *Guernica*, mural commemorating the aerial bombing by Nationalists of the town of Guernica during the Spanish Civil War (Fr)
Architecture	• Formation of the *Tecton* group of architects, comprising Berthold Lubetkin and six others (UK) • Moisei Ginzburg displays his "Green Moscow" city design project, an attempt to eliminate the distinction between urban and rural (USSR)	• Palace of the Soviets competition, for which entries are submitted by, among others, Walter Gropius, Le Corbusier, Auguste Perret and Erich Mendelsohn. The winner is Soviet architect B.M. Iofan (USSR)	• Le Corbusier: *Swiss Pavillion*, Cité Universitaire, Paris (Fr) • Bauhaus school moves to Berlin, where it remains in an old warehouse for nine months until closed down by the Nazi regime in 1933 (Ger)	• Arne Jacobsen: *Bellavista Housing Estate*, near Copenhagen (Den) • Sutemi Horiguchi: *Okada House*, Tokyo (Jap)		• Edwin Lutyens: *Headquarters Building of the Press Association and Reuters*, London (UK) • Wallis, Gilbert and partners: *Hoover Factory*, London (UK)	• Albert Speer: *Zeppelinfeld*, Nuremberg, built as a site for Nazi mass rallies (Ger)	• Frank Lloyd Wright: *"Falling Water"* house, Pennsylvania (USA) • B.M. Iofan: *Soviet Pavillion*, at the Paris Exhibition (Fr)
Performing Arts	• Luis Buñuel and Salvador Dalí: *L'Age d'or*, Surrealist film (Fr) • Vladimir Mayakovsky: *Moscow is Burning*, a circus pantomime (USSR) • Martha Graham: *Lamatation* dance (USA)	• André Gide: *Oedipe*, play (Fr)		• F.T. Marinetti and Pino Masnata: *The Futurist Radiophonic Theatre*, a manifesto laying out the principles of Futurist radio presentations (It) • Foundation of Black Mountain College, in North Carolina (USA)		• Leni Riefenstahl: *The Triumph of the Will*, a Nazi propaganda film (Ger) • T.S. Eliot: *Murder in the Cathedral*, play based on the life and death of Thomas à Becket (UK)		• Jean Renoir: *La Grande Illusion*, film (Fr)
Music	• K.S. Sorabji: *Opus Clavicembalisticum*, for solo piano (UK)	• Maurice Ravel: *Piano Concerto* for the left hand, written for the one-armed pianist Paul Wittgenstein (Fr) • Edgard Varèse: *Ionisation*, for percussion orchestra (USA)	• Arnold Schoenberg: *Moses und Aron*, opera (Ger) • Carl Ruggles: *Suntreader*, for orchestra (USA)	• Kurt Weill: *The Seven Deadly Sins*, stage cantata, text by Bertolt Brecht (Ger) • Otto Klemperer becomes conductor of the Los Angeles Philharmonic Orchestra (USA)	• Anton Webern: *Concerto*, for nine instruments (Aut) • Paul Hindemith: *Mathis der Maler*, opera, banned by the Nazi regime (Ger) • Foundation of the Berkshire Festival, firstly in Stockbridge, Mass., moving to Tanglewood in 1937 (USA) • William Walton: *First Symphony* (UK)	• Alban Berg: *Violin Concerto*, dedicated to the memory of Manon Gropius, daughter of Alma (Mahler) and Walter Gropius, who had died of polio (Aut)	• Arnold Schoenberg begins teaching at the University of California (until 1944) (USA) • Olivier Messiaen, André Jolivet, Daniel Lesur and Yves Baudrier form the group La Jeune France to promote new French music (Fr)	• Samuel Barber: *Adagio*, for strings (USA) • Arturo Toscanini takes up the directorship of the NBC Symphony (until 1954) (USA) • John Cage: *The Future of Music*, manifesto on the use of noise in musical composition (USA)
Literature	• T.S. Eliot: *Ash Wednesday*, poem (UK) • Katharine Anne Porter: *Flowering Judas*, novel (USA) • Miron Grindea founds his literary periodical *Adam* (UK) • Wyndham Lewis: *The Apes of God*, novel (UK)	• Antoine de Saint-Exupéry: *Night Flight*, novel in the form of reportage (Fr) • Virginia Woolf: *The Waves*, novel (UK) • Giorgos Seferis: *Turning Point*, poems (Gr)	• Gunnar Ekelöf: *Late on Earth*, poems (Swe) • Alberto Moravia: *The Indifferent Ones*, novel (It) • Aldous Huxley: *Brave New World*, novel (UK) • Louis-Ferdinand Céline: *Journey to the End of the Night*, novel (Fr)	• John Cowper Powys: *A Glastonbury Romance*, novel (UK) • Last issue of Karl Kraus's journal *Die Fackel* (founded 1899) (Aut) • Giuseppe Ungaretti: *Sentimento del Tempo*, poems (It) • André Malraux: *La Condition humaine* (Fr)	• René Char: *Le Marteau sans maître*, poems (Fr) • John A. Lee: *Children of the Poor*, novel (NZ) • W.E.G. Louw: *The Rich Fool*, poems (SA) • Louis Aragon: *Les Cloches de Bâle*, novel (Fr) • Henry Miller: *Tropic of Cancer*, novel (Fr)	• Elias Canetti: *Auto da Fé*, novel (Ger) • Halldór Laxness: *Independent People*, novel (Ice) • J. Dos Passos: *USA*, a novel trilogy (*The 42nd Parallel*, *Nineteen Nineteen* and *The Big Money*) (USA)	• Yannis Ritsos: *Epitaphios*, poems (Gr) • F.R. Leavis: *Revaluations*, critical writings (UK) • Aldous Huxley: *Eyeless in Gaza*, novel (UK)	• Karen Blixen: *Out of Africa*, novel (Den) • David Jones: *In Parenthesis*, poem (UK)
Misc.				• Martin Heidegger pledges allegiance to the newly-elected Nazi regime (Ger)	• Andrei Zhdanov's first statement on social realism given at the Writers' Congress in Moscow (USSR)	• Nuremberg laws legitimize antisemitism in Nazi Germany; Jews are forced out of high-ranking positions in public and private sectors	• Nationalist uprising in Spain and Morocco led by Francisco Franco, aided by Germany and Italy, sparks off the Spanish Civil War	

	1939	1940	1941	1942	1943	1944	1945
...ustus John: ...it of Dylan ...as, painting (UK) ...ador Dalí is ...ed from the ...list group by ...Breton for his ...rt for Hitler (Fr) ...national ...alist exhibition in ...Fr)	• René Magritte: *Time Transfixed*, painting (Fr) • Shikō Munakata: *The rakan subodai*, woodblock print (Jap)	• Paul Klee: *Death and Fire*, painting (Swi) • Pablo Picasso: *Woman Dressing Her Hair*, painting (Fr)		• Max Ernst: *Europe After the Rain II*, painting (USA) • Edward Hopper: *Nighthawks*, painting (USA) • Peggy Guggenheim opens the Art of This Century Gallery in New York (USA)	• Piet Mondrian: *Broadway Boogie-Woogie*, painting (USA) • Cecil Collins: *The Sleeping Fool*, painting (UK) • Jackson Pollock: *Mural*, painting (USA) • John Piper: *Castle Howard*, painting (UK)	• Art Concrète exhibition in Basle, including works by Klee, Kandinsky, Arp and Mondrian (Swi) • Rita Angus: *Portrait of Douglas Lilburn*, painting (NZ) • Francis Bacon: *Three Figures at the Base of a Crucifixion*, triptych painting (UK)	• Yves Tanguy: *The Rapidity of Sleep*, painting (Fr) • Hans Richter: *Liberation of Paris*, collage (USA) • Oskar Kokoschka: *Minona*, painting (UK) • Jean Fautrier: *Hostage*, painting (Fr)
...hold Lubetkin ...ecton: *High Point ...ngate*, London, a ...of flats (UK)	• Alvar Aalto: *Villa Mairea*, Noormarkku (Fin)	• Albert Speer and Adolf Hitler: *Plan for a New Berlin*, urban designs (Ger) • Raymond Hood and others: *Rockefeller Centre*, New York (USA)	• Walter Gropius and Marcel Breuer: *Workers' Housing*, New Kensington, nr. Pittsburgh (USA)		• G.E. Bergstrom: *Pentagon*, Washington (USA) • Oscar Niemeyer: *Restaurant, Yacht Club, Dance Hall and Church*, Pampulha (Bra)		• Marcel Breuer: *Geller House*, New York (USA)
...gei Eisenstein: *...nder Nevsky*, film, ...music by Sergey ...fiev (USSR) ...i Schawinsky: *...e Macabre*, dance ...presented at ...Mountain ...ge (USA)	• Eugene O'Neill: *The Iceman Cometh*, play • Jean Renoir: *The Rules of the Game*, film (Fr)		• Bertolt Brecht: *Mother Courage and Her Children*, play (Swi)	• Jean Anouilh: *Antigone*, play (Fr)	• Akira Kurosawa: *Sanshiro Sugata*, film (Jap)	• Tennessee Williams: *The Glass Menagerie*, play (USA) • Jean-Paul Sartre: *No Exit*, play (Fr)	
...n Cage first ...es his "prepared ..." (USA)	• Béla Bartók completes his *Mikrocosmos*, a set of 153 piano teaching pieces (Hung) • Michael Tippett: *Concerto for Double String Orchestra* (UK) • John Cage: *Imaginary Landscape No. 1*, the first composed piece for electrical reproduction apparatus (record turntables) (USA)	• Igor Stravinsky: *Symphony in C* (USA) • Douglas Lilburn: *Aotearoa Overture*, for orchestra (NZ) • Establishment of the Berkshire Music Centre at Tanglewood (USA)	• Michael Tippett: *A Child of Our Time*, oratorio (UK) • Paul Sacher begins conducting the Collegium Musicum of Zürich, with programs of new music, some commissioned by Sacher himself (Swi)	• Dmitri Shostakovich: *Seventh Symphony*, commemorating the defense of Leningrad against the German siege (USSR) • Aaron Copland: *Rodeo*, ballet (USA) • Douglas Lilburn: *Landfall in Unknown Seas*, pieces arranged around poems by Allen Curnow (NZ)	• Ralph Vaughan Williams: *Fifth Symphony* (UK) • Eduard Tubin: *Sinfonia Lirica (No.4)* (Est) • Nikolaus Skalkottas: *The Return of Ulysses*, overture (Gr)	• Béla Bartók: *Violin Concerto* (USA) • Vagn Holmboe: *Fifth Symphony* (Den)	• Richard Strauss: *Metamorphosen*, for 23 solo strings (Ger) • Benjamin Britten: *Peter Grimes*, opera (UK)
...n-Paul Sartre: *La ...ée*, novel (Fr) ...nuel Beckett: *...hy*, novel (Fr) ...ham Greene: *...ton Rock*, novel	• James Joyce: *Finnegans Wake*, novel (UK) • Thomas Wolfe: *Look Homeward, Angel*, novel (USA) • John Mulgan: *Man Alone*, novel (NZ) • John Steinbeck: *The Grapes of Wrath*, novel (USA)	• Arthur Koestler: *Darkness at Noon*, novel inspired by the trial of Bukharin (USA) • Ernest Hemingway: *For Whom the Bell Tolls*, novel (USA) • Carson McCullers: *The Heart is a Lonely Hunter*, novel (USA) • Mikhail Sholokhov: *The Don Flows Home to the Sea*, novel (USSR) • C.P. Snow: *Strangers and Brothers*, novel (UK)	• Eudora Welty: *A Curtain of Green*, short stories (USA) • Maurice Blanchot: *Thomas the Obscure*, novel (Fr) • Allen Curnow: *Island and Time*, poems (NZ) • Louis Aragon: *Le Crève-coeur*, poems (Fr)	• Albert Camus: *L'Étranger*, novel (Fr) • Mao Zedong redefines the didactic and utilitarian function of literature in his essay *Talks at the Yenan Forum on Art and Literature*, in which he advocates a literature for the people in works of revolutionary political content and perfection of artistic form (China)	• Hermann Hesse: *The Glass Bead Game*, novel (USA) • Robert Musil: *The Man Without Qualities*, novel, unfinished on the author's death (USA) • Halldór Laxness: *The Bell of Iceland*, novel (Ice)	• Pär Lagerkvist: *The Dwarf*, novel (Swe) • Jorge Luis Borges: *Fictions*, stories 1935-44 (Arg) • T.S. Eliot: *Four Quartets*, poem sequence – Burnt Norton (1935), East Coker (1940), The Dry Salvages (1941) and Little Gidding (1942) (UK)	• Ezra Pound is arrested by the US military authorities for his wartime profascist radio broadcasts, and incarcerated at Pisa, where he works on his *Pisan Cantos* (It) • Hermann Broch: *The Death of Virgil*, novel (USA) • Evelyn Waugh: *Brideshead Revisited*, novel (UK)
...chskristallnacht, ...emitic pogrom in ...Germany ...mund Freud flees ...gland after the ...hluss (Aut)		• Leon Trotsky is murdered in Mexico City by a Stalinist agent (Mex)			• Jean-Paul Sartre: *Being and Nothingness*, existential philosophic tract (Fr)		

Datafile

During the 1930s and early 1940s, which were dominated by the fascist governments, European artists and intellectuals took on a defensive role. Institutions such as the Bauhaus were closed down. Many artists fled to the United States: during World War II almost all the major Surrealists could be found in New York. Picasso's decision to remain in occupied Paris made him the cultural representative of a world struggling for its freedom.

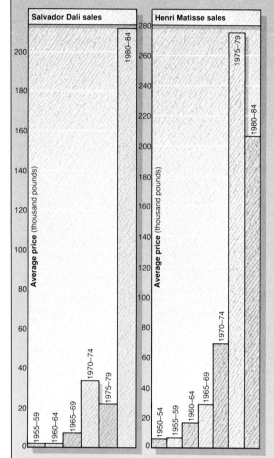

▲ The Spanish painter Salvador Dalí became famous as much for his appearance and behavior as for his extraordinary, highly skilled but essentially formulaic painting. In this respect he was the perfect Surrealist, setting out to shock and disconcert as much of the civilized world as would grant him a platform.

▶ The Venice Film Festival was an indication that the medium had acquired the status of high art. Certainly it reflected the greater seriousness with which Europe viewed cinema, with several literary adaptations among its winners, including *Anna Karenina* and Olivier's *Hamlet*. The award system was dropped in 1968.

"Degenerate Art" exhibition
A. Archipenko (Ukraine)
Ernst Barlach (Germany)
Willi Baumeister (Germany)
Max Beckmann (Germany)
Marc Chagall (Russia)
Otto Dix (Germany)
Christof Drexel (Germany)
Max Ernst (Germany)
Lyonel Feininger (USA)
George Grosz (Germany)
Erich Heckel (Germany)
Wassily Kandinsky (Russia)
Ernst Ludwig Kirchner (Ger)
Paul Klee (Switzerland)
Oskar Kokoschka (Austria)
El Lissitzky (USSR)
Franz Marc (Germany)
Jean Metzinger (France)
Laszlo Moholy-Nagy (Hun)
Piet Mondrian (Netherlands)
Emil Nolde (Germany)
Pablo Picasso (Spain)
Hans Richter (USA)
Oskar Schlemmer (Germany)
Karl Schmidt-Rottluff (Ger)
Kurt Schwitters (Germany)

▲ The Nazis sent an exhibition of "Degenerate Art" on tour round Germany in 1937. This was intended to show that modern art, both in style and subject-matter, was perverting normal human values. In fact, it was a quite exciting gathering (if rather badly hung) of more than 100 painters from Germany and elsewhere in Europe.

◀ Henri Matisse, a generation older than many of his "contemporaries" in the avant-garde, had little of the flamboyance of Dalí. But his genius for color made him one of the most sought-after modern masters. These figures are compiled from the averages of his three highest prices per year, converted into sterling at current rates.

Venice Film Festival – best foreign film award		
1934	*Man of Aran*	Robert Flaherty (UK)
1935	*Anna Karenina*	Clarence Brown (USA)
1936	*Der Kaiser von Kalifornien*	Luis Trenker (Germany)
1937	*Un Carnet de Bal*	Julien Duvivier (France)
1938	*Olympia*	Leni Riefenstahl (Germany)
1940	*Der Postmeister*	Gustav Ucicky (Germany)
1941	*Ohm Kruger*	Hans Steinhoff (Germany)
1942	*Der grosse König*	Veit Harlan (Germany)
1946	*The Southerner*	Jean Renoir (France-USA)
1947	*Sirena*	Karel Stekly (Czechoslovakia)
1948	*Hamlet*	Laurence Olivier (UK)
1949	*Manon*	H.G. Clouzot (France)
1950	*Justice is Done*	André Cayatte (France)
1951	*Rashomon*	Akira Kurosawa (Japan)
1952	*Forbidden Games*	René Clement (France)
1954	*Romeo and Juliet*	Renato Castellani (Italy-UK)
1955	*Ordet*	Carl Dreyer (Denmark)
1957	*Aparajito*	Satyajit Ray (India)
1958	*Muhomatsu no Issho*	Hiroshi Inagaki (Japan)
1959	*Il Generale della Rovere*	Roberto Rossellini (Italy)
1960	*Le Passage du Rhin*	André Cayatte (France)
1961	*Last Year at Marienbad*	Alain Resnais (France)
1962	*Childhood of Ivan*	Andrei Tarkovsky (USSR)
1963	*Le Mani sulla Città*	Francesco Rosi (Italy)
1964	*Red Desert*	Michelangelo Antonioni (Italy)
1965	*Of a Thousand Delights*	Luchino Visconti (Italy)
1966	*Battle of Algiers*	Gillo Pontecorvo (Italy)
1967	*Belle de Jour*	Luis Buñuel (France)
1968	*Artists of the Big Top*	Alexander Kluge (Germany)

The term "International Style" first became current through the publication in 1932 in New York of a book of the same title, written by the critic and historian, Henry Russell Hitchcock, in collaboration with the architect Philip Johnson. Thirty years later, Hitchcock still maintained that the style was the "dominant architectural development" of the second quarter of the 20th century.

Architects of the 19th century had sought long and hard for a new "modern" style. This quest can be seen to have produced the *fin de siècle* Art Nouveau style and the subsequent revolt against excessive ornament had prompted the Viennese architect Adolf Loos to declare in 1908: "Ornament is crime."

While the English Arts and Crafts Movement had been influential in Germany before World War I, the Deutscher Werkbund, formed in 1907 by Hermann Muthesius, was more concerned to involve architects and designers in the possibilities of modern manufacturing processes. Connnections between the Werkbund and the Bauhaus, and later with the Congrès Internationaux d'Architecture Moderne, produced a heady mixture of ideas concerned not only with the potential of modern materials and methods of construction, but with variants of a social program that veered from revolutionary socialist to humanist egalitarian or even elitist meritocratic. Following a prewar exhibition in Cologne in 1914, which had displayed a number of proto-modern buildings in glass, concrete and steel, Ludwig Mies van der Rohe, the vice-president of the Werkbund, directed an exhibition primarily of modern housing prototypes in the Stuttgart suburb of Weissenhof in 1927. The houses, which were all required to have flat roofs, were designed by a glittering array of avant-garde architects, including Mies himself, Walter Gropius of the Bauhaus, the Dutch architect J.J.P. Oud and the Swiss-born French architect, Le Corbusier. Every form of modern construction was used and the architecture was consistently recognizable as belonging to what is now usually known as the "International Style".

At one level, the style is easy to define: loosely, it is what we still call "modern" architecture. At another level, though, it is an illusion, for the superficial stylistic consistencies of architecture gathered together by the term conceal a wide range of variations of approach by individual architects. Apart from a concern with new materials and rational forms of building construction, the quality which marks the style most clearly in the minds of theorists is the promotion of spatial organization as the overriding concern. To non-architects, the chief distinguishing features tend to be flat roofs, a lack of color and ornamentation,

RESPONSES TO TOTALITARIANISM

and the dominance of areas of rectilinear plain glazing – or "white architecture", as some critics have called it.

In 1928, following the Weissenhof exhibition, Hélène de Mandrot, a Swiss patron of architecture, aided by an academic, Siegfried Giedion, and by Le Corbusier, set up a cycle of "Congrès Internationaux d'Architecture Moderne" (CIAM) that was to continue into the 1950s. It attracted wide support from "modern" architects. The thematic meetings resulted in manifestos and more serious reports: CIAM II, held in Frankfurt in 1929, resulted in a report on low-cost housing, *Die Wohnung für das Existenzminimum*. By 1933, when CIAM IV was held on the steamship *Patras* between Athens and Marseilles, the focus had moved to "The Functional City" and town planning issues. The resulting Athens Charter was an influential manifesto for modernist city development, and typical of the way in which the conferences promoted international debate on architecture in an ambience of general agreement about the appropriateness of modern construction techniques and architectural forms.

The Lovell Health House in Los Angeles (1927–29), designed by the expatriate Austrian architect Richard Neutra, and much influenced by Loos, is an early and enduring icon of the International Style, with its steel frame structure and light cladding. But it is probably the work of Le Corbusier and Mies van der Rohe which

▼ Villa Savoye, designed by Le Corbusier (1930). He did a series of designs in the 1920s to illustrate his architectural theory. In 1914 he had patented "Dom-ino", a skeletal frame for mass-produced housing. In doing so he was following a central principle of the International Style, established in 1895 by Otto Wagner. Modernist architects favored the reinforced concrete frame and larger areas of glazing made possible by industrial advances.

broadly encompasses the range of the style. The flowing space of Mies's German Pavilion at the 1929 Barcelona Exhibition, with its sheer planes and refined columns, was hugely influential. He spent the rest of his life refining the design elements employed: column, articulating plane and glass curtain. Le Corbusier's range was broader, and his work, both hypothetical and actual, ranged across the globe from Europe to North Africa and India, and in scale from single dwellings to plans for whole cities. Despite the variety of his work, the quality of complex flowing space manipulation was constant. Two houses, Maison Stein at Garches (1929) and Villa Savoye (1930), Poissy, France, perhaps most embody the common qualities of the International Style.

In many countries of the world, more International Style architecture was built after World War II than before. The prewar avant-garde had often become the postwar establishment, and recovery from global war gave rise to more social programs and the need for rapid construction, both apparently well served by modern architecture.

A "New Deal" for the arts

In the United States, the stockmarket crash of October 1929 brought an end to the expansionist years of the 1920s. For the next three years, one in four of the American labor force was out of work. The knock-on effect on European economies was, if anything, even more disastrous. In Germany,

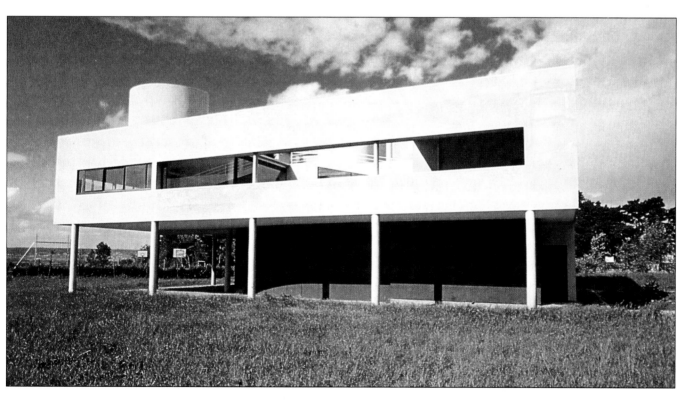

the National Socialists gathered support as the government failed to contain the economic crisis, and Hitler became Chancellor in 1933. Everywhere hardship fostered extremism. Ironically, full employment returned only when World War II created a demand for men, munitions and food that reached far beyond Europe itself.

As a response to the economic state of the nation, President Franklin D. Roosevelt, elected in 1932, inaugurated in 1933 his New Deal, a wide range of funded initiatives to stimulate growth and relieve suffering. As part of this, the Works Progress Administration set up various programs to provide employment in the arts. The best-known was the Federal Arts Project, begun in 1935. There were similar programs for theater workers and writers. In the same year the Farm Security Administration (FSA) began to document the appalling conditions in some of the depressed agricultural regions of the country such as the Oklahoma Dustbowl (also commemorated in John Steinbeck's novel *The Grapes of Wrath*). The Administration employed a team of photographers including Walker Evans, Dorothea Lange, Margaret Bourke-White and Arthur Rothstein. Photography has always had a clear documentary function, but now between Lange's direct, warm and compassionate work and Walker Evans's strict "defining of observation", with its almost Cubist passion for pictorial organization, the possible range of documentary photographic art was brilliantly extended. Indeed, much of the impulse behind the Federal Projects in the various arts was documentary. The writers produced guidebooks to America, the actors developed Living Newspapers, pungent clips of acted news following one another like film newsreel. Nearly ten thousand painters, sculptors and other artists were employed in the eight years the Federal Arts Project (FAP) was running. Between them they produced well over four hundred thousand works – murals, paintings, sculptures, prints, posters, designs – much of which recorded the regions and social conditions of America. The projects were in the hands of enlightened administrators, notably Roy E. Stryker, who ran the FSA photographic program, and Holger Cahill, who directed the Federal Arts Project. The governing philosophy was not so much to do with producing masterpieces as with providing the means for as many artists as possible to create in comparative freedom and to bring about a "naturalization" of art throughout the whole country, rather than merely "an effervescence along the Atlantic Seaboard".

While there was a definite emphasis on expressing social and regional awareness, there was no enforcement of a particular line or style, and among the major beneficiaries of the scheme were young abstract artists. They tended to gather in New York, where the group known as American Abstract Artists was formed in 1936. A number of artists who were to become prominent on the international painting scene in the next wave of American painting, such as William Baziotes, Willem de Kooning, Jackson Pollock and Mark Rothko, were all supported by the scheme. Another artist who was to become central to American abstract art, Arshile Gorky, an Armenian who had emigrated to the United

[Lange's] photographs, as well as those of other FSA photographers, were dramatic evidence of the tragedy of displacement but they included moments of hope, laughter and tranquility as well. All who photographed for the FSA maintained an abiding respect for human nature and constant consideration for the feelings of the people they portrayed. When the office was closed in 1943, the FSA photographers had created a mirror of America and established definitive procedures for implementing the attitudes and intentions that were now known as documentary photography

MINOR WHITE, 1974

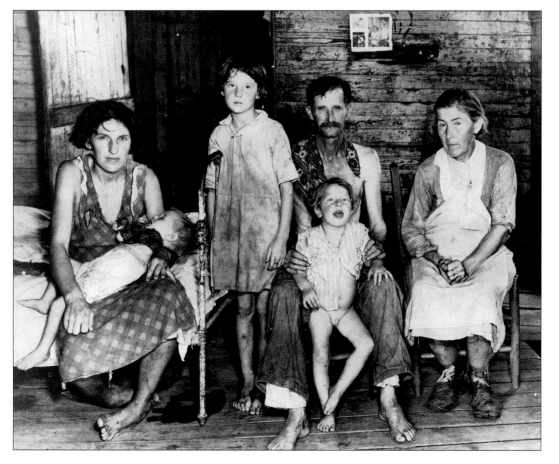

◄ In 1935, under the "New Deal", the US Farm Security Administration commissioned a number of photographers to document the appalling conditions in the Dust Bowl at the height of the Depression. The starkness of the results appalled America. A ramshackle dreariness was recorded with compassionate but uncompromising attention to detail. Dorothea Lange portrayed familes of "white trash" on the move, at their wits' end, searching for work, investing her subjects with a moving grandeur and a sense of spiritual resourcefulness. Walker Evans, who took this photograph of a family in Alabama, was described, famously, as having put "the physiognomy of the nation on your table".

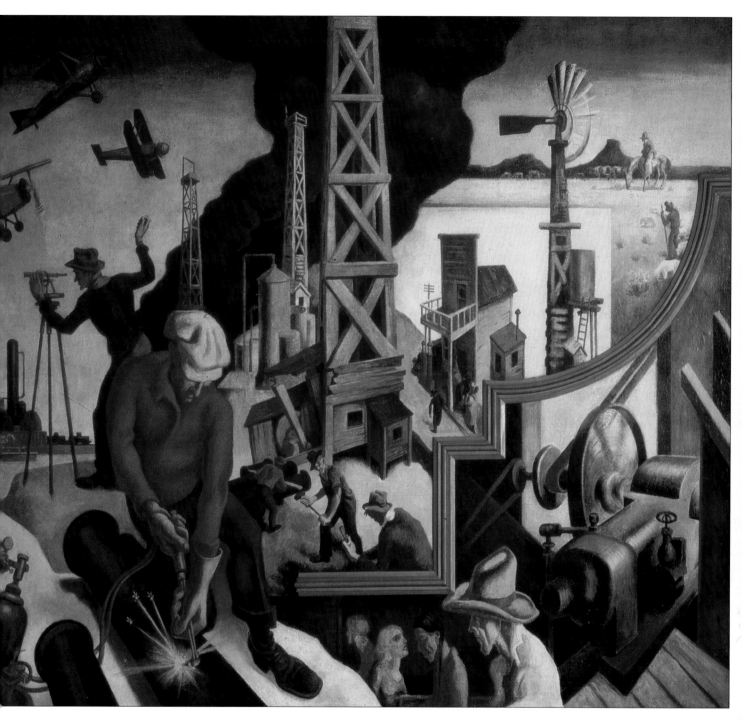

▲ *The Changing West I*, by
T.H. Benton, from a series of
murals painted in the early
1930s with the Mexican artist
Orozco for the new School of
Social Research, New York.
Benton adhered to the
sentimental Regionalist
movement. However, these
twisting figures owe
something to European
Modernism. This might have
influenced one of the models
Benton used, his young pupil
Jackson Pollock.

States in 1920, painted a mural on aviation under
FAP auspices at Newark airport.

An earlier emigrant, Ben Shahn, who had
come to the United States from Lithuania in 1906,
also worked with the FAP, both as a photo-
grapher and a muralist. In 1933 he worked on
murals at the Rockefeller Center in New York,
helping Diego Rivera, who, like fellow Mexicans
José Clemente Orozco and David Alfaro Siquei-
ros, carried out mural projects in the United
States in the 1930s. Shahn was a key social realist
painter. In 1931–32 he painted a superb series
documenting the murder trial in Massachusetts of
Nicolà Sacco and Bartolomeo Vanzetti, immigrant
Italian anarchists who were executed on 28
August 1927 after a manifestly unjust trial that
aroused international condemnation. It was these

paintings that led Rivera to take on Shahn. In
many ways Shahn's impassioned directness and
humanity summed up FAP aims. Fittingly, one of
his most moving paintings was *The Blind Accor-
dion Player*, showing the accordionist who played
as Roosevelt's funeral cortège passed after his
sudden death in 1945. It was Shahn's tribute to
the New Deal President and to the simple dig-
nities of human feeling.

During the later 1920s Edward Hopper, a pupil
of Robert Henri of the prewar Ashcan School, had
been as concerned with portraying American
subjects as they had been, though in a more
Romantic mood. Hopper painted the loneliness
of American urban life – deserted suburban
streets in the early morning, hotels, a corner
drugstore at night – but in such a way as to extol

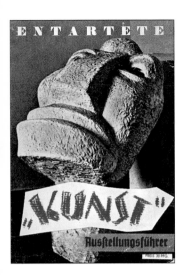

▲ The catalog for an exhibition of "Degenerate Art," selected by the Nazis in 1937. Hitler, who twice failed the entrance exam to the Viennese Academy of Fine Arts, wished to persuade the German people that art should be subservient to the state.

its poignant beauty. By the 1930s, concentration on purely American concerns resulted in the flowering of the work of the Regionalist painters led by Thomas Hart Benton. Benton and Grant Wood both used Realist styles, and Benton also painted murals. Here too a preoccupation with the documentary was evident. In *City Scenes*, at the New School for Social Research in New York, in order to get as many aspects of the city into view as possible, he divided up the painted area with heavy irregular frames, a photomontage device used in newspapers of the time. Grant Wood's style was clean and precise. His landscapes have an idyllic air, but in his portrayal of crabbed mid-Western faces something seems to have dried up in the American pioneer soul.

The dangers of looking only within the United States at a time of international ferment, or of looking only to Europe, were partly answered by Gorky and Shahn but most emphatically of all by the Cubist painter Stuart Davis. Davis held executive posts in both the Artists' Union and in the Artists' Congress, edited the campaigning journal *Art Front*, worked in the FAP and was generally militant in the 1930s. But while he saw his art as a response to "the dynamic American scene", tak-

ing its energies from neon signs, gas stations, chainstore fronts, jazz music and the hard, strident colors of the street, he used techniques derived from French Synthetic Cubism which he felt had "universal validity". He was immensely dedicated to his art. For a full year, 1927–28, he painted his "Egg-Beater" series, based on the multiple optical suggestions he derived from an egg-beater, an electric fan and a rubber glove he nailed to his table. He was wryly witty and agile enough as a painter to bring together, in an entirely personal style, his response to the drab streets of the social realists, to the America of the Regionalists and to the abstract sense of picturemaking possessed by the young artists of the New York school.

The Nazis and "degenerate art"

While the United States looked inwards, Europe was rapidly reaching a state of turmoil that would only be resolved by war. The Spanish Civil War broke out in 1936, commanding active support from both Hitler in Germany and Mussolini in Italy. In the Soviet Union, Stalin began a reign of terror in which no one was safe. In Germany, Nazi power became supreme. All other political

The Harlem Renaissance

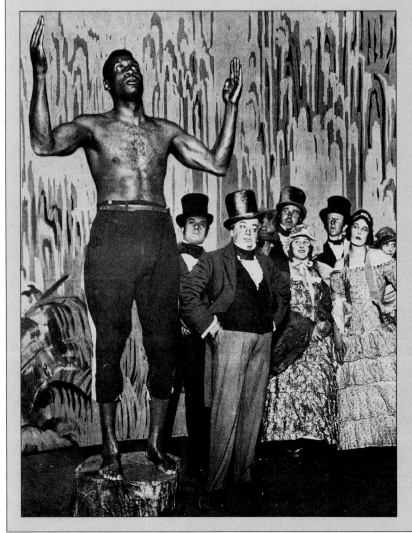

A number of black writers came to prominence in the United States during the 1920s. Their center was Harlem, New York's black ghetto, and the movement included historians, musicians and artists as well as writers. They dispersed with the Depression in the 1930s, but this did not stop their work. That of Langston Hughes (1902–67), in particular, developed strongly through the 1930s and 1940s. Their ideas and examples influenced both the American black protest tradition and the "Negritude" movement of French-speaking black writers in Africa, Madagascar and the French West Indies. Another important black American writer of the time, not so deeply associated with New York but, in retrospect, one of the most impressive figures, was Jean Toomer (1894–1967), whose book *Cane* (1923) mingled poetry, prose and drama in a startling and very modern way.

Various themes were given prominence by Harlem Renaissance writers. They celebrated a distinctive African heritage, soulful and beautiful, which linked different phases of the history of African peoples. "My soul has grown deep as rivers", wrote Hughes and he recalled equally the Euphrates, the Congo, the Nile and the Mississippi. The writers of the Harlem Renaissance showed both a love and a fear of the American South, particularly strong in the work of Jean Toomer. They affirmed the black contribution to the United States. Some looked for a spiritual fusion of the various elements in American society, while showing clearly the problems posed by the actions of white society. Countee Cullen (1903–46), who was the most influenced by the English poetic tradition, wondered ironically why God should make a poet black and "bid him sing". There was a wide response in these writers to black music. It was strongest in Langston Hughes, who spoke of jazz as "honey mixed with liquid fire".

◀ Paul Robeson in *All God's Chillun Got Wings* (1924).

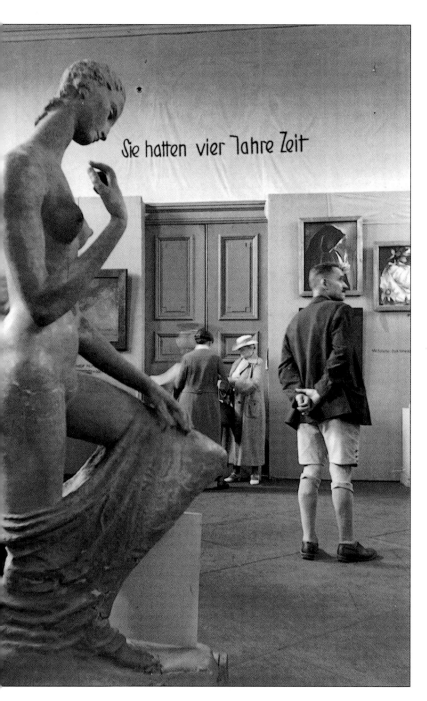

Sie hatten vier Jahre Zeit

▲ At the exhibition of "Degenerate Art", the slogan over the door reads "They have had four years" – referring to the period elapsed since the Nazi accession to power in 1933. This appeal to the lowest common denominator of the public taste was typical of the Nazis' strategy of slow corruption. In the place of such "Decadent Expressionism" they would institute the allegorical nude and the Aryan family. "Classical" standards had become as distorted as any figure by Picasso.

sented, as well as a number of international giants such as Picasso and Chagall – a total of 730 works by over a hundred artists. It toured to huge crowds. Between July and November it was visited by over two million people.

The day before the exhibition of "Degenerate Art" opened, Hitler inaugurated a companion "Great Exhibition of German Art", also in Munich, directly opposite. Some of the things that he said were not unlike the things said by advocates of the Federal Arts Project in America: "The artist does not create for the artist but just like everyone else he creates for the people." He looked in painting for "the good" and "the decent". However, he opposed this to the "insane" and the "criminal", which could be seen across the way at the Degenerate Art Exhibition. In fact, most of his speech was not about the exhibition he was opening but about "degenerate" art, especially that of the German Expressionists, whose own aim, ironically enough, had been precisely to create a "German art". (In the case of the unfortunate Emil Nolde, whose pictures naturally graced the "Degenerate" exhibition, he had actually derived his manner from the art of the people.) Hitler denounced all the Expressionist phrases – "inner experience", "original primitivism" – and the Futurist slogans – "emotions pregnant with the future", "forceful will" – as so much "jabbering". Curiously, the posters advertising the Degenerate Art Exhibition used Expressionist and even Cubist techniques, presumably recognizing that they worked as art. The Exhibition itself, with its careless display and its use of wall captions, which were quotations from "degenerate" critics praising the work, had much of the air of a Dadaist show.

Elsewhere in his speech, Hitler laid great stress on "cultural" values. Germany's defeat in World War I had led to the release of a "flood of slime and ordure", and international art was the main sign of the country's "inner decomposition", having no necessary relationship to an "ethnic group". Cut off from such origins and defined only by its period as "modern", it became modish, not essential. He wished to replace such "modern" art with "true and everlasting" German art. Such modern canvases dirtied "with color droppings" would no longer be available to the German people.

It was a terrifying performance. Many artists, including Wassily Kandinsky, Paul Klee and Kurt Schwitters, had already left the country when the Nazis first came to power in 1933, but now more fled, Max Beckmann the very day after the opening. Many were to settle in the United States and to help broaden the base of American painting. Since Hitler's view of modern art was shared by Stalin in Russia, except that he called it fascist art, the United States received Russians as well, some directly, some by way of other European countries. Marc Chagall, Pavel Tchelitchew and Ossip Zadkine all spent time there.

The recourse of artists who stayed in Germany, if they survived, was to enter into an exile of the mind. Otto Dix and Ernst Heckel retreated close to Switzerland and painted noncontroversial pictures. Käthe Kollwitz defiantly sculpted sturdy

parties were outlawed, trade unions abolished, and the civil service and judiciary brought under Nazi control. Heavy censorship was imposed on the press and radio, and on all forms of art and literature.

Hitler, himself a painter of sorts, held strong views on the place of art in the German state. Works of art that did not meet with Nazi approval were confiscated, later to be sold at auction in Switzerland, destroyed, or siphoned off on the quiet by Nazi collectors such as Josef Goebbels, Hitler's minister for propaganda. In 1937 an exhibition totally unlike any other this century opened in Munich. It was billed by the Nazis as an exhibition of "Degenerate Art", the decadent work of "Bolsheviks and Jews", and drawn from a collection of some twenty thousand such pictures confiscated from German museums. Nearly all Germany's leading modern artists were repre-

expressive figures of grieving solidarity. And in various secret ways artists painted on, at night after approved daytime jobs or in the army in occupied territories far from Germany. This enforced privacy was to lead inevitably, after World War II, to the rehabilitation of abstract art among German artists, as an art which answered only to the demands of the artist's mind. In Italy Benito Mussolini had taken dictatorial powers in 1925, but his view of art, though also based on the premise that what was needed was a "pure Italian art", was far less coercive than Hitler's. Various

styles coexisted, many claiming to interpret the ideals of the state. Futurists, Realist painters, Geometrical Abstractionists and impressionistic naturalists could all claim to represent or at least not to be in conflict with some aspects of the Fascist program, populist, ordered and technological as it sought to be. The Novecento style, with its modernist simplification of classical styles most powerfully represented by the work of Mario Sironi, bid fair to be recognized as a state style for some time during the 1930s, but eventually its own sentimentality and provincial eclecticism

▼ The entrance to the New Chancellery, Berlin, built by Albert Speer, the mastermind of architectural theory in the Third Reich. He used classical theory to create overblown monuments to the principles of fascism. This led to the bizarre postwar spectacle of Allied troops demolishing buildings because of their underlying ideological principles.

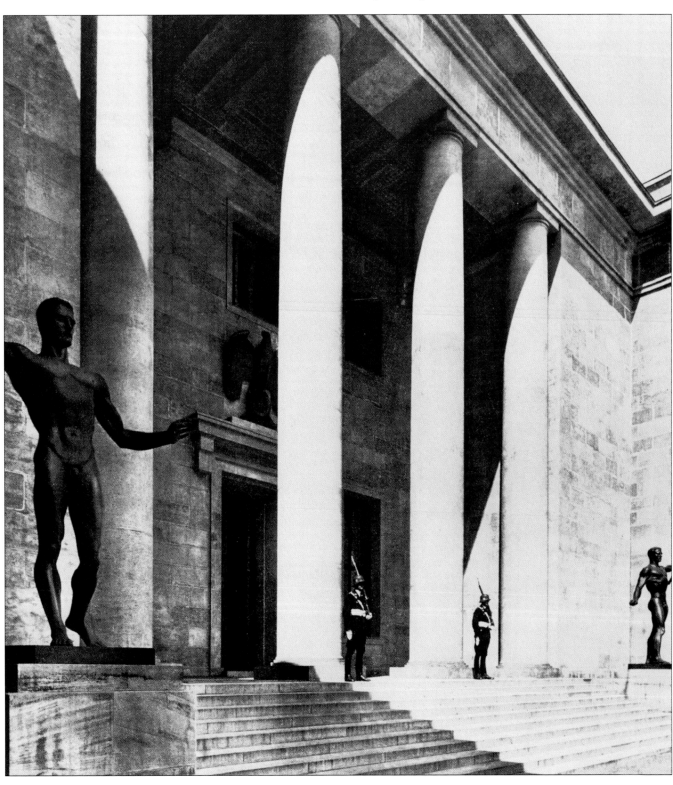

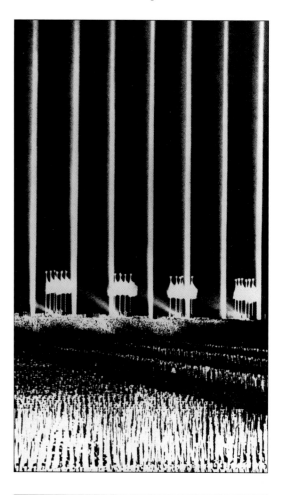

▶ A nighttime rally at
Nuremberg. These elaborately
organized events marked the
highpoint of the Nazi year.
Between 1927 and 1938 the
average attendance was half
a million. These dazzling
military displays of
searchlights and marching
amounted to a national
delusion. The theme of the
1939 rally, abruptly cancelled,
was "Peace".

*If today I could go back
31 years and choose
whether to lead a
peaceful, settled life in
Augsburg or Göttingen ...
this, then; or instead
everything over again as
it was, the glory and the
guilt, the capital of the
world and Spandau, as
well as the sense of a
miscarried life: how
would I decide? Would
I be ready to pay the
price again? I am dizzy
with these questions. I
hardly dare to ask them.
I cannot answer
them.*

ALBERT SPEER, 1964

▲ *Head of Mussolini* by R.A.
Bertelli, 1933. Il Duce's
attitude towards modern art
was an embarrassment for the
Nazis. He had stated: "A new
state, a new people, can
prosper only if the whole of
art is revolutionized." The
Futurists, fascistic in
temperament, were eager to
comply.

undermined its credibility. The perennial question of the relationship between art and the state is only obscured by the manic attitude of a Hitler or Stalin. The case of Italy perhaps shows a more realistic picture of the unending and shifting relationship between the independence of the artist, the power of the state, and the assumed needs of the public, into which both state and artist claim insight.

Architectural intimidation

There is little doubt that the stripped monumental classicism of the major public buildings of the Nazi era was deliberately chosen for its power to overawe and intimidate, as well as for its obvious reference to previous imperial rule. In the country or the provinces, Aryan culture was represented by the crude pseudo-vernacular *Heimatschutzstil* ("protected home style") that linked international military might to the national *Blut und Boden* (blood and soil) of the "master race".

Following his seizure of power, Hitler moved swiftly to take a controlling interest in the architecture of the Third Reich. The force of the stylistic preference of the new government was not immediately perceived. In 1933 a competition was held for the first major Nazi building in Berlin, and a broad range of architects submitted entries, including the Bauhaus architects Ludwig Mies van der Rohe and Walter Gropius. The winning design by Heinrich Wolff was, however, selected personally by Hitler, overruling the views of the juries.

The style favored by Hitler was not in fact exclusive to Nazi architecture. The starkly colonnaded House of German Art (1933–37) in Munich, designed by the first architect of Nazi Germany, Paul Troost, is similar in style to Paul Cret's American Battle Monument at Château Thierry (1928) and his Federal Reserve Board Building in Washington DC (1935).

It is with the work of Albert Speer, the architect of the Nuremberg Arena (1935) and the New Chancellery in Berlin (1938–40), that Nazi architecture is most closely associated. Speer was Hitler's protégé, and in 1936 was charged by him to produce a redevelopment plan for Berlin, for his personal approval. The most striking feature of the plan was a new north–south axis for the city. This was to culminate in the colossal Great Hall at one end and a vast station square at the other. The square was to be entered through a triumphal arch 120 meters (400 feet) high, designed by Speer directly from a detailed sketch made by Hitler in 1925. The Hall, which dwarfed the Reichstag, was to be 320 meters (over 1000 feet) high; it would hold 180,000 people and was to be mirrored in a huge reflecting pool.

In Italy Fascism produced a similar architecture, largely influenced by the work of Marcello Piacentini, whose Senate Building for the University City in Rome (1935) is strikingly similar to the work of Cret. A remarkably different building was designed by Giuseppe Terragni for the Fascists of Como (1932–36). Although demonstrably classical in conception and proportion, this is a rare example of an undeniably modernist building accepted to serve the Fascist cause.

Bayreuth under the Nazis

The Bayreuth Festival inaugurated by Wagner in 1876 continued after his death under the watchful direction of his widow Cosima and his son Siegfried. Cosima's death in 1930 was shortly followed by that of her son, and when the young Hungarian composer Miklós Rózsa revisited Bayreuth in 1934 after a gap of four years, he found it totally changed: "The old Bayreuth of Toscanini had gone, and had become the Bavarian arsenal for the National Socialists." Instead of rapturous applause for the performers, Rósza recounts how at the end of each act the audience would turn to face Hitler's box and raise their arms in the "Heil Hitler" salute.

Ironically, Bayreuth was facing decay when Hitler turned it, at the warm invitation of Siegfried Wagner's English widow Winifred, into his private court theater. The Festival suddenly found itself in receipt of generous subventions from the Reich Chancellery as well as from Hitler's private funds. In Nazi ideology, all acts, however atrocious, were elevated in the cause of a supposed higher good. Hitler and his colleagues found in the operas of Wagner the perfect expression of such spurious "noble and sacred" ideals. His new acquisition allowed Hitler to indulge to the full his belief in himself as Nietzschean superman and Wagnerian hero. Unfortunately for him, he did not foresee his own *Twilight of the Gods*. Bayreuth survived to become once more a festival where Wagner's music could be appreciated, not used.

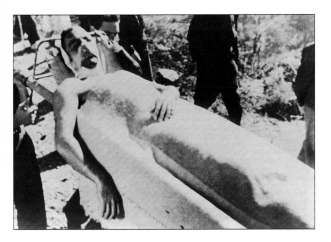

The Spanish Civil War

The Spanish Civil War of 1936–39 was a human disaster: a million dead, a catalog of appalling atrocities, a bitter ravaged land and hundreds of the best minds in exile for the next thirty years. And yet it stood as a rallying cry for many people from all parts of the world, holding out for both right and left elusive hopes of a better tomorrow and a more united world. And in that spirit many were drawn to the battle lines, including in their numbers an astonishing array of artists and writers.

Spain had suffered from political instability for many years, and in 1931, in reaction against military dictatorship, had become a republic with a parliament elected by universal suffrage. But by 1936 the government – now composed of socialists, republicans and Communists – had lost control. In July 1936 a military revolt was started by General Franco, with support from the Falange, the Spanish Fascist party. They had expected little resistance, but the people were against them and civil war was inevitable. Military and economic intervention on the part of Hitler and Mussolini to help Franco, and of the Soviet Union on behalf of the Republicans, escalated the conflict, which rapidly took on the nature of a struggle to the death between Fascism and Communism – or between faith and godlessness. As World War I had been "the war to end all wars", the Spanish Civil War became for many "the last great cause". Writers, poets, painters from all over the world rallied to the Republican cause as members of the International Brigades, coordinated in Paris by the Soviet Communist party. Robert Jordan, the fictional hero of Ernest Hemingway's novel *For Whom the Bell Tolls* (1940), spoke for them all when he said: "If we win here we will win everywhere." The French novelist Georges Bernanos was in Majorca at the time. In *A Diary of My Times* (1938), his outraged account of the atrocities committed there, he described the war as the "pretext and alibi" for the war that was to come in Europe, a "foretaste of the tragedy of the Universe".

◀ A scene from the film *L'Espoir*, by André Malraux, 1939. At the outbreak of the Spanish Civil War, the French novelist organized a squadron to fight on the Republican side, and himself became a bomber-pilot in the International Brigade. In this scene a pilot being shot down brought out the entire local community in a display of solidarity which, Malraux stated, stretched from mountain-top to valley. Malraux survived the war and went on to work for the French Resistance during World War II.

▼ *Guernica* by Picasso, 1937. On 26 April, the German Condor Legion, testing its ability to destroy civilian targets, bombed this Basque town; 1600 people were killed. Picasso's painting universalized the horror of the event.

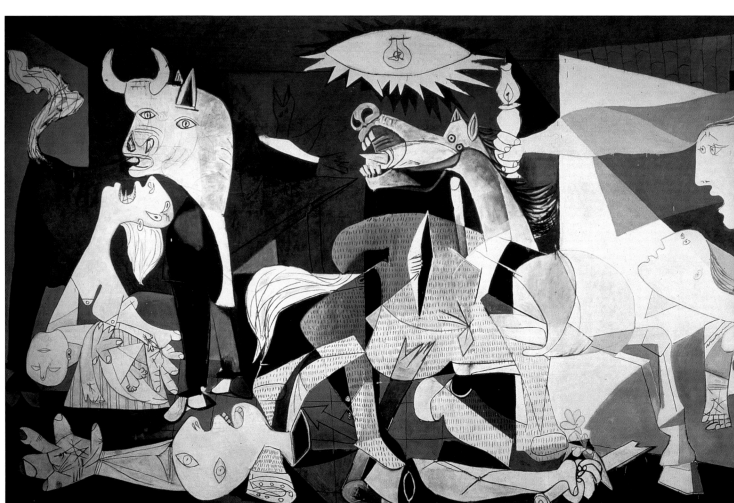

English poets who went to Spain included Stephen Spender, W.H. Auden, C. Day Lewis and John Cornford, who was killed there. They all supported the Republic, but Roy Campbell, poet, bullfighter and author of the long pro-Fascist poem *Flowering Rifle* (1939), fought for the rebels. The French novelist André Malraux was in the Republican Air Force; his novel *Days of Hope* (1938) graphically recorded the defense of Madrid. Many South Americans responded too. The great Chilian poet Pablo Neruda was ambassador to the Republic during the Civil War, when he wrote *Spain in the Heart* (1937). The Peruvian César Vallejo raised money for the Republic and wrote a sequence of poems that was printed behind the Republican lines in Catalonia, *Spain, Take Thou This Chalice From Me* (1938).

The English writer George Orwell, who was wounded in the war, documented the confusions of the left, their complex allegiances and "organized disorder", in the classic *Homage to Catalonia* (1938). His experiences in Spain also shaped his later *Animal Farm* (1945), a chilling fable of the perversion of dreams and decency by political force. The most brazen use of such force in Spain came from Hitler. It included the operations of the Condor Legion, Germany's crack aviation unit, which was to blast civilian targets to pieces in bombing raids. On 26 April 1937 it destroyed the Basque town of Guernica. Pablo Picasso commemorated the bombing in one of his most

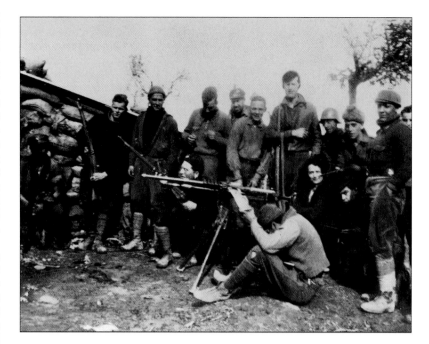

▲ The British novelist, George Orwell, on the Aragon Front in Huesca, March 1937. Many artists and liberal intellectuals joined the Communist-organized International Brigade. Orwell ended up in the POUM, a smaller organization.

famous paintings, simply called *Guernica*. He had earlier that year illustrated a pamphlet he wrote, *The Dream and the Lie of Franco*, with a series of horrific engravings of destruction and suffering. *Guernica* maintained that searing visual pressure. It was as stark and impassioned a response to inhumanity as anything this century, full of passion and inhumanity, has produced. And it was appropriate that it should come from the hand of a Spaniard, rather than from one of the many strangers drawn into the conflict.

As with the poets, so with the painters: the best of them were for the Republic. Like Picasso, the Spanish Surrealist Joan Miró supported the Republican cause, and produced work whose horror derived directly from the war. There was a spectacular output of posters, both educational and propagandist, from both sides, but again the more impressive examples, in a lively Socialist Realist style, were from the artists of the Republic. But when the war ended on 1 April 1939 and the count of dead, exiled and imprisoned was there for all to see, Spain was the heaviest loser. The death at the hands of the rebels of Federico García Lorca, one of Spain's finest poets ever, was the most grievous loss, but many other major writers were driven into exile, imprisoned or had their work banned. The immensely promising poet Miguel Hernandez died in prison in 1942. The list was enormous and the loss intellectually impoverishing – though by the same token the life of Latin America in particular was enriched.

A quest for meaning: Existentialist writers
In a century in which individual freedom had been so curtailed, so many cherished assumptions declared suspect, so many agonizing choices presented to men and women, and in which life itself had come to seem so overwhelming as to be without meaning, it was not surprising that a major philosophy should be built around exactly those conditions. Existentialism concerned itself with the reality of human freedom, the nature of what can be said to be "given"

The Spanish struggle is the fight of reaction against the people, against freedom. My whole life as an artist has been nothing more than a continuous struggle against reaction and the death of art. How could anybody think for a moment that I could be in agreement with reaction and death? When the rebellion began, the legally elected and democratic republican government of Spain appointed me director of the Prado Museum, a post which I immediately accepted. In the panel on which I am working which I shall call Guernica, and in all my recent works of art, I clearly express my abhorrence of the military caste which has sunk Spain in an ocean of pain and death.

PABLO PICASSO, 1937

and the necessity of choice, however impossible that choice might seem.

Existentialist ideas were not new. In the 17th century, the French mathematician Blaise Pascal had argued that religious faith involved unavoidable decisions taken in the face of unavoidable doubt: "God is or He is not: which side should we come down on?" The Danish 19th-century thinker Søren Kierkegaard saw the answer to that, beyond a reasoned balance of probabilities, as a "leap" of commitment. The German Martin Heidegger, who held a professorial chair of philosophy at Freiburg right through the Nazi period, saw people as "thrown" into existence, a "given" state beyond which decisions had to be made which either merged individuals into the crowd or led them to self-realization. It was from such ideas that Existentialism developed, and it became especially important in France during the 1930s and 1940s, when its leading ideas were propounded by Jean-Paul Sartre, who had studied under Heidegger. Albert Camus and Simone de Beauvoir were also major French Existentialist writers. Although Paris was the acknowledged center for Existentialist thought during these years, it was developed outside France too by

◄ The Egyptian desert, photographed by Lee Miller, the American photographer and companion of Man Ray. The window on a desolate landscape, combining claustrophobia with emptiness, expressed the Existentialist vision.

French Cinema in the 1930s

At the end of the 1920s the focus of imaginative filmmaking shifted from Germany to France, where it entered the 1930s in a blaze of Surrealism, encouraged by René Clair's inventive *Entr'acte* of 1924 (a work that involved Erik Satie, Marcel Duchamp and Man Ray) and by Jean Epstein's atmospheric *The Fall of the House of Usher* (1928). A galaxy of great French directors included Jean Renoir, son of the great Impressionist artist, Jean Vigo, Marcel Carné and Clair himself. The Spanish director Luis Buñuel was also working in Paris at the time. His films *Un Chien andalou* (1928; made in association with Salvador Dalí) and *L'Age d'or* (1930) challenged familiar notions of time and space. Bizarre images were presented as a form of assault upon the viewer. Those of a razor slashing an eye and of two dead donkeys draped over two grand pianos became justly famous. Among the central themes of his work were attacks on the Catholic church and middle-class values; these images recurred in his films up to the late 1970s. Interesting experimental work followed, notably in Jean Cocteau's *Blood of a Poet* (1930). This was the multi-talented artist's first film, and it was greeted with incomprehension at the time. Many of its themes reappeared in his later works such as *Beauty and the Beast* (1946) and *Orphée* (1950).

In the 1930s French film tended to settle into a smoother and more conventional representation of contemporary life – too smooth and conventional, later directors were to feel. Nevertheless, there was much wit and fantasy in Clair's *A nous la liberté* (1931), and evidence of a memorable personal vision in Jean Vigo's *Zéro de conduite* (1933) and *L'Atalante* (1934). The decade produced one undisputed master in Jean Renoir, whose *La Grande Illusion* (1937) and *La Régle du jeu* (1939) are classics by any standards. The former is set in a World War I prison camp in Germany, the latter in a French country house, but both explore the ways in which men and women manage to keep or break their promises,

and point out the dangerous charm, even the necessity, of maintaining fictions and lies from the past. Renoir's other notable films from the late 1930s were *La Bête humaine* (1938) and *Une Partie de campagne* (1936).

During the German occupation of France many of the French directors, including Renoir, and Clair, went to Hollywood, returning to France after the war. In the 1960s, the so-called New Wave of French film directors – Claude Chabrol, Jean-Luc Godard, Louis Malle, François Truffaut – were to reject both the gloss and the sentiment they found in the national cinema that had developed following this period. Instead, they sought to return to Renoir's concern for human subjects, though investing them with the new energies they found in the blossoming Hollywood genres.

▼ *La Grande Illusion*, by Jean Renoir, 1937. An anti-war film set in a German prison camp for officers in 1917, often considered one of the greatest films of all time. Renoir claimed the story was true, and certainly drew on his experience in the French air force in World War I. In this scene the prisoners perform a vaudeville routine in women's clothing.

▲ Jean Cocteau in his studio.
As well as poet and painter,
Jean Cocteau played social
gadfly to prewar Paris. In the
1920s he worked on ballets,
including *Antigone* (1922), on
which he collaborated with
Picasso and Coco Chanel. In
the 1930s he turned to film,
including the experimental
Blood of a Poet (1930) and
Beauty and the Beast (1946),
possibly his masterpiece.

*The chestnut tree's root
plunged into the ground,
just under my seat. I no
longer remembered that
it was a root. Words had
disappeared, and with
them the meaning of
things, their modes of
use, the faint landmarks
men have traced on their
surface. I was sitting, a
little hunched, head
down, alone before this
black knotty mass,
wholly insensate, and
which frightened me. And
then this enlightenment.
Never, up to the last few
days, had I guessed what
"to exist" meant.*

JEAN-PAUL SARTRE, *NAUSEA*
(1938)

writers such as Miguel de Unamuno in Spain, Nikolay Berdyayev in the Soviet Union and by the Germans Martin Buber and Karl Jaspers.

Sartre's view was that we are "given" our existential state and that our subsequent actions are the measure of our authenticity, of our being in good or bad faith, as he put it. Action has no meaning beyond itself in a meaningless world. The condition of the world is absurd and human beings are alienated from it, in a condition of "nausea" – the title of his major novel of 1938. In fact, just because it was concerned precisely with how people act or should act in a harrowing world, Existentialism lent itself readily to the concerns of fiction: the determination of human character by human choices, and the consequences, culpable or not, of human action. Novels and plays were therefore as valid ways of examining questions of meaning and responsibility as a philosophical treatise. It was the heroic dedication to useful action in a world shorn of meaning that characterized the philosophy, and these novels and plays emerged less as bodies of words than as actions in themselves. *Nausea* demonstrated the otherness of the world as Sartre's hero Roquentin confronted it. Sartre's plays, such as *The Flies* and *No Exit*, come across as vivid action even though ideas are central to them.

The outbreak of war made questions of human responsibility even more crucial. Simone de Beauvoir prefaced her novel of the French Resistance, *The Blood of Others* (1945), with a quotation from the Russian novelist Dostoyevski: "Each of us is responsible for everything and to every human being." Sartre, who worked with the French Resistance during the war, declared in his major philosophical work, *Being and Nothingness* (1943): "I am as profoundly responsible for the war as if I had myself declared it." In the novel *The Outsider* (1942), by the Algerian-born Albert Camus, the unemotional Meursault shoots an Arab and is condemned to death. In the uncannily clear and objective world of the novel, the whole world seems to come to a standstill under the Algerian sun, and it crosses Meursault's mind that "one might fire or not fire – and it would come to absolutely the same thing." This is the existential world, to live and die with the absurd or to wrench it into meaning by right action. In the real world of the 1930s and 1940s, with the specters of depression, repression and war never far away, it was a philosophy that held much intellectual appeal.

Writers of World War II

In World War I writing concentrated on the trenches and the stalemate of the Western Front. During World War II writing was more dispersed. The war was much more fluid, characterized by interminable waiting and lightning strikes rather than locked in stalemate. It was much more widely spread geographically, too, and because of the extensive bombing campaigns deep into enemy territory, the civilian populations were on a front line of their own. Equally, with the

▲ Henry Moore sketching in the London Underground. The terrible conditions which prevailed in London during the Blitz gave rise to his extraordinary series of drawings of sleepers, in which Londoners were portrayed as if caught up in a collective nightmare. The experience of recording the impact of the war on ordinary people had a subtle influence on Moore's work. Like the work of other artists caught up in documentation, his sculpture acquired a more popular basis in the postwar period.

tured by another English novelist, Olivia Manning, in her *The Balkan Trilogy* (1960, 1962, 1965), based on her experiences in Bucharest. The French playwright Jean Anouilh found a way of communicating the experience of living under occupation in his play based on Greek myth, *Antigone* (1945).

Poets and writers from as far afield as New Zealand and the United States were among those who produced work rooted in wartime experiences. Of the English poets who died in the war the most powerful was Keith Douglas, whose cool detachment from the deaths he saw was never to be mistaken for lack of feeling. Some of those who were not involved in the fighting, such as Stephen Spender, Edith Sitwell and Dylan Thomas, also wrote memorably of the war. In occupied and wartorn Europe, many writers and poets were part of their countries' Resistance movements.

From the French Resistance came writers such as the Existentialist Albert Camus, and the Surrealist poets René Char, Paul Eluard and Louis Aragon. Zbigniew Herbert wrote his first poems during the savage Nazi occupation of Poland, when he served in the Polish underground Resistance movement. The Italian writer Primo Levi survived Auschwitz to publish his particularly poignant memoir of his experience, *If This is a Man*, in 1947. Picasso's friend, the poet Max Jacob, died in a concentration camp. For many people all over the occupied world the free life of writing became symbolic of another possibility than the face of war. "What is poetry", asks the Polish writer Czeslaw Milosz, "which does not save/ Nation or people?" Exiles too, like the Greek Giorgos Seferis, were not exempt from the stresses of war. Seferis spoke of heroes "groping

occupation of large parts of Europe by German troops, whole populations, including their writers, had to decide whether to resist, acquiesce or collaborate. The concentration camps added another more appalling range of experience to Europe's misery. And the war in the Pacific brought the horrific potentiality of modern technology, first into the lives of Pacific islanders and then into the lives of the whole world when the destruction of Hiroshima and Nagasaki signaled the possibility of universal destruction.

In a war where there is such overlap between the everyday and the violent, the category "war writing" tends to lose its particularity. Much of T.S. Eliot's major spiritual poem *Four Quartets*, for example, was written between spells of firewatching on the London roof of the publishing house where he worked. The atmosphere of the war contributed some notable material to the poem, but more importantly, it led Eliot to the particular meditative form it takes, which seems to fit in with the rhythm dictated to his life by the circumstances of war. Similarly the atmosphere of suspicion and danger on all sides within the civilian population is not just the setting but almost the meaning of Graham Greene's novel of wartime London, *The Ministry of Fear* (1950). The sense of uncertainty and near panic of rumor-filled Romania at the outbreak of war was cap-

over our pain" as they howl, "we advance in the dark, we move forward in the dark". The final exile was death. The Hungarian Miklos Radnoti, near to the end of the war and his own death, wrote of a man, like himself on a forced march to the concentration camp, collapsed in a ditch, calling, "friend ... my friend ... don't go on ... shout at me and ... I'll get up."

Politics in the cabaret

Cabaret culture had flourished in Europe's major cities, particularly in Paris, Berlin and Vienna, since the turn of the century. Cabaret offered a sympathetic social setting to young artists at odds with Establishment culture, and evolved its own style, a curious blend of the sentimental and the satirical. Singers (or rather *diseuses*) such as Yvette Guilbert, angular and unconventionally attractive, ruled the small stages of the smoky clubs, singing sweet-sounding ballads with emotional sourness or political bite. Debussy, Milhaud, Satie and Schoenberg were all at one time attracted to the cabaret, and as the changing political environment inexorably limited freedom of expression, the "underground" nature of cabaret could give – at times not without risk – a home to the freethinking and the experimental.

The cabaret was one of the genres informing the work of the German playwright Bertolt Brecht, particularly in his collaborations with two fellow-Germans, composers Hanns Eisler and Kurt Weill. Brecht's ideas for an epic (ie objective) theater were both political and esthetic. His first collaboration with Weill had been the *Mahagonny Songspiel* (1927), a setting of five related poems. Three years later, after working together on *The Threepenny Opera*, *The Lindberg Flight* and *Happy End*, Brecht and Weill expanded the *Songspiel* into

a full-scale opera, *Rise and Fall of the City of Mahagonny*. Mahagonny itself is a capitalist symbol, in which pleasure is strictly related to the ability to pay. The various dubious characters who people the city are given music that is often both lyrical and catchy. Brecht was ambivalent about its effectiveness, however, feeling that he and Weill had not moved far enough from the attitudes of conventional opera, where the members of the audience are allowed the luxury of not following the implications of the stage action for their own lives.

One of Weill's most successful scores was for a later collaboration with Brecht. The Jewish composer had fled to Paris with little more than he stood up in after a Nazi-inspired campaign to have all his work banned in state-subsidized theaters. *The Seven Deadly Sins* (1933) is both song sequence and ballet score. The character of Anna is split into two: the hard-headed "good" Anna (who sings) has constantly to keep in check her soft-hearted "bad" sister (who dances). Conventional morality is stood on its head as the virtues are shown to be wasteful and uneconomic. Brecht's irony acquired a pungent, touching wistfulness as well as an occasional jokiness in Weill's realization.

Hanns Eisler had studied with Schoenberg and Webern, but he joined the German Communist party and broke with Schoenberg. When he met Brecht he was already seeking a way to use music to serve and change society. Between 1926 and 1933 he wrote many marching songs for leftwing groups, which were used throughout Europe. His tunes were straightforward and often in minor keys, which Eisler believed to be more threatening than the major. His first collaboration with Brecht was *The Measures Taken*, followed in

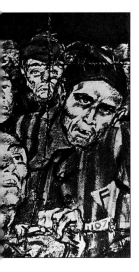

▲ *Behind Barbed Wire*, by Henri Pieck, drawn in Buchenwald concentration camp. Despite the risks and the insurmountable difficulties of getting materials, art persisted, and with it, the morale of the victims.

▼ *Europe after the Rain II* (1940–42) by Max Ernst. The painting was begun in Europe, then, with typical Surrealist nonchalance, wrapped in a parcel and posted to America. Ernst, by this time in exile, then completed the image. This muddy world, strewn with fragments of bodies and presided over by half-human soldiery, was a disconcertingly realistic portrait of Europe in the early 1940s.

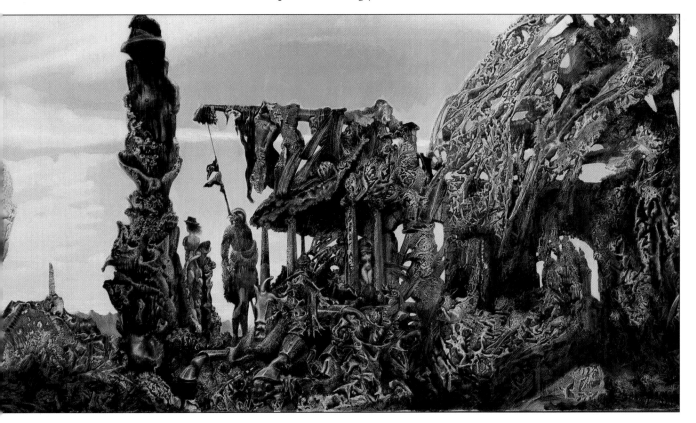

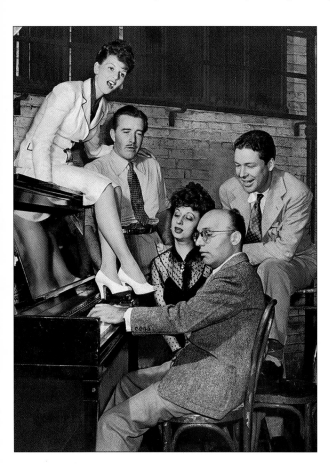

their art into the service of the state. Music was no exception. If it was to be acceptable to the authorities it had to ignore all the developments in compositional techniques that had happened since the turn of the century. Socialism under Stalin demanded optimism and aspiration. In creative terms this meant diatonic tonality and hummable soaring tunes.

In the 1920s, Dmitri Shostakovich had been closely allied with the experimental principles of composers such as Webern, Berg and Hindemith. By the time of the 1932 decree that brought music under state control, he had already completed a number of works including his satirical opera *The Nose* (1930), and was nearing completion of his second opera, *The Lady Macbeth of the Mtensk District*. *Lady Macbeth* did not fit Stalin's scheme

◄ **Kurt Weill rehearsing in America. Weill and his fellow German Bertolt Brecht were only two among a mass exodus of artists, writers, musicians who flooded America and New York in particular. As the situation in Europe became clear, more socialist and Jewish intellectuals arrived, galvanizing American culture. The exiles included Piet Mondrian, André Breton, and Salvador Dalí.**

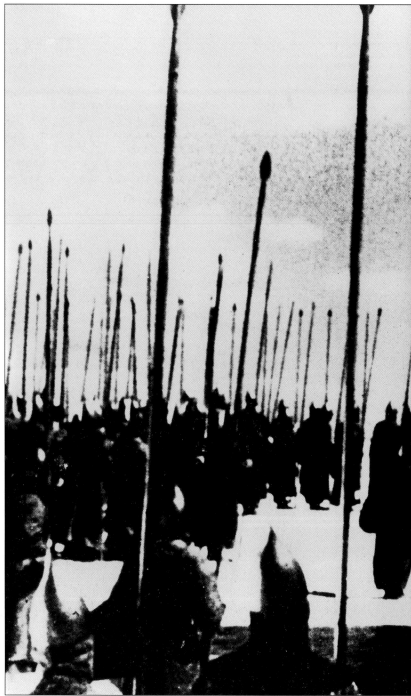

1931 by the Gorky adaptation, *The Mother*, which Brecht undertook in memory of Rosa Luxemburg. When Hitler came to power in 1933, Eisler's music was banned. There followed 15 years in exile and a series of highly political, anti-fascist works. Eisler collaborated with Brecht on *Round Heads and Pointed Heads*, and later, in the United States in 1945, on the montage of eyewitness accounts of Nazi persecution, *Fear and Misery in the Third Reich*.

Another German composer, Paul Hindemith, was also an early Brecht collaborator. He approached the pressures on the artist in a time of political repression in a different way. His opera *Mathis der Maler*, set at the time of the Peasants' Revolt in Germany, follows the inner debate of the German painter Matthias Grünewald as he decides to abandon his art and devote himself to political action, and his discovery of the futility of such a course. The opera is clearly personal; Hindemith wrote that Grünewald's experiences had "shattered his very soul". He too proved a target for the Nazis. His membership of an "international" group of atonal composers, the "immorality" of his operas and his "parody" of a favourite Nazi Bavarian military march inspired a personal attack by Goebbels at a 1934 rally. He lost his teaching position and his music was boycotted. In 1937 he left for Switzerland and in 1940 went to New York.

Writing to order: Russian music under Stalin

In parallel with Nazi persecution of artists whose views did not support those of the party, in the Soviet Union throughout the 1930s Stalin increased the pressure on artists of all kinds to put

of things. Although it was well received at its première in 1934, in 1936 Stalin saw a performance, and almost immediately afterwards it was denounced in a famous article in *Pravda* entitled "Chaos instead of Music" as being "fidgety, screaming, neurotic, coarse, primitive and vulgar". As a result of this officially sanctioned outburst, the Union of Soviet Composers convened a meeting to discuss the "correct" future for Soviet music. Composer after composer denounced Shostakovich.

He could have turned out some bombastic celebratory work to regain his position. Indeed his next major work, the Fifth Symphony, did restore his political fortunes, but it did so without artistic compromise. He had been pondering the question of tragedy in a socialist environment

(part of the complaint about *Lady Macbeth* was that it portrayed tragedy, which was of necessity pessimistic). Shostakovich saw this as a false connection: "I think Soviet tragedy has every right to exist. But the contents must be suffused with a positive inspiration, like, for instance, the life-affirming pathos of Shakespeare's tragedies." It was a wise analogy. The lyricism and final optimism of the symphony bore out his words, and probably saved him from one of Stalin's camps.

In June 1941 Hitler invaded the Soviet Union and Shostakovich was trapped in the siege of Leningrad, where he joined a firefighting squad. His Seventh Symphony, the "Leningrad", was the musical result of that 900 days. A microfilm score was flown to the United States and immediately taken up by the conductor Arturo

▼ A still from *Alexander Nevsky*, an epic film dealing with Russian national glory, made by Eisenstein in 1938. Prokofiev collaborated on the score. The partnership was resumed on the even larger-scale production *Ivan the Terrible*, released in two parts (1942 and 1945). Eisenstein's presentation of Russian history fulfilled a Soviet need for nationalistic solidarity in the face of Germany's aggression.

Writers under Totalitarianism

The relative freedom enjoyed by Soviet writers in the 1920s came to an abrupt end in 1929, when Stalin decided to bring both the peasantry and the intelligentsia under the total control of the Communist party. Through the militant Russian Association of Proletarian Writers (RAPP), a campaign of terror was unleashed aimed at breaking the will of those who opposed such control. Vladimir Mayakovsky was put under great pressure to join RAPP, and finally capitulated in February 1930, only to shoot himself in despair two months later. Evgeny Zamyatin, marked down as a scapegoat, managed to leave the country. His emigration together with Mayakovsky's suicide marked the end of creative freedom. In 1932 RAPP was replaced by an organization called the Union of Soviet Writers, membership of which was essential for anyone who wished to write professionally. At the First Congress of Soviet Writers in 1934, Andrey Zhdanov, Stalin's spokesman on cultural matters, announced a new policy of "Socialist Realism": literature was to be easily intelligible to ordinary people, to present positive heroes and happy endings, in order to affirm the existing order. By the late 1930s all Soviet literature was also required to contain glorification of Stalin. Not surprisingly, most writers of any stature gradually disappeared from the scene. Many hundreds were imprisoned, executed or exiled in the purges of 1936–38, among them Isaac Babel, Osip Mandelstam and the theater director Vsevolod Meyerhold. Only a few writers were fortunate enough to return from exile. Stalin himself affected a great interest in the arts, asserting that writers should be "engineers of human souls", and apparently chose to spare the lives of Boris Pasternak and Mikhail Bulgakov – though Bulgakov's masterpiece *The Master and Margarita*, written in the 1930s, was not published until 1966–67. Others too, such as Andrey Platonov and Anna Akhmatova, produced "underground" literature that was only published after Stalin's death.
World War II brought some relief, but in 1946 the expulsion of Akhmatova and Mikhail Zoshchenko from the Writers' Union signaled the bleak period known as the "Zhdanov era". The years from 1946 to Stalin's death in 1953 were to be the most sterile of all.

Toscanini. Its celebration of the Russian struggle against Nazism proved an ideal symbol of heroic resistance for the American public. His Eighth Symphony (1944) was more successful as an evocation of the horrors of war. The unavoidability of pain and the eternal desire for peace run through the work, and if the optimism called for by the authorities is present, then it is there in a very dark but also very truthful form.

Shostakovich's compatriot Sergey Prokofiev had spent much of his early life in Paris, with visits to the United States. Although he knew what the situation was like for composers in the Soviet Union, he decided in the early 1930s to return home. He was not a natural diplomat, and although he subscribed to the party line of making music appeal to everyone and including some didactic content, his work frequently did not meet with approval. His Sixth Symphony (1945–

47), much influenced by the war, showed none of the required optimism; and his opera *War and Peace*, based on Tolstoy's novel, had to be repeatedly revised and was not staged until after his death. In 1948 both men were again out of favor, accused of representing "the cult of atonality, dissonance and discord" and of demonstrating an "infatuation with confused, neurotic combinations which transform music into cacophony".

Music for film
By the end of World War II film music had come a long way from the days of a pianist or small instrumental ensemble tucked away in the cinema pit. The first major sound film was *The Jazz Singer* in 1927. The first film to have synchronized sound was Alfred Hitchcock's *Blackmail* (1929), closely followed in Germany by Josef von Sternberg's

It is the duty of the composer, like the poet, the sculptor, or the painter, to serve his fellow men, to beautify human life and point the way to a radiant future. Such is the immutable code of art as I see it.
SERGEY PROKOFIEV, 1946.

Ballet and Dance in Europe and the United States

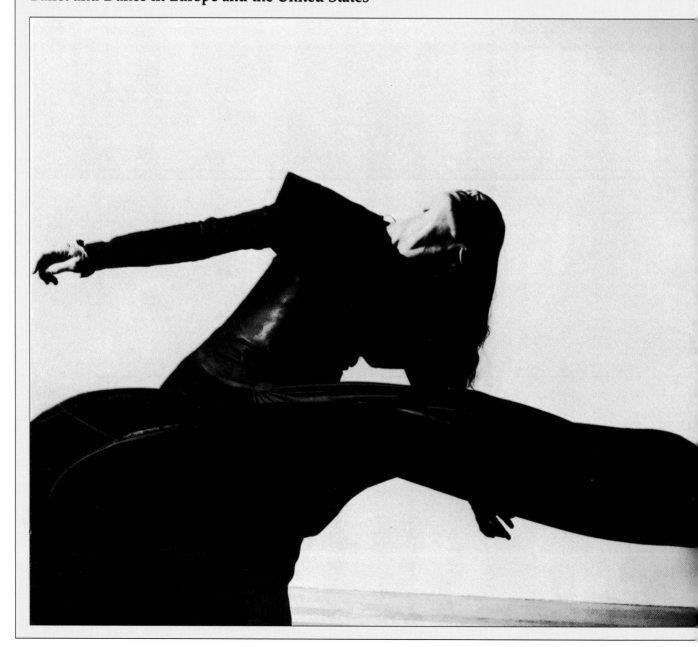

The Blue Angel, which had a score by Friedrich Hollaender. Gradually, both young and established composers began to involve themselves with film.

Writing music for film involves very precise timings. The demands on both composer and conductor are considerable. When working on documentary films in the mid-1930s, the young Benjamin Britten was renowned for his ability to cut to the precise length of soundtrack required by the final film, without leaving an obvious join – though he had reservations about the result being "music". For the film *Night Mail*, a collaboration with W.H. Auden, Britten was required to write "train noises". Britten's full score for the memorable sequence as the locomotive gets up a head of steam calls for steam (compressed air), sandpaper on slate, rail (small trolley), booms, aluminum drill, motor Moy (a hand-cranked,

► William Walton's music being recorded for Laurence Olivier's *Hamlet* in 1948. Walton had also written the score for Olivier's production of *Henry V*, one of the British cinema's major contributions to national wartime morale. The technical difficulties and theoretical questions underlying the writing of a film score appealed to a number of other British composers, including Benjamin Britten.

After Diaghilev's death in 1929, various rival attempts were made to recreate the glittering ambience of the *Ballets Russes*, but it was the brand new companies, which chose to shed the Russian image, that had greater long-term success. In Britain, Marie Rambert and Ninette de Valois set up their own schools and companies, determined to develop a distinctively British style of ballet. The small-scale Ballet Rambert was notable for encouraging the first British choreographers, Frederick Ashton and Anthony Tudor, while de Valois' Vic-Wells ballet was to become Britain's Royal Ballet in 1956. Ashton's restrained, lyrical style was in perfect accord with classical principles, while Margot Fonteyn, the company's leading ballerina, came to define the quintessential purity of the English style. American ballet was a much tougher, more extrovert affair. George Balanchine was invited to the United States in 1933 and founded first the School of American Ballet then the American Ballet, which in 1948 became New York City Ballet. Working with his own specially trained dancers, Balanchine developed the style that was to become the hallmark of American ballet – fast, long-limbed and dangerous, with jazzy inversions of academic steps and positions.

Modern dance emerged during the late 1920s and early 1930s as a systematized alternative to classical ballet. In Central Europe the prime initiator was Rudolf Laban, who set out to analyze all the expressive possibilities of the body, including the relation of movement to space and the connection between psychology and motion. His findings were put to powerful theatrical effect in the starkly expressive dances of his pupil Mary Wigman. In the United States the two great pioneers of modern dance were Martha Graham and Doris Humphreys, both of whom sought to make dance expressive of real emotion and relevant to the complexities of 20th-century life. Both women developed techniques which actively spurned the decorative virtuosity of academic ballet, using abrupt, extreme or contorted physical gestures to express extremes of emotion. Many of the principles of classical ballet were inverted to invest the body with new drama; and movements like crouches and falls made dramatic play of gravity.

◄ *War Theme* by Martha Graham (1941).

chain-operated camera), hammer, siren and coal falling down a shaft.

For feature films, styles of working could vary considerably. The composer might be brought in at very much the last moment to write a score to fit the edited film, or might be involved from the very beginning in a true collaboration. The Frenchman Georges Auric had a rather eccentric arrangement with Jean Cocteau for *Blood of a Poet* (1930). The music was composed and recorded without regard for the action. Cocteau would then edit by means of arbitrary cuts and *montage* effects, so that the music was as much raw material for his editing creativity as the film itself. Typical of the Hollywood way of working was Dimitri Tiomkin's contribution to Frank Capra's *Lost Horizon* (1937). Tiomkin provided a score to fit the rough cut, a version running some five hours. Thereafter music was trimmed along with film. Tiomkin wanted to express the film's tension between East and West in musical terms, so he used two main themes, a stylized and conventional love theme for the Westerners and a much looser, rhythmically indeterminate melody, with elements of timeless folksong, for the Shangri-La inhabitants.

In Russia, a near-seamless collaboration was achieved between Prokofiev and the director Sergei Eisenstein on the films *Alexander Nevsky* (1938) and *Ivan the Terrible* (1942). Nevsky was the perfect hero to please the Soviet authorities: a noble, brave 13th-century Russian leader. Each night Prokofiev would view the day's rushes with Eisenstein; in the morning the score for the scene would be delivered to the studio. "Prokofiev works like a clock", declared Eisenstein. Even Stalin was delighted by the result.

ART AND REALISM

Realism is not easily defined. It should mean "the portrayal of what is real". But this gives rise to questions of whether reality is what we see (or think we see); or the quality behind the appearance. Artists who have used the term "realism" have sought sometimes to capture surface appearances, and at other times to probe for an underlying, more fundamental reality.

The word is used by historians of art to describe a particular tendency in 19th-century art, focusing on the French painter Gustave Courbet and his followers, who painted scenes of everyday life (often the lives of peasants and ordinary townsfolk). In this case the subject was life as it really is, not some idealized version of it. And for writers too, the term "realism" has tended to be applied to a concern for the ordinary life of the streets, unsentimental and a bit bedraggled. In the 20th century this has often implied, for both writers and painters, urban subjects and a documentary style. In the United States the strongest tradition of painting, until World War II, was realist in manner, and presented in a way that was nationalist and expressive of the isolation of American culture and politics from the European mainstream.

Edward Hopper, who painted *New York Movie* in 1939, had been, early in his career, taught by Robert Henri, leading spirit of the Ashcan School. Hopper in some ways can be seen as a prime realist, painting lonely figures in lonely places, wastelands for the eye and the mind. But this is to see both Hopper and the realist tradition too simply. If we described *New York Movie* in these terms we would have a study of a lonely and pensive usherette in a half-full cinema. She is bored and waiting, not for more movie-goers but to go home. But this does not account for much else that is carefully included by the artist. The picture is centrally divided by a large column, ornate and fanciful on one side, squared on the other. The people in the cinema, their backs to us, look at a screen only partly visible to us, its squared nearer edge interrupted by the irregularly curved line of the three ceiling lights as they lead the eye away and out of the picture. On the other side of the picture, the usherette stands under a triple light and beside another point of exit, stairs to an implied outside world. She is absorbed, central to the scene but, in her mind, far away from it. And the scene is a movie-house, one of the palaces of the people which have fed the dreams of America and of the world in the 20th century. Realism is as much about dreams of what might be as it is about the daily grind. Hopper has used the fictional arena of the movie-house to show us these dreams as we are drawn away to the screen we scarcely see and to stairs we are yet to climb. "Life" and "reality" are enshrined in the head and pensive stance of the usherette who stands between two half-perceived worlds. If Hopper saw loneliness, it was a kind of love that made him see it.

▶ *New York Movie* (1939), by Edward Hopper.

Datafile

The arts in the East responded to European Modernism with less urgency than the American continent had done. But the work of poet-turned-painter Rabindranath Tagore brought a new sensibility to Indian art, based in his studies of Freudian theory. Ernest Fenollosa, an American living in Japan at the turn of the century, had a pervasive influence on that country's careful filtering of foreign trends. Not even Fenollosa, though, could have anticipated the fervor with which some Japanese intellectuals were to embrace Surrealism. Amrita Sher-Gil, who trained in Europe, returned to India to measure her acquired techniques against the pictorial demands of her own culture.

▼ Tsuguharu Foujita was perhaps a little ahead of his time in his approach to world culture. Settled in Europe for most of this period, he cultivated the popular press with an image that vies with that of modern "performance" artists. He wore his hair in what would become known as a Beatle cut, affecting the stereotypical Japanese outfit of pebble glasses and thin mustache. Despite this extravagant appearance, his art maintained a rather dry, impressionistic calm.

Nobel Prize for Literature

Year	Recipient
1929	Thomas Mann (Germany)
1930	Sinclair Lewis (USA)
1931	Erik A. Karlfeldt (Sweden)
1932	John Galsworthy (UK)
1933	Ivan A. Bunin (USSR)
1934	Luigi Pirandello (Italy)
1935	Reserved
1936	Eugene O'Neill (USA)
1937	Roger Martin Du Gard (France)
1938	Pearl Buck (USA)
1939	Frans E. Sillanpää (Finland)
1940	Reserved
1941	Reserved
1942	Reserved
1943	Reserved
1944	Johannes V. Jensen (Denmark)

Tsuguharu Foujita sales

Average price (thousand pounds)

1955–59 / 1960–64 / 1965–69 / 1970–74 / 1975–79 / 1980–84

▲ Nobel prizes began to show a political bias. The German Thomas Mann, who won in 1929 for *Buddenbrooks*, published in 1930 a novella, *Mario and the Magician*, which explored the fascist mentality. The American Pearl Buck won in 1938 "for her rich and truly epic descriptions of peasant life in China," a theme of increasing interest to the West. Ivan Bunin won the prize in 1933 "for the strict artistry with which he has carried on the classic Russian traditions in prose writing," while in exile.

▼ André Malraux's *La Condition humaine*, which won the Prix Goncourt in 1933, was a study of the struggle in China between Nationalist and Communist forces. He went on to serve in the Republican government during the Spanish Civil War. The US Pulitzer Prize was also for prose works. Both Margaret Mitchell's *Gone with the Wind*, and John Steinbeck's *The Grapes of Wrath*, are great, mythologizing works; while Steinbeck attacked the injustices of the "American way", Mitchell sanctioned them.

Major literary prizes

	Prix Goncourt	Pulitzer Prize for novels
1929	Marcel Arland *L'Ordre*	Julia Peterkin *Scarlet Sister Mary*
1930	Henri Fauconnier *Malaisie*	Oliver La Farge *Laughing Boy*
1931	Jean Fayard *Mai d'Amour*	Margaret Ayer Barnes *Years of Grace*
1932	Guy Mazeline *Les Loups*	Pearl Buck *The Good Earth*
1933	André Malraux *La Condition humaine*	T.S. Stribling *The Store*
1934	Roger Vercel *Capitaine Conan*	Caroline Miller *Lamb in His Bosom*
1935	Joseph Peyré *Sang et lumières*	Josephine Johnson *Now in November*
1936	M. van der Meersch *L'Empreinte du Dieu*	H.L. Davis *Honey in the Horn*
1937	Charles Plisnier *Faux passeports*	Margaret Mitchell *Gone with the Wind*
1938	Henri Troyat *L'Araignée*	J.P. Marquand *The Late George Apley*
1939	Philippe Hériat *Les Enfants gâtés*	Marjorie K. Rawlings *The Yearling*
1940	Francis Ambrière *Les grandes Vacances*	John Steinbeck *The Grapes of Wrath*
1941	Henri Pourrat *Vent de Mars*	No award
1942	Marc Bernard *Pareils à des Enfants*	Ellen Glasgow *In This Our Life*
1943	Marius Grout *Passage de l'Homme*	Upton Sinclair *Dragon's Teeth*
1944	Elsa Triolet *Le Premier accroc coûte 200 francs*	Martin Flavin *Journey in the Dark*

India has had a perennial fascination for the Western mind. This is in part to do with its sheer difference from Europe. Its kaleidoscopic vigor, its range of religion, type, climate and scene could never be generalized and yet the "idea" of India has always persisted, especially for English-speaking peoples, fueled by the image of the British Raj, as documented especially by Rudyard Kipling in the years around 1900. V.S. Naipaul, the Trinidadian writer of Indian descent, later said of that world: "India distorts and enlarges: with the Raj it enlarged what was already a fantasy."

The British had been in India since the middle of the 18th century, leaving the French and Portuguese with toeholds on the coast and gradually subduing this huge, ancient and culturally diverse subcontinent. Such possession of the country allowed them to impose on India their own views of the country, and not just in an administrative sense. Both within and outside the country, Europeans persisted in selecting meanings from India's variety of meanings and calling them "India". One recurring European perception of India was as a reservoir of religious values in a world denuded by Western materialism. The German writer Hermann Hesse, son of a missionary father, visited India in 1911 and wrote his novel *Siddhartha* from the knowledge he gained of the country. Based on the early life of the Buddha, the book has an eponymous hero who swings between religious austerity and indulgence before learning truth. Elsewhere Hesse spoke of wanting to show that beneath the world's variety there was a unity in which opposites like beauty and ugliness, sin and sanctity, are opposites only for a moment, and continually "pass over into each other"; this was the lesson of *Siddhartha*. All Hesse's writing, most notably *The Glass Bead Game* of 1943, was concerned with resolving such dualities. He found in India a version of himself, an image of his own preoccupations.

India could exemplify dualities outside a purely religious context too. The English writer E.M. Forster was similarly obsessed with opposites, though in social rather than religious terms. His greatest novel, *A Passage to India* (1924), was built around oppositions and misunderstandings. It is a fine and tense account of racial misunderstanding. The central misunderstandings in the story are between Muslim and English, and between both of these and Hindu. Beyond these misunderstandings at the level of incident and personality, there is an ambiguity of meaning at a deeper level. The everyday workings of law and order, friendship and good intentions, cannot deal with the doubt about ultimate meaning that India provokes. *A Passage to India* reflected a good

INTERACTIONS: ASIA AND EUROPE

deal of the diversity of India as it was moving towards its successful independence campaign, but it reflected even more clearly Forster's view of India as at one with the pattern that preoccupied him throughout his work, the need for relationship at the human level and the difficulty of achieving it. Once more, India became a symbol for the writer's own concerns.

By the turn of the century an Indian middle class educated by the British had discovered the richness of India's own cultural inheritance, paving the way for the independence movement that was eventually to achieve its goal in 1947. Mulk Raj Anand was born in Peshawar (now in Pakistan) in 1905 and educated at the universities of Punjab and London. After World War I he settled in Bombay. Written in English, his novel *Untouchable* (1935) describes a day in the life of Bhakya, a latrine cleaner and sweeper, lowest of the low in the strict Hindu social order. Written partly as an impassioned protest against the injustices of the Hindu caste system, the novel also adroitly presented a panorama of Indian society.

▼ The British novelist E.M. Forster (fifth from the left) in India in the 1920s. As British rule in India became less morally tenable, Kipling's picture of enlightened despotism gave way to more troubled visions, in Forster's *Passage to India* and George Orwell's *Burmese Days*.

Bhakya's view was inside and outside, none more so, at the same time. It was a mixture of passive acceptance and passionate rejection. Nor did the book propose any single solution, but canvased several. Mulk Raj Anand chose not to force either a solution or the impossibility of a solution – both unifying views – upon India. Instead he simply let a wide vista of Indian life and attitudes unfold and so left his country's multiple vigor intact. At the end, as a perhaps characteristically Indian touch, it is a poet who says that the flush toilet will solve Bhakya's problems, and by extension India's.

Indian painting

The tradition of painting, sculpture and the applied arts in the subcontinent of India is ancient and extremely varied. Characteristically India has absorbed foreign art forms rather than succumbed to them. European Modernism, like the art of the Moguls before it, has taken on an Indian aspect. Most of the leading features of modern painting – simplification, distortion, expression –

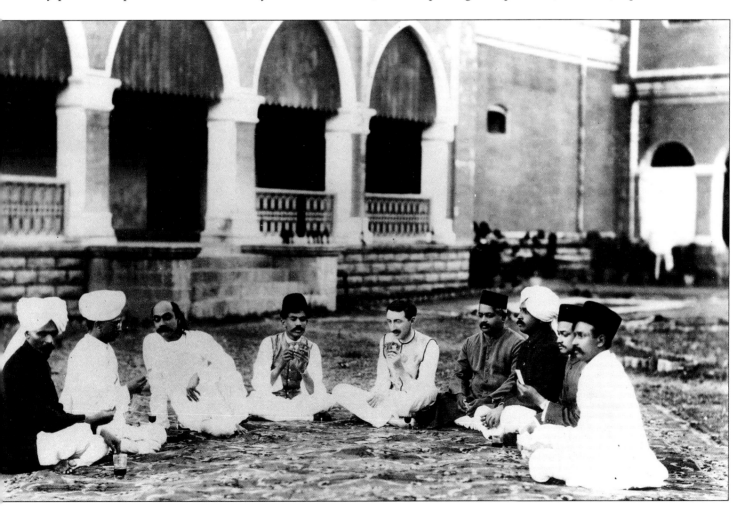

were all available within Indian tradition, and indeed practiced in popular painting if not in the art academies, which since the mid-19th century had been conducted on predominantly English lines. The English art educationalist E.B. Havell had attempted to "Indianize" academic methods following his appointment to the Calcutta School of Art in 1896, but he did so with a narrow view of what "Indian" might be. He chose to stress the spirituality rather than the range of Indian art.

The first painter to demonstrate the spiritual in painting in an original and modern way was not a product of Havell's Calcutta art school at all, but the elderly poet Rabindranath Tagore. Tagore was 67 and had already won the Nobel Prize for Literature when he took up painting in 1928. The only training he could claim was the sense of rhythm he arrived at in his poetry, which he simply transferred from the verbal to the pictorial line. However, the "line" that resulted in the paintings and drawings is not as romantic and singing as are his poems. It is as if a man of words had entered into the depths of expression that precede words. The contents of his paintings seemed often to be released from any control other than an instinctive sense of dramatic expression. A single, virtually continuous line, the silhouette of a peacock, separates the world and its green foliage from the blue and purple browns of the bird's body, into two complementary spaces. The bird's outline is like a flash of lightning dramatizing the world it stalks through. Tagore used the profiles of faces or the outlines of

bodies in this way to establish a conjunction of forms rather than provoke an opposition between them. This sense of a reconciled oppposition suggested a spiritual or even unconscious origin for much of Tagore's work. It invited symbolic interpretation, much like the work of the Surrealists or of the American artist Georgia O'Keeffe – though it was not the sort of spiritual image that Havell's encouragement to Indian artistic renewal would have expected.

But there were other ways for artists to reveal the vital life of India. This became the major concern of a young woman of mixed Hungarian-Indian parentage, Amrita Sher-Gil. Before she died in 1941, aged only 29, she had at least fulfilled her wish to produce "an art connected with the soil". Trained in Paris, she was deeply struck by the methods of Paul Gauguin. She saw how she could use them to portray life in the villages of India, where Indian nationalists were seeking a sense of the uniqueness of their country. In the mid-1930s Sher-Gil painted some remarkable pictures of villagers and hill people, which are striking for their melancholy dignity. The simplified forms were as much a part of Indian traditions of representation as they were suggestive of Gauguin's paintings of Pacific islanders. A year before she died Sher-Gil painted *The Ancient Story-Teller*. The intimate group of figures, somber and as ageless as the stories they listen to, is set in a foreground darkness. Behind it are white Indian walls with half-openings leading to a mysterious dome. The mystery is not

▼ *Brahmacharis*, by Amrita Sher-Gil. Sher-Gil epitomized the cross-fertilization which was taking place between Europe and India as it moved toward independence. She was born in Hungary, trained in Paris, and applied Post-Impressionist techniques to traditional Indian subjects. This involved a rethinking of the principles behind such painting. Whereas Gauguin's Tahitians might still be regarded as idealized noble savages, Sher-Gil's Indians already and indisputably possessed an artistic heritage. Their traditional vocabulary of significant gesture and expression was therefore simplified and revitalized by her Western techniques. By the time of her early death in 1941, she had established a means by which the two cultures could look at themselves and each other as equals.

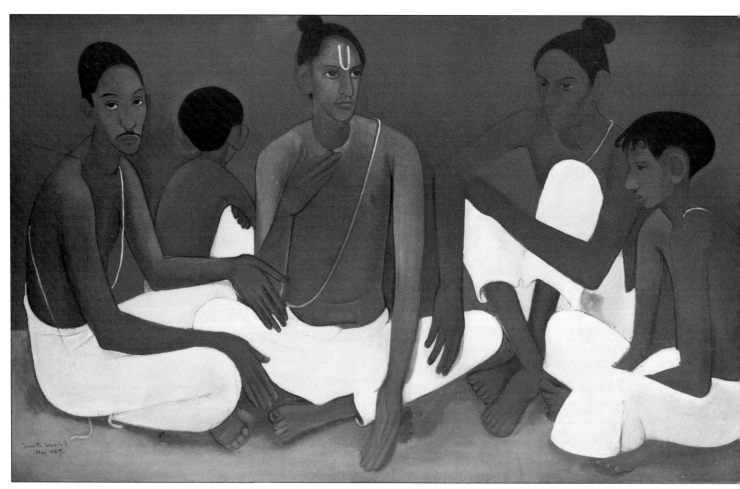

The Revival of Indian Dance

It was the performer and choreographer Ram Gopal who brought real popularity to Indian dance, after an extended period of neglect, both in his own country and in the West.

Against his father's wishes, Gopal disdained a "respectable" legal career in favor of dance training. He studied the grueling dance-drama form Kathakali in Kerala, and then sought out gurus to teach him the other great forms, like Bharat Natyam from southern India. Although he did not undergo the long training demanded by purists, he opened his own school in 1935 and the beauty and charisma he displayed as a performer won audiences for dance all over India. He first visited London in 1939, where he not only became an exotic cult but over three decades helped to develop an awareness of the sophistication of his art. This in turn prepared the ground for a later generation of British-based Indian dancers who in the 1970s and 1980s were to build an informed public for themselves and to explore possible connections between Indian classicism and the techniques of modern Western dance.

▶ **Ram Gopal dancing.**

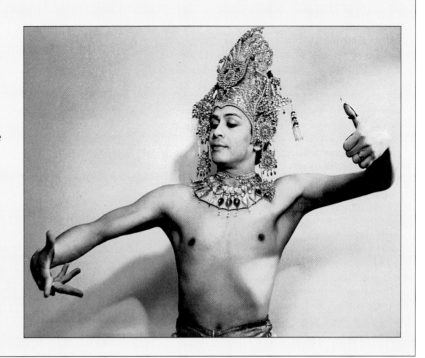

exotic, though, or given alien meanings. It is Indian everyday life transfigured, much in the way that Marc Chagall had understood and portrayed his home town of Vitebsk in Russia.

Another way of looking at the village was demonstrated by Jamini Roy. Where Sher-Gil seemed somber, Roy touched the hieratic Indian dignity with humor, not to satirize it but to relish it. He found his style by developing elements in the paintings sold around the Kalighat temple in Calcutta and from the art practiced by wandering minstrels who painted scrolls to illustrate their songs. His figures were often repeated as in friezes and fixed the viewer with an enigmatic frontal concentration. They were outlined in lampblack and usually painted in Indian natural colors made from vegetable and earth dyes. His motifs too – animals, gods, goddesses and holy men – were traditional to village art. As well as this, although he was not a Christian, Roy painted some impressive Christ figures, concentrating attention on the victimized man who has mysteriously overcome suffering. His use of this central Christian icon was reminiscent of the bold extension of a traditional Christian view that José Clemente Orozco had made in Mexico. Roy's firm outlines took on an additional excitement in some of his swift sketches of dancers or animals, becoming more statuesque in his fully worked paintings.

In these artists the new forms of modern Western art met a revived Indian tradition and generated an instantaneous strength within a culture attuned to visual expression and receptive to outside influences, but with its own massive resources on which to draw.

Music and dance in Southeast Asia

By the beginning of the 20th century the combination of British rule and Indian neglect had resulted in the rich and sacred traditions of Indian dance falling into decay. Many of the original temple dances were appropriated by prostitutes and the few teachers and performers who understood the subtleties of their art were tucked away in rich households. Most public performances, such as those witnessed by the Russian dancer Anna Pavlova on a visit in 1923, were Europeanized kitsch of the worst kind. Pavlova helped to kindle Western interest in Indian dance with the semi-authentic duet *Krishna and Radha* that she performed with a young Indian, Uday Shankar, who went on to win a worldwide reputation as a dancer. The position of Indian dance was later consolidated both in India and in the West through the efforts of the dancer and choreographer Ram Gopal, who devoted most of his life to this task, and was feted internationally, although some belittled his work.

▼ *Krishna and Balarama*, by Jamini Roy. Another "crossover" artist, Roy was more traditional than Sher-Gil in his technique. However he brought a modern sensibility to ancient subject matter, transferring the techniques of temple art and folk painting into his studio with Modernist detachment. This gave his work a vitality and humor that underlined his commitment to Indian art and its spiritual resources.

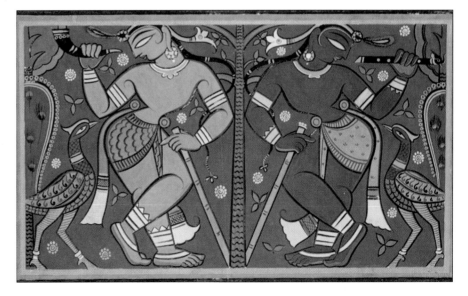

Just as Pavlova became fascinated by Indian dance, so a Canadian composer and ethnomusicologist, Colin McPhee, found himself intrigued and inspired by the extraordinary sound of the Balinese orchestra, the gamelan. He first visited the island of Bali in 1931, and was so captivated that he spent two years living in Bali, studying with a local composer, I Lotring. He made a further visit between 1936 and 1938 to transcribe the music he heard and to learn the performance styles and techniques that were so alien to contemporary Western music.

McPhee was not the first Western composer to be fascinated by the gamelan orchestra: Debussy had been enthralled by the Javanese ensemble in the 1889 Paris Exhibition and Messiaen was thrilled by the sounds of the Balinese instrumentalists at the 1931 Exposition Coloniale.

To Western ears the gamelan has a jangly, percussive quality, full of bright resonance, blurring together into circles of shimmering sound. The instruments are made out of bronze, iron, wood and bamboo and the orchestra may comprise any combination of gongs, metallophones, xylophones, drums, cymbals and some stringed or woodwind instruments as well as the human voice. Of the two distinct types, the Balinese is the more energetic and brilliant, with frequent sharp contrasts of tempo and dynamic, and a respect for virtuoso solo playing. The Javanese gamelan is markedly more tranquil. McPhee described it as having "an incredibly soft, *legato*, velvet sound; the hammers and mallets that are used to strike the metallophones and gongs are padded so thickly as to eliminate all shock. Tempos are slow and stately, and there is little change in dynamics; the prevailing mood is one of untroubled calm and mystic serenity." Balinese

▲ *Portrait of Tagore*, by Xu Beihong. A distinguished traditionalist who nonetheless studied in Paris, Xu (1895–1953) was a revolutionary painter politically as well in technique. His early experiments settled down into a personal, expressive style which absorbed Western influences without being overwhelmed by them. His popular series of ink drawings of horses typifies this mature position. The portrait of Tagore was one result of a lecture series the poet invited him to give in India in 1938.

music, on the other hand, was "turbulent and dramatic, filled with contrast and bold effects", "vigorous, rhythmic, explosive in quality; the gamelan sound bright and percussive; hard hammers of wood or horn are used for many instruments, and the thin clash of cymbals underlies every tone; only the great gongs are gently struck." There is no standard tuning and orchestras are tuned within themselves. Pieces are controlled by the gong and the drum. All the instruments may play simultaneously in free heterophony, each instrument making the melody its own in its own terms. Traditionally the gamelan has been used to accompany religious rites, dances and dance dramas, and because of their religious significance the instruments are treated with great solemnity. It is forbidden to walk across them and offerings of incense are made before a performance.

The French composer Olivier Messiaen was able to listen to the Balinese instrumentalists in Paris in 1931 at a particularly crucial time in his career. During the 1930s Messiaen was developing new compositional techniques, and this involved the development of a non-Western attitude to composition. For Messiaen, the static had as much fascination as the dynamic; music does not have to change and develop, but can be circuitous and static. His interest in the East ran deep, and his discovery of the 120 ancient Indian rhythms itemized in a 13th-century treatise, with their ametricality, was another step away from traditional Western composition. Many of his works from this period examined time and human experience of time. For instance, in his *Trois petites liturgies de la Présence Divine*, written

◀ *Head of a Woman*, by Rabindranath Tagore (1861–1941). The Indian poet and Nobel Laureate took up painting late in life, possibly in response to Freudian theory, certainly under the influence of Paul Klee. His interest in chance and the unconscious bypassed the traditional Indian art education with its emphasis on technique and theme, heralding a rejuvenation of both.

in 1944 for women's voices, piano, ondes Martenot (an early form of synthesizer), celesta, vibraphone, percussion and strings, the lives of man and planet, mountain and insect, are contrasted and united as one.

Art and literature in China

China has had as turbulent a 20th-century history as anywhere in the world. Revolution in 1911 ended the reign of the Manchu dynasty, but from then until the declaration of the People's Republic under Mao Zedong in 1949, there was constant war to establish or maintain government against factions, powerful warlords, coups, conspiracy or the Japanese invaders. Whoever was in power, the burden fell hardest where it had always fallen, on the peasants. It was indeed the Chinese Communist party's zeal on behalf of the peasants that eventually consolidated the mass of the country in its favor and gave it the military depth to sustain guerrilla war both behind enemy lines in the Sino-Japanese War of 1937–45 and in the civil war against Jiang Jieshi (1945–49). This attention to a new power base brought changes in the arts too, which, with an enormous heritage behind them, were at the beginning of the century the property of an elite of scholars, aristocrats and bureaucrats, as traditionally they always had been. There was, for example, a literary language totally inaccessible to most people. But following reforms forced in the final Manchu years there had been a vast,

though mainly urban, spread in education. The New Culture Movement (1919), centered on Peking (now Beijing) University, succeeded in bringing the vernacular into use as a literary medium.

In painting too, though traditional forms were very much to the fore, there was also influence from Europe, often coming through Japan. Chinese painting was traditionally aimed at seizing the spiritual intensity waiting behind the appearance of things. Landscape was the favored subject and the ways of painting it were laid down in pattern books built up from the best practice over the centuries. With the traditions totally under control and ready to use, the artist sought to record the sublime moment which transcended them. It was a highly symbolic art, generalized and abstract in its means, sweeping in its ink-brush lines and subtle in its watercolor atmospheres. The modes of Western 20th-century art, characteristically abstract and symbolic, should have been immediately sympathetic; but politics intervened and the Western elements that were absorbed into Chinese painting were from the Realist tradition, an art felt to be accessible to the people.

Sometimes there was a deflection of traditional means toward an Expressionist method, as in some of the work of the versatile Xu Beihong, or a Fauve-like attention to color, as appears in Lin Feng-mien; both had studied in Paris in the 1920s. Nothing quite caught on, but as artists

.... Beautiful speech is common to all mankind in spite of its diversified enunciation. By means of his rhythmic lines and colors, the Chinese art master Xu Beihong provides us with our forgotten scenes of antiquity without impairing the local flavor and peculiar style acquired through his own experience.

RABINDRANATH TAGORE, 1940

▼ *Flood of Wrath* by Li Hua. This woodcut depicts a curiously brutish Chinese peasantry resisting the invading Japanese. The Nationalists and Communists had united against their common enemy by the late 1930s. Work like this covered up the political gaps as well as stirring up support.

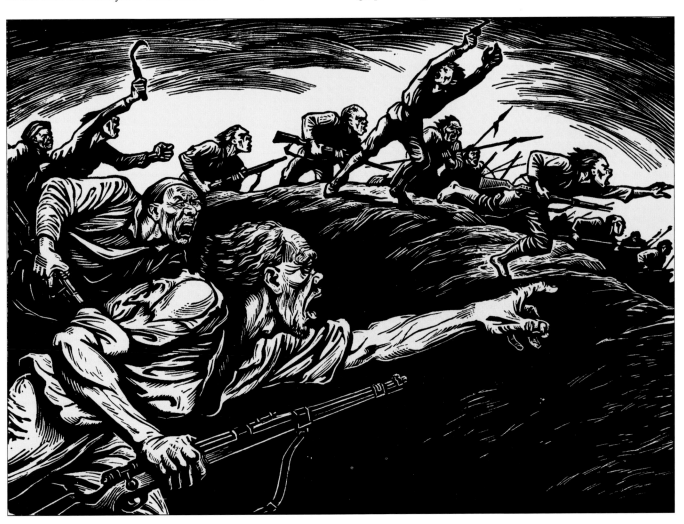

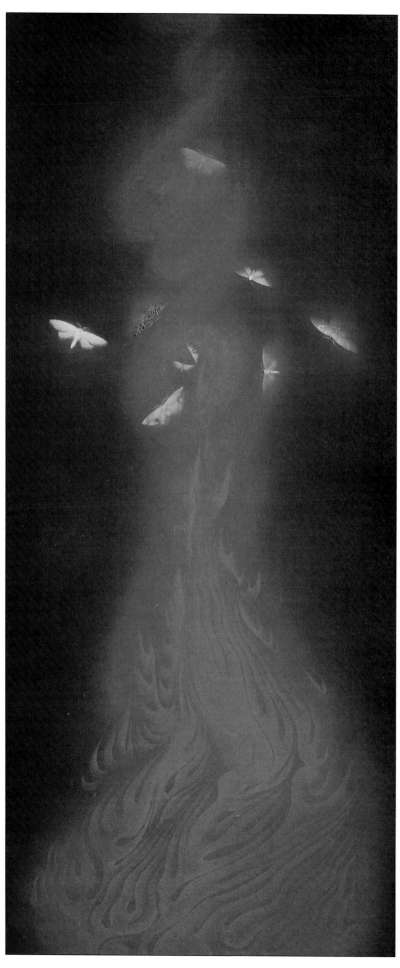

pushed into western China from the wartorn eastern lands, so a new subject area opened up. The French-trained Pang Xun-qin produced exquisite accounts of traditional dress which are at the same time beautifully composed pictures. It is in the woodcut, though, that the influence of the West showed most clearly. Here was a traditional form, cheap to reproduce and capable of striking effects. The work was overwhelmingly Realist and political in intention. The work of the German artist Käthe Kollwitz, who had depicted the poverty of Weimar Germany was an important influence. Li Hua's work illustrates the moving power that was often achieved in the woodcut.

Realism dominated fiction too, as in Mao Tun's novel *Midnight* (1933) or Ba Jin's trilogy *Torrent* (1933–40). There were some striking short stories which, while propagandist, often incorporated elements from older popular Chinese tradition. Xu Dishan's *Blossoms on a Dried Poplar*, for example, a story of loss and reunion, seems at moments like a medieval romance. The close link between the sentimental and Realism was often clear, as in Wang Tong-zhao's *The Child at the Lakeside*. Such writing cannot be dismissed as being less subtle than the Western psychological mode. Its wellsprings were different, born in the disruptions of war and revolution and existing for the people. A striking feature of much of this writing is that, although it was telling the story of a particular moment in history, its feelings of loss and desperation, its relishing of small consolations, seem timeless, the story of all oppressions. The most interesting Western insight into revolutionary China was André Malraux's *La Condition humaine* (1933), which detailed the conflict between Jiang Jieshi and the Communists in the late 1920s. It was a major political novel, swift and exciting in the telling.

Japanese arts in transition

The arts in 20th-century Japan, in common with the whole of Japanese culture, have evolved in a vexed if often eager relationship with the West. Japanese poetry, traditionally cast in brief syllabic forms, taught its methods to the West and gave more than it received. Drama absorbed some of the methods and subjects of Western realism, to the detriment of traditional Japanese forms. Here again the West was the debtor, gaining a stylized symbolic mode from the ancient but still current Noh theater.

The modern novel showed the strongest development and from Futabatei Shimei on there had been a steady stream of able writers. So fast was Japan's transition from feudal state to industrialized society, and from isolation to world power, that the lonely alienated hero, out of tune with society, and driven either to inert indifference or paralyzed despair, dominated writing in Japan earlier than anywhere else, as if Japan were the testing ground for the world's malaise. At its least tormented, this feeling of being at odds with the modern world registered itself as nostalgia for the old Japan, as in the work of Nagai Kafu, with its memories of Tokyo summoned up by prostitutes, the remnants of the Geisha world of the past. A whole succession of novelists used relationships

► Foujita on the beach, "sketching" the singer Suzy Solidor. Tsuguharu Foujita enchanted Western gossip journalists throughout the 1920s. But he was also absorbing the influence of Expressionism. In the 1930s, his work began to readmit Japanese techniques through this European filter.

◄ *Flame Dance*, by Gyoshu Hayami, 1939. Surrealism had a profound if subtle effect on a number of Japanese artists in the 1930s, despite the repressive reactions of the authorities. Shuzo Takiguchi, a leading poet and theorist, was actually imprisoned for "Surrealism" in 1941.

▲ *Women with Hawk*, by Munakata Shiko. Munakata (1903–75) was one of Japan's most dynamic printmakers. Influenced strongly by German Expressionism, he brought a Zen temperament to their raw technique. His images express a vibrancy which seems to be part of the nature of things, rather than due to the emotions of the artist.

► Shoji Hamada with the British potters Bernard and Janet Leach. From the 1920s until his death in 1978, Hamada maintained links with British potters, allowing a remarkable cross-fertilization to take place. The Leach family absorbed what he had to teach about Japanese, Korean and Chinese techniques. He admitted into his own work aspects of medieval European styles and techniques. Both cultures profited.

with women to define their displacement. This characteristically erotic and yet clinical approach extended the psychological novel beyond the mental complexities of Henry James to anticipate the concern with sexuality in Western writing of the 1960s. Tanizaki Junichiro is the most compelling of these novelists.

As the xenophobic elements in Japanese society took the political initiative in the 1930s, leading the country into the Sino-Japanese war and eventually into World War II, so Tanizaki countered its very modern strivings modeled on the West by invoking the cultural ambience of Japan, mirrored in its women, in *Some Prefer Nettles* (1928), then in *Ashikari* and the *Story of Shunkin* (1936), in *The Makioka Sisters* (1943–48) and in his translations from the medieval *Tale of Genji*. Another writer in a similar vein was Kawabata Yasunari, who won the Nobel Prize for literature in 1968. He was influenced in part by the discontinuous methods of European Dada and Surrealist writing in his novel *The Izu Dancer* (1925), but such abrupt changes and apparent incongruity had also been part of Japanese technique as far back as the 15th century.

The painters were similarly perplexed by the depth of the Japanese tradition and the intruding attractions of the West. Paradoxically enough, it had been the American Ernest Fenollosa (1853–1908) who, while in Tokyo, had warned against over-diluting Japanese styles in imitation of the West. The style that developed from his promptings was termed Nihonga. It fused Western color and contrast with firm Japanese brushline. The manner of these paintings is often quiet, using

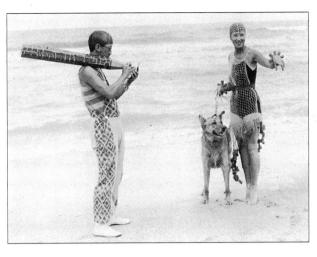

subtly suffused colors as in the work of Kobayashi Kokei. Maeda Seison painted with more powerful colors and a firmly disposed line, as in his *Poppies* (1930), red, white and green on gold in a magnificent horizontal sweep. He also used an old Japanese technique of painting additional colors on top of an earlier one before it had dried to achieve a visual softness. A notable painter who more fully absorbed Western styles was Tsuguharu Foujita, sometimes known as Leonard (after Leonardo da Vinci) Foujita. He had gone to Paris in 1913, and although he was in Japan during World War II he normally lived in France. In Paris he became associated with Marc Chagall and Amedeo Modigliani and painted first in an Expressionist manner, gradually in the 1930s reintroducing a more Japanese feel into his work.

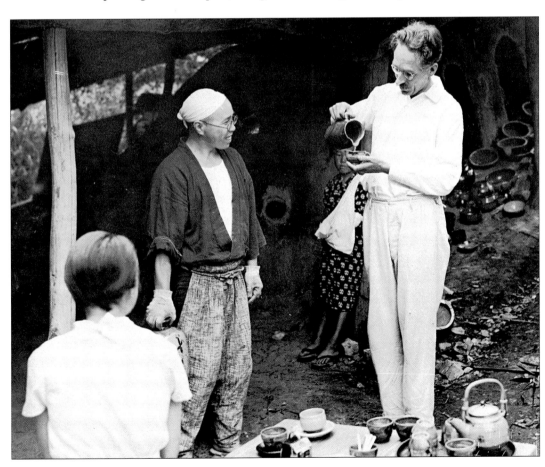

ART AND NATURE

"For the artist communication with nature remains the most essential condition. The artist is human; himself nature; part of nature within natural space," wrote the Swiss painter and Bauhaus teacher Paul Klee in 1923. Klee deduced all artistic procedures from some pre-existent aspect of nature or human action in nature – movement of water, the articulation of muscles, the spin of the top. His attitude to the natural world was one of attentive humility; he felt that, as an artist, he must return to the actual moment of creation of his subject. He found this by looking deeply into the dynamics of its structure and thus participating in it.

The connection between art and nature has clearly always been intimate. Cézanne derived his crucial ideas about underlying structures, which were to shape the course of painting in this century, from contemplating natural landscape form. And before him the Impressionists had painted "*en plein air*" – in the open air, rather than in the studio – directing attention not to the human being as part of nature, nor to art as a separate language, but to nature itself. Architecture has characteristically not simply imposed itself on a landscape but accommodated itself to it. At times this has been a structural and strategic consideration, building the settlement where the river could be forded or bridged, building on rock rather than sand. But added to these practicalities have been esthetic ideas, conforming the lines of buildings to contours and blending the materials used with those that are dominant in the landscape.

But the relationship of art to nature is not a simple one. The British abstract painter Patrick Heron drew attention to this in a phrase, "the unnatural image which is art". "Art" and "artifice" are related words and although art may exist in relationship with nature, it inevitably distorts it, however faithful the artist tries to be to nature. In philosophical discussion the problem is as old as Plato and Aristotle and is bound up with the question of whether or not art was an imitation of nature. The English Elizabethan playwright Robert Greene wrote, "Painted eagles are not eagles", and insofar as art and nature were not the same, it seemed possible in the 16th century that the two were rivals, with man asserting dominion over a natural world that had been created specifically to serve him. The issue, though no longer expressed in these terms, still persists. Even some "earth artists" in the 1970s have been interventionist and assertive, rather than, as Klee would suggest, acting as "part of nature within natural space". And earlier in the century, Art Nouveau's exploitation of natural forms as design elements seemed to be more part of a world of elegant sophistication than a true celebration of nature.

Nevertheless the bond is close. Even abstract and surreal art, whatever sources their creators may have claimed to tap in the unconscious or in the realm of ideas, usually seem to echo forms somewhere pre-existent in the natural world.

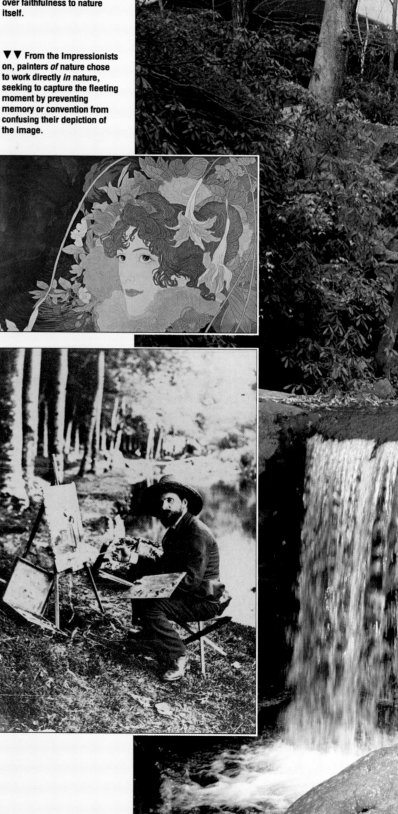

▼ Drawing in the Art Nouveau style by Georges de Feure, a Javanese-born French designer. His work typified much of the idealization of nature (and womanhood) in art at the turn of the century; in many cases the requirements of the design took supremacy over faithfulness to nature itself.

▼▼ From the Impressionists on, painters *of* nature chose to work directly *in* nature, seeking to capture the fleeting moment by preventing memory or convention from confusing their depiction of the image.

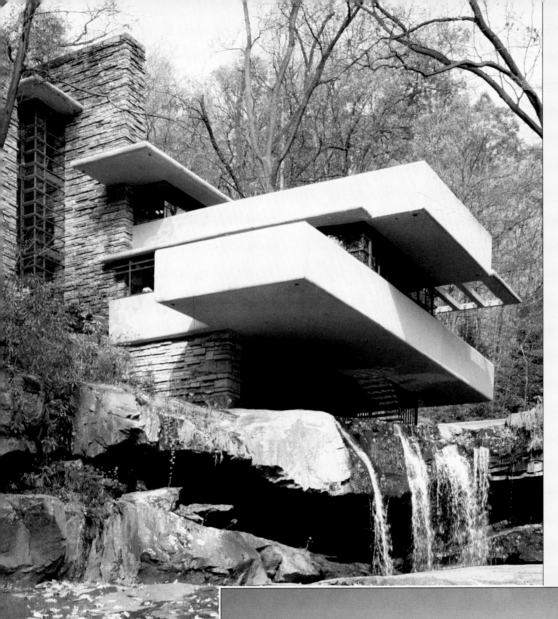

◀ Frank Lloyd Wright built *Falling Water*, in Pennsylvania, in 1936–37, as a classic example of a form of architecture that combined the modernist esthetic with a sensitivity to the natural setting. His prairie houses, with long, sweeping planes, were widely imitated. Here he reveals the influence of Japanese design on his work; it was structurally bold, with the floors cantilevered over the waterfall.

▼ *Spiral Jetty* (1970), a sculpture made in Great Salt Lake, Utah, by the American Robert Smithson, was one of the most notable works of "land art", in which the artist uses nature itself as both setting and material for his work. In this case the spiral evokes natural forms of growth, subverting the concept of "jetty", which is normally a straight, non-natural object.

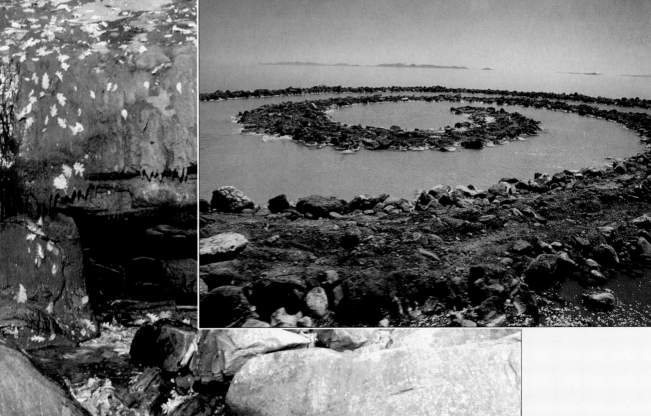

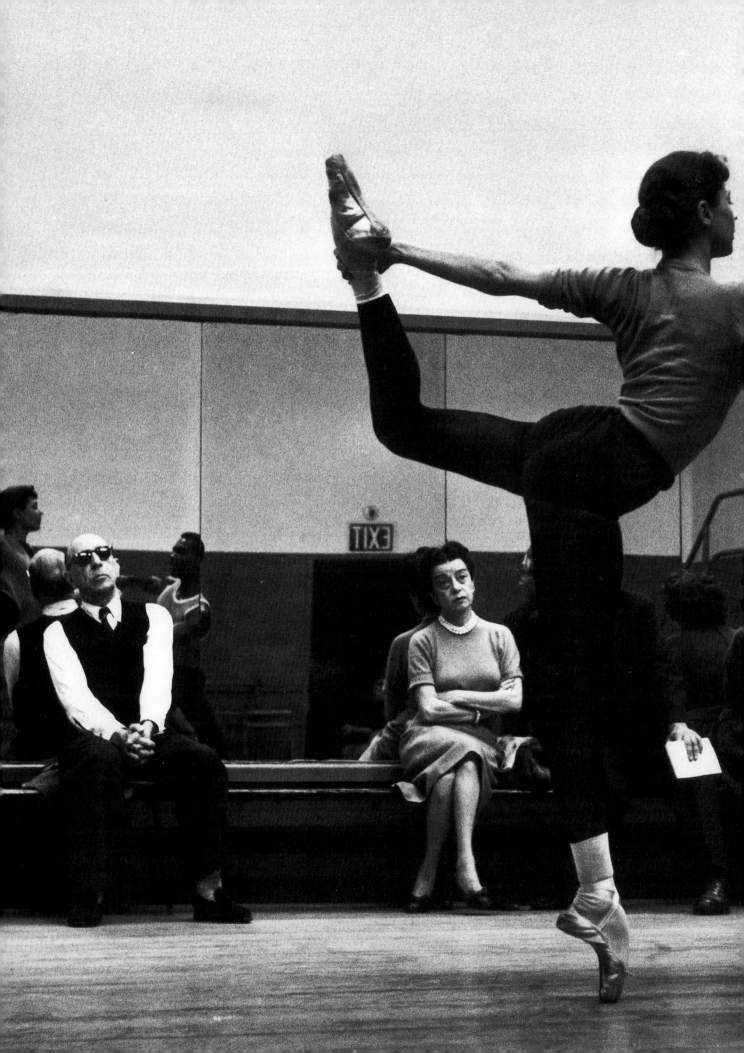

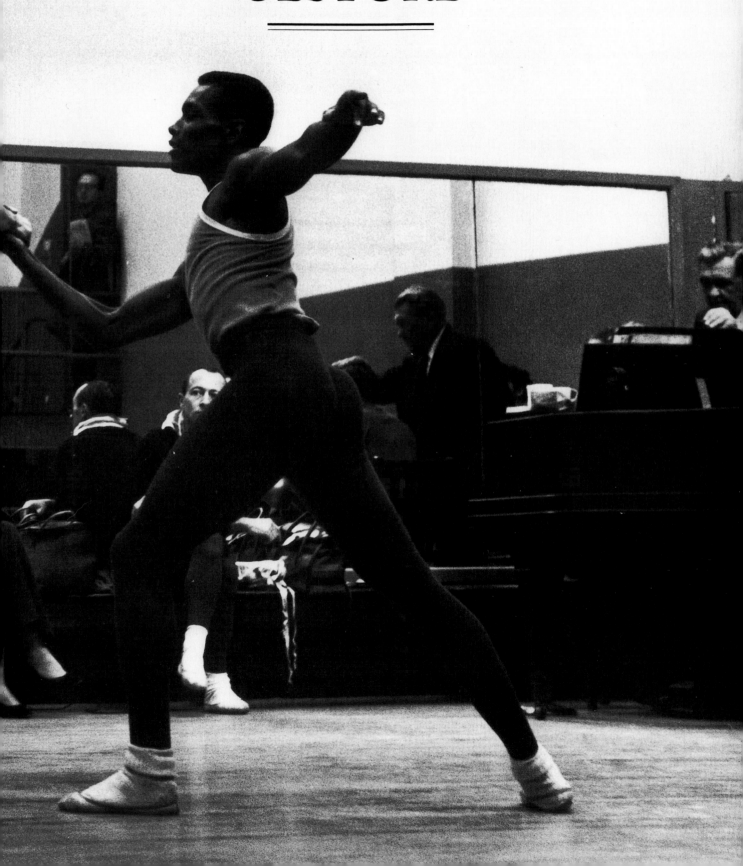

Time Chart

	1946	1947	1948	1949	1950	1951	1952	1953
Visual Arts	• Roberto Matta: *Being With*, painting (USA) • Hans Hofmann: *Immolation*, painting (USA) • Wols: *The Blue Pomegranate*, painting (Ger)	• Jackson Pollock develops his "drip painting" technique, beginning with *Full Fathom Five* (USA) • Marino Marini: *Cavaliere*, sculpture (It) • Arshile Gorky: *The Betrothal II*, painting (USA)	• Phillippe Halsman: *Dali Atomicus*, photograph (USA) • Kōshirō Onchi: *Poème no.7: May Landscape*, woodblock print (Jap) • David Bomberg: *Monastery of Ay Chrisostomos, Cyprus*, painting (UK) • The tour of Peggy Guggenheim's collection of new American paintings introduces Abstract Expressionism to Europe	• Graham Sutherland: *Somerset Maugham*, painting (UK) • Henry Moore: *Family Group*, sculpture (UK) • Joan Miró: *Women, Bird by Moonlight*, painting (Fr) • Edouard Pignon: *The Miner*, painting (Fr)	• Fernand Léger: *The Constructors*, painting (Fr) • David Smith: *The Letter*, sculpture (USA) • L.S. Lowry: *The Pond*, painting (UK) • Franz Kline: *Chief*, painting (USA) • Jean Dubuffet: *Corps de Dame*, painting (Fr)	• Salvador Dalí: *Christ of St John of the Cross*, painting (Sp) • Robert Motherwell publishes an anthology of the works of Dadaist poets and painters, presaging the appearance of "Neodadaism" (USA) • Adolph Gottlieb: *The Frozen Sounds Number 1*, painting (USA) • Pablo Picasso: *Massacre in Korea*, painting (Fr)	• Mark Rothko: *No.8*, painting (USA) • Lucian Freud: *Portrait of Lady Caroline Blackwood*, painting of the artist's future wife (UK) • Alan Reynolds: *The Keeper of the Dark Copse II*, painting (UK) • Ad Reinhardt: *Red Painting* (USA) • Helen Frankenthaler: *Mountains and Sea*, painting (USA)	• Henri Matisse: *Memory of Ocean*, painting (Fr) • Willem de Kooning: *Woman*, series of paintings (USA) • Mark Tobey: *E August*, painting (• Francis Bacon: *Study After Velas Pope Innocent X*, painting (UK)
Architecture	• Ludwig Mies van der Rohe: *Alumni Memorial Hall*, IIT, Chicago (USA) • Sven Markelius: *Markelius House*, Stockholm (Swe)		• Walter Gropius and The Architects Collaborative (TAC): *Harkness Common dormitories*, Harvard University (USA) • Harry Seidler: *Seidler House*, near Sydney (Aus)	• Charles Eames: *Eames House*, Santa Monica (USA)	• Wallace Harrison and Max Abramovitz: *United Nations Headquarters*, New York, based on an original idea by Le Corbusier (USA)	• R. Matthew, L. Martin and others: *Royal Festival Hall*, London (UK) • Alvar Aalto: *Baker House*, Cambridge, Massachusetts (USA)	• Ludwig Mies van der Rohe: *Lake Shore Drive Apartments*, Chicago (USA) • Le Corbusier: *Unité d'Habitation*, Marseilles (Fr)	• Louis I. Kahn: *Y Art Gallery* (USA)
Performing Arts		• Tennessee Williams: *A Streetcar Named Desire*, play (USA) • Kjeld Abell: *Days on a Cloud*, play (Den) • Jiří Trnka: *The Czech Year*, film (Czech)	• René Char: *Le Soleil des eaux*, radio play with music by Pierre Boulez, the published edition illustrated by Georges Braque (Fr) • Merce Cunningham, Willem de Kooning and Buckminster Fuller reconstruct Erik Satie's stage-drama *The Ruse of Medusa* at Black Mountain College (USA)	• Jean Genet: *Deathwatch*, play (Fr) • Arthur Miller: *Death of a Salesman*, play (USA)	• Eugène Ionesco: *The Bald Soprano*, play (Fr) • Akira Kurosawa: *Rashomon*, film (Jap) • Jean Cocteau: *Les Enfants terribles*, film (Fr)		• Merce Cunningham forms his own dance company (USA) • Samuel Beckett: *Waiting for Godot*, play (Fr) • John Cage, David Tudor, Robert Rauschenberg, Merce Cunningham and others: *Untitled Event*, the first "happening" (USA)	• Arthur Miller: *Th Crucible*, play (US
Music	• Founding of the Summer Courses for New Music at Darmstadt by Wolfgang Steinecke, taught by René Leibowitz, Olivier Messiaen, Karlheinz Stockhausen, Pierre Boulez, Bruno Maderna among others (FRG) • Juilliard School of Music formed from the merging of the Institute of Musical Art and the Juilliard Graduate School (USA)	• Thomas Beecham founds the Royal Philharmonic Orchestra (UK) • Maurice Duruflé: *Requiem* (Fr)	• Pierre Schaeffer: *Etude aux chemins de fer*, first *musique concrète* work (Fr) • T.W. Adorno: *Philosophy of Modern Music*, an analysis of the relations between art and society (USA) • Richard Strauss: *Four Last Songs*, settings of poems by Hesse and Eichendorff (FRG)	• Olivier Messiaen: *Mode de Valeurs et d'Intensities*, for piano, the first work employing total serial procedures (Fr)	• Arnold Schoenberg: *Modern Psalms* (USA) • Revival of the Donaueschingen Festival, promoting the music of the new avant-garde (FRG)	• John Cage: *Music of Changes*, for piano, composed by a coin-tossing procedure derived from the *I Ching* (USA) • Douglas Lilburn: *Second Symphony* (NZ) • Wolfgang and Wieland Wagner (grandsons of Richard Wagner) assume joint directorship of the Bayreuth Festival (of Wagner's music) (FRG)	• John Cage: *4'33"*, a totally silent piece for variable forces (USA) • Jean Barraqué: *Piano Sonata* (Fr) • Pierre Boulez: *Structures*, for two pianos, first book (Fr) • Earle Brown: *December 1952*, the first instance of a "graphic" score, to be interpreted by any sound sources (USA)	
Literature		• Foundation of the *Gruppe 47* association of writers (FRG) • Yasunari Kawabata: *Snow Country*, novel (Jap) • Italo Calvino: *The Path to the Nest of Spiders*, novel (It) • Malcolm Lowry: *Under the Volcano*, novel (UK)	• "George Orwell": *Nineteen Eighty-Four*, novel (UK) • Norman Mailer: *The Naked and the Dead*, novel (USA) • Tanizaki Jun-ichirō: *The Makioka Sisters*, novel (Jap) • Founding of *Les Temps modernes*, by Jean-Paul Sartre and Simone de Beauvoir (Fr)	• Henri Michaux: *Poetry for Power*, poems, two later set by Pierre Boulez in 1958 (Fr) • Jean-Paul Sartre: *The Roads to Freedom*, novel trilogy (*The Age of Reason*, *The Reprieve* (both 1945), *Iron in the Soul* (1949)) (Fr)	• Doris Lessing: *The Grass is Singing*, novel (UK) • Isaac Bashevis Singer: *The Family Moskat*, novel (USA)	• J.D. Salinger: *Catcher in the Rye*, novel (USA) • James Jones: *From Here to Eternity*, novel (USA) • W.H. Auden: *Nones*, poems (UK) • Ōoka Shōhei: *Fires on the Plain*, novel (Jap)	• David Jones: *Anathémata*, long poem (UK) • Founding of *Drum* literary magazine (SA)	• Czeslaw Milosz *Usurpers*, poems • Nadine Gordim *The Lying Days*, (SA)
Misc.			• Robert Graves: *The White Goddess*, a historical-mythological text (UK)	• Simone de Beauvoir: *The Second Sex*, a sociological study of women (Fr)	• Senator Joe McCarthy claims the presence of Communists in the US State Department			

	1955	1956	1957	1958	1959	1960
am Baziotes: *Congo*, g (USA) hus: *Nu jouant avec t*, painting (Fr) olas de Staël: *nte*, painting (Fr) e Hartigan: *Grand Brides*, painting Glarner: *Relational g Tondo No. 20*, g (USA) ry Moore: *Internal xternal Forms*, ure in wood (UK)	● Robert Rauschenberg: *Bed*, assemblage (USA) ● Pablo Picasso: *The Women of Algiers*, painting (Fr) ● Richard Diebenkorn: *Berkeley No. 54*, painting (USA) ● Jasper Johns: *Target with Four Faces*, painting (USA) ● Barbara Hepworth: *Hollow Form (Penwith)*, sculpture in wood (UK)	● Richard Hamilton: *Just What is it That Makes Today's Homes so Different, so Appealing?*, photomontage (UK) ● Joan Mitchell: *Hemlock*, painting (USA) ● Georges Braque: *Studio IX*, painting (Fr)	● Clyfford Still: *1957-D No.1*, painting (USA) ● James Brooks: *Boon*, painting (USA) ● Maurice Estève: *Composition 166*, painting (Fr)	● Jasper Johns: *Three Flags*, painting (USA) ● Adja Yunkers: *Tarrassa XIII*, painting (USA) ● Philip Guston: *The Return*, painting (USA) ● Colin McCahon: *Tomorrow will be the same but not as this is*, painting (NZ) ● Sam Francis: *Blue on a Point*, painting (USA)	● Ad Reinhardt: *Abstract Painting* (USA) ● Stanley Spencer: *Christ Preaching at Cookham Regatta*, painting (left unfinished) (UK) ● Alberto Giacometti: *Portrait of Jean Genet*, painting (It) ● Carlos Cruz-Diez: *Physichromie no.1*, op art painting (Ven) ● Jasper Johns: *Numbers in Color*, painting (USA) ● Piero Manzoni: *Line 20 Metres Long*, painted on to a rolled strip of paper (It)	● Sadao Watanabe: *Listening*, stencil print (Jap) ● Robert Motherwell: *Elegies to the Spanish Republic* (since 1955), sequence of paintings (USA) ● Alexander Calder: *Antennae with Red and Blue Dots*, mobile (USA) ● Jean Tinguely: *Homage to New York*, mechanical sculpture (USA) ● Alberto Giacometti: *Man Walking III*, sculpture (Swi)
on Rodia: *Watts s*, Los Angeles (since 1) (USA) ys Lasdun: *Cluster*, al Green, London, a g tower block (UK)	● Le Corbusier: *Church of Notre-Dame-du-Haut*, Ronchamp (Fr) ● Kenzo Tange: *Peace Memorial and Museum*, Hiroshima (Jap)	● Eero Saarinen: *General Motors Technical Centre*, Michigan (USA)	● Ludwig Mies van der Rohe: *Seagram Building*, New York (USA) ● Frank Lloyd Wright: *The Solomon R. Guggenheim Museum*, New York (USA)	● Yannis Xenakis (of the atelier of Le Corbusier): *Philips Pavilion* at the World Exhibition, Brussels (Bel) ● Minoru Yamasaki: *Pruitt-Igoe Housing*, St Louis, dynamited in 1972 (USA)	● Gio Ponti and Pier Luigi Nervi: *Pirelli Tower*, Milan (It)	● Eero Saarinen: *TWA Terminal*, Kennedy Airport, New York (USA) ● Atelier 5 group: *Siedlung Halen*, near Berne, a housing complex (Swi) ● Oscar Niemeyer: *State Building*, Brasilia (Bra)
n Thomas: *Under Wood*, radio play (Ire) rich Böll: *The arded House*, play çois Truffaut: *Une ne tendance du a français*, theoretical written for *Cahiers éma* (Fr)	● Andrzej Wajda: *Pokolenie (A Generation)*, film (Pol) ● Tennessee Williams: *Cat on a Hot Tin Roof*, play (USA) ● Jean-Paul Sartre: *Nekrassov*, play (Fr)	● N.P. van Wyk Louw: *Germanicus*, play (SA) ● Friedrich Dürrenmatt: *The Visit*, play (Swi) ● John Osborne: *Look Back in Anger*, play (UK)	● Akira Kurosawa: *The Throne of Blood*, film (Jap) ● Ingmar Bergman: *Wild Strawberries*, film (Swe) ● George Balanchine: *Agon*, ballet (USA)	● Yves Klein: *The Anthropometries of the Blue Period*, in which nude models produce a picture by rolling first in Klein's own (later patented) International Klein Blue paint then on a large canvas laid out on the floor, while a chamber group performs Pierre Henry's *Symphonie Monotone*, a single note held for ten minutes alternating with ten minutes silence (Fr)	● Eugène Ionesco: *Rhinoceros*, play (Fr) ● T.S. Eliot: *The Elder Statesman*, play (UK) ● Allan Kaprow: *18 Happenings in 6 parts*, a live art piece, held at the Reuben Gallery, New York (USA)	● Jean-Luc Godard: *A bout de souffle (Breathless)*, film (Fr) ● Federico Fellini: *La Dolce Vita*, film (It) ● Harold Pinter: *The Caretaker*, play (UK)
on Babbitt: *Second Quartet* (USA) nis Xenakis: *tasis*, for orchestra ndation by Pierre z of the Petit-Marigny usic concerts, ed Domaine Musical 5 (Fr)	● Pierre Boulez: *Le Marteau sans Maître*, cantata for chamber ensemble setting poems by René Char (Fr) ● Herbert von Karajan becomes director of the Berlin Philharmonic, a post holds until his death in 1989 (FRG)	● Luigi Nono: *Il Canto Sospeso*, setting for voices and orchestra of letters of political prisoners (It) ● Yannis Xenakis: *Pithoprakta* for orchestra, an early instance of Xenakis's "stochastic" music (Fr)	● Lejaren Hiller: *Illiac Suite* for string quartet, written using a computer (the Illiac) as a compositional aid (USA) ● Karlheinz Stockhausen: *Gruppen*, for three spatially-arranged orchestras (FRG)	● Edgard Varèse: *Poème électronique* for tape, relayed through Yannis Xenakis's Philips Pavilion at the World Exhibition (Fr) ● György Ligeti: *Artikulation* for tape (FRG) ● Olivier Messiaen: *Catalogue d'oiseaux*, notations of birdsong for piano (Fr) ● Igor Stravinsky: *Threni*, the work signaling the composers' adoption of the twelve-note technique of composition (USA)	● Completion of the Beethovenhalle in Bonn (FRG)	● Havergal Brian: *Sixteenth Symphony* (UK) ● Krzysztof Penderecki: *Threnody to the Victims of Hiroshima* for orchestra (Pol)
one de Beauvoir: *The arins*, novel (Fr) am Golding: *Lord of es*, novel (UK) çoise Sagan: *ur tristesse*, novel (Fr) mas Mann: *ssions of Felix Krull*, (FRG) gsley Amis: *Lucky ovel (UK)	● Alain Robbe-Grillet: *Le Voyeur*, novel (Fr) ● George Seferis: *Logbook C*, poems (Gr) ● Ariano Suassuna: *The Rogue's Trial*, novel (Bra) ● Czeslaw Milosz: *The Captive Mind*, essays on Polish intellectual life under the communists (Fr)	● Allen Ginsberg: *Howl*, poems (USA) ● Samuel Beckett: *Malone Dies*, novel (Fr) ● Albert Camus: *La Chute*, novel (Fr) ● J.R.R. Tolkien: *The Lord of the Rings*, fantasy novel trilogy (UK)	● Ian Cross: *The God Boy*, novel (NZ) ● Michel Butor: *La Modification*, novel (Fr) ● Max Frisch: *Homo Faber*, novel (Swi) ● Boris Pasternak: *Doctor Zhivago*, novel (USSR) ● Janet Frame: *Owls Do Cry*, novel (NZ)	● Primo Levi: *If This is a Man*, memoirs of the period spent by the author in Auschwitz concentration camp (It) ● Vladimir Nabokov: *Lolita*, novel (USA) ● William Burroughs: *Naked Lunch*, novel (USA) ● Iris Murdoch: *The Bell*, novel (UK)	● Yukio Mishima: *The Temple of the Golden Pavillion*, novel (Jap) ● Günter Grass: *The Tin Drum*, novel (FRG) ● Pier Paolo Pasolini: *A Violent Life*, stories (It) ● Alan Sillitoe: *The Loneliness of the Long Distance Runner*, novel (UK)	● First UK publication of D.H. Lawrence's *Lady Chatterley's Lover* by Penguin Books, who are subsequently charged under the obscenity laws ● W.H. Auden: *Homage to Clio*, poems (UK) ● Claude Simon: *The Flanders Road*, novel (Fr)
				● André Malraux appointed Minister of Cultural Affairs by De Gaulle (until 1968) (Fr)		

129

Datafile

In the postwar period the mantle of arts capital of the world began to pass from Paris to New York. Various movements started up in Europe and new styles emerged, principally that of "lyrical abstraction." Little of this work, however, compared with the ferocity of the American Abstract Expressionists. (The terrifying visions of Frances Bacon provide a solitary exception). Paradoxically, artists like Arshile Gorky were profoundly influenced by the calligraphic styles of Surrealist painters like Miró and André Masson. By developing the expressiveness of his line to the point of abstraction, Gorky suggested an autobiographical element which now seems typical of American painting at this time. As ever, the term "abstract" must be applied generously to these artists' work. Some, like Franz Kline, can be said to be "writing" in a private alphabet. Others, principally Willem de Kooning, are only recognizable as "abstract" painters because of their vigorous and spontaneous handling of paint.

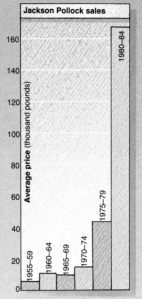

Jackson Pollock sales

▲ Jackson Pollock is often seen as the archetypal Abstract Expressionist. Living recklessly, splashing paint in an instantly recognizable manner, dying relatively young, he epitomized the stereotypical role of the artist as "possessed." This strong romantic appeal is reflected in his popularity in the sale rooms.

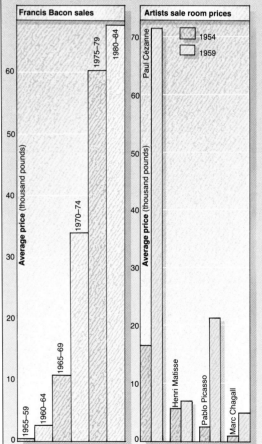

Francis Bacon sales

Artists sale room prices

☐ 1954
☐ 1959

◀ These prices, like other similar charts, have been arrived at by taking an average of each artist's best three prices each year, converted into sterling at current rates. The extraordinary leap in Cézanne's prices during this period indicates a recognition of his role as a founding father of modernism.

▼ The cinematic style most praised by critics at the Brussels World's Fair was Expressionism. In their different ways, *The Cabinet of Dr Caligari*, *The Battleship Potemkin*, and *Citizen Kane* all exploited the capacity of the big screen to distort reality, employing the strong contrasts possible in black and white.

▲ When the Briton Francis Bacon first came to prominence, his unflinching stare into hell seemed a heroic response to a terrible age. As most of us have become inured to the extremes of the 20th century, however, Bacon's reactions have intensified, until his position seems increasingly isolated and idiosyncratic.

Brussels World's Fair – best films of all time 1958

1 *The Battleship Potemkin* (USSR) 1925
2 *The Gold Rush* (USA) 1925
3 *Bicycle Thieves* (Italy) 1949
4 *The Passion of Joan of Arc* (France) 1928
5 *La Grande Illusion* (France) 1937
6 *Greed* (USA) 1924
7 *Intolerance* (USA) 1916
8 *Mother* (USSR) 1926
9 *Citizen Kane* (USA) 1941
10 *Earth* (USSR) 1930
11 *The Last Laugh* (Germany) 1925
12 *The Cabinet of Dr Caligari* (Germany) 1919

Recovery from World War II was very different from recovery from World War I. After the 1914–18 war a generation of lost young men was mourned amid an acute sense of waste. The 1939–45 war involved civilians in a way not known before and in the aftermath two discoveries were made that would not allow humanity to consider itself in the same way ever again: the degree of man's inhumanity to man demonstrated by the concentration and extermination camps, and the dropping of the atomic bomb that exposed the near-limitless potential for destruction that man and nature together now possessed. In the following decades it was not only the dead who were mourned, but the loss of a kind of collective innocence.

Europe and the United States

In Europe, the end of World War II signaled the beginning of an attempt to reconstruct from the fragments that had survived, both physically and emotionally. The coherent nationalist drive of the Americans to international acclaim, confirmed and accelerated by victory and by the new superpower status of the United States, was not possible in a continent that had been morally and economically shattered by war. German art, so long sunk in an "inner exile", emerged to celebrate just those abstract and Expressionist-inspired images that Hitler had suppressed. Much of the work done there and throughout Europe was colored by that suppressed experience – if not actually despairing, then gloomily savage. In Germany there was, too, a tendency to pick up old threads, to reconstruct old continuities, rather than to confront the painful reality of the new divided Germanies. In particular, Willi Baumeister's undulant and caressing surreal forms in diffused blue-violets, browns and gentle reds seem quietly to have come through, consolidated rather than changed. His article on "The Unknown in Art" (1947) was a notable defense of abstraction. One German artist, Ernst Wilhelm Nay, found it possible to infuse his primitivism, which looked back to the work of Emil Nolde, with a joy born of liberation. But Wols (Wolfgang Schulze), who died aged 38 in 1951 after a life aggravated by drink, hounded by the police, in fear of the Gestapo and driven to exile in Spain and France, did display the torments of the age. His bloodshot *Eye of God* (c. 1949), surreal and throbbing like a wound, stands as a symbol of how artists rebuilt their lives or perished through postwar self-examination.

Elsewhere in Europe, too, many artists were only stitching together the remnants of earlier styles and ideas, rather than moving positively forward. There were, of course, exceptions. The Spaniard Antonio Tápies, in his heavily textured

RECONSTRUCTION IN THE ARTS

**Postwar art in Europe
and the United States**

Symbolic cities

Abstract Expressionism

**The reaction against
abstraction**

**Latin America: poets,
politics and myth**

Political theater

Postwar music in Europe

**Fishermen catching
sounds**

▼ The Festival of Britain,
1951, a postwar rallying point
for designers, industry and the
general public.

collage surfaces, combined a sense of the protesting world of the streets with a considered attention to the way things are worn and eroded by time. The Paris-based Portuguese, Maria Vieira da Silva, painted meticulous and delicate geometrical traceries, using blacks, cool grays, greens and browns, hinting at but not rendering urban landscapes. Jean Dubuffet in France derived disturbing forms from children's art. The highly rhythmic paintings of Algerian-born Jean-Michel Atlan came to the fore in the 1950s. In his work heavy blacks enforced a rhythm but took away a sense of the spontaneous. In common with much European painting the degree of control was strong, in contrast to the raw yet satisfying excitement of the most characteristic American work. The Belgian-born poet and artist, Henri Michaux, experimented with mescalin and man-

aged to convey the effect of his heightened but unreal perception. Nicholas de Staël kept his abstract painting closer to observed natural forms, but the real key to its satisfactions is in its carefully disposed color harmonies. Color was again central to Serge Poliakoff, like de Staël a Russian-born French citizen. The work of Georges Mathieu, with large canvases occupied by a single color, modified by tone and surface texture, approaches something very closely related to American techniques. Asger Jorn from Denmark, one of the Surrealist Cobra group, painted in a colorful and myth-laden Expressionist style.

One artist who seemed to achieve serenity by disposing irregular patches of color on highly charged contrasting color grounds in a very distinctive way was the British artist Patrick Heron. Heron painted in St Ives in Cornwall. A location

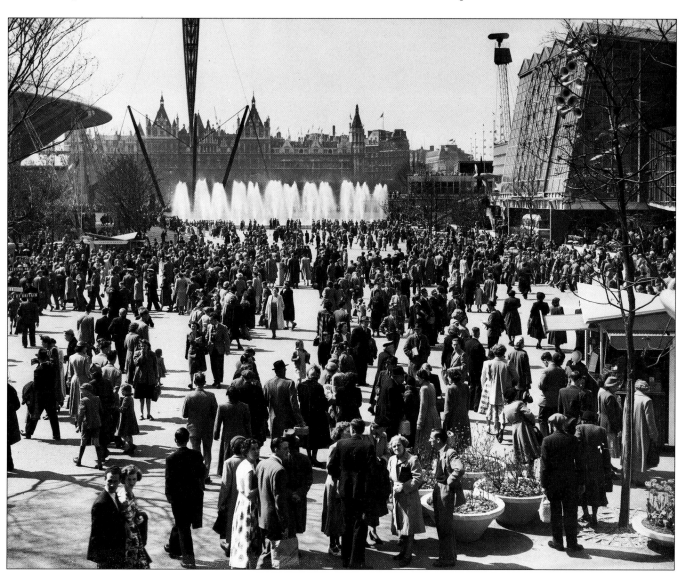

international prizes and competitions ushered in a period in which sculptors regularly won commissions abroad, and so contributed to a sense of human solidarity and a universal desire for peace. A notable example was his monument (1951), at the entrance to the port of Rotterdam. It was the work of the Russian-born French sculptor Ossip Zadkine who had been in the United States during the war. The sweeping movement of the giant figure pleads with the skies and defies them at the same time, a supporting colossus and spread-eagled victim. Nowhere was sculpture better represented than in Britain, where Moore and Hepworth were the precursors of a wide and successful development of younger artists. These included Reg Butler, who won First Prize in the International Unknown Political Prisoner Competition in 1953. He was equally interested in welded grids – suggesting traps or at least enclosure – and tenderly treated human figures; his work balanced on the dividing line between human oppression and protection. Lynn Chadwick's birds and

◀ The British sculptor Barbara Hepworth looking through the plaster model for *The Meridian*. Hepworth's sculpture carried poetic suggestions of both plant and landscape elements.

▶ The commemorative monument to the destruction of Rotterdam, by Ossip Zadkine. Zadkine's imagery, though superficially modernist, effectively worked within the classical tradition.

▼ *Study after Velazquez's Portrait of Pope Innocent X* (1953) by Francis Bacon. The visceral effect of this painting is achieved, paradoxically, by manipulating its "high" art references. The pope's serene authority is shattered by allusion to an image from Eisenstein's film *The Battleship Potemkin*, of a nurse being shot in the eye.

for painters since the turn of the century, Cornwall had witnesssed the development of a powerful British abstract tradition. Artists there included Ben Nicholson and the sculptor Barbara Hepworth. It was not quite accidental that such a remote and beautiful part of Britain should carry a major part of the country's artistic life. The quality of the light was the usual reason given for painting there, but a look at the work of Barbara Hepworth gives a clue to something further. Her sculptural forms are often pierced by holes and they seem as if smoothed by wind and sea into natural shapes, human figures that are still voices of the landscape. In the north-east of England the more clearly figurative Henry Moore, who was influenced less by European abstraction and more by pre-Columbian sculpture, was at work. His pieces too set up an interplay between figures and landscape. Indeed, part of what British artists at this time were striving for was an interplay with the natural world as a means of reconstruction. It was as if World War II had been fought to allow individual nationhood its freedom. And so artists like Graham Sutherland and Keith Vaughan, as well as the St Ives artists, naturally derived timeless abstract shapes from the immediacy of landscape forms. The new Coventry Cathedral, one of the postwar symbols of recovery, was built next to the bombed but still standing shell of the medieval cathedral, to establish a continuity with the past and a new flowering in the present. Fittingly, it housed many works of art, including Graham Sutherland's towering tapestry of the Crucifixion, barbarous with thorns. Another more disturbing triptych of studies centered on the Crucifixion, its figures viscous with existential anguish, was painted by Francis Bacon in 1944. His paintings served perhaps as an antidote to too much Romantic hope.

But hope, even if conditioned by anxiety, was in the air. One evidence of it was in the extraordinary vitality of sculptural form in the 1950s. Sculpture fitted in with architectural reconstruction and the desire to exorcise the past by commemorating the struggle to be free of it. An era of

insects, chunky metal, full of menace and fear, raised from the ground on fragile spiky legs, again emphasize the hazards and hopes of this problematic time. Interestingly, few of the later British sculptors seem to be in a direct line of descent from either Moore or Hepworth. Their work seems more in line with both the painting and sculpture of the Swiss-born Alberto Giacometti, whose thin figures, their bodies extended like rough wire, seem to echo the haunted spirituality of El Greco.

Symbolic cities

It is easy to assume that most cities have developed and grown like natural organisms, but throughout history many have been deliberately designed. Roman cities were planned on a rectangular grid, generally with a triumphal axis, while some Renaissance cities were laid out on a star plan. The reasons were various, military defense and respect for religious sites among them. Planned cities usually combine efficiency with grandeur, and the city plan as a symbol of principle or power is not uncommon, at least in theory. Opportunities to design a city come rarely, however. In 1912 the British architect Sir Edwin Lutyens was commissioned to design an imperial capital for India. A two-mile-long axial processional way was punctuated with a huge triumphal arch and terminated at the hill on which Government House was situated. Lutyens devised a new "order" for his architecture, with Mughal-cum-Classical proportions and "Indian" details. The Viceroy's residence was as large as Versailles. Though not completed until 1931, New Delhi served its purpose well as a symbol of Empire and has adapted comfortably to changing requirements since Indian independence in 1947.

Yet the plan for New Delhi was basically a simple concept. More ambitious was the winning entry in a competition for the design of Canberra, the new federal capital of Australia. Walter Burley Griffin, an American inspired by Garden City ideals, planned "atomic clusters" for different urban functions. Begun in 1913, Canberra had a population of only 32,000 fifty years later. The spaces between functional areas are still green, but empty.

Many architects and planners disliked New Delhi and Canberra for their disregard of modern urban demands. A greater awareness of 20th-century requirements was evident in the work of Tony Garnier, a socialist architect in Lyons, France, whose design for a Cité Industrielle (1901–03) was never executed, but strongly influenced planners half a century later. He distinguished between work, leisure and educational areas, segregated vehicles from pedestrians, proposed urban parks and planned low-rise, flat-roofed hospital, station and assembly buildings with glazed walls and concrete construction.

Tragically, another visionary planner, Antonio Sant'Elia, was killed in World War I and saw none of his ideas for a "Città Nuova", designed in 1914, built in any form. Sant'Elia was taken up by the Futurist movement and his statement about his city plan adopted by Marinetti. The Città Nuova was to be a soaring metropolis served by

external elevators, with layered roads crossed by bridges on many levels. Highly industrialized, with modern factories and power stations, it anticipated the rapid growth in automobiles and air transport in an exhilarating vision of a dynamic future.

Both Garnier and Sant'Elia were influential on the planning ideas of Le Corbusier. He too, in his 1925 scheme for Paris, the Plan Voisin, segregated pedestrians from vehicles, industrial areas from residential and business areas, with high-rise housing blocks standing in parkland. To reduce traveling distances, his plan for a Ville Radieuse of 1931 had rigidly banded zones and diagonal routes laid over a grid. Le Corbusier was largely responsible for the "Athens Charter" of propositions on "The Functional City", committed to high-rise, high-density housing blocks and the separation of urban functions by green belts. In the ensuing years he planned new cities for Algiers, Barcelona and São Paulo among others; but none of them was built.

After World War II, the master planner Lucio Costa and the architect Oscar Niemeyer designed a capital city for Brazil that clung to the principles of the Athens Charter. Brasilia (1950–60) was like an airplane in plan, with 42 residential blocks on an inflexible grid extending like wings from the axial triumphal route. This leads to the Congress Building with its symbols of the Three Powers of Government, twin towers flanked by bowls, one concave and the other convex. Though self-consciously beautiful, the esthetic of such buildings separated this symbolic focus from the rest of the city.

Other capital cities have been built since World War II. Dhaka, Louis Kahn's capital for Bangla-

desh, with its abstract blocks and geometric shapes is made more human and more local in character by the use of brickwork. The Greek planner C.A. Doxiades was responsible for Islamabad, capital of Pakistan, a "Dynamically Growing Dynametropolis" (1960) where the undulating landscape was largely ironed out to accommodate its colorless, low-rise extendable grids. By far the most celebrated is Chandigarh (1951–59), in northwest India, the only radiant city planned by Le Corbusier that was actually built, though posthumously, under the direction of his British team, Maxwell Fry and Jane Drew. Its major buildings – the High Court, the Governor's Palace, the Assembly – are striking with their monumentality, their sculptural roofs, their three-dimensional application of forms first explored in Le Corbusier's early paintings. But this attention to design was not apparent in the proportional grid of the rest of the city, with its broad

◄ The Cathedral, Brasilia, designed by Oscar Niemeyer, and begun in 1957. Brasilia was a city carved out of the jungle to serve as a developing country's capital. Exhibiting everywhere the most radical face of architecture, it became immediately a symbol of postwar optimism and idealism, a gesture of trust in the new technology that, people felt, would shape the future.

Building Anew

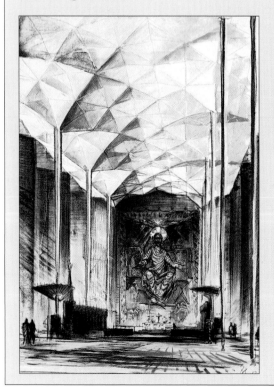

◄ The new Coventry Cathedral, by Sir Basil Spence.

After widespread wartime destruction, two primary impulses competed in the thoughts of both experts and the population at large: to reconstruct what was there before in order to cancel out and soothe away the obvious malign effects of conflict; or to build anew, with a fresh look at the needs of the future. In most of Europe after World War II, technical and commercial practicality embraced both impulses, yet with significant variation from place to place. Long before the war was over, town planning experts in Britain were replanning a modern and expanded London, heavily influenced in conception by both Garden City ideals and Modern Movement thought, but visualized almost exclusively in the International Style. Coventry, an engineering city in the English Midlands, was notably devastated by German bombing. The medieval town was replaced by a crisp new shopping center, but at the same time the ruins of the city's ancient cathedral were left standing as a memorial to the war, cheek by jowl with the new cathedral designed by Sir Basil Spence. In Germany the major cities were more than half destroyed. The ancient cities were frequently rebuilt. Other cities chose to leave the blackened, bombed-out shells of churches as permanent reminders of the conflict.

European-style highways burning under the relentless Indian sun.

Perhaps the symbolic city is most convincing on the drawing board, for the task of designing a city that carries such a weight of meaning while serving the needs of both state and people is probably beyond the capacity of most planners. The organically growing city may best meet these complex and changing demands, after all.

Abstract Expressionism

After World War II the international art center of the world shifted from Paris to New York. The leading edge of world art was represented by the artists collectively known as the Abstract Expressionists or the New York School. They included Mark Rothko, Jackson Pollock, Willem de Kooning, Franz Kline, Robert Motherwell and Barnett Newman. A synthesis of the fluid painting techniques of European teachers based in New York, such as Hans Hofmann, and the automatism of Surrealist painters fleeing the war in Europe, led to the action painting practiced in particular by Jackson Pollock. Pollock would lay his large canvases on the floor so that he could attack them from all four sides and so participate in them more fully. He dribbled diluted paint directly from the can or flicked it on with a stick so that the colors trailed and interlaced across the surface in an all-over pattern of highly charged rhythms. The picture was literally built up by a series of physical gestures or actions resulting in the falling

Note the apparatus with which man responds to architecture: he has two eyes which can only look ahead; he can turn his head sideways or upwards, he can turn his body, or carry his body along on his legs and keep turning all the while. It takes hundreds of successive perceptions to make up his architectural sensation.

LE CORBUSIER, 1954

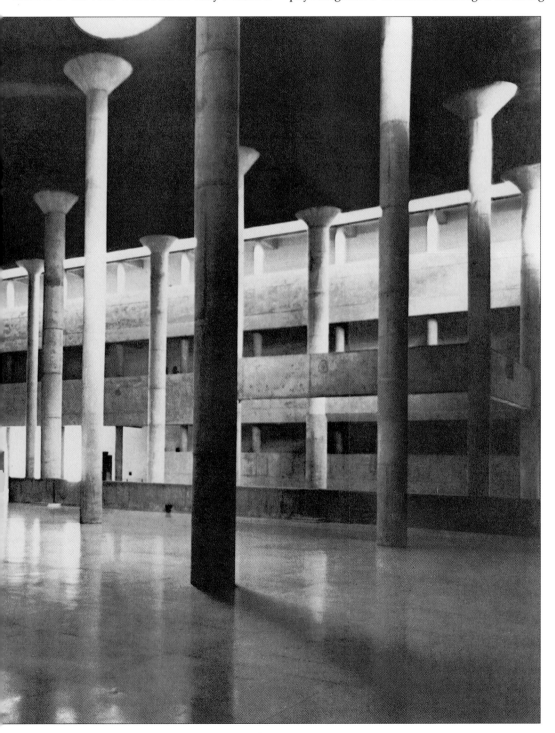

◄ Lobby of the Assembly Hall at Chandigarh, designed by Le Corbusier. The ancient capital of the Punjab, Lahore, lay in Pakistan after partition. Therefore a new capital had to be selected for the rest of the Punjab, now part of the newly-formed Haryana State. Acting in the spirit of radical development the period seemed to demand, the Indian government determined to build a city from scratch. The commission was given to Le Corbusier, a high priest of Modernism. He set out to marry traditional styles of architecture with his own principles of complete utility. Here and there, however, are signs that the union is forced. The streets are set out on the rectilinear basis first employed in the 18th-century New Town of Edinburgh, and seen most famously in Manhattan's numbered grid, but are perhaps too exposed to the ferocious heat. The High Court, however, built in Le Corbusier's favorite reinforced concrete, has an enormous curved double roof, to offer protection from the sun. It has the appearance of a giant tortoise shell. The end result is at once unique and appropriate, both practical design and symbolic unit.

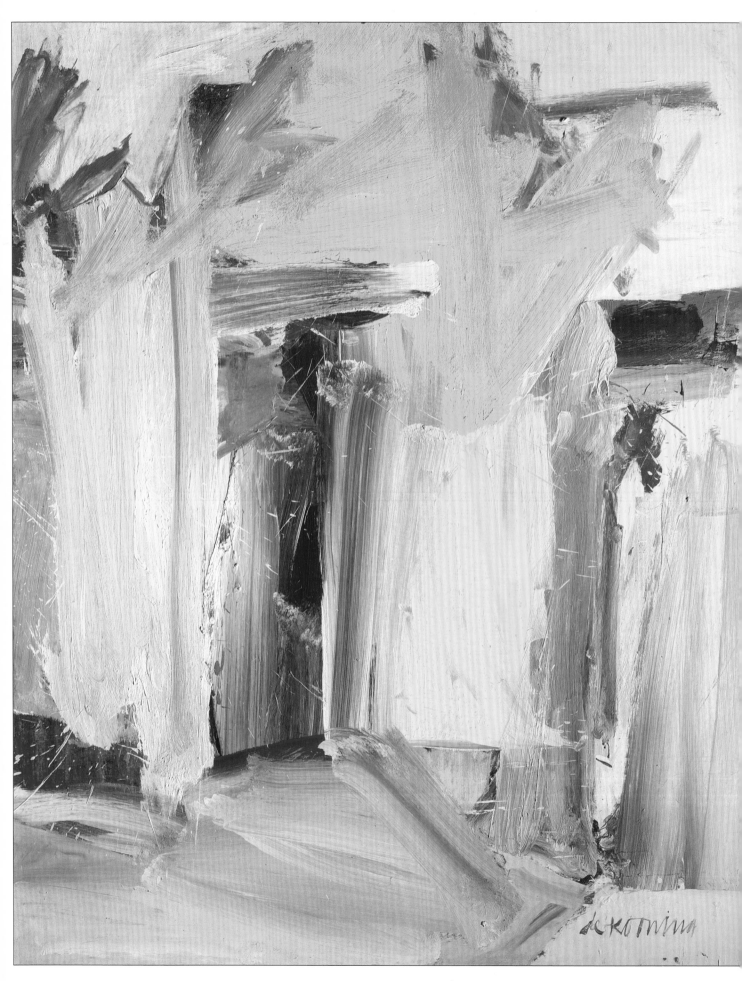

◄ *Door to the River* (1960), by Willem de Kooning. De Kooning's work, Abstract Expressionist in the broad slashing use of color, contained more traditional elements, whether figurative or, as here, references to a landscape. What he shared with his contemporaries was their sense of the canvas as a dramatic field, a surface upon which their personalities could be recorded.

► The Abstract Expressionists at an exhibition in 1950. Reading from left to right, they are (top row): Willem de Kooning, Adolph Gottlieb, Ad Reinhardt, Hedda Sterne; (middle row): Richard Pousette-Dart, William Baziotes, Jackson Pollock, Clyfford Still, Robert Motherwell, Bradley Walker Tomlin; (bottom row): Theodoros Stamos, Jimmy Ernst, Barnett Newman, James Brooks, Mark Rothko. This group, also known as "The Irascibles", were promoted by the State Department as living examples of the dynamism of American culture during the Cold War.

▼ *Elegy to the Spanish Republic, No. 34*, by Robert Motherwell, who was well aware of modern European art, and anxious to define the art of his fellow Abstract Expressionists in distinction from it. He edited the *Documents of Modern Art* series from 1944 to 1957, and introduced many American painters to the exiled Surrealists as well as their ideas. His involvement with Spain stemmed from his love of modern Spanish art as much as from his politics.

or dripping of paint. It is difficult to "interpret" such paintings and, in that sense, the paintings might be said to be "about" paint on the one hand and about the artist's need to perform actions on the other, an exercise in creativity. A Pollock canvas is more paint than painting, but is certainly abstract and clearly expressive of the controlling attitude that has made it. It exists as texture, a self-sufficient object, which is at once its point and meaning, except in so far as we can relate it to the artist in action. Franz Kline showed similar tendencies, but was more attached to a visible world of sights and messages, a rendering of the world as calligraphic sign. In Kline's manner, a sort of blown-up oriental calligraphy, using housepainter's brushes, and in fact often derived from industrial shapes such as trains and girders, it is gesture that determines the distribution of the paint. Willem de Kooning, a Dutch painter who settled in New York in 1926, was more figurative in his approach, but nonetheless his human figures all but disappeared in a total assault of color, mass, texture and line. Of all these painters, de Kooning was the one who related most closely to the traditions of European Expressionism.

For the work of Barnett Newman the term Abstract Expressionism is perhaps at its most apt. Newman was not pursuing some visceral automatic expression but rather abstract ideas expressed through paint. He was the least gestural of these painters, the least concerned with physical human action and the most concerned with an abstract idea, possibly of a religious and transcendental kind. He worked in great slabs of smooth color, juxtaposing one band against another in broad vertical blocks, sometimes using a single color, with tonal variation, to cover a very large canvas. He gave such paintings titles such as *Day One*, *Onement* and *Adam*. The titles indicate an interest in origins and that the paintings are symbolic accounts of creation. But his paintings can equally be seen as expressions in pure

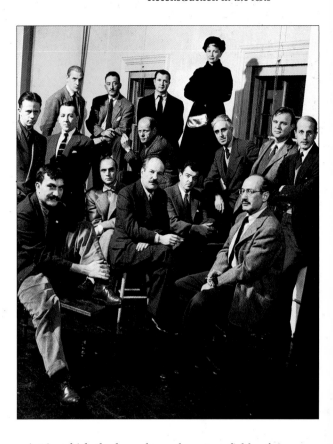

paint in which the boundary where two fields of color meet is a moment of both visual and symbolic change, a moment of "creation". In Mark Rothko's large canvases, rectangular color-shapes in broad horizontals give a sensation of vertical ascent, as if through planes of earth, horizon and sky. They seem to float into one another. There is a sense of search for some universal value, beyond a humanly conceived idea. The agony of that, for a painter, is that it is also beyond expression. Painting, as much as politics, has to do with the art of the possible. No American artist was better equipped to understand the confusion between the painter's concern for the very real worlds of technique and material and the pursuit of the beckoning idea than Robert Motherwell, whose career got off to an early start when he won a fellowship to the Otis Art Institute in Los Angeles, aged 11. His next step, at 17, was to study philosophy at Stanford University. He moved on to esthetics at Harvard and further study at Columbia. At 26 he determined on painting as a career, exhibiting with Jackson Pollock in 1943, and from then on was one of the central voices of American Abstract Expressionism. Yet his work has been consistently inspired by political events. The collage *Pancho Villa Dead and Alive* dates from 1944, and from the late 1940s on he painted a massive sequence of pictures commemorating the Spanish Civil War and the demise of the Republic. The pictures are purely abstract, large, black and white, and built from egg-like shapes and jagged rectangles. As with much painting that relies on large areas of contrast color, spaces between the shapes are as important to the visual impact as the shapes themselves. What is remarkable about this particular series is that such careful abstraction

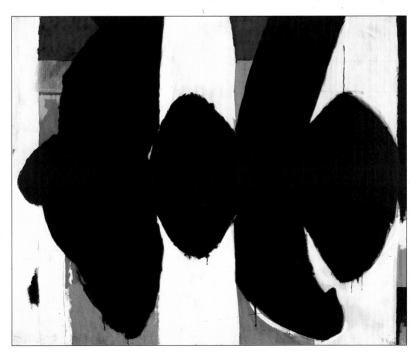

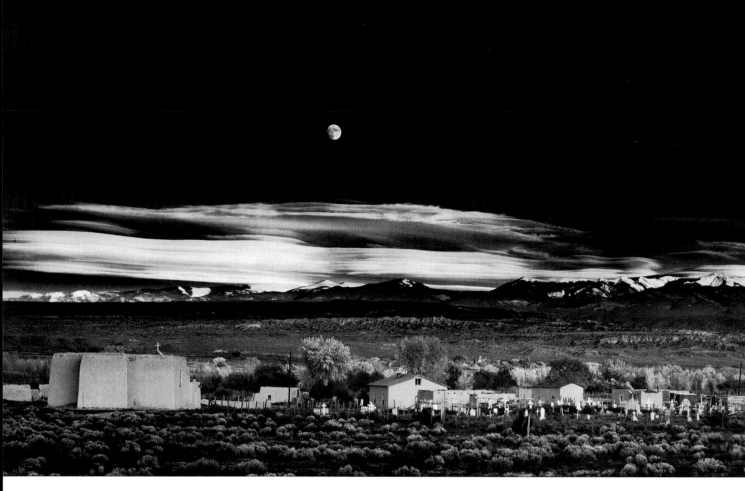

nonetheless achieves a monumental and austere homage to the political events it commemorates.

Other important Abstract Expressionist painters include Philip Guston, whose canvases were built up by the painter's actions, visible in the texture of the layers of paint, to a quiet and settled conclusion rather than a virtuoso display of energy. Clyfford Still achieved a similar quietude, with subtly textured colors lit by sudden flashes or gaps of contrasted pigment or a dramatic white. William Baziotes and Adolph Gottlieb, both from a Surrealist background, fed a symbolic or figurative sense into their predominantly abstract methods.

The reaction against abstraction: Pop art

The reaction against abstract art, when it came, took an unexpected turn, in that it was also a reaction against the terms that society had set on art itself. Pop art took as its domain the ordinary objects of a commercial, technological and particularly a consumerist society. In Britain, where it first arose and acquired its name in the late 1950s, this meant things like American cars, advertisements, images from the movies and science fiction: in the United States it meant brand names, strip cartoons, cans of soup and the Stars and Stripes.

As always, there were precursors: Marcel Duchamp's ready-mades, the mechanistic Cubist images of Fernand Léger, the constructions of Kurt Schwitters, elements from Surrealists like Max Ernst and the whole Dada impulse, as well as, in the United States, the paintings of Stuart Davis. But the main drive came form a feeling

that painters ought to live within their own culture. A mass-produced urban world, bombarded by signs, ought to be celebrated. In Britain, Pop art was in some degree a reflection of the loosening effect on the social fabric brought about by World War II. Educational policy after the war, embodied especially in the 1944 Education Act, had resulted in wider access to universities and colleges of art. Urban children of working-class backgrounds either risked rootlessness in seizing those opportunities or found some sort of continuity by celebrating a background they had left behind. The Pop artists in particular felt that there was a continuum between fine art and the popular art of the streets and the shop display, and it was their job to reflect it.

In Britain for a time there was a good deal more theory, centered on London's lively Royal College of Art, than there was art. One of the first of the effective Pop presences was Eduardo Paolozzi, whose 1950 "scrapbooks", collages of magazine and technical material constituting a "universe of pictures", were really a set of notes towards a redefinition of culture. Richard Hamilton celebrated the American car and its association in advertising with images of women. One of the key Pop icons was Hamilton's collage, *Just What is it That Makes Today's Homes so Different, so Appealing?*, which featured in the "This is Tomorrow" exhibition at the Whitechapel Art Gallery in 1956. It was a witty construct of consumerism and cult, both celebrating pop culture and mocking it. The mockery is simply a recognition that some of the images at least are inherently funny, and made more so by the juxtapositions of collage.

▲ *Moonrise, Hernandez*, by Ansel Adams, is an evanescent image in an American tradition that reached back to the 19th-century landscape painters, who had sought to represent the grand theme in their environment. Photography at this period, unlike painting, could convey a Romantic, precise image.

Technic is the result of a need – new needs demand new technics – total control – denial of the accident – states of order – organic intensity – energy and motion made visible – memories arrested in space, human needs and motives – acceptance –

JACKSON POLLOCK

In the United States, while the Abstract Expressionists were enjoying international acclaim, Jasper Johns and Robert Rauschenberg were beginning to produce work much closer to that of the British Pop artists. In the mid-1950s Johns produced a series of paintings of that icon to end all icons, the American flag, which was the immediate precursor of American Pop art. Johns, however, stayed in the traditional painterly world; his paint surfaces were not flat, hard and blatant. Once Pop discarded that old-world touch, then the icons themselves began to look unreal. And if the most commonplace items in our surroundings became unreal, what could be trusted?

Latin America: poets, politics and myth

Latin American literature has a long history, but it was only in the 20th century that Latin American voices emerged to sound a distinctive note. Paradoxically, they achieved this through a resolute internationalism, which took the whole world as its territory. Among those who have made their voices heard are the Peruvian poet César Vallejo (1892–1938) and the Mexican poet and essayist Octavio Paz. But two names above all are unavoidable, since their owners created most of the possibilities for the writing that came after them. The Argentinean Jorge Luis Borges (1899–1986) and the Chilean Pablo Neruda (1904–1973) would seem to have very little in common. Borges was indirect, conservative, intellectual, a man of libraries and fantasies; Neruda was a diplomat who traveled widely, expansive, a Communist, intellectual too in his way but also immensely popular, one of the few 20th-century

▼ Jackson Pollock painting, 1950. The act of painting became, in Pollock's hands, a spiritual statement. Having eliminated any other means of gauging his work, only his own integrity could be measured. As he said, "It is only when I lose contact with the painting that the result is a mess."

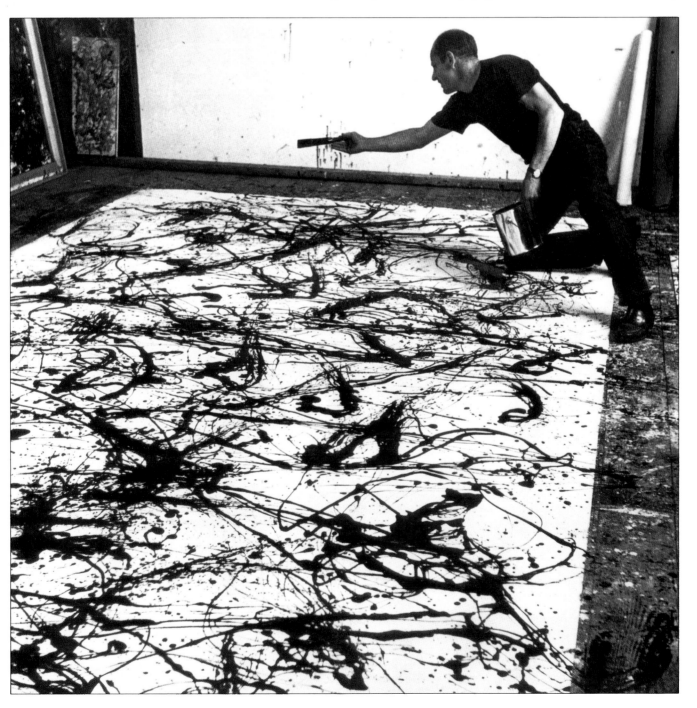

poets whose works are recited everywhere, part of ongoing ordinary life. Both men were poets, but Borges is much better known for his disquieting prose, a series of stories written chiefly between 1941 and 1957, in which familiar thoughts and gestures become very strange and dislocated (a selection was published in French as *Labyrinthes* in 1953 which established his international reputation). Neruda's *Residence on Earth* (1933, 1935, 1947) and *Canto General* (1950) are lyrical celebrations of places and moods, poetic concentrations of history and memory, which recall and develop the work of Walt Whitman.

In spite of these real differences, Borges and Neruda do belong together, because they were both liberators of the imagination. They provided the chief grounds for what came to be called "magic realism", since they dramatized the fragile, provisional nature of what is called reality and evoked the wonders of a world which has traditionally been beyond the reach of the westernized mind. Borges's brief fictions hinted at

New Homes for Modern Art

In 1929, New York's Museum of Modern Art (MoMA) was set up, to allow modern work to be displayed permanently, but free from any direct association with the art of the past. In the postwar period several important new buildings were constructed for this purpose, redefining the role of the art gallery. Philip Johnson's design for MoMA (1951) allowed for the museum to be used as a social as well as a cultural center, while the Guggenheim Museum (1957), also in New York, designed by Frank Lloyd Wright, exemplified the dominance of the architect's vision over the works of art on display, forcing the viewer to experience them in a particular order by placing the entire exhibition space on a spiral ramp. Other important postwar museums for modern art were built in Humlebaek, Denmark (1958), and Otterlo, Netherlands (1953).

▼ **The Guggenheim Museum, New York.**

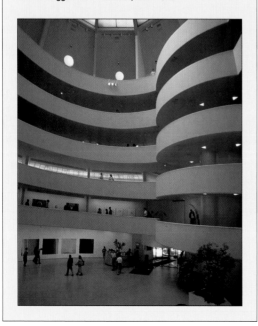

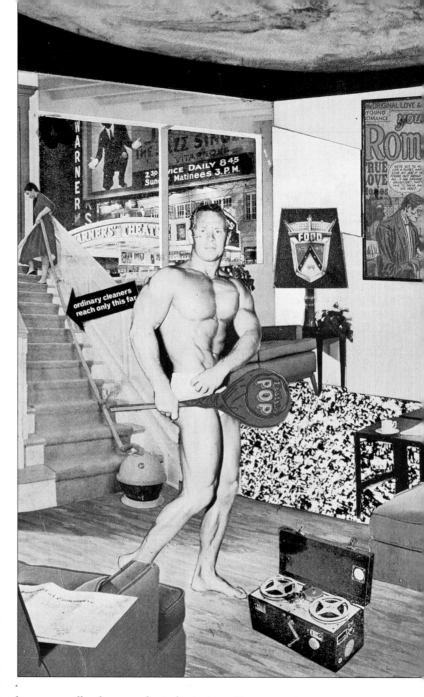

longer, endlessly complicated stories. He reviewed imaginary novels, rewrote old texts from new points of view. He pictured the universe as a vast library on one of whose shelves stands the book (but no one will ever find it) which answers all questions; invented an encyclopedia of which one copy only describes an entirely unknown country; described a man whose memory is so perfect that it retains every tiny detail and event, and therefore makes it impossible for him to think, since "to think is to forget differences". Borges wrote science fiction in an extended sense; fiction which examined the (often untested) hypotheses we take for truths.

Neruda's many love poems are memorable, and perhaps no other poet has moved so easily or so securely from Surrealism to a kind of epic loyalty to the world as it is. "The blood of children", Neruda wrote in a poem about the Spanish civil war, "ran simply in the streets, like the blood of children" – no poetic simile will suffice, because nothing is *like* the blood of children

▲ *Just What is it That Makes Today's Homes so Different, so Appealing?* (1956) by Richard Hamilton. Hamilton's iconic image was one of the first Pop art works, and summed up many of the movement's themes and methods. The use of collage and the satirical attack on consumer values all link the movement with Dadaist tactics 50 years before. The Pop artists reacted against the apparent divorce between the tastes of the public and the art market, which had taken Abstract Expressionism to its heart and wallet. They pointed to a parallel between the crassness of public taste and the greed of private collecting. They were also simply enjoying the rich vulgarity of modern society.

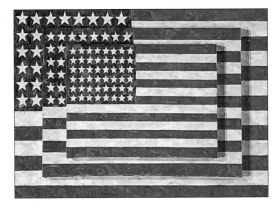

except that blood itself. But Neruda's masterpiece is the section of *Canto General* called "The Heights of Machu Picchu". Machu Picchu was an Inca city, its ruins therefore a trace of a splendid South America before the Spanish Conquest, and Neruda takes the site as the focus for a spectacular meditation on history and possibility. "Stone upon stone", Neruda wrote, "but where was man?" The answer lies in the thought of suffering and solidarity: across the "confused splendor" of these ruins Neruda was able to hear the forgotten heart of those who built and lived here. Calling their names, he revived what he saw as a submerged America, a past which is also a promise for the future: "The dead kingdom is still alive."

Political theater in Europe and the United States
In Europe and in the United States, the late 1940s and the 1950s saw a theatrical resurgence. After a period of repression and artificiality, there emerged a new and forceful movement that owed much of its vigor to one man: Bertolt Brecht. Much of Brecht's important work had been done before and during World War II, when he was in exile in the United States, but the years of his influence and fame came a little later. Brecht was a great director as well as an original and powerful writer, and in the 1950s his Berliner Ensemble offered performances that altered the whole course of theater history. Brecht's example became a dominant force in French, English and American theater, and remains so today.

"We need a theater", Brecht wrote in 1948, "which not only expresses the sensibilities, insights and impulses of a particular historical field, but uses and brings into being the thoughts and feelings which play a role in the alteration of the field." Brecht's early plays borrowed much of their atmosphere from German Expressionism, but his enormously successful *Threepenny Opera* (1928) looked forward to what Brecht was to call "epic theater". Epic theater offered audiences not the illusion of reality but a glimpse into the illusion's construction. His plays were littered with invitations to what he named the "alienation

effect", a whole string of devices designed to locate the audience in the theater and the theater in the hard historical world. Posters, music, stage-hands wandering on stage, actors stepping out of their parts all serve to remind us that a play is a vision of reality and not a mere copy of it; and that reality itself is made by men and women and can therefore be changed. Brecht's major plays, *Mother Courage* (1939), *Galileo* (1939), *The Good Person of Setzuan* (1940) and *The Caucasian Chalk Circle* (1945), explore the themes of war, greed, knowledge, kindness and oppression.

Brecht's influence in France was transmitted through Jean Vilar at the Théâtre National Populaire, and through the theoretical writings of Roland Barthes. In Britain, the Royal Shakespeare Company put on memorable Brecht productions, notably of *The Caucasian Chalk Circle*, and a generation of British dramatists including John Arden, Edward Bond and David Edgar brought Brecht's mixture of historical reflection and political urgency to bear on issues of the 1960s and 1970s. In the United States, much of the Brechtian work was done by Brecht himself, with the actor Charles Laughton directing and starring in an impressive 1947 production of *Galileo*, a play which acquired a new timeliness with the invention of the atomic bomb. If Galileo had managed to withstand the Inquisition, Brecht suggested, then the physical sciences might have evolved

▶ ▲ *Three Flags* (1958) by Jasper Johns. Johns worked in series, employing extremely familiar cultural images. His technique in reproducing these images could be extremely sensitive and individual, but this only heightened the viewer's disorientation. He challenged us to determine whether anything can really be esthetically "worn out".

▶ *Brooklyn Gang* (1959) by Bruce Davidson. Images like this fill the prose of Jack Kerouac and the poems of Allen Ginsberg. The Beat Generation all refused the standards of the literary establishment, disappearing on endless car journeys, bouts of drug-taking, alcohol abuse and Eastern mysticism.

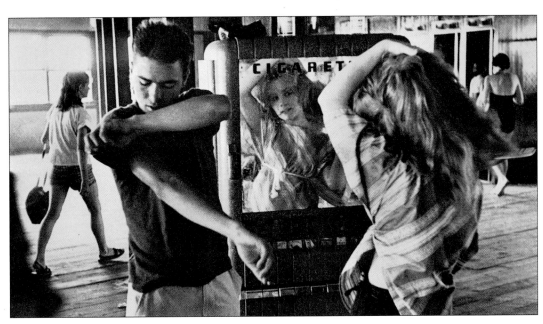

One day you'll say to yourself, I'm tired, I'll sit down, and you'll go and sit down. Then you'll say, I'm hungry, I'll get up and get something to eat. But you won't get up. You'll say, I shouldn't have sat down, but since I have I'll sit on a little longer, then I'll get up and get something to eat. But you won't get up and you won't get anything to eat. You'll look at the wall a while, then you'll say, I'll close my eyes, perhaps have a little sleep, after that I'll feel better, and you'll close them. And when you open them again there'll be no wall any more. Infinite emptiness will be all around you, all the resurrected dead of all the ages wouldn't fill it, and there you'll be like a little bit of grit in the middle of the steppe.

SAMUEL BECKETT,
ENDGAME, 1958

► *Mother Courage*, as produced by the Berliner Ensemble. Bertolt Brecht returned to Germany from the United States in 1949 with his wife, the actress Helene Weigel. Together they set up the Ensemble in order to put on the big plays he had brought back from his exile, including *Galileo* and *The Good Person of Setzuan*. All his theories of theater were to be put into action. Brecht was suspicious of the emotional spectacle of drama; he wished his audience to be able to think about the issues his work raised. So great emphasis was placed on the clarity of the *Fabel* (story). As Brecht put it: "the individual events have to be knotted together in such a way that the knots are easily seen."

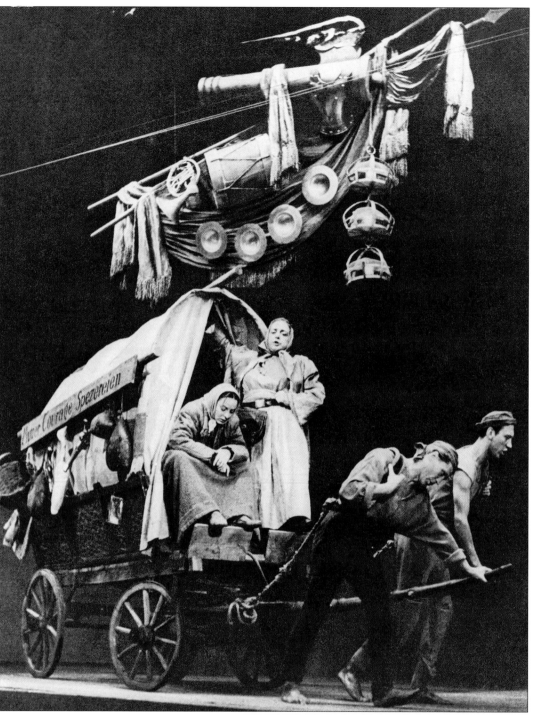

their own ethic, rather than launching themselves on the perpetual search for knowledge, whatever the cost to the planet and its inhabitants. But Brecht also understood Galileo's weakness under torture and in answer to a complaint about the ill-fortune of a country which doesn't have the heroes it needs, has Galileo memorably say that a really unfortunate country is one which *needs* heroes. Brecht's theater promised an epic for ordinary, non-heroic men and women, a future not just for the stars but for history's mass of extras.

The master of Modernism: Samuel Beckett

If Brecht's vision was of a theater deeply concerned with understanding as a means to political and social change, Samuel Beckett might be seen as using the theater as a means to search for a much more personal and internalized understanding of the mind's solitude. "Life", a character is reported as saying in one of Beckett's novels, "is a thing of a beauty and a joy for ever." Another character, learning of this ripe and comfortable cliché, is slightly puzzled; pauses and then asks his companion, "Do you think he meant human life?" The joke is casual and dark and deep, a glance at despair which manages to find even despair grimly comic, or at least as absurd as hope; and this effect is Beckett's signature in the theater and in prose fiction. In this, as in other respects, he is Franz Kafka's heir.

Born near Dublin in 1906, Beckett went in the late 1920s to Paris, where he formed a lasting

and no means to express it with – though this is itself an expressive formulation, of course.

Beckett's masterpiece of prose fiction is his trilogy – *Molloy*, 1951; *Malone Dies*, 1951; *The Unnamable*, 1953 – a series of novels in which a set of tramps and finally an anonymous speaking self are haunted by memories which progressively lose their shape and their connection to old emotions. His high international standing, however, rests on his theatrical works, notably *Waiting for Godot* (1952–55), *Endgame* (1956), *Krapp's Last Tape* (1958) and *Happy Days* (1961). Here his crippled and querulous, yet often very funny, characters engage in tussles with words and meaning and death. Beckett, along with Brecht, is the great renovator of the modern theater, because he found unforgettable images for our contemporary disarray. "We are not very reliably at home in the interpreted world." said the Austrian poet Rainer Maria Rilke in his *Duino Elegies*. Beckett's vagrants are not at home anywhere, and "home" itself is a ragged and uncertain memory.

Perhaps Beckett's most important, most vital trait, the spark of life in all the drifting toward death, was his restless formal experimentation. Beckett wrote novels, poems, short stories, plays of all lengths for the theater, radio plays, television plays, a film, plays without words, words without action. What these works all reveal is an extraordinary artistic curiosity about their particular medium. Beckett not only made the various media work for him, he incorporated their characteristics into the thematic concerns of each piece. His plays, whatever their subjects, are also about seeing and hearing; his novels are about reading; his film is about watching and being watched.

◄ *Not I*, by Samuel Beckett, Billie Whitelaw in a 1973 production. Beckett's trajectory towards silence made ruthless demands on audience and performer alike. By *Not I* the role of the actor is reduced to a mouth in a spotlight. Earlier he had deconstructed the conventional novel in *The Unnamable*, dispensing with events, memories, even paragraphing. His plays abandoned plot and character development. Like the paintings of Francis Bacon, this seemed the typical work of an agonized age, but, as the rest of Europe recovered, Beckett continued his unrelenting voyage.

friendship with James Joyce. Having produced some striking early work in English (*More Pricks than Kicks*, 1934, *Murphy*, 1938), he began to write in French, later translating the material himself into English, perhaps partly because he admired the French writer Marcel Proust; indeed, he wrote by far the best early book on that author (1931), in which he mapped out many of his own themes to come: solitude, habit, anxiety, silence, writing. French was also the language of Descartes, of a supposedly ideal philosophical clarity, and therefore offered Beckett the perfect mocking vehicle for his muddled heroes, all the lucidity they could never hope to handle. His comedy is essentially intellectual knockabout: characters fall over ideas in the way that expert circus clowns fall off their bicycles. Beckett said more than once that being a modern writer (or his kind of modern writer) involves both the obligation to express and the acknowledgment that there is nothing to express

Italian Neorealist Film

In the cinema, a new kind of realism grew up after World War II. Luchino Visconti's *Ossessione* (1942), a compelling thriller, signaled a move away from the sanitized cinema enforced by Fascism, but it was Roberto Rossellini's *Roma Città Aperta* (1945) that was recognized as the movement's first film. The new realism portrayed dark or neglected patches of the ordinary world. Characteristically, neorealist films were shot on location and made use of documentary techniques; they often used nonprofessional actors, especially children. Vittorio da Sica's *Shoeshine* (1946) and *Bicycle Thieves* (1948), the latter a particularly haunting story of a father and son scouring a minutely observed city for a stolen bicycle, typify the genre. The aim was not simply to record, but to awaken the conscience of the viewer. Such films were at times a little sentimental, but their directors understood how much the unaided image can convey. The movement spread worldwide and was modified by directors outside Italy. In Mexico, Luis Buñuel's *Los Olvidados* (The Forgotten) of 1950 emphasized the subjectivity of the observer as well as the plight of the observed. In India, Satyajit Ray introduced a reflective mood into the Calcutta of *Pather Panchali* (1955).

▶ *La Strada*, directed by Federico Fellini, 1954.

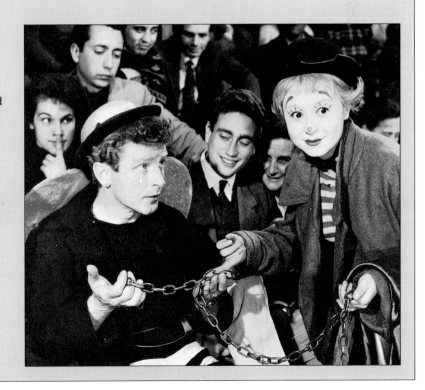

► *Red on Maroon* (1959) by Mark Rothko, one of a series orginally intended for the Four Seasons Restaurant in the Seagram Building, New York. Rothko's art was environmental in inspiration: it was intended to convey a certain atmosphere to the viewer, usually meditative. However, this may not have been Rothko's intention here. Irritated at the ostentatious wealth of the restaurant's clientèle, he is reported as saying he would "ruin the appetite of every son of a bitch who ever eats in that room".

▲ A Messiaen score. The French composer Olivier Messiaen allowed himself to be influenced by a large number of different musical sources, including the serialism of Schoenberg, Hindu music and birdsong. His eclecticism had an enormous influence on younger composers. Boulez and Stockhausen both studied with him.

► Messiaen notating birdsong. Messiaen developed a great interest in birdsong, which showed itself in a number of works composed during the 1940s and 1950s, especially *Réveil des oiseaux* for piano and orchestra (1953), *Oiseaux exotiques* for piano, wind and percussion (1955–56), and *Catalogue d'oiseaux* for piano (1956–58).

When I hear music, and also when I read a score, I see internally, with the mind's eye, colors that move with the music.

OLIVIER MESSIAEN, 1967

Postwar music in Europe

In Europe after World War II, composers and musicians paid tribute to those who had suffered and died, and began to search for new methods of expression in the postwar world. The Polish composer Krzystof Penderecki wrote his *Threnody for the Victims of Hiroshima* in 1960. His natural tendency to dramatic Expressionism and his taste for advanced compositional techniques found a passionately expressed outlet in this work for 52 strings. Arnold Schoenberg's *A Survivor from Warsaw* (1947) is his tribute to all who died under Nazi persecution. It is a six-minute evocation of a story reported by survivors of the Warsaw ghetto. A group of Jewish prisoners, beaten and forced to count out their own numbers for the gas chamber, spontaneously started singing the Hebrew song of triumph, "Shema Yisroel". A narrator figure, not unlike the solo performers of Schoenberg's earlier *Pierrot Lunaire* or *Erwartung* recounts the tale against agonized and militaristic accompaniment. The English composer and pianist Benjamin Britten toured the concentration camps at the end of the war with violinist Yehudi Menuhin, giving recitals for the survivors. He returned to England and wrote *The Holy Sonnets of John Donne* within a fortnight. It is an arrangement of nine of the 17th-century English poet John Donne's religious sonnets, which moves toward something between reconciliation

and resignation: death can finally be braved through redemption.

In Italy, the composer Luigi Dallapiccola was politically awakened by Mussolini's Ethiopian campaign and the Spanish Civil War. Profoundly antifascist, he was often obliged to go into hiding during the war. His opera *Il prigionero*, set in 1570 in the dungeons of the Spanish Inquisition, was his response to this period and his recognition of all those who had offered resistance.

In the search for resolution, the English composer Michael Tippett turned inward to Jungian psychology. His great wartime choral work, *A Child of Our Time*, moved out from a particular experience of oppression and violence into a concern for all who are "rejected, cast out from the center of our society", and ended with a difficult optimism: "I would know my shadow and my light." His ensuing operas, whose music and ideas are complex and challenging, were concerned with the outer chaos that results from inner imbalance. Before the lovers of *The Midsummer Marriage* (1955) can unite, they must cast off "our ignorance or illusion about ourselves".

A new musical language: serialism

After World War II there was a general need to rediscover a coherent musical language. Serialism, first explored by Schoenberg, Berg and Webern in the 1920s, seemed to answer that need. It was above all un-Romantic and non-emotional, yet it also allowed great freedom of individual expression. As a method of composition, serialism is usually understood as a particular organization of the twelve notes of the chromatic scale so that each appears only once. This apparently arbitrary arrangement can then take the place of the scale or mode in the process of composition. Instead of the inner relationships of the different notes of the scale, which produce subtly different responses in the listener, the given intervals of the series (note row or tone row), which can be manipulated forwards, backwards and upside down, carry something of the same "meaning" for the listener. It is debatable how readily the ear can register such a scheme. However, the most successful of serial compositions certainly achieve a coherence due to their method of composition, whether or not the listener is capable of sensing exactly how that coherence is being communicated.

The center for debate and performance for new music – particularly for the serialists – during the 1950s was Darmstadt, where Wolfgang Steinecke had set up a summer school in 1946. Many of the most innovative postwar composers have at some time been associated with the Darmstadt summer school, including Babbitt, Berio, Boulez, Cage, Henze, Ligeti, Maderna, Messiaen, Nono, Pousseur, Stockhausen, Varèse and Xenakis. The career of Pierre Boulez is typical. Composer, conductor and theorist, he has a strong background in mathematics, has produced serial and nonserial works and has been involved in new developments in electronics. Particularly as a young man, his approach to music was ascetic and puritan; he constantly sought the scientific, logical approach to the production of sound.

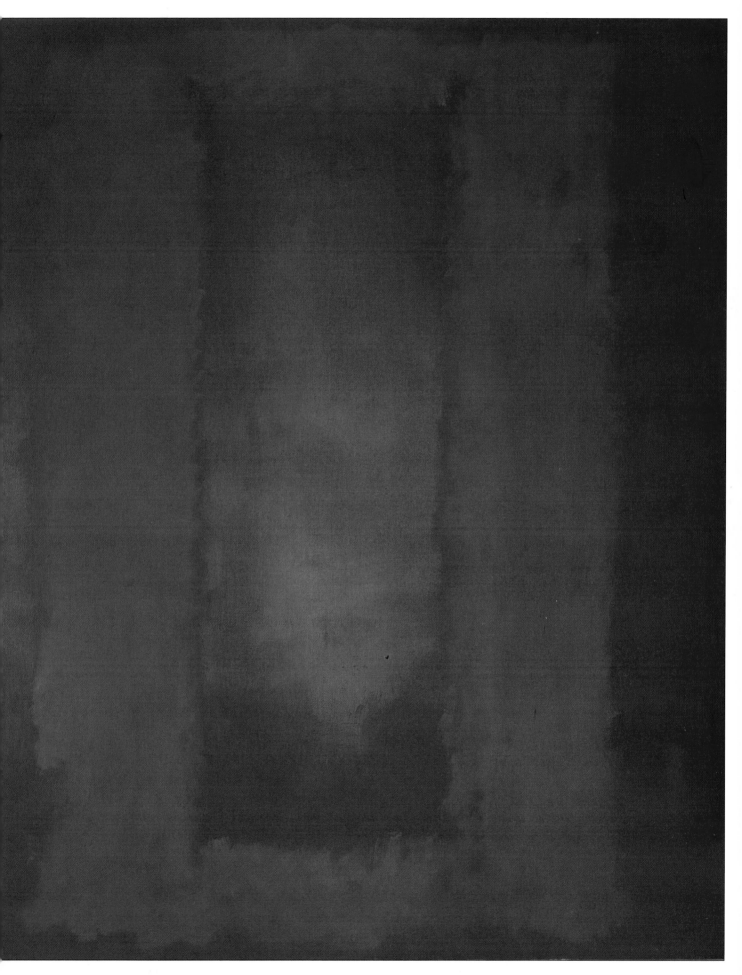

Dance and Chance: Merce Cunningham

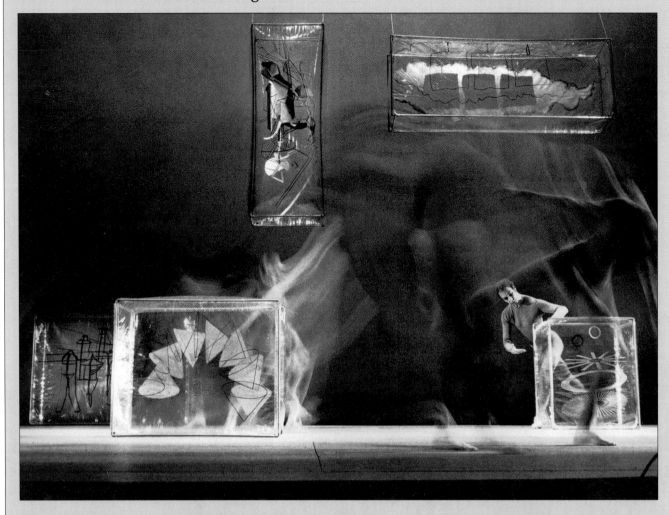

▲ **Merce Cunningham in** *Walkaround Time* **(1968). The set design is by Jasper Johns, based on** *The Large Glass* **by Marcel Duchamp. Cunningham had worked with John Cage since the early forties, and, as Cage had said, "one way to write music: study Duchamp."**

▶ **Merce Cunningham (plus chair) in** *Antic Meet* **(1958). Cunningham was translating John Cage's musical theories into his own medium: dance. As Cage had argued that noise was music, so Cunningham expanded his dancers' physical vocabulary to include their ordinary gestures.**

Merce Cunningham began his career as a dancer with Martha Graham's company, yet when he started choreographing in the late 1940s his attitude to dance was completely different from hers. Graham believed that movement ought to be motivated by some sort of emotional expression, but Cunningham argued that dance could be about itself and that the subject of his works was simply the movement out of which they were created. Cunningham's style was unusually eclectic. He ignored the classical/modern divide in his approach to the body, mixing the free curving torso of modern dance with the high leg extensions and fast, rhythmic footwork of ballet. Cunningham was also intrigued by the contribution that methods of composition involving chance could make to his work. He tried tossing coins to determine the order of a movement sequence, or marking the imperfections on a piece of paper to decide the dancers' path through space. In another radical break with tradition, he rejected the notion that dance, music and design should be united in one carefully orchestrated spectacle, leaving his composers and designers almost complete freedom of creation, and often bringing the three elements together as late as the dress rehearsal or first performance. Cunningham's main reason for refusing to follow the usual process of collaboration was that he remained in total control of the choreography. But he also felt that the work was more "interesting" if the relation

between the three elements was governed by accident, since this allowed the viewer to read whatever he or she wanted into the final product. This playful approach to meaning, reminiscent of John Cage's approach to composition, had a huge influence on later dancemakers. Working with composers such as Cage and artists such as Robert Rauschenberg and Jasper Johns, Cunningham took modern dance into the sophisticated milieu of postwar American abstract art.

In common with other composers of his generation, Boulez was extraordinarily influenced by Messiaen's piano work, *Modes de valeurs et d'intensités* (1949), when he heard it at Darmstadt in 1951. The work extends the ideas of serialism to aspects of composition other than pitch. Duration, volume and "intensity" are governed by a hidden sequence. Boulez, who had studied with Messiaen in Paris, had been experimenting along similar lines in his Second Piano Sonata (1948). Its four-movement form takes Beethoven as its reference and its instructions to the performer – *encore plus violent, pulveriser le son* – indicate the degree of violence underlying the first and final movements. By the time of his major work of this period, *Le Marteau sans maître* (1953–55), Boulez was able to use serialism as a compositional tool rather than an inflexible *diktat*.

Like Boulez, Karlheinz Stockhausen, who was born near Cologne in 1928, had experimented with total serialism and developed his own variation of the techniques. Also like Boulez, he had access to his national radio's *musique concrète* studios. His *Gesang der Jünglinge* (1955–56) was a highly sophisticated treatment of electronic resources. An electronically transformed boy's voice singing the *Benedicite* is combined with sounds generated purely electronically. A little later he was beginning to experiment spatially as well. *Gruppen* (1955–57) surrounds the audience with three separate orchestras. This allowed Stockhausen to employ different tempos simultaneously and also opened up the dramatic possibilities of the relationship between performer and listener.

The use of serialism has varied from the extremely rigid to the relatively free. In the United States Milton Babbitt, another mathematician, has pioneered ways of considering composition and usefully adopted terms and concepts from mathematics to enable clear analysis of serial works. In Italy Bruno Maderna and Luigi Nono, in their different ways, extended serialism by softening its tendency to aridity and sterility. Maderna's *Composizione in tre tempi* (1954) took Italian popular songs as its basis. Nono's Communist political beliefs led him to seek ways of responding musically to social events. The *Epitaffio per Federico García Lorca* and *La Victoire de Guernica*, for which the choral material is derived from the Internationale, both loosen the bonds of strict serialism to express considerable emotional passion and political commitment.

Fishermen catching sounds

A totally different approach was that of the American, John Cage, long the apostle of chance in composition. Cage set-up process after process to circumvent not only the conscious mind and its desire for order and predictability, but the devious pattern-making of the unconscious mind as well. His approach is both seriously philosophical – it has its roots in his study during the 1940s of Eastern thought and Zen Buddhism – and enormous fun. The only purpose he could find for writing music in 1957 was "purposeless play". He continued: "This play, however, is an affirmation of life – not an attempt to bring order out of chaos nor to suggest improvements in crea-

tion, but simply to wake up to the very life we're living." It is indeed possible to look at Cage's creative methods and to see how the situation he sets up might lead toward a sharpening of perception in an audience, not simply of the work in question, but of their own existence. His major concern was with awareness.

The most famous, or notorious, of all his musical pieces contained no planned sound at all. *4'33"* (1952) is a work for any instrument or combination of instruments. The "music" is the aural experience in the concert hall or performance space occuring during that length of time. Although the première was greeted with amusement and outrage, Cage was delighted. The Maverick Hall, Woodstock, opened on to woods and during the first movement there was the sound of wind in the trees; during the second, the patter of rain on the roof, and during the third, the confused mutterings and gigglings of the audience. *Imaginary Landscape No. 4* (1951) is a four-minute piece for 12 radio receivers. The musical material is anything that might come out of the speakers: a broadcast, static or silence. Each radio is "played" by two performers, one responsible for the tuning and the other for the volume and tone. It was a gentle assault on taste, expectation and tradition. The musicians were, for Cage, "like fishermen catching sounds".

▼ John Cage with D.T. Suzuki. Suzuki was the author of a number of books introducing Zen Buddhism to the West. Cage was only one of the American writers and musicians profoundly influenced by Zen. The Beat poet Gary Snyder, for instance, also spent periods studying in Japan. Cage's *Music of Changes* was dependent on the *I Ching*, or Chinese book of Changes, for all the elements of its composition. However, his total surrender to the *Tao*, or way of things, meant that Cage established a relatively predictable pattern, like that of a kaleidoscope, in which all the possibilities turn out to be interesting.

ART AND ABSTRACTION

Abstraction is a manner of painting in which the subject is not represented in a realistic way. Instead the artist seeks to erode or evade the observable facts of life, to abstract from them, so as to arrive at a pattern of shapes, volumes, color and line that is interesting for its own sake, without any necessary reference back to any external source. Abstraction has been a dominant mode of art in the 20th century. It has offered a means of resisting the pervasive materialist view of the world. It is at the same time partly an echo of the extremely abstracted world of basic matter that modern science has presented. And it has also been used, in part, as an individualist resistance to common symbols. The abstract artist's symbols must be individually achieved, outside normally accepted definitions.

Cubist paintings by Picasso or Braque are rarely absolutely abstract since the figures in them, though drastically broken down into their underlying forms, are usually apparent, held in the planes and volumes of the design. Closer to the ideal of nonrepresentation is the work of Piet Mondrian, in which a grid of black lines on a white ground provided spaces, some of which Mondrian chose to block in with primary color. The method he used is geometrical rather than organic.

An extreme abstraction was that explored by Kasimir Malevich in the 1910s, culminating with the white square on white background, an object of contemplation like a Russian Orthodox icon.

Another approach to abstraction, first practiced by Wassily Kandinsky, was to paint "ideas" which do not manifest themselves in nature. Similarly – and this was the case with some American Abstract Expressionists, like Jackson Pollock – the means of delivering the paint to the picture surface, in apparently free, even random, ways could result in nonrepresentational painting. Some Abstract Expressionists however were concerned with arriving at their paintings in a more contemplative manner, so that the abstract qualities of the works seem to derive not from random action but through the artists' emotion or vision. Mark Rothko's huge canvases are examples of that.

Another American painter of the 1950s and 1960s, Morris Louis, removed the gestures and human intrusion of Pollock's methods, as well as any suggestions of emotion, by a further refinement in pursuit of "pure" painting. By tipping much-diluted acrylic paint down a sloped, untreated canvas he achieved paintings of such surface thinness that they have no texture other than that of the canvas. The flow of colors, interacting one with another only at their edges, formed shapes so undifferentiated as to resist interpretation. All that exists in the painting is delicately interacting color, without idea, rather like the original color chart of all painting, presented so large – *While* is 2.4m x 3.3m (8 x 11ft) – as totally to occupy the viewing eye.

▶ *While* (1959), by Morris Louis.

Datafile

The term "the Jazz Age" took on a different meaning in postwar America as the bebop movement began to restructure music hitherto considered "popular." Influenced by Charlie Parker, saxophonists like Dexter Gordon and Sonny Rollins began playing themselves into the role of the artists, a practice which led to a great deal of self-destructive behavior. In Africa itself, thanks in some measure to funding from sympathetic Europeans like Ulli Beier, painters and sculptors were beginning to establish an indigenous cultural indentity. In Mozambique, for instance, Malangatana Valente was expressing the conflict between Christianity and his traditional beliefs in violent paintings.

▼ Wifredo Lam, the Chilean painter, is one example of the circuitous routes by which black culture defined itself. His painting, enormously influential in Africa, is in fact based on his South American subject matter and experience. It is also strongly influenced by Picasso. The aspects of Picasso that appeal to Lam are, naturally, the influence of African traditional art on his early Cubist style. Eventually an individual art appeared.

Nobel Prize for Literature	
1945	Gabriela Mistral (Chile)
1946	Hermann Hesse (Switzerland)
1947	André Gide (France)
1948	T.S. Eliot (UK)
1949	William Faulkner (USA)
1950	Earl Bertrand Russell (UK)
1951	Pär Lagerkvist (Sweden)
1952	François Mauriac (France)
1953	Sir Winston Churchill (UK)
1954	Ernest Hemingway (USA)
1955	Halldór K. Laxness (Iceland)
1956	Juan Ramón Jiménez (Spain)
1957	Albert Camus (France)
1958	Boris Pasternak (USSR)
1959	Salvatore Quasimodo (Italy)

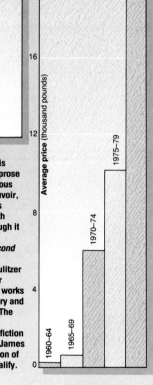

Wifredo Lam sales

▲ The award to Gabriela Mistral, the Chilean poet, was the first to be given to a writer outside the "First World". More typical perhaps was the award in 1953 to Winston Churchill for his historical writings and his "brilliant oratory in defending exalted human values". Another political gesture was the award in 1959 to Boris Pasternak, essentially for *Doctor Zhivago*, which had been banned in the Soviet Union. Pasternak, still as intent on survival as on not compromising, declined the prize.

▼ The Prix Goncourt is awarded for works in prose published in the previous year. Simone de Beauvoir, who won in 1954, was closely associated with John-Paul Sartre, though it is for her pioneering feminist work *The Second Sex* (1949) that she is principally famous. Pulitzer prizes are awarded for plays, novels, poetry, works on United States history and American biography. The award for novels was redefined in 1947 to "fiction in book form" so that James A. Michener's collection of short stories could qualify.

Major literary prizes		
	Prix Goncourt	Pulitzer Prize for fiction in book form
1945	J.L. Bory *Mon Village a l'heure allemande*	John Hersey *A Bell for Adano*
1946	J.J. Gautier *Histoire d'un Fait divers*	No award
1947	Jean-Louis Curtis *Les Forêts de la nuit*	Robert Penn Warren *All the King's Men*
1948	Maurice Druon *Les Grandes Familles*	J.A. Michener *Tales of the South Pacific*
1949	Robert Merle *Week-end à Zuydcoote*	James Gould Cozzens *Guard of Honor*
1950	Paul Colin *Les Jeux sauvages*	A.B. Guthrie *The Way West*
1951	Julien Gracq *Le Rivage des Syrtes*	Conrad Richter *The Town*
1952	Béatrix Beck *Léon Morin, prêtre*	Herman Wouk *The Caine Mutiny*
1953	Pierre Gascar *Le Temps des morts*	E. Hemingway *The Old Man and the Sea*
1954	Simone de Beauvoir *Les Mandarins*	No award
1955	Roger Ikor *Les Eaux mêlées*	William Faulkner *A Fable*
1956	Romain Gary *Les Racines du ciel*	MacKinlay Kantor *Andersonville*
1957	Roger Vailland *La Loi*	No award
1958	F. Walder *St-Germain ou la négociation*	James Agee *A Death in the Family*
1959	A. Schwartz-Bart *Le Dernier des justes*	R.L. Taylor *The Travels of Jamie McPheeters*

The story of the arts in the 20th century has been inextricably entangled with politics, and this is nowhere more true than it is for black culture. The emergence of a specifically "black" consciousness has been a complex process, involving strands not only from Africa but from all the countries of the black diaspora – the United States, the West Indies, South and Central America – as well as the traditional imperial centers of France and Britain. Out of oppression and exploitation, black culture has fashioned new and unique forms of expression, in painting and sculpture, in literature, in music and in dance.

As early as 1914, the charismatic Jamaican Marcus Garvey advocated the establishment of a self-governing black nation, not in Jamaica but in Africa. In New York's predominantly black Harlem district Garvey audaciously called for a self-sufficient black economy within the white economic framework. He was eventually deported from the United States in 1927, but his ideas had considerable influence on the black writers of the so-called Harlem Renaissance, whose assertion of the beauty of the black soul in the 1920s and 1930s helped foster not just a sense of nationalism, but a universal feeling of "blackness".

Equally important were the ideas of "Negritude" of the French-speaking black writers, Léopold Senghor from Senegal and Aimé Césaire from Martinique. At first sight they both seemed to have a mystical awareness of black civilization, more inspirational than practical, but in fact both men were involved in practical politics: Césaire served in the French parliament and Senghor was to become the first president of independent Senegal in 1960. Their politics transcended race, though. In Senghor's words, they looked forward to "the civilization of the universal" in which black culture would play a full role. Césaire's most famous work, *Return to my Native Land* (1939), celebrated the Negro "from the depths of the immemorial sky". As he wrote: "In the whole world there is no poor fellow lynched, / No poor man tortured, in whom I am not / Murdered and humbled." Senghor's poems appeared in a succession of volumes throughout the 1940s and 1950s, while he was active in politics both in France, where he had fought in the Resistance during World War II, and in Senegal.

Compared with the strong note of universalism in the work of the Negritude writers, the tone of African nationalist writers working in English tended to be much more down to earth. In the complex situation of South African writing, with its range of languages each indicating a social division, nearly all writing was conditioned by the inhumanities of the system of apartheid. When *Drum* magazine was founded in 1952, it provided an outlet for black and "colored" or

AFRICA AND BLACK CONSCIOUSNESS

mixed-race writers. Many of them concentrated on short stories that expressed life as they saw it. Both Ezekiel Mphahlele and Alex La Guma were contributors. La Guma's later novel *A Walk in the Night* (1962) told of murder, social injustice and police oppression, exact in all its detail, and Mphahlele's autobiography *Down Second Avenue* told the story of his life until he left South Africa in 1957. Some white writers too became involved in the struggle against apartheid. Doris Lessing (*The Grass is Singing*, 1950), Alan Paton (*Cry the Beloved Country*, 1948) and Nadine Gordimer (*Occasion for Loving*, 1963) all dealt with human relationships as South African society had constructed them.

Rethinking traditions: the visual arts in Africa

Much of the traditional power of African visual art had been undermined in the colonial period. Most of the forces applied to African societies by the West – in religion, trade or paternalistic administration – had tended to weaken the relationship between art and the spirit that was traditional in African life, and that was particularly exemplified by the traditional masks used in religious ceremonies. Western religions scorned the masks and statues as devilish or idolatrous, rather than recognizing their spiritual and functional position. New social orders modeled on Western lines altered the structure of the clans and villages where the masks had their place. Yet Western anthropologists and traders were only too eager to extract such "artifacts" for display in museums and exhibitions at home. Artists in Paris in the early years of the century much admired such masks, but totally failed to appreciate their significance. They were admired because their distortion and simplicity of form seemed to fit in with the aims of modern art and because sophisticated society hungered for the *frisson* of the "primitive". This view was misplaced, for as art the masks were not "primitive" but key elements in a longstanding social and artistic tradition. Nor was the African interest in them formal so much as spiritual and functional. The masks summoned spirits into the midst of society and were created by harnessing spiritual powers. They were channels of religious rather than simply artistic feeling, not something made to hang decoratively on walls but to bring out for sacred and socially fulfilling ceremonies. And as the African people became more Westernized, becoming in turn traders, believers or bureaucrats, so they too lost their grip on their ancestral spirit. By some at least the masks came to be regarded as "primitive" objects.

In the late 1950s and early 1960s a number of Europeans such as Frank McEwan in Rhodesia, and Father Kevin Carroll and Ulli Beier in

Nigeria, began to foster local art by opening schools, supplying materials or commissioning work. By this time they were not so much helping to repair a broken thread as inviting people to a new art, Western in its individualism but African in its styles. When Frank McEwen founded the Central African Art School in 1957 in what was then Salisbury, Rhodesia, sculpture had died out in the area, although it had once been a great center for carving. A mixture of generosity of spirit, enthusiasm and talent produced sculptors such as Nicholas Mukomberanwa and painters such as Thomas Mukarobgwa, and exhibitions followed in London, Paris and New York. In Nigeria, Father Carroll encouraged local people to produce objects for use in worship, and fine work came from the carvers Bamdele and Lamidi. Osagie Osifo's *Crucifixion in the Chapel* at University College, Ibadan, is in a style derived from the great Benin bronze tradition.

Also in Nigeria, Ulli Beier was very active in encouraging African artists and writers. In 1953 he started the magazine *Black Orpheus*, which published not only stories but also reproductions of work by African artists. Beier worked with a

▼ **Selbi Mvusi working on a sculpture. The South African artist Mvusi (1929–67) soared to fame on the strength of the painting *Parents of the World – Adam and Eve*, which depicted the primeval pair (accurately enough) as black. In the 1960s he lectured in Fine Arts in Nairobi.**

number of Nigerian writers in workshops at the Mbari Center in Ibadan, and Oshogbo. Along with his wife Georgina and the Austrian artist Suzanne Wenger, he also helped a number of distinguished artists to prominence. These included Asunu Olatunde, whose work in sheet aluminum had distinct traditional features, and Twins Seven-Seven, whose illustrations to Amos Tutuola's books were quite exceptional, perfectly catching their spirit. Artists in other African countries were also receiving encouragement to pursue their work. The Portuguese architect Amancio D'Alpoim Guedes encouraged Malangatana Valente to paint in Lourenço Marques (now Maputo), while others such as Ibrahim Salahi in the Sudan, Skunder Boghossian in Ethiopia and Jimo Akolo trained in Europe and the United States and became recognizably internationalist in style.

New writing out of Africa

As well as its importance in the revival of the visual arts in modern Africa, Nigeria also played a key role in the development of African writing in English. Such writing had two major themes: the particular qualities of African life, and the changes wrought in that life by Western intervention, together with the consequent difficulties of adjustment. In the main it is a literature based in

▲ *Initiation*, by Malangatana Valente. Malangatana, a Mozambiquean artist, evolved a powerful Expressionist style to depict his major themes. He was brought up a Christian in a culture still powerfully imbued with pagan spiritual values. His response to that repressed culture was to create a densely populated nightmare world. In this no natural event is without its supernatural, usually threatening, accompaniment.

▶ *King Cock in the Ibembe Forest*, by Twins Seven-Seven. Seven-Seven is an immensely assured and fluent artist. He was an early star of the Oshogbo School, West Nigerian artists whose work is rooted in Yoruba culture. His approach to its spirits and deities is inspired and playful.

◀ Suzanne Wenger working on a sculpture. Wenger, an Austrian, first went to Oshogbo in 1950, and began to integrate herself into the Yoruba religion. In the 1960s she was responsible for the restoring of a grove dedicated to the river goddess Oshun.

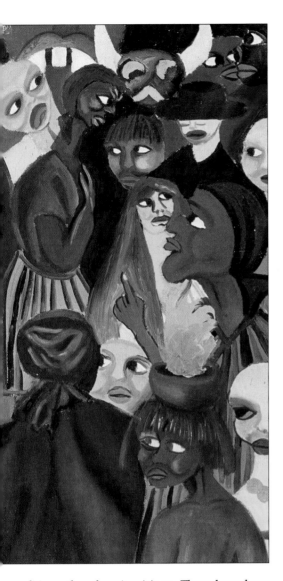

Missionary Society, Achebe could choose to use formal English, but he too inflected the language toward the rhythms of the proverb and the balance of the fable, as if his Ibo language were running like a current beneath the English words and could carry them off to a new realm. This was particularly marked in his books with a tribal setting such as *Things Fall Apart* (1958), the first of four novels that were to chart the crucial transformations in Nigerian society from the traumas of colonial life to the problems of independence and beyond. The title is taken from the Irish poet W.B. Yeats's poem "The Second Coming", which was written in the 1920s as he watched his own country's anguished independence struggle. Achebe's second book, *No Longer at Ease* (1960), mirrored the uncertainties of the years before Nigeria achieved independence. Both before and after the chaos that his country, split by the war of Biafran secession, experienced in the 1960s, Achebe maintained a strong sense of the writer's responsibility to help his people regain their dignity and self-respect, "all but lost in the colonial period", to show that dignity to the outside world and to help shape its development.

Achebe's near-contemporary, the playwright and poet Wole Soyinka, was educated in Nigeria

▲ Calligraphic painting, by Shilakoe. Since Islam forbids the representation of figures, much Muslim art has concentrated on the decorative. Artists like Shilakoe or Shibrain have developed this into a nearly abstract calligraphic art, where composition has triumphed over legibility.

realities rather than in visions. There have been marked differences in the degree to which writers have departed from African storytelling models and the use of fables and proverbs traditional to them, in the direction of Western styles. To write a novel was in itself to absorb a non-African form, but in many cases it proved possible to acclimatize it surprisingly closely to African method.

One of the first Nigerian writers to arouse international interest was Amos Tutuola, whose novel *The Palm Wine Drinkard* (1952) was a great hit when it appeared in England, though its popularity may have been on account of its piquant foreignness rather than in appreciation of the new ground it was breaking. All Tutuola's books involve quests, used as a way of stringing together myths and legends in an exotic English – a form that was the author's natural speech form, a legitimate and poetic extension of the range of spoken English. One of Tutuola's early admirers was the Welsh poet Dylan Thomas, himself deeply concerned with the possibilities that a deviation from ordinary language could offer the writer.

There could be no doubt about the ability of Nigeria's finest novelist, Chinua Achebe, to command whatever style of English he chose. Born in 1930, the son of a schoolteacher for the Church

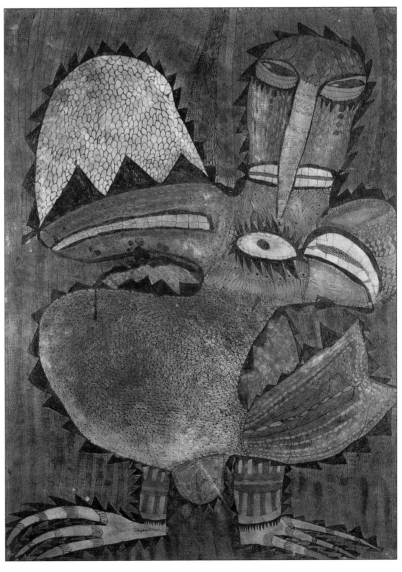

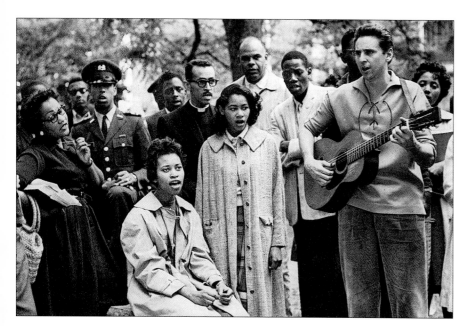

▲ Blacks and whites together sing protest songs in the United States. From the 1920s, through the pioneering achievements of Woody Guthrie to Bob Dylan, white radicals explored and borrowed from the blues tradition to express working-class grievances, developing a solidarity between white radicals and black people, and bringing much black oral culture to a wide public.

tion of the American black, torn between poverty and oppression. In 1947 Wright moved to Paris and later became deeply involved in Third World issues, seeing the black American experience repeated all over Asia and Africa in the wake of colonialism and industrialization. Both James Baldwin and Ralph Ellison, two major black writers of this period, met Wright and were encouraged by him before his death in 1960. Although both men resisted taking up a similar role themselves, Ellison spoke later of Wright as having turned the black impulse to "go underground" into a "will to confront the world".

Ellison's own reputation rests largely on one amazing book, *Invisible Man* (1952). Its young black hero lives in a "warm hole" full of light "confirming his reality". The light comes from 1369 electric light bulbs, the electricity illegally tapped from the resources of "Monopolated Light and Power". By these means he achieves invisibility, the condition for psychic survival. The need to take cover is clear in the sometimes comic, often horrifying narrative of his journey from the South to the North, seeking a visible role in the community with always at his back the message: "Keep this Nigger-Boy Running".

James Baldwin, on the other hand, has traced the theme of black and personal identity through a considerable number of books since *Go Tell it on the Mountain* was published in 1953. His subjects include black religion, the city and homosexuality – and inevitably, as the condition throbbing through black life, racism. In *The Fire Next Time* (1963) he speaks against separatism in the Black Muslim mold in favor of an integrationist love. He denies that "Hell is other people" as Sartre wrote, instead regarding people as the essence of the universe; and he laments "the inability of white Americans to renew themselves at the fountains of their own lives."

and England. He returned to Nigeria in 1960, producing his play *The Dance of the Forest* in celebration of Nigerian independence in that year. It showed considerable sense of theater, which grew in his work over the following years.

Black writing in the United States

As Nigerian writers responded to their situation with a pragmatic assessment of loss and gain, rather than the encompassing visions of the Negritude writers, so in the United States black writers of a new generation responded to the problems they experienced in their everyday lives by creating a new realism. Richard Wright's realist protest writing, particularly in *Uncle Tom's Childhood* (1938), *Native Son* (1940) and his autobiography *Black Boy* (1945), spoke for the situa-

▶ In the 1950s and 1960s several leading Western photographers went to Africa and produced images of traditional life that recalled the Western fascination with the myth of the noble savage. One notable example was the German photographer and filmmaker Leni Riefenstahl, whose images of the Nuba tribe were published in 1972. This image of Kao-Nyaro girls was taken by the American photographer George Rodger.

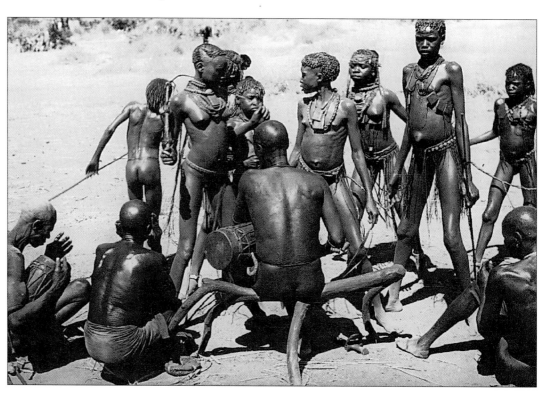

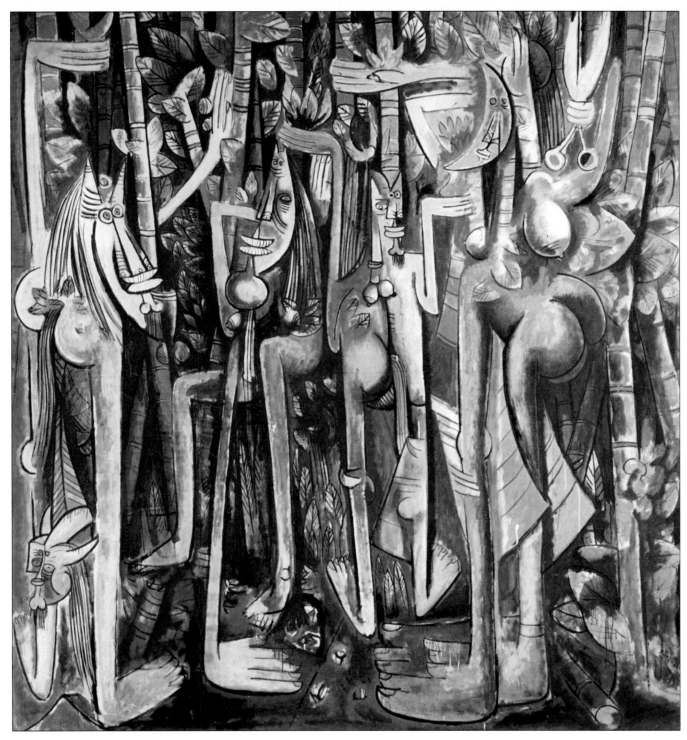

Meanwhile another episode in the story of black societies in their contacts with Western white society was unfolding in Britain, especially in London, as West Indian immigration built up after World War II, signaling a new thread in the fabric of English writing "at home". Two writers in particular, the Barbadian George Lamming and the Jamaican Andrew Salkey, wrote impressively out of their knowledge of two worlds.

Black dance and dancers

One of the most important moves toward a celebration of black culture in the United States came about in the 1940s and 1950s through the determined efforts of two women, both black and both accomplished dancers and choreographers: Katherine Dunham and Pearl Primus. Until the late 1930s, black dance in the United States had

never been seriously investigated. African-derived dances such as the Cake Walk, Snake Hips and Tap flourished on the popular stage, while dances like the Charleston, the Black Bottom and the Lindy Hop – all forms developed either by black dancers or by the crossover between white and black dance steps – dominated the dance halls of the Jazz Age. Dunham and Primus, who both had degrees in anthropology gained through research into Afro-Caribbean dance traditions, chose to use that research as a basis for staging sophisticated theater dance.

Dunham was perhaps more of a showperson, directing dance reviews like *Bal Nègre* and *Caribbean Song*, which combined popular numbers with fullscale black ballets. Her special interest was in ritual, and her *Rites of Passage* (1941), one of the first pieces ever to transfer African folk

▲ *The Jungle*, by Wifredo Lam. Lam, who has expanded from his Cuban base to absorb European Surrealism in both France and Spain, strongly influenced modern African painting. But his jungles were South American, whilst his Africanness extended to Haiti. His work was influenced by Picasso, but as he said, "what made me feel empathy with his painting more than anything else was the presence of African art and the African spirit that I discovered in it." As a result Picasso's *Demoiselles d'Avignon* can be seen peering through the trees. It is by such circuitous routes that black consciousness began to assert itself.

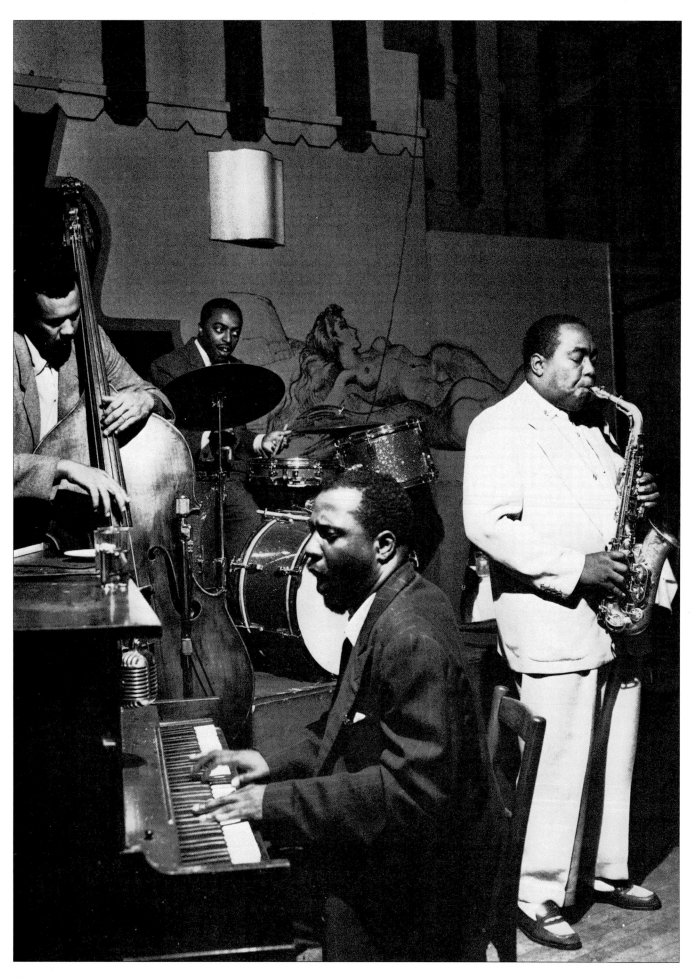

dance on to the conventional stage, depicted the course of a young man's initiation into tribal adulthood. The expressiveness of her choreography and her vivid use of costume prevented the works from being dry scholarly re-creations, and her shows reached a wide and enthusiastic public. Pearl Primus presented a less glamorous performing image and her dances were often concerned with the oppression suffered by black Americans; *Hard Time Blues* (1943), for example, spoke out against the harsh existence of the sharecroppers. Like Dunham, though, Primus also re-created dances and rituals from African and the Caribbean, such as *Fanga* (1949), which was based on a West African greeting dance.

Primus and Dunham not only paved the way for the wider cultural acceptance of black dance traditions, they also helped blacks to a similar wide acceptance as dancers and choreographers. In modern dance, the man who took most spectacular advantage of this was Alvin Ailey, a dancer who began performing professionally in 1950 with Lester Horton and started to create his own work in 1953. By 1965 he had retired from the stage to devote himself to his choreography and his company, the Alvin Ailey American Dance Theater, which was the first completely multiracial troupe in modern dance.

Ailey's repertoire was as mixed as his dancers. On the one hand he wanted to work with a genuine range of choreographers, black and white, so he acquired works by, among others, Anna Sokolow and José Limon. On the other hand, he wanted to celebrate his black heritage, and much of his own work was set to black music (blues, jazz, spirituals), mixed classical and modern dance with black steps and rhythms and dealt specifically with black themes. For instance, the company's powerful signature piece *Revelations* (1960), charted a communal religious journey from baptism, through despair, to salvation. What all the works in the repertoire had in common, though, was an exuberant theatricality and an electric energy. Ailey's sassy, athletic and dramatic dancers were as carefully trained to wow their public as any Broadway chorus line.

A far more difficult territory for black dancers to penetrate was classical ballet, but in 1956 Arthur Mitchell became one of the first black male dancers to join a world class company, New York City Ballet. His beautifully proportioned body and confident technique scotched any lingering prejudice that blacks were unsuited to classicism and he created the leading role in one of George Balanchine's greatest works, *Agon*.

Mitchell was aware, though, that his position was exceptional and in 1969 he opened a school in Harlem exclusively for black dancers. The resulting all-black company, Dance Theater of Harlem, made its official debut in 1971 and went on to develop a repertoire which mixed black work with a range of 20th-century ballets hitherto performed only by white dancers. Productions of *Paquita* and *Giselle* (effectively transposed to a Creole setting) also showed that the company was capable of handling the 19th-century classics.

Despite the best efforts of Mitchell and others, however, black dancers and choreographers re-

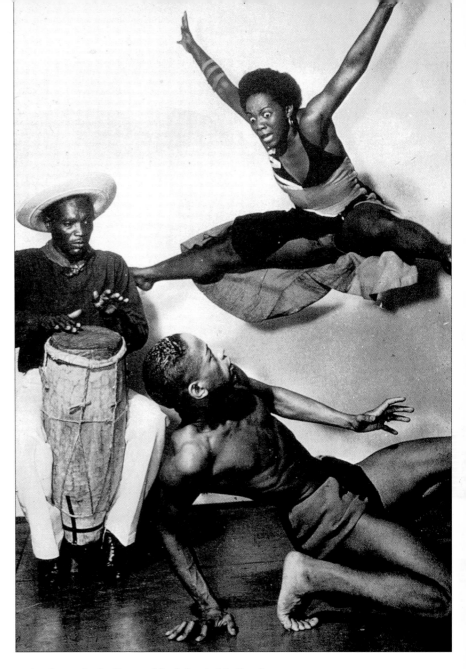

mained a rarity in the world of classical ballet. In modern dance they won an easier acceptance, and in Britain and the United States several groups went on to define a contemporary black presence in the dance scene. As well as this, a number of British companies gradually began to extend the work originated by Primus and Dunham, actively seeking out traditional Afro-Caribbean dances and adapting them to the conventional stage.

Black American music, which had been gaining acceptance as a serious art form as well as entertainment before the war, sought to assert its cultural autonomy by emphasizing its potential for expression. Bebop, a form of jazz developed by the saxophonist Charlie Parker, trumpeters Dizzy Gillespie and Miles Davis and others in the late 1940s, expanded the musical vocabulary of jazz by using the entire chromatic scale as well as exploring rhythmic variations of great subtlety. The resulting complex improvisations were initially unpopular but were eventually incorporated into the jazz mainstream and influenced other composers concerned with improvisation.

▲ Pearl Primus (in mid air), Joe Nash and Alphonse Cimber, on a concert tour in 1946–47. Primus was an American anthropologist whose researches inspired her to introduce the American contemporary dance scene to African dance.

◄ The high priests of bebop. From left to right: Charlie Mingus, Roy Haynes, Thelonious Monk and Charlie Parker, at the "Open Door", New York, September 1953. Bebop was the sudden musical breakthrough that took jazz from the popular to the avant-garde.

ART GALLERIES AND EXHIBITIONS

Artists need their work to be displayed and, with the decline of private patronage, bought, whether by institutions or by individuals.

Until the foundation in the 1920s of the first museums specifically devoted to preserving and displaying the rich variety of trends in modern art, the selection of esthetically radical works proved hard for traditional museums, such as the Louvre in Paris, which had their collections founded on the works of established Old Masters. And, as artists continued to challenge the boundaries of art, some brought *objets trouvés* into the gallery and frequently commanded high prices with them; even the museums of modern art found themselves drawn into controversy about their selection and purchasing policies.

Just as an object can "become" art by being placed in an environment – such as a purpose-built gallery – in which it is seen as art, so the galleries themselves have taken on a key function in defining the trends and categories of art criticism. The way in which pictures are hung, and the works with which they are juxtaposed, have an effect on the way the viewer "reads" them. Since the 1960s there has developed an important trend – the special exhibition – bringing together comprehensive or representative works from around the world, in a selection determined by the exhibition organizers, for commercial or academic ends. Exhibitions – such as the Post-Impressionism exhibitions organized in London in 1910 and 1912 – can add a completely new term to the vocabulary of art criticism.

Alongside the prestigious exhibitions and metropolitan museums, the municipal or local art gallery has become an ever more common feature worldwide. Such galleries provide a channel for two-way communication, between the mainstream of the world's art scene, and the local art of the region.

► **London's Royal Academy** annually shows thousands of works by lesser-known artists; many more fail the selection procedure. Preservation of works of art, many of them deteriorating fast, forms an important part of a gallery's work.

►► **Purpose-built galleries,** such as the Museum of Contemporary Art in Los Angeles, provide spacious but sometimes forbidding accommodation for works of art. Some galleries seem to insulate the art from the outside world; others place it in a more natural setting.

▼ **The exhibition catalog** provides a permanent record of an exhibition and may become a weighty and scholarly volume or, as here, a work of art in its own right. This catalog, for an exhibition at New York's Museum of Modern Art, had a hinged, metallic cover.

► **Marc Chagall at a** retrospective exhibition organized in honor of his 95th birthday. Such exhibitions can survey the lifetime's work of a single artist, bringing it together under one roof for the first time, and allow the reassessment of his entire achievement and of the relative quality of each individual work.

►► **The public curiously** inspect the items on display in an American museum of trash. In a gallery even discarded plastic can be seen as objects of pure color and form.

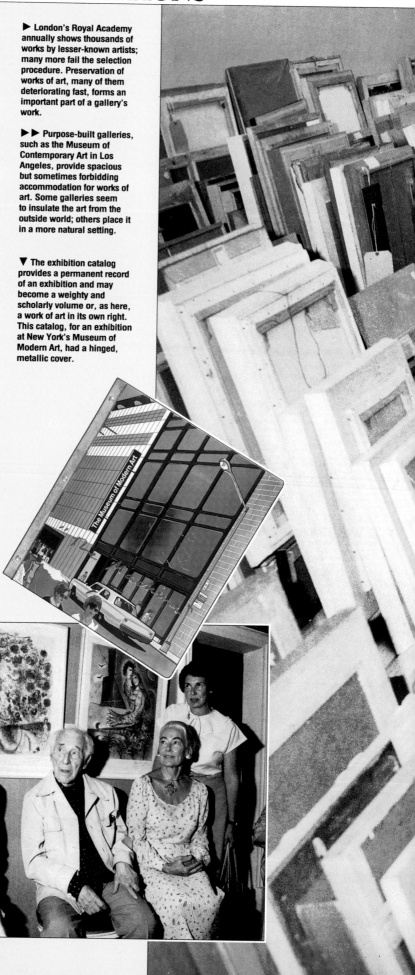

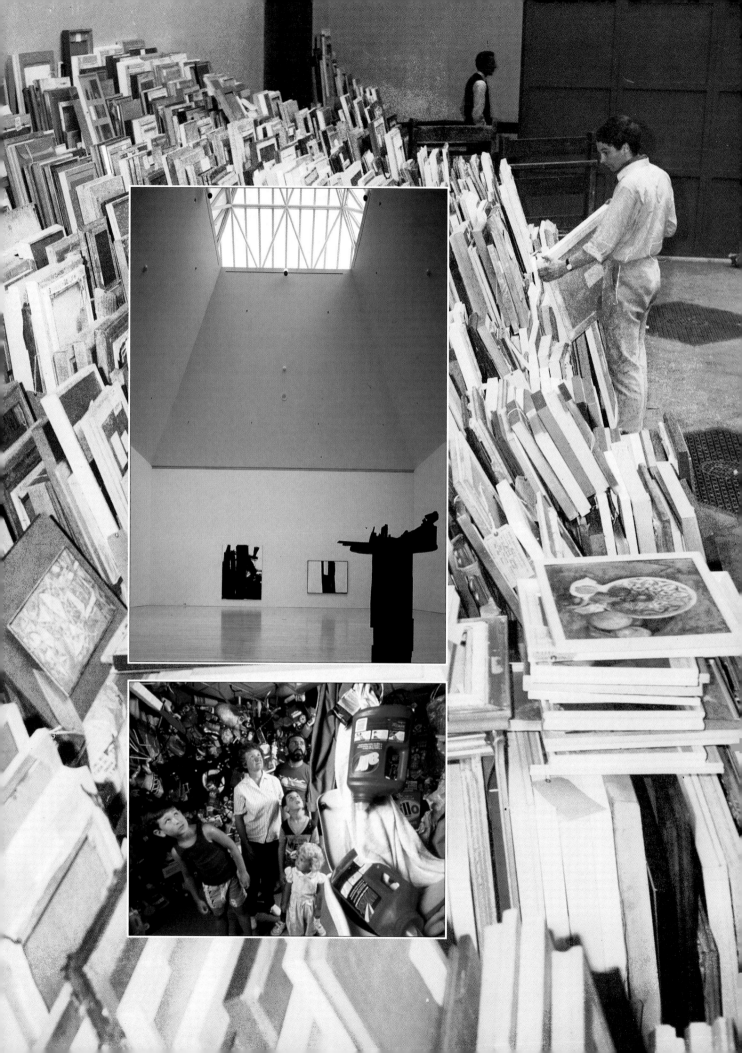

1960 - 1973

THE
DYNAMIC
ARTS

Time Chart

	1961	1962	1963	1964	1965	1966
Visual Arts	• Josef Albers: *Study for Homage to the Square: See*, painting (USA) • Museum of Modern Art in New York mounts "The Art of Assemblage" exhibition (USA) • Joan Miró: *Blue II*, painting (Sp) • Frank Stella: *New Madrid*, painting (USA) • Morris Louis: *Unfurleds*, painting sequence (USA) • F. Hundertwasser: *The Hokkaido Steamer*, painting (Aut)	• Andy Warhol: *Marilyn Monroe*, silkscreen (USA) • Robert Rauschenberg: *Barge*, painting (USA) • Michelangelo Pistoletto: *Seated Figure*, cut-out photographic image attached to a mirror (It)	• Allen Jones: *Hermaphrodite*, painting (UK) • Anthony Caro: *Month of May*, sculpture (UK) • Bruce Conner: *Couch*, assemblage (USA) • David Hockney: *Picture Emphasizing Stillness*, painting (UK) • Roy Lichtenstein: *Whaam!*, Pop Art painting based on a cartoon strip (USA) • Heinz Mack: *Light Dynamo*, a kinetic light picture (FRG)	• Jim Dine: *Double Red Self-Portrait (The Green Lines)*, painting (USA) • Roy Lichtenstein: *As I Opened Fire*, pop art painting (USA) • Hans Hofmann: *Rising Moon*, painting (USA) • Frank Auerbach: *Head of Helen Gillespie III*, painting (UK) • Bridget Riley: *Crest*, painting (UK) • David Smith: *Cubi XVIII*, sculpture (USA)	• René Magritte: *Exhibition of Painting*, painting (Fr) • Kenneth Noland: *Grave Light*, painting (USA) • Rita Angus: *Scrub-burning, North Hawkes Bay*, painting (NZ) • Martial Raysse: *Tableau simple et doux*, painting (Fr) • Peter Blake: *Doktor K. Tortur*, painting and assemblage (UK) • Sergio de Camargo: *Large Split White Relief no. 34/74*, relief composed of cylinders set into a surface (Bra)	• Claes Oldenburg: *Stuc Giant Chocolate*, sculptu (USA) • Tess Jaray: *Garden of* painting (UK) • Arman: *Clic-clac Rate*, assemblage composed c cameras (USA) • EAT (Experiments in A Technology) founded by Rauschenberg and other (USA) • Yaacov Agam: *Appear* in which the picture chan when viewed from two di angles (Isr)
Architecture	• Foundation of Archigram by Peter Cook, Warren Chalk, Ron Herron, Dennis Crompton, Michael Webb and David Greene, whose initial pamphlet, *Archigram I*, advocates space capsules, a throwaway environment and mass-consumer imagery in architecture (UK)	• Pier Luigi Nervi: *Exhibition Hall*, Turin (It)	• Hans Sharoun: *Philharmonic Concert Hall*, West Berlin (FRG) • Peter Johnson: *Johnson House*, Sydney (Aus) • Kenzo Tange: *National Olympic Gymnasium*, Tokyo (Jap)	• Alvar Aalto: *Otaniemi Institute of Technology* (Fin)	• Eero Saarinen: *CBS Building*, New York (USA) • Le Corbusier completes the *Parliament Building*, Chandigarh (since 1951) (Ind) • Louis I. Kahn: *Jonas Salk Institute for Biological Studies*, La Jolla (USA)	• Foundation of the Arch atélier (It) • Jørn Utzon and others: *Sydney Opera House* (sir 1956, opening in 1973) (A • Paul Rudolph: *Art and Architecture building*, Ya University (USA)
Performing Arts	• François Truffaut: *Jules et Jim*, film (Fr) • Samuel Beckett: *Happy Days*, play (Fr) • Alain Robbe-Grillet: *Last Year in Marienbad*, film (Fr) • Piero Manzoni: *Living Sculpture*, in which the artist signs various individuals' bodies, then gives them a "certificate of authenticity" as a work of art (It)	• Edward Albee: *Who's Afraid of Virginia Woolf?*, play (USA) • Yves Klein: *Immaterial Pictorial Sensitivity Zone 5*, in which Klein offers his "immaterial pictorial sensitivity" (an imaginary substance) to a buyer who pays in 20g of gold leaf, which, due to the spirituality of the transaction, is thrown into the Seine by Klein as the buyer burns his receipt (Fr) • Formation of the Judson Dance Group, extending the new dance techniques first advocated by Merce Cunningham (USA)	• Andy Warhol begins to direct films involving the antics of his "Factory" in New York (USA) • Rolf Hochhuth: *The Representative*, play (FRG) • Robert Rauschenberg: *Pelican*, performance by two roller-skaters and a dancer in ballet shoes on a skating rink (USA)	• Carolee Schneemann: *Meat Joy*, in which performers cover themselves with the blood of meat carcases and wrestle on a blank canvas laid on the floor (USA) • Robert Lowell: *The Old Glory*, play (USA) • Pier Paolo Pasolini: *The Gospel According to St Matthew*, film (It) • Peter Shaffer: *The Royal Hunt of the Sun*, play (UK)	• At an exhibition of his works in Düsseldorf, Joseph Beuys, his head covered with honey and gold leaf, carries a dead hare around the exhibition, touching each picture with its paws, then sits down in a corner and explains the meaning of his works to the dead animal (FRG) • John Cage, Merce Cunningham, Barbara Lloyd, David Tudor and Gordon Mumma: *Variations V*, an audio-visual piece in which the movements of the dancers through photoelectric beams control the sound and light aspects of the piece (USA)	• Andy Warhol: *Chelsea* film (USA) • Yayoi Kusama: *Endless Room*, a "happening", m lined room filled with red balloons (Jap) • Nicholas Roeg: *Fahren 451*, film (UK) • Jean-Luc Godard: *Mas féminin*, film (Fr)
Music	• Elliott Carter: *Double Concerto for Harpsichord, Piano and Two Chamber Orchestras* (USA) • Luciano Berio: *Epifanie*, vocal work for the singer Cathy Berberian (It) • Luigi Nono: *Intolleranza 1960*, opera (It) • Franco Donatoni: *Puppenspiel*, for orchestra (It)	• György Ligeti: *Aventures*, for voices and chamber group (FRG) • Olivier Messiaen: *Sept Haïkaï*, for piano and small orchestra (Fr)		• First performance of Deryck Cooke's completed version of Gustav Mahler's *Tenth Symphony* (1911), in London (UK) • Yannis Xenakis: *Eonta*, for piano and brass, in which calculations of musical parameters are made by an IBM 7090 computer (Fr) • Henri Dutilleux: *Métaboles* for orchestra (Fr)	• György Ligeti: *Requiem* (FRG)	• Harrison Birtwistle: *Pu and Judy*, chamber oper • Yannis Xenakis establi the School of Mathemati Automatic Music (EMAM • Harry Partsch: *Delusio the Fury: A Ritual of Drea Delusion*, opera, an insta the composer's use of in' instruments and his scal microtones to the octave
Literature	• Patrick White: *Riders in the Chariot*, novel (Aus) • Tadeusz Różewicz: *The Nameless Voice*, poems (Pol) • Octavio Paz: *The Labyrinth of Solitude*, essays (Mex) • Zbigniew Herbert: *Study of a Subject*, poems (Pol) • Yevgeni Yevtushenko: *Baby Yar*, poem, set by Dmitri Shostakovich in his *Thirteenth Symphony* (1962) (USSR)	• Alexander Solzhenitsyn: *One Day in the Life of Ivan Denisovich*, novel (USSR) • Doris Lessing: *The Golden Notebook*, novel (UK) • Carlos Fuentes: *The Death of Artemio Cruz*, novel (Mex) • Anna Akhmatova completes her *Poem without a Hero* (since 1940) (USSR) • Anthony Burgess: *A Clockwork Orange*, novel (UK)	• Mario Vargas Llosa: *The Time of the Hero*, novel (Per) • Günter Grass: *Dog Years*, novel (FRG) • Thomas Pynchon: *V*, novel (USA) • Yukio Mishima: *The Sailor Who Fell From Grace With the Sea*, novel (Jap) • Paul Celan: *Die Niemandsrose* (The No One's Rose), poems (FRG)	• William Golding: *The Spire*, novel (UK) • Johannes Bobrowski: *Levins Mühle*, novel (GDR) • Philip Larkin: *The Whitsun Weddings*, poems (UK)	• Wole Soyinka: *The Interpreters*, novel (Nig) • Basil Bunting: *Briggflatts*, poem (UK) • Henry Miller: *The Rosy Crucifixion*, novel trilogy (USA) • Yves Bonnefoy: *Pierre écrite* (Stone Writes), poems (Fr) • Sylvia Plath: *Ariel*, poems (UK)	• Alberto Moravia: *The L* novel (It) • Isaac Bashevis Singer: *Father's Court*, autobiog (USA) • Johannes Bobrowski: *Wetterzeichen*, poems (posthumous) (GDR) • Yannis Ritsos: *Testimo* poems (Gr)
Misc.	• Adolf Eichmann, architect of the Nazi "Final Solution" captured in Argentina and tried in an Israeli court				• Beginning of the Cultural Revolution; mobilization of Red Guards throughout China in a drive for ideological purity (until 1968)	

	1968	1969	1970	1971	1972	1973
Walker: *Touch –* painting (UK) / ...get Riley: *Late ...g*, painting (USA) / ...elangelo Pistoletto: *...rtrait with Soutzka, ...re* (USA) / ...s Rafael Soto: *Petite ...Face*, sculpture / ...Tomasello: *...phère ébromo-...ue no.180*, relief	● Tomio Miki: *Ears*, bas-relief in cast aluminum (Jap) / ● Tom Wesselmann: *Great American Nude No.99*, painting (USA) / ● Ed Kienholz: *The Portable War Memorial*, assemblage (USA) / ● David Hockney: *A Bigger Splash*, painting (USA) / ● Tetsuya Noda begins his series of diary prints, using mimeograph, woodblock and silk screen (Jap)	● R.B. Kitaj: *Synchrony with F.B. – General of Hot Desire*, diptych painting (UK) / ● Christo Javacheff: *Wrapped Coast*, Little Bay, area of coastline wrapped in plastic and rope (Aus) / ● Jan Dibbets: *TV as a Fireplace* (24-minute film broadcast on Westdeutsches Fernsehen) (FRG) / ● Mark Rothko: *Orange Yellow Orange*, painting (USA)	● Valerio Adami: *Bedroom Scene*, painting (It) / ● Ralph Goings: *Airstream*, superrealist painting (USA) / ● Robert Smithson: *Spiral Jetty*, outdoor sculpture made of rubble (USA) / ● Colin McCahon: *Victory Over Death*, painting (NZ) / ● Dennis Oppenheim: *Reading Position*, two photographs showing the effects of sunburn on the artist's torso, partially covered by a book (USA)	● Malcolm Morley: *St John's Yellow Pages*, painting (USA) / ● David Hockney: *Mr. and Mrs. Ossie Clark and Percy*, painting (USA) / ● Oyvind Fahlstrom: *Exercise (Nixon)*, in which magnetized pieces are to be moved about on a magnetic surface by the spectator (USA) / ● Guilio Paolino: *Apotheosis of Homer*, conceptual piece, thirty-two music-stands with a photograph on each (It)	● Richard Long: *Walking a Line in Peru*, long line inscribed in the earth (Peru) / ● Tony Smith: *Gracehoper*, outdoor sculpture (USA) / ● Reg Butler: *Girl on a Long Base*, superrealist sculpture (UK)	● Duane Hanson: *Florida Shopper*, superrealist sculpture (USA) / ● Robert Smithson: *Amarillo Ramp*, outdoor construction, finished posthumously as the artist died in a plane crash while photographing the site (USA) / ● Dorothea Rockburne: *Drawing Which Makes Itself* (USA) / ● Richard Estes: *Paris Street-scene*, superrealist painting (USA)
...erick Gibberd: *...olitan Cathedral of ...he King*, Liverpool / ...minster Fuller: *US ...n at Expo '67, ...al*, a geodesic ...here (Can)	● Ludwig Mies van der Rohe: *New National Gallery*, West Berlin (FRG) / ● Denys Lasdun: *University of East Anglia*, Norwich (UK) / ● Foundation of the Ant Farm group of architects, specializing in inflatable architecture (USA)	● Kevin Roche and John Dinkeloo: *College Life Insurance Building*, Indiana (USA) / ● I.M. Pei, H. Cobb and others: *Hancock Tower*, Boston (USA) / ● Michael Graves: *Benacerraf Addition*, Princeton (USA)	● Hassan Fathy and the citizens of Gourna: *New Gourna*, a new town, near Luxon (since 1947) (Egy)	● James Stirling: *Queens College*, Oxford (UK)	● Kisho Kurokawa: *Nakagin Apartment Tower*, Tokyo (Jap) / ● Louis I. Kahn: *Kimbell Museum*, Fort Worth (USA)	
...Forman: *The ...n's Ball*, film (Czech)	● Bernar Venet: *Relativity Track*, consisting of simultaneous lectures delivered by three physicists on relativity and a doctor on the subject of the larynx (USA) / ● Tom Stoppard: *Rosencrantz and Guildenstern are Dead*, play (UK)	● Meredith Monk: *Juice*, dance piece in three parts held in the spiral space of the Guggenheim Museum (Part I), a conventional theatre (Part II) and an unfurnished loft (Part III) (USA) / ● Vito Acconci: *Following Piece*, in which Acconci follows randomly-chosen people in the street (USA) / ● Gilbert and George: *Underneath the Arches*, a singing sculpture in which the two artists mime to the Flanagan and Allen song of the same name (UK)	● Jean Renoir: *The Little Theatre of Jean Renoir*, film (Fr) / ● Derek Walcott: *The Dream on Monkey Mountain and Other Plays* (Trin) / ● Klaus Rinke: *Primary Demonstrations*, sculptures in which geometric configurations are mapped out slowly by bodily movements (FRG)	● Andrei Tarkovsky: *Solaris*, film (USSR) / ● Samuel Beckett: *Breath and Other Short Plays* (Fr) / ● Roman Polanski: *Macbeth*, film (USA) / ● Rebecca Horn: *Unicorn*, in which a naked woman with a unicorn horn walks through a park in the early morning (USA)	● Chris Burden: *Deadman*, in which Burden wraps himself in a canvas bag and lies in the middle of a busy Los Angeles boulevard. He is later arrested for causing a false emergency to be reported (USA) / ● Bernardo Bertolucci: *Last Tango in Paris*, film (It) / ● Bruce McLean, Ron Carra and Paul Richards form the satiric performance art group Nice Style, The World's First Pose Band (UK)	● Dan Graham: *Two Consciousness Projections*, in which two people, one filmed by a video camera, the other looking through the camera, describe at the same time the face of the former, thus both become spectator and performer at once (USA)
...einz Stockhausen: *...n*, an electronic and ...e music work ...on national anthems / ...Pousseur: *Votre ...pera* (Fr) / ...ert von Karajan ...the Salzburg Easter ...l (Aut)	● Luciano Berio: *Sinfonia*, an orchestral montage (It) / ● Italian ensemble Musica Elettronica Viva create *Sound Pool*, in which both musicians and audience may take part (It) / ● Formation of the London Sinfonietta, an orchestra dedicated to the performance of new music (UK)	● Mauricio Kagel: *Ludwig van*, a music and film commentary on the music of Beethoven (FRG) / ● Cornelius Cardew founds his Scratch Orchestra, of amateur and untrained musicians (UK) / ● Peter Maxwell Davies: *Eight Songs for a Mad King*, for voice and chamber ensemble (UK)	● Spherical auditorium built for Karlheinz Stockhausen at EXPO '70 in Osaka is the first hall built exclusively for the performance of electronic music (Jap) / ● Benjamin Britten: *Owen Wingrave*, opera (UK) / ● Robert Crumb: *Ancient Voices of Children* for orchestra and voices (USA)	● Yannis Xenakis: *Persepolis*, a *son et lumière*, involving lasers and torches with an eight-track electronic tape (Iran) / ● Cornelius Cardew: *The Great Learning* for organ, written as a Maoist statement (UK)	● Frederic Rzewski: *Coming Together*, for ensemble and voices, setting of the words of prison rioters (USA) / ● Christian Wolff: *Accompaniments I*, for singing pianist, a setting of a Maoist text (USA)	● John Rimmer: *At the Appointed Time*, for orchestra (NZ) / ● George Rochberg: *Third String Quartet* (USA)
...Narayan: *The Sweet ...*, novel (Ind) / ...ge Steiner: *...ge and Silence, ...* (UK) / ...Kundera: *The Joke, ...Czech*) / ...el García Marquez: *...ndred Years of ...e*, novel (Col) / ...Masuji: *Black Rain, ...ap*)	● Aleksandr Solzhenitsyn: *Cancer Ward*, novel (USSR) / ● Janet Frame: *The Rainbirds*, novel (NZ) / ● René Char: *Dans la pluie giboyeuse*, poems (Fr) / ● Geoffrey Hill: *King Log*, poems (UK)	● Philip Roth: *Portnoy's Complaint*, novel (USA)	● Peter Handke: *The Goalie's Anxiety at the Penalty Kick*, novel (FRG) / ● James K. Baxter: *Jerusalem Sonnets* (NZ) / ● Saul Bellow: *Mr Sammler's Planet*, novel (USA) / ● Jorge Luis Borges: *Dr Brodie's Report*, stories (Arg)	● Miroslav Holub: *Although*, poems (Czech) / ● C.K. Stead: *Smith's Dream*, novel (NZ) / ● V.S. Naipaul: *In a Free State*, novel (Trin) / ● Alexander Solzhenitsyn: *August 1914*, novel (USA)	● Vasko Popa: *Earth Erect*, poems (Yug) / ● Allen Curnow: *Trees, Effigies, Moving Objects*, poems (NZ)	● Wole Soyinka: *Season of Anomy*, novel (Nig) / ● Henri Michaux: *Moments: Traversées du Temps*, poems (Fr) / ● Thomas Pynchon: *Gravity's Rainbow*, novel (USA)
	● Threat of civil war in France as rioting and strikes spread over the country (Fr)	● Student Jan Palach burns himself to death in protest at the 1968 Warsaw Pact invasion of Czechoslovakia (Czech)				

Datafile

While writers tackled seriously the political issues of the day, painting was more detached. By now the confirmed center of the art world, New York in the early 1960s merely had to wait for the next fashionable art movement to come along. Pop art promptly filled the galleries, but also managed to confound the public. Reacting to the Abstract Expressionists with an art that was practically expressionless, Andy Warhol revived the old Dadaist tactic of the readymade, stacking Brillo boxes in galleries and painting Campbell's soup tins. His background in commercial art stood him in good stead in an era where artists had to take the art market on at its own games. Movements began to proliferate in the 1960s as the artist became an increasingly specialized creature, producing Op art, or kinetic, or "hard-edge" abstraction. Only in the performance art scene and the Happening were there any signs of the adaptability of the early modern masters, who had turned to sculpture, stained glass or pottery with equal facility.

Roy Lichtenstein sales

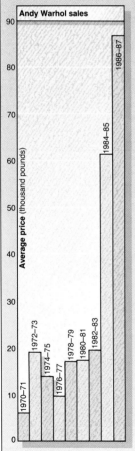

Andy Warhol sales

▼ These figures offer us a kind of league of acceptable modern art. In this period the Old Masters such as Rembrandt were still attracting higher prices than 20th-century artists. The prices are achieved by taking an average of each artist's best three figures for 1974, converted to sterling at current rates of exchange. The same technique has been employed when considering other artists' sales in this part. The major groupings are related to the artists' positions on the family tree of Modernism, which can be described as being rooted in Cézanne and having its first shoots in the Cubism of Picasso. Matisse, the other main modern master of the French school, comes third.

▲ Roy Lichtenstein plundered the derided artform of the cartoon for the visual vocabulary of his witty, highly-intellectualized paintings, even copying the shading technique of the lithographic dot like a latter-day Seurat. His work has proven somewhat subject to the whims of fashion, perhaps because of its apparent flippancy.

▲ Andy Warhol's marketing skills ensured that his work represents a solid investment. When a stack of prints was hit by a bullet, he repackaged them as "Shot Marilyns." When he himself was shot he posed for Alice Neel to display his scars to the world. Warhol's behavior, like his work, displayed a perfect control of the image.

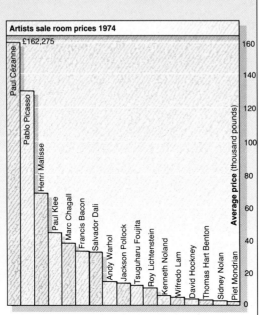

Artists sale room prices 1974

Although the death of Stalin in 1953 had introduced a limited "thaw" in literature, it was not until Khrushchev's "Secret Speech" denouncing Stalin at the Twentieth Party Congress of February 1956 that liberal Soviet writers became considerably bolder in their treatment of Stalinism and contemporary social problems. The year 1956 was marked not only by the publication of some controversial works, such as Vladimir Dudintsev's *Not by Bread Alone*, but also by the emergence of literary dissidence. Dissident writers were those who ventured beyond the ideological, political and esthetic limits that were permissible, even in the more liberal atmosphere of the thaw.

The expectations aroused by Khrushchev's de-Stalinization campaign and the party's erratic procedure of alternating thaws and freezes set in motion two new literary phenomena: *samizdat* ("self-publishing", the unofficial copying and circulation of "underground" manuscripts); and *tamizdat* (publication "over there", that is, in the West). A hitherto unknown anonymous writer, "Abram Tertz" (Andrei Sinyavsky), sent two works written in 1956 abroad for publication: *On Socialist Realism*, a devastating critique of the concept and methods of Soviet literary theory; and *The Trial Begins*, a surrealistic depiction of the late Stalin period and an indictment of the view that "the ends justify the means".

As the process of de-Stalinization speeded up, the hitherto unknown Alexander Solzhenitsyn, a provincial schoolteacher who had been writing in secret since his release from prison in 1953, sent his manuscript *One Day in the Life of Ivan Denisovich* to Alexander Tvardovsky, the liberal editor of the journal *Novy Mir*. Its publication in October 1962, sanctioned by Khrushchev himself, was a sensation: it was the first work published in the Soviet Union to reveal the daily misery of an inmate of a Soviet prison camp. Solzhenitsyn's main theme, though, is not merely physical survival, but the survival of a human being's moral integrity even in the harshest conditions.

Immediately following the publication of *Ivan Denisovich*, Khrushchev put a brake on the de-Stalinization process, and many fine works on the same theme were suppressed; subsequently they circulated in *samizdat* form or were sent abroad for publication. Among these were Evgenia Ginzburg's memoir *Into the Whirlwind* (1967), which shows the impact of arrest and imprisonment on Soviet women, and Varlam Shalamov's *Kolyma Tales* (1966–75), which presents a bleak picture of the spiritual numbness and bestial cruelty of life in the terrible Arctic camps of Kolyma. In this repressive atmosphere Solzhenitsyn's second story, *Matryona's House* (1963), published in *Novy Mir*, was heavily criticized for its depiction of the poor conditions on collective farms, the greed and

PROTEST AND COMMITMENT

corruption of the peasantry and the "un-Soviet" virtues of charity and humility displayed by its heroine.

After Khrushchev's fall in October 1964 there was a lull until the trial of Sinyavsky and Yuri Daniel in February 1966. It was the first trial of Soviet writers in which the main evidence against them was their own literary work, and the sentences of seven and five years' hard labor respectively created great indignation in the Soviet Union and throughout the world. This trial was followed by another, that of the dissidents Yuri Galanskov and Alexander Ginzburg, who had compiled a *White Book* containing transcripts of the Sinyavsky/Daniel trial. In 1967 Solzhenitsyn sent a passionate appeal against censorship to the delegates of the Fourth Writers' Congress, but the Congress was prohibited from discussing this or any other important issue. The Soviet invasion of Czechoslovakia in 1968 finally set in motion a series of repressive measures which compelled liberals to fall silent, adversely affected the quality of published literature, and forced dissidents underground. In late 1969 Solzhenitsyn was expelled from the Writers' Union, and the editorial board of the liberal journal *Novy Mir* was disbanded. From 1969 until the accession of Gorbachev in 1985, the KGB employed a policy of selective terror against dissident writers.

By the late 1960s Solzhenitsyn had become convinced that his works could no longer be published in the Soviet Union. His two major novels, *Cancer Ward* and *The First Circle*, were published in the West in 1968. Like *Ivan Denisovich*, both use the device of a closed society – a hospital and one of Stalin's "special prisons" for scientists – in order to juxtapose characters from many different walks of life and paint a picture of a whole society; they present a vivid, realistic reflection of many aspects of the Stalin era. *August 1914*, the first volume of his historical cycle on the Revolution, *The Red Wheel*, appeared in 1971, followed by the *Gulag Archipelago* (1973–75), a monumental history of the Soviet prison-camp system. This proved the final straw for the Soviet authorities, and Solzhenitsyn was forcibly deported in 1974.

Many of the best works by other Russian writers produced in these years were also published only in *samizdat* or *tamizdat* and frequently smuggled back into the Soviet Union. One of the most important themes in Soviet dissident literature was an exposure of the workings of the Soviet internal security system, encompassing prison-camp literature like Anatoly Marchenko's *My Testimony* (1969) and Sinyavsky's *Voice from the Chorus* (1973), the incarceration of political offenders in mental hospitals and the persecution of writers. Another major theme was Stalinism and the falsification of history: Nadezhda

Mandelstam's memoir *Hope against Hope* (1971) is a moving account of the effect of Stalinism on the Soviet intelligentsia in the 1930s. Other writers such as Joseph Brodsky and Vladimir Maksimov took as their theme the affirmation of spiritual and religious values. Other works too were unacceptable because they employed fantastic or surrealistic devices, such as Vasily Aksyonov's *The Steel Bird* and Vasily Erofeyev's *Moscow to the End of the Line*.

In the 1970s most of the best Soviet writers suffered varying degrees of persecution. The Soviet authorities adopted a new policy towards dissident writers, encouraging them to emigrate, so that they would have less influence on their fellow countrymen. Some chose to leave; many others were so severely harassed that they were virtually forced to emigrate, leaving the Soviet Union with only a few writers of any stature.

European revaluations

The end of World War II had left European writers struggling to define and establish a freedom of a different kind. Problems of physical survival and reconstruction could not for long mask the mental and emotional scars of the war. The Cold War confrontation between East and West affected Europeans more than anyone, their continent split in two and one of the most obvious battlegrounds for any future war. The strongest hopes in a progressive technology could scarcely hide the potential for destruction that the

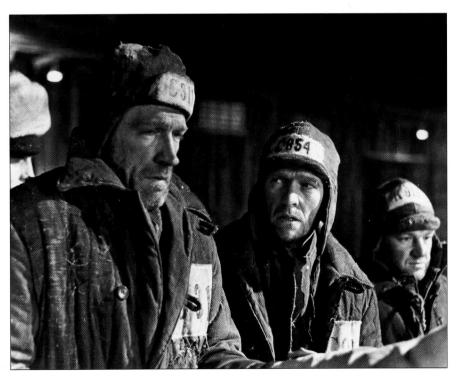

▼ A scene from the 1971 film of *A Day in the Life of Ivan Denisovich*. Alexander Solzhenitsyn's novel, published in the Soviet Union in 1962, provided a momentary glimpse of the misery of the Soviet prison camps. As such it proved an attractive product for the West. Its author was eventually expelled from the Soviet Union and settled in the United States.

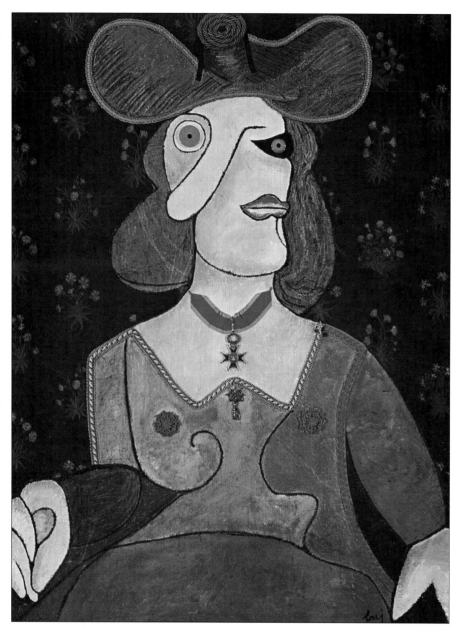

▲ *Portrait of a Woman with a Hat* (1969), by the Italian painter Enrico Baj. Based on a 1941 Picasso, Baj's reworking employs assemblage, or the accumulation of material and objects, in order to make visual puns. The picture's wit relies on the analogy between corded buttons and nipples, or between the coil of braid which makes the hat's crown, and the spiral brush strokes Picasso might have employed.

same technology brought. In such a situation the traditional frameworks of humanism and religion were brought under question. If their values had permitted the world to carry out such atrocities, of what use were they?

Writers reacted to the condition of the times in various ways. The French writer Alain Robbe-Grillet, protagonist of the "New Novel", saw himself in a world that was "a smooth surface, with no meaning, no soul, no values, on which we have no further hold". His work was characterized by relentless description of physical objects, of a cold and deliberately uninviting kind. In *The Erasers* and *Dans le labyrinthe*, and in his script for the film *Last Year in Marienbad* (1961), he created a special world through a description so meticulous as to be unreal and to exist only as itself. At the heart of such writing lay the need to establish the limitations of an outside world in order to sustain a claim to "personal liberty". Max Frisch, the German-speaking Swiss playwright and novelist, was preoccupied with themes whose roots lay in the deforming mental ex-

periences of the war. Most of all he was concerned with the effect of casting people in roles, imposing identities upon them and exploring the possibilities, even the fact, of guilt. His play *Andorra* (1961) was centered specifically on anti-semitism. His novels from *I'm Not Stiller* (1954) through to *The Wilderness of Mirrors* (1964) all worked variations on this clutch of themes. Another Swiss playwright, Friedrich Dürrenmatt, used grotesque fantasy to comment on a world "turned upside down, a world about to fold like ours". The use of the grotesque made tangible "the face of a world without a face" existing "out of fear of the bomb". In his most celebrated play, *The Physicists* (1961), a scientist retreats to a mental hospital to keep his knowledge from being misused, but is pursued there by other scientists after his ideas, who pose as patients. All of them are imprisoned by the director of the hospital, who is in any case mad.

Both Frisch and Dürrenmatt thought harshly of what they saw as Swiss complacency. The German novelist Günter Grass also located a growing and dangerous complacency in postwar Germany, bred by economic revival. He too used fantasy as a key to a moral consideration of recent history, and in *The Tin Drum* (1959) related the story of Germany from the 1920s to the 1950s through the eyes of a drumbeating dwarf with extraordinary powers.

If fantasy could be used as a scalpel to dissect the insanities of society, it could also be seen as the sanest response to those insanities, a best option, both to cloak dissent and as a correct response where madness already ruled. The poetry of the Czech Miroslav Holub probed such possibilities. Each poem is an anecdote that is moved to become a philosophical position. The Italian novelist Italo Calvino used similar starting points for much more sustained examinations of the conditions of life. In *Invisible Cities* (1972), Marco Polo describes a series of cities to Kublai Khan and all of them are in some way elegant derivations from a simple but fantastic notion; cities without shape, cities of daily obsolescence, all "approximate reflections", either of what we have made life or of what we might ideally reach through it. Fantasy for Calvino was a means to describe both what is and an ideal to be sought.

But at the base of all these writers' work lay the history bequeathed to the century, where a terrible reality had seemed to outstrip the possibilities of imagination. The work of Isaac Bashevis Singer, the Yiddish writer born in Poland in 1904, who had lived in the United States since 1934, reminds us that it was not just the message of the century but of all history.

Catch-22: the world of American fiction

Across the Atlantic many writers were responding to the demands of an overpowering reality. The 1960s saw a remarkable surge of good writing in both the Americas, particularly in the realm of the novel and the short story. Writers in Latin America rediscovered the fabulous at the heart of the real, and in the United States minority writers achieved substantial recognition. What is perhaps most striking about this work is

that so much of it centered on the idea of conspiracy, on the sense of a crazy design in history, as if coincidences could scarcely ever be merely coincidences. The most authoritative exponent of this sensation was Vladimir Nabokov, whose *Lolita* (1955) and *Pale Fire* (1961) portray subtle, scary, and thoroughly demonized universes; but there are plenty of hints elsewhere, as much in the Argentinean Julio Cortazar's *Hopscotch* (1963) as in the Chicago writer Saul Bellow's *Herzog* (1964). But the book which most fully caught the feeling was Joseph Heller's *Catch-22* (1961). Ostensibly a war novel, chiefly set on an imaginary island in the Mediterranean during the 1940s, *Catch-22* reads as if the Marx Brothers had taken

over Franz Kafka, and had also acquired the logical and philosophical interests so characteristic of the 1960s. Catch-22 is a clause in the US Air Force regulations which says that a person who is insane may be excused from combat duty. Heller's irresistible point is that those pilots who are crazy enough to want to fly dangerous missions over occupied Europe could be excused but will not ask to be; while those who are sane enough to **not** to want to fly such missions are for that very reason not insane enough to be excused. Gradually the meaning of Catch-22 is extended to cover any official unanswerable explanation for the intolerable. "That's some catch, that Catch-22", the hero says, appalled but also strangely

It began in mythical times, when the sly hare who nests in the Moon brought death among men, instead of the Moon's true message. The true message has never come. Perhaps the Rocket is meant to take us there someday, and then Moon will tell us its truth at last.

THOMAS PYNCHON, 1973

Art Cinema in the 1960s

Directors always mattered in the cinema, but often not as much as studios or trends in national industries. In the 1960s the film director came into his or her own; became not so much a star as a name, a visible magician. Audiences thought of films by individual directors as having identifiable styles, preoccupations, ambition – everything that adds up to the notion of authorship. This idea was encouraged by those critics who sought to assert the claim of cinema to be a major art form. It was less the case in the United States than elsewhere, although even there the names of Orson Welles and Alfred Hitchcock raised very particular expectations. The major international names were Italian, Swedish, Indian, Japanese, and were those of directors of widely differing temperaments and traditions. Even where they belonged to a single nation, as Federico Fellini, Luchino Visconti and Michelangelo Antonioni did, their approaches were different. Fellini's *La dolce vita* (1960) was a frenzied and fast-moving commentary on a bewildered contemporary Italy, while Visconti's *The Leopard* (1963) was a sumptuous, slow-moving evocation of a vanished Sicilian world. Antonioni's *L'avventura* (1960) and *La notte* (1961) explored the elusive states of mind of people who were literally and figuratively lost.

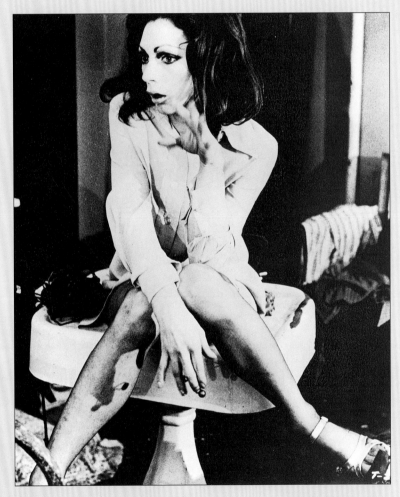

The work of the Swedish director Ingmar Bergman, notably *Persona* (1966), *Shame* (1968) and *Cries and Whispers* (1972), involved both realism and allegory, and touched on grim questions of guilt and personality and power. Satyajit Ray built on his *Pather Panchali* (1955) to form his *Apu Trilogy*, with its delicate Indian characters. Several Japanese directors had distinguished reputations, but Akira Kurosawa was best known internationally; his *Ikiru* (1952) and *Seven Samurai* (1954) continued to reach wide audiences, as did *Throne of Blood* (1957), his version of *Macbeth*, and the spectacular movies he made in the 1960s.

▲ A still from *Trash* (1969) by Andy Warhol. Warhol's fascination with repetition and duration inevitably led him into film-making.

◄ French director Jean-Luc Godard (left) filming on a shoestring. He effectively rewrote the vocabulary of film in the 1960s. He employed documentary material, interviews, subtitles, in order to expand our sense of what a story is and how it can be told.

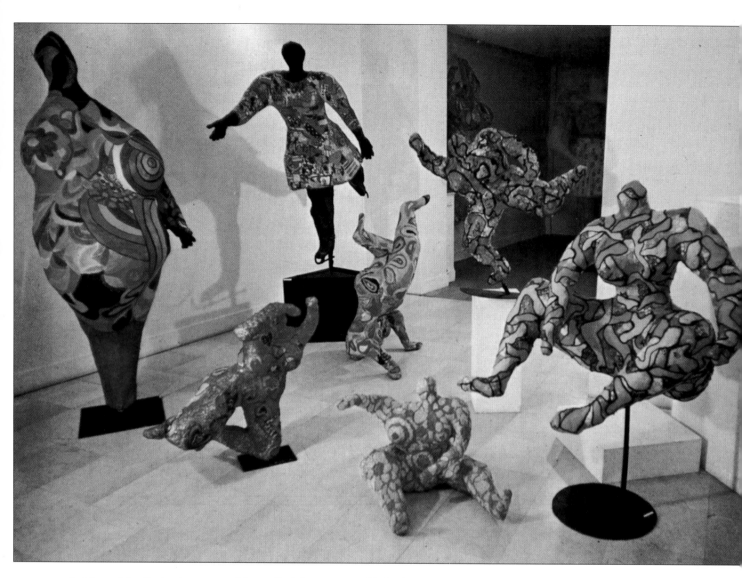

admiring of the "spinning reasonableness" of the clause.

Paranoia was the age's favorite word for the idea that Catch-22 ruled most of our affairs, and the novelist who went deepest into this possibility was Thomas Pynchon. Pynchon's novels *V* (1963) and *The Crying of Lot 49* (1966) were cult books with the young, part of the indispensable equipment for conversation, along with the lyrics of Bob Dylan and the Beatles; and were then taken over by academic critics. *Gravity's Rainbow* (1973), a *tour de force* set in Europe at the end of and after World War II, confirmed his reputation as one of the most brilliantly comic and formidably well informed of modern writers, drawing on a range of references as disparate as movies and the intricacies of modern physics. The dominant thought in these novels is that of an unbearable option: either what happens to us is random and meaningless, a series of events which sometimes fall into patterns but really have no design, so that even the wildest coincidences just are coincidences and can be nothing more; or everything is planned, down to the smallest detail, there is a master conspiracy and we are caught in it. In a memorable image, Pynchon sees this dilemma as a modern disease picked up somehow in the later 19th century.

It is likely that the assassination of John F. Kennedy was a symptom rather than a cause. But in part it was a different kind of reaction to the Cold War, with its atom spies and its hysterical fears and witch hunters. This was also the age of the rise of spy fiction to great popularity: James Bond solved our problems, and the seedy heroes of Len Deighton and John Le Carré were the problem's victims, unfortunate operatives caught in the middle, agents of a conspiracy which seemed to be everywhere yet aimed at nothing.

Writers on the "Hippy Trail"

Yet another response to the loss of traditional stabilities and belief was a sometimes obsessive quest for self-understanding. The 1960s saw a steady popularization of Western interest in the East, most spectacular in the "Hippy Trail" to India and in its stay-at-home parallel, flower power, where drugs and frequently ill-digested elements of Eastern religions were seen as a way to salvation, or at least to a good time, characterized as personal fulfillment. In 1962 the American poet Allen Ginsberg, who, along with Jack Kerouac and William Burroughs, had been a major figure in the Beat Movement of the 1950s, went to India for a year and a half with his lover Peter Orlovsky. Ginsberg had come to prominence and

▲ *An assembly of "Nanas"*, by Niki de Saint Phalle, 1965. An antidote to the relentless misogyny of much male Pop art, which presented "woman" as another debased commodity. Saint Phalle's women seem humorously aware of their dual role as mothers and sex objects. One giant "Nana" was constructed so that the audience could enter her pregnant body through her vagina.

▶ *Babe Rainbow*, by Peter Blake. The iconic treatment of everyday imagery (young women preferred) was a staple of Pop art. Blake, who saw himself principally as a painter in the English tradition, nevertheless had a love of all the minutiae of modern culture.

poetic maturity with his scathing poem *Howl* (1956), a powerful account of the destruction or self-destruction of the "best minds of his generation". In his *Indian Journals*, published in 1970, he documented the rigors of the Hippy Trail, "marching on Ganja to Ganga", hazed by dope and diarrhea and in pursuit of gurus. As the Indian writer G.V. Desani had said in his comic novel of 1948, *All About H. Hatterr*, "All improbables are probable in India." Ginsberg was as improbable as any. For all his rejection of the values of his own society, he remained inescapably American. Although he gathered wise words from holy men such as the Dalai Lama, pulsing through his account is the more Western aim of somehow fixing India, of recreating it. In spite of the *Journals'* vivid evocation of an India hidden from the tourist, Ginsberg was so obsessed by that vision that he saw, like others before him, not so much India as his own "tortured introspection".

The West Indian writer V.S. Naipaul, of Indian descent but born in colonial Trinidad, also visited India around this time and recorded his impressions in *An Area of Darkness* (1964). His reporting is less self-obsessed, wider in its range and more objective. Skeptical where Ginsberg is naive, he is none the less moved when he goes on one of India's most celebrated pilgrimages, to the Armanath Cave in Kashmir. But looking at the joyous faces of the pilgrims, he can only wish that he was "of their spirit". In the end his sense of India was as personal and unlikely as Ginsberg's. Faced with so much variety, he could see only a total negation at the center of things, a reflection of his own dispossession, pitched between East and West.

What Ginsberg never got to, by his own admission, was the streets and figures of daily

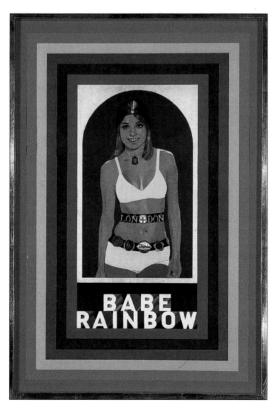

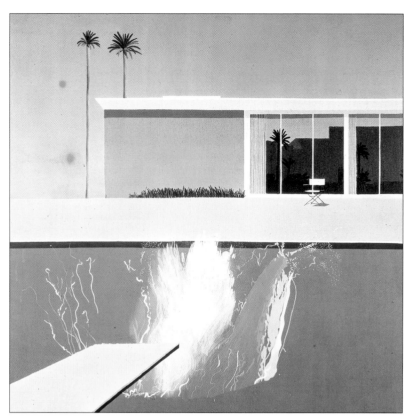

India. It was those same streets that the Indian novelist R.K. Narayan took as his territory. His books are set in the fictional but deeply Indian town of Malgudi, a place that is as alive as Thomas Hardy's Wessex or William Faulkner's Yoknapatawpha County. Nearly all Western readers warm to Narayan's stories. They are totally Indian while drawing on common human experience handled with extreme delicacy. His virtues lie in his honesty, humor and total acceptance. Such acceptance in different, especially Western hands, would be indifference or detachment, but Narayan's perception was that there exists a wider importance and permanence than the individual itself. His roots in the attitudes of village storytellers are revealed in his collection of Indian myths, presented as if they were told by such a storyteller, *Gods, Demons and Others* (1964). The actions take place in a world of good and evil in which good will always prevail, if not in our time, then in the timelessness of the Ultimate Godhead. Narayan reminded the West of what it had lost, and it is fair to say he troubled Westernized India.

Pop art in the 1960s

It was not long before artists in the United States caught up with the movement for Pop art that had sprung up in Britain in the 1950s. In the United States, it was the New York artists Roy Lichtenstein and Andy Warhol who provided the images that popularly defined the tradition: Lichtenstein's blowups of strip cartoons and Warhol's tins of soup cans, multiple Marilyn Monroes and Brillo boxes. The hard-edged, clean look of their work was characteristic and originated in their background in commercial art. James Rosenquist, Tom Wesselmann and Claes Oldenburg, who

▲ *A Bigger Splash* (1967) by David Hockney: one of the "California" paintings by this British artist, executed in a cool, "realistic" style with the aid of an airbrush. Hockney, whose origins in Pop art made him a public celebrity, devoted his mature career to reconciling the apparent contradiction between the avant-garde and tradition. This tendency is seen at its most basic form in canvases where a realistic figure is placed without comment beside a more "abstract" configuration. It led him to form a pantheon of significant artists from whom he built an art of considerable technical accomplishment. Chief among these was Picasso, whose etching techniques Hockney mastered and developed.

were also leading exponents of Pop art, had similar commercial trainings.

Pop art was one reaction to the extreme subjectivity of Abstract Expressionism. Nearly all Pop painting was so close to its origins that it was instantly verifiable in shared experience, and objective in a way Abstract Expressionism could never be. As Andy Warhol put it, "Pop art is liking things." However, such intense concentration on objects with a limited cultural resonance – commercial packaging, multiple reproductions of movie stars – tended to give these objects a sense of unreality, just as repeating a word over and over again reduces it from meaning to sound only. It makes it, in other words, abstract.

Post-Painterly abstraction

In parallel with Pop art, another perhaps more predictable development was into a further phase of abstraction, christened Post-Painterly abstraction by the New York critic Clement Greenberg. Post-Painterly abstraction took its lead from Barnett Newman's way of using broad bands of dense color divided by startlingly thin bands, almost shafts, of a contrasted color. Ellsworth Kelly, Kenneth Noland and Frank Stella all went for cool bands of color and were less concerned with tone than Newman. These paintings seem-

ed to get back towards the sources of abstraction in Malevich and Mondrian, with their interest in the relationship of pure color and in linear design. Feeling disappears and the internal rhythms of the pictures are reduced to a sequence of careful blocks. The eye moves with pleasure through a sequence of colors. As the French anthropologist Claude Lévi-Strauss remarked: "The abstract artist paints the idea of the picture he would paint if, by chance, he should ever paint one." Post-Painterly abstraction is in that sense painting reduced to its elements. Just as Newman painted pictures which gave the idea of the world's creation, so a Kelly picture, more limited but as primary, gave the idea of art's origin in color and the simplest of juxtapositions. The term "hard-edge" was applied to much of this work, denoting an extreme economy of form, neat surfaces and full color.

Op art, mobiles and kinetic machines

Pattern played a central role in another type of painting of the 1960s, Op (=optical) art. The best exponents were in Europe, among them the Hungarian Victor Vasarely, working in Paris, and the British artists Bridget Riley and Peter Sedgley. Their object was to generate energy from the flat surface of the painting in such a way that the

▼ *Tahkt I-Sulayman 1* (1967) Frank Stella. Stella, along with Kenneth Noland and Morris Louis, was part of the movement known as Post-Painterly abstraction. Reacting against the Expressionist aspects of their predecessors, they preferred to stain their colors onto the canvas, or to produce hard-edged images with no brushstrokes. Stella's early work was even more rigorous, consisting of monochrome stripes in oddly-shaped canvases. His conversion to color emphasized the rather decorative basis of his work.

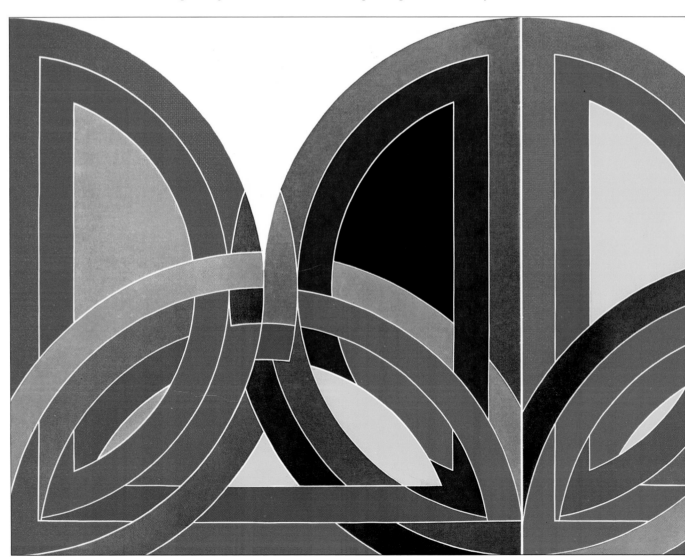

viewer experienced optical illusion, a type of movement. Vasarely used perspective tricks so that the elements in his lattice-like patterns seem to corrugate, to tip out or to recede. The pictures were cheerful and their colors beautifully lit. On the other hand, Bridget Riley did not use color at all till 1967. Her most familiar images were undulating patterns of black and optically disturbing white. The speed at which her patterns flutter and dazzle is much greater than that in Vasarely's work and the effect has a certain austerity. Color, when it came into her work, was used to create a further optical effect in that the jazzing movement now included an after-image of complementary color. Where there is red the viewer also sees a greenish edge which, though still disturbing, softens the assault on the eye.

Just as with most of the more attractive styles in the post-World War II period, Op art has had its followers in many countries. In America the work of Richard Anuszkiewicz achieved a particular delicacy. In Israel Yaacov Agam painted in such a way that the patterns perceived changed as the viewer moved from one side of the picture to the other. Other artists such as Jesus Soto and Carlos Cruz-Diez in Venezuela, Guenther Uecker in Germany and Enrico Castellani in Italy, used a variety of materials – plexiglass, metal rods, nails

set in patterns – to create a variety of optical effects and illusions of movement.

One of the impulses behind Op art was to overcome the static nature of the picture surface, but this was largely impossible other than in a purely illusionist way. Sculpture, relying either on currents of air turning carefully balanced individual elements (mobiles) or motor-driven (kinetic machines), has proved a more fruitful way of harnessing movement for its visual effects. Here the pioneering career of the American Alexander Calder stretched from the 1930s into the 1970s. In one year, 1967, Calder built large structures at the Montreal World Exhibition, the Olympic Stadium in Mexico and at Dallas airport.

▲ The British artist Bridget Riley in the early 1960s. Bridget Riley pioneered the clinical but disturbing Op art movement. Here the emphasis was on the capacity of the human eye to process certain kinds of information. Her art focused on the manner in which a series of black lines obliges us to see perspectives. The results seemed to express private states of mind the viewer was obliged to share.

Happenings

"Happenings" were an important part of the Pop package. Visual art played out its ideas as a kind of live theater. The spectator became participant in a plotless communal act, often on the streets and so crossing over into street demonstration, a zany entry of the imagination into politics. The word was first coined in 1959 by Allen Kaprow, a painter first in New York, later in California. Art as traditionally conceived was too permanent for him. Pop assemblages, collages and constructions were accumulations that the spectator walked round. Even "environments", Kaprow's own invention, three-dimensional spaces that the spectator walked into and where things happened, were too static. The happening went further to stimulate the senses.

It was an event in which the spectator was, in effect, creator. However, Kaprow's earliest attempt, *18 Happenings in 6 Parts* at the Reuben Gallery, New York, in 1959, was carefully premeditated and involved its actors in making scripted responses like painting canvases, playing musical instruments and reading messages from handheld placards for one and a half hours, all simultaneously in 18 compartmentalized rooms, through which the spectators moved at intervals in response to the ringing of the bells. Kaprow's technique loosened up considerably later, but the Happening, because its events were so bizarre

and so dependent on the private whim or invention of the original artist, was always prone to artificiality, even at its most participatory. In Europe, with Joseph Beuys for example, in Japan with the Gutai group and in Britain, where there was a strong link with street theater, there was a more pronounced political element. In Austria and France an equally strong moral preoccupation revealed itself, often directing its criticism at the values of the audience it sought to attract. The most productive element in Happenings was the extension of the boundaries of the visual arts into performance and participation, even if the effects were sometimes banal and selfconscious.

Opera: spectacle and staging

If art and theater were taking to the streets, new developments in staging were making the field of opera more exciting and accessible. In the improved economic conditions of the 1960s and early 1970s, with the expansion of public subsidy and private sponsorship for the arts in the West, it became possible for major opera houses to give elaborate and spectacular staging to contemporary works as well as the established classics. At the same time a number of younger composers were beginning to experiment with small-scale music-theater pieces, which could be quite startling in their aggressive use of imagery and sound.

Two British composers, Peter Maxwell Davies

▲ *Masculine, Feminine*, a performance piece by Klaus Rinke, typical of the way in which German art asserted itself in the early 1970s. Highly politicized, often retaining Expressionist elements, the German "Happening" could be a grueling affair of intestines, polemic, or both.

Building New Societies

and Harrison Birtwistle, founded the Pierrot Players (later the Fires of London) in 1967. The group was based on the forces required for Schoenberg's *Pierrot lunaire* and was associated for many years with new developments in contemporary music and music theater. Typical of this strand of work was Davies's *Eight Songs for a Mad King* (1969). As in *Pierrot*, a solo singer, on whom extraordinary vocal demands are made, pits himself against an instrumental ensemble. The figure is George III – or someone who believes himself to be George III. The work presents a powerful image of a human figure trapped by his own mind. Other music-theater pieces by Davies also involved an element of shock, designed both to push back the borders of acceptable performance and, perhaps, to outrage the bourgeoisie. In *Revelation and Fall*, a blood-red nun shrieks through a loud-hailer; and in *Vesalii Icones* (1969), a naked male dancer plays a Victorian hymn on an out-of-tune piano. Harrison Birtwistle's treatment of *Punch and Judy* (1968) is so abrasive that it demands considerable tolerance on the part of the listener. "His brass roars and brays," wrote Peter Heyworth, a champion of the piece, in 1979, "voices are pushed to their extremities and the woodwind squeals and screams so implacably in its uppermost register that it is not long before the ear is begging for mercy."

In the 1960s radical ideas about the nature of society were reflected in visionary architecture by designers who considered the kind of environment in which new societies might thrive. A singular figure who supported himself by casting bronze bells, Paolo Soleri, planned "Arcologies" ("Architecture" plus "Ecology") that were to be entire, monolithic, utopian cities. Of Soleri's dream cities, only one, Arcosanti, has been partially built, on the edge of an Arizona canyon, largely by students. It was a time of gurus, of whom the American engineer Buckminster Fuller (1895–1983) was the foremost. In 1927 Fuller had designed a totally mechanized "Dymaxion" house ("Dymaxion" from "dynamic" and "maximized efficiency"), which demonstrated both his persuasive wordspinning and his innovative approach to design. Fuller's "geodesic domes" were influential in the years after World War II. His engineer's confidence in new technology was an inspiration to many younger designers, like Peter Cook, Ron Herron and members of the Archigram group. They proposed new concepts of urban living in "megastructures" which took account of increasing mobility and highly serviced living "pods". Herron's "Walking City", Cook's "Plug-in City" (1964) and the group's "Instant City" (1969) were never built, but their use of oil refinery imagery and space-age technology projected in brilliant, comic-book graphics and Lego models challenged conventional ideas of urban dwelling. A decade later, Richard Rogers and Renzo Piano's Pompidou Center in Paris showed how an Archigram city might have been realized.

◀ An American commune built of geodesic domes.

Even in what one might consider the British mainstream, a degree of experiment was taking place. In 1964 Benjamin Britten, working with librettist William Plomer and colleagues in the English Opera Group, staged the first of three "church parables", *Curlew River*. Ideologically and musically this represented a change of direction, toward the pared-down forces and collective approach of chamber opera. Some of the concerns of the time – a collaborative attitude to creativity and the ritualization of performance – are reflected in the structure of these works, in which the performers are anonymous monks, who temporarily take on their parable roles with didactic intent. ·*Curlew River*, the most effective of the three "church operas", transplants the Japanese Noh play *Sumidagawa* to the English Fens. In 1970 Britten experimented, not wholly to his own satisfaction, with an opera written specifically for television. *Owen Wingrave*, based on a short story by Henry James, is avowedly pacifist. Owen resists family and social pressures to make war his career, but is finally destroyed by history and legend in the form of a mystically repeating

▲ *Event for the Image-Change of Snow*, the GUM group, 1970. The pictorial qualities of this event mark it out as more linked to conventional art than most Happenings, which are essentially theatrical in origin. Nonetheless, this Japanese group, perhaps drawing on their culture's traditional capacity for pageant, produced something both pleasurable and beautiful.

▲ The Argentinean composer Mauricio Kagel in a scene from his *Staatstheater*, (1967–70). The distinction between composer, performer, dancer, and even instrument, was breaking down.

▼ A new concert hall in Courcheval, France. The increasing popularity of classical music in the 1960s and 1970s meant that architects began considering new methods of presenting it.

family myth. The medium proved an advantage to the composer in some ways, such as the ability to cross-fade between scenes or images and the use of the close-up to reveal inner thoughts, which by-passed the staginess of opera-house soliloquy convention. In his final major opera, *Death in Venice*, Britten again took up a personal political stance, addressing homoeroticism more directly than anywhere else in his *oeuvre*. The libretto – by Myfanwy Piper, like that of *Owen Wingrave* – is a dramatization of the Thomas Mann novella of the same name. As in some Greek tragedy, Gustav von Aschenbach is torn between the two sides of his own nature represented by the elemental forces of Apollo and Dionysius: contemplation and action, esthetic satisfaction and sexual desire, social restraint and emotional abandonment. The opera is also interesting for its incorporation of dance into the dramatic structure. It is used to emphasize the impossibility of a real connection between Aschenbach and the boy Tadzio. With a vocal line or a physical gesture one may reach out toward the other, but cannot, finally, be truly answered.

The Bassarids (1966), by Hans Werner Henze, a version of Euripides' *The Bacchae* with a libretto by W. H. Auden and Chester Kallman, also looks at the demolition wreaked by the darker side of our natures if any attempt is made to deny it. It

combines the techniques of Schoenberg with the theater of Wagner; the librettists' precondition for supplying the text was that Henze should "make his peace with Wagner".

Intolerance was the theme of both the Italian composer Luigi Nono's *Intolleranza 1960* (1961) and of Polish-born Krzystof Penderecki's *The Devils of Loudun* (1969). Nono's vast political canvas follows an immigrant as he is oppressed and exploited in incident after incident. The work does, however, achieve an optimistic ending as the immigrant discovers the kinship and support of his fellow prisoners and they sing an anthem setting Bertolt Brecht's poem "To the Newborn". Penderecki takes John Whiting's play *The Devils* (1961), in turn based on Aldous Huxley's *The Devils of Loudun*, as his source. It too is an emblem of the destruction of the individual by the forces of repression, in yet another form; the agent of the priest Grandier's undoing is the sexual hysteria of a convent of nuns.

Changing relationships in music
The popular political movements of the 1960s had implications for all the arts. In music, an urge towards democratization resulted in changes in the relationships between composer and performer and between performer and audience. The former brought greater autonomy to the

The Ballet Boom and the Superstar Era

During the 1940s and 1950s ballet had consistently flourished in Europe and the United States, but it was the appearance of Russian companies in the West for the first time in decades that sparked off the huge increase in its popularity during the 1960s and 1970s. The Bolshoi Ballet electrified audiences in the mid-1950s with their flamboyant athleticism and charged powers of expression, and similar excitement was generated by the Kirov Ballet's tours in the early 1960s. The defection of the Russian star Rudolf Nureyev in 1961, and his charmed partnership with Margot Fonteyn, turned ballet into headline news. Wherever they performed, the couple were treated as superstars. Nureyev himself transcended even Nijinsky's image as super-athlete and sex symbol. Later fugitives from the Kirov Ballet, Natalia Makarova and Mikhail Baryshnikov, attracted comparable publicity; and their careers clinched the new role of the dancer as media star. Through television and the commercial theater, ballet companies from the 1960s onward began to cater directly to the newly expanded audience. The New York-based Joffrey Ballet performed works with loud rock scores; John Cranko commissioned pieces for the Stuttgart Ballet that emphasized raw theatricality over academic purity of style, while in Britain Kenneth MacMillan updated the narrative ballet by incorporating film and speech into his choreography. The 1960s and 1970s also saw ballet become genuinely global. The Australian Ballet was fully established in 1962, the Beijing Ballet (later Central Ballet of China) was founded in 1959, the Tokyo Ballet in 1964 and Portugal's Ballet Gulbenkian in 1965. Performers began to move freely between companies as repertoires became more international and interchangeable.

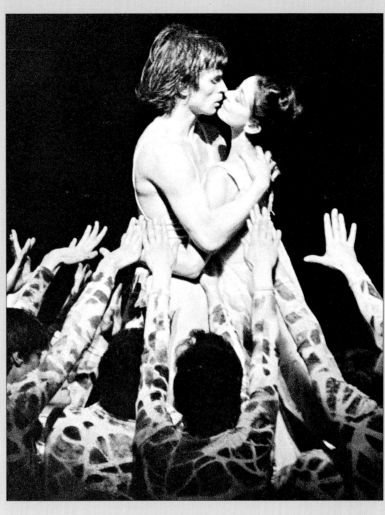

▶ **Rudolf Nureyev and Margot Fonteyn.**

performer; sometimes an improvisatory element was introduced, or the performer could exercise a degree of choice over the ordering of the elements of a work. The latter found expression in a change in the physical layout of performing spaces, which sometimes allowed the listener to feel in some sense a participant in the making of music; at its extreme, it brought into question the professionalism of the performer; technical ability could even seem alienatingly exclusive.

The acknowledged central figure of the avant-garde during the 1960s was Karlheinz Stockhausen, who extended his exploration of serialism from "points" and "groups" to "moment form", a concept that does away with the hierarchies of relevance: no "moment" is more or less important than any other. The structure is provided by the listener's varying concentration. This abdication of control over the relative importance of elements of a work apparently grants equality to all sound units and between creator and auditor. Stockhausen's 1961 piece, *Momente*, for soprano solo, four choral groups and thirteen instrumentalists, is a sequence of "moments", not all of which are essential to the work. It combines sound, including clicking, stamping and clapping, with fragments of text taken from various

sources. In *Prozession* (1967), the players perform passages from Stockhausen's earlier works from memory and with a degree of improvisatory freedom. *Ensemble* is the collective result of a 1967 summer school at Darmstadt. Twelve students each wrote a section of a work structured by Stockhausen, composing for one particular instrument or for tape and for short-wave receiver. *Stimmung* (1968), for six vocalists, is a remarkable incantatory work, calling for Asian vocal techniques in 75-minute examination of the natural harmonics of a low B flat.

Pierre Boulez, too, continued to work with both natural and electronic sound, incorporating improvisatory elements into his music and experimenting with physical space. In *Domaines* (1968), for instance, a solo clarinettist moves between six symmetrically placed instrumental groupings. Control of the direction of the piece alternates between the soloist and one of the instrumental groups, which consists of a second soloist, a duo, a trio, a quartet, a quintet and a sextet. His *....explosante-fixe....* (1971) can be described as "a sort of composition kit". The work was written as a memorial to Stravinsky, and the almost limitless form the piece can take is dictated by its performers – whose number and

What is the series? The series is – in very general terms – the germ of a developing hierarchy based on certain psycho-physiological acoustical properties, and endowed with a greater or lesser selectivity, with a view to organizing a FINITE ensemble of creative possibilities connected by predominant affinities, in relation to a given character. This ensemble of possibilities is deduced from an initial series by a FUNCTIONAL generative process... This idea can be applied to all the components of crude sound: pitch, duration, dynamics and timbre...
PIERRE BOULEZ, 1963

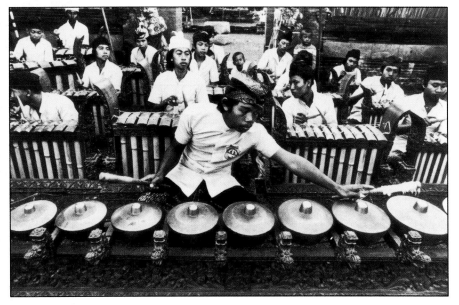

▲ ▼ The music of Steve Reich (below), with its use of regular patterns and a multiplicity of percussive instruments, had a natural affinity with the gamelan orchestras of Indonesia (above), sometimes echoing it directly. Reich introduced an element of chance into his compositions, particularly in relation to the shifts in his rich patterns.

► The dissolving of a clear distinction between art-works and art-performances led in the 1960s to the mixed-media event such as this concert and light show by the Greek composer Iannis Xenakis. In the work of kinetic artists like Nicolas Schoffer, visual and aural elements could be equally important. This development matched the increasingly sophisticated use of light and laser shows in rock concerts.

instruments are not specified. A similar freedom was offered to the performers of the 193-page graphic score, *Treatise* (1963–67) by Cornelius Cardew: "No one is told what to play; each person must find this out for himself by reading the score." Cardew had worked as an assistant to Stockhausen from 1950 to 1960 and then as a graphic artist from 1961 to 1970. He worked with both highly experienced jazz improvisers and untrained amateurs. He formed the Scratch Orchestra in 1969, a band of variable but large size comprising professionals and amateurs, whose performances were marked by random and anarchic aspects. His philosophy gradually changed from libertarianism to Maoism and by 1971 he was repudiating his earlier avant-garde work in favor of the more conventionally accessible use of melody and harmony of such overtly political statements as *The East is Red*.

The student riots in Paris in May 1968 had repercussions throughout the Western world. Luciano Berio, who had emigrated to the United States in 1963 (and was to return to Italy in 1972), used the students' slogans alongside other quotations in his 1968 *Sinfonia* for voices and orchestra, an attempt to invoke the spirit of the time in dramatic musical form. He took his choice of text a stage further for *Questo vuol dire che* (1969), which includes a setting of its own program note.

The French composer Iannis Xenakis, born in Romania of Greek parents, is fascinated by that area of pure mathematics that touches on both moral philosophy and social science. His compositions owe much to the area where pure mathematics and philosophy meet. *Stratégie* (1959–62), for example, draws its coherence from the theory of games: the work is an exchange of possibilities between two orchestras and two conductors. Each player is required to evolve a game plan to respond most effectively to the choice made by the preceding performer(s). Xenakis was active in the Greek Resistance during World War II. He was badly wounded in the face, losing the sight of an eye,

and later captured and condemned to death. His political commitment, now expressed as a desire to find "a new path for man", is unchanging. Despite the illusion of coldness produced by his use of mathematical formulae and computer-aided calculation, his music is full of human warmth. *Nuits* (1967–68) carries the dedication: "For you, unknown political prisoners ... and for you, the thousands of the forgotten whose very names are lost."

Playing games with expectations

Many of the composers working with minimalism in the 1960s were also associated with the performance artists then working in New York, and particularly with the Fluxus movement. Fluxus events can be thought of as having a musical structure, in that activity is prescribed along a time continuum and that sound produced (or sometimes even *not* produced) by, among other objects, musical instruments is often a central element. Fluxus was both profoundly serious and deeply flippant. Its seriousness lay in playing games with expectations, in tantalizing perceptions and breaking down assumptions about time, value, relation and meaning. For instance, the entire "score" of George Brecht's *Solo for Violin, Viola, Cello or Contrabass* (1962) is a single word: "Polishing". For Robert Watts's *Solo for French Horn* (1964), the performer is required to "Fill French horn with rice / bow to audience".

The American La Monte Young brought many non-Western influences to his work. His interest in Indian music, the Japanese gagaku orchestra and the use of drones and organum in early Western music led him to use long-sustained sounds to give cohesion to his music. In 1962 he began experimenting with just intonation – a form of "pure" tuning readily available to both stringed instruments and computers, in which the frequency ratios differ slightly from those of the more familiar (and marginally irregular) diatonic scale. His music is close to theater and Young's troupe, the Theater of Eternal Music, was set up solely for the performance of his work.

Young's compatriot Steve Reich has taken rhythm as the unifying factor in his music. Reich studied the techniques of Ghanaian drummers and adopted as his own the endlessly subtly shifting texture of West African music. "Phasing", the generating principle of much of his work, is the relationship between two or more instruments playing the same material with a defined time delay. Reich worked first with tape-recorders set at infinitesimally different speeds playing back the same sounds. The ear registers the fluctuation as a kind of musical development, seeking patterns, and succumbing to a form of aural hypnosis. *Drumming* (1971) is a major 90-minute work for two women's voices, piccolo, four pairs of tuned bongos, three marimbas and three glockenspiels. Again, pulse is the dominant factor and melody and harmony are irrelevant. In performance the work takes on a ritual quality, as the performers, dressed in black and white, work in pairs, facing each other and progressing from one instrument to the next before bringing all the instruments into use for the finale.

POP ART

The Spanish Surrealist Salvador Dalí once said, "It is a common error to think of bad taste as sterile; rather it is good taste, and good taste alone, that possesses the power to sterilize and is always the first handicap to any creative functioning". In the 1960s Pop art took as its source consumer taste and projected it as high art. The motives were mixed. In part Pop artists were detaching themselves from the emotional intensity of the Abstract Expressionists by painting objects like soup tins and comic strips about which little emotion could be felt. Second, they were casting an ironic eye on art and commerce, sending both up at the same time. But third, there was a genuine element of delight at the vigor of the streets, commercial art and the "visual inflation" of advertising which the Pop artist James Rosenquist described as "one of the foundations of our society".

Insofar as Pop art had its brief moment of glory in the 1960s, especially but not exclusively in the United States and Western Europe, it could be argued that the art fitted the mood of the times. Technology informed its methods. In *Whaam!*, as generally in his work based on comic strips, Roy Lichtenstein imitated the screen dots used in lithographic modes of reproduction, found particularly in newspaper and magazine printing. It was an egalitarian art in that it overrode accepted notions of good or bad taste, or rather converted bad taste to good taste. It was also graphic rather than painterly.

Pop art was about image, and its trailblazer was Andy Warhol. As well as carefully cultivating his personal image as a bland, emotionless figure whose almost albino coloring gave a deadpan shock value, he produced portraits of packaged stars such as Marilyn Monroe and Elvis Presley, glamorous projections whose private "real" lives were kept under wraps. Feelings were also modishly excluded from the work of other Pop artists such as Tom Wesselmann, Mel Ramos, Allen Jones and, to some extent, Richard Hamilton, in which there were some exploitative, even fetishistic presentations of women from which any sense of the subjects as people was conspicuously absent.

Whaam! illustrated another sign of the times, the prevalence, and high level of awareness, of violence in a society that was becoming partially anesthetized to it. This numbness was to increase later in the 1960s in reaction to the spectacle of the massive fire power of the US Air Force, deployed in the blanket bombing and chemical devastation of Vietnam. Pop art seemed at times to stem from a blankness in the face of feeling. *Whaam!* is a blow-up of strip cartoon, taken out of its context, so that the viewer is free simply to focus on destruction but made into image only, and an image of an image. The effect is to send up the comic, the artworld and ultimately feeling itself. Although Pop art may be superficially vigorous and challenging, ultimately it is empty, its appeal deriving from an awareness that the modern world has been saturated with images and information.

▶ One panel of the diptych *Whaam!* (1963) by the American Pop artist Roy Lichtenstein. In his work based on strip cartoons, the artist appears to give himself no more than a passive role, choosing the image and blowing it up grotesquely larger than the original illustrator ever intended, to let its content strike us more directly than ever before. In fact Lichtenstein's art was more interventionist than this, as he subtly redesigned the cartoon frames that were his models to suit the large canvas. And his images were achieved not with the lithographic press that he celebrated, but with a paintbrush, using traditional painterly techniques to imitate the crude images of popular culture.

What I do is form, whereas the comic strip is not formed in the sense I'm using the word: the comics have shapes but there has been no attempt to make them intensely unified.... And my work is actually different from comic strips in that every mark is really in a different place, however slight the difference seems to some. The difference is often not great, but it is crucial.... One of the things a cartoon does is to express violent emotion and passion in a completely mechanical and removed style. To express this thing in a painterly style would dilute it; the techniques I use are not commercial, they only appear to be commercial – and the ways of seeing and composing and unifying are different and have different ends.

ROY LICHTENSTEIN 1963

Datafile

The Pacific region became an important new focus in the 1960s. While Japan was coming to challenge the West economically, and transforming much of the Western culture, the wars of Southeast Asia brought a quite different attention to the region. The arts in Australia and New Zealand had to define themselves against a rather mixed background in the 1960s. While painters and writers were reacting against a sense of themselves as colonials, they were also resistant to the resulting tidal wave of Americanization. There was also the problem of how to belong to someone else's country: the Australian Aborigines and the New Zealand Maoris remained second-class citizens, their culture protected rather than integrated.

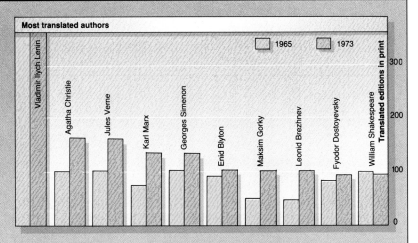

Most translated authors

1965 | 1973

Vladimir Ilyich Lenin · Agatha Christie · Jules Verne · Karl Marx · Georges Simenon · Enid Blyton · Maksim Gorky · Leonid Brezhnev · Fyodor Dostoyevsky · William Shakespeare

Translated editions in print

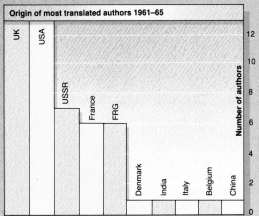

Origin of most translated authors 1961–65

UK · USA · USSR · France · FRG · Denmark · India · Italy · Belgium · China

Number of authors

▲ The figures for most translated author (based on number of translated editions in print) often make bizarre reading, suggesting most of the world confines itself to political tracts with some detective fiction for light relief. It is doubtful whether as many people read Brezhnev as Blyton.

◀ The most translated authors issue from the most powerful Western nations in a fairly unsurprising manner. These figures are based on the country of origin of the 50 most translated authors.

◀ The Nobel prizes continued to display the bias of Western democracy. Thus two Jewish writers won in 1966, when Israel was being supported by the United States. And Solzhenitsyn was praised in 1970 "for the ethical force with which he has pursued the indispensible traditions of Russian literature."

▼ The Prix Goncourt was established to honor younger French writers. The Pulitzer prize is awarded for plays, novels, poetry, works on US history and American biography.

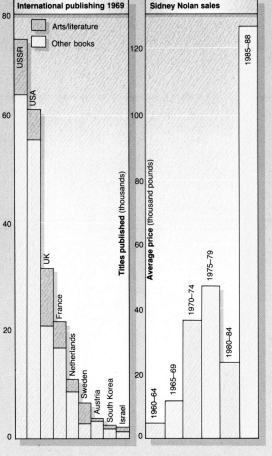

International publishing 1969

Arts/literature | Other books

USSR · USA · UK · France · Netherlands · Sweden · Austria · South Korea · Israel

Titles published (thousands)

Sidney Nolan sales

Average price (thousand pounds)

1960–64 · 1965–69 · 1970–74 · 1975–79 · 1980–84 · 1985–88

Nobel Prize for Literature

Year	
1960	Saint-John Perse (France)
1961	Ivo Andrić (Yugoslavia)
1962	John Steinbeck (USA)
1963	Giorgos Seferis (Greece)
1964	Jean-Paul Sartre (France)
1965	Mikhail Sholokov (USSR)
1966	Shmuel Y. Agnon (Israel) and Nelly Sachs (Germany)
1967	Miguel Asturias (Guatemala)
1968	Yasunari Kawabata (Japan)
1969	Samuel Beckett (Ireland)
1970	Alexander Solzhenitsyn (USSR)
1971	Pablo Neruda (Chile)
1972	Heinrich Böll (Germany)

▲ The proportion of arts and literature books in the total publishing output of a country averaged about 30 percent, but rose to more than 50 percent in some cases. The immense output of technical and scientific literature from the superpowers, however, reduced the proportion in those countries. The sudden appearance of South Korea does not indicate a drive for education, or a vast increase in technical manuals to aid development, so much as the production of political tracts.

▲ Sidney Nolan, perhaps most famous for his series of paintings on Ned Kelly, was one of the Australian artists who established an indigenous mythology. For Nolan this involved a narrative element, the sense that something has happened and something will happen after the moment of the picture. In a sense he willed Australian history into motion. His work had some analogies with Chagall's treatment of Vitebsk or Vence, but it is a measure of his success that it appeared totally original.

Major literary prizes

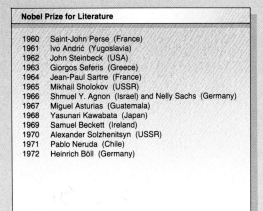

	Prix Goncourt	Pulitzer Prize for fiction in book form
1960	Vintila Horia *Dieu est né en exil*	Allen Drury *Advise and Consent*
1961	Jean Cau *La Pitié de Dieu*	Harper Lee *To Kill a Mockingbird*
1962	Ann Langfus *Les Bagages de sable*	Edwin O'Connor *The Edge of Sadness*
1963	Armand Lanoux *Quand la Mer se retire*	William Faulkner *The Reivers*
1964	Georges Conchon *L'Etat sauvage*	No award
1965	Jacques Borel *L'Adoration*	Shirley Ann Grau *The Keepers of the House*
1966	Edmonde Charles-Roux *Oublier Palerme*	Katherine Ann Porter *Collected Stories*
1967	André Pieyre de Mandiargue *La Marge*	Bernard Malamud *The Fixer*
1968	Bernard Clavel *Les Fruits de l'hiver*	William Styron *The Confessions of Nat Turner*
1969	Félicien Marceau *Creezy*	N. Scott Momaday *House Made of Dawn*
1970	Michel Tournier *Le Roi des aulnes*	Jean Stafford *Collected Stories*
1971	Jacques Laurent *Les Bêtises*	No award
1972	Jean Carrière *L'Epervier de Maheux*	Wallace Stegner *Angle of Repose*

THE PACIFIC BASIN: A NEW FOCUS

Vietnam and the Pacific Basin

Painting in Australia and New Zealand

Symbols of culture: music and architecture

Japan: realignments in the arts

China during the Cultural Revolution

Japanese cinema

Dance and martial arts in Japan

One of the effects of World War II was to give a new prominence to the Pacific Ocean in the concerns of the world. In strategic terms it became in effect an inland sea, bordered by the Americas, Russia and China and enclosing Australia, Japan and New Zealand among a host of smaller islands. Many such islands became vital refueling stations, airstrips and essential links in a chain of sea battles fought for world domination. Military and civilians alike throughout the Western world began to recognize the names of places they had not hitherto known existed.

With the acceleration of communications of all kinds after the war came a growth in contact between many of the countries of the Pacific Rim and those of the West, running in parallel with efforts to come to terms with very different problems and opportunities, many of them the result of colonial insensitivity and exploitation. While still under American occupation, Japan laid the foundations for industrial supergrowth. Australia began to look more and more toward the United States and Japan, rather than to past links with

▼ A wealthy area of Saigon after the May 1968 battle, photographed by Philip Jones-Griffiths. Images like this focused public attention on Vietnam and Southeast Asia in general.

Britain. In China, Mao Zedong's proclamation of the People's Republic in 1949 heralded collectivization, the economic disasters of the so-called Great Leap Forward, and the repressive period of the Cultural Revolution. Meanwhile Southeast Asia suffered yet further warfare. The Korean War resulted in the partition of the country, and in Vietnam American intervention in 1954, after the defeat of the French colonial powers, brought about a war of attrition on a scale never seen before, which lasted until 1975.

In terms of the artistic imagination, Vietnam was another numbing war, one which in effect called into question the role of art itself in such shattered contexts. Simply to document seemed the only possible response; to attempt more was gratuitous. Norman Mailer's *The Armies of the Night*, the story of an anti-Vietnam protest in Washington in 1967, relentlessly expanded into a total examination of the American way of life, yet never strayed far from Mailer himself. Even here Vietnam was the victim, a means to test the soiling of the American dream. The analysis was

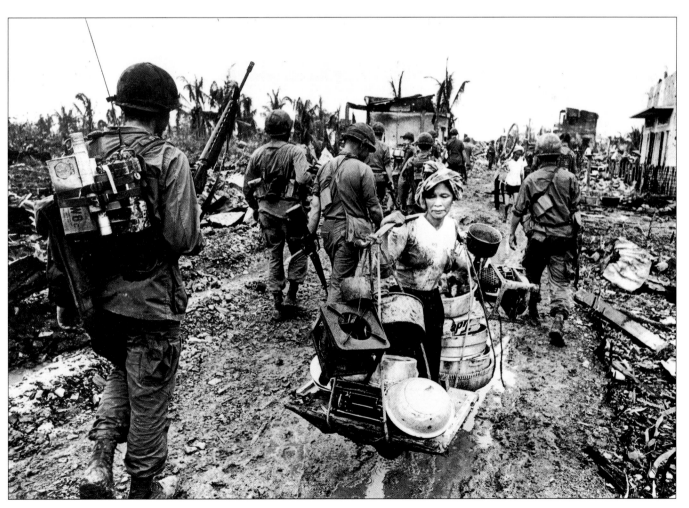

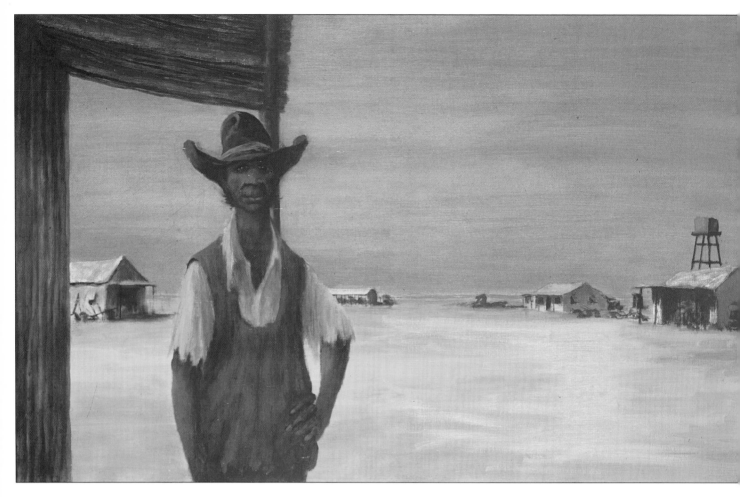

▲ *The Outstation* (1965), by the Australian painter Russell Drysdale. His art provided an insight into life in the townships of the Australian outback, creating a wry mythology from monotony.

Nudes in Australian landscapes. They have become more identified with the bush or with the countryside, mixed up with dead wood ... The nudes look a bit like frogs.... I have painted nudes flying over mud banks of red earth in the depth of the bush, flying or diving into deep black pools with gold fish swimming around them ... women turning into fireflies or vice versa; hovering over black landscapes with quickly rushing water ...

ARTHUR BOYD, 1961

better conducted – because more analytically – by philosopher and political critic Noam Chomsky in *For Reasons of State* (1973).

More telling was the response of Australian writers. Whereas for Americans, the war was a tale of soured failure in intervention, for Australians it was a bitter commitment. Australians had been involved in two World Wars, seen the death throes of the old British Empire and had built a national identity around these events, notably in the Gallipoli disaster of 1915, when Australian troops had suffered terribly in an attack on Turkey. But now, in a war which (since the French departure from Southeast Asia) was in no way European, Australia acted from a new persuasion. Much of the response was documentary, as with Lex McAulay's *When the Buffalo Fight* (1980), but poets such as A.D. Hope and Bruce Dawe, who could be briefer in their comments, brought the *frisson* of World War I writing to the new war. In terms of the geography of art, where the center is a new power base opened up with the seizing of the moment by the Australians. For the Pacific region as a whole it confirmed a new literary and artistic awareness, born of new rigors.

Painting in Australia and New Zealand

Colonialism had been a shaping force in Australia and in New Zealand. Both countries were dominantly white settler societies, with European settlement going back to the late 18th century. For those in the West, they had seemed distant from

the world's actions, except when they sent their people abroad in two world wars to fight and die in far-off battlefields, or when their role as suppliers of primary farm produce to Europe was altered by economic depression generated elsewhere. In both countries the original inhabitants had been decimated by the coming of white settlers, their diseases and their guns. Deprived of their ancient possession of the lands, which were not merely theirs but sacred to them, and their ways of life disrupted, the nomadic Aboriginals in Australia and the Maoris in New Zealand were very nearly overwhelmed.

But there have always been substantial differences between the two countries. Australia has had a continental cast of mind, a largely urbanized people staring inward to the barren and hostile heart of a vast country. New Zealand has had an island mentality, its two islands the last stop before the Antarctic icecap. Australia's land was ancient, gnarled; New Zealand, hiding volcanic fires, seemed still in touch with the freshness of a primal world. Both landscapes were myth-laden and have gradually effaced merely European dreams of utopia or nightmares of exile. Australian painting had its real contact with modern European painting delayed virtually up to the beginning of World War II. In 1939 the *Melbourne Herald* organized a major art exhibition, which showed painting by Post-Impressionists such as Cézanne, Gauguin and Van Gogh, Cubists such as Braque and Léger, Surrealists such as Dalí and also work by Picasso and Matisse. Before that

▶ One of the series of paintings of the Australian bushranger *Ned Kelly* by Sidney Nolan. This painting was done in 1955. Nolan was fascinated by the events of Australian colonial history around which legends had gathered, and especially by the legends surrounding Ned Kelly. Kelly had led an outlaw gang in a series of robberies in New South Wales in the 1870s, before capture and execution in 1880. His most notable visual feature was his home-made armor.

artists had to go abroad, a big undertaking then, to see such work, or rely on photographs. In any case, it was an uphill battle trying to paint in a modern style in a society where taste was cautiously Impressionist at its boldest. But in the 1950s and 1960s a new, more complex, account of Australia emerged in the painting of Sidney Nolan, Albert Tucker, Arthur Boyd and Russell Drysdale. It was more complex because it absorbed and then looked beyond landscape and light, the prime elements that gave Australian painting its individuality. These painters sought subjects that gave the land an imaginative history, myths that acted deeper than words. And although there were Expressionist and surreal elements in what they did, there was little in Western painting to correspond with it. They gave their pictures a sense of story, as did the American Ben Shahn and the Russian Marc Chagall. With Nolan, a picture seems to be in mid-story. Something led up to it and something will follow from it; there was not just something to say, but something to tell. Usually a story: there was the folk-hero Ned Kelly, the explorers Burke and Wills or a weirdly reimagined Greek myth like Leda and the swan. With Drysdale, there is no story as such; in outback townships men sit reading newspapers or stand in silent streets. An Aboriginal fixes the viewer with depthless eyes. Yet there seems to be a story within these scenes, however unchanging and merciless it is, like a recurring dream. Tucker's gamblers all lay down the ace of spades while flying parrots menace them. And Boyd's curled lovers invite questions and hint at melancholic answers.

Such is the mythic power of these paintings that the more international-style Abstract Expressionist work that followed, individually impres-

sive as some of the paintings were, seemed to have little to add. Instead the best of the painters stayed close to a sense of the land, to a delineated environment, or drew on Aboriginal art. Fred Williams made a minimal sticklike notation describe a limitless landscape. Ian Fairweather suggested but in no way imitated Aboriginal barkpainting, and Jeffrey Smart painted an exact hallucinatory urban world. The tradition, for such it is, has been built up by painting a world that is lonely, "out there" but so pervasive that we are ourselves inside it.

While Ian Fairweather, an artist who had originally come to Australia from Scotland in 1934, used Aboriginal-like color and line in his work, the most famous Aboriginal painter of this time, Albert Namatjira, was painting with total skill in a wholly derived European style. The richness of the symbolic Aboriginal mode as it might be integrated with the techniques of the West did not emerge to public awareness until the 1970s with the setting up of the Papunya Tula artists' company. It can be seen in the work of Clifford Possum Tjapaltjarri and Michael Nelson Tjakamarra, and again at the heart of the painting is storytelling, stories linked with places and with the Dreaming, the Aboriginal Creation.

New Zealand painters have traditionally confronted and delighted in a light and a landscape with which, as in Australia, techniques derived mainly from the rainladen atmosphere of the British Isles were inappropriate. No particular school of New Zealand painting has emerged, though the arts have fought their way through as a defining cultural mode. But the pattern of painting in New Zealand has been rather one of individuals who have benefited from the very isolation of the land. Frances Hodgkins, full of precocious talent, settled in England and painted landscapes dotted with random objects, making the ordinary quirky and in some way her own. Her example is a reminder that both in Australia and New Zealand, women have produced many of the most exciting images of the century: Thea Proctor, Margaret Preston and Grace Cowley through the 1930s and 1940s in Australia, Rita Angus and more recently Louise Henderson in New Zealand. Other individuals who have produced some distinguished paintings include

▼ *Sleeping Nude* (1962), by Arthur Boyd, an Australian painter who sought to incorporate mythological and symbolic elements from the European tradition in his work. In this painting he was looking back to Manet's and Giorgione's paintings of nudes in a landscape; in some of his other works he drew on Shakespeare.

Christopher Perkins and Toss Wollaston, both concerned primarily with landscape. One artist in particular stands out: Colin McCahon, who painted almost abstract visions of the New Zealand hills, allegorizing them into a spiritual drama of light and dark.

While white painters struggled to comprehend and portray their new land and landscape, so the original settlers, the Maoris, began to fight to revive their arts and so spiritually renew their people. The School of Maori Arts and Crafts was founded in 1927, and helped to ensure that Maori traditions, especially in woodcarving, were not simply consigned to museums as they might so easily have been, but still animate landscape and life alike. Traditional carving skills also began to be linked with modern techniques and styles; the carvings of Para Matchitt in the 1960s and his later murals at Ngauruawahia are fruits of this link. The work of Selwyn Muru and Ralph Hotere too was rooted in Maori tradition.

Exploring the terrain: writing in the Pacific

New Zealand's greatest artistic strength has lain in its poets, who have been concerned to unravel rather than simply accept their land. One Prime Minister of New Zealand said in the 1960s: "We are not separated from England by 12,000 miles of water but joined by it." That same irony has perplexed many poets. Allen Curnow's intelligent formulation of the predicament of island isolation did much to shape his own writing as well as that of other such as Denis Glover. James K. Baxter, arguably the finest of New Zealand's poets, was totally different in approach. His final works, like his own life, played their part in bridging the Maori-European gap. Buried on Maori land, his requiem mass was a great gathering celebrated by the Maori poet Hone Tuwhare.

Novelists too were concerned with mapping new territory. In New Zealand, Janet Frame's explorations of mental illness, *Owls Do Cry* (1957), *Faces in the Water* (1961) and *The Edge of the Alphabet*, have an almost painfully beautiful style and are seldom less than disturbing. Probably the best-known novelist of the 1960s was Australia's Patrick White, who was awarded the Nobel Prize for Literature in 1973 for a series of novels that included *Voss* (1957), *Riders in the Chariot* (1961) and *The Solid Mandala* (1966). His books enact a lonely existential pursuit of meaning and identity in precisely imagined Australian settings. Problems of adjustment and understanding affected the smaller Pacific islands too, as well as the great land masses of Australia and New Zealand.

In Samoa, the novelist Albert Wendt began a series of books in 1973 with *Sons for the Return*

▼ The Sydney Opera House was commissioned in 1956 from the Danish architect Jørn Utzon, yet this emblem of Australia's cultural quality was nearly an ironic comment. The actual construction posed unforeseen problems, and the building was not completed until 1973, since Utzon himself apparently had no idea how his "shells" would stay up. The problem was eventually solved by the engineers, Ove Arup, but not before the interior was totally redesigned. This "flawed" masterpiece was nonetheless accepted by Australians as a national symbol – perhaps of the triumph of the practical over the precious – and was soon recognized worldwide.

▲ *Landscape Series A.* (1963), by the New Zealander Colin McCahon. New Zealand's painters, like their Australian contemporaries, were concerned with the need to define their relationship with the country they had colonized. The vivid light, the remoteness from Western influence and the social position of the Maori, all meant that their landscape presented them with pictorial and moral difficulties. McCahon's landscapes reveal a constant, baffling succession of vistas and barriers. They depict New Zealand both as problematic and as compelling, beautiful reality.

Big hills stood in front of the little hills, which rose up distantly across the plain from the flat land: there was a landscape of splendour, and order and peace. (The Crucifixion hadn't yet come I saw an angel in this land. Angels can herald beginnings.)

COLIN McCAHON, 1960

Home, concentrating on the effects of change on traditional village society, and the mesh of passions engendered by it. His work is on a grand, mythic scale, stocked with towering characters who, faced by darkness and the terrors of life without meaning, urge themselves on to self-questioning, achievement and success. Indo-Fijians such as Subramani, Raymond Pillai and Satendra Nandan have written well on the bleak inheritance of displaced Indian communities, while in New Guinea lively dramatic traditions flourished and novelists began to emerge.

Symbols of culture: music and architecture

It was not until the early decades of the 20th century that the impulse towards exploring and defining a new national identity that motivated writers and artists led composers too towards the possibility of a distinctly Australian music. The composer and pianist Percy Grainger, born in Melbourne in 1882, studied in Europe and lived in the United States before returning to Australia in the 1930s. His interest in collecting folk songs led him to suggest that Australian composers should take into account the music of the South Pacific and even Asia, a suggestion that was taken up by recent composers such as Anne Boyd and Peter Sculthorpe.

The postwar years were marked by a great spurt of musical activity. Opera too became very popular, perhaps partly as a reflection of the international success of the Australian soprano Joan Sutherland, and Australian Opera was created in 1956. As public demand for music grew, concert halls were built, and in Melbourne and Sydney opera houses were commissioned to cater for a rapidly growing and sophisticated audience. Sydney Opera House in particular was intended to show the world that both musically and

architecturally Australia had now come of age.

In 1956 the Dane Jørn Utzon won the international competition for the design of the new opera house. His proposal for Bennelong Point near the Sydney Harbor Bridge was for stepped terraces leading to two halls – one for concerts, one for opera – that would be spanned by "elliptical paraboloid" shells of reinforced concrete. Billowing like sails, unfolding like flower petals, they were beautiful but, unfortunately, difficult to construct in the form he had sketched. The project was not completed until 1973, at vast cost. To some extent the lightness of Utzon's original design was forfeit to the practicalities of building, but the halls remain remarkable soaring spaces, the shells rising up to 60 meters (200 feet), clad in ceramic tiles that take on the colors of the sky.

Although Utzon was Danish, the most important movement in world architecture in the 1960s and 1970s was towards an emergent self-identity in the countries of the Pacific Rim. At first, Australian architects conservatively and uncritically adopted the International Style. Architects such as Harry Seidler, who had worked with Gropius, Breuer and Niemeyer in Europe, and Miles Warren in New Zealand, represented an international Modernism that was very persuasive, but others such as Robin Boyd, Philip Cox and Ian Athfield challenged such views, working with an emphasis on the Australian vernacular and community participation. Native-born architects of the western Pacific Rim began to make their mark in the 1960s. Leandro Locsin of the Philippines produced elegant, technologically sophisticated buildings; the Cultural Center of the Philippines (1969), with the Theater of Performing Arts cantilevered over water, is acknowledged as his outstanding achievement. Chong Keat Lim and William Lim have both produced fine work in

Singapore and various parts of Malaysia. If these architects still revealed an indebtedness to Western Modernism, those in Japan had a greater problem in coping with the ties of a powerful tradition. The debate over tradition that obsessed Japanese architects in the postwar years was resolved by Kenzo Tange, who alluded to traditional forms while developing radical concepts, as in his proposal for "megastructures" – immense, fully serviced frames to which living capsules could be attached or integrated – with upswept profiles, extending over Tokyo Bay. Such structures were also planned by the Metabolist Group, formed in 1960, of whom Kisho Kurakawa was among the most adventurous: his Toshibu film theater was an early example of computer-aided design. In some respects Japanese respect for tradition and fascination with innovation, esthetic sensibility and enthusiasm for technology, together reconciled some of the problems of exploring a regional architecture in an international age.

Olympics and World Fairs

Indications of the impending architectural importance of the Pacific Basin countries were also apparent in the World Fairs and Olympic Games of the 1960s. The 1964 Tokyo Olympics were the first to be held in Asia; they demonstrated to the world the quality of modern Japanese architecture. To accommodate the traffic Tokyo added eighty kilometers (fifty miles) of motorways and link roads to serve the sports complexes. These included the Meiji Olympic Stadium with its electronic wizardry of Japanese timing systems, and the Komazawa Olympic Park with its enclosed gymnasium and elegant, tiered, open control tower, both designed by Yoshinobu Ashihara. At the Yoyogi Sports Park, Kenzo Tange designed a breathtaking 15,000-seat covered swimming pool spanned by a sweeping roof tent of light metal sheets slung from massive ridge cables. His smaller basketball arena had a spiral roof carried by a cable from a single concrete shaft.

Across the Pacific four years later the Mexico Olympics added a new concept by holding a Cultural Olympiad within the Games, at which artists, writers, dancers and musicians all met. In a context unique for its color the 1968 Olympics were notable for its integrated design under the general direction of Ramirez Vazquez, and the graphics systems of Eduardo Terrazes. The great copper-sheathed, domed sports palace was designed by a team led by Felix Candela, the master of "hyperbolic paraboloid" structures.

A longer tradition existed for international Expositions. Three were held in the 1880s in Australia and one in San Francisco in 1915. But though the eastern Pacific saw the 21st Century Exposition in Seattle (1962), with its "space needle" topped by a revolving restaurant, it was Japan that shifted the focus from the Atlantic to the Pacific with the World Exhibition at Osaka in 1970. It was visited by a record-breaking 64 million people and 77 countries took part and competed for attention. Kenzo Tange's colossal and

▼ The rigorous discipline of the Kodo drummer troupe recalls the Japanese martial tradition. By focusing selflessly on the act of drumming, and the interaction of the group, the drummers enact the Zen principle of accepting the flow of experience. This dedication, paradoxically, brought them a great deal of attention in the West, where the purity of their music refreshed attitudes toward percussion and led Western musicians to reevaluate their own traditions.

central space frame was the largest ever built. Weighing 4000 tonnes, it covered the Festival Plaza and the Symbol Area where Towers of Motherhood, Youth and the Sun gave a focus to the entire exhibition.

Japanese realignments

After World War II Japan was torn between the deep shame of defeat, emphasized by the subsequent American occupation that did not end until 1952, and an eagerness to pick up again the economic impetus that even before the war had made it unique among non-Western nations. Ironically, it was to the late enemy and subsequent occupying nation, the United States, that Japan turned for both cultural and economic contact – though at the same time it began to attempt to build itself into a closer community with its

Pacific neighbors, and by the 1970s Australia in particular had become a major trading partner.

In the postwar world some Japanese artists still went to Paris, but many went to that most beguiling of all cultures in the modern world, the United States. Western Abstraction and Surrealism were the dominant modes. Three artists illustrate the range of Japanese response. Jiro Yoshihara painted in a European manner from the 1930s, but in the 1950s founded the Gutai group, which promoted Dada Happenings and also responded positively to American Abstract Expressionism. His own simplified abstract paintings of the 1960s strike parallels with ancient Zen freehand painting and are, in essence, objects of contemplation. Throughout all these changes he continued to work in Japan. Shusaku Arakawa was a founder member of the Tokyo-based

▲ The mural for the Hiroshima Peace Center, built by Kenzo Tange in the early 1950s. This harrowing, cathartic reliving of the impact and aftermath of the atomic bomb was done by Masako Yamashita. The project took 20 years to complete. It commemorates the dropping of the first atomic bomb on Hiroshima on 6 August 1945, which devastated an area of nearly ten square kilometers (four square miles) and directly or indirectly killed over 136,000 people.

Dance and Martial Arts in Japan

The effect of the ballet boom in the 1950s and 1960s was to create a demand for this most Western of art forms all around the world, with China for instance setting up its own native company, the Peking Ballet, in 1959. In Japan, however, the public's appetite for things Western had already initiated an earlier interest in ballet with visits from foreign dancers during the 1930s and 1940s resulting in various ballet schools being established. But it was during the 1960s that native companies really took hold, and the Tokyo Ballet was formed by the impresario Tadatsugu Sasaki. Like most ballet institutions in Japan, this company has consistently looked to Russia for its training methods, style and much of its repertoire.

During the 1960s Japan also developed its own highly distinctive genre of dance performance – Butoh. Originally called "ankoku butoh" or "dark soul dance", it was developed by Tastumi Hijakata and Kazuo Ohno, who was still performing in his eighties. This form combines

the physical control, economy of gesture and slow pace which characterizes traditional Japanese movement forms like Noh and Kabuki with the intense expressiveness of early modern dance. (Ohno in fact studied with a pupil of one of the pioneers of modern dance, Mary Wigman.) With its white face paint and its ritualized, often violently distorted movements, the dancer's individuality is frequently suppressed in the creation of a dark and desolate vision of man's inner life. Traditional and new martial arts flourished in postwar Japan, sometimes achieving a spiritual dimension equal to any other modern artform. In the 1920s Ueshiba Morihei had developed aikido, a form exploiring the unifying energy of the cosmos. In the 1960s Hiroyuki Aoki developed Shintaido, a reappraisal of martial art knowledge to develop new forms of communication and contact between people of every cultural tradition.

▼ Hiroyuki Aoki wth his Rakutenkai group in about 1970.

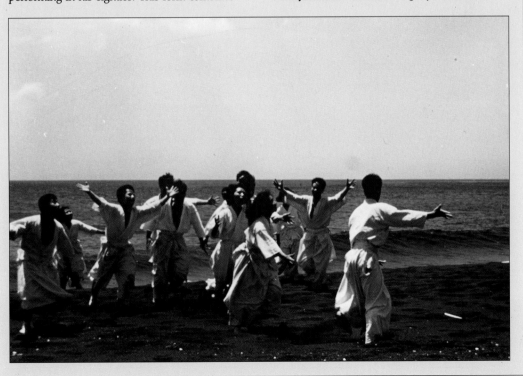

Neo-Dada Organizers (1958–63), a group that was preoccupied with destruction, a principal feature of the demonstrations its members organized. Ruins for them were the symbol of the future world. Arakawa's most vivid contribution to this mood was in 1960 when he exhibited misshapen figures in coffin-like boxes, a response to a sick society. The following year he left Japan to live in New York. Arakawa concentrated, by first reducing objects to silhouettes and then silhouettes to words, on opening up a "pregnant vacuum" in the mind of the viewer, who instead of being given a picture must create innumerable ones in the imagination. The sculptor Tetsumi Kudo left Japan for Paris in 1962. He too built boxes, in order to illustrate his "philosophy of impotence". His "Your Portrait" series featured dice-like boxes which opened to reveal objects symbolic of current society – hypodermics, contraceptives, gaping mouths, all in spasmodic motion.

Kudo criticized himself as much as he criticized society, and this sense of guilt also concerned the leading postwar Japanese dramatist Kinoshita Junji, in plays like *Okinawa* (1961) and *Shimpan* (The Judgment, 1970). Perhaps the most spectacular evocation of this soured postwar spirit lay in the life and death, as well as the writings, of the novelist Mishima Yukio (1925–70). His books deal with homosexuality, suicide and bodybuilding, and his own life shadowed these concerns. He deplored Japan's shaming defeat in the war, the

subject of *Sun and Steel* (1970), and its subsequent assimilation of Western values. He formed a rightwing private army. With four of its members he stormed an office in the Tokyo army headquarters on 25 November 1970, made a speech to assembled troops and then disemboweled himself as a ritual protest against the military impotence of modern Japan. Two of his most celebrated books are *Confessions of a Mask* (1948) and *The Sailor who Fell from Grace with the Sea* (1963).

But there were other Japanese values to hand as well as the concerns for shame and militarism that Mishima exemplified. Some of Japan's more meditative ideals have exercised considerable influence, on the United States especially. The Zen Buddhist tradition influenced, among others, the Californian poet Gary Snyder, who studied Buddhism in Japan in 1956 and in the mid-1960s. His poems have a simplicity born of a concentrated gaze, and which derives in part from Zen method. Traditional Japanese calligraphy, too, had a formative effect not only on the styles of a number of Japanese artists but on those of American and German artists too; Morita Shiryu was probably the most important figure in the recent Japanese calligraphic tradition. Such a tradition ran parallel to, though it did not duplicate, Western concern with the word as a sign to be used for its visual effect just as much as any other object, a preoccupation going back to the early days of Cubism.

◄ The two stadia for the 1964 Tokyo Olympics, designed by Kenzo Tange, a radical solution to the conflict between tradition and the new technology which preoccupied postwar architecture in Japan. Tange's shapes have a calligraphic simplicity, and their adoption of a north-south axis reinforces their connection with the surrounding town and shrine; but they were achieved by a virtuoso deployment of the principles of Modernist architecture – including the world's largest suspended roof.

Architecture always should be a reflection or expression of social structure ... This advancing social structure has some kind of energy inside, otherwise it cannot move itself. I think this energy is hidden or sleeping in the people's bodies and minds but they do not recognize this energy in themselves.

KENZO TANGE

Japanese Cinema

The Japanese had been interested in the cinema from the early days of its invention, and distinguished directors like Kenji Mizoguchi and Yasujiro Ozu had made names for themselves in the days of silent films. The industry developed hugely in the 1930s, when it promoted domestic films of middle-class life and after the chaos of World War II and its aftermath, it regrouped into a major productive force in the 1950s. This was the period of some of the most renowned films to emerge from Japan. They included Akira Kurosawa's historical melodrama *Rashomon* (1950) and Mizoguchi's *Ugetsu Monogatari* (1953) as well as Ozu's decorative and subtle investigations of life in postwar Japan, *Early Summer* (1951), *Tokyo Story* (1953) and *Early Spring* (1956).

Japanese films are traditionally divided into historical pieces and contemporary works, but the division is slighter than it looks, a matter of costume and fictional setting rather than areas of concern. The bold samurais and shrinking princesses of Kurosawa and Mizoguchi have the same courage and inhibitions, the same sense of the world's difficulties and ambiguities, as the cautious middle-class parents and children of Ozu's subtly underplayed movies.

Younger directors, like Kaneto Shindo, Hiroshi Teshigahara and Nagisa Oshima, built on the firm and delicate work of their predecessors, but were anxious to explore further the violence and terror of the modern world, the ways in which superstition and modernity seemed to have become impossible to disentangle. They also understood that sexual relations were both subject to and a source of vast repression, and needed to be demystified. The result was a series of brilliant films which were both caring and

explicit, including Shindo's horrific historical legend, *Onibaba* (1964), Teshigahara's *Woman in the Dunes* (1966) and Oshima's *Empire of the Senses* (1976).

Financial difficulties during the late 1960s and early 1970s meant that the industry had to cut back and that more than half of the films Japanese audiences saw were now foreign, mainly American. However, major directors continued to produce films and to find an international following. The Japanese is the most distinctive, and perhaps the most distinguished, of all national cinemas.

▲ *Ai no Corrida* (*Empire of the Senses*), directed by Nagisa Oshima, 1976. This depiction of a rather extreme love affair can be seen as archetypally Japanese in both its frankness and its intensity.

▲ A Chinese painting of *The Commune Fish Pond*, from Shenshi Province of China. This exuberant image (1966), by Tu Chien-jung, is typical of the work produced under China's Cultural Revolution. The restrictive hand of the authorities on the traditional Chinese intellectual classes allowed an upsurge of communal painting, drama and writing. The government insisted, in the way of totalitarian governments, on a "realism" which would celebrate the people's labor. The creation of these lyrical and popular works was one result.

Two sculptors spanned West and East. Noguchi Isamu, largely to be seen as an American sculptor, has nevertheless worked in Japan and his work has a Japanese quietude. Appropriately, he designed a memorial bridge at the point of the most appalling episode in East–West confrontation, Hiroshima. The other and younger sculptor, Nagare Masayuki, brings an unmistakably Japanese quality to his often monumental work.

China and the Cultural Revolution

While Australia, Japan and other nations of the Pacific developed new cultural contacts and crossovers, the great nation of China, whose cultural history went back so far, turned inward and refused virtually all contact with the decadent West. Mao Zedong's victory over the Nationalist forces of his former ally Jiang Jieshi in 1949 established the People's Republic of China, and with it Mao's determination to remodel Chinese society on truly Communist lines. After his defeat, Jiang Jieshi retired to the offshore island of Taiwan, nursing hopes that internal problems would one day make an invasion of mainland China possible. But that day did not come, and the two men

died within a year of each other, Jiang in 1975 and Mao in 1976. But for a long time the People's Republic felt itself beleaguered. Old enemies could resurrect themselves. Foreign powers, whether the Soviet Union or the United States, blew hot and cold about the country's frontiers and its very status. External wars, in Korea, in Tibet and in Vietnam, gave good cause for concern and awoke deepseated worries. Always Mao looked to consolidate the basis of his power, in the rural masses of his vast country.

Countries like India might celebrate the village as the real India, but the aims and expectations of the governing classes there were more urban than rural, based on New Delhi, Calcutta and Bombay. Not so with China. For Mao, the avowed enemies of the state had from the beginning been the landlords and business interests depending on foreign capital. The peasant was the solid center of effective revolt and effective social organization. In essence, each peasant community was a link in a chain of rural democracy, which all other Chinese classes ignored at their peril. It was a formula which invited rural justice but also sanctioned terror. Nonetheless, it can be argued that

the requirements of the whole nation were substantially satisfied by this social formulation. The enthusiasm of many intellectuals and artists for working closely with the peasants was not necessarily the product of brainwashing or fear but in many cases of conviction. All the same, there was dissent, and Chinese society has characteristically found it hard to accommodate dissent. One area of disquiet was among young people in the cities whose education seemed to fit them for personal advancement as much as for advancing the interests of the state. Intellectuals too tended to arouse the distrust of party officials. Hu Feng, party spokesman for the arts, was purged, as were others who took views that differed from the party's strong moral and political line on the purposes of art. In 1956, following the line "let a hundred flowers blossom", discussion and dispute were suddenly sanctioned, only to be cut off by a sudden clampdown in 1957, so sudden and absolute that one view was that the flowers were allowed to blossom only so that they could be picked off with greater ease.

In the years around the Great Leap Forward of 1958 and the so-called Cultural Revolution of 1966, informing, denunciation and self-criticism were the order of the day. The party line was rigidly communal and nonindividualistic. Art perforce became communal and participatory. With their leader Mao as example, the people were exhorted to write plays and poems. Theater groups toured the countryside and artists forsook the towns to learn from the peasants. One example of what they learnt was the Rent Collection Courtyard, a collective narrative sculpture of 119 life-size clay figures modeled by 18 artists, some amateur, some professional, in Sichuan province in 1965. It vividly depicted the past iniquities of rent collecting and the development through peasant suffering of revolutionary spirit. Its intention was less emotional than ideological, to arouse the mind to action.

To gain their insights the artists lived with the peasants, and indeed the sculpture was first mounted in a rent collection courtyard before being transferred to Peking. They were not there to "experience" life as artists had in the past, but to get "an education in class struggle" and proletarian feeling. The tradition they invoked was not from foreign models but that of a new socialist proletarian art; not classical but of the people, clay rather than marble. Art, just like the barrel of a gun, was seen as a political instrument. Curiously, though, the dictum of Mao's that the artists quoted to explain their intentions was much more traditional: "When we look at a thing we must examine its essence and trust its appearance merely as an usher at the threshold and once we cross the threshold, we must grasp the essence of the thing." Here is the old Chinese impulse to grasp the essence of things behind appearances. In this case the figures represent not one rent collection courtyard but all of them, and through them the whole revolution, anger aroused to destroy injustice. In the past the same pursuit of the essence had led Chinese artists to catch the spirit of the world behind the appearances of landscape.

Music and theater, too, were pressed into the service of the state. The stylized opera, known as the Beijing opera since it was sung in Mandarin (the dialect of Beijing), had been a popular form of musical verse play since the mid-19th century. Movements were carefully choreographed, though extreme acrobatic forms were sometimes used. During the Cultural Revolution the traditional operas were banned, and only eight works could be performed, all of which extolled revolutionary virtues. Mao's wife Jiang Qin was a leading, even tyrannical, figure in the Beijing opera throughout this period; after his death and her fall from power in 1976, traditional drama was revived, and several opera companies toured the West and attracted great interest.

► The Rent Collection Courtyard, (detail: 1965). A massive collective project, remarkable for its theory as much as its enthusiastic political message. The scale of the project is reminiscent of imperial grave sculpture. In order to appreciate such a large piece (there are 119 separate figures), the audience must be able to interact with the sculptures, moving around them or through them. They therefore participate, consciously or unconsciously, in a vast performance piece with static and kinetic elements. In short, an "official" Happening!

ART AND SEX

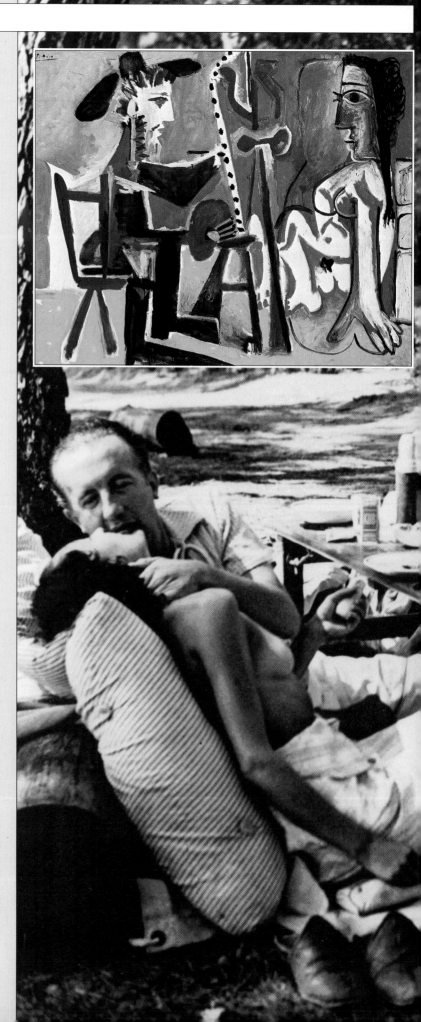

In the 19th century books about art frequently discussed beauty: today this is rarely true. Throughout the century artists have tried to widen the area of artistic interest from the ideal landscape, the ideal society and the ideal body, to face the true condition of the world and still to see it as worth celebrating. In doing so they have run into new problems.

The French artist Jean Dubuffet, writing in the 1950s, asked himself why he had spent a year painting "the body of a naked woman"; a subject "so typical of the worst painting". He thought it was because the female body is the object that has longest been associated (for Westerners at least) with the notion of beauty. This vision – which Dubuffet thought specious – had been accepted from the ancient Greeks and sustained in art from the classical nudes of the European Renaissance to the exposed figures of the modern girlie magazine. Dubuffet found the whole idea "miserable and depressing", based on the fallacy that some people and some objects had intrinsic beauty and others not. An object's beauty depended, he declared, "on how we look at it", and, searching for beauty in the most destitute of places, he saw his work as "ardent celebration".

Many feminists have felt that it is both burdensome and distorting for women to be set up as the bodily ideal of beauty and that this burden carries with it exploitative and voyeuristic elements. Elizabeth Lenk writes, "The dehumanizing character of art can perhaps disappear only when woman stops being that strange alienated being who can be circumscribed by the gaze".

Matisse and Picasso took a particular interest in this question; both returned again and again to the theme of the male, clothed artist and his naked, recumbent female model. Of the two, Picasso focused more clearly on the sexual implications of the scene. He arguably lessened the "alienation" of the woman by incorporating both painter and woman into the one highly organized form. Even so, Picasso's painting implies the unseen easel and so suggests voyeurism.

Almost certainly the situation Picasso depicts implies a traditional regard for female beauty; it also clearly stems from the awareness of the powerful sense of sexuality that has run through the 20th century, amplified by Freud's analyses of the springs of human behavior. The Surrealists took a particular interest in this, and their works frequently explicitly touch on questions of sexuality and the libido. So too did the Pop artists; though Allen Jones, like Tom Wesselmann, celebrated not the woman, nor indeed sex, but the consumerist idea of them. Perhaps the American painter Alice Neel succeeded in celebrating sexuality in a more fully realized context. The constant drive behind her work was to find the reality behind the image so often presented by society. Hence her paintings of nude men, in the vulnerable pose of classical female nudes, offer a troubling dislocation of conventional images of manhood.

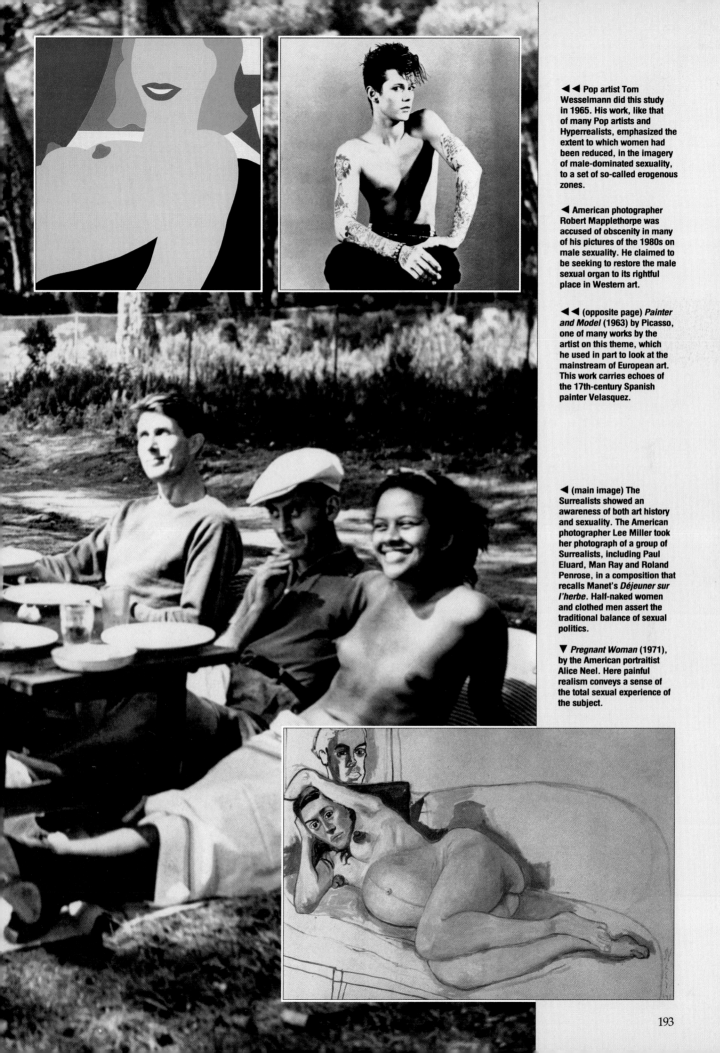

◀◀ Pop artist Tom Wesselmann did this study in 1965. His work, like that of many Pop artists and Hyperrealists, emphasized the extent to which women had been reduced, in the imagery of male-dominated sexuality, to a set of so-called erogenous zones.

◀ American photographer Robert Mapplethorpe was accused of obscenity in many of his pictures of the 1980s on male sexuality. He claimed to be seeking to restore the male sexual organ to its rightful place in Western art.

◀◀ (opposite page) *Painter and Model* (1963) by Picasso, one of many works by the artist on this theme, which he used in part to look at the mainstream of European art. This work carries echoes of the 17th-century Spanish painter Velasquez.

◀ (main image) The Surrealists showed an awareness of both art history and sexuality. The American photographer Lee Miller took her photograph of a group of Surrealists, including Paul Eluard, Man Ray and Roland Penrose, in a composition that recalls Manet's *Déjeuner sur l'herbe*. Half-naked women and clothed men assert the traditional balance of sexual politics.

▼ *Pregnant Woman* (1971), by the American portraitist Alice Neel. Here painful realism conveys a sense of the total sexual experience of the subject.

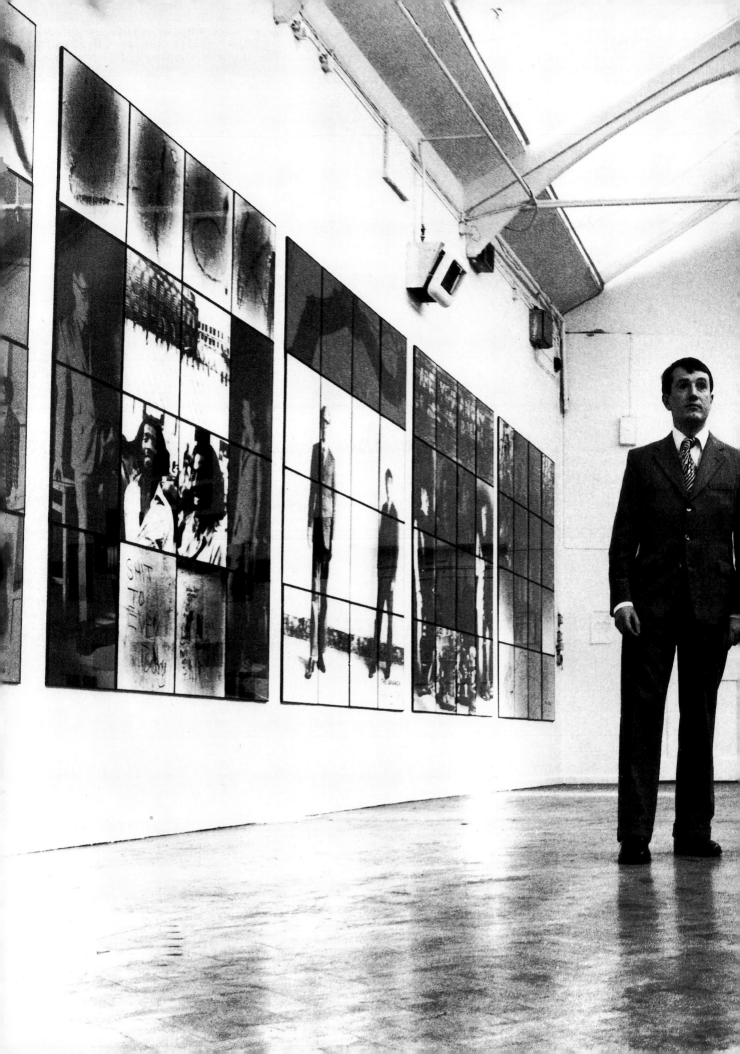

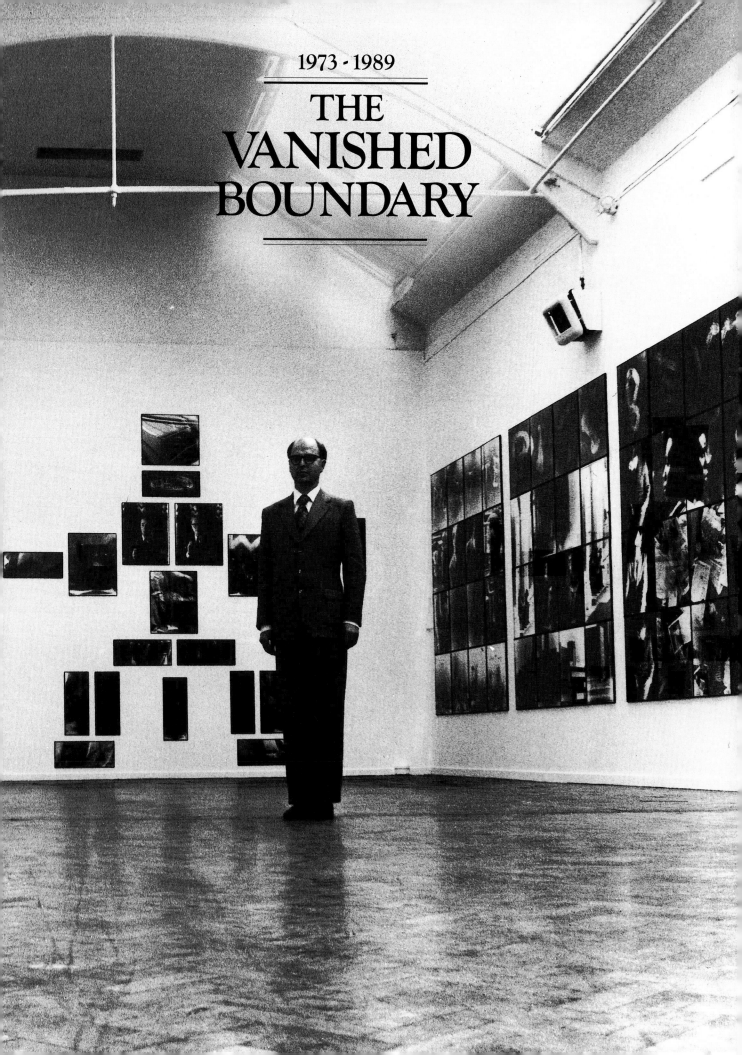

1973 - 1989
THE VANISHED BOUNDARY

Time Chart

	1974	1975	1976	1977	1978	1979	1980	1981
Visual Arts	• John de Andrea: *Freckled Woman*, sculpture (USA) • Al Held: *Solar Wind III*, painting (USA) • Ed Paschke: *Minnie*, painting (USA)	• Suzanne Lacey: *Prostitution Notes*, presentation of data on prostitution presented on ten large city maps (USA)	• Jake Berthot: *Walken's Ridge*, painting (USA) • Balthus: *La Japonaise à la table rouge*, painting (since 1967) (Fr) • Daniel Buren: *On Two Levels With Two Colors*, a vertically-striped band running at floor level through a gallery (USA)	• Agnes Martin: *Untitled No. 12*, painting (USA)	• Brice Marden: *Conturbatio*, painting (USA) • Philip Guston: *The Ladder*, painting (USA) • Stephen Posen: *Boundary*, painting (USA) • Carl Plackman: *Any Place You Hang Your Hat: Wedlock* (UK)	• Arakawa: *Study for the I*, painting (USA) • Jim Dine: *Jerusalem Nights*, painting (Isr) • John Walker: *Conservatory*, painting (USA)	• Power Boothe: *The Gift*, painting (USA) • Richard Diebenkorn: *Ocean Park No. 122*, painting (USA) • Balthus: *Sleeping Nude*, painting (Fr) • Jack Beal: *The Harvest*, painting (USA) • Herbert George: *Visit and the Apparition*, sculpture (USA)	• Jon Borofsky: *Hammering Man a 2,772,489 (JB27 sculp)*, sculpture (• *A New Spirit in Painting*, importan exhibition of post-modernist paintin the Royal Academ (UK) • Francesco Clemente: *Tootha* painting (It) • Jake Berthot: *Belfast*, painting (
Architecture	• Norman Foster: *Willis, Faber and Dumas Building*, Ipswich (UK) • Louis I. Kahn: *Parliament Building*, Dhaka (Bang) • Herman Hertzberger: *Central Beheer Office Building*, Apeldorn (Neth)	• Foundation of OMA (Office for Metropolitan Architecture) in New York (USA) • Jørn Utzon: *Church at Bagsvaerd* (Den)	• Kisho Kurokawa: *Sony Tower*, Osaka (Jap) • Denys Lasdun: *National Theatre*, London (UK) • André Ravereau: *Medical Centre*, Mopti (Mali)	• Richard Rogers and Renzo Piano: *Centre National d'Art et de la Culture Georges-Pompidou*, Paris (Fr) • Alison and Peter Smithson: *Project for the Royal National Library*, Tehran (Iran)	• Yannis Xenakis: *Diatope*, curvilinear structure of steel and vinyl constructed at the Place Beaubourg, Paris, for the performance of Xenakis's *son et lumière* electronic tape piece *Legend of Er* (Fr)	• Richard Meier: *The Atheneum*, Indiana (USA) • Denys Lasdun: *European Investment Bank* (Lux)	• Frank Gehry: *Spiller House*, Venice, California (USA) • Venice Biennale Exhibition: *The Presence of the Past* (It) • Judith Chafee: *Ramada House*, Arizona (USA)	• Denys Lasdun: *Hurva Synagogue* Jerusalem (Isr) • Balkrishna V. D *"Sangath" Studio* Ahmedabad (Ind) • Mario Botta: *Ca Rotonda*, Ticino (S
Performing Arts	• Joseph Beuys: *Coyote: I Like America and America Likes Me*, a performance work in which the "performer" (Beuys) shares a space in a New York gallery with a wild coyote, conversing with the animal and introducing it to various objects upon which it urinates (USA)	• Milos Forman: *One Flew Over the Cuckoo's Nest*, film (USA) • Václav Havel: *Audience*, the first of the "Vaněk" plays (Czech) • Dennis Oppenheim: *Theme for a Major Hit*, in which a puppet in a dimly-lit room dances endlessly to its own theme song (USA)	• Colette: *Real Dreams*, in which the artist lies, naked as if asleep, in an "environment" of crushed silk (USA) • Julia Heyward: *Shake! Daddy! Shake!*, performance piece for solo arm (USA) • Scott Burton: *Pair Behavior Tableaux*, in which two figures strike a total of eighty poses over the period of an hour (USA)	• Wim Wenders: *The American Friend*, film (FRG) • Marina Abramovic and Vlay: *Imponderabilia*, in which the pair stand naked facing each other against the frames of a door, leaving a narrow space between through which the public have to pass to see the exhibition (USA)	• Pina Bausch: *Kontakthof*, in which men and women in line formation enact repetitive and banal movements (such as straightening tie, adjusting hair, touching eyebrow) to form rhythmic patterns (FRG)	• Rainer Fassbinder: *Lili Marlene*, film (FRG) • Werner Herzog: *Nosferatu the Vampire*, film (FRG) • Andrei Tarkovsky: *Stalker*, film (USSR)	• Akira Kurosawa: *Kagemusha*, film (Jap) • Laurie Anderson: *United States Parts I and 2*, an 8-hour combination of electronic music and film (USA)	
Music	• György Ligeti: *San Francisco Polyphony*, for orchestra (FRG) • Formation of the Hilliard Ensemble, specializing in pre-1600s and contemporary vocal music (UK)	• Aulis Sallinen: *Third Symphony* (Fin) • Pierre Boulez: *Rituel*, for orchestra (Fr) • Witold Lutoslawski: *Les Espaces du Sommeil*, for baritone and orchestra (Pol)	• Philip Glass: *Einstein on the Beach*, opera (USA) • Hans Werner Henze: *We Come to the River*, opera (FRG) • Steve Reich: *Music for 18 Musicians* (USA) • Formation of the Ensemble Intercontemporaine by Pierre Boulez (Fr)	• Founding by Pierre Boulez of the *Institut de Recherche et de Coordination Acoustique/Musique* (IRCAM) in Paris (Fr) • Realization of Yannis Xenakis's UPIC system – graphic composition on a drawing board connected to a computer converts the "score" into sound (Fr)	• Yannis Xenakis: *Pléiades*, for percussion ensemble (Fr)	• John Cage: *Roaratorio, an Irish Circus on Finnegan's Wake*, for orchestra and voices (USA) • John Adams: *Shaker Loops*, for string sextet (USA)	• George Benjamin: *Ringed by the Flat Horizon*, for orchestra (UK) • Douglas Lilburn: *Soundscape with Lake and River*, for tape (NZ) • Karlheinz Stockhausen: *Donnerstag aus Licht*, opera (FRG) • Jonathan Harvey: *Mortuos plango, vivos voco*, a work for tape, realized at IRCAM (UK)	• Debut of the 4X music computer i Pierre Boulez's *Répons* (Fr) • Arvo Pärt: *Pass domini nostri Jesu Christi secundum Joannem* for voic and chamber ensemble (FRG)
Literature	• Peter Redgrove: *Sons of My Skin*, poems (UK) • Philip Larkin: *High Windows*, poems (UK)	• E.L. Doctorow: *Ragtime*, novel (USA) • René Char: *Aromates chasseurs*, poems (Fr) • Seamus Heaney: *North*, poems (UK)	• Paul Celan: *Zeitgehöft* (Time-Farmyard), poems (posthumous) (FRG)	• Günter Grass: *The Flounder*, novel (FRG) • Ted Hughes: *Gaudete*, prose poem (UK)	• Alexander Solzhenitsyn: *The Gulag Archipelago*, chronicle of the author's time in a Soviet labor-camp (USSR) • János Pilinszky: *Crater*, poems (Hung) • Czeslaw Milosz: *Bells in Winter*, poems (USA)	• Samuel Beckett: *Company*, prose-piece (Fr)	• Joseph Brodsky: *A Part of Speech*, poems (USA)	• Janet Frame: *Li in the Maniototo*, (NZ) • Salman Rushdi *Midnight's Childr* novel (UK) • Claude Simon: *Georgiques*, nove • John Updike: *F is Rich*, novel (US
Misc.				• Appearance of Charter 77, a human rights document signed by Václav Havel, Jiří Hájek, Jiří Ruml and others (Czech)			• Formation of the *Solidarność* trade union at the Lenin Shipyards, Gdansk, led by Lech Walesa (Pol)	• Martial law dec in Poland by Gen Wojciech Jaruzel after strikes again the government of for by *Solidarnoś* (Pol)

82	1983	1984	1985	1986	1987	1988	1989
• eph Beuys: er espace avec pecteur, ture (FRG) • ert Anderson: rnian Artist, ture (USA) • ncis Bacon: A ... of Waste Land, ng (UK) • nk Auerbach: ose Hill, Early ner, painting (UK)	• Bridget Riley: Midi, painting (UK) • Mimmo Paladino: Noa Noa, painting (It) • Brad Davis: Evening Shore, painting (USA) • Jorg Immendorf: Café Deutschland Horerwunsch, painting (FRG) • Nancy Graves: Triped, sculpture (USA)	• Alberto Abate: Gorgonica, painting (It) • Sandro Chia: I am a Fisherman, painting (It)	• John Keane: The Exchange, painting (UK) • Eileen Cooper: Baby Talk, painting (UK) • Lucian Freud: Self-Portrait, painting (UK) • Don Driver: Bushfire Installation, a room-sized assemblage with sound tape of gongs and drums (Aus)	• Jeff Koons: Rabbit, cast stainless steel sculpture (USA) • Frank Auerbach: Head of Catherine Lampert, painting (UK) • Gilbert and George: Class War, Militant, Gateway, photo-montage triptych (UK)	• Jannis Kounellis: Installation at Walcot Chapel, Bath (UK) • Rainer Fetting: Embrace at the Pier, painting (FRG) • Georg Baselitz: Double Painter, painting (FRG) • Lucian Freud: Painter and Model, painting (UK)	• Roberto Marquez: Mirrors Have No Mercy, painting (Sp) • Ansel Krut: The Student of Philosophies, painting (UK) • Anselm Kiefer: The High Priestess, photographs mounted on lead (since 1985) (FRG) • Gilbert and George: Force, photomontage (UK)	• Roger Brown: Chicago Taking a Beating, painting (USA) • Peter Halley: Red Cell, painting (USA) • David Hockney sends a picture piece by piece via a fax machine from the USA to be assembled in the UK
• Rewal: Asian es housing, New (Ind)	• Philip Johnson: AT&T Building, New York (USA) • Ricardo Bofill: Les Espaces d'Abraxas, Marne-la-Vallée (Fr) • Kohn, Pedersen and Fox: 333 Wacker Drive, Chicago (USA)	• Norman Foster and Associates: Hong Kong and Shanghai Bank (Hong Kong) • James Stirling and Michael Wilford: Neue Staatsgalerie, Stuttgart (FRG) • Fumihiko Maki: Fujisawa Municipal Gymnasium (Jap)	• Jørn Utzon: National Assembly Building (Kuw) • Rafael Moneo: Museo de Arte Romano, Merida (Sp)	• Richard Rogers: Lloyds Headquarters, London (UK)	• Quinlan Terry: Howard Building, Downing College, Cambridge (UK) • BOOR/A, ELS Design Group and Barton Myers Associates: Portland Centre for the Performing Arts, Oregon (USA)	• Frank Gehry: California Aerospace Museum, Los Angeles (USA)	• HRH The Prince of Wales: A Vision of Britain, in which the prince voices his objection to "modernism" and calls for a return to classicism and the use of traditional materials in the vernacular styles (UK)
• rzej Wajda: n, film (Fr) • ner Herzog: arraldo, film (FRG) • llo, a iatheater" tribute seppe Verdi, film and graphs as well tors, by Falso mento, a group d in 1977 (It)	• Tom Murrin: Full-Moon Goddess, solo stage work using materials found on the street for his costume (USA) • Merce Cunningham: Quartets, dance-pieces (USA) • Molissa Fenley: Hemispheres, a dance theater piece, music by Anthony Davis (USA)	• Sanhai Jukk: Jomon Sho ("Homage to Pre-History – Ceremony for Two Rainbows and Two Grand Circles"), a dance theater piece for the Japanese group Buton (Jap) • Vincent Ward: Vigil, film (NZ) • Krzysztof Kieślowski: No End, film (Pol)	• Akira Kurosawa: Ran, film, the director's interpretation of King Lear (Jap) • Václav Havel: Temptation, play (Czech) • Richard Foreman: Birth of a Poet, a musical, in collaboration with writer Kathy Acker, painter David Salle and composer Peter Gordon (UK)	• John Jesurun: Deep Sleep, in which three characters are imprisoned in a film projected on the walls of the stage, leaving a fourth to man the projector (USA) • Miranda Payne: Saint Gargoyle, in which the artist stands on a wall-mounted pedestal against a poster background of a landscape, playing the part of a figure in the landscape (UK)	• Godfrey Reggio: Powaqqatsi, film, music by Philip Glass (USA) • Krzysztof Kieślowski: A Short Film About Killing, one of his Decalogue cycle of films based on the Ten Commandments (Pol)	• Peter Brook: Mahabharata, film of the Indian holy book (UK)	• Jim Sheridan: My Left Foot, film (Ire) • Peter Sellars directs three Mozart–Da Ponte operas at Pepsi Summerfare, all reset in contemporary New York (USA) • Václav Havel: Redevelopment, play (Czech)
• athan Harvey: i for ensemble ape (realized at M) (UK/Fr)	• Olivier Messiaen: Saint François d'Assise, opera (Fr) • Harrison Birtwistle: The Mask of Orpheus, opera (UK) • Hans Werner Henze: The English Cat, opera (FRG) • Steve Reich: The Desert Music for ensemble (USA)	• Philip Glass: Akhnaten, opera (USA) • Olivier Messiaen: Livre du Saint Sacrement for organ (Fr) • Karlheinz Stockhausen: Samstag aus Licht, opera (FRG) • Luciano Berio: Un re in ascolto, opera (It) • Michael Tippett: The Mask of Time, oratorio (UK)	• Arvo Pärt: Stabat Mater for voices and string trio (FRG) • Luigi Nono: Prometeo-Tragedia dell' ascolto for orchestra and tape, performance environment specially designed by Renzo Piano (It) • Yannis Xenakis: Thallein for orchestra (Fr)		• George Benjamin: Antara, for two DX7 synthesizers (using sampled panpipes as sound source) and chamber orchestra (realized at IRCAM using the 4X computer) (UK)	• Karlheinz Stockhausen: Montag aus Licht, opera (FRG) • First performance of Barry Cooper's "completed" version of Ludwig van Beethoven's Tenth Symphony (UK) • Elliott Carter: Oboe Concerto (USA) • Philippe Manoury: Pluton (Création) for piano and 4X computer (Fr)	• Claudio Abbado assumes directorship of the Berlin Philharmonic after the death of Herbert von Karajan (FRG) • Michael Tippett: New Year, opera (UK) • Pierre Boulez: Le Visage Nuptial, the final revision of the original 1947 cantata on texts by René Char, for voices and orchestra (Fr)
• is Lessing: ng of the esentative for t 8, novel (UK) • ek Walcott: The tunate Traveller, s (Trin)	• Alice Walker: The Color Purple, novel (USA) • Peter Handke: Der Chinese des Schmerzes, novella (Aut) • Geoffrey Hill: The Mystery of the Charity of Charles Péguy, poem (UK)	• Milan Kundera: The Unbearable Lightness of Being, novel (Fr) • Ted Hughes made Poet Laureate on the death of John Betjeman (UK) • Keri Hulme: The Bone People, novel (NZ)	• Anita Brookner: Hotel du Lac, novel (UK) • Amy Clampitt: What the Light was Like, novel (USA)	• Patrick White: Memoirs of Many in One, novel (Aus) • Paul Auster: The New York Trilogy (City of Glass, 1985; Ghosts and The Locked Room, 1986), novellas (USA)	• Mario Vargas Llosa: The Storyteller, novel (Per) • Peter Redgrove: The Apple Broadcast, poems (UK) • Tom Wolfe: The Bonfire of the Vanities, novel (USA)	• Iris Murdoch: The Book and the Brotherhood, novel (UK)	• George Steiner: Real Presences, essay on meaning in literature (UK) • Feb: Ayatollah Khomeini issues his fatwa (death sentence) against British author Salman Rushdie for offence to Muslims caused by the latter's novel The Satanic Verses (Iran)
			• Greenpeace vessel Rainbow Warrior mined by French agents in Auckland Harbor (NZ)	• Mikhail Gorbachev initiates glasnost policy, opening contacts between USSR and the West			• 29 Dec: Václav Havel made president of Czechoslovakia after the "velvet revolution" topples the Communist government

197

Datafile

The 1970s saw a greater focus on artistic conception than any period since the manifestos of the Futurists and Surrealists. Yet few coherent groups emerged from this tendency. Rather there was an increased specialization, with artists focusing their attentions on a few subjects or techniques. Minimalism forced the observer into a kind of collusion in the significance of its gestures, while "earth" art saw people working in distant or inaccessible places, relying on documentation for "evidence" of their projects. Performance art developed a radical political element, as in the work of German groups, or focused on the personality or ordinary activities of the artist, as in the case of the Britons Gilbert and George. The capacity for humor sometimes seemed to be equally polarized. The Superrealists concentrated considerable painterly skill on the perfect reproduction of photographic realism, often with little apparent interest in the subject thus recorded. World art entered a stage of greater plurality than previously experienced, where no single style or approach could be said to be exercising a central or stabilizing influence. This opened up the market to a wide range of new possibilities, resulting in the assimilation of forms such as graffiti art.

The late 1970s and 1980s also saw a growing awareness of the place of the arts within a country's economy. State subsidies were provided for prestigious companies and galleries in many countries, while commerical sponsorship of major events became commonplace. This trend meant that the arts placed increasing reliance on techniques of marketing.

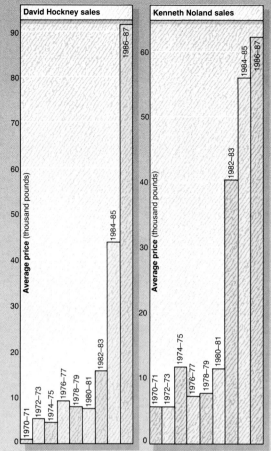

▲ David Hockney, who had risen to fame in the 1960s on the first wave of British Pop artists, turned in the 1970s to a re-examination of the modernist tradition. He began to produce works mingling different pictorial techniques. This led to the creation of what was virtually an academic modernism. His achievement was appreciated by his buyers.

▲ The prices, like other similar charts, are achieved by taking an average of best three figures each year, converted into sterling at current rates. Kenneth Noland was one of the hard-edge American abstract artists who became popular in the 1960s, using irregularly shaped canvases to produce increasingly complex compositions.

▼ Most European countries maintain some form of support to the arts, though the balance between central and regional government may vary. Ireland, whose figure appears small, actually operates a compensatory system of tax relief for artists. The arts are broadly seen as industries attracting prestige and foreign currency.

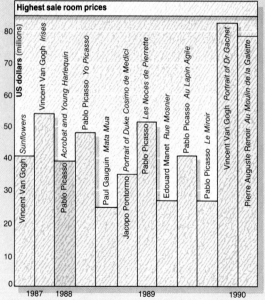

▲ These extraordinary prices are testament to the role of art as a simple commodity, in which the raw material is reputation, not talent. There is some irony in Van Gogh's position, but the response constitutes a distorted acknowledgement of genius. It was frequently argued that these huge sums were artificially inflated by the auction houses.

► Picasso's status as pre-eminent modern artist is confirmed here by his final overtaking of Cézanne. The poor showing by Dalí probably reflects the market being flooded by forgeries. For many artists, though, prices doubled between 1987 and 1988, and trebled the following year with prices over one million pounds almost commonplace.

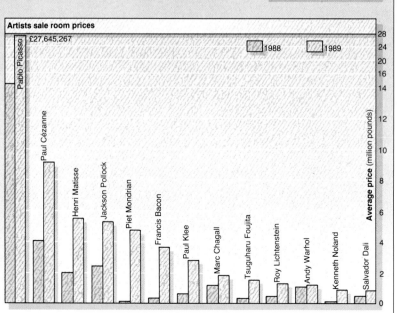

ISSUES IN CONTEMPORARY ARTS

The artist in the last quarter of the century has been faced with a series of problematic choices. Because experiment in the arts has been so wideranging and because modern technology makes so much experience immediately available as a subject or example, the artist's range of options has never been greater. At the same time such range can be seen as fragmenting and arbitrary, dictated not by the pressures of a coherent society so much as by a plethora of information. Art may be spoilt for choice. In a world where nothing is seasonal or regional any more, there is no home base from which to operate. And so the arts today can be seen as responding to a number of issues, some from within their own structures of means and techniques, some more widely understood as issues within society. Typically, none is resolved. Architects engage in a battle of styles. Artists hesitate between their idea of art and its execution, or choose between technology and nature, between figure and abstraction. Writers give their skills over to political and social issues or explore their concerns for contemporary society in symbolic narrative or lyric poetry.

Architecture: Postmodernism and High-Tech

For almost seven full decades of this century the avant-garde of artistic architects embraced Modernism and the general principle of using architectural form to reflect both the function that the project served and the technological means employed in building. Toward the close of the 20th century obvious stylistic preoccupations again came to the fore. These are sometimes based on complex references to the past; alternatively, they appear in explicit virtuoso technological display, which often has little to do with the function of the building or its context.

That master of the Modern Movement, Ludwig Mies van der Rohe, spent his creative life refining spatial definition and the expression of an architecture through its detail, summed up in his view that "less is more". Only ten years after the completion of Mies's Crown Hall Building in Chicago, the American architect Robert Venturi published his book *Complexity and Contradiction in Architecture* (1966), proclaiming that "less is a bore". The Modern Movement creation was fully unified from the detail to the whole conception. Postmodern architects now admire a quite different approach, never committed to a simple concept. In a television interview in the 1960s, the American architect Philip Johnson defended the new approach: "I'm a plagiarist ... you must take everything from everybody ... this is copied from Corbusier, that's copied from Byzantine churches – this is taken from Jaipur India."

In 1980, the Venice Biennale exhibition took the theme "The Presence of the Past", both noting and heralding an increasing revival of architectural interest in the use of precedent. Many of the best examples of architecture from the past, be they Gothic cathedrals, Hindu temples or the palaces of princes, function well at different levels of perception. We do not need to know the stories they tell in order to enjoy proportion and carved figures and scenes from myth or scripture. Postmodernism has made some claim to this quality. But those works that appear easily accessible – such as Michael Graves's Portland Building in Oregon (1981–83), with its surface treatment of pop-classicism, or Philip Johnson and John Burgee's AT&T Building in New York City (1978–82), with its "Chippendale" broken-pedimented top – seem to leave little to be gained by further reflection. There is a danger, too, more marked in architecture than in other arts, of trying to consider the qualities of a piece without experiencing it *in situ*.

The Postmodern approach has produced some striking architecture. Venturi, Rauch and Scott Brown's Gordon Wu Hall (1981–83), for Princeton University, is a striking example of an intense

▼ The *Piazza d'Italia*, New Orleans, designed by Charles Moore (1975–80). This project indicates one manner in which Postmodern design can serve a community. New Orleans' Italian population holds a Carnival once a year, and this piazza was designed as its focal point.

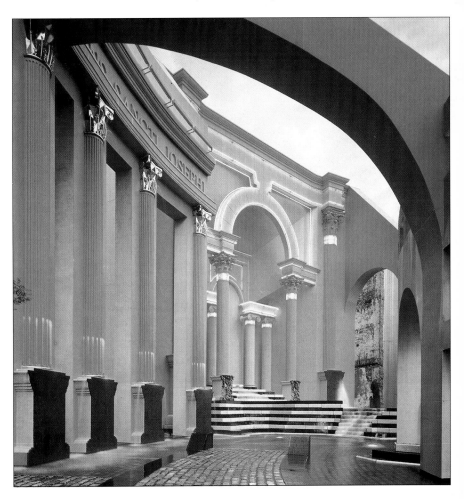

Postmodernism, demonstrating a level of richness lacking in most Modern Movement buildings. Together with the use of mellow brick and stone, and its august context, it recalls the atmosphere of rich and comfortable days before World War I. James Stirling and Michael Wilford and Associates' Neue Staatsgalerie in Stuttgart (1977–84) is redolent with sign and imagery. Like Philip Johnson, Stirling and his colleagues have moved from a clearly Modernist to a Postmodernist approach. In this design a German cultural building is created, based on the neoclassical forms that added vividly recall the work not only of Schinkel and Leo von Klenze, but of Troost and Speer, Hitler's rationalist imperial architects. However, Stirling added vividly colored Constructivist metalwork and Modernist glazing; and he even treated the stonework of the parking floor in a manner that is surprisingly Romantic. It is interesting to note that, in an ever-shrinking world, the themes of this building are also strikingly worked in a Japanese context by Arata Isozaki in his Tsukuba Civic Center (1980–83).

But while Postmodernity is arguably a general theme for the times, architecture sustains a variety of developments and alternative approaches. Late Modernism, High-Tech and Deconstructionism are generally recognized trends. At the same time, practical architects around the globe are engaged in "community" projects, making ordinary buildings for the everyday lives of people, often with more visual reference to the succession of buildings that make the local context than to any particular style. The buoyant "science fiction" approach to technology as savior, promoted by the Japanese Metabolists and the English Archigram group around 1960, owed much to the work of the American Buckminster Fuller (1895–1983). A delight in the display of technology as the

essential of architecture is the unifying characteristic of those architects whom we now call High-Tech. The Pompidou Center (1972–77) in Paris, by Richard Rogers and Renzo Piano, was one of the first examples of an architecture that showed its technological all, as a feast for the eyes and imagination. The exposure of human movement within the building takes this urban culture factory beyond the Modern Movement machine esthetic. Rogers's City offices for Lloyds of London (1986) shuns the dirty city and leaves us only the building's shiny entrails on the outside, but stuns with its technological mastery of space within. These and many more High-Tech buildings make their architecture out of technology. In this respect, their creators are undoubtedly Late Modernists, for they are forward-looking and seek to express the function of their construction through the visible form. In spirit, if not always in engineering, they are also the inheritors of the 19th-century delight in new structures for modern uses.

Deconstructionism is in many ways the "last word" of late 20th-century architecutre, under-

◀ The Korean artist Nam June Paik at work on his video installation *Fish Flew in the Sky* (1976). The relative cheapness and ease of working in video has meant that an increasing number of artists have turned to it as a means of performance. Paik often seems to present nothing more than a technological kaleidoscope, but the medium's possibilities are as endless as its sources. It has access to the vocabularies of television and cinema, animation and the static image.

▶ *Klamauk* (1979), by the Swiss Jean Tinguely. Tinguely's veneration for the machine is not the uncritical worship of the Futurists, but an ironic realization that our creations express our foibles too. His metallic creations are, paradoxically, very human, often condemned to pointless repetition or a slow decay. *Klamauk* not only runs on its own wheels, it produces music; it has even performed at a racetrack. Tinguely has planned an enormous automobile sculpture, a mechanical carnival that would contrast richly with the modern dependence on computer entertainment.

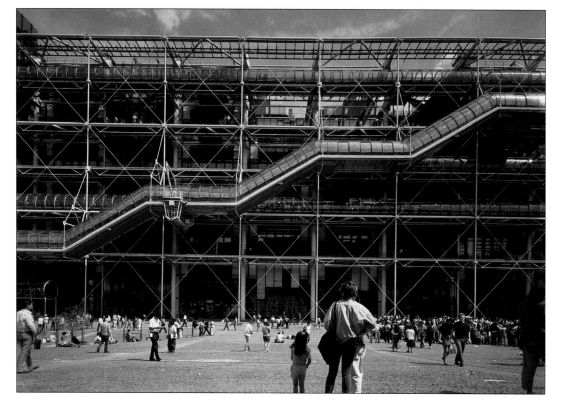

◀ The Pompidou Center, Paris, designed by Renzo Piano and Richard Rogers. An enormous gallery space sited in a dying area of Paris, the center has proved a triumphant justification of High-Tech Postmodernist architecture. In what is something of a Rogers trademark, all services are placed outside the building envelope. This frees the exhibition spaces, whilst the exterior escalators give spectacular views of Paris. The building has become a popular promenade for Parisians and visitors alike, rejuvenating the entire area around it.

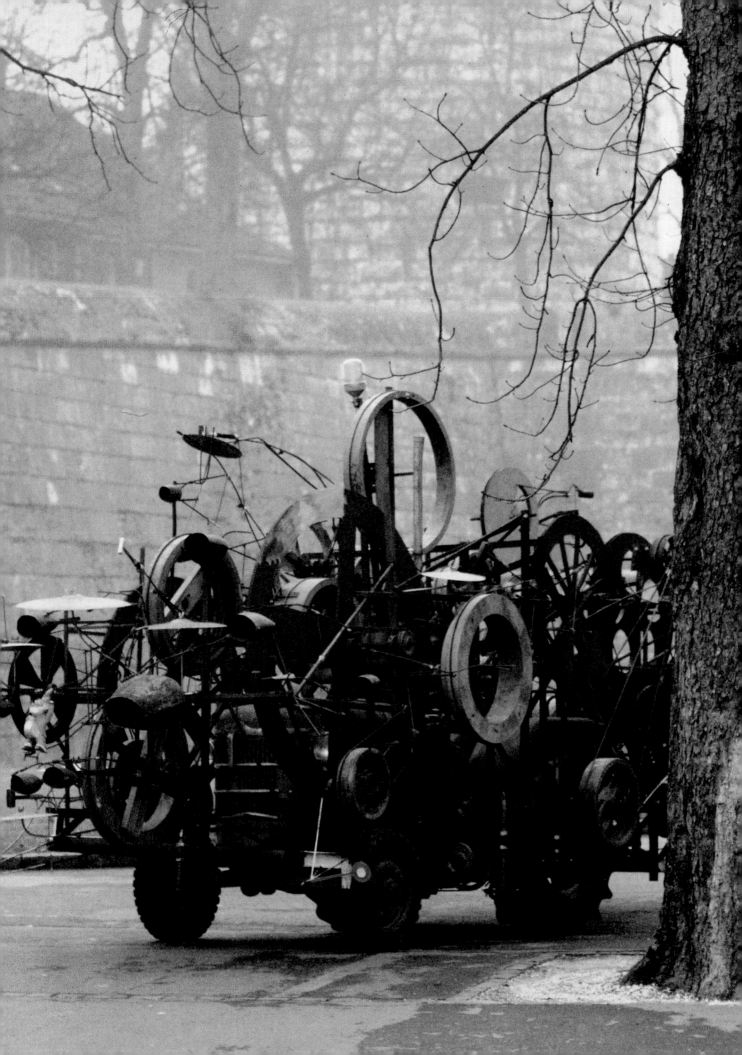

standably characterized more by polemic projects than realized buildings. Its best-known proponents are Peter Eisenman, John Hejduk and Zaha Hadid. The former two were members of the "New York Five", who established an avant-garde discourse in the United States in the late 1960s, paralleled in London by Rem Kookhaas's Office of Metropolitan Architecture (OMA), which nurtured the talent of Hadid. In her winning entries for the Hong Kong Competition (1983) and the Berlin Kurfürstendamm Office Competition (1986), Hadid's drawings show an elegance in the complex portrayal of sculptural tension and spatial restlessness. There is technology, composition, light and air, but little peace and repose in this architecture.

The demise of Modernism in the visual arts

As the art of the century refined its means of expression, largely through simplification of form, so it attempted to gain breadth by assimilating other artistic territories. An art without boundaries was in prospect, to be expressed with minimal rather than lavish resources. There was no baroque profusion spilling over the façades of buildings, no crowded interiors, but rather a puritan spareness. The notion took hold that an artist's idea was the art itself. Thus in the work of Sol Lewitt elaborate grid drawings or compartmentalized metal box-frames are generated by an "idea", a logical formula. And it is the idea rather than the visualization of the idea that is important. In fact, the visualization only confuses the idea, because it then becomes subject to outside influences – the point from which we look at it, light conditions and so on. Such art was called "conceptual" and could be less energetic than more old-fashioned types of art. Describing the act could be sufficient for some artists, and consequently some works of art existed only in their documentation. This was an extreme way of giving full rein to the imagination to shape the invisible, but, like most things taken to their logical conclusion, it ended not so much "beyond"

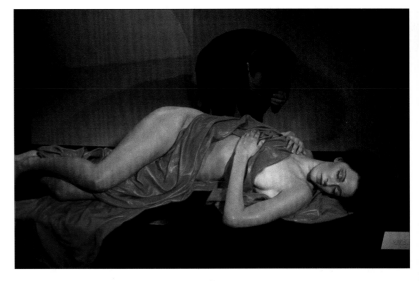

meaning as without meaning. When, for instance, the American John McCracken leant colored planks of wood against walls and explained them as functioning interactively with things around them, or when his compatriot Walter de Maria contemplated the possibility of getting someone to dig a big hole and said that the process of digging it would be part of the art – then the question should have arisen, preferably for the artists themselves, whether this had any value at all. Such a viewpoint may play its part in the philosophical pursuit of fundamental questions, but it can also lead to a kind of decadent elitism, from which there is only one way out: to regroup around the primary skills of art, as perceived by common sense. Such skills are often found, especially in provincial locations, to have been preserved till more propitious times.

Figurative painters were, indeed, always around – some of them, such as Lucian Freud and Francis Bacon in Britain, of great distinction. Freud's painting had a tightness of handling and an attention to detail which is particularly telling if precision and draftsmanship can be seen as

▲ **A Superrealist sculpture by John de Andrea.** The refusal to do more than record reality like a camera, a failing of which Superrealism has been accused, can be seen as a logical development of minimalism. In fact, de Andrea's figures, with their bland prosperous appearance, seem to contain an element of social comment.

▼ *Cadillac Ranch* (1974), by Ant Farm (Chip Lord, Hudson Marquez, Doug Michels), is a trenchant comment on the fickle nature of American consumerism. The concept of these nosediving cars producing any kind of marketable product is absurd in the extreme, yet this San Francisco collective's handling of their materials is calculated, "cool". The cars range from 1948 to 1962, as though elegizing a "Golden Age." Such flamboyant gestures exhibit one extreme of the Minimalist movement.

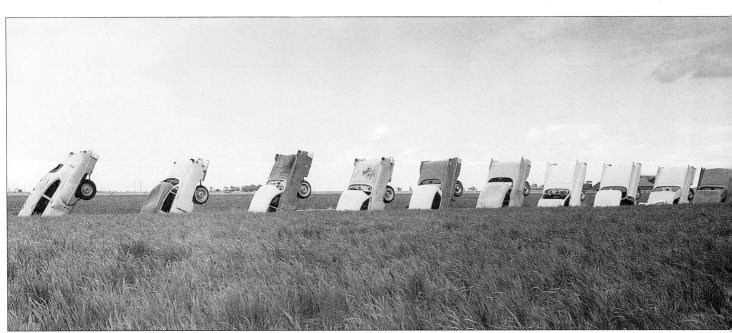

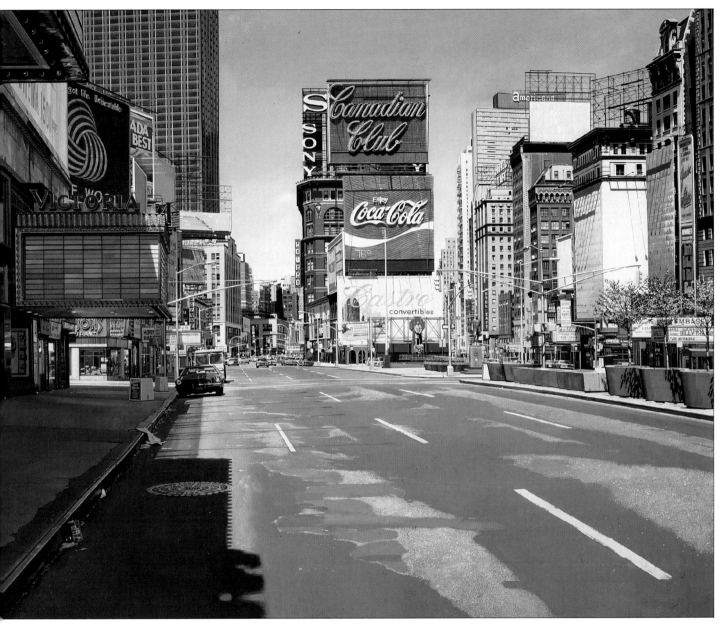

virtues in themselves. Expressionist fervor was absent from his work, and the only interpretative element was a degree of depression, as if detailed examination of the realities of the flesh had drained life of its power and pleasure. Such work was central to the traditions of art; it was not scrabbling around on some imagined frontier. And so it was with the majority of figurative painters. Artists like Alexander Colville in Canada, the Australian Jeffrey Smart and the American Andrew Wyeth all minutely dissected the scene before them. Smart's almost hallucinatory urban precision, bright but never gauche with light, had its roots fixed firmly in past practice. He studied with Léger, but the organizational stability of his pictures goes back to early Italian painters like Piero della Francesca. A number of artists in America, such as Richard Estes and Ralph Goings, offered minutely detailed, not quite photographic versions of the world, perhaps best seen as an illusionistic extension of Pop art. Malcolm Morley and Chuck Close worked from photographs to produce postcard or mugshot

effects, usually termed Superrealism. In Britain, the work of Tom Phillips had a conceptual element, in that his paintings present an interplay between their various visual components which is also a play of ideas. But his precise realism made his work a kind of compendium, gathering the threads of the times together.

The swish of the Expressionist brush can still be heard, but often firmly based in figuration even when the subject seems buried in paint. In Germany George Baselitz executed upside-down paintings which could surprise reality into its abstracted shapes by the fact of its inverted representation, but everybody could see that they were upside-down paintings. Painting something upside down may have drawn the viewer's jaded attention to something new, but it did not preclude an obvious and sane reaction.

The machine against nature
Another path can be threaded through the farther reaches of the century's art. It leads back from mechanism to the celebration of nature. The

▲ Superrealism, expending an enormous amount of painterly skill to produce an image, such as *The Canadian Club* (1974) by Richard Estes, nearly indistinguishable from a photograph, may seem a relatively pointless movement. In fact Estes's compositions contain innumerable small alterations in order to establish a coherent composition. This degree of order is as high as that of Kandinsky's abstract compositions.

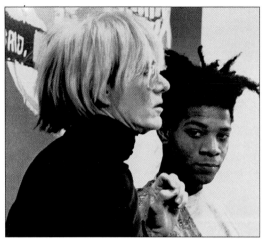

▶ Jean-Michel Basquiat and Andy Warhol, 1985. Basquiat, who started out as graffiti artist Samo, abandoned his street tag as he began to be accepted by the New York art market. In 1982 he had eight one-person shows; a few years later he was working with Warhol. By 1988 he was dead from a drugs overdose.

▼ *Jungle City* (1986), by Say, Rade and Side. Graffiti art had its origins in the arduous painting of subway trains in New York. This spread naturally to less risky sites like handball courts, and from there to the attention of the ravenous art market. Placing enormous weight on lettering has led to the build-up of an elaborate calligraphic form called "wildstyle." The genre is aptly defined by one practitioner: "Graffiti is not vandalism, but a very beautiful crime."

machine had manifested itself in art in two ways. Artists painted industrial and urban subjects, best seen as an attempt to legitimate society's newly urbanized roots. But more pervasive than this, and different in kind, was the feeling that manmade and machined shapes were more vital in the modern world than the shapes of nature. It was a response to the optimistic claims of technology for world betterment. Design was no longer seen as an applied byproduct of "fine art" but as constituting, or even replacing, it. The sculpture of David Smith in the United States or Anthony Caro's work in Britain in the 1950s and

1960s had made use of pieces of metal prepared for industrial use. Much Minimal art had about it this sense of a machined world. For example, the work of Americans Donald Judd and Robert Morris exploited the right angles proper to "rigid industrial materials", even though they were often used in random ways. But Morris, in an ideological quest for an art that seems always to be a little less exciting than the ideas behind it, saw that shapes and materials were not to be confined to the studio or the gallery. Beyond the studio walls were other untapped shapes, notably masses of earth waiting to be re-formed. This route took Morris into earthworks. Of course, earth could be brought into the gallery just as well as anything else. In Munich in 1968, Walter de Maria filled a whole room with wall-to-wall earth, 45 cubic meters (1600 cubic feet) of it. Most of the bigger manifestations of artistic tampering with the face of nature took place in the United States, which had land to spare. Art pushed a line through the Nevada desert (de Maria again), branded mountains and seeded crops (Dennis Oppenheim), and shifted 240,000 tonnes of vastly documented rhyolite and sandstone in much-abused Nevada for Michael Heizer's *Double Negative*. The work was concerned with density, mass, volume and scale. Since access to locations like these was often difficult, gallery reception of earthworks was often by documentation, photographs, drawings and models.

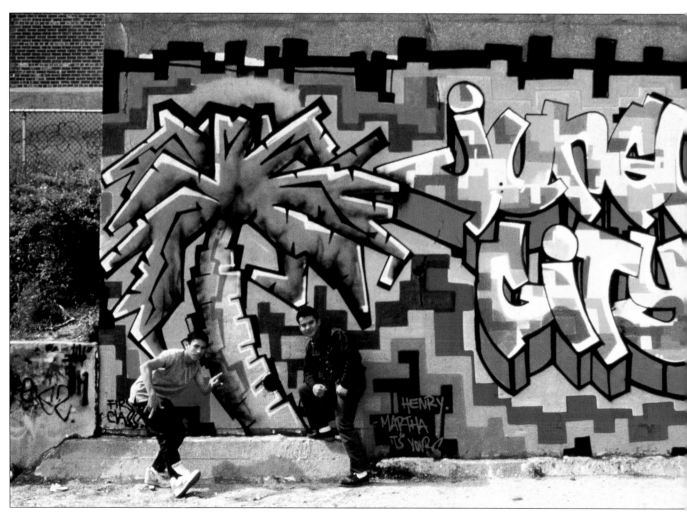

The American Carl André, notorious in the United Kingdom for his collection of bricks bought by the Tate Gallery in London in 1972, was, in his Minimal phase, a very industrially oriented artist, stacking prefabricated pieces and, in a later development, laying them in horizontal, mathematically determined patterns; but he too, as a "post-studio artist", was an early earth artist. The Bulgarian Christo, who had been resident in the United States since 1964, chose to adopt a different way with nature. He wrapped it up. He first began wrapping objects in Paris in 1958, at first on a small scale (there are some fine domestic-sized early packages), drawing attention to form by concealment. He gradually raised his sights through motorbikes and trees to buildings and from there to large tracts of land. These included a substantial piece of the Australian coastline; *Running Fence* in California, 38 kilometers (24 miles) of fabric 6 meters (18 feet) high; and, from 1980 to 1983, *Surrounded Islands*, Biscayne Bay, Greater Miami, Florida, which used 2 million square meters (6.5 million square feet) of pink fabric. These large maneuvers are "transformative acts", of a temporary nature it is true. When the objects are unwrapped we see them freshly. It is an audacious art. One of the most elegant inventions of earth art was an early one, Robert Smithson's *Spiral Jetty*, built out into the Great Salt Lake in Utah, in 1970. It was attractive because it appeared to have some symbolic

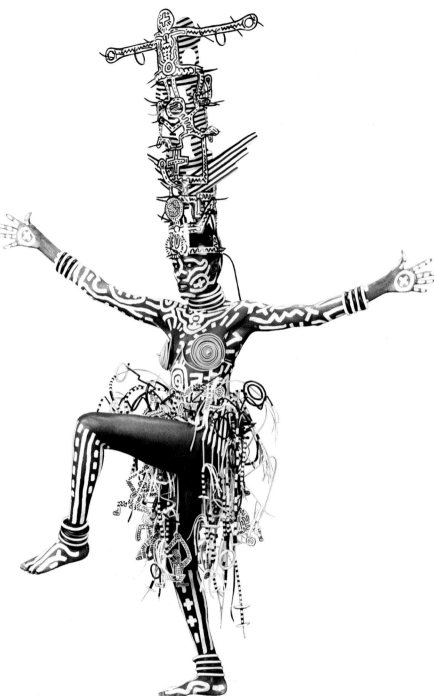

resonance. It looked like spiral motifs carved into rocks by earlier civilizations, but it was functionless rather than social or motivated by genuine ritual needs, nostalgic rather than vibrant. But its harmony with its surroundings pointed up how much of other earth art was interventionist, even when intending to speak for nature. Dennis Oppenheim once used magnesium flares to spell out the word "poison" over 275 meters (300 yards) long. This is not art at one with nature but at odds with it, a grandiose gesture that does not see the trees because they have been manhandled into pulp.

Commitment and protest in art
Another artist given to spirals was the Austrian, Hundertwasser. In his work spirals symbolized virtually everything, notably life-affirming things

▲ Pop star Grace Jones made up by the American Keith Haring, who attempted to fight the market which absorbed his cartoon-like art. Believing art should be publicly available, he opened a store, Pop Shop, to sell his own works for as little as $10. His style was based on similar principles: "Graffiti art is an instant gesture. And because I'm capturing that instant, I do not believe in mistakes."

▼ *BrrrD-DDrrr (Café Deutschland – Winter* (1978) by Jorg Immendorf. The *Café Deutschland* series portrayed a café miraculously perched on the Berlin Wall, expressing what seemed a dream in the late 1970s and early 1980s. The title puns slyly on the German acronyms for East and West Germany. He and his associate A.R. Penck (an East German painter) exploited the kind of painting which celebrates a historical scene or significant group. This was in order to set up a fictional realm in which dialog is possible. Fortunately, they were overtaken by events in the changes of the last months of 1989.

such as creation, and he drew them obsessively in psychedelic colors and with mandala-like religious intentions. He enlisted himself on the side of world peace, incorporating the word "Friedensreich" (The Kingdom of Peace) into his signature in a way that suggests mania rather than meditative calm. An altogether quieter and less portentous approach to elemental symbolism is to be found in the work of the American Susan Rothenberg, who in the 1970s, started painting horses, one to a picture, with the image flattened into the picture ground by the use of a single color throughout and lifted only by its outline. The abstract effect was like an image on some ancient wall. Although she says "it was a way of not doing people", it was by substitution "a symbol of people, a self-portrait really", and carried for

her "a universal religious impulse". Although this feeling clearly has a personal rather than a public sanction, its very simplicity makes it feel right and not a posture.

Another artist who makes a more militant assertion of deep and mythic meaning is the Californian Judy Chicago, whose mixed-media presentation *The Dinner Party* involved 39 place settings at a triangular table, each plate painted with a vagina-like flower, and set for a particular woman. "Feminism", said the artist, "is humanism." Attempts by women to change society's perspectives so that male-oriented attitudes would be transformed, at least to the point where women could express themselves freely and without repression and ultimately to remake the whole of society, have been vexed. Feminists

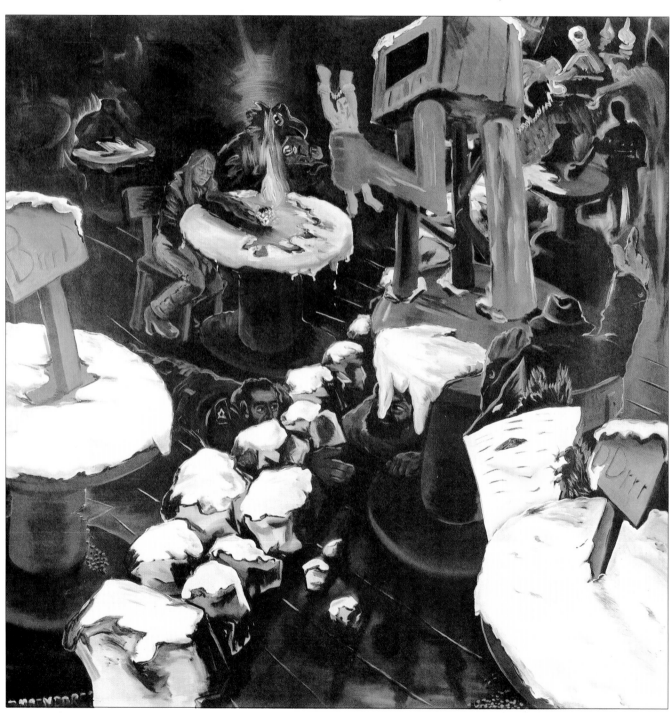

▼ *BrrrD-DDrrr (Café Deutschland...)*

have been perplexed as to how best to achieve their goals, by isolation and separate assertion or by education and infiltration. And the goals themselves have not always been agreed. In the visual arts, in particular, many feminists deliberately chose to reject the whole tradition of Western painting and sculpture as a masculine tradition and turned instead to ready-mades, photo-collage and performance, but this could seem simply to align their program with that of other avant-garde and protest artists in rejecting the classical use of paint and traditional sculptural materials. Similarly, concentration on female sexuality or female sitters might seem only to continue, if in modified form, male exploitation and voyeurism. It was at the point that assertion became celebration that a feminist art seemed most secure, as in Chicago's *The Dinner Party*. The German artists Ithes Holz, Ulrike Rosenbach, Angela Radersheidt and Elvira Bach, working in various media, achieved visual impact which, while not propagandist, seemed to treat women newly, engaging their work beyond masculine stereotype and not succumbing to feminist ones.

The British Body Artists, the so-called living sculptures Gilbert and George, aroused controversy too, but a wry comedy attended them as they presented their immaculately suited selves, canes in hand, or backed by their not-so-hot drawings. Essentially they offered their lives as a continuous form of art, never "not-art". It is the nature of art itself that is again at stake here. Is the word a piece of elastic which, however much it is stretched, will never snap? Or is it this assertion that is itself controversial?

We associate protest with the streets more than with the gallery, but occasionally motifs genuinely streetwise will be taken up, emasculated and gutted by the galleries. It offers the opportunity to savor the streets with less fear of mugging. Graffiti painting is a case in point. In the 1970s young artists of the streets spraypainted surfaces, especially train exteriors, in New York, and did such a startling job that some won through to the galleries. Jean-Michel Basquiat, working with oilstick and acrylic, produced cartoon pictures of cars and weapons and personalities like Nixon and Hitchcock. However, such work filled a gallery fashion rather than developed an artist of potential; it continued to make money after his death by drugs overdose. Kenny Scharf, perhaps with more commercial flair, founded his own Fun Gallery to project paintings that are less graphic than Pop, less protesting than the streets.

In Europe, too, protest in the arts has had little effective to say to or for the streets. In Italy, the Arte Povera movement had nothing to do with the poor, only about what sort of materials might legitimately be used for art. Joseph Beuys in Germany has been active in alternative politics and for the Greens. His work was characterized by its use of apparently unrewarding objects – lumps of fat, iron stanchions, kitchen chairs – to generate personal symbolic accounts usually to do with the nature of the cosmos. On the whole, art's uncertainty about what it is, in the wake of the delirious probing of its boundaries in recent times, disabled it from genuine political action,

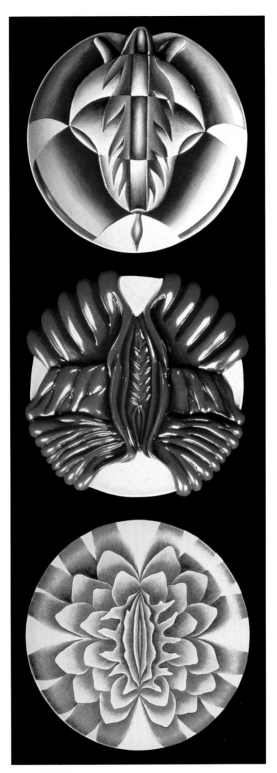

◄ Three plates from *The Dinner Party* (1974–79) by Judy Chicago. Beginning with the idea of a feminist Last Supper "from the point of view of those who had done the cooking", Judy Chicago constructed a celebration of 1038 women, all historical figures whose roles had been obscured by the focus on male achievement. Thirty-nine were to sit at the triangular table in a triple Eucharist, their settings displaying the traditional women's arts of china-painting and needlework. The remaining 999 were celebrated on porcelain floor-tiles, becoming the literal foundation of the supper. *The Dinner Party* eventually became a communal activity as its scale increased, a development that Judy Chicago also found ideologically supportive. Each setting was conceived as appropriate to the woman who would have occupied that place, with, for instance, textile techniques typical of her period. The plate designs, too, were carefully considered, displaying semi-abstract images based on the vagina, the butterfly, the flower. These settings are, from top to bottom, for Petronilla de Meath (burnt as a witch c.1324), the birth control pioneer Margaret Sanger, and Sappho.

if by genuine we mean effective and not simply dissenting. For to be effective in this context art must either espouse a possible political program and work within its scope, as a rallying cry or pungent statement; or it must relieve the oppressed by giving them voice, hope, recognition and an assurance, at least, of their dignity. Few recent Western European or American artists have even attempted that in a way that could be recognized. Among, for example, black South African artists the case is different. The Rorke's Drift Art and Craft Center, founded by the Swedish artist Peder Govenius in 1963, has generated a whole range of

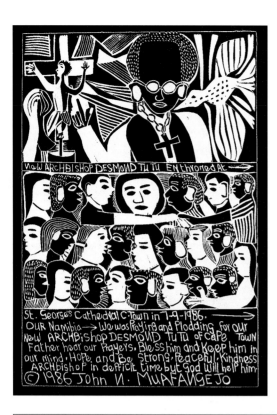

graphic work that would fulfil all those conditions. The black condition is described in work such as Vuminkosi Zulu's *Looking for the One Who Has Lost* (1973) or *Awaiting Trial* (1974). Such art itself sanctions the hope of regeneration. Cyprian Shilakoe's ghostly figures staring from prison, the life of the townships in the work of Judus Mahlangu, Eric Mbatha's *Self-portrait*, all assure the rising of a people into life. John Muafangejo's intricate linocuts tell of a life already there. As the pace of pressure for political change quickened, so the arts flourished. Elements of all sections of South African society joined in an art of protest and affirmation. The range and vigor of the work is astonishing. Traditional carving techniques have been modified to satirize the luminaries of apartheid in the work of Johannes Maswanganyi. Dorothy Zihlangu's fabrics incorporate slogans like "A Woman's Place is in the Struggle" where a biblical text would once have stood. In Michael Mosala's Stations of the Cross the agonized African face of Jesus crumples. Titus Moteyane and Derrick Nxumalo use felt-tip to achieve images of the townships uncannily reminiscent of Japanese prints. Chabani Cyril Manganyi incises designs into veneered woodpanels and then applies oil paint to them in his deeply

◄ *New Archbishop Desmond Tutu Enthroned* (1986) by John Mafanguejo. Mafanguejo (1943–87) moved between Namibia and Angola for most of his life, and his linocuts reflect the violence as well as the spiritual strength that he found there. The text of his prints gradually acquired the role of commentary on the images shown. Thus in this print there is a prayer asking for support, while the new archbishop oversees the temporary unification of black and white.

The New German Cinema

In 1962 the "Oberhausen Manifesto" announced the birth of the "new German feature film", but of its 26 signatories only two became internationally known, Edgar Reitz for the television series *Heimat* (1984) and Alexander Kluge for the socialist, feminist *Yesterday Girl* (1966) and *Occasional Work of a Female Slave* (1974). Munich became the base of a "second generation" of filmmakers, which led world cinema in the 1970s. Multilingual directors Jean-Marie Straub and Danièle Huillet's films *Not Reconciled* (1965) and *Chronicle of Anna Magdalena Bach* (1968) were followed by *The Bridegroom, the Actress and the Pimp* (1968), featuring Rainer Werner Fassbinder as the pimp. Fassbinder became the most prolific writer/director of all. His critical view of society's corruption and hypocrisy shaped his best-known film, *The Marriage of Maria Braun* (1979). In his films,

biting wit and stark realism often clashed with melodrama inspired by American movies and garishly theatrical artifice.

Werner Herzog was a documentarist as well as a storyteller, who ranged the world in pursuit of adventure, and created heroes from the past in *Aguirre, Wrath of God* (1972) and *Fitzcarraldo* (1982), both set in South America. Volker Schlondorff directed *The Lost Honor of Katharina Blum* (1975) and *The Tin Drum* (1979) before turning international with *Swann in Love* (1983) and *Death of a Salesman* (1985). His wife Margarethe von Trotta made woman-centered political films such as *Rosa Luxemburg*. Wim Wenders made American movies such as *Paris, Texas* (1984), then returned to set *Wings of Desire* (1987) in Berlin. By 1990, though, the "second generation" of the New German Cinema was largely dead or dispersed.

▼ In 1974 Rainer Werner Fassbinder's *Fear Eats the Soul* (below left) won the International Critics' Prize at the Cannes Festival. This established him as one of the New German Cinema's foremost directors. About the marriage of a middle-aged German woman and a Turkish immigrant worker, it explored Fassbinder's typical themes of love and betrayal through the metaphor of German racism. *Desire* (below), made in 1977 and starring Dirk Bogarde, again expanded Fassbinder's reputation.

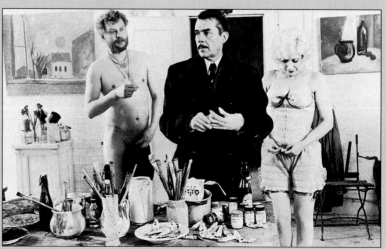

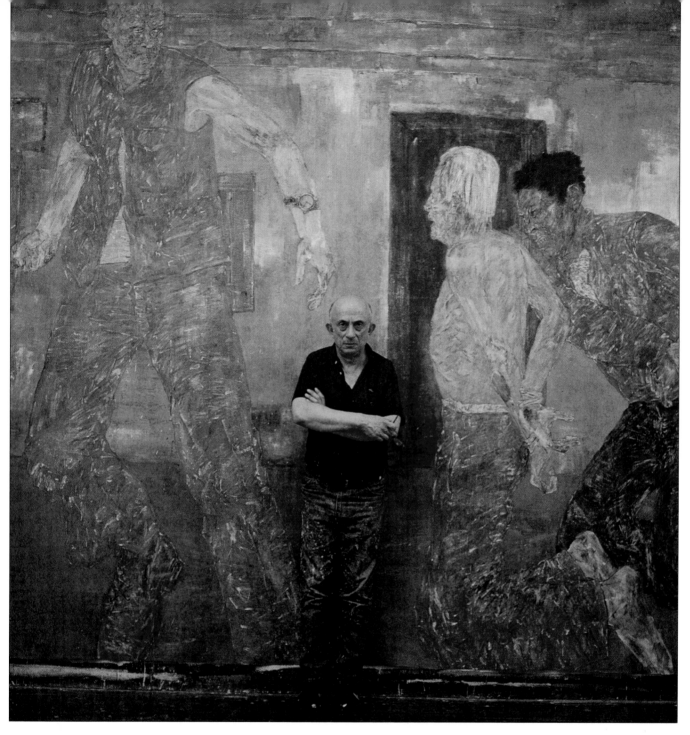

moving Hero series celebrating Steve Biko, who died in 1977 in police hands. When artists use Western manners more directly, as with the abstract work of Louis Khela Maqhubela or David Nthubu Koloane's Jackson Pollock lookalikes or Duran Sihali's atmospheric accounts of townships in the early 1970s, the excitement remains.

The same affirmation, which is not romantic but necessary, against the double societal travails of black women, can be seen among black women writers in the United States such as Gwendolyn Brooks, Alice Walker, Maya Angelou and Toni Morrison. Brooks has since 1967 taken a black rather than an integrationist line and has worked largely for black society and audiences. "Audience" is the right word, because she is a thrilling reader of her poetry, in which she recognizes that the life of the ghetto has its own meanings, where a "broken window is a cry of art".

Toni Morrison in a number of novels, notably *The Bluest Eye* (1978), *Song of Solomon* (1977) and *Tar Baby* (1981), has shown an impressive symbolic power, her richly textured books taking over where Ralph Ellison left off in *Invisible Man*.

But the proper adjustment of social and political causes to art remains enigmatic. No art, and no act, can be without its politics; but such a formulation only conceals the varieties of commitment that are possible to the artists without descending into complacency. Silence, in the extreme politics that the 20th century has seen, can indeed be a statement. It was the Soviet writer Isaac Babel who in the Stalinist 1930s said that he was a master of the genre of silence. Fortunately for both art and politics, many artists have not had such silence thrust upon them. Events in the north of Ireland since the civil rights marches of 1968 have nurtured a whole generation of writers,

▲ The American artist Leon Golub before one of his canvases on the theme of imprisonment. Golub's interrogators are unashamed of their profession. They engage in it or watch us watching with open expressions, encouraging camaraderie. If we try to deflect our attention into Golub's technique, we are presented with a metaphor of torture. He said "I visualize the canvas as a kind of skin", and achieved his finish by scraping the paint with a small meat cleaver. The result is a simultaneous assault on our consciences and our sensibility: a kind of torture.

▼ **Artist's Mother** by the Soviet artist Igor Pchelnikov. The art of the *glasnost* era has become a new hunting-ground for the international art market. Artists like Pchelnikov and his close contemporary Irinia Lavrova, born during Stalin's reign, concerned themselves with finding a human space amid the dehumanizing daily round of Soviet society. This expresses itself in their paintings as a lyrical, dream-like landscape, full of an almost architectural poise.

especially poets, of whom the most powerful is Seamus Heaney. The complex claims of cause and art have brought from him such impressive books as *North* (1975) and *Station Island* (1981). In the even harsher climates of Eastern Europe, art has played a startling part in politics. The massive changes in Poland, Czechoslovakia, the German Democratic Republic and Romania in the late 1980s all had their input from the arts. None has had more spectacular success than the once-imprisoned absurdist Czech playwright Vaclav Havel, who has emerged as philosopher-king, skilled negotiator and visionary politician. Havel's plays and essays have rehearsed the contradictions of the Communist state and the problems of skeptical dissidence. They leave no room for Western triumphalism, however. The atti-

tudes of compromise wittily dissected in his Vanek trilogy of plays (*Audience, Protest, Private View*), for example, are based on Czech experience but are recognizable in the West, where artistic protest has tended, in this century, to take radical or leftwing forms. Obviously Havel does not move in that direction. He is a gradualist in a country uncertainly suspended between residues of a dead Communism and the seduction of crude consumerism. Havel does not prove the case that politics needs the subtlety of art to humanize it. An electrician in the shipyards, Lech Walesa changed the face of politics in Poland without such advantage. But such changes do require a sense of the dignity and needs of people, and artists often enough draw the world's attention to just those things.

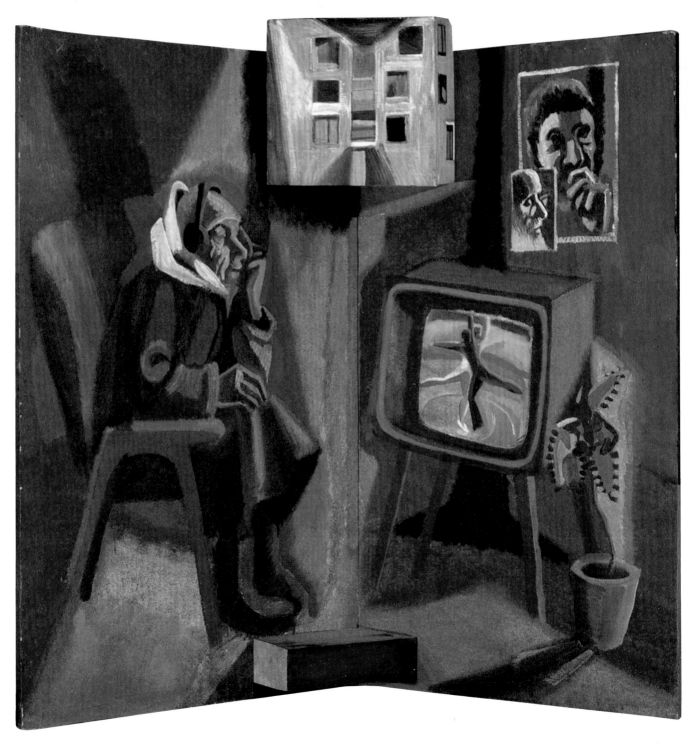

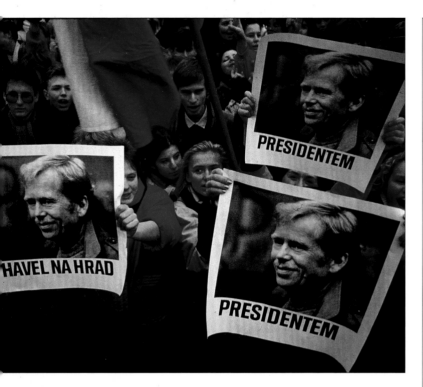

▲ Demonstrators in Czechoslovakia in early 1990, holding placards urging playwright Vaclav Havel to take up the presidency of his country. A few months earlier such activity might well have been about freeing the dissident playwright from prison. His plays concerned themselves with the role of the artist in an oppressed society, the degree of compromise any individual can tolerate, and the nature of moral purity in a corrupt system. Suddenly his role as conscience for the Czech people has acquired a more than symbolic status. Vaclav Havel, President of Czechoslovakia, is one example of a phenomenon unthinkable in Western Europe or North America, but all too common in Eastern Europe or Latin America: the artist as statesperson. Like Mario Vargas Llosa in Peru or Ernesto Cardenal in Nicaragua, Havel demonstrates that there need not be a divorce between culture and society.

The response to *glasnost*

Another politician with vision has opened up the artistic life of the Soviet Union. Mikhail Gorbachev's accession to power in March 1985 resulted in an almost immediate revival in all the arts, but especially in literature, when in 1986 Gorbachev introduced his policy of *glasnost* – openness – in both the press and literature. Vladimir Karpov, formerly editor of the liberal journal *Novy Mir*, became first secretary of the writers' union, and well-known liberals such as Valentin Rasputin, Yevgeny Yevtushenko and Bela Akhmadulina were elected to the secretariat.

The reassessment of the Stalinist past has been a major theme of the Gorbachev era, beginning with the posthumous publication of Alexander Bek's novel *The New Appointment* in 1986, and followed in 1987 by two great poems, Tvardovsky's *For the Right of Memory* and Anna Akhmatova's *Requiem*. Since then a wide range of historical themes has been treated in fiction, helping to radically alter the Soviet people's perception of their own history. Historians in turn have begun to reevaluate the past. In the new climate many previously censored foreign works have appeared for the first time, including the works of many Russian émigrés such as Vladimir Nabokov and Evgeny Zamyatin. The question of publishing Russian editions of works by émigrés who had left in the 1970s and 1980s was a more controversial issue. However, since the publication of some of Joseph Brodsky's poems in 1987, after he received the Nobel Prize for Literature, a more open-minded approach has prevailed. Alexander Solzhenitsyn's *Gulag Archipelago* was finally published, though in an abridged form, in the Soviet Union in 1989. *Glasnost* has led to the breakdown of barriers between official and unofficial, Soviet and émigré literature. Originally introduced from above, it has now gone unstoppably beyond what the party leaders had in mind.

Modern Soviet Cinema

The Soviet films released in the atmosphere of *glasnost* and *perestroika* after 1986 were not new; they were films that had been "shelved" or banned outright over the previous 20 years or more, and reflected their makers' definitive rejection of Soviet Socialist Realism. Alexander Askolodov's *The Commissar* (1967), a Civil War film directly confronting Soviet antisemitism, finally became a festival hit in 1988. Romanian-born Kira Muratova's long-banned *Brief Meetings* (1969/87) and *Long Farewells* (1971/87) also surfaced at last. Sergei Paradjanov's Ukrainian-made *Shadows of Our Forgotten Ancestors* (1964) was the crucial breakthrough for modern Soviet cinema, a kaleidoscopic, folkloric whirligig of village life. He was allowed to complete *The Color of Pomegranates* (1969/73), but thereafter nothing until *Legend of Suram Fortress* (1984) and *Ashik Kerib* (1988). Foremost among those who fought censorship battles in the 1960s and ultimately left the Soviet Union were Andrei Tarkovsky and Andrei Mikhalkov Konchalovsky. Konchalovsky's unsentimental tale of rural life, *Asya's Happiness* (1967/88) met with disapproval, and he went to the United States to make skillful commercial films such as *Maria's Lovers* (1985) and *Runaway Train* (1986). Tarkovsky made *Solaris* (1972) and *Stalker* (1979), big-budget allegories concerning the vanity of human wishes and materialistic values, lightly disguised as science fiction, but his obscurely personal autobiographical masterpiece, *Mirror* (1974/75), ran into criticism as "elitist", and he too left, to make *Nostalgia* (1983) in Italy and *The Sacrifice* (1986) in Sweden before his death in 1986.

▼ Scenes from *Stalker* (1979) by Andrei Tarkovsky.

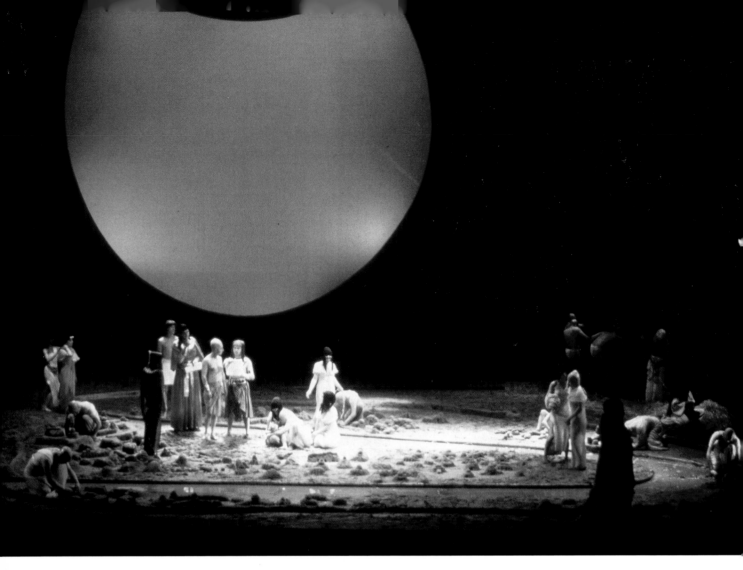

Musical contrasts

The 1970s and 1980s were a time of contrasts in music. Composers pushed technical advances and staging possibilities to their limits and also rediscovered a middle course, which can produce music accessible to a wide audience and make use of "old-fashioned" structures and conventions. But there has also been a great contrast in the scale of work. Many major composers have taken a number of years to write vast (and often operatic) philosophical and esthetic statements, and have concurrently been working on short pieces requiring small forces. For instance, Benjamin Britten's 1976 dramatic cantata for mezzo-soprano and small orchestra, *Phaedra*, has all the force of a full-scale opera. It sets four passages from the American poet Robert Lowell's translation of Racine's famous tragedy, and from them builds a powerfully cathartic structure out of all proportion to its brief 15-minute duration. Karl-heinz Stockhausen's *Donnerstag aus Licht* (Thursday from Light) and *Samstag aus Licht* (Saturday from Light), the first of his projected seven-evening cycle of operas, are each made up of a number of units, which may be performed separately. The British composer, Harrison Birtwhistle, is another whose preparation for major works frequently results in a number of offshoot pieces. The opera *The Mask of Orpheus* (1986) occupied him off and on from 1973. It treats not only the myth of Orpheus, but many other related myths.

The appeal of myth for Birtwhistle lies in its non-linear narratives, its contradictions and ambiguities.

The American Philip Glass draws on "the tradition of non-literary theater", in which inspiration is derived "not from a text, but from an idea, a drawing, a poem, or an image". His best-known opera, which has had considerable international success, is *Akhnaten* (1984), the story of an Egyptian pharaoh martyred for his belief in monotheism. Glass's minimalist style is unfussy and influenced by Indian music. It is slow and repetitive and at its best creates a hypnotic effect ideally suited to the sense of suspended animation evoked by his treatment of one of the "historical figures who changed the course of the world events through the wisdom and strength of their inner vision".

During the 1970s the German composer Hans Werner Henze completed his journey away from the lush lyricism of his early music to a dynamic, harsh expression for his large-scale operatic works. At the same time he achieved a thinner, gentler sound quality for chamber pieces and discovered an accessible, often joyful, open-air style for the works designed for performance in his festivals at Montepulciano in Italy by inexperienced or amateur musicians. Henze found in the British Marxist playwright Edward Bond the ideal librettist with whom to collaborate on his overtly political operas. *We Come to the River* (1974–76), with

▲ A scene from the opera *Akhnaten* (1984) by Philip Glass. He can be seen as a modern paradox, the minimalist composer who attempts opera. Glass's diversity extends to film and dance, including *Einstein on the Beach* (1976). His combination of Indian influences, modern electronics, and harmonic simplicity forms a useful building block for large-scale works. The subject-matter here is the maverick Pharaoh Akhnaten, who attempted to institute a monotheistic religion. This may seem an odd choice, but it comes in the tradition of classical operas like *The Magic Flute*.

its complex staging – much of the action is simultaneous – is a demonstration of the dehumanization of war. While Henze has found an ideal base in his small Italian town, Peter Maxwell Davies has found a similar liberation and sense of ease on Kirkwall in the Orkney Islands. He has continued to write disquieting operas, such as *The Martyrdom of St Magnus* (1976), and *The Lighthouse* (1979), both taking their northern remoteness from the composer's surroundings, but has also written many pieces informed by the liberating tranquility of his island setting.

Composers who have expressed their personal vision of life in large-scale operatic works include Olivier Messiaen in *Saint François d'Assise* (1983); György Ligeti, with the Surrealist-erotic nightmare picture of the end of the world, *Le Grand Macabre* (1974–77); and Michael Tippett, whose freshness of vision and energetic creativity seem to increase with age. *The Ice Break* (1973–76) is his most directly political work, with its examination of the conflicts of age, race and political per-

spective. *The Mask of Time*, a mammoth oratorio written between 1977 and 1982, summarizes Tippett's world view. It is typically ecletic in its textual sources, ranging across Jacob Bronowski, Anna Akhmatova, T.S. Eliot, W.B. Yeats and the *I Ching*, among others. Tippett has pointed to two pervasive themes: the notion of the *fixed* and the idea of *reversal*. That he should find these elements present in astronomy, philosophy, psychology and physics is indicative of his all-embracing, conceptualizing imagination, displayed again in his opera, *New Year* (1989).

No survey of trends in music would be complete without reference to three major figures: American Elliott Carter, Russian Alfred Schnittke and the Pole, Witold Lutoslawski. All three continued to write music which is both intellectually stimulating and emotionally satisfying. While not pushing back the frontiers of experiment, they found a way to use both serial techniques and vestigial tonality in a way that is utterly contemporary and rewarding.

Essentially I'm concerned with repetition, with going over and over the same event from different angles so that a multidimensional musical object is created, an object which contains a number of contradictions as well as a number of perspectives. I don't create linear music, I move in circles; more precisely, I move in concentric circles.

HARRISON BIRTWHISTLE,
1986

Dance: From Minimalism to Outrage

During the 1960s a new generation of American choreographers began to redefine what dance was about, reducing choreography to its basic elements and questioning the need for dance to be restricted to specially trained dancers. Dancemakers began to construct deliberately low-key works using "natural" movement. In the 1970s this Postmodern approach developed in two directions, toward full-scale improvisation on the one hand, and toward a deceptive simplicity on the other. By the 1980s choreographers were ceasing to limit themselves. Trisha Brown's choreography became increasingly sensuous and intricate, and Twyla Tharp came to work exclusively with ballet dancers. Meanwhile European dance saw the emergence of a new theatricality, with choreographers using aggressive shock tactics to jolt their audiences into awareness. The initiator of this development was Pina Bausch, whose works deal with power, humiliation and fantasy, and combine an epic

▶ British dancer Michael Clark in characteristic pose. Clark undermined traditional dance expectations in a series of collaborations with the unconventional Manchester rock group The Fall.

▼ The Pina Bausch Company in the piece *1980*. Pina Bausch's choreography experiments with a series of cultural expectations. Creating large, somber tableaux, she explored sexual politics and the power balance and violence that lies behind conventional behavior.

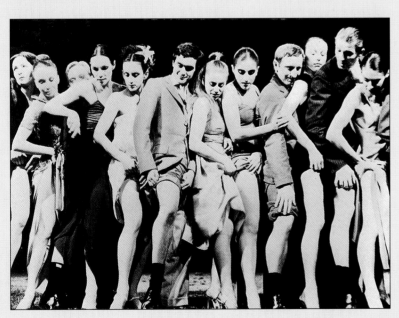

sense of scale with surreal imagery. Bausch's methods have proved the biggest single influence on contemporary European choreography. A more exuberant assault on audience sensibilities was made by the British choreographer Michael Clark. Working in a distinctive blend of classical ballet and Cunningham technique, Clark's works incorporate a ragbag of high and low cultural images, mixing Chopin, bagpipes and punk rock. The American choreographer Mark Morris also acquired an early reputation for outrage, but he thereafter established himself as one of the most musical and inventive choreographers of the 1980s.

CONCEPTUAL ART

Conceptual art, as it has been understood since the 1960s, is a type of art in which the idea that lies behind or the process that brought or might bring about a work of art is more important than the fully-realized work. The "idea" is what counts. Thinking of this kind goes back to the Greek philosopher Plato, who argued that objects on Earth, such as chairs and tables, were imitations of the "idea" or "form" of the chair or table which existed eternally as a kind of divine template. Paintings of chairs were no more than imitations of imitations and consequently Plato rather disparaged them. Conceptual art can be seen as an attempt to avoid this rather meager notion of artistic creation, to bring it to a prior and more distinguished level. By not actually painting the chair, not even making it, but only thinking about it, the artists could be in the eternal realm with the gods.

Despite the questioning of Plato's "forms" and his theory of imitation as the role of the arts – and both concepts have been heavily criticized – Conceptual art still needed some interesting "ideas". It was, however, rarely visually interesting yet provided a natural medium for the communication of social issues. Joseph Beuys, also a performer and politician, refuted the view of art as an activity exclusive to artists, affirming it as a natural human function; he involved wild animals, living and dead, in his work, and soon abandoned "making" for action in an attempt to disarm the cultivated public tendency to make fetishes of artwork.

The Bulgarian Christo, resident in the United States since 1964, has come up with some startling projects, nearly all based on the idea of packaging objects in order temporarily to transform them. At its simplest this is a way of discovering objects by drawing attention to them. The Irish playwright and wit Oscar Wilde once suggested that there were no fogs in London until James Whistler painted them; and in the same way Christo might have said that there was no Museum of Contemporary Art in Chicago until Christo packaged it in 1969, using 930 sq m (10,000 sq ft) of tarpaulin and 1100m (3,600 ft) of rope.

Many of Christo's ideas, such as wrapping all the trees in the Parisian Champs-Elysées, exist only in pleasant collages and architectural drawings. These are true Conceptual art. Christo is different from many other artists who are given the label "Conceptual," and is more zanily exciting because he has the will and the organizational ability to carry out his immense projects, not just think about them. The skill in organization and joky audacity of surrounding 11 islands in Biscayne Bay, Miami, Florida with 600,000 sq m (6.5 million sq ft) of pink polypropylene fabric for two weeks in 1983 is impressive: the project took three years to set up. Christo commented that it was "a work of art that underlined the various elements and ways in which the people of Miami live, between land and water."

▶ *Surrounded islands* (1983), by Christo.

Datafile

The so-called Postmodern age is often typified by a violent clash of cultures. This tendency is perhaps epitomized by the riotous and colorful plundering of the past indulged in by architects who felt liberated from the constraints of the International Style; some produced High-Tech machine-age fantasies, others used historical pastiche. A different mode of response was suggested by the New Zealand author Keri Hulme in her novel *The Bone People*, which examined the interface between Maori culture and that evolved by mainly Scottish settlers. In Scotland, the school of Glasgow painters led by Steven Campbell used narrative elements to evolve an expressive neofigurative style that discussed the nature of another marginalized culture.

The localization and reexamination of the principle of provincialism, typical of this period, was forcefully exploited by the British Boyle family in their longterm project, *A Journey to the Surface of the Earth*. This began with darts thrown as a globe by blindfolded Boyles. The family then traveled to the location thus randomly arrived at, and attempted to record its surface precisely using fiberglass and paint. A not dissimilar activity was being enacted by Aboriginal artists in Australia, who transferred pictorial techniques from sand and rocks onto canvas. This sanctioning by the market of a primal form of graffiti signaled that art in the 20th century has described a full circle since the point when the Post-Impressionists first noticed the beauty of Japanese prints, or when Picasso first sketched his own impressions of African art.

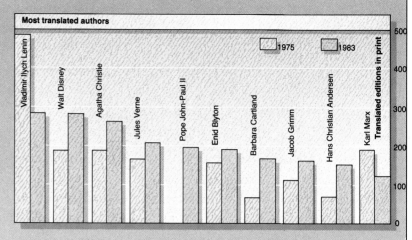

Most translated authors

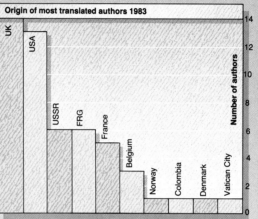

Origin of most translated authors 1983

▲ A table of the most translated authors, in terms of the numbers of translated editions of their work in print around the world, shows an odd mix of politicians, writers for children and middlebrow novelists. The posthumous blossoming of the Walt Disney's literary talents is due to the proliferation of titles which bear his company's name. The presence of political theorists and the Pope would suggest all of these authors in some way express an ideology, suggesting in turn an undiminished need for ideologies.

Nobel Prize for Literature

1973	Patrick White (Australia)
1974	Eyvind Johnson and Harry Martinson (Sweden)
1975	Eugenio Montale (Italy)
1976	Saul Bellow (USA)
1977	Vicente Aleixandre (Spain)
1978	Isaac Bashevis Singer (USA)
1979	Odysseus Elytis (Greece)
1980	Czeslaw Milosz (USA)
1981	Elias Canetti (UK)
1982	Gabriel Garcia Marquez (Colombia)
1983	William Golding (UK)
1984	Jaroslav Seifert (Czechoslovakia)
1985	Claude Simon (France)
1986	Wole Soyinka (Nigeria)
1987	Joseph Brodsky (USA)
1988	Naguib Mahfouz (Egypt)
1989	Camillo José Cela (Spain)

▲ This table is calculated from the country of origin of the 50 most translated authors. The most surprising name on this list is Colombia; otherwise the cultural dominance of the developed world remains unchallenged. This figure is probably due to the extraordinary success of the novelist Gabriel García Márquez, who won the Nobel Prize for Literature in 1982. The circle described by the visual arts, from appropriating the world's resources to sharing them, may yet be duplicated by the printed world.

▶ While the interest in puppets and opera may reflect a national taste, these figures, which are based on the number of people attending performances in each major field, can be taken as a general indication of European interests. In fact the Italian fascination with puppet shows and operetta has been slowly declining, perhaps under the impact of the other cultures in the European Community. There were rises, however, in both the legitimate theater and in the number of classical music concerts, a movement paralleled in France.

Performing arts in Italy 1984

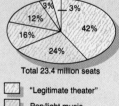

Total 23.4 million seats

- "Legitimate theater"
- Pop/light music
- Classical music
- Opera, ballet, modern dance
- Musical comedy
- Operetta/puppets

▲ The 1980s saw the Nobel awards go to Africa, with the Nigerian playwright and poet Wole Soyinka winning in 1986, and the Egyptian novelist Naguib Mahfouz in 1988. Harry Martinson, who shared the laureateship in 1974, perhaps introduced a new genre to the Nobel prizes in the form of his science fiction poem *Aniara*, or, as the judges put it, "writings that catch the dewdrops and reflect the cosmos." William Golding, who won it in 1983, seems to expose a characteristically British terror in modern society.

▶ The Prix Goncourt was established to honor younger French writers; though prestigious, the prize remained 50 francs, as it had been since 1903. The Pulitzer prize is awarded for plays, novels, poetry, works on U.S. history and American biography. Whereas in the 1960s and early 1970s, the prize often reflected the heavyweights of the contemporary novel, the appearance of Alice Walker and Toni Morrison indicates the upsurge in writing about the experience of black women, and the tremendous popularity of such writing.

Major literary prizes

	Prix Goncourt	Pulitzer Prize for fiction in book form
1973	Jacques Chessex *L'Ogre*	Eudora Welty *The Optimist's Daughter*
1974	Pascal Lainé *La Dentellière*	No award
1975	Emile Ajar *La Vie devant soi*	Michael Shaara *The Killer Angels*
1976	Patrick Grainville *Les Flamboyants*	Saul Bellow *Humboldt's Gift*
1977	Didier Decoin *John l'Enfer*	No award
1978	P. Modiano *Rue des boutiques obscures*	James A. McPherson *Elbow Room*
1979	Antonine Maillet *Pélagie la Charrette*	John Cheever *The Stories of John Cheever*
1980	Yves Navarre *Le Jardin d'acclimation*	Norman Mailer *The Executioner's Song*
1981	Lucien Bodard *Anne-Marie*	John Kennedy Toole *A Confederacy of Dunces*
1982	D. Fernandez *Dans la Main de l'ange*	John Updike *Rabbit is Rich*
1983	Frédérick Tristan *Les Egarés*	Alice Walker *The Color Purple*
1984	Marguerite Duras *L'Amant*	William Kennedy *Ironweed*
1985	Yann Queffelec *Les Noces barbares*	Alison Lurie *Foreign Affairs*
1986	Michel Host *Valet de nuit*	Larry McMurtry *Lonesome Dove*
1987	Tahar Ben Jelloun *La Nuit sacrée*	Peter Taylor *A Summons to Memphis*
1988	Erik Orsenna *L'Exposition coloniale*	Toni Morrison *Beloved*
1989	J. Vautrin *Un grand pas vers le Bon Dieu*	Anne Tyler *Breathing Lessons*

GLOBAL CROSSCURRENTS

Latterly a global art, available to all through technology and open to all through shared attitudes and problems, has seemed possible: Indian village families watching *Hamlet* on communal television screens, French apartment dwellers tuning in to a soap-opera version of the Hindu classic, the *Mahabharata*, artists in Djakarta and New York sharing their techniques instantaneously by satellite. It was part of a late 1960s vision articulated by the Canadian Marshall McLuhan, which was tested and, to some extent, applied from the 1970s on. The ideal testing ground for a global art in action is not Europe. Europe has always, with an imperial graciousness, welcomed and accommodated the exotic and it still does, with a tried and tested mixture of curiosity, rapacity and conscience. The truer test is in the Third World, where Europe has met and mingled with societies, once colonized and dependent, now politically free but economically as vulnerable as ever. As their politicians and economists danced to the tunes of world banking and multinational corporations, to what extent would artists in areas like Latin America, the Caribbean and India become internationalized,

rootless and cosmopolitan? What would be the loss and the gain? Latin America has, to some extent, reversed the roles and set standards that the world has followed, nowhere more strikingly than in the novel. Others have not been so lucky.

Latin American fiction: history and fantasy
The so-called "boom" in Latin American fiction was a development of the 1960s, with Julio Cortázar's *Hopscotch* (1963) its earliest major work and José Donoso's *The Obscene Bird of Night* (1970) its latest, and with Gabriel García Márquez's *One Hundred Years of Solitude* (1967) as its great worldwide bestseller. But Latin American writers continued to produce important work in the 1970s and 1980s, notably in the genre of the "dictator-novel" and in the dismantling of the barriers between highbrow fiction and its popular counterparts. García Márquez, the Nobel prizewinner for literature in 1982, played a significant role in both movements.

The term "dictator novel" was deliberately chosen. Toward the end of the 1960s a group of Latin American novelists planned a series of novels about national dictators, those figures who

▼ A version of Picasso's *Three Musicians* (1986) by Lubaina Himid, a mural at the Roundhouse, London. Picasso's borrowings from African culture are used here as a vocabulary with which to address other issues. As Himid says, these reworkings are "about Africans today not using traditional music, but a mixture of Western music and traditional music".

▲ José Gamarra's early abstract work gave way to an examination of Uruguay's history and myths. Focusing on the image of the "virgin" forest, he has examined the prejudices inherent in European perceptions of South America. His work, such as *Five Centuries Later* (1986), nonetheless expresses a powerful mystique somewhat akin to that of magic realist novelists like Gabriel García Márquez.

have so haunted and terrified the subcontinent throughout its history, and – at a distance – amused even their victims. "What time is it?" the dictator asks in García Márquez's *Autumn of the Patriarch* (1975). His aide-de-camp answers eagerly: "Whatever time you like, General." It is an old joke, but a good one. This general is a man who has children butchered but weeps over his favorite radio serial. Genuine horror, in these realms, is not incompatible with genuine comedy. Of the planned novels, only this one and the splendid *I, the Supreme* (1974), by the Paraguayan Augusto Roa Bastos, finally emerged – although the Cuban writer Alejo Carpentier independently

produced a wonderful dictator novel in *Reasons of State*, also published in 1974. All of these novels brood not only on the nature of power but on the appeal of these monstrous characters, who are in a sense a sequence of strange historical dreams come true, a huge projection of the needs of the thousands of people who believe they cannot do without them. *Fathers of the Country* was the apt title for the planned series. Mario Vargas Llosa's *War of the End of the World* (1981), while not a dictator novel, was also concerned with Latin American history, a disturbing meditation on fanaticism and freedom, and on the fate which awaits those who defy the prejudices of their age.

Meanwhile a different development was taking place, seemingly far away from the arena of national politics, in fact a good deal closer to that area than first appeared. In a row of sad, funny, understated novels – *Heartbreak Tango* (1968), *Betrayed by Rita Hayworth* (1970), *Kiss of the Spider Woman* (1976) – the Argentinean writer Manuel Puig recreated the sentimental world of glamorous movies and fan magazines, of romantic fiction and advice columns. Tenderly, without mawkishness and above all without judging his characters, Puig showed how personal and even political lives borrow and adapt the most threadbare of myths. It remained for García Márquez, in *Love in the Time of Cholera* (1985), to write the great sentimental novel of the age, in which clichés finally transcend their own limitations, not through the author's irony or bursts of originality, but because the novel's characters themselves are able to use clichés as a means of understanding, to make clichés say just what they need to say. Towards the end of this extraordinary love story (about a romantic pair who are 75 and 72 years of age respectively), the man makes an unlikely (and untruthful) remark about his long fidelity. The woman, we are told, would not have believed it even if it had been true, because she knows how he talks; but she likes the way he says it. She responds not to the content of his words and not exactly to their style; rather to their spirit. She is skeptical about his fidelity, but believes in his love, and she is right on both counts. Sentimental stories can hide the world from us, but only if we want it hidden.

The two movements in fiction may well be connected, since both involve a recognition of the authority as well as of the superstitions of the popular imagination. If the "boom" put writers in touch with the nightmares and marvels of a history which had often seemed merely alienating, the dictator novels and the sentimental novels tapped the connection between history and fantasy: love and tyranny are not only shapers of dreams, but dream-productions, fruits of the desperate longings that many popular songs (but until recently few writers) have known how to respect. Countries may get the fathers and the lovers they deserve. *One Hundred Years of Solitude*, García Márquez told a friend, was "like a *bolero*". *Love in the Time of Cholera*, too, is a *bolero*, a song of sadness and patience and the triumph of feeling, reflecting the politics of the heart.

Forging a new culture: West Indian writing

Throughout this and previous centuries, the people of Latin America struggled to come to terms with the destruction of their indigenous cultures by the Spanish *conquistadores*, to find a way in which writers, artists and musicians could weave together the strands of the old history with those of the new. For the much more recently colonized countries of the world, such a process was accelerated as the dominance of European culture lessened, and artistic influences from all over the world took their place. As the world becomes more closely interwoven, so we have to find a new world in which to live. The West Indian poet Derek Walcott, in a distinguished writing career,

has provided a series of insights, first into his own condition, and then, through that, into all our conditions. Like most writers, Walcott begins from where he is, as a West Indian, his "hammock swung between Americas", considering the alternatives offered by the two halves of the huge continent: to the south, the bullet-ridden death of the freedom fighter, to the north, "cherry pie" – both in effect constituents of the Americas' power and pain.

One of the massive and benign influences on Walcott's writing was the anguished American poet Robert Lowell, whose rhythms and manner reappeared at this time in the work of many poets worldwide. But through these painful oppositions Walcott seized an opportunity, to opt for one world which is at same time many worlds.

▲ *Eye of Light* (1987) by Oswaldo Viteri. The myriad ragdolls which make up this image are traditionally made in villages in his native Ecuador.

▼ A mural in Port-au-Prince, Haiti, showing an angel lancing a Tonton Macoute. Murals were a very widespread form of social protest during the uprising against the despotic "Baby Doc" Duvalier, and had fairly clear "messages" for the local population. A Last Supper, for instance, invariably alluded to the widespread starvation, whilst a Crucifixion might symbolize the martydom of protesters.

Again, it was an opportunity offered him by the Americas. He imagined the sleeping eyes of the Argentinean writer Jorge Luis Borges entered by an Amazonian Indian, the writer in his world of bookshelves "forested with titles", the other in a forest of trunks waiting for names. Between the two of them, they constitute "the one age of the world". It was this ability to perceive a world in which very different conditions and styles of life might exist at the one time, in mutual recognition but not forced into uniformity, that was central to Walcott's vision. The view comes across as a sort of tensed contentment, not a passive complacency. In the West Indian case, of course, the most fraught conjunction was with the former imperial power, England, which, in the shape of his own "randy white grandsire", drunkenly seeded the islands so that "his blood burns through me". But instead of feeling anger, Walcott saw that now the staring English faces were only "guiltless". "Like you grandfather", he said, "I cannot change places. I am half-home." It is this ability

to see the in-between state as a genuine position that distinguishes Walcott. He was not suspended between two worlds but an inhabitant of one. Christopher Okigbo, the Nigerian poet, who was killed in the Biafran War of the late 1960s, also observed that it was possible to belong both to one's own society and to societies other than one's own. The modern African, he argued, is no longer a product of an entirely indigenous culture, and has values drawn from many sources. In the West Indies there was still less chance of "an entirely indigenous culture". Even the bodies of the inhabitants had been "imported" to cut sugarcane to sell in exploitative imperial markets, and that heritage of oppression remained. But from it – and with it – Walcott rose, "convinced of the power of provincialism", into a "second birth".

Walcott was by no means the only Caribbean poet of distinction. He achieved a momentum through a particular understanding of his heritage. Another major Caribbean poet, Edward Brathwaite incorporated, more fully than Walcott, a singing vernacular West Indian rhythm into his writing. The Caribbean experience, yet another aspect of the wider black suffering at white hands, formed the basis of his work, such as the large-scale trilogy *The Arrivants*, but there is a confirmed joyousness in his writing. The island air is fragrant with "birth" and "beginnings". Sustaining humor based on West Indian characters informed the work of poets like Louise Bennett and James Berry. The same freshness formed the very direct oral poetry of Linton Kwesi Johnson and Michael Smith. Johnson is representative of the black British writers who use West Indian vernacular speech and the rhythms of popular music to comment on British society, of which they are a firmly established part. Johnson has written poems of great power. Michael Smith, Jamaican-based, was a major and moving performer until his death aged 29 in 1983.

The penalties of rootlessness

If Walcott is a major beneficiary of the "half-home" condition of modern culture, Salman Rushdie might be seen as its victim. Rushdie, from a Bombay family now living in Pakistan, lived in England from the age of 14. In that sense he has three countries and his books reflected this: *Midnight's Children* about India, *Shame* about Pakistan, and *The Satanic Verses*, at least by intention, about England. In no single one of these countries could Rushdie be said to have located himself. Rather, his reality is in the world of the novels themselves, phantasmagoric massings of hybrid materials.

The controversy between the Islamic East and the liberal West over Rushdie's portrayal of the life of Muhammad in *The Satanic Verses* obscured the brittle brilliance of the book. But also, by focusing on the perfectly legitimate questions of censorship and blasphemy, of racial and religious offence and the claims of the free artist to create freely, it diverted attention from the book's enquiry into cosmopolitan rootlessness, satisfied at its end by the death of one of its dual heroes, Gibreel Farishta, and the return "home" of

▼ Photograph by the Indian M.F. Husain, whose origins as a painter of cinema hoardings rendered him extraordinarily sensitive to the discrepancies between image and reality. He reveled in the contrasts between the giant simplified passions of the Indian cinema and the small intensities of life which go on beneath such demigods. But his witty juxtapositions also pointed to interdependencies, the cinema's capacity to blot out its massive audiences' woes.

Crossfertilization in Modern Dance

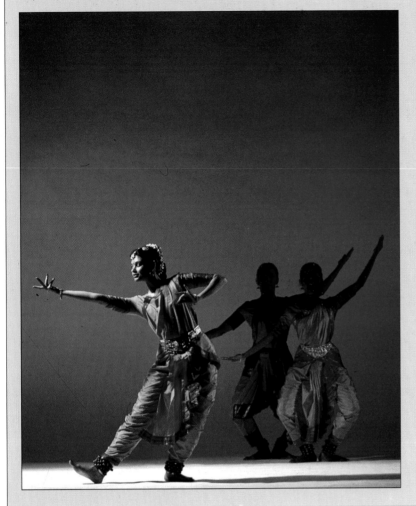

Just as Merce Cunningham developed a new breadth of movement in the 1950s by mixing elements from ballet with those of modern dance, so many avant-garde choreographers in the 1970s began to shift from the spare minimalism of the 1960s to a much more eclectic style. From the late 1960s onward many different boundaries were dissolved. Ballet choreographers began increasingly to use elements from modern dance, while more and more dancers were expected to have both classical and modern training. Even more adventurously, a number of Western choreographers started to look East for inspiration; the weighted, meditational style of movement of the Chinese martial art form of Tai Chi meshed perfectly with the relaxed simplicity of much experimental choreography. The British soloist Laurie Booth used the Brazilian martial art form Capoeira as the basis for his own more acrobatic technique. At the same time, Eastern performers began to look to Western dance forms for new ideas. Classical Indian dancers in particular played with the possibilities of using Western music and Western movement to extend the range of their traditional dances. Black dancers also began to move freely between Afro-Caribbean and white dance forms.

As the world grew smaller, its various dance forms became less and less ethnically exclusive. Choreographers have always borrowed from other cultures and dance influences have always migrated between different countries. Now, however, the process of borrowing has become more instantaneous, more casual and often more tongue-in-cheek: in 1989 the British choreographer Lea Anderson made a duet which delightfully and improbably blended flamenco dancing with a Scottish jig.

◀ The Indian dancer Jeyasingh.

▼ ▶ An anti-Rushdie demonstration in Bangkok. The furore surrounding Salman Rushdie (below) and his novel *The Satanic Verses* was an inverse of the jubilation surrounding Vaclav Havel. While one writer was launched from prison to presidency, the other was plunged into incarceration under the name of police protection.

Salahuddin to Bombay, where "in spite of all his wrong-doing, weakness, guilt — in spite of his humanity – he was getting another chance". Rushdie spoke more for those who can choose to be rootless, those for whom another country is only a jet stop away, rather than for those who have the conditions of exile thrust upon them. And that address to an international audience formed part of the source of the controversy. The book was banned in India in October 1988 and termed "literary colonialism" orchestrated by the "liberal band". Rushdie's treatment of the life of Muhammad was seen not simply as offensive but as a further putting-down of the Muslim East by the Godless West, with the author, however much he might correctly disclaim it, seen as a turncoat, savaging his own past. The controversy built as it was taken up, first by many ordinary Muslims living in Britain as well as some politically-minded ones, all of whom knew the range of insults that their community had endured and which, indeed, Rushdie graphically, sometimes fantastically recounts and condemns in the book. Iran's entry into the quarrel brought the death sentence on the author; many Muslims burned the book and others undertook to kill Rushdie, who went into hiding for several years. But at all times the question was being dealt with

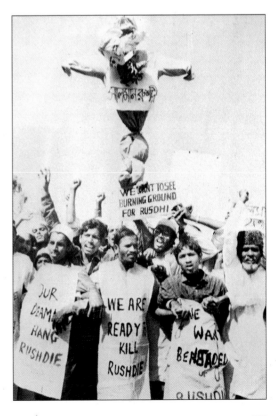

on two different levels which never met and could not meet. Rushdie's defense of his book was scrupulous and exact, but cast in terms that were intelligible only to a literary critic. He appeared not to take into account that it was not literary critics who were burning the book, and thus seemed simply to bolster the arguments of those who already believed what he said, leaving those unconverted to the unlimited claims of art to draw their own conclusions, which were simply and humanly understandable: "Not a word of apology can be found." The controversy demanded on the one side give and take, not critical analysis, on the other forgiveness, not intolerance. Neither came, in a frightening episode that displayed both the power and the helplessness of art. Part at least of the reason for it can be found in the growing internationalism of art, in a sense quite different from Derek Walcott's "one world". The audience for *The Satanic Verses* was clearly not any one nation but an international set, and, from the point of view of many, an elite. The book, though impressively alert to the facts of street life whether in Bombay or London, had lost touch with the people of those streets, leaving its author genuinely between worlds, feted as a brilliant entertainer in one, despised as an apostate in another, when he wished to be neither, only a serious and thoughtful novelist dedicated to his massive fictions.

The role of history

In keeping with the aspirations of the age, the novel, above all literary forms, has achieved a cosmopolitan audience and has sometimes seemed deliberately to seek it out. No single globally dominant type of novel has emerged but many writers have revived the historical novel and used it to cast light on some contemporary question. Umberto Eco's *The Name of the Rose* was an im-

mensely successful application of the methods of Sherlock Holmes to a series of murders in a medieval Italian monastery, but it was the more remarkable for engaging a wide audience with tricky questions of scholastic theology and modern critical theory. José Saramago from Portugal also used historical settings. *Baltasar and Blimunda* (1982), in its historical disguise and baroque language, carries a humanitarian commitment which fits with Saramago's earlier Socialist Realist style. The Japanese writer Shusaku Endo used 17th-century Japan to explore elements in the Japanese character which he saw as constants, as in the powerful novels *Silence* (1980) and *Samurai* (1982). More recent history preoccupied Kazuo Ishiguro in *An Artist of the Floating World* (1986), a searching and ultimately tender examination of postwar Japanese guilt which, at the same time, raises the question of the relationship between politics and art. A number of Australian writers including Thomas Kenneally (*Schindler's Ark*, 1982), David Malouf (*The Great World*, 1990) and Roger McDonald (*1915*, 1975) examined characters in wartime settings drawn from the century's past wars. New Zealander Keri Hulme drew on sources even further distant in *The Bone People* (1985), where Maori myth with Celtic overtones permeated a story of contemporary human problems. The Egyptian Naguib Mahfouz, like Salman Rushdie threatened with death by religious authority, won the Nobel Prize in 1988 for the first part of his *Cairo Trilogy*, which looks at his country from 1917 to 1945 and examines the deep historically conditioned textures of Islamic society. In India Anita Desai explored Hindu society both in the subcontinent and, in *Bye-Bye Blackbird* (1971), as it translated to Britain.

A fusion of West and East

Architects have perhaps found it easier than writers to experiment with forms taken from all over the world, to mix one style with another with frequently surprising, and sometimes stunning, results. The Western fascination with the

▲ *Cidade de Goa* (1978–82) designed by Charles Correa. This hotel typifies Correa's approach to the function of Eastern architecture. Lavishly fitted with *trompe l'oeil* illusions by the film poster painters he invited to Goa from Bombay, the complex concentrates on the interchange of closed and open spaces in a way that recalls traditional Indian architecture.

◀ The New Parliament Building in Sri Lanka by Geoffrey Bawa. Standing on a small artificial island in the middle of a lake, this design employs traditional design and materials. The pavilions have copper roofs, supported by timber and stone columns, echoing monastic and royal buildings. Bawa's building nonetheless accommodates an efficient deployment of the Sri Lankan administration.

◀◀ The *Institut du Monde Arabe*, Paris (1984–87), designed by Jean Nouvel, showing a view through the Arabic ornamentation of one of this building's extraordinary south-facing windows, which contain mechanisms which filter the light. Nouvel's design is an example of the silver esthetic, a strategy for building in architecturally sensitive areas. It incorporates silver and blue-gray in order to harmonize its High-Tech frontage with its Parisian background. The use of Arabic motifs is placed against this muted presence.

▲ A scene from Stockhausen's opera *Donnerstag aus Licht*. From 1977, Karlheinz Stockhausen was engaged on a seven-evening cycle of operas. By 1989 *Thursday* and *Saturday* had appeared. *Thursday's* three acts follow the musical and spiritual development of Michael: in the first act he establishes himself through a musical examination, at which he is accompanied by Stockhausen's daughter, Majella. His subsequent journey round the Earth features the orchestra as a globe and Stockhausen's son Markus as the traveler, a solo trumpet. Scoring particularly for his children, as he seems to have done, stresses the personal, symbolic nature of Stockhausen's composition.

arts and culture of the East goes back to Marco Polo's near-legendary travels in China and Tibet in the 13th century.

As imperial Japan for centuries excelled at the selective reinterpretation of Chinese culture, from philosophy and art to religion and political doctrine, so it is hardly surprising that postwar Japan was susceptible to the influence of Western ideas. During the 1950s and 1960s the International Style became international in every sense, with architects from the West designing "white" buildings, from banks and office blocks to hotels, in countries throughout the world, and local architects (often European or American-trained) working in a similar style. Nigerian architects like A. Ifeanyi Ekwueme and the prolific Oluwole Olumuyiwa worked in an assured Modernist vein.

In Latin America International Modernism had a secure foothold, though indications of a more nationalist approach emerged in Mexico, where Juan O'Gorman drew upon Mayan imagery to clad his monolithic National Library in mosaic at the State University, Mexico City. Luis Barragan created monumental, dramatic yet minimalist buildings of an Aztec clarity, and Ricardo Legoretta drew inspiration from the color and simplicity of Mexican vernacular architecture for his Camino Real hotels. Legoretta acknowledged the influence of Hassan Fathy, an architect who employed traditional Nubian builders and craftsmen for the construction of the village of New Gourna in West Luxor in Egypt. Slowly, Modern-

ist architects in many countries paid greater attention to indigenous forms, for instance Charles Correa in India, whose Bay Island Hotel on the Andaman Islands draws inspiration from the vernacular.

As early as 1940 the Turkish architect Sedad Eldem was facing the problem of a national architecture appropriate to landscape, tradition and culture; after World War II architects such as Geoffrey Bawa in Sri Lanka took up the challenge. Regarded as reactionary at first, they are now acknowledged as being sensitive to local conditions and requirements. The lessons of modern technology have been learned, but the most promising trend for the future is the discarding of the indiscriminate application of the International Style and a growing confidence in regional architecture. The compression of space and time in the "Postmodern world" has produced a fusion of Eastern and Western developments in architecture which may sometimes be second-rate and destructive of a sense of place, but can also be good and exhilarating and full of subtle cultural reference.

Music across the cultures
Western music in the 20th century has involved a quest for new form. A variety of different disciplines have been developed in the search to provide composition with a coherent, accessible language. Some, such as the different forms of serialism, were arrived at scientifically, while

others borrowed structures and techniques from oriental and other ethnic music. Now, there is no single dominant fashion or theory in composition, but a remarkable freedom to employ all the means that have been put at the disposal of 20th-century composers.

Ethnomusicology has grown in stature as an academic subject over the last twenty years. It has brought an informed anthropological attitude to bear on the music of nonliterate peoples, the unnotated music of orally transmitted cultures, and folk music. It has looked at the use to which a culture puts its music and has opened up a wide range of musical techniques and instruments to the composer. For example, it is now almost commonplace to hear the Indonesian gamelan orchestra's "halo" effect created by a conventional Western-style symphony orchestra. Instrumentation, too, has widened in potential, most notably in the percussion department, where the enormous array of tuned and untuned struck instruments would be unrecognizable to a 19th-century performer. Technology has intervened, too, producing such instruments as the "ondes Martenot" – the eerie electronic keyboard instrument so beloved of horror-film music, – as well as the near-infinite potential of the computer.

As these developments have been absorbed, the individual strands of the transcultural mix have become less readily identifiable. Just as the breadth of treatments of tonality has become accepted, so too has the influence of non-Western music – and the exchange has not been loaded in one direction. The compositions of the Japanese Toru Takemitsu, for instance, are as familiar and comprehensible to Western audiences as they are to his compatriots. Takemitsu writes frequently for Western ensembles, but will sometimes include Japanese instruments such as the *biwa* or *shakuhachi*. His manner is largely Western but his attitude is undeniably Eastern. His works are often short and seemingly unambitious, inspired by natural and timeless phenomena such as rain, dawn, dream or silence.

The East has not only allowed Western composers to escape the obligations of developmental music; it has also, in the most surprising ways, offered subject matter to opera composers. Surely one of the most unlikely of operatic subjects is the visit of the then American President Richard Nixon and his wife to Chairman Mao's China in 1972. Yet that is the subject of the opera *Nixon in China* (1987) by the American composer John Adams. The opera was created in collaboration with director Peter Sellars and librettist Alice Goodman. Adams employs his own minimalist style – a very busy, shimmering surface sound, covering slow-moving shifts of musical emphasis – in the service of both the kitsch lyricism of Middle America and the creative rigidity of China in the throes of its Cultural Revolution. The British composer Judith Weir has also drawn on Chinese art for her witty and disorientating *A Night at the Chinese Opera* (1987), for which she not only adopts an authentic Chinese tale – the 13th-century "Chao Family Orphan" – but uses the tripartite tragicomic Chinese Opera form, extending it yet farther with musical parody and distor-

tion. More and more, the availability of all the resources developed during the century make it possible for composers to move freely between cultures and styles, to continue to develop musical shape and form.

The fruits of all these crosscultural links are yet to be finally assessed. But they seem to be more important than dashes of local color lighting up a jaded international sameness. Genuine transactions are being made. And the individuality of artists and the traditions in which they work seems still to guarantee that something other than the synthetic and the rootless will survive. But where the global center for all this activity might finally be located is another question. After Paris, London, New York, where next? New Delhi, Sydney or Prague? Only new waves of artists will determine that.

▼ One view at the "Magiciens de la Terre" exhibition, Paris 1989. On the wall is a mud circle by British artist Richard Long, while on the floor before it is a ground painting by the Yuendumu community from Australia. Long's respect for and celebration of his environment, which accords with Aboriginal artistic function, may indicate that Western art has absorbed some spiritual substance from other cultures. There is a sense that it was in the 20th century that the industrialized West caught up with the rest of the world.

ART AND MONEY

Vincent Van Gogh barely sold a painting in his lifetime; by the early 1990s his works commanded prices of more than $50 million each. In the later 20th century some kinds of art – and especially the so-called "modern masters" – were better than money.

In 1961 the art world was shocked when the New York Metropolitan Museum of Art paid US$2.3 million for Rembrandt's *Aristotle Contemplating the Bust of Homer*. But from the late 1960s and 1970s, the prices asked for works by Cézanne, Picasso or Van Gogh meant that it became increasingly hard for public galleries, without special endowments, to compete in the market for such works. Many of the best-known works entered the private collections of exceptionally rich individuals – or of institutions. Some collectors built private museums, such as the oil-baron John Paul Getty, who built a museum in Malibu, Los Angeles, for his vast collection.

In the 1980s the major art auctioneers and commercial galleries stimulated a boom in the art market, encouraging a new generation of purchasers, particularly among Japanese industrialists. The sharp rise in prices, following a long period in which the market had been rising generally faster than inflation, brought an element of frenzied financial speculation to the art scene, with paintings bought for investment (and lodged in bank vaults) rather than for display or enjoyment. Others were bought for personal or institutional prestige: when the Yasuda Fire and Marine Insurance Co. in Tokyo bought Van Gogh's *Sunflowers* for almost US$41 million in 1987 and displayed it in the foyer of the head offices, long queues of Tokyo residents came to view the wonder.

The burgeoning market attracted its share of cynics, among them some genuine artists. In the mid-1980s the value of genuine works by Salvador Dalí dropped after it was revealed that he had signed countless blank pieces of paper. The century had seen several notorious forgers already, notably the Dutchman Hans van Meegeren who produced several forged "early Vermeers" before detection in 1945; his justification was that he sold his paintings only to the Nazi occupiers of his country, thus helping the resistance effort.

The buoyancy of the art market meant that hitherto unfashionable styles and periods of art, both modern and pre-20th-century, were taken up and fortunes made on them. By the 1970s and 1980s the market, eager for new areas to develop, sought out contemporary art and artists of all kinds. The best of the New York subway graffiti artists were taken up by the art establishment, and their works sold at astronomical prices; and traditional and tribal art was adapted for sale in the smart galleries. After the Soviet Union developed new contacts with the West in 1986, Soviet artists were "discovered" and their works appeared in Western galleries. Only occasionally did this trend significantly benefit the artists themselves.

►► Australian Aborigine art, frequently done on bark, has for millennia been very different from Western art, both in its esthetics and its intention. It has not been something set apart from everyday life, but was produced for ceremonial use. In the 1980s, however, this art was "discovered" by the art market; paintings by artists such as Michael Nelson Tjakamarra were done in acrylics and on canvas for the first time, and brought to the West where they changed hands for large sums. Such developments involved a whole set of changed values in traditional societies.

► Major sales of paintings are often conducted in London or New York, but may be broadcast live on television throughout the world. The major auction houses have been accused of encouraging massive inflation in the prices paid for top-quality painting in the 1980s.

►▼ One of the great modern collections has been that of Charles and Doris Saatchi in Britain, put together in the 1980s. Such large collections have a powerful influence on taste; here Doris Saatchi is seen in front of *Three Elvises*, by Andy Warhol. The collection, in London, was opened to the public in 1985.

▼ *Arch* (1982), by Andy Goldsworthy. As the art market grew more heated, some artists showed their disgust for its commercial values by producing art that could not be traded. Land artists, particularly, sought a transience that could not be brought into the gallery.

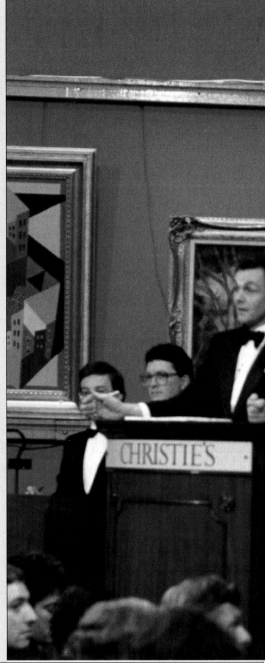

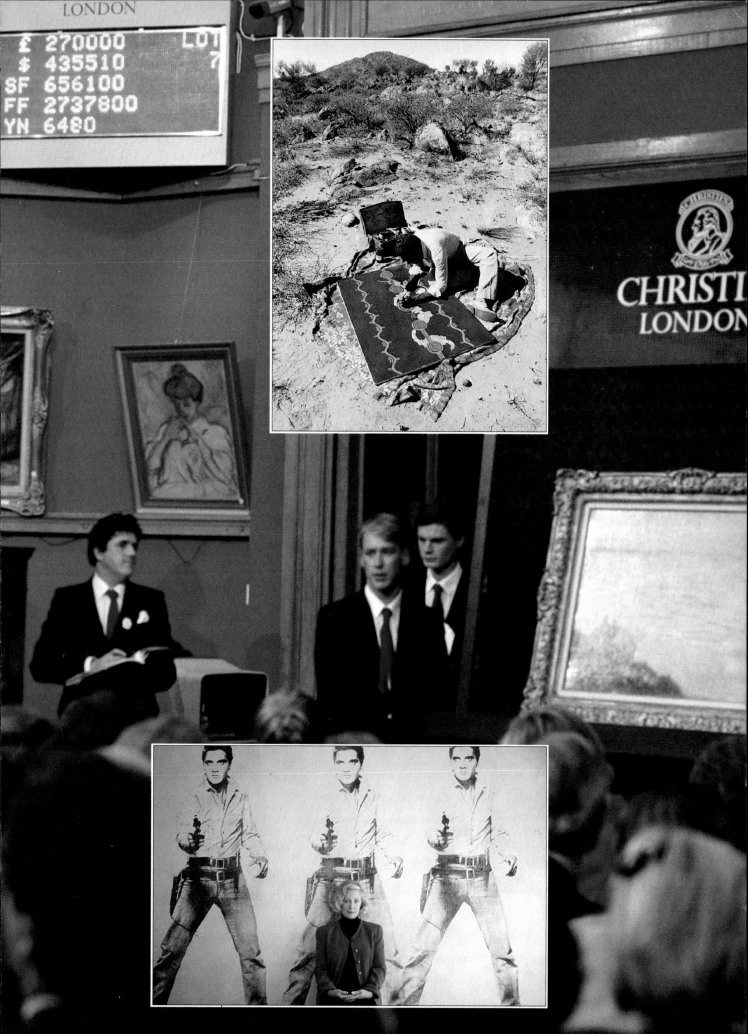

BIOGRAPHIES

▲ Anna Akhmatova

▲ George Balanchine

▲ Samuel Beckett

Achebe, Chinua 1930–

Nigerian writer. Son of a teacher, Achebe was an early graduate of Ibadan University, proceeding to two English universities. From 1954 he worked for the Nigerian Broadcasting Corporation, becoming external broadcasting director in 1961. He taught at the University of Nigeria from 1967, with a brief interlude in the USA (1973). His first novel, *Things Fall Apart* (1958), deals, like all his work, with the clash between African tribal culture and colonial innovation. Achebe's moderation on this theme, and the high value he places on the English language, have cost him some popularity at home. He also wrote short stories, and *Morning on Creation Day* (1975), essays dealing with the relation of writer to politics.

Akhmatova, Anna 1889–1966

Russian poet. Writing from 1900, in 1910 Akhmatova, her husband Gumilev, and Mandelstam founded Acmeism, eschewing the Symbolists' fuzzy mysticism for concrete clarity. Her first collection, *Evening* (1912) dealt mostly with the pain of love. After the execution in 1921 of her first husband, she was increasingly oppressed; her son, and later husbands, were interned, and she was banned from publishing from 1923 to 1940, and 1946 to 1956. She remained a prolific poet, acknowledged as great; works like *Poem Without a Hero* (1940–62), dealing powerfully with the dilemma of being a poet in such times, and *Requiem* (1963), exemplify the responsibility she felt of bearing witness to the truth.

Arp, Jean (Hans) 1887–1966

German-born French sculptor, painter and poet. After studies in Strasbourg, Paris (where he saw modern art) and Weimar, Arp took up poetry. In 1909 he met Klee in Switzerland, and in 1912 exhibited with the *Blaue Reiter* group. In 1914, in Paris, he mixed with the avant-garde, and showed "abstract" paintings. He was a founder member of the Zurich and Cologne Dadaists. From 1926 to 1930 he was with the Surrealists, and then turned increasingly to sculpture; he founded the Abstraction-Création group. He had a sense of fun, reflected in subjects like *Fork and Navel* (1927), and *Head with Three Annoying Objects* (1930). His forms are smooth, and quasi-organic; he believed the forms of art should arise spontaneously: "Art is a fruit that grows in man".

Ashton, Frederick 1904–88

British choreographer. After studying dance under Massine, Ashton worked in the Ballet Rambert company (1926–33); Marie Rambert encouraged him as a choreographer; his first piece, *The Tragedy of Fashion*, was produced in 1926. In 1933 Ashton, a fine character dancer and mime, joined the Vic-Wells (later Royal) Ballet, as dancer and principal choreographer. *Symphonic Variations* (1946) is perhaps his masterwork; he choreographed many innovative and popular pieces, including *La Fille Mal Gardée* (1960), and *Marguerite and Armand* (1963) for Fonteyn and Nureyev. Director of the Royal Ballet (1963–70), from 1970 on, he choreographed exclusively, save the occasional dancing appearance, as in his 1971 film, *Tales of Beatrix Potter*. Ashton brought lyricism and wit to classical dance, and taught dancers how to work with their minds as well as their bodies.

Auden, Wystan Hugh 1907–73

British US poet. Auden's first poem was published in 1924. In 1925 he went up to Oxford to read natural sciences; he changed to English, and became leader of the group of poets, influenced by Marx and Freud, who dominated the literary scene in 1930s Britain. He collaborated with Christopher Isherwood on several plays, including *The Ascent of F6* (1936). He visited Spain during the Civil War and China in 1938, and in 1939 emigrated with Isherwood to the USA. He was a guest professor at many US colleges. *The Double Man* (1941), heralds his reconversion to Christianity. Auden published three long poems, *For the Time Being* (1944), *The Sea and The Mirror*, in the same volume, and *The Age of Anxiety*, which won the 1947 Pulitzer Prize, and collaborated with his companion Chester Kallman on libretti, including Stravinsky's *The Rake's Progress* (1951). As a Christian, Auden repudiated many of his earlier leftwing poems. In 1972 he moved back to Oxford. Auden's poetry is by turn cynical, satirical, dogmatic and didactic; he was much admired by later poets such as Joseph Brodsky and Derek Walcott.

Balanchine, George 1904–83

Russian US choreographer. Balanchine studied at the Imperial Ballet School, and then (1921–24), the Petrograd Conservatory. He defected in 1924, and in 1925 became principal choreographer of the *Ballets Russes* until Diaghilev's death; he produced ten ballets, including *Apollo* (1928), and traveled widely. He cofounded the avant-garde *Les Ballets 1933*, and as a result in 1934 was invited to cofound the New York School of American Ballet and its company. In 1948 he helped set up the New York City Ballet, becoming its director and chief choreographer. He also choreographed for Broadway musicals and was a major choreographer at two posthumous Stravinsky festivals, in 1972 and 1982. He always studied musical scores in depth, and choreographed on the dancers, from the first rehearsal. He incorporated popular dance and gymnastic movements into his work, and has been a major influence on later choreographers.

Balla, Giacomo 1871–1958

Italian painter. A lithographer from 1883, he attended Turin Academy, and in 1900, in Paris, encountered Neo-Impressionism, and came under the influence of the poet Marinetti, progenitor of Futurism. In 1910 Balla signed the manifesto of Futurist painting. *La Lampe Électrique* (1909) embraces Futurist principles, but Balla's work, although innovative, remained lyrical, like *Dynamism of a Dog on a Leash* (1912). He also moved further than his fellows into Abstraction. In 1916 he was the acknowledged leader of the new Futurist movement, but his work lost its force, and he reverted to a traditional, decorative style.

Balthus 1908–

French painter. His parents were both painters, and among family friends were Bonnard and Derain, who told him he should paint. He also knew Rilke, who influenced him most, and who published a book of Balthus' drawings in 1921. In 1924 Balthus moved to Paris, and, self-taught, painted childhood themes, explored Impressionism, and then discovered his own style, based on Italian Renaissance painters like Masaccio and on oriental art – *La Rue* (1934) is an example. He had a strong moral vision, and sought, like the Surrealists, profoundly significant subject-matter. Works such as *Nu jouant avec un chat* (1954) and *Japonaise à la table rouge* (1976) demonstrate the tender eroticism found in many of his figure paintings, especially those of pubescent girls; he painted many fine landscapes (see *Bouquet of Roses on a Window Sill*, 1958) and portraits, notably of Derain (1936) and Miró (1938). His sketches reveal a matchless draftsmanship.

Bartók, Béla 1881–1945

Hungarian composer. Bartók's mother taught him piano from the age of five; he began to compose at nine, and studied at the Budapest Academy (1898–1903). His earliest compositions were Straussian in flavor – *Also Sprach Zarathustra*, heard in 1902, was a revelation to him. He also became a nationalist, and began to notate Hungarian folk songs. In 1905 his lifelong collaboration with Zoltan Kodály began; they recorded thousands of folk-songs from Europe and other places. This music led Bartók to employ pentatonic and modal systems in his own music. His music was unpopular until 1917, when his ballet *The Wooden Prince*, followed by *Bluebeard's Castle* (1918), brought him fame. *The Miraculous Mandarin* (1926) initially offended audiences with its sexually explicit and farcical subject-matter. In 1927–28 Bartók toured the USA, playing his own and Kodály's music. His palindromic, "Brückenform" is exemplified in the superb choral *Cantata profana* (1930). In 1940, devastated by his mother's death, as his tragic Sixth Quartet shows, he moved to the USA, but although awarded a doctorate, and a post researching folk-music, he missed public acceptance, and his home; in 1942 a blood disease was diagnosed, and he died before completing his third piano concerto.

▲ Joseph Beuys

▲ Jorge Luis Borges

Bausch, Pina 1940–

German choreographer. An excellent dancer in childhood, Bausch trained in classical and modern dance at Essen, under the Expressionist Kurt Jooss and from 1959 to 1961 under Anthony Tudor at the Juilliard School, New York. She then joined the Metropolitan Opera Ballet Company, and in 1962 returned to Germany, as a soloist in Jooss's company. She began choreographing in 1968: the strong formalism and emotional intensity of her work brought recognition. She became the company's artistic director, and *In the Wind of Time* (1969) won a prize in Cologne. After a brilliant staging of the dances in *Tannhäuser* (1972), she was made director of the Wuppertal Opera Ballet. She explored sexuality, in the physically violent *Bluebeard* (1977) and *Kontakthof* (1978), worked out with the dancers. In 1980, her companion and collaborator, designer Rolf Borsik, died – after this the range of her dances altered, from the dynamics of close human relationships, to the global fear of disaster, as in *Dance Evening: Cremations* (1984). She does not claim that her work is dance but "expressing feelings".

Beckett, Samuel 1906–89

Irish writer. After graduating from Trinity College, Dublin, Beckett began to write, then taught French. In 1933 he went to Paris, as Joyce's friend and secretary. Between 1938 and 1958 he wrote novels, culminating in the postwar trilogy, *Molloy* (1951), *Malone Dies* (1951), and *The Unnameable* (1953). His greatness was in his plays, written in French, notably *Waiting for Godot* (1952), *Endgame* (1957), and *Krapp's Last Tape* (1958). Beckett wrote in the tradition of Joyce and O'Brien, with the Absurd sense of the futility of life; most of his characters are disabled or physically or psychologically trapped, remarkable mostly for their persistence. His bleak poetic manner became increasingly austere, until *Breath* (1969) a 15-second wordless piece. Beckett won the 1969 Nobel Prize. His influence has been enormous.

Beckmann, Max 1884–1950

German painter. Beckmann studied in Weimar, Paris and Florence until 1906, after which came several exhibitions of his work. In 1915, after serving as a medical orderly, he was discharged with a nervous breakdown. At this point his work became a symbolistic critique of a corrupt world: painting had become a moral rather than an esthetic imperative. He continued to exhibit internationally and in 1925 became professor at the Frankfurt Städelschule. In 1933, however, the Nazis dismissed him and he painted the triptychs *Departure*, and then *Hölle der Vögel* (Birds' Hell). He moved in 1947 to the USA, where he taught in Washington and Brooklyn art schools. In 1950 he won the first prize for painting at the Venice Biennale and received an honorary doctorate.

Behrens, Peter 1868–1940

German architect and designer. Behrens, then a painter, joined the Darmstadt artists' colony in 1900. Influenced by William Morris, he believed in the esthetic integration of an environment, and that national pride and dignity could be fostered by architecture. Co-founder of the *Deutscher Werkbund* (1907), in 1909 he built Germany's first steel-and-glass building, the AEG (Berlin) turbine factory. From 1920, as director of the Vienna Academy School of Architecture, he produced International Modern white cuboid buildings; he held a post at the Berlin Academy under the Nazis. Behrens lacked vision, but was an important teacher of more talented architects.

Béjart (Berger), Maurice 1927–

French choreographer and opera director. At 14, Béjart attended ballet school in Marseilles and in 1945 he studied in Paris, then London. He began to choreograph with the Swedish Ballet in 1952. In 1953 he cofounded *Ballets de L'Étoile* (later *Ballet-Théâtre de Paris*). His *Symphonie pour un homme seul* (1955) was the first concrete music ballet. In 1959 his *Le Sacre du printemps* was a critical triumph, and he, with most of his dancers, set up the Ballet du XXme siècle in Brussels. From 1961 he also directed opera and incorporated jazz and acrobatics into his choreography. *Messe pour le temps présent* (1967) incorporated Eastern philosophy and audience participation (in meditation). In 1970 he founded MUDRA, a center for theater research, in Brussels.

Berg, Alban 1885–1935

Austrian composer. Berg turned from literature to music in his teens, and in 1904 met Schoenberg, who taught him and remained, with Mahler, a lifelong influence. His first mature works (1907–10) were a piano sonata, four songs and a string quartet. In 1913 uproar broke out at the première of two of his *Altenberglieder*, with lyrics taken from postcards sent by the poet Peter Altenberg. Mahler's widow helped to publish *Wozzeck* (1922), the first atonal opera; it was hailed as a masterwork. His *Lyric Suite* (1925–6) contains musically-coded "messages" to his mistress. Berg traveled widely, and in 1930 was elected to the Prussian Academy of Arts, but he refused a teaching post under the Nazis. His last and perhaps finest work, the lyrical *Violin Concerto* (1935) was premièred posthumously.

Beuys, Joseph 1921–86

German sculptor. After studying at Düsseldorf Academy of Art, Beuys taught there from 1961 until his dismissal in 1971. Prominent in the Anti-Form movement, Beuys created "assemblages" of refuse and found objects; he particularly liked felt – he traveled to America wrapped in felt for his piece *Coyote* (1974). In the 1960s he began to conduct public rituals, and organize "happenings", often involving the disarrangement and restoration of his works. His intentions were to release emotional trauma and communicate healing. He stood unsuccessfully, for Parliament in 1976 and represented West Germany at the Venice Biennale.

Boccioni, Umberto 1882–1916

Italian painter and sculptor. Boccioni, whose first ambition was journalism, began painting in 1900, in Rome, under the tutelage of Giacomo Balla. After visiting Paris and Russia, in 1907 he moved to Milan and worked as a commercial artist. He joined the *Famiglia Artistica* group, meeting Marinetti, and was the main writer of two Futurist art manifestos (1910, 1912). In 1911, with other Futurists, he visited Paris and met avant-garde artists; he also painted *The City Rises*, using brushwork to express animation. Energy imbued Boccioni's work – he saw even still objects as moving. *Unique Form of Continuity in Space* (1913) exemplifies this perception.

Bonnard, Pierre 1867–1947

French painter. After failing law examinations, Bonnard studied art in Paris. In 1890 he took a studio with Vuillard and Denis, exhibited in 1891, and produced many illustrations, some for *La Revue Blanche*, and prints; in 1894 he met Vollard, who published his lithographs and, in 1896 had his first one-man show. He was a member of *Les Nabis*, known as *Le Nabi Japonard* from his fondness for Japanese art. By 1905 he was painting exclusively, producing the sunlit interiors for which he is renowned, usually featuring the female figure, like *The Breakfast* (1907). Bonnard made dazzling use of color and light, but painted from memory. His style was christened "Intimism" for his use of domestic scenes. From 1910 he worked increasingly in the Midi, and his colors became more vivid, as in *Getting Out of the Bath* (1930).

Borges, Jorge Luis 1899–1986

Argentinean writer. A lover of English from childhood, Borges numbered Stevenson, Chesterton, and Old English literature among his influences. He traveled Europe from 1914 to 1921, encountering the Spanish *Grupo Ultra*, who believed in "pure" poetry, not dependent on context. He later judged his first three collections too Ultraist, but they contain the metaphysical games and questions of time and identity which characterize his mature work. From 1925 Borges wrote pieces for a Sunday newspaper, and magazine stories. He was becoming more and more blind. In 1946 Perón dismissed him from his librarianship, but in 1959 he was restored, and made Director of the National Library until 1973. Borges wrote superb stories, jewel-like in their clarity and vision, exemplified in *Fictions* (1944) and *The Aleph and other Stories* (1949).

▲ Bertolt Brecht

▲ Benjamin Britten

▲ Albert Camus

Boulez, Pierre 1925–

French composer and conductor. After studying higher mathematics, Boulez studied at the Paris Conservatoire with Messiaen and Leibowitz. He started composing in 1945; in 1946 he became musical director of the Renaud-Barrault theater company. His early style is forceful and expressive; he moved gradually from dodecaphony to total serialism, as in *Structures* (1951–61). His chamber-group setting of Char in *Le Marteau sans maître* (1953–55) was very influential. Boulez worked worldwide as a teacher and a conductor. He used "mobile form" – elements of ordering left to choice – in his *Third Piano Sonata* (1957), and *Pli selon Pli* (1957–62), a musical portrait of Mallarmé. In 1975 he became director of the Institut de Recherches et de Coordination Acoustique, Musique (IRCAM), a centre in Paris for the development of electronic music; his *Répons* (1981) introduced the 4X music computer, developed at IRCAM, which was subsequently used by many other composers.

Brancusi, Constantin 1876–1957

Romanian sculptor. Already a fine woodcarver, in 1898 he entered the Bucharest School of Fine Arts. In 1904, influenced by Rodin, he went to Paris, and worked at the École des Beaux-Arts. Breaking with custom in doing his own carving, and painstaking in his pursuit of the essence of things, with *The Prayer* (1907), Brancusi began to produce more abstract forms, including the superb *The Kiss* (1908). In 1913 his work appeared in the American Armory Show. From 1918 he produced several *Endless Columns*, culminating in 1937 in one 30m (100ft) high, in a Romanian park. These, like his bird sculptures, well expressed his spiritual aspiration. Works like *Caryatid* (1915), and *Socrates* (1923), showed his love of primitive art. Brancusi was a towering figure, who influenced such great artists as Epstein, and Gaudier-Brzeska.

Braque, Georges 1882–1963

French painter and co-founder of Cubism. After attending Le Havre Art School, in 1900 Braque moved to Paris, where from 1902 to 1904 he studied at the Académie Humbert. In 1906 his work appeared in a Fauvist exhibition. The Cézanne Retrospective (1907) impressed him deeply. In 1907 he began a close collaboration with Picasso, to last until 1914, which fathered Cubism. In 1908 H. Kahnweiler put on a Braque one-man show. In 1910, Braque began to use collage. The *Canéphores*, a series of paintings of women with fruit and flowers, were produced in the 1920s. By 1930, Braque was an internationally acknowledged master of still life, with frequent retrospectives held worldwide. He began a series of drawings in white on black ceramic, influenced by Greek art. From 1948 to 1955 he painted the eight *Ateliers*, probably his finest work. In 1961 he became the first living artist to be exhibited in the Louvre.

Brecht, Bertolt 1898–1956

German playwright. Brecht won the Kleist prize for his first play, *Drums in the Night* (1922); he was given a post as artistic advisor to a theater in Munich, and then, from 1924, to one in Berlin: 1928 saw the production of his great popular success, *The Threepenny Opera*, written with Kurt Weill, with whom other work followed. From 1929 to 1936 Brecht embraced Communism, finally becoming disaffected with party organization. *Galileo* (1938), written in exile in Scandinavia, resulted. In the USA during World War II Brecht wrote *Mother Courage* (1941), *The Good Woman of Setzuan* (1943), and *The Caucasian Chalk Circle* (1944). In 1949 he settled in East Berlin, and founded the Berliner Ensemble, where he developed his dramatic theory of "alienation" – preventing the audience from identifying unconsciously with characters by narrative devices and interpolated songs.

Britten, Benjamin 1913–76

British composer. Britten began to compose aged five, when his mother taught him piano. In 1924 Frank Bridge began to teach him composition, and in 1930 he studied at London's Royal College of Music. In 1934, after hearing *Wozzeck*, he visited Berg, but was not able to study with him. In 1936 he began to collaborate with W. H. Auden on sociopolitical pieces like *Ballad of Heroes* (1939). After Auden's emigration Britten, too, emigrated to the USA with the tenor Peter Pears, his lifelong companion, who inspired his finest vocal works. They returned in 1942; Britten, a conscientious objector, gave concerts. In 1945, his opera *Peter Grimes*, performed at Sadler's Wells, was a resounding worldwide success. In 1947 Britten cofounded the English Opera Group, which in 1948 launched the first Aldeburgh festival. Operas like *Billy Budd* (1951) and the dodecaphonic *The Turn of the Screw* (1954) followed. Britten was later influenced by oriental music and theater, as in *The Prince of the Pagodas* (1957). *The Young Person's Guide to the Orchestra* (1946) was written for children, for whom Britten wrote many works. Britten's work is marked by its craftsmanship and Mozartian purity.

Brook, Peter 1925–

British theater director. Brook began directing as a 17-year-old undergraduate at Oxford, with *Dr Faustus*. After spending two years at Birmingham Repertory Theatre, he directed *Romeo and Juliet* at Stratford (1947). In the 1950s he worked also in Europe and the USA, and directed a celebrated *Titus Andronicus* with Olivier (1955). In 1962 he joined the Royal Shakespeare Company (RSC). Inspired by Artaud's work, Brook ran an RSC Theatre of Cruelty season, and, also in 1964, won the New York Drama Critics' directing award for his *Marat/Sade*. After a very successful version of *A*

Midsummer Night's Dream (1970), Brook set up the International Center for Theater Research in Paris, based on the ideas of Polish director Jerzy Grotowski, and toured Africa and Asia. In 1989, he directed for the vast and ambitious film of the Indian holy book, *Mahabharata*.

Cage, John 1912–

US composer. After college, Cage studied music in Europe, and composition in the USA, with Schoenberg and others. In 1938, Cage developed his "prepared piano" – a piano made percussive by the placing of various objects between the strings. After teaching in Chicago, in 1942 Cage settled in New York; he became musical director for Merce Cunningham's dance group. Cage was influenced by Eastern philosophers, and in the 1950s, working with the *I Ching*, began to introduce chance elements into composition, as in *Music of Changes* (1951). In 1952 he organized an event at Black Mountain College which prefigured the 1960s' "happenings". In 1958, Cage toured Europe, and worked with Berio in Milan. Back in New York, he taught experimental music and mushroom identification. In *Musicircus* (1962), the audience was invited to perform. *Roaratorio* (1979) was the realization of a means of translating *Finnegan's Wake* into music. Cage's influence was immediate but short-lasting.

Calder, Alexander 1898–1976

US sculptor. A graduate in mechanical engineering, and a fine draftsman, Calder's first job was illustrating the National Police Gazette. He produced, over a period around 1926, when he visited Paris, a *Circus*, of small figures made of miscellaneous materials, like used corks. He also made portraits out of wire, and exhibited them in 1927 in New York. In 1931 he moved to Paris, where he began to produce the seminal hanging thin, flat shapes, which Duchamp named "mobiles". Through these, Calder gained international fame, winning the 1952 Venice Biennale Sculpture Prize. Calder's sense of play was paramount; he never called himself an artist, but his work touched millions.

Calvino, Italo 1923–85

Italian writer. Calvino's first novel, *The Path to the Nest of Spiders* (1947), written after his wartime experiences in the Resistance, examined war and Resistance through a child's eyes. Always exploring the various forms and conventions of communicating symbols, in *The Castle of Crossed Destinies* (1969) he uses Tarot cards to develop the plot. This also introduces elements of mystery, enigma, and traditional allegory, all typical of Calvino's work. *If on a Winter's Night a Traveller* (1979), a novel about novel-reading which consists of ten novel openings, increased his popularity outside Italy.

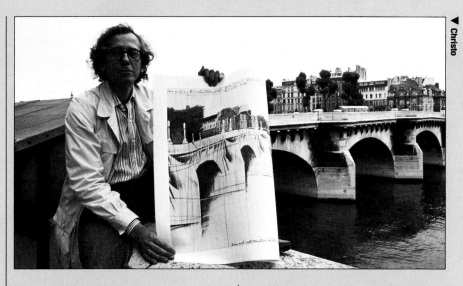

▼ Christo

▼ Joseph Conrad

Camus, Albert 1913–60

French writer. Son of an Algerian farmworker and a charwoman, Camus' academic career – he read philosophy – was arrested by TB. In 1936 he wrote: "People think only in images. If you want to be a philosopher, write novels." *L'Étranger* (1942) followed by *Le Mythe de Sisyphe*, brought him instant fame. Camus joined the Resistance in 1942, editing its journal. *La Peste* (1947), uses a plague-stricken Algerian town as an analogy of occupied France. Camus quarreled with Sartre after denouncing Communism in *L'Homme Révolté* (1951). He also rejected Christianity; but *La Chute* (1956), reveals a painful self-doubt with comic irony. Camus' writing was in the Absurd tradition, pinpointing the futility of life in view of death; he also celebrates intense pleasure of living – and he ratifies the Absurd paradox with the possibility of a nobility of spirit, a stubborn creativity which seems either blind, or immune, to circumstance.

Cartier-Bresson, Henri 1908–

French photographer. Cartier-Bresson took up photography in 1931, after studying painting and literature in Paris and Cambridge, UK. He assisted (1936–39) film director Jean Renoir, another powerful influence; and in 1945 made a documentary film on the postwar experiences of prisoners-of-war. In 1947, with Robert Capa and others, he set up Magnum cooperative photographic agency. From 1948 to 1950 Cartier-Bresson worked in India, China, Indonesia and Egypt; in 1952 his collection, *The Decisive Moment*, appeared, and in 1955, another book, *People of Moscow*. Cartier-Bresson has been instrumental in the acceptance of photo-journalism as an art form. In pursuing his art he has shown courage, as on the streets of Paris in 1968, and integrity; he never intrudes on what he sees to be "private" emotion.

Cavafy, Constantine 1863–1933

Greek poet. Cavafy wrote early, in English, French and Greek. Being out of touch with the Greek literary tradition due to living in England (1872–77) and Istanbul (1882–85), and out of tune with its contemporary poets, Cavafy matured as a writer late, about 1911. He wrote on the ancient Greek period, and wrote homoerotic pieces; the two modes often combined. He also used a mixture of "high" and demotic Greek, influencing other writers worldwide.

Celan (Antschel), Paul 1920–70

Romanian-Jewish-born German-language poet. In 1942, Celan's family were deported and murdered in a Nazi extermination camp; Celan himself escaped but spent until 1944 in a labor camp. After World War II, he moved first to Bucharest, where he worked as a publisher's reader and translator, then Vienna, and finally in 1948 to Paris, where he studied German literature and became a university lecturer. His poetry reflects exactly his traumatic circumstances in a manner that grew more epigrammatic and stark as it matured; *Sprachgitter* "Speech-Grille" (1959) and *Die Niemandsrose* "The No-one's Rose" (1963) exemplify this manner in chiseled and concise language that grew close to silence, a state toward which Celan believed all true poetry tended. His late collections, *Lichtzwang* "Light-Forcing" (1970) and *Zeitgehöft* "Time-Farmyard" (1976), express his despair at the incapacity of language in terms paradoxically at once direct and unyielding. Celan was the finest German-language poet since Rilke; he drowned himself in the Seine in 1970.

Cézanne, Paul 1839–1906

French painter. Cézanne studied art in Paris, and his early work was crude, with often violent subjects, and he was repeatedly rejected by the Salon, exhibiting instead at the *Salon des Refusés* (1863). He met Renoir and Monet (1867–68), and from 1872 worked with Pissarro. He had works in the Impressionist Exhibitions of 1874 and 1876. From then, he worked mainly in Provence, with its brilliant light and dark foliage, producing many paintings of Mont Ste Victoire. Public acclaim came in the 1880s and in 1890 he exhibited in Brussels with *Les Vingt*. Vollard set up his first one-man show in 1895. Although he had virtually no public career, Cézanne pursued his art assiduously. He rejected Realism and Impressionism, and broke forms into facets, using color and modeling with care, seeking an underlying abstract structure. The posthumous Retrospective of 1907 was a great influence on the whole of 20th-century art.

Chagall, Marc 1889–1985

Russian-Jewish-born French painter. Introduced to modern French art by his teacher Léon Bakst, Chagall, already producing paintings of Jewish life, encountered Cubism in Paris in 1910, and turned its methods to his own use, in works like *I and the Village* (1911). In 1915 , detained in his hometown of Vitebsk by the war, he married Bella Rosenfeld, subject of many of his paintings. Made Commissar of Fine Arts after the Revolution, he left in 1919 after conflict with Malevich, and designed for the Moscow State Jewish Theater. Back in Paris from 1923, Ambroise Vollard commissioned many illustrations, notably a series of etchings for Gogol's *Dead Souls*. 1930 saw the publication of his autobiography *Ma Vie*. In 1944 Bella died, and Chagall's sorrow was reflected in paintings like *Around Her* (1945); that year he also created designs for Stravinsky's *Firebird*. In the 1950s he took up sculpture and ceramics. He created the stained glass windows for the New York United Nations building (1964). Chagall's work was unique, using symbols from his Jewish heritage and his own poetic images to create works of ecstatic fantasy.

Christo (C. Javacheff) 1935–

Bulgarian "wrapping" sculptor. Christo studied at the Academies in Sofia and Vienna, (1955–57), then went to Paris, where he joined the *Nouveaux Réalistes*. He was also a founder member of the KWY. Opposed to materialist values, in 1958 Christo began wrapping objects, at first bottles and cans, and after moving to New York in 1964, larger and larger things. In 1968 he wrapped a public building in Italy, in 1969, a bay on the Australian coast, and in 1971, he made *Valley Curtain*, a long fence made of sheet plastic, in Colorado. Christo also produced, from 1961, assemblages made out of oilcans.

Cocteau, Jean 1889–1963

French writer, film-maker, and artist. Although a poor scholar, Cocteau soon mixed with the artistic-literary-musical talents of his time. After driving an ambulance in World War I, he met *Les Six* and worked with them: his first ballet, *Parade*, was created with Satie and Picasso. Such glittering cooperation, and virtuosity, was a keynote of Cocteau's life. In 1923 his first novel, *Thomas L'Imposteur*, appeared. It dealt with his war experiences; also in this year he turned to opium, following the death of his 21-year-old protégé, Raymond Radiguet. Cocteau made fine films, including *La Belle et la Bête* (1941) and *Le Testament d'Orphée* (1950). His novels included the famous *Les Enfants Terribles* (1929), which he later filmed, and *La Machine Infernale* (1934) was his best-known play; he worked in glass, ceramics, and illustrated books, decorated public buildings, and wrote libretti, yet he called himself a poet. He saw the artist's task as the "rehabilitation of the commonplace"; the weakness of his work may be that he tended to subsume ethics in esthetics. In 1955, Cocteau became the first person ever to be elected to the Académie Française without paying court to its members.

Conrad (Korzeniowski), Joseph 1857–1924

Polish English writer. Son of a revolutionary Polish poet, and orphaned in 1869, Conrad always admired England, and read English books as a child, although it was his third language. In 1874 he became a sailor, qualifying in 1886 as master seaman. He studied English, and in 1884 became a British subject. His first novel, *Almayer's Folly* (1895) shows a mature command of English; in 1896 he settled in Kent. The brilliant novels *Lord Jim* (1900) and *Nostromo* (1904) show the power and beauty of his style, and the depth and complexity of plot and character which marks his work out. In 1910 he suffered a mental breakdown; his second political novel, *Under Western Eyes*, appeared the following year. Conrad wrote of men put to the utmost test; the settings are often menacing – the sea, the jungle – but the real threat comes from the "heart of darkness" within.

▼ Salvador Dalí

▼ Claude Debussy

▼ Isadora Duncan

Cunningham, Merce 1919–

US choreographer. Cunningham studied dance from age twelve; in 1939 he joined Martha Graham's company as a soloist. He began to choreograph in 1942 with *Totem Ancestor*. In 1945 he began working with John Cage; he developed "choreography by chance", tossing a coin to determine movement sequences; in 1952 he formed his company, and did *Suite by Chance*, the first modern dance with an electronic score. In 1974, influenced by non-theater-based performance, he took his work apart and produced "Events", using excerpts from it, reconstructed. He made dances for videotape, like *Quartets* (1983). Cunningham has taught all over the USA. He is an indefatigable visionary, who has redefined choreography.

Dalí, Salvador 1904–89

Spanish painter. Suspended (and imprisoned) for subversion during his studies at Madrid Fine Art School, he was expelled in 1926. He went to Paris, where he met Picasso and Miró, and studied Freud's work. In 1929 he joined the Surrealists and had a one-man show. During this time he collaborated with Luis Buñuel on two films, *Un Chien andalou* and *L'Age d'or*. Dalí's "paranoiac-critical" method of invoking quasi-hallucinatory images while retaining a critical consciousness of the imaging process, coupled with his brilliantly realistic style of execution, produced work like *The Persistence of Memory* (1931) and made him the most popular of the Surrealists. In the 1930s, he began to emulate Raphael; he also flirted with Fascism, and this led to a rift with the Surrealists, although he continued to exhibit with them. From 1940 until 1955 he lived in the USA, during which period his work drew more and more on his Catholicism, as in *The Crucifixion of St John of the Cross* (1951) and *The Last Supper* (1955). After returning to Spain he spent much of his time decorating the museum of his works in Figueras.

Davis, Stuart 1894–1964

US painter. Davis studied with Robert Henri, and exhibited five paintings in the 1913 Armory Show, causing some outrage. His work was of the New York Ashcan School; he was influenced in color by the Fauves, and in construction by Cubism. In the 1920s he produced abstract paintings featuring juxtaposed shapes and mass-produced objects – *Lucky Strike* (1921). He also painted the 1927 *Eggbeater* series. A visit to Paris in 1928–29 boosted his confidence. In 1932 he painted murals in Radio City. His work was influenced in theme and manner by jazz – *Swing Landscape* (1938), and *The Mellow Pad* (1951). He used stronger color and texture in the 1940s, and his paintings of the 1950s were large and striking – *Little Giant Still Life* (1950). Before Warhol, Davis was producing icons of the waste products of a consumer society.

Debussy, Claude 1862–1918

French composer. Debussy began to study piano in 1871 with a pupil of Chopin. In 1872 he entered the Paris Conservatoire, and in 1884 won the Prix de Rome – but absconded from Rome and returned to Paris; his first major work, *La Demoiselle élue*, was completed in 1888, when he fell for a time under Wagner's influence; Debussy's more lasting influences were gamelan music, Mussorgsky, and Satie. *Prélude à l'après-midi d'un faune* (1894) earned him the epithet "Impressionist", though he repudiated this. Debussy's subtlety of touch did not lend itself to opera – *Pelleas et Mélisande* (1902) was his only successful opera. As well as the poetry of Mallarmé, Maeterlinck and others, Debussy was inspired by painting, as in *La Mer* (1905). The *Préludes* (1910–13) contain some of his best-known pieces, like *The Sunken Cathedral*. Debussy retained the discipline of the classical tradition, but introduced unusual harmonic procedures, employed chromaticism and the whole-tone scale, and employed orchestral color as a structural element in itself.

de Chirico, Giorgio 1888–1978

Italian painter. Born in Greece, de Chirico studied engineering, then art, in Athens and Munich, where his family settled in 1906. *The Enigma of the Oracle* (1910), painted in Milan, is an early imitation of Böcklin. In 1911 he was inspired by the colonnaded architecture and empty piazzas of Turin to depict a strange and menacing world in works like *Mystery and Melancholy of a Street* (1914) and *The Disquieting Muses* (1917), where he used flattened perspective, looming statues, sharp shadows, distant or peripheral figures, surreal images and deadened lighting, to convey a trancelike mood of muffled horror and pain. De Chirico influenced the Surrealists in his fluent articulation of "unconscious" imagery; he had in 1917 a short but important partnership with Carlos Carra, founding the "Metaphysical School". After 1919, when he left Paris, he abandoned metaphysical imagery, except for a brief period, 1924–30, when he returned to Paris and to Surrealist acclaim.

de Kooning, Willem 1904 –

Dutch American painter. In 1916, while an apprentice decorator in Rotterdam, de Kooning attended painting classes. In 1926 he stowed away to the USA, where, with Arshile Gorky and the Greenwich Village Group, he imbibed European art, notably that of Kandinsky. He was a fine draftsman, and in the 1930s was employed by the Federal Arts Project, producing among other works a mural for the 1939 New York World's Fair. He was a leading Abstract Expressionist, with a physical approach that prefigured Action Painting. The monochrome *Painting* (1948) was the product of a five-year period when he used only black and

white; with *Excavation* (1950) he returned to color. *Woman I* (1952) was the first of a series of studies of the female figure; in 1955 he abandoned figures, painting huge, brilliant abstracts; in 1960, retaining the brilliance, he reverted to the female figure, less structured, more sensuous. In the 1970s he took up sculpture, figurative and abstract.

de Saint Phalle, Niki 1930–

French sculptor. Saint Phalle became famous in the early 1960s for her assemblages featuring bags of paint, which she shot at so that they burst and splashed the whole piece. She moved on to gaudy, grotesque, blown-up female figures, such as *Nana*; she created, in collaboration with Tinguely and Ultredt, the *Hon*, a sculpture large enough for people to walk on.

de Staël, Nicholas 1914–55

Russian-born French painter. De Staël, an aristocrat, was a brilliant student at Brussels Fine Art Academy, but left after a year to travel Europe and North Africa. Settling in Paris in 1938, he served in the French Foreign Legion during World War II, and then, in 1944, influenced by his close friend Braque, began to produce abstracts; using a palette knife, he painted piles of cubes, with fine lines, communicating a feeling of joy – *Untitled* (1951) is a fine example. De Staël moved in the 1950s through the use of abstract forms to indicate land – and seascapes, to a more overtly representational art – *Le Bâteau* (1954) was painted in Antibes, his new home. He committed suicide the following year.

Delaunay, Robert 1885–1941

French painter. After apprenticeship to a stage designer, and studying painting in Paris, Delaunay became a full-time artist in 1904. His work was influenced by Fauvism and Cubism, and in 1907–08 he studied Neo-Impressionism and color theory; color was Delaunay's main concern. Delaunay painted many pictures of Paris, like *Eiffel Tower in Trees* (1909), and investigated the rhythmical effects of color. Apollinaire named his style Orphism. In 1911 he contributed to, and influenced, *Der Blaue Reiter*. He soon left natural forms for Abstraction and cosmic symbolism, eventually producing a "color disk", emotionally-related colored shapes, mosaic-like, on a wheel – *Disks: Sun and Moon* (1913). From 1921, when he painted a second *Eiffel Tower* series, his work lost its spontaneity. Delaunay influenced many other painters, especially Klee.

Dix, Otto 1891–1969

German painter. Dix was apprenticed to a painter (1905–9), and then studied art in Dresden (1909–14) and Düsseldorf (1919–22). In 1923 he joined the *Neue Sachlichkeit* school. He was professor of art at Dresden from 1927 to 1933, when the Nazis

◀ Thomas Stearns Eliot

◀ Max Ernst

◀ William Faulkner

dismissed him. His paintings had pseudo-Romantic traits and a Mannerist-Realist style deriving from 16th-century art. This slightly distorted despairing hyper-realism is exemplified in *The Artist's Parents* (1921). His finest works were portraits painted in the 1920s, and his lithographs of World War I after Goya's *Horrors of War*.

Duchamp, Marcel 1887–1968
French artist and art theorist. In 1911 Duchamp joined the Parisian *Section d'Or* group. His supra-Cubist and erotic *Nude Descending a Staircase* (1912) caused a furore at the New York Armory Show in 1913. He then turned to "ready-mades", signing a bottle-rack and a urinal in an attempt to eradicate estheticism, to pinpoint the artist as chooser, and admit chance to the field of art. He was important in Dadaism; his copy of the Mona Lisa, bearded and superscribed "L.H.O.O.Q." (*elle a chaud au cul*) became a symbol of the movement. From 1915 he lived in New York, where he produced his major work, the glass, metal and painted *The Bride Stripped Bare by her Bachelors, Even* (1915–23), unfinished. After this, he devoted himself to chess, producing optical devices, and propounding his artistic philosophy.

Duncan, Isadora 1878–1927
US dancer. Duncan rejected the rigidity of ballet in childhood; in 1894, after moving to England, she was popular as a dancer at parties. In 1905 she toured Europe. She aimed to bring expressive life to dance; her movements came from the solar plexus, and she worked with, not (as classical ballet) against gravity; her dances were improvised. She modeled her flowing, draped costumes on those of ancient Greece. In 1921, by invitation, she founded a school of dance in Moscow; in 1922, she left the USA. She married a Soviet poet, Yesenin; the marriage foundered, and in 1925 he killed himself. She lived a lonely and dissipated life in Nice until her own tragic death. Duncan's vision of the dancer as a creator has infused modern choreography.

Eliot, Thomas Stearns 1888–1965
US British poet, playwright and critic. Eliot read philosophy at Harvard, then studied under Bergson and Alain-Fournier at the Sorbonne. He absorbed Laforgue's writing, and Indian philosophy. *The Love Song of J. Alfred Prufrock*, written in 1910, revolutionized poetic diction, imagery, and tone. Ezra Pound encouraged and supported him, editing *The Waste Land* (1922), his major work. Eliot founded *The Criterion*, a literary journal, and in 1925 became poetry editor of Faber and Faber the publishers. In 1927 he became a British citizen and an Anglican. He received the 1947 Nobel Prize for the *Four Quartets* (1935–44), a long meditation on time, and history both personal – there are elements of autography – and collective.

Eliot's verse drama is not great, except for *Murder in the Cathedral* (1935). His criticism is; he brought about the revival of Elizabethan and Jacobean drama, and of the Metaphysical poets, through his influential critical essays, and coined phrases like "dissociation of sensibility", and "objective correlative" – which became literary-philosophical stock in trade. Eliot fused layers of allusion and literary reference, achieving a directness and clarity in expressing the transcendent which is unsurpassed in modern poetry.

Éluard (Grindel), Paul 1896–1952
French poet. Éluard, after running away from home and traveling the world, started writing poetry in 1917. He was a co-founder of Surrealism. *Capitale de la Douleur* (1926) explores the dream world; *L'Immaculée Conception* (1930), poems written with Breton, runs the gamut of mental disturbances. In 1938 Éluard left the Surrealists; in 1942 he became a Communist, and joined the Resistance, expressing his hatred of the Occupation in *Poésie et Verité*, and two further volumes; these books were parachuted to Resistance fighters. His erotic poetry is arguably even better than his political work, as in *Poésie Ininterrompue* (1946). Passion, and a lyrical esthetic, marked Éluard's work.

Epstein, Jacob 1880–1959
US British sculptor. In 1901, while working in a bronze factory, he took evening classes in drawing, and then studied in Paris; the Louvre's primitive sculptures impressed him. He finished his first major commission, of 18 figures for the British Medical Association, in 1908. Showing Rodin's influence, this work caused a furore, because of its nudity, and expressive exaggerations. Epstein was branded controversial, and was heavily criticised. Epstein's meeting with Brancusi at this time confirmed and speeded him in his artistic direction. Epstein produced serene pieces like doves and marble Venuses; he also approached abstraction, as in *The Rock Drill* (1913); he produced religious work, in a primitive style, like *Risen Christ* (1919), but he was still widely scorned: some pieces were bought for a seaside freak show. He is best remembered now for his realistic bronze busts, like *Einstein* (1933) and *Shaw* (1934).

Ernst, Max 1891–1976
German-born French painter. Reading philosophy and psychology at Bonn University, Ernst neglected his studies for painting, and investigating the art of the insane. In 1911 he met *Der Blaue Reiter* group, and exhibited with them in Berlin in 1913, the year he first visited Paris. After World War I, Ernst was a leading Cologne Dadaist, "Dadamax". In 1919 he made his first collages and in 1925 developed the *frottage* technique, taking rubbings of leaves, paper or wood. He also used

the reverse, *grattage* – scraping paint off over objects under the canvas. A much-loved central figure in Surrealism until he left after a quarrel (1938) with Breton, in 1934 Ernst produced a superb book of collages, *Une Semaine de Bouté*. In 1942, now in New York, he dripped paint on to the canvas in executing *Man Intrigued by the Flight of a Non-Euclidean Fly*. In 1953 he returned to France, and won the 1954 Venice Biennale first prize.

Faulkner, William 1897–1962
US novelist. Mississippi-born Faulkner traveled the world early, but remained a Southern writer. After the publication of a book of poems, he met Sherwood Anderson, and turned to fiction with *Soldier's Pay* (1926). His most productive years, 1929–36, saw the issue of his first stream-of-consciousness novel *The Sound and the Fury*, the superb *As I Lay Dying* and *Light in August*, and *Sanctuary* (1931), which shocked the public and brought him fame. As a Hollywood script-writer until the 1950s, he scripted *The Big Sleep* (1946) among other films; his reputation declined during this time, until winning the 1950 Nobel Prize revived it. Faulkner was a brilliant innovator, playing with narrative time and using multiple perspective. His influence has been far-reaching.

Fitzgerald, F. Scott 1896–1940
US writer. *This Side of Paradise* (1920), a popular success, made Fitzgerald, an advertising copywriter, rich enough to marry Zelda Sayre. Despite his continued success, with both short stories and novels, including *The Great Gatsby* (1925), Fitzgerald lived beyond his means, and became part of the French Riviera's "jet set". In 1930 Zelda suffered a schizophrenic breakdown, and was hospitalized in 1935, the year after the publication of *Tender is the Night* (1934), perhaps Fitzgerald's finest novel, which deals with his married life. In 1937 Fitzgerald, ill with heart problems and incipient TB, tried film-writing. Although his life seems marked by a lack in commitment to his art, Fitzgerald was a superb writer drawing on the pain, mania, and tragedy of his life. His writing style, nerved by his intense sensitivity, is exemplary – beautiful and lucid.

Fokine, Michel (Mikhail) 1880–1942
Russian choreographer. From 1889 to 1898, Fokine studied at the Imperial Ballet School. In 1904 he made his first ballet, *Daphnis and Chloe*; and in 1905 he created, for Pavlova, *The Dying Swan*. Fokine was a rebel, who sought integration in all aspects of a ballet, eschewing the "ballerina set-piece" syndrome. From 1909 to 1914 he worked with the *Ballets Russes*, using Nijinsky, and producing his finest work, like *Les Sylphides* (1909), *The Firebird* (1910), and *Petrushka* (1911). In 1923 he settled in the USA, and worked extensively in the USA and Europe.

André Gide

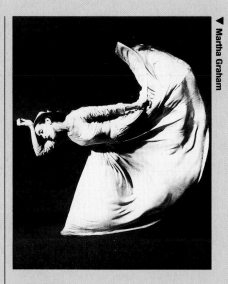

Martha Graham

Günter Grass

Foster, Norman 1935–

British architect. From 1956, Foster studied architecture at Manchester, and then Yale, where he met Richard Rogers. After working (1962–63) for Urban Renewal and City Planning Consultants, Foster set up a practice in Britain with Rogers, and their wives. In 1967, he left to set up Foster Associates; from 1968–83 he worked with the architect and philosopher Buckminster Fuller. Foster's work includes the Willis, Faber and Dumas office-block in Ipswich (1974) featuring black mirror glass, curved to fit the street, and incorporating trees inside and a turfed roof-garden. Popular abroad too, Foster designed an Arts Center in Nîmes (1984) and the Century Tower, Tokyo (1987). Since 1987 he has directed the Japanese branch of his company.

Fuentes, Carlos 1928–

Mexican writer. Son of a diplomat, Fuentes, himself a diplomat and an international lawyer, pioneered the modern novel in Mexico. *The Death of Artemio Cruz* (1962), is a fine example, weighty, subtle, touched with eroticism, and bringing together the Mexican cultural/historical heritage and Western technical sophistication. The massive *Terra Nostra* (1975) is a brilliantly organized, fantastic, allusive, historically complex masterwork, with the magical quality so often found in the best Latin American writing.

Gaudí, Antonio 1852–1926

Spanish architect. After training as a blacksmith, he studied architecture, and in 1877 began work on a fountain in Barcelona. He was commissioned by Count Güell to create many buildings, including the Casa Güell (1885–9) and Güell Park. From 1884 he took over the construction of the church of the Sagrada Familia, working exclusively on it from 1914. It remained unfinished. Gaudí's extraordinary work is distinguished by a Gothic profusion of forms, with sculptured and pictorial detail, and an imitation of living organic forms.

Giacometti, Alberto 1901–66

Swiss sculptor and painter. Taught by his painter father Giovanni, Alberto attended art school in Geneva, and then traveled Italy, afterwards working in Bourdelle's workshop in Paris. From an Impressionist style his work now took on a Cubist influence, and one from Cycladic sculpture. From 1929 to 1935 he was involved with the Surrealists, and did less painting and more sculpture, including *Palace at 4 a.m.* (1932). After 1937 his sculpture became more realistic, but increasingly tiny. Returning after World War II from Geneva to Paris, he evolved the sculptural form for which he is chiefly remembered, slender human figures attenuated as if by fear or pain; he began to produce groups, but these if anything only accentuate the sense of individual isolation.

Gide, André 1869–1951

French writer. *Les Nourritures Terrestres* (1897), published four years after his realization of his homosexuality, advocates an impulsive hedonism. 1902 saw the publication of *L'Immoraliste*. In 1909 he helped set up the *Nouvelle Revue Française*. World War I left Gide more introspective. In 1926 his most ambitious novel, *Les Faux Monnayeurs*, appeared – it dealt with sexual ambivalence in teenage boys; the autobiographical *Si le grain ne meurt* also came out this year. Gide wrote plays, like *Oedipe* (1931), libretti, essays, and his finest work, the Journals (1939 onward). He battled with religious ideas (becoming finally an agnostic), traveled Africa, wrote on colonialism, was briefly Communist, until put off by a visit to Russia in 1936. He won the 1947 Nobel Prize.

Graham, Martha 1894–

US choreographer and founder of "modern dance". Graham attended the Denishawn dance school, where she explored ethnic and primitive dance. Her dance debut was in 1920. In 1923 she joined the Greenwich Village Follies and from 1924 taught dance, and began to choreograph. Her social and feminist conscience showed in her work, such as *Revolt* (1927). As a performer, Graham was intense, graceful, and dramatic. In 1929 she founded her own school and company; the members were all women, until 1938. She has created a dance form which is disciplined, but radically different from classical ballet – the spine is flexible, movement comes from the solar plexus, gravity is an ally, "floorwork" is important, and the "contraction" of the body, in and back, at the solar plexus, is a basic element. Graham's technique is taught widely, and companies like the London Contemporary Dance Company are based on it. In content, Graham has explored myth, ethnic and ancient dance, but with vigor and certainty, as in *Appalachian Spring* (1944), *Cave of the Heart* (1946), and *Clytemnestra* (1958). The fusion of dance and design, and three-dimensional sets, is integral in her work. She has used Japanese mime and Absurd themes – *Lucifer* (1975), *Phaedra's Dream* (1983).

Grass, Günter 1927–

German writer. A member of Hitler Youth, and a prisoner of war, Grass took various jobs before studying art in Düsseldorf and Berlin. In 1956 he moved to Paris. *The Tin Drum* (1959), an attack on Nazism, affronted many with its obscenity, and despite its intractability, was internationally acclaimed. It was the first of a trilogy exposing Hitler's grip on ordinary people. Unpopular with the right, he wrote speeches for Willy Brandt and proselytized for the Social Democrats. *The Flounder* (1977) is arguably his masterpiece. Seen as "the nation's conscience", Grass calls himself rather "the court jester".

Gris, Juan (Victoriano Gonzalès) 1887–1927

Spanish painter. After studying at the Madrid School of Industrial and Applied Arts, he worked as a caricaturist, moving in 1906 to Paris where he met Picasso and other avant-garde artists. In 1911 he began to paint seriously, using an analytical Cubist style in works like *Oil Lamp* (1912). His work was characterized by an austere clarity of line, and blocks of luminous color; he soon began to use collage, moving into Synthetic Cubism, of which he was the foremost proponent; in 1912, under contract to Kahnweiler, he exhibited with the *Section d'Or*. During World War I he was supported financially by his friend Matisse. He also designed for Diaghilev and illustrated books. During the 1920s, becoming increasingly ill, his style softened, with more curves and muted colors. Gris was a brilliant and articulate theorist, writing works like *L'Esprit Nouveau* (1921), with a deep understanding of Synthetic Cubism; rather than analyzing representational form, he applied the principles of Cubism to create a harmonious structure.

Gropius, Walter 1883–1969

German architect. After studying architecture in Berlin and Munich, Gropius was assistant (1907–10) to Peter Behrens. He then set up a practice in Berlin, in 1911 designing, with Adolf Meyer, the Fagus shoe factory in Alfeld-an-der-Leine, an innovative structure using curtain-wall glass. This striking use of glass continued. In 1918, made head of Weimar Academy and School of Arts and Crafts, he made them into the Bauhaus. He propounded the essential unity of art and architecture, and designed the new Bauhaus in Dessau, perhaps his *chef d'oeuvre*, in 1925. He also wrote *Internationale Architektur* this year. Wishing to make well-designed housing universally available, Gropius went into prefabrication. In 1928 he resigned from the Bauhaus, and continued to design prefabricated housing and multistory blocks. He went in 1934 to England, where he produced a single-story school community center. In 1937 he became Professor of Architecture at Harvard University; in 1941 he developed a low-cost housing scheme in Pittsburgh, which generated his "Packaged House System". From 1945 he worked with his "Architects' Collaborative" designing, among other buildings, the US embassy in Athens.

Grosz, George 1893–1959

German painter. After studying art in Dresden and Berlin, Grosz worked as a caricaturist, using *Jugendstil* technique. He developed a powerful drawing style, incorporating Expressionism and Futurism, and, in collaboration with the Herzfelde (and Heartfield) brothers, produced series of prints attacking capitalism, like *Metropolis* (1917). In 1918 he moved to Berlin and cofounded Dadaism there;

▲ Walter Gropius

▲ Barbara Hepworth

▲ David Hockney

he produced drawings which violently attacked the Weimar Republic, like *Ecce Homo* (1920); he was often sued for the outrageousness of his work. In 1925 he joined the *Neue Sachlichkeit* movement. In 1933 he moved to New York, taught there, and produced more romantic pieces until World War II, when grim images returned. Grosz's sardonic work vibrates with anger and bitterness, and was cuttingly satirical.

Hemingway, Ernest 1899–1961
US writer. Invalided out of the wartime ambulance service aged 18, Hemingway returned to the USA as a reporter, soon becoming a foreign correspondent. He settled in Paris, and *The Sun Also Rises* (1926) and *A Farewell to Arms* (1929) secured his fame. He wrote four more novels, including *For Whom the Bell Tolls* (1940), and some superb short stories. In 1952 he won the Nobel Prize for Literature and the Pulitzer Fiction Prize. Despite his evident flaws – cardboard characters, a self-conscious and sentimental machismo barely concealing an anguished sensitivity – Hemingway's writing is without doubt great. His style is stark and resonant, and his descriptive passages outstanding, compulsively beautiful. He committed suicide.

Henze, Hans Werner 1926–
German composer. Henze began to compose around 1938; from 1946 to 1948, he studied counterpoint with Fortner; the success of his *Kammerkonzert* gained him a publishing contract. He worked in several opera houses; his *Piano Concerto* (1951) won the Schumann prize, and the radio opera *Ein Landarzt* won the 1953 Prix d'Italia. In 1953, Henze settled in Italy – his music acquired a new warmth and lyricism, and he continued to produce fine operas and orchestral works. *The Bassarids* (1965) had a libretto by Auden and Kallmann. *Das Floss der "Medusa"* (1968), a requiem for Guevara, shows his increasing preoccupation with the politics of the left; he worked with Edward Bond on the opera *We Come to the River* (1976), and all his later dramatic work is socialist in import. Henze's music is eclectic and highly organized, influenced by Stravinsky, Weill, and Berg, as well as Italian opera. His opera *Das Verratene Meer* (1990) based on Mishima's *The Sailor who Fell from Grace with the Sea*, received much adverse criticism.

Hepworth, Barbara 1903–75
British sculptor. Hepworth studied sculpture in London and Italy (1920–26), meeting Henry Moore, who was to be a close friend for 20 years. Working in a classical style, she exhibited first in 1928 with her first husband, the sculptor John Skeaping. In 1931 she produced *Pierced Form*, the first work in which she explored interior and exterior space by piercing. In 1933 she joined the Abstraction-Création group and Unit One; she was now developing space with the use of strings and of color. By 1935 her work was fully abstract. In 1944, inspired by the Cornish landscape she had made her home, she produced *The Wave*, a beautifully shaped hollow ovoid. The Greek landscape inspired her to such works as *Curved Form (Dolphin)* (1955). By now internationally known, she started bronze casting. In 1963 she made *Single Form* as the UN Dag Hammarskjold Memorial, in New York. Always moved by landscape, especially in relation to human figures, Hepworth, in the tradition of Brancusi, was a mistress of forms, organic and abstract, always making manifest a spiritual essence.

Hockney, David 1937–
British artist. In 1961, Hockney won the Royal College of Art Gold Medal, the Guinness Award for etching, and two other prizes; and, still a student, he won international success with his series of etchings "The Rake's Progress". With the resulting income he visited California, later his home, and, inspired by the light, painted many pictures of swimming pools. He has also lived and exhibited in Paris. In 1962 Hockney taught in England and at three US universities. In 1966 he designed *Ubu Roi*, at London's Royal Court theater; in 1978, he designed *The Magic Flute* at Glyndebourne. A brilliant draftsman, he has received many international awards. In his pursuit of simplicity and realism, his work has become more conventional.

Hopper, Edward 1882–1967
US painter. After studying under Robert Henri at the New York School of Art, Hopper visited Europe three times (1906–10), without absorbing any influence. He was a commercial artist until his first one-man show in 1920. His style did not change throughout his life, and epitomized, especially, small-town and rural America. He used dramatic but mellow lighting effects, and large, solid masses – see *House by the Railroad* (1925). His work also conveys a sense of human loneliness, as in *Nighthawks* (1942), in which the figures seemed as estranged from one another as from the architecture that dwarfs them.

Hundertwasser (Stowasser), Fritz 1928–
Austrian painter. He traveled extensively in Europe and N. Africa before settling in Rome in 1957. By 1952, when he had a one-man show in Vienna, he had evolved the abstract decorative style he is known for, using vivid, luminescent colors including gold and silver – see *The Hokkaido Steamer* (1961) – and from 1953 using spirals extensively in his, mostly watercolor, work. His major influences are Klimt and Schiele. In 1959 he became a visiting lecturer at Hamburg Art College. He lives in Normandy, Venice and Vienna.

James, Henry 1843–1916
US British writer. James, son of a philosopher, and brother of the philosopher/psychologist William, settled in 1876 in London. His work can be divided into three periods: 1876–79, dealing with personal tragedies arising from the US-European culture clash; works include *The Europeans* (1878); explorations of feminist issues in *The Bostonians* (1886–99), and inter-generation conflict in *The Awkward Age* (1899); *The Golden Bowl* (1904) has a much more elaborate style and complicated webs of relationships which govern and dwarf the action. James consistent suspension of moral judgement aroused controversy; he was famed, and respected also, as an extraordinary and masterful prose stylist, with long, finely-balanced sentence structure.

Janáček, Leoš 1854–1928
Czech composer. A choirboy from 1864, Janáček became choirmaster in 1870, when he began to play the piano and compose. He went to teacher training college, and Prague Organ School (1874–75). In 1881 he married and became director of Brno music school. His first published work, in 1886, was choral. He wrote his first opera, *Šarka*, based on a story in Czech folk-mythology, in 1887. Janáček used nature, mythic and folk tales, and speech rhythms, in his music – as in the opera *Jenůfa*, completed in 1903, the year his last surviving child died. In 1904 Janáček became director of the Brno Organ School. Following the theory he had formulated of speech-rhythms as music he continued to compose especially choral and operatic works. He usually wrote his own libretti. His finest period was 1916–28; the superb *Katya Kabanova* (1921), *The Cunning Little Vixen* (1923), and the powerfully religious *Glagolitic Mass* (1926), exemplify the flowering of this work. Janáček, like Smetana before him, was a Czech nationalist; he intended his *Sinfonietta* "to cleave to the simple Czech soul".

Johns, Jasper 1930–
US painter. After a university course and army service, Johns established himself as a mature artist with a series of works using familiar images: flags, numerals, and letters. In 1959, the year after his first one-man show, he met Duchamp, who, along with Wittgenstein, was a major influence; he started to add the names of colors, painted in other colors, to his work; Johns' subject was the technique he used, and the nature of art. In 1961 he produced the bronze *Beer Cans*, exact copies with painted labels, and began to fix found objects to his canvases. In 1966 he became artistic advisor to the Merce Cunningham Dance Company. He also began to paint large abstracts. Johns' work became more personal in feeling in the 1970s, but he remained the person who said "I don't know anything about art."

James Joyce

Franz Kafka

Yasunari Kawabata

Johnson, Philip 1906–

US architect. In 1932 Johnson co-wrote *The International Style: Architecture since 1922*, which defined modern architecture. He trained as an architect in the early 1940s, and achieved fame through the *Glass House* he made for himself in 1949; it showed the influence of Mies van der Rohe, with whom he collaborated on the Seagram Building, New York (1958); this style climaxed in the 1980 *Crystal Cathedral* in Los Angeles, and spawned a host of imitators. Johnson also produced more moderate works, with a neoclassical bent, and usually harmonizing with the landscape. They include the Sheldon Art Gallery (1962), and the superb New York Theater (1964). Johnson's interiors are usually impressive, with relatively dull exteriors.

Joyce, James 1882–1941

Irish novelist. A Dublin University graduate, Joyce, with his wife Nora Barnacle, fled the circumscription he felt in Ireland in 1904 to Trieste, where he wrote the *Dubliners* stories. In 1916 he produced the autobiographical *Portrait of the Artist as a Young Man*. He moved to Paris in 1920. His great stream-of-consciousness novel *Ulysses* initially appeared chapter by chapter in a magazine. Published in 1922, it was banned in many countries for obscenity, and copies were seized and destroyed. In 1939, the year before Joyce's move to Zurich, *Finnegan's Wake*, a vast iconoclastic, inaccessible, poetic dream-piece, devastated the literary establishment. He drew heavily on myth, using Wagnerian themes, images, and scope; his treatment of form and linguistic innovations have revolutionized language and changed the face of literature.

Kafka, Franz 1883–1924

Czech-Jewish-born German-language novelist. A law graduate, Kafka worked in accident prevention and in his domineering father's shop – he had to write at night, producing short magazine pieces. In his most famous work, *Metamorphosis* (1912), he treats the theme of the impossibility of communication, represented by Gregor Samsa's own difficulties after his "metamorphosis" into a giant insect. In 1917, after TB was diagnosed, Kafka told his friend, Max Brod, to burn his unpublished work. Brod disobeyed, and the great unfinished novels, *The Trial* (1914–15) and *The Castle* (1922), were preserved, both of which develop further the theme of *Metamorphosis* – the "protagonist" (K) is at once driven and opposed in his actions by omnipresent and inscrutable forces, with whom he cannot adequately communicate, a projection, perhaps, of his relationship with his father. Kafka's intellectual honesty and anguished moral concern shed light on the human landscape in works of unparalleled lucidity and profoundly direct insight.

Kandinsky, Wassily 1866–1944

Russian painter. In 1896, abandoning a career in law, he went to art school in Munich. In 1901 he founded the Phalanx group. He traveled widely, often exhibiting in Paris, and experimented technically, often painting on dark paper; he used line both as content and to contain colored areas. In 1912, with Franz Marc, he formed *Der Blaue Reiter*. He became interested in Theosophy and wrote *On the Spiritual in Art*, advocating the use of color as emotional language. Disillusioned with the potential for change in post-revolutionary Russia, in 1921 he returned to Germany and taught philosophy of form at the Bauhaus. In 1924 Kandinsky, Jawlensky, Feininger and Klee were the "Blue Four", exhibiting together. 1926 saw the publication of his *Point and Line to Plane*. In 1933 the Nazis closed the Bauhaus, and Kandinsky went to Paris; impressed by Miró and Arp, he developed softer, biomorphic forms in his work – *Et Encore* (1940). The driving force of Kandinsky's always lively work was the search for life implicit in pure form.

Kawabata, Yasunari 1899–1972

Japanese writer. Kawabata graduated in 1924 from Tokyo University. Influenced by the European avant-garde, he co-founded the journal "The Artistic Age", opposing the leftwing Realist movement. Fame came with his story "The Izu Dancer" (1926). His work falls into four periods, named after the localities of his settings: the "Izu period", the "Asakusa period", the "Snow-country" (prewar) period, and the "Kamakura period". In 1968 he became the first Japanese to win the Nobel Prize for Literature. *Snow Country* (1947), his finest novel, deals, characteristically, with loneliness and love's impossibility. Its action is interior. Kawabata's lyricism is in the Japanese mainstream – a certain disjointedness in his work, sometimes imputed to a Surrealist tendency, also resembles Japanese medieval verse, *renga*.

Kazantzakis, Nikos 1883–1957

Greek writer. In 1906, studying law in Athens, Kazantzakis was already writing plays and translating philosophy, which he studied in Paris. He campaigned for the adoption of demotic (everyday) Greek as the official language, and was always politically active. He traveled, and wrote, between 1920 and 1940. In 1938 he produced the 33,333-line epic poem *Odyssey*, a towering 20th-century work. *Zorba* (1941), depicts the Apollo-Dionysus conflict. In 1942 he settled in the south of France. The best-known of the six novels he wrote there, *Christ Recrucified* (1954), consolidated the international fame *Zorba* had brought. It also deals with the light of God, the abyss, and humanity. Kazantzakis was very prolific, producing many Biblical and other verse plays, travelogs, and translations.

Kirchner, Ernst 1880–1938

German painter. Kirchner studied architecture, and then, at art school in Munich, absorbed *Jugendstil*. He produced stronger work, influenced by the Post-Impressionists, after 1905, when he cofounded the *Die Brücke* group: *Self-portrait with Model* (1910) is typical. He moved in 1911 with other *Brücke* members to Berlin, leading a bohemian life. His angular, tense urban paintings of this period, like *The Street* (1913) are superb. In 1913 he criticized other members in the "Brücke Chronik" – and the group broke up. Kirchner became increasingly hostile, and in 1916, while serving in the army, he had a nervous breakdown. During his convalescence in Switzerland his work was calmer, but 1922 saw a return of his nervous dynamism. In 1926 he painted a nostalgic group portrait of *Die Brücke*, including himself. Harassed, like many others, by the Nazis from 1933, he finally killed himself.

Klee, Paul 1879–1940

Swiss painter. Born to musician parents, Klee was a poet and professional violinist before studying art in Munich (1898–1900) under Franz von Stück. After touring Italy, Klee did a series of grotesque etchings, influenced by Blake and Goya. In 1906 he encountered the Impressionists and Post-Impressionists, and began to work from nature. 1911 saw his first one-man show, and meeting with Marc and Kandinsky. In 1912 he exhibited with *Der Blaue Reiter*. In 1914, visiting Tunisia, he dedicated himself to painting, writing: "Color and I are one". Influenced by Delaunay, he turned to Cubism, but always depicted Nature. In 1920 he taught theory of form at the Bauhaus, and wrote his *Pedagogical Sketchbook* (1925). He exhibited as one of the "Blue Four" (1924). The Surrealists admired paintings like *Fish Magic* (1925); Klee admired, but never embraced Surrealism. In 1933 the Nazis closed the Bauhaus, and Klee returned to Switzerland; in 1935 he contracted skin cancer; he painted as prolifically as ever, producing an extraordinary 2,000 works in 1939. Klee's work combined sensitive, childlike images with a sophisticated style and maturity of vision; he saw the artist as a part of Nature, not its observer, and believed that one must attune oneself to Nature, and "be newborn". "Art", he said, "does not reproduce the visible, but makes visible".

Klimt, Gustav 1862–1918

Austrian painter. Klimt attended the Vienna School of Decorative Arts from 1876 to 1883. He was a *Jugendstil* painter; in 1894 he was commissioned to paint a ceiling at Vienna University, featuring *Philosophy, Medicine* and *Jurisprudence* (1899–1907). In 1897 he became president of the Vienna Secession. The impact on him of the Byzantine mosaics he saw at Ravenna in 1903 was evident in his subsequent work,

Le Corbusier

Fernand Léger

Roy Lichtenstein

including the *Beethoven-frieze* (1902), and the huge mosaic frieze he made at the *Palais Stoclet* in Brussels (1905–11). His later work contained powerful erotic imagery – *The Kiss* (1908), for example. Klimt's work combined luminosity of coloring, strong emotional force, and fine draftsmanship.

Laban, Rudolf 1879–1958

Hungarian dance theorist. Laban moved from painting to the study of dance. In 1915 he set up the Choreographic Insitute in Zurich. In 1928 he perfected *Kinetographie Laban*, now called Labanotation, a system for recording all human movement. In 1930 he became director of Berlin Allied State Theaters. In 1938, with two ex-pupils, he went to Dartington School in England. He remained in England, teaching, and researching industrial efficiency. His theories influenced Central Europeans, like Kurt Jooss, and paved the way for dance Expressionism. Laban advocated the use of "choreography" to increase the efficiency and safety of factory workers.

Lawrence, David Herbert 1885–1930

British writer. Lawrence, son of a violent-tempered miner and a bourgeois mother, taught from 1902, and attended Nottingham University. He left teaching on the publication of *The White Peacock* (1911) and in 1912 eloped with Frieda Weekley, wife of one of his teachers. *Sons and Lovers* (1913), an exorcism of his childhood, shocked the public with its sexual frankness and its grip on the nettle of class. *The Rainbow* (1915), a story of young woman's self-development against the background of provincial society, was suppressed as immoral after World War I, yet it and *Women in Love* (1922) are his two greatest novels. The Lawrences entered a nomadic exile, living in Italy, Australia and Mexico. He wrote nearly a thousand poems, as well as essays, short stories and travel-writing. Penguin publishers were taken to court in 1960 on account of his last book *Lady Chatterley's Lover* (1928), a tale of passion across class barriers. It was innovative in its sexual explicitness, in the lovers' dialog, but marred by a characteristic flaw of Lawrence's fiction: a tendency for the author to intrude, expounding a "doctrine" (Birkin in *Women in Love* is just such a "self-portrait"). However, Lawrence is an unquestionably great figure; his expression of the human "life-force" is equalled by few. He died of TB in the south of France.

Le Corbusier (Charles Jeanneret) 1887–1965

Swiss architect. After art college, Jeanneret worked briefly with several great architects, including Berlin's Peter Behrens. Touring Europe in 1911, he was enormously impressed by Greek and Turkish architecture. In 1914 he produced the steel-framed concrete Domino Housing Project. He went to Paris in 1908, where he joined the Atelier of Perret;

from 1911 he traveled extensively, until, in 1917, he returned to Paris, where he began work with a building company specializing in the use of reinforced concrete. He adopted the name "Le Corbusier" in 1920 as a pseudonym when writing for *L'Esprit Nouveau*, the magazine he cofounded. In 1922 he went into partnership with his cousin in Paris. His 1922 design, for the Palace of the League of Nations, was ultimately rejected. Le Corbusier's *Vers un Architecture* (1923) remains the most influential book written by any 20th-century architect. The block of flats designed in postwar Marseilles (*Unité d'Habitation*) prefigured his project, completed 1951, of designing virtually the whole of Chandigarh, new capital of the Punjab. Le Corbusier called a home "a machine for living in". His influence was universal, although unfortunately, through the work of many lesser architects, has resulted in today's ubiquitous barren concrete cityscapes.

Léger, Fernand 1881–1955

French painter. Léger studied architecture, and later painting, at various Paris art schools. He was deeply affected by the 1907 Cézanne Retrospective. With *Nudes in a Forest* (1909), he began to explore Cubism, using cylindrical, not flat, forms. He exhibited in 1911–12 with the *Section d'Or*. In 1913, he began to produce abstract works, called *Contrasts of Forms*. *The City* (1919) shows his awareness of machine forms, developed during the World War I, and his wish to reconcile them with life; in its depiction of the workers who build and maintain the city, it also reflects Léger's passionate Socialism. He was influenced by *de Stijl* and Surrealism; he also designed for ballet, worked as an illustrator, and, in 1924 made a film, *Ballet Mécanique*. In 1933 his first murals were shown in Paris. From 1940 to 1945 he was a professor at Yale University. He then joined the Communist party, attending two Peace Conferences. He intended his art to be accessible to all, in its simplicity and clarity of form and color.

Lichtenstein, Roy 1923–

US artist. In 1949, after studying art, he had his first one-man show. He worked as a commercial artist until 1957, when he took a teaching post in New York. He was producing Abstract Expressionist work, until in 1961 becoming a leading Pop artist, producing, most notably, blown-up copies of strip cartoon images, like *Whaam!* (1963). In 1962 his was the first Pop one-man show. He also produced ceramics and enamelwork, and from 1977, bronze sculptures also using dots and the same Pop images of the consumer society. He also imitated Art, as in *Artist's Studio: The Dance* (1947), a Cubistic still life including Matisse's *The Dance*. Lichtenstein's work holds its subjects up for reassessment; it does not presume to assess.

Ligeti, György 1923–

Hungarian composer. After studying composition in Kolozsvàr (1941–43), and postwar, at the Budapest Academy, Ligeti became a professor at the Academy in 1950. Under the Communist régime, Ligeti was unable to work as experimentally as he wished, or to publish or perform his innovative material. In 1956 he escaped to Vienna, where he worked in electronic music, with Stockhausen and Boulez. The orchestral *Atmosphères* (1961) brought recognition, and fame came with *Requiem* (1965). He produced humorous work, like *Trois Bagatelles* (1961), satirizing Cage. *Lux Aeterna* (1966), is a choral work, famous for its being used in *2001: A Space Odyssey*, developing further the tonal experiments of the *Requiem*. Ligeti's work is characterized especially by "micropolyphony" – numerous interweaving melodic lines often causing aural illusions – and by an impressionistic approach to harmony and orchestral color.

Loos, Adolf 1870–1933

Austrian architect. Loos studied architecture, then, after three years in the USA, returned to Vienna and worked as a journalist, commenting on architecture and fashion. Two essays of his, *Ornament and Crime* (1908), and *Architecture* (1910) influenced the Modern Movement, and it is this for which he is important. He denounced decoration, the Secession movement, the Wiener Werkstätte, and the Bauhaus, and proposed a return to Classicism. His 1910 Steiner House is the first example of a simple cube building. From 1920 to 1922 he was Chief Architect of the Housing Estates Movement. From then until 1928 he lived in Paris. Later in his life he mitigated his earlier austerity, feeling that it had been too extreme.

Lorca, F. García 1898–1936

Spanish poet and playwright. Lorca, also a painter and a musician, briefly studied law at Granada University. In 1921 his "folk-style" *Book of Poems* appeared. *Romancero Gitano* (1928) brought massive popularity. Lorca visited New York, and empathized with black Americans. His trilogy of "folk tragedies", *Blood Wedding*, *Yerma*, and *The House of Bernarda Alba* (1933–36), crowned his dramatic achievement. Lorca's writing deals always with the magnetic, dark, natural forces, the "*duende*", and the ethos of Andalusia. He used songs, children's games and Surreal devices in his drama – he influenced Miller, O'Neill, and Williams. His poetry was written for speech – he called the poet "teacher of the five body senses". He was also a painter, friend of Dalí, and musician, collector of folk songs and friend of Falla. Social comment, as in *Mariana Pineda* (1925) gave him a leftwing reputation, and it was perhaps for this, and for his homosexuality, that Francoist soldiers shot him.

Gustav Mahler

Thomas Mann

Katherine Mansfield

Machado, Antonio 1875–1939

Spanish poet. A Madrid University graduate, Machado produced his first volume, *Solitudes*, in 1903. He then taught French; tragedy hit him with the death in 1912 of his 19-year-old wife; he returned to his native Andalusia. The 1915 edition of *Campos de Castillo* includes poems of the desolation of widowhood – he identified Castille with his wife. Machado had a strong feeling for the landscape as the soul of a Spain he wished to see great again. He was, with Lorca, one of the greatest modern Spanish poets.

Mackintosh, Charles R. 1868–1928

British architect and designer. After studying architecture, and apprenticeship, Mackintosh met Herbert MacNair, Frances and Margaret MacDonald. Known as "the Four", they originated Art Nouveau in Glasgow. Mackintosh regarded architecture and design as one, and the Glasgow School of Art (1897–1909) is an elegant monument. In 1900 his designs were exhibited in the Vienna Secession; Hill House, Glasgow (1902), is another fine example of his work; however, in England, where he lived from 1914 to 1923, such fame eluded him, and he could not establish a practice. He moved to France, where he painted fine landscapes, but was forced by illness to return to London in 1928.

Magritte, René 1898–1967

Belgian painter. Magritte studied fine art in Brussels (1916–18). From 1920 to 1924 he produced work influenced by Cubism and Futurism but in 1925, after de Chirico's *Le Chant d'Amour*, subject matter became vitally important, and he became a Surrealist. 1927 saw his first one-man show, in Brussels; he then lived in Paris, and from 1928 to 1930 used words in his work, exploring word-object relationships. In 1929 he visited Dalí, with whom he shared an intense clarity of execution; but his paintings shocked by incongruity of subject matter, and implied but never expressed intensity of feeling. *The Human Condition* (1933) dealt with the split consciousness humans create by "recreating" the world they are part of. In 1938 Magritte had work in the International Surrealist Exhibition in Paris. He then took on Impressionism (1943–46), and in 1947–48 worked in a violent, grotesque style, before reverting to his previous calm. He was commissioned in the 1950s and 1960s to do many murals. Magritte strongly influenced the Pop artists.

Mahler, Gustav 1860–1911

Bohemian-Jewish-born Austrian composer and conductor. Mahler learned the piano aged six, and aged ten gave his first recital. In 1875 he entered the Vienna Conservatory, where he met Anton Bruckner, whose music he later championed. After leaving the Conservatory in 1878 he wrote the cantata *Das Klagende Lied* (1880), achieving an original sound-world from the beginning. He began a period (1881–91) conducting at Cassel, Prague, Leipzig and Budapest, until he became a chief conductor in Hamburg, where he met the conductor Hans von Bülow. It was at Bülow's funeral that Mahler was inspired to use Klopstock's ode *Resurrection* in the finale of his *Second Symphony* (1888–94). In 1897 he was appointed director of the Vienna Opera, a post he held until 1907, when he went to New York as the conductor of the Metropolitan Opera, until his death from a streptococcal blood infection. His works consist of ten symphonies (the *Tenth* left unfinished) and a sequence of song-cycles, of which *Das Lied von der Erde* (1907–09), a setting of Chinese poems, is the finest. In the greatest of his symphonies – the *Sixth* (1903–05) and *Ninth* (1909–10) – passion and poetry are balanced by a concise and chiseled structure. His music, though championed by Schoenberg, Zemlinsky and Webern among others, suffered neglect after his death until the 1960s when it began the climb to its present level of popularity. Nevertheless, his influence has been profound.

Malevich, Kasimir 1878–1935

Russian painter. Malevich's early work, after studying at a Moscow art school, was Post-Impressionist in style. In 1907, influenced by Matisse, he adopted a vivid, primitive style. He then absorbed influences from the European avant-garde, approaching Synthetic Cubism in *The Knife Grinder* (1912). In 1913 he designed for the Moscow Opera; he began to use black squares, in design, and in paintings, like *Black Square* (1915). He was soon producing paintings dealing purely with the play of force and mass; he believed that *any* image blocked the communication of sensation, and he did not predicate a "spiritual essence". This work reached its ultimate in *White Square on a White Background* (1918). This genre was called Suprematism, and was exhibited in Moscow in 1919. Malevich then taught with Chagall at Vitebsk; he formed the *Unovi's* group, and quarreled with Chagall, who left. Malevich did not paint again until 1930, but, with *Unovi's*, looked for ideal architecture models ("planity"). His book *The Non-Objective World*, published in 1927 by the Bauhaus, was an important influence on Bauhaus work. Malevich's later paintings were figurative, but primitive, using simple shapes.

Mandelstam, Osip 1891–1938

Russian poet. Mandelstam, a cofounder of Acmeism, aiming at precision and concreteness, and looking back to Hellenism as the supreme cultural expression, produced his first volume of poetry, *Stone*, in 1913. *Tristia* (1922), made him famous; he wrote only prose from 1926, and in 1929 was sent away, and became a provincial journalist. In 1934 he was exiled for writing satirical verses on Stalin, and in 1937 was sent to a labor camp, where he died. His melancholy poetry, using classical underworld and other motifs, addressed the problem of the vulnerability of culture against chaotic forces. It was banned for over 30 years in the Soviet Union.

Mann, Thomas 1875–1955

German novelist. Living in Munich from his father's death in 1891, Mann wrote critical and philosophical essays, but achieved the status of classic writer with his novels, the first of which, *Buddenbrooks* (1901), brought instant success. The elegant *Death in Venice* (1911), on the Apollo-Dionysius conflict, and *The Magic Mountain* (1924), using a Swiss sanatorium as an analog of a Europe menaced by German folly, followed, and he won the 1929 Nobel Prize. He fled Germany in 1933, and took refuge in Switzerland, where he wrote the trilogy *Joseph and his Brothers*, emigrating in 1938 to the USA, where he examined the Third Reich in *Dr Faustus* (1947); in 1952 he returned to Switzerland. His writing pointed to the historical responsibility borne by each human being, the imperative of full consciousness.

Mansfield, Katherine 1888–1923

New Zealand short-story writer. Mansfield went to London in 1903 to study music, and never settled again in New Zealand. A fine collection, *In a German Pension*, appeared in 1911, the year she encountered the Bloomsbury group. In 1915, with her husband-to-be, John Middleton Murry, and D.H. Lawrence, she produced the magazine *The Signature*. The awful trauma of her brother's death that year sharpened her sense of nationality and her desire to put New Zealand on the literary map. The novella *The Prelude* illustrates this. Struck in 1917 by TB, she traveled Europe in search of a cure. Two more collections, *Bliss* (1920) and *The Garden Party* (1922), secured her reputation as a master of the form, writing delicate, subtle, stories, revealing depth of experience through the surfaces of ordinary lives.

Matisse, Henri 1869–1954

French painter. In 1890 Matisse left a career in law to study painting in Paris. In 1896 the State bought one of his works from an exhibition at the *Société Nationale des Beaux-Arts* in Paris. In 1897 he became interested in Impressionism, and met Pissarro. He studied sculpture from 1899. In 1904 he had his first one-man show. In 1905, he painted *Luxe, Calme et Volupté*, increasing the simplicity of his forms; and on his annual summer visit to the South of France to paint, he began to work with Derain, and with him and other friends, exhibited at the Salon d'Automne, earning the name *Fauvistes*. *Joie de vivre* (1905–6) is Matisse's finest nude. During the next few years he traveled throughout Europe and North Africa, and had

▲ Henri Matisse

▲ Arthur Miller

▲ Amedeo Modigliani

exhibitions in Europe and the USA. In 1919 Matisse designed for Diaghilev, but returned to sculpture and painting. An invalid in his last years, Matisse continued to work with the help of assistants, using colored paper cut-outs. *The Snail* (1953) is an example of this work. Matisse believed painting should restore balance and well-being; he has been criticized for excluding dark and disturbing subject-matter.

Mayakovsky, Vladimir 1893–1930
Russian poet. Briefly an art student, Mayakovsky was imprisoned in his teens for his Bolshevik activism. He wrote poetry from 1912; his first publications *I* (1913), and *V. Mayakovsky* (1914) are self-centered and set out to shock. After the revolution, now a prominent Futurist, he did Bolshevik propaganda work at home and abroad. From 1923 to 1928, he edited the Journal *Lef*; his move to functionalism made him increasingly unpopular with the literary mainstream, though he still wrote lyrically. His best play, *The Bedbug* (1929) satirized the stifling boredom of the everyday. He committed suicide.

Mendelsohn, Erich 1887–1953
German architect. An Expressionist, Mendelsohn produced curving, quasi-organic buildings, like the *Einstein Tower* at Potsdam (1921). He produced numerous factories and stores, before fleeing the Nazis in 1933; he settled in Britain and, with Chermayeff, designed Bexhill's *De La Warr Pavilion* (1934). He moved in 1934 to Palestine, where he designed several hospitals, and in 1941 to the USA. His energetic, sculptural, horizontally focused work can be seen in synagogues there and in the Maimonides Hospital, San Francisco (1946).

Messiaen, Olivier 1908–
French composer. Messiaen began to compose at seven. In 1919 he entered the Paris Conservatoire, where he won all major prizes. On leaving in 1930, he became principal organist at La Trinité, Paris. In 1936 he began to teach, and was one of a group, *La Jeune France*, dedicated to restoring seriousness to French music. As a prisoner-of-war he wrote *Quartet for the End of Time* (1941). His *Turangalîla-symphonie* (1946–48) is based on the legend of Tristan and Isolde. After the war, he became professor of harmony at the Paris Conservatoire, and in 1966, professor of composition – he has taught many celebrated musicians, including Boulez, Stockhausen, Xenakis and George Benjamin. Always interested in birdsong, in 1953, with *Réveil des Oiseaux*, he began to transcribe it; Messiaen's rhythmic innovations draw on this and Ancient Greek and Hindu rhythms, and the work of Stravinsky and Debussy. He developed his own modes and wrote the first total serial work, the *Mode de valeurs et d'intensités* (1949).

Mies van der Rohe, Ludwig 1886–1969
German/US architect. Apprenticed as a stonecutter (1900–02), he later (1908) worked for Behrens; in 1911 he set up a practice. From 1920 he undertook ambitious skyscraper schemes, using the motto "Less is more" in producing good-quality, cheap mass housing. He designed the German Pavilion for the 1929 Barcelona World Exhibition, a modular, largely transparent piece. Director of the Bauhaus (1930–33), in 1937 he went to the USA and became director of architecture at the Illinois Institute of Technology (IIT). His designs included several IIT buildings, apartment blocks, the Seagram Building in New York, and the National Gallery in Berlin. He used simple forms, believing that as a building's use was liable to change, beauty was the priority in architecture.

Miller, Arthur 1915–
US playwright. His early experience of the Depression engendered in Miller an understanding of poverty, and a compassion that pervades all of his work. *All My Sons* (1947), an Ibsenesque drama, and the Pulitzer-prizewinning *Death of a Salesman* (1949) brought him fame. *The Crucible* (1953) compared McCarthyism to the Salem witchhunts. *The Misfits* (1961) was his screenplay for the last film of Marilyn Monroe, his marriage with whom is portrayed in *After the Fall* (1964). Whereas Miller's early plays examine individuals in the context of a harsh society, later plays, like this one and *The Prince* (1968) deal with intimate relationships.

Miró, Joán 1893–1983
Spanish painter. He studied at Gáli's School of Art in Barcelona (1912–15), after a nervous breakdown. He absorbed many influences, including those of Cubism and Fauvism. In 1918 he had his first one-man show. In 1919, he became friendly with Picasso, and moved to Paris in 1920, meeting Dadaists and Surrealists. As his style developed, his work became very detailed and "fantastic". He joined the Surrealists in 1924, and painted the near-abstract "dream paintings" (1925–27). With Ernst, in 1926, he designed for Diaghilev. Influenced by Vermeer, in 1928 he painted his detailed "Dutch Interiors". Paintings like *Seated Woman* (1932) show his distress at the rise of Fascism. In 1940–41 he painted the series *Constellations*. 1947 saw his first US visit, though his work had been shown in New York in 1930. He produced only ceramic work from 1955 to 1959, notably a wall design for UNESCO in Paris. He started to sculpt in the 1960s.

Modigliani, Amedeo 1884–1920
Italian artist. Modigliani studied painting in Rome, Florence, and Venice. He settled in Paris in 1906, met other painters, taking in Fauvism, Expressionism and Cubism, and adopted a

dissolute, drug-ridden lifestyle which hastened his death. He was deeply affected by the 1907 Cézanne Retrospective. In 1909 Brancusi, introduced to him by a patron, inspired him to sculpt. In 1911 he produced a series of stylized *Caryatids*, paintings influenced by the primitive sculpture he admired. These features became central to his work. From 1916 to 1920 he produced his most powerful work, including portraits of Gris (1915) and Cocteau (1916). Modigliani was influenced by Cubism, but was atypical, using graceful, elongated lines in his figures, strongly reminiscent of Botticelli.

Moholy-Nagy, László 1895–1946
Hungarian artist, designer and theorist. Moholy-Nagy, an ex-law student wounded in the Great War, co-founded the MA (="today") group in 1917, and from the following year devoted himself to art. Influenced by Malevich, he used circles, crosses and squares; and in 1922 he produced his first "photograms", images resulting from the exposure to light of photographic paper with objects placed on it. After his first one-man show, Gropius invited him to teach at the Bauhaus, which he did from 1923 to 1928. After a time in Amsterdam, Moholy-Nagy went to London, where he worked on posters, books and films, with a Constructivist group, and developed Space Modulators – arrangements of plexiglass and metal producing fascinating lighting effects when in motion. From 1937 he lived in the USA, first directing the New Bauhaus in Chicago, then opening his own design school. His last book, *Vision and Motion*, was published posthumously. Moholy-Nagy is less important for the quality and stature of his work, more for the impact he had on others; he was a forerunner of Pop, as well as other postwar movements.

Mondrian, Piet 1872–1944
Dutch painter. Mondrian came from a Calvinist background. His early works were quiet, dim, landscapes, which become brighter, as in *The Red Tree* (1908), a Fauvist work. In 1909, he took up Theosophy; he turned to Symbolism, then Cubism, but sought more extreme abstraction. From 1913 he moved away from the use of perspective, into compositions, monochrome and color, using lines and rectangles. In 1915 he cofounded *de Stijl*, asserting that natural forms hid "reality". He reduced his technique even further in the 1920s, in Paris, and broke with van Doesburg (*de Stijl*) in 1925 because the latter used diagonals. Mondrian believed that the right angle represented the fundamental polarity of existence, and contained all other relationships. In 1938 he moved to London, and in 1940 to New York, a city he loved for its lines and its jazz music, where he produced some of his finest work, like *Broadway Boogie-Woogie* (1943). His first one-man show was held there in 1942.

▼ Claude Monet

▼ Eugenio Montale

▼ Pablo Neruda

Monet, Claude 1840–1926

French painter. In 1856 Monet, already a good caricaturist, met Boudin, and began landscape painting. In the next few years he met Pissarro and Jongkind, and from 1862–64 studied art in Paris, and became friends with Renoir. He had his first show in 1865. His constant aim was to find more effective ways of representing light and color. *Impression: Sunrise* (1874), which gave the Impressionists their title, was one of a series of small landscapes; most of Monet's work was more fully executed. In 1883 Monet moved to Germany, and, ever more sensitive to changes in light, had to finish his paintings in the studio. *Haystacks* (1890–91) are fifteen paintings in exploration of light changes. From 1900 he produced his celebrated paintings of water-lilies and trees, culminating in 1914 in a set of huge canvases for the Paris *Orangerie*.

Montale, Eugenio 1896–1981

Italian writer. Montale turned to writing after World War I blocked his singing career. His first book of poetry, *Cuttlefish Bones* (1925), is a powerful expression of his deep pessimism – he was opposed to Fascism. After working for a publisher, Montale became director of Florence's Gabinetto Vieusseux Library, dismissed in 1938 by the Fascists. *The Occasions* (1939), is esoterically allusive, as is *Land's End* (1943). As literary editor of the newspaper *Corriere della sera* from 1948, he began to publish his short stories in it, releasing a collection, *The Butterfly of Dinard*, in 1956. In 1966 he published *Auto da Fé*, a critical work, and the superb and poignant *Xenia*, poems in memory of his dead wife. Montale became more prolific in old age, producing volumes of poetry, criticism, stories, and excellent translations from English. Montale changed the face of Italian poetry, and won many awards, including the 1975 Nobel Prize for Literature.

Moore, Henry 1898–1986

British sculptor. Moore studied art in Leeds and at London's Royal College (RCA). His *Mother and Child* (1924–25), like all his work, show the influence of primitive art. He taught at the RCA (1926–31), had his first one-man show in 1928, and then taught at Chelsea School of Art (1931–39). He explored Surrealism, in work like *Composition* (1931), and was a founder member of the English Surrealist Group. From then on, he worked mainly on the human figure. As a war artist (1940–42), he made many drawings in the air-raid shelters. After the war, he exhibited and had public commissions worldwide, winning the 1948 Venice Biennale sculpture prize. In 1968 he started to produce more drawings and etchings. His masterpiece, *Reclining Figure* (1929), epitomizes his work, showing Mexican influence, and presenting the female figure as a landscape.

Moore, Marianne 1887–1972

US poet. After studying biology at Bryn Mawr, Moore taught shorthand, and worked as a teacher, then a librarian in New York from 1918 to 1925. In 1915, T. S. Eliot published several of her poems, and in 1921, unknown to her, a collection, *Poems*, appeared in England. *Observations* (1924) won the *Dial* award, and Moore became editor of *Dial* till it closed in 1929. Her *Collected Poems* appeared in 1951. Moore's poetry often uses remarkable animals to reflect, and later, to prescribe, ways of being human. Although didactic, it is quirky and appealing, often using quotations like collage. Her work developed from an early angry stance, to an "ethics of the appropriate".

Morris, Mark 1956–

US choreographer. Morris learnt folk dance and flamenco from the age of eight, then modern dance and ballet; he began choreographing around 1970. He danced with a Balkan dance ensemble, loving its community spirit and simplicity. In 1974 he studied flamenco in Madrid, returned to study ballet in New York, joined a company in 1976, but soon left, and toured Asia and Australasia. His own works were first performed in 1980 in Cunningham's studio. In 1981 he set up the Mark Morris Dance Group. His pieces reflect on the vagaries of love – *New Love Song Waltzes* (1982), violence – *Dogtown* (1983, with Yoko Ono's music), and his climactic solo *O Rangasayee* (1984), to an Indian raga, took audiences and critics by storm. He has also worked from literature, like Barthes' essays on semiotics, in *Mythologies* (1986). Morris' consummate skill and creativity has brought comparisons to Graham and Cunningham. In 1988 Morris took over the *Ballet du XXme Siècle*, in Brussels, from Béjart.

Motherwell, Robert 1915–

US painter. Motherwell won an art fellowship at eleven; but at Stanford University (1932–36) he became bored with the art department and switched to philosophy. In 1937 he studied esthetics at Harvard, and art history at Columbia, where he was encouraged to paint, and met European Surrealists, becoming interested in automatism. He spent time in Europe and exhibited there. A visit to Mexico in 1940 inspired works like *Little Spanish Prison*. Although he was one of the Abstract Expressionist group, Motherwell's work differed fundamentally from that of Rothko or Pollock. In 1943, with *Pancho Villa, Dead or Alive*, he turned to collage; in 1944, Peggy Guggenheim set up his first one-man show. His major work was the *Spanish Elegies* series (1947). In 1948 he and others set up a school for the discussion of abstraction in art. Motherwell believed that ethics must inform art; he has written many books, and is now included in all major US art exhibitions.

Munch, Edvard 1863–1944

Norwegian painter. One of Munch's first paintings, after he attended art school, was *The Sick Child* (1885), depicting his sister, who had died of TB, as had his mother, in Munch's teens. In 1885, he saw Impressionist paintings in Paris and was influenced by Van Gogh and Gauguin. The bleak and claustrophobic dramas of Strindberg also affected his work, and themes of dark sexual turbulence – *The Vampire* (1894), and *Puberty* (1895), and the self-portrait *In Hell* (1895) reflect his neurotic, tortured mental state, as does his best-known work *The Scream* (1893). His later work, like *Horse Team* (1919), or *Starry Night* (1924) could be as bright as that of Van Gogh. Munch was the major forerunner of Expressionism and controversy over his 1892 exhibition led to the Berlin Secession. Munch was also a fine portraitist.

Narayan, R.K. 1906–

Indian novelist. Son of a headmaster, and a teacher himself, Narayan found international acclaim with *Swami and his Friends* (1935), a novel about schoolboys, and through the patronage of Graham Greene. Narayan wrote over a dozen more novels, in elegant English, all social comedies set in the fictitious town of Malgudi. Often, as in *The Guide* (1958) he looks through the surface of Hinduism to a mystical center. *The Sweet Vendor* (1967), his best novel, centers on a man alienated and uprooted by his son's marriage to a non-Hindu. Narayan also wrote autobiography, essays, and produced modern versions of the *Ramayana* (1972) and the *Mahabharata* (1978).

Neruda, Pablo (Ricardo Reyes) 1904–73

Chilean poet. Neruda, who changed his name in 1920 to avoid embarrassing his father, started writing poetry in childhood, and was famous at 20, with three books published, including his most popular, *Twenty Love Poems and a Song of Despair* (1924). From 1927 he was Chilean ambassador in various Asian countries, where he wrote *Residencia en la Tierra* (1931). He moved in 1934 to Spain, where he founded a poetry magazine. In 1940 he went to Mexico, where Rivera's work influenced him, and he became a Communist. In 1945, back in Chile, he was made a senator; in 1948 he had to leave for eastern Europe. During this period he wrote the massive, superb *Canto General* (1950) an epic history of the Americas, including *Heights of Macchu Picchu*, on his own spiritual progress and political career. In 1952 he returned to Chile. He won the 1971 Nobel Prize.

Newman, Barnett 1905–70

US painter. Newman studied art (1922–26) in New York, then did graduate work at Cornell University. In the 1940s he began to paint huge canvases, often of only one, luminous, color, the variety coming from brushwork or vertical lines.

◀ Sidney Nolan

◀ Georgia O'Keeffe

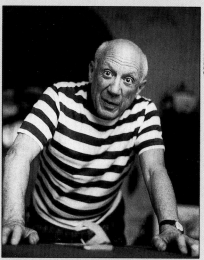

◀ Pablo Picasso

From 1944 to 1946, concerned with the emotions experienced when painting, he explored Surrealist "automatism", and then the use of symbols; in 1947 he cofounded the school "Subjects of the Artist", which generated Abstract Expressionism. Works like *Pagan Void* (1946) and *Ornament I* (1948) addressed the issue of the destruction of the primal void – he progressed to an exploration of space. His work approached and sought the numinous, and does communicate spiritual force, as titles like *Cathedra* (1951) and *Stations of the Cross* suggest.

Nijinsky, Vaslav 1889–1950

Russian dancer and choreographer. Nijinsky danced from the age of three. He attended the Imperial Ballet School (1898–1907) and from 1907 to 1911 danced lead roles in the Imperial Ballet, and the Bolshoi. In 1909 he began to dance with the Ballets Russes, joining them in 1911. He left Russia for good in 1911. He shone in Fokine's choreography for him, like *Le Spectre de la Rose*, and *Petrushka* (1911) and showed innovative choreographic power with *L'Après-midi d'un faune*, *Jeux*, and *Le Sacre du printemps* (all, 1912–13). In 1913 he married, and the jealous Diaghilev dismissed him. His career ended in 1917, with the onset of schizophrenia. Nijinsky redefined the role of the male dancer, and paved the way for later virtuosi like Nureyev and Baryshnikov.

Nolan, Sidney 1917–

Australian painter. Nolan studied art in Melbourne, and began to paint full time in 1938, at first in Abstraction, moving in the 1940s into representational work, using mythological themes, especially, increasingly, Australian myth, ancient and modern, as in the two series of paintings of the outlaw Ned Kelly (1945–47, 1954–57) which brought him international fame. His work retained a haunting, atmospheric, abstract component, and was controversial. He traveled widely, and in 1953 settled in Europe.

O'Keeffe, Georgia 1887–1986

US painter. After studying art, O'Keeffe worked (1908–12) as a commercial artist, and then as an art teacher until 1918. She undertook further studies from 1912 to 1918; and in 1917 joined Alfred Stieglitz's 291 Gallery group. Stieglitz organized her first solo show in New York in 1923, and they married in 1924. O'Keeffe's paintings were Precisionist, from early flower paintings (often with sexual overtones) like *Black Iris* (1926), to southwestern American scenes like *Ranchos Church Front* (1929). From 1929 onward she spent much time in New Mexico, settling there in 1945. In the 1940s she approached abstraction, using single magnified or extensive images – *Pelvis Series*; *Red with Yellow* (1945). She visited Europe in 1953 and traveled widely; after this aerial views appeared in several of her works.

Oldenburg, Claes 1929–

Swedish-born US artist. Son of a diplomat, Oldenburg's childhood was nomadic; in self-protection he created, in detail, an imagined island he called Neubern. After studying art and literature at Yale, Oldenburg became a crime reporter, and took art evening classes. From 1956 he painted, and wrote poetry, prompted by the New York slums – *The Street* (1960) – and began to create "Happenings", working with Jim Dine, Allan Kaprow and others, and staging such events, from 1961, in "The Store" a Pop Art gallery selling replicas of food and everyday items. He continued this theme with a series of *Soft Typewriters*, *Soft Toilet*, giant hamburgers, and other larger-than-life consumer fantasies.

O'Neill, Eugene G. 1888–1953

US playwright. Son of an actor-manager, O'Neill was a sailor, then a journalist before beginning to write in 1912. His first play, written for his company, the Princeton Players, rejected drab naturalism for a drama of poetry and passion. He won a Pulitzer Prize in 1920, the beginning of his most prolific period. *Anna Christie* (1921), *All God's Chillun Got Wings* (1924), *Desire Under the Elms* (1924), *The Iceman Cometh* (1939), *Long Day's Journey into Night* (1939–41) are among the best of his many plays. In 1936 he became the first US playwright to win a Nobel Prize. O'Neill treated drama as high literature; he imitated classical tragedy in *Mourning Becomes Electra* (1931). He revered tragedy, seeing it everpresent in the gap between aspiration and reality.

Orozco, José 1883–1949

Mexican painter. Orozco trained as an agronomist, and studied art intermittently from 1908 to 1914. His early paintings were Post-Impressionist in style. He was a political caricaturist during the Mexican revolution. From 1923 he executed many large, prodemocracy murals in public buildings. His style was now Realistic Expressionism, with the influence of folk art, and in his work he denounced the oppression of ordinary people. *Prometheus* (1950) is an example. From 1927 to 1934 he was in Europe and the USA, painting murals of the same nature. Among his works are the pacifist frescoes for Mexico City's Palace of Fine Arts (1934) and a mural for New York's MOMA (1940). With Rivera and Siqueiros, he was one of the major Mexican muralists.

Paz, Octavio 1914–

Mexican writer. Paz, after attending the University of Mexico, produced *Forest Moon*, his first book of poetry, aged 19. In Spain in 1937 he published the excellent *Beneath your Clear Shadow and Other Poems*; he was deeply influenced by the Surrealists. *On Parole* (1949) made his name as a brilliant Latin American poet. He wrote several other volumes of

poetry, and some of prose, the best of these being *The Labyrinth of Solitude* (1950); he also edited and set up several literary journals. In 1962 he became ambassador to India, resigning in 1968 in protest against the government's brutality toward radical students. He lived in Europe and in the US, lecturing at Harvard in the 1970s. Paz's poetry has a strong metaphysical-mythological flavor, is inquiring and sometimes whimsical.

Picabia, Francis 1879–1953

French painter. Picabia studied art in Paris, under Pissarro among others, and his first one-man show was in 1905. An outstanding exponent of Impressionism, he moved on to become one of the first artists to explore abstraction. In 1909 he met Duchamp, and was in 1911 a founder member of the *Section d'Or*. In 1913, now a prominent Cubist, he exhibited at New York's Armory Show. With Duchamp, he took Dadaism to New York, traveled widely propounding it, and, in 1914, produced his pamphlet, *391*. After a time in Zurich he returned to Paris (1919), and in 1924 joined the Surrealists; he exhibited with them, and visited the USA frequently, showing there as well. In 1945 he returned to Paris. Picabia was witty, ingenious, and an innovative thinker, and his importance lies in these qualities rather than in his painting.

Picasso, Pablo 1881–1973

Spanish painter. Picasso began at the age of 14, in Barcelona, to produce avant-garde, experimental work. His romantic, melancholy "Blue Period" (1901–04) followed; then he moved to Paris, meeting many artists and writers, and numbering Gertrude Stein among his patrons. The lighter, poignant "Rose Period" (1904–06) followed. *Les Demoiselles d'Avignon* (1907) was a startling, iconoclastic piece, savage, influenced by primitive art, hinting at Cubism, and a major 20th-century work. From 1909 to 1914 Picasso collaborated intimately with Georges Braque, founding Cubism. In 1912, using collage, he moved into Synthetic Cubism. After working on ballets in Rome and London, he moved into his "neoclassical period", and by 1925 developed a reciprocal relationship with the Surrealists, which showed in his reorganized anatomies. During the 1930s he illustrated Ovid's *Metamorphoses* among other books. In 1936 he became director of the Prado; in 1937 his painting *Guernica*, of the destruction of a village in the Spanish Civil War, was exhibited at the Paris World Fair. This work is often considered his masterpiece. In 1946, in Antibes, he painted murals, and in 1947 began ceramic work. He became active in peace congresses, and became, for a time, a rather unconvincing communist. Picasso was the most influential figure in modern art, and an artist of volcanic creativity; he mastered many styles, but said he wanted style to be subsumed in emotional effect.

▲ Sergey Prokofiev

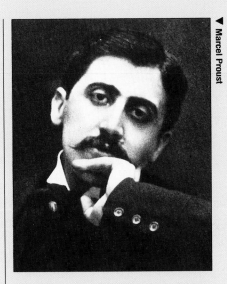

▲ Marcel Proust

▲ Maurice Ravel

Pirandello, Luigi 1867–1936

Italian playwright. After studying philology at Rome and Bonn universities, Pirandello wrote poetry, short stories, and novels. Success came with his third novel in 1904, the year of his wife's breakdown, which culminated in violent insanity, and her commital in 1918 to an asylum. His shift into drama as primary medium was marked in 1916 by his writing nine plays, including *Right you are (if you think so)*. The Paris production in 1923 of *Six Characters in Search of an Author* (1921) and *Henry IV* (1922) made him famous worldwide. In 1925 to 1928, he extended this success with his own company, "Teatro d'Arte". Pirandello won the 1934 Nobel Prize. He was innovatory in theatrical techniques, employing lighting to point the drama, and in writing, using the "play within a play" in his exploration of "appearances" versus reality. Pirandello uses the theatrical illusion to reveal inner truth, in the cause of human happiness, which he saw as achievable only in conscious contact with reality.

Pollock, Jackson 1912–56

US painter. Pollock studied painting in New York, and then, during a struggle with alcoholism, became interested in Jung. He admired primitive art, and Picasso, and began in the 1940s to use mythic symbols in his paintings. But this did not provide the access he sought to the Jungian "unconscious", so in 1947 he began to work splashing paint straight from the can on to canvas pinned to the floor, in a trancelike state in which his whole body was involved, which became known as Action Painting. Although attacked for this method, he produced fine work, like *Full Fathom Five* (1947), and later, incorporating broad, accurate brushwork, masterpieces like *Ocean Greyness* (1953). Pollock was a leading figure in the Abstract Expressionist movement; his influence on other painters was enormous.

Pound, Ezra 1885–1972

US poet. Pound, a philosophy graduate and M.A., was briefly professor of Romance Languages in Indiana before leaving for Venice in 1908, where his first volume of poetry, *A Lume Spento*, was published. He met Yeats, joined the Imagists, and became London correspondent for Chicago's *Poetry* magazine. He wrote the first Imagist manifesto, and in 1914 worked with Wyndham Lewis on the periodical *Blast*. He associated with Yeats, Joyce and T.S. Eliot, whose *The Waste Land* he was later to edit. Pound also published his own work, including fine translations of Chinese poetry and the much-praised *Hugh Selwyn Mauberley* (1920). In 1915 he began work on his poem-sequence, the *Cantos*. In Paris from 1921 to 1924, he wrote for *The Dial*, helped Hemingway and Eliot, and wrote an opera, *Le Testament*. He spent the next 20 years in Italy, writing the *Cantos*, arranging concerts – he

"discovered" Vivaldi, and becoming increasingly pro-Fascist. Pound made wartime broadcasts against the Allies, and in 1945 he was arrested and imprisoned in Pisa where he translated Confucius and wrote the very fine *Pisan Cantos*. He spent the next 12 years in a hospital for the insane; he continued writing and translating. After pressure from Eliot, among others, he was released in 1958 and returned to Italy, in time for the publication of *Thrones* (1959), the final volume of the Cantos. After 1961 he fell virtually silent, producing only fragments. Pound's influence on 20th-century culture has been immense; as a poet he was a superlative craftsman, but near the end of his life he began to doubt the validity of his achievement.

Prokofiev, Sergey 1891–1953

Russian composer. By 1902, when he had his first formal music tuition, Prokofiev, a proficient pianist, had written two operas and several piano pieces. He studied at St Petersburg Conservatory (1904–14) under Rimsky-Korsakov. He first played his own work in public in 1908, galvanizing audience and critics, who denounced him as an *enfant terrible*. His First Piano Concerto (1912) nevertheless won the 1914 Rubinstein Prize. In 1914 he was deeply impressed by the *Ballets Russes*, and Stravinsky's *Le Sacre du printemps*. He worked, at first unproductively, with Diaghilev until 1929. Prokofiev's *Classical Symphony*, (1917) brought world fame; in 1918 he moved to the USA, producing another celebrated work, *The Love for Three Oranges* (1919), for the Chicago Opera. In 1922 he returned to Europe, settling in Paris until his return in 1936 to Russia. Here he composed *Romeo and Juliet* (1935) and *Peter and the Wolf* (1936). In 1948, Prokofiev was censured by Zhdanov for writing "anti-democratic" music. The erstwhile iconoclast toed the party line, although he produced further fine work. Prokofiev's music, often Romantic in flavor, and often playful, shocked and engaged audiences in its exploration of deep, atavistic emotions.

Proust, Marcel 1871–1922

French novelist. Asthmatic from 1880, and very close to his mother, Proust took degrees in law and philosophy, and absorbed most of the world's classic works in all art forms. From 1901 to 1922 he lived entirely in one soundproof room. After publishing a few stories and poems, he wrote his seven-part masterwork, *A la Recherche du temps perdu*; Volume I was rejected by two publishers, so in 1913 Proust paid for its publication. It was quite successful, and he further revised the whole work, and in 1919 received the Prix Goncourt, becoming world famous. *A la Recherche* is a nostalgic, self-analytic, comic autobiography, exploring sexuality, jealousy, the pain of love, disillusionment and psychological rebirth; his style is complex, with long, reverberating sentences.

Rauschenberg, Robert 1925–

US painter. After serving in World War II he studied art in the USA and in Paris. He began by painting conventional abstracts; in the 1950s he began to introduce black numerals, in evidence in his first one-man show, in 1951. He also began to work increasingly with collages and assemblages, and what he called "combine" paintings, with collage added. He moved into painting entirely in black, and, in 1953, proceeded to red, as in *Charlene* (1954). Works like *Bed* (1955), with real linen, and *Monogram* (1959), a stuffed goat in a car-tyre, are famous combines. In the 1960s he adopted Max Ernst's technique of frottage to produce illustrations for Dante's *Inferno*. Rauschenberg won the 1964 Venice Biennale first prize for painting, and in 1966 he cofounded EAT (Experiments in Art and Technology). From 1955 he designed for the Merce Cunningham Dance Co., and even danced himself, with Surplus Dance Theater.

Ravel, Maurice 1875–1937

French composer. Ravel attended the Paris Conservatoire from 1899–1905, composing *Jeux d'Eau* in 1901, antedating the innovative work of Debussy, who is often cited as an influence. Ravel repudiated this (though admiring Debussy), claiming Fauré and Satie as influences. *Shéhérazade* (1903), an oriental song-cycle, shows Ravel's characteristic clarity and precision. He composed prolifically until 1914, and in 1920 declined the Légion d'Honneur (resentful that he had never been awarded the *Prix de Rome*). In 1925 he produced the powerful opera, *L'Enfant et les Sortilèges*. *Bolero* (1928) in many ways epitomizing, almost parodying, his incisive musical style, was his only popular success. He suffered a progressive nervous disease from 1932. His music was always crisp and elegant, with a harmonic surety akin to Mozart. He was an early proponent of objectivity in music.

Ray, Man (Emanuel Rabinovitch) 1890–1976

US photographer and painter. In 1915, after studying painting in New York, and trying to start an artists' community, Ray met Marcel Duchamp. Both witty and curious, they were lifelong friends, and spearheaded New York Dadaism. In 1918 Ray painted imitation photographs, using an airbrush. He began to produce surreal objects, like *Gift* (1921), an icon with tacks attached. In 1921, Ray moved to Paris, mixed with the Surrealists, and earned money with fashion and portrait photography. He also made films, like *L'Etoile du Mer* (1925). He developed the "Rayograph" (photogram), and "solarization" – introducing light while processing film. This technique featured in *The Age of Light* (1934). In 1935, Ray collaborated with Paul Éluard on a book of love poetry, *Facile*. In 1940 Ray moved to Hollywood, and in 1951, to Paris, where he remained.

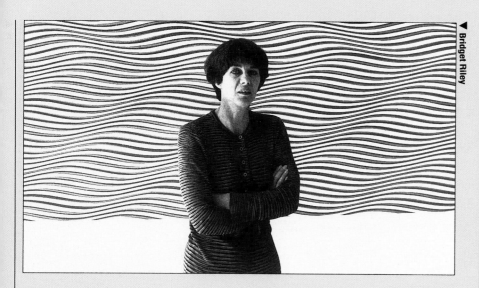

Bridget Riley

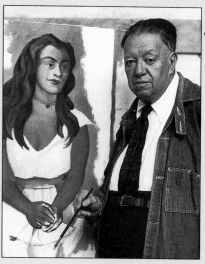

Diego Rivera

Riley, Bridget 1931–

British painter. Riley studied art from 1949 to 1955, and had her first solo show in 1963. She was influenced by Vasarely, but concerned herself in her work solely with optical effect; she was the major proponent of Op Art. At first using only black and white, she moved through grey and blue until, in 1967, employing full color, as in *Late Morning*. Although her technique is mechanistic, the presentation her work makes of the subjective nature of perception gives it a unique place in modern art history.

Rilke, Rainer Maria 1875–1926

Austrian poet. Rilke's unsympathetic father sent him to military academy, then business school, until in 1895, after publishing a book of poetry (1894), he went to university in Prague. He left, and went to Germany, where he met Lou Andreas-Salomé and became her lover. She imbued in him a deep love of Russia, his "spiritual homeland", which inspired *The Book of Hours* (1905). In Paris, his second "spiritual home" (1902–14), he met Rodin, whose secretary he became. Rodin's down-to-earth approach to sculpting influenced Rilke's engagement with his own craft. The result was *New Poems* (1907–08). The novel *The Notebook of Malte Laurids Brigge* (1910) reveals a vastly sensitive being, too passive to use his gift creatively. A "barren" period of 13 years ensued, before the *Duino Elegies* which Rilke considered his major work, and *Sonnets to Orpheus* (both 1922). Rilke's vision is of a hierarchy of life-forms, transcended by the human creative consciousness, which can "redeem" the visible, by rendering it invisible – see the *Ninth Duino Elegy*.

Rivera, Diego 1886–1957

Mexican painter. After studying art in Mexico and Madrid, and touring Europe, Rivera settled in 1911 in Paris, where he met Picasso and others, and took up Cubism. In 1921, returning to Mexico, he embraced its folk art, and became active as a revolutionary. In 1923 he began to execute enormous murals on public buildings, in a realistic manner with a political and historical narrative content, like *Workers of the Revolution*, painted in 1929, the year he became director of Mexico's Central School of Fine Arts. His influence on Mexican art was enormous, and it spread to the USA and Europe; in the 1930s he also painted murals in the USA. It is these monumental works that have left the most enduring mark on 20th-century painting.

Rodchenko, Alexander 1891–1956

Russian artist and designer. After studying fine art, Rodchenko discovered, and was impressed by, Futurism. From 1915 he painted abstracts; spurning the mysticism of the Suprematists, he began in 1917, influenced by Tatlin, to create constructions of wood and iron. In 1918 he became the first director of the Museum of Artistic Culture, and in 1919, co-director of Moscow's Industrial Art workshops. In 1920, he painted *Black on Black*, in response to Malevich's *White Square on a White Background*; he also made Constructivist hanging pieces, and started to design posters. In 1925 he designed the Russian stand at the Paris exhibition of decorative arts. He also made in this year his only visit to Paris, to set up a Workers' Club.

Rodin, Auguste 1840–1917

French sculptor. Rejected by the École des Beaux Arts, Rodin worked to pay for sculpture classes. Shocked by his sister's death in 1862, he became a monk, but the Father told him sculpture was his vocation. He worked as assistant to other sculptors, and in 1872 had a bust accepted in the Brussels Salon. In 1877, the showing of *The Age of Bronze*, a male nude originally a tribute to the war dead, caused uproar, because people could not believe an unknown had produced such brilliant work. Rodin was still a journeyman, until the showing of *John the Baptist* that year brought him acknowledgement as a master. Given money and studios, he was commissioned to design doors for the Paris Museum of Decorative Arts; he used imagery from Dante's *Inferno*, producing hundreds of figures, with *The Thinker* as centerpiece – he worked on this all his life. In 1884 he produced, on commission, *The Burghers of Calais*, and the profoundly erotic *The Kiss*, for the State, in 1887. In 1888 he was made *Chevalier de la Légion d'Honneur*, and in 1893 the president of sculpture at the *Société National des Beaux Arts*. He was disappointed by the rejection in 1898 of a monument to Balzac, which he considered his best work, but the State considered "unfinished". Rodin's greatness overshadowed later 20th-century sculptors; the fine modeling and emotional power of his work remained unsurpassed.

Rogers, Richard 1933–

British architect. Born in Italy of Anglo-Italian parents, Rogers worked for an Italian architect before studying in London, and at Yale University, where he won several scholarships, and met Norman Foster. From 1963 to 1967 he worked with Foster in Team 4, then went into practice with his wife. From 1971 he worked with Renzo Piano. They shared a conviction that technology must be used to solve social and ecological problems. They won a competition to design the famous Paris *Centre Georges Pompidou* (1977). Rogers also designed the Lloyd's Bank HQ in London (1986). Rogers' work is responsive to environmental and human needs he is intensely concerned with the interface of public and private space. Later chairman of Richard Rogers and partners, he has lectured at universities, and received many awards, including (1986) the Légion d'Honneur.

Rothko, Mark 1903–70

US painter. Rothko, self-taught, began to paint in 1925; he had his first one-man show in 1933. In 1935 he co-founded "The Ten", a group producing Expressionistic pieces. In the 1940s he moved into Abstract Surrealism, and in 1947, to the "transcendental" abstraction for which he is best known. He painted canvases often large enough to fill a wall, of iridescent tones melting into one another; Rothko saw painting as a religious experience, and his work, like *No 8* (1952), conveys a powerful numinosity and feeling quality; in the sixties he painted eight pictures for the walls of an octagonal secular chapel in Texas. Around this time his work became darker, and in 1970 he committed suicide.

Rouault, Georges 1871–1958

French painter. After an apprenticeship as a stained-glass worker, Rouault studied art in Paris, notably under Gustave Moreau, whose favorite student he became. He met Matisse and other Fauves, and although he painted in the same style, adhered in subject matter and sensibility to the Romantic and Baroque traditions. The dealer Vollard bought all his work in 1913, and in 1917 gave him a room to work in; Rouault produced several series of prints, including the *Miserere* (Psalm 51) set. From 1918 he painted strong oils, often on religious themes. He also (from 1908) produced a series of lawcourt paintings. The passionate, anguished moralism of his work fits his description of it as "A cry in the night, a stifled sob".

Roy, Jamini 1887–1974

Indian painter. After imbibing the Western academic artistic tradition at Calcutta Art School, Roy came under the influence of the Bengal School, which attempted to revive ancient art. His realization of the impossibility of doing this amounted to a spiritual crisis, and he proceeded to develop an individual style which drew on his beloved folk art. He used organic pigments. As Roy's sense of the importance of art in society grew, he abandoned "original" for "mass" art, to be generally accessible, and normally executed his work with his pupils.

Saarinen, Eero 1910–61

Finnish/US architect. Returning to Finland in 1935 after his studies in Paris and at Yale University, Saarinen soon went into partnership with his architect father, Eliel. In 1949 he won a competition to design the Jefferson National Expansion Memorial. In 1956 he completed work on his first independent design, for General Motors. He was not a great architect, but a versatile one, with a talent for airports, such as the TWA terminal at Kennedy Airport, New York, which resembles a bird poised for take-off.

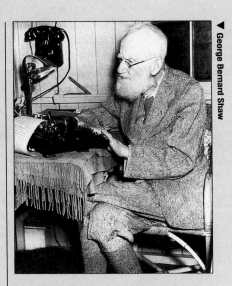

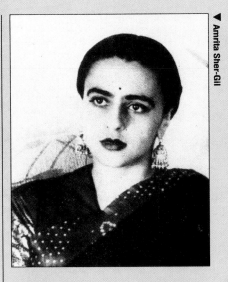

Sartre, Jean-Paul 1905–80

French novelist, philosopher and playwright. Sartre studied philosophy at the Sorbonne, where he met Simone de Beauvoir, his lifelong partner. He taught until 1945, and imbibed the phenomenology of Husserl and the existentialism of Nietzsche. *Nausea* (1938) is a diary-novel describing a neurotic repulsion from objects; *Being and Nothingness* (1943) further expounds Sartre's existentialism and theory of consciousness. Sartre believed that freedom included concern for society (engagement), and *The Roads to Freedom* trilogy (1945–49), is an ethical exposition in novel form. His excellent plays, like *The Flies* (1943) and *No Exit* (1944), dramatize the passionate hostility bred of human alienation. In 1948, with Beauvoir, he produced the review *Les Temps Modernes*; the entrenchment of his radical position as he embraced Maoism caused him to break with many friends, including (1952) Camus. His autobiography, *The Words* (1963), won him the Nobel Prize, which he declined. The later years of his life were spent writing a biography of Flaubert, on which he worked until he went blind.

Schiele, Egon 1890–1918

Austrian painter. While attending the Vienna Academy of Art, Schiele joined the *Wiener Werkstätte*. His early works, like *Orchard in Spring* (1907), were Impressionistic; the influence upon him of Gustav Klimt caused a rift with his teacher, and he left the Academy in 1909 and joined the *Neukunstgruppe*, exhibiting all over Europe. A fine draftsman, and influenced by the theories of Freud, Schiele produced vital, powerful works, frequently depicting tortured, brooding figures, and often erotic. In 1911 he was jailed for a month for "immoral drawings". During and after World War I, in which he served as a war artist, he painted major portraits like *Edith Seated* (1917–18).

Schoenberg, Arnold 1874–1951

Austrian composer. Schoenberg, took violin lessons from the age of eight and began composing in 1883. He was largely self-taught. His work until the *Second String Quartet* (1908) was an attempt at maintaining the tonal basis while exploring chromaticism, but eventually expressive needs drove him to atonality. From 1910 he taught at the Vienna Academy where Berg and Webern were among his pupils. In 1911, in Berlin, he exhibited his paintings with the *Blaue Reiter* group. He achieved a degree of popularity with the remarkable *Pierrot Lunaire* (1912). With his *Piano Suite* (1923) he broke through into dodecaphony, the method he created to tame the chaos of atonality that laid the foundation for postwar serialism. In 1926 he directed the composition masterclass at the Prussian Academy of Arts. In 1933, under the threat of Nazism, he left the Academy, and Germany. Schoenberg returned to

Judaism, which he had abandoned in 1898. He settled in the USA, worked as a teacher and, from 1936, university professor in Los Angeles, and was naturalized in 1941. Schoenberg felt that the problems of harmony and harmonic direction created by his entry into the non-tonal world had not been solved, and his theoretical writings explore this dilemma.

Schwitters, Kurt 1887–1948

German painter and poet. After studying art in Dresden, Schwitters at first embraced Expressionism, then, influenced by Arp and Dadaism, began in 1918 to produce abstracts, using torn-paper collage, which he named *Merz* (a meaningless word echoing *schmerz* = pain). In 1920 he built a *Merzbau*, a Dadaistic construction filling his house. The Berlin Dadaists rejected him as a "bourgeois reactionary" for the esthetic content of his work and his assertion that *Merz* was art, and that art was "an arch-principle". Still he promoted Dadaism; in 1923 he published *Merz* magazine. In 1932 he joined the Abstraction-Création group, and in 1937, branded "degenerate" by the Nazis, emigrated to Norway, and built his second *Merzbau*. In 1940 he moved to Britain, where he built his last, unfinished, *Merzbau* (1947).

Seferis (Seferiades), Giorgos 1900–71

Greek poet. Seferis started writing after graduating in law; in 1931 his first collection won him acclaim as a major poet. *The Thrush* (1947), and some fine translations of English poetry, including *The Waste Land*, consolidated his reputation. "Helen" from *Logbook C* (1955), is probably the finest modern Greek poem. From 1957 to 1962 he was Greek ambassador to the UK. In 1963 he won the Nobel Prize. He was harassed for his public denunciation, in 1969, of the junta. Seferis draws on the classical Greek tradition, to confine passion in cool, lucid language; his work is suffused with compassion for Greece's tragic position in the modern world, its fall from grace.

Shahn, Ben 1898–1969

Lithuanian-born US painter. Shahn's parents emigrated in 1906 to the USA, where he worked as an apprentice lithographer before (1919–22) studying art. Influenced by Rouault and Rivera, he was a Social Realist, painting in photographic detail; after visiting Europe, he adopted elements of the style of the early Italian masters. *The Passion of Sacco and Vanzetti* (1931–32) exemplifies the social protest which constantly fired his work, like that of Rivera, with whom he collaborated in 1933 on the Radio City murals. Other major works are the Bronx Post Office frescos (1938–39) and the Washington Social Security Building mural (1940–42). Shahn moved into poster production in the 1940s, with work like *Hunger* (1946) for the State Department.

Shaw, George Bernard 1856–1950

Irish playwright. Shaw left school at 15 and worked as a clerk before joining his mother (who had decamped with her lover and daughters in 1873) in London; he worked as a critic, of art, books, music and theater – he began writing plays in the 1880s: he also became a socialist, and in 1884 joined the Fabian Society. *Candida* (1894) is Ibsenesque; others followed, and he became famous in Europe, but success in England came only in 1904, with the production of *John Bull's Other Island*, and the Royal Court theater staged eleven of his plays between then and 1907. *Pygmalion* (1913) is his most popular, and funniest play, dealing with love and class barriers – it has been filmed, and adapted into a hugely successful musical. Shaw is a master of English prose; his didacticism is balanced by his freshness and wit, and the integrity of his socio-political commitment. Until 1930, he produced a stream of high-quality plays, including *Caesar and Cleopatra* (1901), *Man and Superman* (1903), *Major Barbara* (1905), *Heartbreak House* (1920), and *St Joan* (1923). The last, a superbly moving exemplary drama with soaring lyrical passages, won him the 1925 Nobel Prize.

Sher-Gil, Amrita 1913–41

Indian painter. Sher-gil studied at the Paris École des Beaux-Arts, and was influenced initially by Cézanne and Gauguin, exhibiting in 1933. In 1934 she returned to India, and studied ancient art, notably the 2000-year-old Buddhist cave-paintings of Ajantá. She was led by this art and that of Gauguin to a strongly stylized idiom, without perspective, dealing with Indian life.

Shostakovich, Dmitri 1906–75

Soviet composer. Shostakovich attended the Petrograd Conservatory (1919–25), producing his First Symphony at his graduation, and winning acclaim as pianist and composer. In 1936 his opera *Lady Macbeth of the Mtsensk District*, was attacked in *Pravda*, as a warning against modernism. Shostakovich produced a *Fifth Symphony* which pleased the Party, and reestablished him as the leading Russian composer. His *Seventh Symphony* (*The Leningrad*), used to symbolize the fight against Fascism, was massively popular. The *Ninth Symphony*, a breezy, serene celebration of the war's end, was not well received and in 1948 a decree was issued denouncing "anti-democratic music". He confessed, and proceeded to compose accessible, non-formalistic music. At the same time he was producing, and withholding, "anti-democratic" pieces like the *First Violin Concerto*; these were released after Stalin's death. The *Thirteenth Symphony* (*Babi Yar*) was also attacked, for its use of Yevtushenko's lyrics. Shostakovich was unique in the survival and triumph of his genius under the difficult and dictatorial conditions of the Communist régime.

Sibelius, Jean 1865–1957

Finnish composer. In 1886, Sibelius switched from studying law to studying music, in Helsinki, Berlin (1889), and Vienna (1890). His choral *Kullervo Symphony* (1892) made his name as the supreme Finnish composer. Like most of his works, it draws on the Finnish epic *Kalevala* and on the Finnish landscape. In 1897 he was granted a State pension, and *Finlandia* (1899–1900) brought him international fame. His preoccupation with thematic unity and a severely logical approach to the symphonic form led to his famous disagreement with Mahler, who believed that "the symphony…must contain everything". He produced a series of works inspired by the *Kalevala* – *Pohjola's Daughter* (1906), *The Swan of Tuonela* and *Tapiola* (1925), the latter of which, a bleak, visionary tone-poem, is one of his greatest works. He explored the limits of tonality in the *Fourth Symphony* (1911), but drew back from the atonal abyss; his *Seventh Symphony* (1924) is one of the most structurally perfect of all symphonies. Sibelius fell silent after 1925, and an unfinished *Eighth Symphony* was destroyed before his death.

Singer, Isaac Bashevis 1904–

Polish US Yiddish writer. Son of a Hasidic rabbi, Singer settled in 1935 in the USA, and wrote for a Yiddish newspaper. He became famous in 1953 with a translation by Saul Bellow of his short story "Gimpel the Fool", which appeared in the eponymous collection in 1957. His first novel, *Satan in Gray*, was revised, appearing in 1958. Singer uses Jewish tradition and supernatural concepts in his works, which are affectionately realistic, except in the introduction of incomprehensible, numinous powers, interacting with men. *The Family Moskat* (tr. 1950) tells of a family's loss of religion and degeneration; in *The Magician of Lublin* (1960), as in many other works, he examines temptation. He won the Nobel Prize for Literature in 1978.

Smithson, Robert 1938–73

US sculptor and "land artist". After studying art in New York, Smithson spent two years hitch-hiking around the USA and Mexico. He had his first one-man show of paintings and assemblages in 1959; he retired from 1962 to 1964, then worked as a sculptor and wrote essays on art. He embarked in the 1970s on the massive al-fresco projects for which he is chiefly known, *Partially Buried Woodshed* and *Spiral Jetty* (1970), *Broken Circle – Spiral Hill* (1971) using naturally-occurring materials like boulders to produce an art form whose effect on life was his main consideration. After many rejections for industrial design projects, Smithson was commissioned to execute a pond project, *Amarillo Ramp* (1973) – it was completed posthumously, for he died in a plane crash while photographing the site.

Solzhenitsyn, Alexander 1918–

Russian writer. Solzhenitsyn graduated in mathematics, and fought in World War II. From 1945 to 1956 he was in labor camps, then exile, for criticizing Stalin in a letter. A math teacher, he then began writing, and *One Day in the Life of Ivan Denisovich* (1962) appeared in the journal *Novy Mir*. Its account of a day in a labor camp caused a sensation in Russia and abroad. He was criticized, his work banned and *The First Circle* (1968), dealing with the dilemma of scientists working for repressive governments, and *Cancer Ward* (1968), both drawn from his own experience, were published abroad. He was awarded the 1970 Nobel Prize. The three-volume *Gulag Archipelago* (1973–78) is a compendious chronicle of the network of prison and labor camps, using historical accounts and personal testimonies, held in memory from the writer's incarceration. In 1974 Solzhenitsyn was arrested and exiled for "treason". He settled in Switzerland, then, from 1976, the USA, where he continued to work on his vast novel-sequence (begun with *August 1914*) about the 1917 Revolution.

Soyinka, Wole 1934–

Nigerian playwright and novelist. Soyinka graduated in English at Leeds University in 1958. *A Dance of the Forests* (1960), written for the Nigerian independence celebrations, was unpopular because it deglamorized the past. He edited the literary magazine *Black Orpheus* until 1964, and taught drama and literature at several universities. From his early comic, village pieces, he progressed to more experimental work, developed with actors; *Madmen and Specialists* (1965) and *Death and the King's Horseman* (1975), a study of the clash between Yoruba tradition and colonial imposition, achieve the universality he sought. Soyinka uses Brechtian alienation techniques. He has also written poetry, much of it while in prison (1967–69) for supporting Biafra's secession. He won the 1986 Nobel Prize.

Spencer, Stanley 1891–1959

British painter. Spencer attended the Slade School, London (1908–12); his work appeared in London's Second Post-Impressionist Exhibition (1912). Military service in the World War I deepened the visionary quality of his painting; he set religious tableaux, crucifixions and resurrections, in scenes of daily life in his home village of Cookham, in works like *The Resurrection, Cookham*, completed in 1927, the year of his first one-man show. He painted the massive mural in the War Memorial Chapel, Burghclere (1926–32). As an official World War II artist, he painted shipyard scenes. From 1945 to 1950 he did a series of *Resurrections*. As well as religious vision, his work contained a strong eroticism which spoke for liberation from sexual guilt.

Stella, Frank 1936–

US painter. Stella studied art, then worked as a house painter, while painting Abstract Expressionist pieces. Throughout his career, he worked in series, and his first series, 23 black canvases, with bare canvas forming fine stripes was shown in 1960. From 1960 to 1963 Stella painted three series in aluminum, copper and magenta, using geometric shapes. Stella began in the sixties to introduce the issue of the interaction of shape and color into structure, and his work, though very formal, does not lack emotional impact – see *Sabra III* (1967). In the 1970s Stella produced a *Polish Village* series, of painted wood reliefs, a Brazilian series, in aluminium and steel, and *Exotic Birdsong*, incorporating found shapes attached straight to the canvas, and scribbled lines. Stella's work is consciously and rigorously developed, yet powerful, with strong feeling and decorative qualities.

Stevens, Wallace 1879–1955

US poet. Stevens studied law, and was called to the bar in 1904. He became involved with a Greenwich Village poetry group, publishing poems in little magazines. From 1916 he worked for an insurance company, becoming its vice-president in 1934, and writing secretly. His first collection, *Harmonium* (1923) had poor sales and good reviews. In 1951 a book of essays, *The Necessary Angel*, appeared, and in 1954, his *Collected Poems* won a Pulitzer Prize. Stevens writes about the difference between reality and human perception, and about loss of belief. In 1940 he wrote, in a letter, that his "major poetic idea is the idea of God". Influenced by Japanese art, and haiku – see "Thirteen Ways of Looking at a Blackbird" – his work uses the natural world to achieve Joycean "epiphanies".

Stieglitz, Alfred 1864–1946

US photographer and art patron. Stieglitz attended university in Germany from 1881, switching from mechanical engineering to photography. In 1890 he left for the USA, and edited a photographic magazine. In 1902 he founded Photo-secession, the group, and the gallery, later known as *291*, and began editing the radical journal, *Camera Work*. He was a technical innovator; he took the first photographs in snow, rain, and darkness. Stieglitz was (from 1908), the first US gallery-owner to show Rodin, Matisse, Cézanne, Picasso, and US painters such as Georgia O'Keeffe, his wife from 1924. *291* broke up after World War I. Stieglitz's own photographs from 1917 to 1937 included portraits of his wife, and pictures of cloud formations. He still exhibited, but only artists who were not already popular. Stieglitz gave many fine artists access to a wide public, brought an unprecedented status to US art in the USA, and took photographs which were the first to be counted as art.

▼ Kenzo Tange

▼ Jean Tinguely

Stockhausen, Karlheinz 1928–

German composer. An accomplished pianist by his teens, Stockhausen studied with Messiaen in 1952; his *Kreuzspiel* (1951) is a response to Messiaen's seminal *Mode de Valeurs*. In 1952 he cofounded an electronic music studio in Cologne, producing his first mature work, *Kontrapunkte* (1953), before studying phonetics and acoustics at Bonn University (1954–56). He introduced physical space as a musical parameter, as in *Gesang der Jünglinge* (1956) and *Gruppen* (1957), in which sound-sources are arranged spatially around the audience. His quest for a "music of the whole world" led him to use "found" material electronically manipulated in *Telemusik* (1966) and *Hymnen* (1967), the latter being a visionary mosaic of anthems and such "found" material. Influenced by Eastern philosophy, his music became a tool in his quest for spiritual enlightenment – in *Inori* (1974), a mime leads the orchestra with his gestures. After 1977 Stockhausen worked on *Licht*, a cycle of seven transcendental operas named after the days of the week, intended to be his crowning work.

Strauss, Richard 1864–1949

German composer. Strauss's earliest pieces where published in 1876. From 1882 he studied philosophy and art history at Munich University, and in 1885 became an assistant conductor; after a month he became the chief conductor at Meiningen. He was among the foremost conductors of his day. He began a series of programmatic tone poems, the finest of which are *Also Sprach Zarathustra* (1895–96) and *Ein Heldenleben* (1898). With *Salome* (1905) and *Elektra* (1909) he reached the bounds of tonality, but this was as far as Strauss went in this direction, and with *Der Rosenkavalier* (1910) he retreated into a Mozartian conservative manner, which made him popular and rich. Approachable works, like the *Alpine Symphony* (1911–15) and *Sinfonia Domestica* (1903), and operas in collaboration with Hugo von Hofmannsthal and Stefan Zweig followed. He remained in Germany after 1933, accepting a post from Hitler, but resigned soon after. *Metamorphosen* (1945) and *Four Last Songs* (1948) are among his last works.

Stravinsky, Igor 1882–1971

Russian composer. In 1905, when Stravinsky graduated in law, he was already composing. He was taught by Rimsky-Korsakov (1903–06), and in 1909 joined Diaghilev's *Ballets Russes*, for whom he wrote *The Firebird* (1910), *Petrushka* (1911) and the seminal *Le Sacre du printemps*, important for its rhythmic innovations – it caused a riot at its first performance. During World War I, Stravinsky lived in Switzerland, moving in 1920 to France, where he composed music in a neoclassical style, such as *Pulcinella* (1920), a reworking of pieces attributed to Pergolesi. He rejoined the Orthodox Church in

1926 and wrote several Slavonic chorales. In 1939 he settled in the USA, producing two major symphonies, and in 1951, *The Rake's Progress*, with a libretto by Auden and Kallmann. He now moved into the dodecaphony he had previously derided, with pieces like *Threni* (1958), and *Requiem Canticles* (1966). Stravinsky adopted many stylistic masks, repudiating each as he moved on, however all of his music exhibits a conspicuous craftsmanship and inventiveness.

Tagore, Rabindranath 1861–1941

Indian poet. Son of the Maharishi Devendranath Tagore. Tagore began to write poems in the 1880s, culminating in *Manasi* (1890), a collection containing some of his most well-known poems; Tagore introduced new forms to Bengali, such as the ode, in this collection. From 1891, he managed his father's estates, and his close contact with the peasants resulted in a collection of stories, *Galpaguccha* (1912). The concern with political and social problems first expressed in *Manasi* continued; several collections followed, including *Sonar Tari* "The Golden Boat" (1893), *Caitali* "Late Harvest" (1896) and *Naibedya* "Sacrifice" (1901). The deaths of his wife and son inspired some of his finest poetry: his *Gitanjali* "Song Offering" (1910) won him the Nobel Prize. Tagore was one of India's finest painters, and he composed hundred of songs. In 1901 he founded a school in Santiniketan, to the end of studying the finest of Western and Indian culture, and in 1921 he founded the Visva-Bharati University there also.

Tange, Kenzo 1913–

Japanese architect. After completing his architecture studies at Tokyo University in 1945, Tange worked with Mayekawa and Sakakura, who had worked with Le Corbusier; they pioneered International Style (often called "Brutalism") in Japan. Tange became Professor of Architecture at Tokyo University, wrote extensively on architectural theory, and achieved international fame with his winning design for the Hiroshima Peace Center, completed 1955. His plan (1960) to reduce Tokyo's traffic congestion by extending the city on stilts into Tokyo bay was not executed. In 1961 he founded URTER, Urbanists' and Architects' team, following Gropius. His buildings and his writings – such as *Function, Structure and Symbol* (1966) – have been very influential.

Tanguy, Yves 1900–55

French US painter. Tanguy came to Vlaminck's attention with some drawings made in 1922; in 1923, inspired by a de Chirico piece, he decided to paint. In 1925 he joined the Surrealists, and painted bleak, eerie dream landscapes with phantom forms; he attempted to paint subconscious contents – *He Did What He Wanted* (1927). Some of his paintings were characterized

by flame-like images and rocks, some contained smoother forms, reminiscent of those of Arp. His consciousness of rock formations was deepened after a trip to Africa in 1930. Tanguy proceeded to paint a series with rugged rock formations, backed by distant, hazy vistas (1931–34).

Tinguely, Jean 1925–

Swiss artist. After (1941–45) attending Basel Art School, Tinguely soon moved from Abstract painting to metal, wood and paper constructions, introducing motors in 1948. He moved to Paris in 1952, and from 1956 to 1959 incorporated random, "metamechanical" elements in his work. He then turned his attention to the act of painting, producing "painting machines" like *Meta-matic-automobile odorante et sonore*, shown at the first Paris Biennale. In 1960 he cofounded *Nouveau Réalisme*, and began to produce machines, like *Hommage à New York*, which smashed themselves to bits; these culminated in *End of the World* (1962), sited in the Nevada desert.

Tippett, Michael 1905–

British composer. Tippett, after attending the Royal College of Music (1923–28), and taking private lessons in composition, worked as a French teacher, conducted an orchestra for the unemployed (1935) and became (1940–51) music director of Morley College. He did not come to public notice until 1944, with the oratorio *A Child of Our Time*. His works of this period are neoclassical – the *Double Concerto* (1938–39) and *First Symphony* (1944–45). Since then, with six operas (and libretti), including *The Knot Garden* (1955), a superb Piano Concerto (1955), three more symphonies, and choral pieces like *The Mask of Time* (1984), he has established and held his reputation as an innovative composer. He has taught at the London College of Music since 1983. Tippett's humanitarian idealism shows in his life and his work; musically, he is eclectic, incorporating jazz and negro spiritual elements into his music: this is very apparent in his opera *New Year* (1988).

Tudor, Anthony 1908–87

British/US choreographer. Tudor studied with Marie Rambert from 1927, then danced and choreographed for her. In 1938 he formed the London Ballet, leaving in 1939 to join the Ballet (later American Ballet) Theater. In 1950 he worked with the Metropolitan Opera Ballet, in 1952 began to teach at the Juilliard Academy; he was artistic director of the Royal Swedish Ballet (1963–4), in 1974 became Associate Director, and in 1980 Choreographer Emeritus, of the American Ballet. *The Lilac Garden* (1936) and *Knight Errant* (1968), are among the many penetrating pieces in which he has examined the deeper, darker reaches of the psyche.

Virginia Woolf

Frank Lloyd Wright

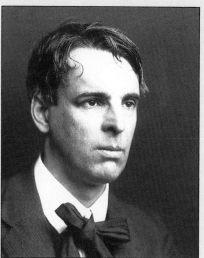

William Butler Yeats

Valéry, Paul 1871–1945

French poet and essayist. As a law student he met Louÿs, Gide, and Mallarmé. Influenced by the latter, Poe and Huysmans, he had produced 200–300 "pure" poems, some published in Symbolist journals, by 1892, when, crossed in love, he "renounced emotion", and wrote only prose, using a character, *M. Teste*, to represent the intellect. He meditated each dawn for the rest of his life, on consciousness and language – his quest was to find "what a man can do". In 1917 *La Jeune parque* appeared, a collection which brought him recognition as the finest living French poet. He followed up with *Album de vers anciens* (1920) and *Charmes* (1922), which contains his best-known poem "Le Cimetière Marin". Valéry's poetry, at once abstract and sensuous, often erotic, bespeaks the tension between contemplation and action he felt in his life.

Varèse, Edgard 1883–1965

French/US composer. Varèse studied under d'Indy, Roussel and Widor from 1903 to 1907, when he began a period traveling around Europe. Rejected as unfit for military service, he moved to New York in 1915; his early works he left behind in Paris. His first American work was *Amériques* (1921), followed shortly by *Hyperprism* (1923), a work demonstrating Varèse's preoccupation with wind and percussion timbres – he disliked the strings. His *Ionisation* (1929–31) is one of the first Western works for percussion only. He sought new sonorities, and welcomed the advent of electronic media – he used theremins (instruments whereby sound is controlled by movements of the hand through a magnetic field) in *Ecuatorial*, and *Déserts* (1954) has a tape part. *Poème électronique* (1958) for tape, written for the Philips Pavilion at the Brussels World's Fair, is a masterpiece of the genre.

Walcott, Derek 1930–

West Indian poet and playwright. Walcott studied in St Lucia, graduating in 1933, and then taught at the West Indies' University until 1958. While there, he began writing folk plays. In the 1960s he directed Trinidad Theater Workshop, and *In a Green Night: Poems 1948–60* was published. *The Dream on Monkey Mountain and Other Plays* (1970) shows his use of traditional Creole idioms and tales. *Another Life* (1973) is an autobiographical poem. Walcott uses Caribbean dialect, and traditional literary forms, in work which is humorous, compassionate, informed by history, and immediate.

Warhol, Andy 1930–87

US artist and film-maker. After attending the Carnegie Institute of Technology, in 1949 Warhol settled in New York and worked as an advertising illustrator. In 1957 he won the Art Director's Club medal. He became known as a Pop Artist with the production, in 1962, of works like *Campbells Soup Cans 200*, which became icons of the consumer society. Warhol also used violent subject matter, distancing it by an ordinary, precise representation. The studio where he began to mass-produce silk-screened copies of media images was called The Factory. Warhol also made films, attempting to remove the element of creative choice by leaving a camera in one position for hours – as in *Empire*. He cultivated inconsequentiality and banality in whatever he did, and his enduring achievement is to have elevated these qualities into art.

White, Patrick 1912–90

Australian novelist. White was born in England, yet brought up on an Australian sheep station until 13, when he was sent to school in England. He read modern languages at Cambridge, then settled in London, where he wrote the early, untypical novels *Happy Valley* (1939) and *The Living and the Dead* (1941). During the war he served in the R.A.F. as an intelligence officer in Greece. *Riders in the Chariot* (1961) concerns four characters – Jew, Aborigine, eccentric woman and laundress – who share a vision of the chariot, symbol of the inner life, one of White's main concerns – *The Vivisector* charts the inner development of a painter. White is often savagely satirical, in highly wrought and resonant prose. His interest in Jung and myth led him to write *The Solid Mandala*, about two complementary brothers unable to escape each other. *The Eye of the Storm* won the 1973 Nobel Prize.

Williams, William Carlos 1883–1963

US poet. Williams studied medicine at the University of Pennsylvania until 1906 and in Leipzig until 1910, when he returned to the USA where he practiced medicine and wrote poetry in his hometown, Rutherford, New Jersey. Williams found his own poetic voice with *Al Que Quiere!* "To Him Who Wants It!" (1917), a voice that celebrated the world of the senses with directness and simplicity – see "Red Wheelbarrow". In Williams' finest work, the five-volume *Paterson* (1946–58), he uses the metaphor of a city on the Passaic River in New Jersey to explore the soul of America and of modern man. Williams also produced a great deal of prose – historical essays, a novel-trilogy, many fine short stories and a play *A Dream of Love* (1948). His autobiography appeared in 1951, and his final collection *Pictures from Brueghel and Other Poems* (1962) won him the 1963 Pulitzer Prize.

Woolf, Virginia 1882–1941

British novelist and critic. Daughter of the eminent literary man Sir Leslie Stephen, Woolf was the central figure in the Bloomsbury Group. She was subject all her life to fits of intense depression and mental illness. In 1917, she and her husband, Leonard Woolf, founded the Hogarth Press. After two "ordinary" novels, she produced the innovative *Jacob's Room* (1922). *Mrs Dalloway* (1925) and *To The Lighthouse* (1927) – brilliant novels, exhibiting a poetic, near-musical, formalism, and exploring the current beneath the surface, in individuals and relationships. *Orlando* (1928) scandalized some readers; its main character's life spans four centuries, and includes a change of sex. *The Waves* (1931) is a stream-of-consciousness tour de force. She was a literary critic – see, for instance, *The Common Reader* (1925), and social commentator, especially in the field of women's rights – as in *A Room of One's Own* (1929). Woolf's work is extraordinary in its poetic and personal sensitivity, limpidity of mind, and commitment to the representation of the natural flow of consciousness, which does not follow the reason imposed by convention, or ordinary language.

Wright, Frank Lloyd 1869–1959

US architect. Wright studied in Chicago under Sullivan, the early skyscraper architect, and in 1895 founded Oak Park Studio. In 1904 he first used reinforced concrete, for an Illinois church. He built long, low, "prairie houses", like Robie House (1909), in Chicago's suburbs. He designed Tokyo's Imperial Hotel, many private houses, the 1938 *Broadacre City Project*, featuring dispersed "organic" office buildings, the Johnson Watt Tower (1950) and New York's Guggenheim Museum (1957) using a center spiral. Wright believed we should live closer to nature, in scattered buildings, and pursued individuality in architecture – houses such as the *Falling Water* (1936) house bear this out.

Yeats, William Butler 1865–1939

Irish poet. Yeats, as an art student in London, cofounded the Rhymer's Club, and took up writing poetry seriously, using Celtic myth and occult symbolism. In 1889 he met Maud Gonne, for whom he had an unrequited passion. In Dublin in 1899, with Lady Gregory, he set up the Irish Literary Theatre, which became, in 1904, the Abbey Theatre. He wrote many plays for it. His collected works of 1908 contain all his mythic lyrics, including "The Lake Isle of Innisfree" and "Down by the Sally Gardens". *Responsibilities* (1914), is a collection on socio-political themes. It was written in the period of Ezra Pound's influence on him. In 1922 Yeats entered the Irish Senate; in 1923 he was awarded the Nobel Prize. *A Vision* (1925) is an occult-based and esoteric text inspired by Blake. He was influenced by Japanese and Chinese art and philosophy – see *Lapis Lazuli*. Yeats' penetrating and uncompromising vision, coupled with an intensity of feeling matched by the lyrical beauty of his language and musicality of his phrasing, and his drawing on his ethnic roots, make him a master poet.

GLOSSARY

abstract art
Art in which form and color are stressed at the expense of, or in the absence of, a representational image.

Absurd
Name for a school of literature, especially drama, reflecting the belief, as set out in Albert Camus's essay *Le Mythe de Sisyphe* (1942), that life is essentially meaningless. Writers in this school include Jean-Paul Sartre, Samuel Beckett and Eugene Ionesco.

Action painting
The type of **Abstract Expressionism** practiced especially by Jackson Pollock, in which the emphasis was on the action of applying paint, sometimes splashing or pouring it over a canvas on the floor.

aleatory music
Music whose components and/or development are determined by chance, either at composition or performance stage.

alienation effect
Concept originated and used by Bertolt Brecht, of using a number of devices to remind the audience that they are watching a play, so that their critical observation is not blunted by powerful emotion. Such devices include absence of illusive scenery, and players stepping out of character to address the audience.

ambiguity
Of a word or words, the property of having more than one possible meaning; an asset in poetry.

applied art
The designing and decorating of functional objects or materials to give them esthetic appeal (opp. **fine art**).

archetype
Symbolic image considered to have a fundamental universal or racial psychic significance and dynamism. Used in this sense in the psychological work of Carl Gustav Jung.

architecture
1. The science or art of building.
2. The structure or style of what is built.

Art Deco
Style of western **architecture, applied arts,** interior and graphic design of the 1920s and 1930s. It was characterized by the combination of decorative **Art Nouveau** with new geometric forms.

Art Nouveau
Decorative style popular in Europe in the late 19th and early 20th centuries; it often employed stylized, curvilinear plant forms.

arte povera (It., poor art)
Term coined in 1967 to describe the work of artists such as Carl André, Richard Long, etc. It stresses the use of ordinary, especially natural, materials such as sand, stones, twigs etc., and the temporary and uncollectable nature of the work.

assemblage
A collection of found objects assembled together.

atonality
The absence of a key in music.

Automatism
Method associated with **Surrealism** in which the artist does not consciously create but allows the subconscious mind and virtually uncontrolled movement of the hand to produce an image.

avant-garde
Artists whose work is unconventional, experimental, innovative; this work.

Bauhaus
School of architecture and modern art, founded in Weimar, Germany in 1919 by Walter Gropius, which aimed to integrate **fine arts, applied arts** and design, and soon became the focus of modern design. It was closed by the Nazis in 1933.

Beat
Term used to denote a free-ranging literary style and lifestyle of the 1950s, expressing alienation from mainstream society in various kinds of permissiveness and an interest in non-Western religions.

Brutalism
Architectural style of the 1950s associated with Le Corbusier and Mies van der Rohe, in which no attempt was made to disguise the building materials used.

calligraphy
The art of fine handwriting, often incorporated into painting style.

chamber music
Secular music to be played in a small auditorium, usually without soloists.

choreography
The art of composing dance works; the compositional structure of a particular dance work.

chromatic scale
Scale made up of twelve semitones (opp. **diatonic scale**).

Classical
Of art, architecture or literature, either produced in or imitative of the style of Ancient Greece and Rome, seen as epitomizing excellence.

collage (Fr, pasting)
Technique originating with **Cubism** in which everyday materials were pasted on to a support, and sometimes painted.

colorist
Artist specializing in the use of color.

Conceptual art
Art in which concept is more important than content.

concerto
Work for a solo instrument and orchestra.

concrete poetry
Poetry whose shape on the page is pictorial and conveys meaning; popular in the 1950s and 1960s.

Cubism
Artistic movement c 1907–15 initiated by Picasso and Braque. It aimed to analyze forms geometrically (Analytical Cubism) or reorganize them in various contexts, often using collage (Synthetic Cubism).

Dada
International "anti-art" movement originating in Zurich in 1916; a forerunner of **Surrealism**.

dance
Art whose medium is the organized movement of the human body, usually to music; human activity involving the expressive movement of the body for its own sake, often connected with celebration.

de Stijl
Artists and architects associated with a Dutch art journal of this name, founded 1917 by van Doesburg and Mondrian, who promoted Bauhaus design during the 1920s.

diatonic
Of music, belonging to a scale made up of tones and semitones.

dissonance
An occurrence, in music, painting or poetry, of clashing elements where **harmony** might be expected.

dodecaphonic
Of music, using all 12 notes of the scale and according them equal value.

esthetics
Philosophy of art which seeks to formulate criteria for evaluating art in terms of its beauty, and for identifying the elements of beauty, in general, the branch of philosophy concerned with the arts.

etching
Print produced by drawing a design on a metal plate through a wax ground, then cutting the design into the plate with acid, and printing it.

Existentialism
A philosophy particularly associated with Jean-Paul Sartre which emphasizes personal responsibility and choice in an absurd or at least enigmatic universe.

Expressionism
20th-century artistic style in which expression of feeling has priority over realistic representation.

Fauves (Fr, "wild beasts")
Originally derogatory term used of a group of painters who exhibited at the Salon d'Automne in 1905, notable for their free use of color; Matisse was prominent among them.

figurative
Of art, representational.

fine art
Art whose origin is in the artist's sensibility, rather than the need to fulfill a function.

folk art
The art of peasant or tribal societies.

fresco
Mural painted on fresh plaster.

Futurism
Italian artistic movement founded in 1909 by Filippo Marinetti, which exalted the modern world of machinery, speed and violence.

graffiti
Drawings or words scribbled in random fashion on a wall.

graphic art
Term covering many techniques of illustration on paper, especially in monochrome, including drawing, engraving, **lithography**.

Happening
An event or display, often prearranged but with spontaneous elements, and dramatic or esthetic overtones; a feature of US and Western European art since the 1960s.

hard-edge
Term describing abstract painting using large flat areas of color with precise edges.

harmony
The simultaneous occurrence of sounds of different pitch in a relation which is congruous to the ear; the science of combining sounds in this way. Also applied to color combination, and even to line.

high-tech
Produced by, simulating, or facilitating the use of modern technology, especially from the 1970s on.

Hyper-realism
Painting style, often achieved with an airbrush, which vividly simulates reality.

Imagism
A short-lived movement in poetry (c1909–17), whose principles were articulated by Ezra Pound. Imagist poems employed clear visual imagery of great concentration.

Impressionism
19th-century French art movement, whose exponents sought to capture visual impressions, with an emphasis on light and color.

International Style
Influential **Bauhaus** architectural style, employing cuboids, and much concrete, steel and glass.

libretto
The text of an **opera**.

lithography
Printing method in which a design is drawn on stone with a greasy crayon, and then inked.

magic realism
Style used by modern (esp. Latin American) novelists and poets, with a rich combination of realistic, surreal and supernatural elements.

Metaphysical art
Movement associated with Giorgio de Chirico, c1915–18. Paintings were dreamlike, but realistic in their manner.

microtonality
In music, the use of tones between the 12 semitones of the chromatic octave.

minimal art
Modern art which rejects texture, subjects, atmosphere etc., and reduces forms and color to the simplest.

mobile
Kinetic sculpture, typically flat metal shapes hanging from wires and moving in air currents, originated by Alexander Calder and named in 1932 by Marcel Duchamp.

mode
Any of a number of ways of ordering the notes of the scale according to intervals (including major and minor scales), producing a basis for melody with a characteristic emotional quality.

modernism
A movement in the arts beginning in the late 19th century, which rejected traditional assumptions of order and value in favor of doubt, relativism, and a self-conscious concern with the formal organization of the artwork.

motif
Repeated distinctive feature in a design, musical or literary work, or artistic *oeuvre*.

mural
Picture painted on a wall.

musique concrète
Music made up of assembled recorded sounds.

myth
A story that a society subscribes to, often traditional or ancient, containing ideas and images which are deeply potent, emotionally and psychologically, and used to account for that society's actions, views or needs. In modern times, many artists have evolved personal myths.

Naturalism
Accurate detailed representation of objects and scenes as they appear.

Negritude
Socio-literary movement of the 1930s to 1950s, asserting the value of African culture and awareness.

Neo-plasticism
De Stijl. Mondrian was its main exponent.

New York School
The nucleus of **Abstract Expressionism** in the 1940s and early 1950s.

novel
Large-scale fictional prose work with complex action normally developed through interactions between characters.

novella
Short, realistic, relatively complex fictional narrative.

Op art (Optical art)
1960s movement in painting dealing with the creation of the illusion of movement by contrasts of geometrical shapes, lines and colors.

opera
Drama set to music, with dialog sung to orchestral accompaniment; in existence since 1600.

painterly
Term coined by art historian Heinrich Wölfflin to describe one of two contrasting painting styles: linear, emphasizing contours; painterly, emphasizing color and tone.

pentatonic scale
Scale made up of 5 whole tones.

perspective
Method of representing objects on a two-dimensional surface so that they appear three-dimensional.

pitch
Frequency (rate of vibration) of a musical note, which locates it in the scale.

plane
Flat surface; may also denote a mainly flat surface.

poetry
Writing, often employing rhyme and or regular meter, usually broken up into "lines", and characterized by the use of imagery.

polychrome
Painted in several colors; usually used of sculpture.

polytonality
The use of more than one key at a time in a musical work.

Pop art
Art derived from the popular culture of the 1950s and 1960s, using commercial illustration and advertising images.

Post-impressionism
Term coined by the art theorist Roger Fry for the style of art of Cézanne, Van Gogh, Gauguin and the Neo-impressionists.

Postmodernism
Blanket term describing current reactions away from the theories and conventions of "modern" art.

Post-painterly abstraction
Term applied to a group of abstract artists working in the 1960s. It includes a number of specific styles and movements, such as color-field painting and **minimal art.**

primitive
Describes oral, pre-industrial, especially tribal communities; carries no pejorative sense.

ready-made
Name given by Marcel Duchamp to prefabricated objects exhibited as works of art.

Realism
The presentation of unidealized subject-matter in the arts.

relief
Carving in which forms project and depth is hollowed out.

Romanticism
Late 18th- and early 19th-century movement in the arts in reaction against Classicism, emphasizing the role of nature and the imagination.

serialism
20th-century musical method developed after World War II, replacing traditional compositional conventions, in which composition is governed by a predefined series of twelve notes; the other musical elements – timbre, duration, attack, and dynamic – also are ordered in series.

social realism
Art dealing with social or political events and conditions.

Socialist Realism
Official, conservative, post-revolutionary style of art in the USSR.

sonata
Musical work with several movements, for one or two players, usually a solo pianist or other soloist with piano accompaniment.

stream-of-consciousness
20th-century literary style which seeks to represent the constant, uncensored and not necessarily logical, flow of thoughts of one or more characters. Notable exponents were Marcel Proust, Virginia Woolf and James Joyce.

Suprematism
Purist Russian **abstract art** movement of 1913–15 led by Kasimir Malevich, with geometric elements.

Surrealism
Literary and artistic movement of the 1920s and 1930s depicting dream and unconscious content, employing **Automatism** and other techniques.

Symbolism
French art movement, originating in poetry c1885. A reaction against **Realism** and **Impressionism**, it aimed to represent the spiritual world united with the physical. In general, the use of one thing to represent and engage with another.

symphony
Large-scale composition for full orchestra, divided into usually four movements. Also, an orchestra that habitually plays such works.

syncopation
Rhythmic device whereby stress falls on a beat not normally stressed (an off beat).

Theater of Cruelty
Term given by Antonin Artaud to a proposed theater whose function he laid down as the liberation of a sick society, using catharsis and ritual and dispensing with the stage. His ideas have massively influenced 20th-century experimental theater.

timbre
Also color; the sound quality characteristic of a particular instrument.

tonality
Musical key. In painting, values of color and light.

tone
Musical sound, or note; the quality of a sound. Degree of lightness or intensity of color or hue in painting.

ACKNOWLEDGEMENTS

Picture Credits

1 Selbi Mvusi working on a sculpture: Bailey's African Photo Archives
2–3 Merce Cunningham in Walkaround Time (1968): © Courtesy Anthony d'Offay Gallery, London, photo: James Klosty
4 Lobby of the Assembly Hall at Chandigarh: Le Corbusier Foundation, Paris
6 William Walton's music being recorded for Lawrence Olivier's Hamlet in 1948: BFI Stills, Posters and Designs
20–21 Party at Kiki's, Paris: Billy Klüver
56–57 Still from *The Cabinet of Dr. Caligari*: BFI Stills, Posters and Designs
92–93 Jean Arp in his studio: Alexander Lieberman
126–127 Stravinsky watching rehearsals: Martha Swope Photography Inc.
162–163 John Cassavetes directing a music session for his film *Shadows*: Joel Finler/British Lion Films Inc.
194–195 Gilbert and George: Jorge Lewinski

9 Roger Viollet, Paris **10** From "Vladimir Tatlin and the Russian Avant Garde" Yale University Press **12–13** Cecil Beaton photograph courtesy of Sotheby's London **15** Magnum/Erich Lessing **16** Magnum/Burt Glinn **18–19** Stuart Windsor **25** Mansell Collection **26** John Hillelson Agency/J.H. Lartigue **27t** Mansell Collection **27b** Hulton Deutsch Collection **28t** National Gallery, London **28b** Mansell Collection **29** Robert Harding Picture Library **30** Bührle College, Zürich **31** Giraudon/Musée de Bagnols-sur-Ceze, donation Besson © ADAGP, Paris and DACS, London 1990 **32** Giraudon/Museum of Modern Art, New York © DACS, London 1990 **33t** L'Oeil Archives, Paris **33b** Giraudon/State Pushkin Museum of Fine Arts, Moscow © DACS, 1990 **34l** Courtesy of the Mattioli Collection, Milan © DACS, 1990 **35t** Equinox Archive **35b** Bibliothèque Nationale, Paris **36** Library and Museum of the Performing Arts, Lincoln Center, New York Public Library **37l**, **37r** Mary Evans Picture Library **38–39** Scala/Musée de Beaux-Arts, Grenoble © Succession de H. Matisse/DACS, 1990 **41** National Széchényi Library, Budapest **42t** Equinox Archive **42b** National Gallery of Ireland, Dublin **43b** Ralph Burnett **44–45** Künsthaus, Zürich **45** Museum Folkwang, Essen **46l** Museum Ludwig, Cologne **46r** Städtische Galerie im Lenbachhaus, Munich © ADAGP, Paris and DACS, London 1990 **47** Städtische Galerie im Lenbachhaus, Munich **48** David King Collection **48–49** Daniel Frasnier, Montpellier **49** Museum of Modern Art, New York © ADAGP, Paris and DACS, London 1990 **50l** Sammlung der Gesellschaft der Musikfreunde, Vienna **50–51** The Covent Garden Archives, Royal Opera House, London **51** Mondadori Archives **52** Städtische Galerie im Lenbachhaus, Munich © ADAGP, Paris and DACS, London 1990 **53t** The Bettmann Archive, New York **53b** Magyar Építészeti Museum, Budapest **54t** Private Collection **54b** Cleveland Museum of Art, gift of Hanna Fund © ADAGP, Paris and DACS, London 1990 **54–55** Clovis Prévost **55t** Francisco Valls **55b** Sonia Halliday Photographs © ADAGP, Paris and DACS, London 1990 **61** The National Trust Photographic Library/Roy Fox **62t** Equinox Archive **62b** BFI Stills, Posters and Designs **63t** Equinox Archive **63b** Staatsgalerie, Stuttgart **64–65** Imperial War Museum, London **65t** By Courtesy of the Trustees of the British Museum **65b** Equinox Archive **66tl** The Tate Gallery, London **66tr** State Central Theatrical Library, Moscow **66bl** Equinox Archive **67** The Tate Gallery, London © ADAGP, Paris and DACS, London 1990 **68** State Literary Museum, Moscow **69** Private Collection **70** The Tate Gallery, London **71t** Centraal Museum, Utrecht/Frank den Oudsten © DACS, London 1990 **71b** Collection Haags Gemeentemuseum, The Hague © DACS, London 1990 **72** Bibliothèque Nationale, Paris **73t** Private Collection © COSMOPRESS, Geneva and DACS, London 1990 **73b**, **74t** Equinox Archive **74b** Národní Museum,

Prague **75** Peter Mackertich **76–77** Bridgeman Art Library/Albright-Knox Art Gallery, Buffalo, New York, © ADAGP, Paris and DACS, London 1990 **79bl**, **79br** Equinox Archive **79tr** International Museum of Photography at George Eastman House **80** Museum of Modern Art, New York **81t** Collection of the Newark Museum, Purchase 1937 Felix Fuld Bequest Fund **81b** Bridgeman Art Library/Philadelphia Museum of Art: The Louise and Walter Arensberg Collection © ADAGP, Paris and DACS, London 1990 **82** Museum of Modern Art, New York, Gift of Abby Aldrich Rockefeller, 1934 **83** The Metropolitan Museum of Art, The Alfred Stieglitz Collection, 1949 **84t** Museo Nacional de la Estampa, Mexico City **84b** Ministerio del Educacion, Mexico City/Bob Schalkwijk **86** BFI Stills, Posters and Designs **86–87** Museo Municipal des viellas artes Juan Manuel Blanes, Montevideo, Uruguay **87** Bibliothèque Nationale © ADAGP, Paris and DACS, London 1990 **88t** Library and Museum of the Performing Arts, Lincoln Center, New York Public Library **88b** Collection du Noyer de Segonzac, Paris/Carlo Bavagnoli **89** Mander and Mitchenson Theatre Collection **90t** Collection of the Heckscher Museum, Huntington, New York © DACS, 1990 **90b** Equinox Archive **90–91** Galleria Schwarz © ADAGP, Paris and DACS, London 1990 **91t** Magnum/David Seymour **91b** Magnum/Bruno Barbey **97** Tom Benton **98** Museum of Modern Art, New York **99** New School for Social Research, New York, Joseph Martin/Scala/Art Resource © DACS, 1990 **100t** Equinox Archive **100b** Topham Picture Source **102** Dr Franz Stoedtner, Düsseldorf **103b** Imperial War Museum, London **103t** Zeitgeschichtlich Bildarchiv Heinrich Hoffmann, Munich **104t** BFI Stills, Posters and Designs **104–105** Bridgeman Art Library/Museo del Prado, Madrid © DACS, 1990 **105** The Library, University College London, George Orwell Archive **106t** Lee Miller Archives **106b** BFI Stills, Posters and Designs **107** Magnum/Inge Morath **108** Lee Miller Archives **108–109** Wadsworth Atheneum, Hartford, The Ella Gallup Sumner and Mary Catlin Sumner Collection © DACS, 1990 **109t** Yad Vashem, Jerusalem **110** Culver Pictures Inc. **110–111** BFI Stills, Posters and Design **112** Library and Museum of the Performing Arts, Lincoln Center, New York Public Library **113** BFI Stills, Posters and Designs **114–115** Bridgeman Art Library/Museum of Modern Art, New York **117** Kings College Library, Cambridge **118** National Gallery of Modern Art, New Delhi **119t** Camera Press **119b** National Gallery of Modern Art, New Delhi **120b** Vishva-Bharati Gallery, Santiniketan **122** Yamatane Museum of Art, Tokyo **123t** Princeton University Library **123b** Bernard Leach Archive, Crafts Study Center, Holburne Museum, Bath **124t** Hamlyn Picture Library **124b** Equinox Archive **124–125** Arcaid/Richard Bryant **125** Estate of Robert Smithson **131** Topham Picture Source **132t** Popperfoto **132b** Marlborough Gallery, London **133** Picturepoint Ltd © DACS, 1990 **134b** The Archives of Coventry Cathedral **134t** Picturepoint Ltd **134–135** Le Corbusier Foundation, Paris **136** Collection of the Whitney Museum of American Art. Purchase, with funds from the friends of the Whitney Museum of American Art © DACS, 1990 **137b** Albright-Knox Art Gallery, Buffalo, New York. Gift of Seymour H. Knox 1957 © DACS, 1990 **137t** Nina Leen/Life Magazine © Time Warner Inc. 1951 **138** Amon Carter Museum/© Ansel Adams **139** Rudolph Burckhardt **140b** Stuart Windsor **140–141** Künsthalle, Tübingen **141t** Collection of Mr and Mrs Burton Tremaine © DACS, 1990 **141b** Magnum/B. Davidson **143t** John Haynes, London **143b** BFI Stills, Posters and Designs **144t** Equinox Archive **144b** Alphonse Leduc et Cie **145** Bridgeman Art Library/The Tate Gallery, London © ARS, New York **146t** Courtesy Anthony d'Offay Gallery, London. Photo: James Klosty **146b** Photo Richard Rutledge, the Merce Cunningham Dance Foundation **147** Collection of John Cage **148–149** Collection of the Harry N. Abrams Family **151** Bailey's African Photo Archives **152–153** Octopus Publishing Group/Michael

Holford **153t** Collection of Ulli Beier **153b** Octopus Publishing Group/Michael Holford **154t** Magnum/Eve Arnold **154b** Magnum/George Rodger **155** Museum of Modern Art, New York © DACS, 1990 **156** Bob Parent **157** Morgan and Marvin Smith, New York Public Library, Joe Nash Black Dance Collection **158t** Museum of Modern Art, New York **158b** Frank Spooner Pictures/Gamma/Bertrand Laforêt **158–159** Topham Picture Source **159t** Richard Bryant **159b** Frank Spooner Pictures/Liason/Ferry **165** Joel Finler/© 1971 Cinerama Releasing **166** Studio Marconi, Milan **167l**, **167r** Joel Finler **168** Archives Galerie Iolas **169t** Bridgeman Art Library/Private Collection **169b** Private Collection **170–171** Pasadena Art Museum © ARS, New York **171** Ida Karr Archives **172b** Magnum/Dennis Stock **174t** Hamburg Oper/Fritz Peyer **174b** Picturepoint Ltd **175** Leslie E. Spatt **176t** Vautier-de-Nanxe **176b** Deutsche Gramophon **177** Agence de Presse Photographique Bernard **178–179** Bridgeman Art Library/The Tate Gallery, London © DACS, 1990 **181** Magnum/P.J. Griffiths **182** IKON/Sir Russel Drysdale **183t** Waddington Gallery **183b** Private Collection of Mr and Mrs Michael Wells **184–185** Colin McCahon **184b** Angela Murphy **186–187** Maruki Museum, Mr and Mrs Masato Yamashita **186b** *The Independent* Newspaper **187** Shintaido of Japan, Tokyo **189** Joel Finler **192t** Private Collection © DACS, 1990 **192–193** Lee Miller Archives **193tl** Hirshhorn Museum, Smithsonian Institution. Photo: John Tennant © DACS, 1990 **193tr** Robert Mapplethorpe **193br** Courtesy Robert Miller Gallery, New York **199** Moore, Perez Associates Inc, UIG and Ron Filson **200t** Galeria Bonino, New York. Photo: Peter Moore **200b** Arcaid/Richard Bryant **201** L. Bezzola, Bätterkinden **202t** Frank Spooner Pictures/Gamma/M. Lounes **202b** Dick Wiser **203** Bridgeman Art Library/Private Collection **204** Geoff Dunlop **204–205** James Prigoff **205** Robert Mapplethorpe/Art and Commerce/Contact Press Images **206** Stedelijk van Abbemuseum, Eindhoven **207t**, **207c** Art Resource/Jane Melnick **207b** The Dinner Party Project Inc. **208tl** John N. Muafangejo **208bl**, **208r** BFI Stills, Posters and Designs **209** Geoff Dunlop **210** Collection of Igor Pchelnikov **211t** Katz Pictures Ltd/Gustavo Gilabert **211b** Joel Finler **212** Clive Barda **213l**, **213r** Sadler's Wells **214–215** Frank Spooner Pictures/Liason/Greenwood **217** Geoff Dunlop **218** Collection of Spencer and Myrna Partrich, Bloomfield Hills, Michigan **219t** Collection of Oswaldo Viteri, Quito **219b** Pablo Butcher **221t** Chris Nash **221b** Popperfoto **222** Magnum/Erich Hartmann **223b** Arcaid/Richard Bryant **224** Clive Barda **225** Quentin Bertoux/Pompidou Centre, Paris **226b** Andy Goldsworthy **226–227** Frank Spooner Pictures/Gamma/Gaywood **227t** Geoff Dunlop **227b** Magnum/Elliott Erwitt **228l** Equinox Archive **228c**, **228r** Popperfoto **229r**, **230l**, **230c** Popperfoto **230r** Hulton Deutsch Collection **231l** Magnum/C. Steele- Perkins **231r**, **231l**, **232c**, **232r**, **233l** Hulton Deutsch Collection **233c**, **233r**, **234l** Popperfoto **234c** Barbara Morgan **234r** Hulton Deutsch Collection **235l** Popperfoto **235c** Ida Karr Archives **235r** Popperfoto **236l** Hulton Deutsch Collection **236c** Equinox Archive **236r**, **237l**, **237c**, **237r** Popperfoto **238l**, **238c**, **237r** Hulton Deutsch Collection **239l**, **239c** Popperfoto **239r**, **240l** Hulton Deutsch Collection **240c**, **240r**, **241l** Popperfoto **241c** Hulton Deutsch Collection **241r** Popperfoto **242l** Novosti Press Agency **242c**, **242r**, **243l** Hulton Deutsch Collection **243r**, **244l** Popperfoto **244c** Equinox Archive **244l**, **245l**, **245c** Popperfoto **245r** Hulton Deutsch Collection **246l** Magnum/H. Cartier Bresson **246r** Magnum/René Burri **247l**, **247c**, **247r** Hulton Deutsch Collection

Equinox (Oxford) Ltd have endeavored to contact and credit all known persons holding copyright or reproduction rights in this book. If any omissions or errors have occurred, persons concerned should contact Equinox (Oxford) Ltd.

FURTHER READING

Author's Acknowledgements

I would like to thank my co-authors, whose material, as it came to hand, was first a delight, then a challenge and a spur to my own writing. The whole Equinox production team has been splendid throughout, concerned and enthusiastic and really a pleasure to work with. Peter Furtado's quiet discipline, sharp insights and well-timed telephone calls have kept the book straight but not at all narrow. In a book which derives so much from its design and range of images, I have been deeply indebted from the earliest discussions onwards to Ayala Kingsley and Christine Vincent. Sue Martin's sensitive stitching together of a complex body of material made my own editorial tasks much more straightforward. The structure of thought behind the book has been generated, more than anywhere, through working alongside my colleagues in American and Commonwealth Arts at Exeter University, Mick Gidley, Bob Lawson-Peebles, Richard Maltby, Peter Quartermaine, Ruth Vasey and, before he was translated to Oxford, Mike Weaver. I owe a similar longterm debt to the conversations, work and friendship of a number of artists, Alan Cotton, Nicholas Eastwood, Arthur Goodwin, Anthony Stones and Robert Tilling. Graham Fice and Joyce Jupp have helped a lot. The staff at the Caixa de Correio in Lagos, Portugal solved many problems at a crucial time in the writing. Lastly, and most of all, my gratitude to my wife Anne, who has borne all the hang-ups of writing and the writer, right up to this – the last word. Thanks.

Editorial and research assistance
Christine Allen, Steven Chapman, Laura Donohue, Andy Over, Philip Reed, Catherine Tranmer, Elaine Welsh, Michelle Von Ahn.

Artists
Alan Hollingbery, Colin Salmon, Del Tolton

Photographs
Shirley Jamieson, Angela Murphy

Typesetting
Brian Blackmore, Catherine Boyd; OPUS Ltd

Production
Stephen Elliott

Color Origination
Novacolour Ltd, Birmingham UK; J Film Process, Bangkok

Index
Ann Barrett

Visual Arts

Ades, Dawn and others *Art in Latin America* (London, 1989)

Bessett, Maurice *The Twentieth Century* (London, 1976)

Brown, Gordon H and Keith, Hamish *An Introduction to New Zealand Painting 1839–1967* (London, 1969)

Castedo, Leopoldo *A History of Latin American Art and Architecture* (London, 1969)

Duvignaud, Jean *The Sociology of Art* (London, 1972)

Elsen, Albert E *Modern European Sculpture 1918–1945* (Buffalo, 1979)

Fuller, Peter *Images of God* (London, 1985)

Gimpel, Jean *The Cult of Art* (London, 1969)

Gosling, Nigel *Paris 1900–1914: The Miraculous Years* (London, 1978)

Gray, Camilla *The Great Experiment: Russian Art 1863–1922* (London, 1962)

Heron, Patrick *The Changing Forms of Art* (London, 1955)

Hughes, Robert *The Shock of the New* (London, 1980)

Hunter, Sam *American Art of the 20th Century* (New York, 1973)

Kapur, Geeta *Contemporary Indian Artists* (New Delhi, 1978)

Lucie-Smith, Edward *Art Today* (2nd ed., Oxford, 1989)

Lynton, Norbert *The Story of Modern Art* (2nd ed, Oxford, 1989)

Quartermaine, Peter and Watkins, Jonathan *A Pictorial History of Australian Painting* (London, 1989)

Richardson, Tony and Stangos, Nikos (Ed) *Concepts of Modern Art* (London, 1974)

Rosenberg, Harold, *The Tradition of the New* (London, 1962)

Sullivan, Michael *Chinese Art in the Twentieth Century* (London, 1959)

Willett, Frank *African Art: An Introduction* (London, 1971)

Literature

Barthes, Roland *Writing Degree Zero* (London, 1967)

Bradbury, Malcolm and McFarlane, James (ed.) *Modernism 1890–1930* (Harmondsworth, 1976)

Brown E J *Russian Literature since the Revolution* (London, 1969)

Ellmann, Richard and Feidelson, Charles *The Modern Tradition* (New York, 1965)

Fiedler, Leslie A *Waiting for the End* (Harmondsworth, 1965)

Greene, H M *A History of Australian Literature* (London, 1961)

Hamburger, Michael *From Prophesy to Exorcism* (London, 1965)

Heaney, Seamus *The Government of the Tongue* (London, 1988)

Heller, Erich *The Disinherited Mind* (Harmondsworth, 1961)

Iyengar, K R Srinivasa *Indian Writing in English* (Bombay, 1973)

James, L (ed.) *The Islands in Between: Essays on West Indian Literature* (London, 1968)

Josipovici, Gabriel *The World and the Book: A Study of Modern Fiction* (London, 1971)

Kenner, Hugh *A Homemade World: The American Modernist Writers* (New York, 1975)

Leavis, F R *The Great Tradition* (London 1948)

McCormick, E H *New Zealand Literature: A Survey* (London, 1959)

Martin, Gerald *Journeys through the Labyrinth: Latin American Fiction in the 20th Century* (London, 1990)

Pacifici, S *A Guide to Contemporary Literature* (New York, 1962)

Paz, Octavio *Children of the Mire: Modern Poetry from Romanticism to the Avant-Garde* (Cambridge, Mass., 1974)

Poulet, Georges *The Interior Distance* (Baltimore, 1959)

Said, Edward W *Orientalism* (London, 1978)

Sartre, Jean-Paul *What is Literature?* (London, 1950)

Stead, C K *The New Poetic: Yeats to Eliot* (London, 1964)

Stearn, G E (ed.) *McLuhan Hot and Cool* (Harmondsworth, 1968)

Zell, Hans and Silver, Helene *A Reader's Guide to African Literature* (London, 1972)

Architecture

Collins, P *Changing Ideals in Modern Architecture 1750–1950* (London, 1965)

Frampton, K *Modern Architecture: a critical history* (London, 1980)

Hall, P *Cities of Tomorrow* (Oxford, 1988)

Harvey, D *The Condition of Postmodernity* (Oxford, 1989)

Jencks, C *Modern Movements in Architecture* (London, 1973)

Kopp, A *Town and Revolution: Soviet Architecture and City Planning 1917–1935* (London, 1970)

Pevsner, N *Pioneers of Modern Design* (London, 1960)

Sutcliffe, A (ed.) *Metropolis 1890–1940* (London, 1984)

Venturi, R *Complexity and Contradiction in Architecture* (New York, 1966)

Music

Abraham, Gerald *A Hundred Years of Music* (London, 1964)

Béhauge *Music in Latin America: an Introduction* (New Jersey, 1979)

Cage, John *Notations* (West Glover, Vt, 1969)

Cott, Jonathan *Stockhausen: Conversations with the Composer* (London, 1974)

Griffiths, Paul *Modern Music: A Concise History from Debussy to Boulez* (London, 1978)

Griffiths, Paul *Olivier Messiaen and the Music of Time* (London, 1985)

Henze, Hans Werne, *Music and Politics* (London, 1982)

Jackson, Irene V *More than Drumming: Essays on African and Afro-Latin American Music and Musicians* (Westport, Connecticut, 1985)

Raeburn, Michael and Kendall, Alan (eds) *Music in the 20th Century* (Oxford, 1989)

Stravinsky, Igor, and Robert Craft *Conversations with Igor Stravinsky* (New York/London, 1959)

Tippett, Michael *Moving into Aquarius* (London, 1959)

Vaughan Williams, Ralph *National Music and Other Essays* (Oxford, 1963)

Whittall, Arnold *Music since the First World War* (London, 1977)

Dance

Buckle, Richard *Diaghilev* (London, 1979)

Buckle, Richard and Taras, J *George Balanchine, Ballet Master* (London, 1988)

McDonagh, Don *Martha Graham* (Newton Abbot, 1974)

Vaughan, David *Frederick Ashton and his Ballets* (New York, 1977)

INDEX